The Heritage of Upper Canadian Furniture

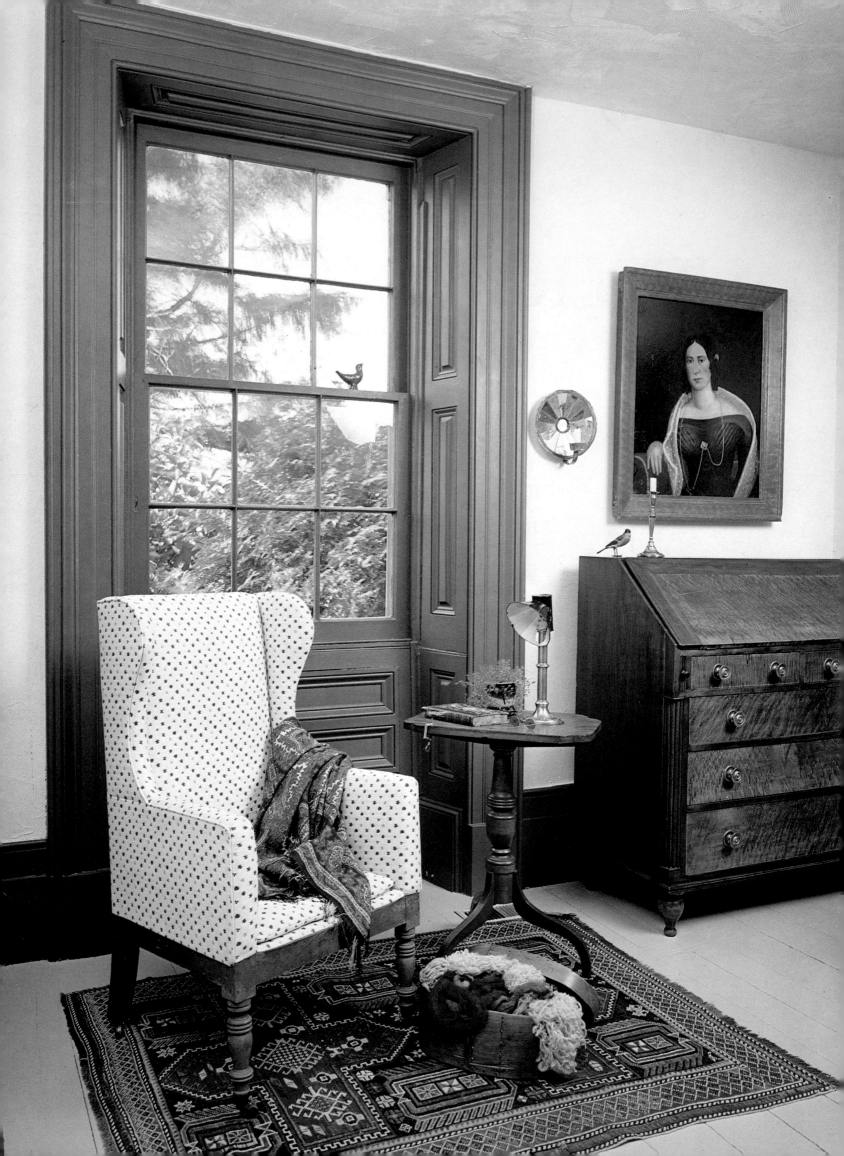

The Heritage of
UPPER CANADIAN FURNITURE

A Study in the Survival of Formal and Vernacular Styles from Britain, America and Europe, 1780-1900

HOWARD PAIN

Foreword by Dean A. Fales, Jr.
Introduction by William Kilbourn

KEY PORTER BOOKS

First Canadian edition published 1978
by Van Nostrand Reinhold Ltd., Toronto.

Key Porter Books
70 The Esplanade
Toronto, Ontario
Canada M5E 1R2

Library of Congress Catalogue Number 78-58661

Canadian Cataloguing in Publication Data

Pain, Howard, 1932-
The heritage of Upper Canadian furniture

ISBN 0-919493-39-4
ISBN 0-442-29830-7 (limited ed.)

1. Furniture — Ontario — History. I. Title.

NK2442.06P33 1984 C84-749.2'113 C84-098678-5

Acknowledgments
The author and publisher wish to express their gratitude to those who have
provided photographic and other material for use in this book. For a
complete list of acknowledgments, please see page 542, which for legal
purposes is considered to form part of the copyright page.

Editorial Consultant: James Wills
Design by Howard Pain
Frontispiece photograph by Peter Paterson
Typesetting by Howarth & Smith Limited
Colour Separations by Herzig Somerville Limited
Halftones and Film Assembly by Offset Film Systems Limited
Printed and bound in Italy
84 85 86 5 4 3

Contents

Foreword

One of an author's most important responsibilities is to sort through his material carefully, organize it properly and present it to the public clearly. An undigested mass of matter frequently resembles the shambles of a junk shop, while a thoughtfully conceived work has all the polish of a well-designed museum exhibition. Those who attend the exhibition – and the readers – are thus inspired with an overwhelming desire to acquire. This feeling is object love; it takes hold of us, shakes us, twists us, and there is no way in which it will let us go. It becomes an uncontrollable anticipation of pleasure; and in it lies the true inspiration of every collector.

Books on antiques and collecting usually appeal more to our intellectual knowledge than to our object love. After all, it is easier to deal with facts than emotions. On a few occasions, however, a work comes along that does justice to both. This book is one of those pleasant rarities. Howard Pain has combined the facts on a major frontier of Canadian furniture with myriad examples which should fan the embers of desire strongly in countless collectors, curators and students of history.

Diversity is the key word for Upper Canadian furniture, and the nineteenth century is the time. If the United States was a melting pot where cultural influences tended to blend into a semi-unified whole, in Upper Canada identities, societies and traditions were retained and tended to remain pure for generations. The heritages of the French Canadians, Irish, English, Scots, Poles, New Englanders, New Yorkers, Germans and Pennsylvania-Germans came with them and frequently remained undissolved until this century. The more formal British furniture styles of the late eighteenth and nineteenth centuries were constantly tempered by nearby American interpretations. At the same time, to the vernacular styles of England, Scotland and Ireland were added other folk styles of Germany, Switzerland, France and Poland, as well as those from French Canada.

All of these influences are carefully traced, and the illustrated foreign prototypes feature the simpler, less ornate pieces which relate directly to the furniture actually produced in southern Ontario. The parallels between the painted chests of the Kazuby region in Poland and those made in Renfrew County, for example, are little short of amazing. Of equal interest is the segregated mingling of both German and Pennsylvania-German influences in the productions of Waterloo County.

While the sources are fascinating, the actual stars of the work are the hundreds of examples of furniture actually produced in Upper Canada. Due to its remoteness and the rural lives of its early inhabitants, styles really did not mean too much. At best, high styles of all sorts tend to be ephemeral. When the look-to-London emphasis was removed from a good local craftsman's vocabulary, he could continue, in a traditional idiom, making objects that still were highly successful. Much Upper Canadian furniture represents country furniture at its best – honest construction, excellent materials and a reliance on basic line and simplicity. The newer styles were often consciously rejected by rural people. After all, what is best, the tried and the true or the unknown and new? The few highly stylish Hepplewhite and Regency pieces seem almost anticlimactic and stilted when compared to the singing rural cupboards, *Schränke*, tables and Windsors. Of course, not every piece of furniture made in Upper Canada was a gem. However, each example shown adds one small square to the highly varied total mosaic.

Through the persistence and patience of the author, countless examples of local furniture have been ferreted out from many sources. These show, as no written document can, material culture at its best. While some established collectors and students might tend to look down their noses at many of the later, lesser examples shown here, the whole body of Upper Canadian furniture will speak very well for itself. Future generations will be thankful that this material has been so carefully gathered at this time. It is vanishing from the collector's landscape all too quickly. But here, between these covers, is a most valuable record wherein Canadians can learn more of their heritage and themselves.

Dean A. Fales, Jr.
April 1978

Preface

Historically, Upper Canada describes not only an area at a particular time but also a distinct society in British North America which grew from a sturdy Loyalist core in the late eighteenth century to embrace tens of thousands of immigrants from many cultural backgrounds in a strongly British environment. This unique Upper Canadian identity survived until the mid-nineteenth century and even later when industrial development, a changing economy and modern communications introduced a new order that became the basis for modern Ontario.*

As Upper Canada was one of the latest major frontiers of the New World, its period of pioneer settlement and development remains uniquely visible. In the years between the arrival of the first Loyalist refugees and the development of extensive industry and transportation, the population grew to more than one million. This number included several major racial and cultural elements which were largely dependent on their own traditional skills for the necessities of living in and developing the new land.

The furniture of Upper Canada, as a result, is a hybrid of stylistic influences, tempered by a harsh, demanding environment and expressed by traditional craftsmanship. In the diversity of forms there is much for esthetic appreciation as well as possibly the most tangible surviving evidence of this romantic, historical period and of the cultural origins of a sizable part of the present Canadian nation.

This book is a celebration of my own twenty-five-year involvement with the early furniture of Ontario, an involvement which has been both fascinating and satisfying. During that time, interest in this field has matured from a small nucleus of local collectors, a handful of dealers and a few museum curators who were concerned with the early furnishings that turned up at auctions and other places where household effects change hands. In those early days, the best material often found its way to a more appreciative and knowledgeable market in the United States. Literature on the subject was non-existent, apart from American and British works that were devoured for relevant guidelines. Yet there were a few individuals whose instincts and knowledge provided inspiration and guidance to many of us.

In the sixties, Canadian heritage, history and particularly early Canadian furniture became fashionable in Canada. Like an Ontario spring, a full-blown antique industry blossomed from a few promising shoots in a very short period. This phenomenon brought mixed results. The interest in early furniture was largely focused on the simple lines and the warm, anti-industrial appeal of stripped pine. Less attention was paid to the finer pieces of formal character, to the provenance of the objects, or to proper restoration techniques (a substantial amount of important material was damaged by naïve enthusiasm). On the other hand, this widespread interest resulted in the assembly of notable public collections such as those in Upper Canada Village and in many local museums and historic restorations. Pioneers like Gerald Stevens, Philip Shackleton, Scott Symons, Donald Webster, Jean

* The Province of Upper Canada was created in 1791 and was renamed Canada West in 1841. With the Confederation of the Canadian provinces in 1867, the region became the present Province of Ontario. Officially, therefore, Upper Canada only existed for fifty years. However, because of the province's distinctive society, it seems appropriate, in a book dealing primarily with the furnishings of the first half of the nineteenth century, to use the all-embracing term, Upper Canada. The county names used throughout the book are those in use for the century or more prior to the introduction of regional government in some areas in 1974.

Minhinnick, Barbara and Henry Dobson and others produced a solid and sizable literary resource, particularly in the important area of Anglo-American styles.

During this period, particularly the last decade, a great amount of important material was identified for study. Today, many knowledgeable and dedicated curators and antiquarians are involved in the field. A growing number of collectors are highly sophisticated and conscientious in all aspects of the subject. At the same time, a broadly based awareness of cultural ancestry has stirred in all parts of the country. In turn, students of early furniture have found the question of origin for the many styles and forms that survive a challenging new dimension of interest.

In my own experience, exposure to furniture of a traditional nature in the United States, Britain and on the Continent brought into focus the relationship of many Ontario examples to several furniture traditions that had evolved elsewhere over the centuries. I became increasingly aware of the diversity and rich, multicultural character of Upper Canadian furniture and of the importance of this aspect as a subject for serious study. That awareness became the genesis of the project that has led to this book.

The objectives of the project were awesome in scale. They were to study, document and photograph the widest possible range of furniture of both formal and vernacular character that had been produced by traditional methods or as direct extensions of earlier style influences in the major areas of settlement during the first century of development in Upper Canada. Central importance was given to establishing the cultural environment from which the objects sprang, and the recurring forms were studied relative to the homeland traditions of the major immigrant groups. In light of the increasing mobility of a thriving antique trade, which can move material from one area to another with few clues to its origin, and the growing quantity of material being imported every day, it was apparent that such a study should be undertaken with some urgency.

In addition to this rather pragmatic definition, it was my hope that the result would embody some of the romance of this early period, provide a glimpse of the traditional craftsmen who made these fine objects and the people for whom they were made. Above all, I wanted to re-create for the reader, within the limitations of the printed image, some of the great pleasure derived from seeing the actual pieces.

In gathering the material for this book I have travelled thousands of miles in the province, examining almost as many individual pieces of furniture and photographing something over four thousand of them. I believe that these illustrations portray the major furniture types made in Upper Canada by traditional craftsmen. Included are many exceptional examples of early furnishing as well as many that are average. Each of them, I believe, is important to an overall understanding of the subject.

Extensive research in Europe permitted the definition, at least on an elementary level, of the relationship between local examples and the earlier traditions. A limited number of individual craftsmen are identified by name or by related groups of anonymous material. Nevertheless, there is still a great need for specific research in this area. It is my hope that this work may provide assistance to such future research.

The task of selecting the 1347 illustrations contained in this work from the much greater number photographed was both difficult and frustrating. Many excellent pieces were rejected in an attempt to achieve balance within the realities of practical book production. The qualitative judgments that are inherent in the presentation and discussion of the illustrated examples have been made according to three criteria: first, quality of design, decorative concept and craftsmanship; second, the condition of structure and integrity of surface finish; and third, historical significance. Many

pieces defy academic evaluation and are simply beautiful in their own right.*

Many people have contributed to this book in countless ways. My family have accepted the endless inconvenience with understanding and humour. For all manner of assistance, counsel and encouragement I wish to thank Dr. Ralph Price, Charles Humber, Nicholas Treanor and Michael Bird. Randy Howard, Clay Benson, Rod Brook, David Tyrer, Dr. Murray Barclay and Dean Fales have made knowledgeable comments of great value on both the visual material and text. The cooperation of editors, James Wills and Diane Mew, signficantly lightened the task of refining the material and greatly improved the result. Robert Wiggington provided photographic and technical advice, and Douglas Birkenshaw assisted at various times with the photography. Brenda Lee-Whiting was most generous with her unpublished research on the Renfrew communities. Blake and Ruth McKendry, Jennifer McKendry, John Harbinson, Joanne Dale, Paul Byington, Dr. and Mrs. B. Lyn, Dr. Harold Good, Tim Potter, Lyn McMurray, Mel and Jean Shakespeare, Michael and Sandy Rowan, M.F. Fehehely, Hank Milberg, W. Schlombe, Marjorie Larmon, Les and Nel Donaldson, Gordon Ball, Stan Johannesen, Rob Lambert, Robert Perkins, Ron O'Hara, Mrs. Kathleen MacKay, Mrs. Jean Innes, Mr. and Mrs. K. Martin, Mr. and Mrs. V. Smart, Mr. and Mrs. R. Henemader, Mr. Sandy MacLachlin and Tony Jenkins all helped in important ways, particularly with local research. The Society of Upper Mecklenburg, the Ontario Museums Association, the United Empire Loyalist Association of Canada, the Ontario Archives, the British, French, German and Polish embassies all were helpful. A grant from the Canada Council made research in Europe possible.

Grateful acknowledgment is made to the many museums across Ontario and in the United States and Europe whose personnel were so helpful and who offered ready access to their collections. A complete list of these museums will be found on page 543, together with the abbreviations used to identify them in the captions to the illustrations in the book.

Finally, I am particularly grateful to the individual collectors listed on page 542 who agreed to the intrusion of cameras and lights into their homes, patiently answered my questions, and offered much appreciated hospitality.

H.G.P.
Bedford Mills,
June 1978

* Even the most ordinary of these objects deserves careful preservation and as owners we are in a sense curators of a part of our cultural heritage. Thoughtful and knowledgeable restoration is of great importance. Furnishings which retain their original surface finish or decoration, whatever the condition, are the most valued of early material. These should not be altered in any way without expert advice and skilful, patient technique. Even those pieces with many layers of paint or varnish may retain a fine patina, painted decoration or early colour which can be restored with skill and care. Power sanders and strong chemicals are the greatest enemies of early furniture.

The practise of written documentation of the provenance of material in private hands is also highly recommended. The family name and origin, place of residence in Canada, where the object came from, who made it and related dates are all factors which add greatly to the interest and value of all early furnishings. These are often lost for all time if left to casual communication.

Early Furniture in Upper Canada:
A Personal Comment in Introduction
William Kilbourn

To cope with the hardships of the North American wilderness our European ancestors were thrown back on the simplest and most fundamental of human resources. Cities they could not have; many of the accustomed arts and pleasures were missing. But their furniture was a reminder and proof of identity and tradition, of the stability and permanence of the home across the seas most of them would never see again. It was indeed, in capsule form, both a sign and a sacrament of civilization itself. At staggering cost and difficulty, many brought with them family chests and cupboards, clocks, tables and chairs. Others used the abundance of New World materials to re-create, usually in cruder and more serviceable form, the styles and shapes they knew.

Dependence on such things has, of course, not been confined to our pioneer ancestors. Such dependence is one of man's fundamental necessities. Our relationship with the artifacts around us is nurture for the hand and eye and body. It touches the desire at the heart's core and speaks intimately of the furnishings of the soul.

"Taking possession of space," Le Corbusier has said, "is the first gesture of living things, of men and animals, of plants and clouds – the occupation of space is the first proof of existence." As surely as trees branch out and blossom and bear fruit or as birds stake out their territory with song, we human animals, to become fully ourselves, since the dawn of time have piled stones, fitted bits of wood, shaped bone and shell into the stuff of our immediate environment.

At first there was little differentiation between furniture and architecture. Even in medieval Europe the cupboard and bed, the stalls and benches, were mostly built into the walls and corners of house or shrine. Later the individual pieces become movable and by the seventeenth century they crowd our domestic spaces; they are our chief, and until recently, our only form of domestic sculpture.

They invite play: we scrape down to the grain and beauty of bare wood, we carve them in fantasies, we veneer or inlay them, we paint on them our stories and designs. A person changes and rearranges the pieces in a room as an expression of the inmost self – or of the social animal. A child makes a ship, a fort, a fire engine, from chairs and other objects of his household domain. Our earliest conscious memories are apt to be of the great fastness of an armchair, of the ball-and-claw foot of a table leg, of the slats of a crib or the sides of a trundle bed – "out of the cradle endlessly rocking . . .," as Walt Whitman recalled.

Older, though not necessarily wiser, we use furniture as metaphor. For government or business we chair meetings or companies, table motions, shelve issues. We put judicious persons on the bench. We get into bed with an opponent or a friend. The potentate's divan is another name for his treasury, the monarch's cabinet for his innermost council.

Furniture is also used as a statement of its owners' wealth or social standing or artistic taste. As John Kirk says in his book, *Early American Furniture*: "the well-to-do sought the latest mode . . . the most fashionable surroundings they could afford. They wanted their homes to appear similar to, or better than, those of their friends." He adds that there were exceptions, people "who because of esthetic preference or religious scruples had things made in a special way." Some of our Pennsylvania-German ances-

tors in Ontario, for example, influenced by Quaker or other puritan principles, determined to have in their homes "only what is decent and according to truth."

What we find in this book of Howard Pain's is not of course furniture, but two-dimensional images and shapes on paper. Similarly, in a museum we do not find chairs and tables and chests as they are really meant to be seen. Furniture is best enjoyed when it is an active member of the household, to be walked around, seen through, sat upon, and generally used in relation to the building, to other pieces, and to the people who own them. But the book itself, like the best museum arrangements, is a work of art and craft of another kind. And one art, especially in a book so superbly researched and designed as this, can illuminate another. Before going on a field trip to find country furniture or to an auction to buy, the amateur and the expert alike will do well to visit a good museum or to read such a book as this to reschool himself in standards and differences, even if in an artificial setting. Such sheer concentration of excellence is a form of tonic for eye and hand.

I have rarely seen an artifact from nineteenth century Upper Canada which I would call ugly, any more than I have seen a group of farm buildings – sheds, barns, stables, house – put up before 1900 or even 1945, which is not beautiful. I would no more call the most primitive pieces of early Ontario furniture ugly than I would use that word about the crayon art of a pre-school child. It is simply there – an expression, an answered need, a work of art. (A four-year-old girl was once asked by a lady what she was painting, expecting the answer "a kitty" or "a flower"; but the girl looked up with some disdain and pity and replied, "I'm painting paper.")

The furniture, like the architecture, of the period covered in this book is either simple, crude and satisfying. Or it is well-crafted and fine and perhaps even more satisfying. Or, just occasionally, it is great and original art, and therefore sublime.

In other ages – almost up to our own time in the more backward places – the simple craftsmen and great artists alike confined themselves to absolute laws of proportion, laws inherent in a few key figures of geometry first named by the ancient Greeks as "holy elements out of which God made the world in its original perfection." The proportion of any piece of furniture or building design – so long as it is kept true to its purpose and its models – needed only those elements in order to be beautiful, in the absolute sense of the word. Most craftsmen did not have the desire or imagination to try for anything else. Equally, there is an absolute sense in which the postmodern kitchen or living room contains much that is ugly – things of styrofoam and plywood and arborite and plastic and chrome, the aluminum flamingo decor, the twirling fantasies of blown glass, the Disneyland modern, the boiler-plate, the benzoid, the kitsch, the Hamtramck, the La-z-Boy, the television set in a machine-fretted pastiche of Chippendale or Spanish Renaissance. This sort of stuff is not just offensive to a few particular people who happen to like other things; it is to some degree absolutely ugly.

What caused the disaster?

It clearly did not happen because men have suddenly degenerated in the last century or so. In many ways – such as humanitarian concerns and actions – it can be argued that they have improved. The disaster has come chiefly for two reasons. First, there is the speed and thoroughness of the coming of industrialization. It has given us an incredible variety of new materials to choose from, a freedom with which so far we cannot cope, and the chance to manufacture almost anything out of almost anything else. So we have, naturally, been tempted to throw away the craftsmen's rulebooks and the old absolutes they contained. Second, there is the great gift of the

historical craft and imagination bequeathed to us by nineteenth century Romanticism. We can now accurately know and choose and mix our styles from any period in history without restraint. Furthermore, the geographic and social mobility of the mid-twentieth century has allowed, or rather forced on us, the freedom to choose from the vast new array of styles and materials available.

The first event to herald clearly the coming disaster was British industry's Great Exhibition of 1851. (Did not the mass-produced Rococo bedstead in cast brass prove that man could do *anything*? And did not Queen Victoria herself remark to her diary that the sight of a vast decorative Irish harp studded with real potatoes was most *gratifying*?)

But the influence of mass production and historicism was at work before 1851. The taste for late Empire style set by Napoleon was already being translated into mass-produced and vulgar imitations of Roman design by British factories in the 1820s. The great Duncan Phyfe was forced to turn out this sort of thing in order to stay in business, and his firm increasingly abandoned the quality of his earlier work. The swift and total revolution of modern times may have stimulated an art form like the novel which could cope very well with the Victorian bourgeoisie, but it brought a freedom which has for the time being been a disaster for design.

To name the arrival of industrialism, in conjunction with historicism, as the chief cause of trouble is not necessarily to be anti-industrial or to sympathize with the artsy-craftsy person who won't have a television set until he can make one on his own loom. On the contrary, the materials and methods of modern technology clearly offer part of the hope for recovery. Inexpensive and simple versions of the Windsor chair, the Barcelona chair and the sling are increasingly available. Hundreds of thousands of television sets are well designed, without resort to fake Chippendale or such extremes as the papier-mâché construction which one late Victorian firm used to make cheap pianos for the English lower middle-class parlour.

To delight in the craft depicted in these pages is no mere exercise in nostalgia. This book is a guide to seeing clearly, an instruction in looking at design with passion and intelligence, and in finding a way back to absolutes. But if we choose to use it simply to recover and enjoy the lost world of our nineteenth century ancestors, it will do that for us too. It is redolent of the atmosphere of early Upper Canada, of pastoral southern Ontario: the mild and temperate land between the lower edge of the ancient rock Shield and the rim of the Great Lakes, full of Holsteins and lush fields, cedar swamps and slow meandering rivers, a land of lawns and verandahs, great shade trees and weathered brick houses, fall fairs and weekly newspapers; a land that grew the Oslers and the Masseys, estates like Jalna, lakefronts and main streets like Mariposa's, Gaelic Glengarry, German Waterloo, Loyalist Prince Edward, and all the myriad counties and townships where these treasures of our early heritage made their home.

The Heritage of Upper Canadian Furniture

1 Wilderness to Cultural Mosaic

It is interesting to consider today that in less than one hundred years a vast wilderness area, greater in size than the British Isles, was transformed into a thriving, productive province. Within this short time span, well-developed farms, prosperous towns and bustling cities were established, grew and were connected by great railway systems, allowing modern industries to operate in many areas. It is even more significant that all this could have occurred within the lifetimes of the most long-lived of the first settlers.

The players in this saga sprang from diverse cultural and national origins, each one of which brought distinctive traditions and skills which came together, melded and reacted, producing, eventually, the phenomenon of present-day Ontario. The furniture produced during this era is tangible and highly emotive evidence of the complex social, cultural and economic factors which were involved.

The Loyalists

In 1791, the Imperial Parliament in London created the provinces of Upper and Lower Canada. Upper Canada encompassed roughly the territory of modern Ontario,[1] although the northern and western limits were not clearly defined until the Ontario Boundary Act of 1889. Upper Canada was an incredibly large area of virgin forests and lakes which, only a decade or so earlier, had been peopled by a scattered Indian population and a few hundred French Canadians, the only settlements a few isolated military and fur-trading outposts. The new province was created in response to the arrival in 1783 and 1784 of just over six thousand refugees from the turmoil of the American Revolution.

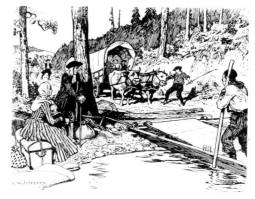

Loyalists on their way to Upper Canada, C.W. Jefferys. Public Archives of Canada

These refugees, who had either fought for the British or suffered losses as a result of their sympathies for the Crown, were known as Loyalists, later called United Empire Loyalists. As a group, they encompassed a wide variety of cultural elements. Many, as might be expected, were of English, Scottish and Irish origin, but there were also Dutch, Swedes, Swiss, Danes, French Huguenots, Spaniards, Germans and Indians. Some came from military and government backgrounds, but the greater part was made up of farmers and all manner of tradespeople who had been involved in the front rank of American colonial expansion.[2] Upper Canada was indeed created to welcome these loyal subjects, yet it was also known in London that they were excellent settlers, having an understanding of the wilderness of North America and the skills required to tame it based on the experience of a generation or more in the American colonies.

The Loyalists were given direct assistance by the British government in the form of land grants in the new province which varied in extent according to the nature of their service to the Crown. This was necessary for the settlers, for by choosing allegiance to Britain many had lost well-established homes, farms and business interests to the rebels, and as a result arrived in Canada destitute.[3] Of course, some were able to bring a few treasured heirlooms with them, and they arrived with their traditional skills and beliefs intact.

In general, Loyalist migration originated in the New England colonies, New York, New Jersey and Pennsylvania and followed two routes into the new province. One was along the north shore of the St. Lawrence or across Lake Ontario, settlement taking place along the river front west to Cataraqui (Kingston) and present-day Prince Edward County. The other route

focused on Niagara as a point of entry, the settlements fanning out across the peninsula from Lake Ontario to Lake Erie. The eastern settlement was initiated in 1784. However, at Niagara several hundred of Butler's Rangers were established on either side of the river and they were producing food for the garrison as early as 1780.

These Loyalist pockets were separated by huge Indian territories, so much so that in 1787 the Governor General, Lord Dorchester, wrote to John Collins, Deputy Surveyor General:

> It being thought expedient to join the settlements of the Loyalists near Niagara, to those west of Cotarqui [sic], Sir John Johnston has been directed to take such steps with the Indians concerned, as may be necessary to establish a free and amicable right for the Government to the interjacent lands not yet purchased on the north of Lake Ontario, for that purpose, as well as to such parts of the country as may be necessary on both sides of the communication from Toronto to Lake Huron.[4]

"British Customs, Manners and Principles"

With the growth of the Loyalist settlements and initial plans for future development underway, it eventually became apparent that the existing form of government, designed originally for the predominantly French province of Quebec, did not meet the needs of this new situation. It was argued at the time that for the colony to succeed, a governmental system was required that would "inculcate British Customs, Manners and Principles in the most trivial, as well as the most serious matters" in order "to assimilate the colony with the parent State."[5] To this end, an Order-in-Council of August 21, 1791, effected the formal division of the Province of Quebec, thereby creating the Province of Upper Canada.

Colonel John Graves Simcoe, first Lieutenant-Governor of Upper Canada, was admirably suited to carry out this concept, to create what he called "the very image and transcript of the British Constitution."[6] An aristocratically-minded soldier, he was also a strong believer in the established church and in the gradation of social classes,[7] and he immediately began to organize the newly formed province along British lines. He initiated surveys in several areas, incorporated towns and through extensive grants of land to his council and other favourites created a landed gentry. Additional settlers were also attracted to the new townships by an aggressive and successful advertising campaign.[8]

Simcoe was motivated to seek immigrants from the United States for two reasons. It would be a satisfying annoyance to his political foes there; but, more importantly, the Americans were highly skilled settlers whose thorough experience of frontier development would be beneficial to the entire community. Particularly gratifying to him was the success in attracting groups of Germans from New York State and Pennsylvania, because they were known to be excellent farmers and craftsmen with little inclination for political activity.

Beyond Simcoe's schemes, the availability of great quantities of good, inexpensive land attracted large numbers of immigrants of many nationalities who were involved in the movement westward from the early American colonies. The very early pioneer era in Upper Canada had seen a large percentage of settlers from the United States, including the Loyalists, but after the hostilities between England and the United States during the War of 1812 the swing was to large-scale immigration from the British Isles. Around this time, American, non-Loyalist applicants were discouraged due to the uneasy American-Canadian political climate. Nevertheless, the "Yankee twang" was a familiar sound in all areas.

By 1815, the original Loyalist settlements (east and west) were loosely linked by scattered communities along a narrow strip fronting Lake

Queen's Rangers under Lieut. Governor Simcoe cutting out Yonge Street, 1795, C.W. Jefferys. Public Archives of Canada

Ontario. Niagara, York and Kingston had become major towns and other centres were developing at the river mouths along the lakefront in much the same way that York had originally begun at the mouth of the Humber. Still, the total population of this huge area was only about 100,000 at this time. The years up to and including 1812-15 may be considered as the "pioneer period," with the following decades being a time of growth and the consolidation of communities.[9]

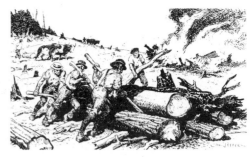

Clearing Land, 1825, C.W. Jefferys. Public Archives of Canada

The Development Era

The impact of land reform policies and the Industrial Revolution left many of the British working class dissatisfied and with little hope for the future. As a result, the British government initiated programs of sponsored emigration to Canada which continued until 1855. Political upheaval in Continental Europe, similarly, caused many to leave their homelands to seek a brighter future in the new world. Between 1815 and 1860, thousands upon thousands of immigrants arrived in Canada from Britain and the Continent. During 1831, a peak year, over 30,000 Irish, 16,000 English and 5,000 Scots arrived at the port of Quebec alone, while in 1847 over 100,000 came to the colonies from the British Isles.[10] The size of this last figure is partially due, of course, to the many destitute Irish who were fleeing the potato famine of 1845. It is estimated that between 1830 and 1870 50,000 Continental Germans came to Upper Canada.[11] These immigrants disembarked at Montreal or Quebec and a good percentage moved on by steamer or stagecoach to one of the Upper Canadian centres. Most brought only personal possessions and few resources to build a new life. From 1846 to 1859, labourers and farmers were far in the majority among these arrivals, carpenters ranked second in number, then came miners, shoemakers and tailors, house servants, blacksmiths and masons.[12] Others came from more privileged circumstances and were able to establish themselves in some comfort rather quickly. Both types of settlers were central to the concept of a well-balanced social structure which had survived from Simcoe's grand plan.

Commerce in the major towns along the lakefront thrived as the settlers arrived and equipped themselves to move into the hinterland. A prosperous merchant class developed; artisans and tradesmen of all types found a ready market for their skills. The immigrant had many choices of location, but often settled as part of a group based on earlier associations, or followed others of the same national, linguistic or religious background. For example, over a period of fifty or more years the settlement of Pennsylvania Germans centred in those areas that had been selected by their countrymen in the last years of the eighteenth century and the first decade of the nineteenth. Further, these same areas attracted Continental Germans, because the German language had survived there and there was some sharing of religious beliefs. Such national or cultural centres overlapped in a complex pattern across the province, and many areas developed a distinct character which survives to the present day.

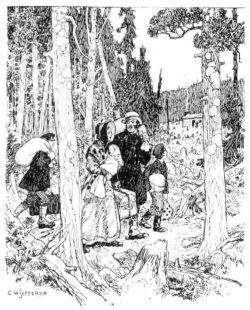

Emigrants in the Woods, 1830, C.W. Jefferys. Art Gallery of Ontario

The Eastern Counties

The Loyalist communities along the eastern front to Prince Edward County had prospered and attracted additional early settlement, principally from the British Isles. The counties of Glengarry, Russell, Prescott, Stormont, Dundas, Carleton, Grenville, Lanark, Leeds, Frontenac, Lennox and Addington, Prince Edward and the southern parts of Hastings and Northumberland were largely settled by 1825-30. By this time, the principal towns along the river and lakefronts were well established and countless hamlets and mill sites were located every few miles throughout the area.

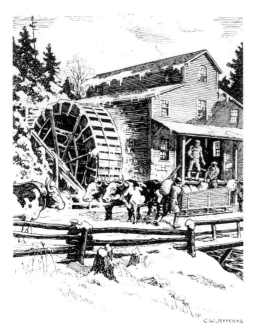

A Grist Mill, C.W. Jefferys. Public Archives of Canada

Next to agriculture, lumbering was the most important factor in the early economy of the counties, providing jobs for many transient workers as well as cash income for settlers in the first difficult years.

Already, distinct cultural patterns of settlement had emerged. Highland Scots centred in Stormont, Dundas and Glengarry. As early as 1800, "there was hardly a Scottish clan that was not represented in Glengarry."[13] Lowland Scots settled large areas of Carleton and Lanark, where Perth became a prosperous centre with a distinct Scottish character. The available land and promise of jobs brought French Canadians from Lower Canada to Prescott, Russell and Carleton along the shore of the Ottawa River and into the northern parts of Glengarry and Stormont. Pensioned British Army personnel settled in Carleton, establishing a landed-gentry society which was in marked contrast to most during the pioneer era. The Irish located in all parts of the eastern counties. In fact, they were the majority in large parts of Leeds, Frontenac, Lanark, Lennox and Addington, Hastings and Northumberland. Similarly, there were strongly English sections of Leeds, Grenville, Prince Edward, Hastings and Northumberland. In addition to the large-scale immigration from the British Isles which augmented the original Loyalist settlements in the eastern region following the Napoleonic Wars, there was a continuous flow of Americans up to 1812, with a major settlement along the front of Northumberland.

The townships near the river and lakefront retained a strong Loyalist character, since sons and daughters of the refugees began to exercise their rights to the land. According to these rights, sons of Loyalists were entitled, under the original agreement, to a grant of two hundred acres when they came of age, while daughters had the same rights either at the age of majority or at the time of their marriage. Among these were a large number of Germans,[14] particularly in Stormont, Dundas and Lennox and Addington. They were long removed from their homeland traditions, however, having been by the second generation largely integrated into the predominantly British character of these communities.

The counties further to the west, Peterborough, Durham and Victoria, were settled by all three English-speaking groups, though somewhat later than those in the extreme east. Several predominantly Irish townships in Peterborough and Victoria counties resulted from a major migration from Cork in 1825, while centres of English gentility were created in the same area by half-pay British military and naval personnel. One of these was the town of Peterborough, observed in 1833 by an aristocratic settler as "a very pretty, picturesque thriving village, with nearly thirty genteel families within visiting distance."[15]

The Central Counties

With the selection of Toronto (renamed York by Governor Simcoe) as the seat of government in 1793, the surrounding Home District became an important focus of settlement. This district included York and Simcoe counties, among the other present-day counties of Peel, Halton and large portions of Grey, Dufferin, Wellington, Ontario, Waterloo and Wentworth. Large grants were given to military personnel as well as other friends of the Simcoe regime, so that lands patented far exceeded those actually settled for many years. Different settlement schemes brought immigrants from Britain and the United States; streams of Americans came to York in the last years of the eighteenth century and the first decade of the nineteenth. Among these were Quakers, who settled in Ontario and York counties, along with Germans from Europe via a short stop in New York State, and Pennsylvania-Germans who settled the townships surrounding the capital. Farther north of the lakefront strip settlement of the townships was rather slow until 1820, when reforms in the land-granting system opened up

many areas which had been held undeveloped by absentee owners for many years. Immigration during this period largely originated in Britain, thousands of English, Irish and Scots moving through York to new areas surrounding Lake Simcoe and northward to Georgian Bay. In 1828, a settlement of French Canadians was established at Penetanguishene, which had been a centre of French trade, a military post and a Jesuit mission before 1791.

The Western Counties

The western region is perhaps the most complex of all in its cultural geography. The earliest settlements originated in Niagara and moved out into the peninsula, particularly along the shores of Lakes Ontario and Erie. By the end of the eighteenth century, these largely British and Germanic Loyalists were well established on excellent peninsular lands. Leading the waves of post-Loyalist immigration from the United States were the Pennsylvania-Germans, who settled largely in the Niagara Peninsula and west along Lake Erie to the Indian lands on the Grand River. Other Mennonite and Tunkard groups from Pennsylvania moved across Lincoln County to the Grand River valley and northward to found early communities in Waterloo County.

American settlement in the west became so great between 1800 and 1812 that there was very real concern about the loyalty of the large Yankee element and its effect on the colony's security. According to one commentator, "in 1812, four fifths of the total population of Upper Canada were of American origin and only one fifth of British origin. Of the American element only one in four was Loyalist or of Loyalist descent."[16] This was sufficient for General Isaac Brock to state in 1811 that, "the great influence which the vast number of settlers from the United States possess over the decisions of the Lower House is truly alarming."[17] Following the War of 1812, Lord Bathurst developed a plan to correct this uneasy situation: British regular troops would be demobilized and given lots along the frontier, government-sponsored immigration would be initiated from Scotland and Ireland, no further land would be granted "to subjects of the United States" and, finally, every endeavour would be made to prevent their settling in either of the Canadas.[18] Although the balance noticeably shifted in favour of the British groups during the next years, Americans continued to cross the border and many early industries were founded on "Yankee know-how."

The encouragement and eventual location of British immigrants in the western counties were greatly assisted between 1812 and 1840 by the Talbot Settlement. Committed to the objective of British dominance, Colonel Thomas Talbot, an English aristocrat who had served under Simcoe, was given large tracts for development. Eventually, the Talbot Settlement extended from Norfolk County to the Detroit River, including large parts of the present-day counties of Haldimand, Elgin, Kent and Essex. Talbot made certain that a very large percentage of the settlers were British or Loyalist; however, American involvement included Pennsylvania-Germans and Quakers in Elgin and Kent, two groups known for diligence and non-political attitudes. Later settlement in the area included Germans from Europe and a number of French Canadians whose presence strengthened the French communities that had survived along the Detroit River in Essex County since the mid-eighteenth century.

The counties of Halton, Wentworth, Brant, Oxford, Middlesex and Lambton developed with similar characteristics to those along the Lake Erie shore. Prior to 1812, Loyalist and American elements were strong, with the emphasis shifting to the English, Scots and Irish after 1815. Oxford and Middlesex were marked by a particularly strong British stamp, yet there

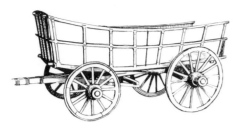

Conestoga Wagon, C.W. Jefferys. Public Archives of Canada

was some settlement of Quakers and Pennsylvania-Germans.

In the heart of the rich farm lands of the western region, a unique and highly complex cultural mix developed which centred in Waterloo and grew to include Perth County as well as parts of Wellington, Oxford and Middlesex. The early settlement of Pennsylvania-Germans was the beginning of a large and almost continuous migration of Mennonites, Tunkards and others who followed the same path northward throughout the first half of the nineteenth century. The "Plain Folk" gravitated to settlements based on religious sects, earlier associations and family relationships. They spread out from the initial Waterloo area into the surrounding counties. Between 1825 and 1855, eighteen to twenty churches or meeting houses were built in the area by these groups.[19]

Other early communities in Waterloo, Perth and Wellington were inhabited by people of British origin, particularly Scots. As a result, the area was already one of cultural contrast in the late 1820s when Germanic immigrants began to arrive from Europe. Some of these were Amish, who shared religious principles with the Mennonites, while others were attracted there because German was the accepted language. This Germanic community was bolstered with the arrival of Rhineland Germans, Bavarians, Prussians, German-speaking Swiss and Alsatians from the north of France. Many were farmers, and they established distinct communities throughout Waterloo, Perth and parts of the neighbouring counties; others were tradesmen or technicians, and they started businesses in Berlin (later Kitchener), Waterloo and other Germanic centres.

At the same time, additional Scots, English and Irish were arriving, leading to the founding of British-oriented towns like Stratford, Guelph and Galt. As well, a number of French Canadians from Lower Canada settled in the northern sections of both Waterloo and Perth counties.

The vast Huron Tract, developed by the Canada Company, encompassed Perth, Huron and parts of Lambton and Bruce counties. This area, bordering Lake Huron, was inaccessible until a road was opened from Waterloo in 1827. Area settlement was heavily British, with Swiss, Germans and Alsatians locating in Perth as part of the large "Waterloo area" Germanic community. Later, groups from the Continent settled along the shore in Huron County and further north in Bruce, some of whom had moved from earlier locations in Waterloo.

A similar type of development occurred in Grey, Dufferin and the northern parts of Wellington. These areas were settled by the British groups toward the mid-nineteenth century, incorporating small German pockets, some of which were the result, again, of movement from Waterloo and Perth in the south.

Later Settlement

Understandably, the areas further north developed later than the more accessible and desirable southern counties. Here, the bulk of settlers came from earlier southern settlements during the last quarter of the century as the interior was opened up. The lines are not clear-cut, however, since counties like Haliburton, for example, saw the involvement of an English land company with some immigration from Britain, later southern settlements and French Canadians in Lutterworth and Minden townships. Similarly, Muskoka attracted the French in Baxter, Gibson and Freeman townships and scattered settlement overall from the south. Gibson itself also possessed a small Indian population.

French Canadians moved into Parry Sound County along with some Germans and Swiss in Gurd, Nipissing and Himsworth. All the townships were settled by people from the south, although in many areas the population remained quite sparse. There were, however, Ojibway communities in

the area, especially in Parry Sound. The French Canadian element of
Nipissing was swelled by a repatriated group from the United States under
the leadership of Father Parades. Calvin and Ferris counties received
English and Highland Scots via the older counties, in addition to the
Germans in Ferris and the Swedes who settled in Ratter and Dunnet. Polish
and Finnish miners came to Broder and McKim, and a sizable Ojibway
population centred in several nearby locations. In Algoma, French Cana-
dians settled along the Canadian Pacific Railway line, and from there
moved throughout the townships. Germans from the earlier Renfrew settle-
ment migrated to Balfour, Dowling and Creighton townships where they
lived closeby British settlers from the older southern counties.

Throughout Algoma, a number of settlements were comprised of Ojib-
ways from Lake Huron, yet Manitoulin Island was settled by both Ojib-
ways, Ottawas and non-native settlers from the south. Thunder Bay was
sparsely inhabited by southern British groups, the majority being French
Canadians centred in White River, Schreiber and other points along the
railway line. The development of mining operations attracted Cornish and
Norwegian miners to Port Arthur, and the Lake Superior Ojibways estab-
lished themselves in such locations as Fort William, Lake Nipigon and
Michipicoten. The French Canadians spread into Rainy River and on to
Pine River near Lake-of-the-Woods. British settlers from Bruce, Grey,
Simcoe, Ontario and Muskoka took up the agricultural lands along Rainy
River and Scandinavian miners came to Rat Portage. The native population
included reserve groups of Chippewas and Saulteaux.

Most of these settlements took place during the last decades of the nine-
teenth century and the early years of the twentieth. Many were made
possible by the railway, and by lumbering and mining operations. There-
fore, they are often more closely related in character to twentieth century
Ontario than to nineteenth century Upper Canada. One important excep-
tion was northeastern Renfrew County. This territory had seen some early
settlement by Scots, Irish and French Canadians along the Ottawa River.
During the 1850s, a major road-building project opened up a large area for
settlement, attracting immigrants from eastern Germany and Poland. The
self-reliant nature of these communities has led to the survival of distinct
cultural traditions to a high degree well into this century.

By the last quarter of the nineteenth century, the province's population
totalled well over one million people, and the foundations of present-day
Ontario were well formed. Today's major cities were already important
towns, and countless villages and hamlets served the fully-settled town-
ships. It is important to remember that some areas, particularly the
northern and eastern counties, were more densely populated in 1860 than
they are at the present time. Indeed, some prosperous communities of that
period have all but disappeared as the population moved from marginal
agricultural areas to the industrialized cities.

The Mosaic Reflected

The years from 1840 to 1867 – from the Act of Union to Canadian Confed-
eration – were ones of tremendous growth and consolidation. Substantial
houses had all but replaced the log cabins of the pioneer period, except in
the most remote locations, where they exist to this day. While the early
phase of settlement had been marked by courage and resourcefulness, the
development era was impressive for the sheer energy involved in building
the physical fabric of a new country. Domestic furnishings were obviously
necessary during the early years, but the quantity required to meet the
demands of rapid expansion is itself awesome in scale. The following
inventory from one prosperous new home of the period is an interesting
illustration of this fact.

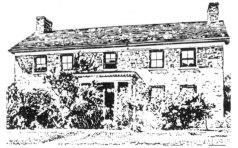

Upper Canadian home, ca. 1810, C.W. Jefferys. Public
Archives of Canada

List of Furniture in our House
Myrtleville Farm
August 1849
Eliza Good

Parlour

12 chairs
1 child's do
1 sofa with hair mattress
1 dining table
1 small table
1 book shelf
1 carpet and rug
brass fender
shovel and tongs
logs, fire board
card racks and 4 pictures

Drawing Room

Piano [Plate 1321]
12 chairs mahogany
1 sofa spring do
1 walnut table
1 small pine do
1 walnut bookcase
1 glass case
3 pieces of silk embroidery
6 colour prints all in gilt frames
1 miniature maple do
India china on mantle piece
1 carpet and rug
1 green fender
fire board and logs
shovel and tongs
1 mahogany writing desk
1 rosewood do
1 mahogany work box
2 rosewood do
2 soft maple do

A & G's Bedroom

1 large four post bedstead
1 trundle child's do
1 child's cot
2 walnut chest of drawers [Plate 651]
1 mahogany looking glass
1 Japan dressing case
1 double walnut wash stand
2 blue chamber sets of ware
1 large easy chair
1 common do
1 deal press [Plate 517]
2 large trunks
old carpetting

Anne Good's Room

1 large four post bedstead
1 walnut chest of drawers

1 deal table and mahogany looking glass
1 white chamber set
1 small common washing stand
2 common chairs

Nursery

1 large four post bedstead [Plate 710].
1 child's do
1 painted table
1 servant's bedstead
1 common chair

Boy's Room

2 low poster bedsteads
1 deal table
2 white chamber sets
1 mahogany looking glass
1 leather trunk
1 deal box
1 child's baby house
1 common chair

Kitchen

2 common bedsteads
2 tables, 4 wash tubs
stove and furniture
shovel and tongs
4 smoothing irons
5 wooden pails
1 tin do
several small tins [?]

Miss Carroll's Room

1 large four post bedstead
1 mahogany looking glass
1 walnut wash stand
1 blue chamber set
2 tables
1 arm chair
1 common do
1 large clothes press
2 trunks
2 deal boxes
carpetting
curtains to bed and windows
Walnut hatstand in Hall
muslin window [?] for drawing
room parlour and A and E's room
muslin do for parlour and drawing room
blinds for all the windows

Bedding and Bedclothes

3 pillowcases
6 large feather bed [?]
3 hair mattresses
10 bolsters
12 feather pillows
18 pair of blankets and under blankets
3 chaff beds for servants
6 white quilts
7 old patchwork do
1 good do
24 pair of sheets
20 pillow cases
8 table clothes
between 5 and 6 dozen of towels of
all kinds new and old
12 bolster cases
baby clothes and sufficient
clothing for 3 boys and 6 girls

In Closet

milk pans yellow English ware
Eastern ware blue, and tea set china
glasses and decanters
1 dozen white ivory knives and forks
spinning wheel and reel
music books
a quantity of cloth, flannel, white and grey
calico and muslin do
[?] dresser not made
2 watches, one gold enamelled, one silver
1 diamond ring, 2 others not very valuable
1 pearl brooch
2 gold with hair pins
1 gold gentleman's pin
1 handsome gold
1 miniature set in gold
hair chain do
1 silver eye glass
1 silver etni [?]
2 cases with silver knife, fork and
spoon in each
3 silver fruit knives

Until the 1850s, furniture was made primarily by individual craftsmen of various traditional backgrounds. They produced one piece at a time to meet the specific requirements of their clients. Some of these craftsmen were joiners who made utilitarian furnishings as well as doing other types of carpentry and building; others were highly skilled cabinetmakers who had learned their craft in sophisticated centres in their homelands. Artisans of both types were important members of their nationally or culturally based communities, because the familiar forms they created were a source of reassurance to their neighbours in a strange and often harsh new land. Thus, a retired colonel from the British Army might obtain a finely crafted Hepplewhite-style candlestand for his drawing room, or a Palatinate German farmer might order a *Schrank*[20] as a traditional gift for his daughter's wedding.

By 1850, however, most towns and villages had several cabinetmakers and cabinet shops serving the local area with a wide range of services in addition to the production of individual pieces of furniture. Often, these services included undertaking, as seen in J. Gibbard's advertisement in Napanee:

> Cabinet and Upholster Work consisting of Sofas of the latest patterns, Couches, Ottomans, Lounges, Bureaus of many patterns, Side, Centre, Toilet, Dining and Work tables. Bedsteads always on hand, Rocking, Parlor, Cane, Windsor, and Children's Chairs, Upholstering done on the shortest Notice. Coffins always on hand. A Hearse will attend Funerals when desirable. – He also Manufactures Sash, Pannel Doors, Blinds, House Moulding & C, & C, Planing and Matching done on the shortest notice and with neatness and dispatch.

With the development of railways and large-scale manufacturing facilities in major centres during the latter part of the nineteenth century, furnishings were readily moved from one area to another. Traditional characteristics became less visible, although some areas retained their cultural segregation to a surprising degree. Nevertheless, this later period saw the emergence of a middle class, based largely on commercial and professional occupations, which was style-conscious and responsive to the fashionable products of the newly developing furniture industry.

For most of the one hundred years under study, however, the Upper Canadian population was primarily agricultural, from humble origins and with modest aspirations. There was, of course, a small, powerful and wealthy elite and the beginnings of a middle class, but these were not sufficient to support a distinct, sophisticated furniture-making tradition. This profile is reflected, rather, in the provincial character of the furnishings that were made and in the absence of many fashionable styles found in older, more urban centres.

The furniture of the pre-industrial period reflects with some clarity the cultural make-up, attitudes and lifestyles of the young colony. The conservatism and traditionalism of the Loyalists, the dominance of British attitudes, the progressive influence from the United States and the incredibly rich heritage of several European cultural traditions are all important factors in the society which developed and, in turn, in the furnishings which it produced.

2 Style Influences in the Furniture of Upper Canada

The expressions of stylistic influences in the furniture of Upper Canada were highly complex, and the chart on page 29 illustrates these patterns in graphic form. A detailed discussion of each will follow in later chapters; however, a brief overview may be useful here. There were three major categories of influence which flowed simultaneously into the young colony. They were: (1) the formal furniture styles of Britain and Continental Europe; (2) the traditional/vernacular styles of Britain, Continental Europe and French Canada; and (3) the formal and vernacular styles of the American Colonies and the early Republic which were largely developments of (1) and (2) in an American context.

Each of these influences is visible in the furnishings which survive from the late eighteenth and the nineteenth century. Most areas of the province reflect all three categories to some degree, yet the predominant styles and types of furnishings in any given area vary in relation to the economic and ethnological nature of the settlement, its location, size and date.

In studying the impact of stylistic influence from sophisticated centres of fashion on furniture made in Upper Canada, particularly in the early period, we are immediately struck by the provincial character of that predominantly rural society. The Upper Canadian expression of a formal style is likely to be caricature-like in its economy of detail, simplified by the immigrant craftsman according to the level of his skill, the selectivity of his memory, the available tools and material and the means of his client. Often, we see details or forms from earlier centuries combined with those of contemporary style, producing hybrids not found in any directory of style. The traditional forms were also modified as a result of exposure to other cultures and to preserve their functional qualities in New World conditions.

Along with the influences in style from these different sources, the immigrant craftsmen brought the distinctive woodworking techniques of their homeland tradition to bear on their products. Despite the fact that a sizable amount of primitive material was produced by ordinary settlers for their own homes, the pieces contained in this study were largely produced by carpenters, joiners and cabinetmakers who had learned their craft in an earlier tradition. In addition to the basic methods of construction which their earlier experience provided, most of these craftsmen had a knowledge of popular forms and details and some understanding of proportion and the organization of elements. In fact, all of these were part of the apprenticeship training that existed in most of their homelands.

These craftsmen selected materials from the abundance of native cherry, walnut, butternut, maple, birch, oak, ash, hickory, basswood and pine for their inherent structural and decorative qualities. These woods were used largely in the solid, with combinations of contrasting colours and carefully planned grain patterns often substituting for the elaborately veneered, inlaid or carved treatments of the original styles. The use of paint as a decorative finish was inherited from most of the earlier vernacular traditions and was used extensively on the large quantity of furniture made from native pine. This included the use of single and contrasting flat colour combinations on utilitarian furnishings, as well as meticulous and exuberant facsimiles of exotic woodgrain patterns where a more formal

Formal Style

Vernacular Style

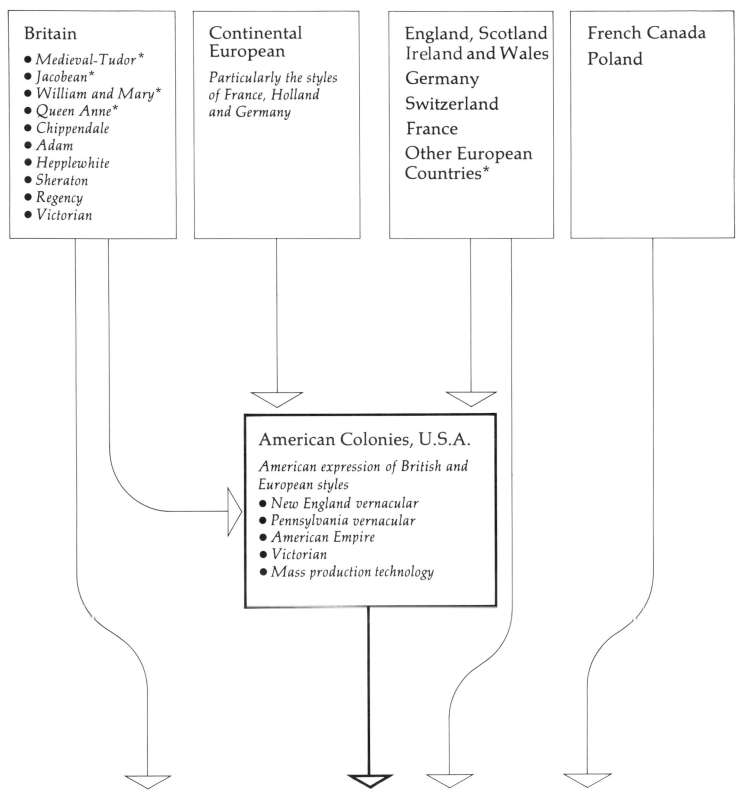

Britain
- *Medieval-Tudor**
- *Jacobean**
- *William and Mary**
- *Queen Anne**
- *Chippendale*
- *Adam*
- *Hepplewhite*
- *Sheraton*
- *Regency*
- *Victorian*

Continental European

Particularly the styles of France, Holland and Germany

England, Scotland Ireland and Wales

Germany

Switzerland

France

Other European Countries*

French Canada

Poland

American Colonies, U.S.A.

American expression of British and European styles
- *New England vernacular*
- *Pennsylvania vernacular*
- *American Empire*
- *Victorian*
- *Mass production technology*

The Furniture of Upper Canada

**Limited direct influence in Upper Canada*

appearance was desired. The large variety of decorative motifs and techniques which were an integral part of Central European and Germanic-Pennsylvanian tradition provides an added and delightful dimension to painted furniture.

The most important factors in the communication of style from the homeland to Upper Canada were the memories and experience of immigrant craftsmen. But considerable influence on local taste was also exerted by the furniture imported from Britain and the United States for the small elite of military and government personnel, Church of England clergy and other prosperous settlers. These pieces often served as the prototypes for locally crafted furniture. Style books, directories and furniture catalogues were additional important reference sources for the more sophisticated craftsmen in the larger centres.

Formal Styles from Britain and Continental Europe

Evidence of pre-eighteenth century British formal styles is primarily seen in influences flowing from the eighteenth and nineteenth century vernacular, so that occasionally a detail or other typical characteristic may appear, suggesting that the maker was in part recreating a memory of furnishings of the Jacobean, William and Mary, or Queen Anne period. Direct, identifiable, academic influence really begins, however, with the eighteenth century styles of Chippendale, Adam, Hepplewhite and Sheraton.

A great many of these styles had already passed out of fashion in England before our sturdy examples were made to furnish the Georgian, Neoclassical and Classical revival homes built by prosperous Upper Canadians in the early 1800s. Strong associations of comfort and stability were connected with these furnishings by transplanted Britons and Americans; they saw little reason to acknowledge the dictates of more current fashion. In fact, the styles of the late eighteenth century period survived the widespread introduction of later fashions and appeared in some popular forms until the end of the nineteenth century.

By 1800, the French-inspired fascination with Classical forms was well established as the Regency style in England. The graceful furnishings of the early phase of the Regency period, coinciding as it did with the Federal period in the United States, included several forms which were widely adopted in Upper Canada, even though this direct influence did not last more than perhaps fifteen or twenty years. The heavier, more ungainly designs of the late Classical phase in England were soon more widely accepted – a trend strengthened by similar influence from the popular American Empire styles.

During the middle years of the nineteenth century, there was a great demand in Upper Canada for up-to-date, formal furnishings as an expression of the new prosperity that many immigrants had achieved by backbreaking effort in the preceding decades. Communications from the centres of fashion in Britain and the United States were, at the same time, almost immediate, rapid industrialization there producing new products in great variety. Local furniture-makers were soon copying this wide range of products.

Beginning in the 1840s, the new romantic revival styles of the Victorian period were introduced to receptive Upper Canada alongside the still popular Empire styles. The elaborate forms of the Rococo, Elizabethan, Renaissance and Gothic revival styles were typical of the extravagant eclecticism which flourished in mid-century. Later in the century, the Eastlake style became a major factor in this proliferation of mass-produced furniture. Technological developments allowed the production of all manner of elaborate objects at prices that could be afforded at all levels. Hand-craftsmanship was a major factor in the production of furniture in Upper Canada

throughout most of the nineteenth century, but the new machines and mass production techniques which were developed in Europe and the United States were integral to the stylish influences flooding the mainstream of Canadian taste at this time. As a result, there was a continual process of phasing in power-assisted tools and assembly techniques from about 1840 to the end of the century. Hence, technology itself became an important dimension of stylistic influence.

Naturally, these new developments were introduced in the urban areas earlier than in more rural situations, and pockets of traditional craftsmanship, such as the Lincoln County community, survived to a late date. In general, the great quantity of furniture produced in the newly equipped factories and shops was soundly constructed, but much of it was characterized by the same poor design and tasteless, elaborate decoration seen internationally. These later mass-produced styles are not of interest in this study, because they are not directly related to traditional style continuity, and because traditional craftsmanship was a less important factor in their production.

Traditional Style Influences from Britain, Continental Europe and French Canada

Throughout the period of this study, perhaps as much as one-half of the furniture produced in Upper Canada does not demonstrate primary influences from formal furniture styles. Usually of a utilitarian nature, these other furnishings traced their ancestry to the vernacular traditions of immigrant homelands. They had little in common with the current, formal styles popular in the world of fashion. Rather, these were the time-tested forms of the peasant and lower classes in a very slow process of evolution and adaptation. Sometimes, though, they did incorporate diluted formal style elements which filtered down to enrich the vernacular. As vernacular expressions of traditional forms, these pieces were also subject to regional variations, even within one national or cultural group, resulting from such practical considerations as the availability of materials or local characteristics of the decorative folk tradition. The vernacular styles often reflected the national personality more accurately than did the formal styles, since the former had developed over centuries, while the latter moved from one idiom to another on the whim or conviction of a few powerful, fashionable designers and wealthy clients.

Several Old World traditional forms occur with some consistency in the major centres of settlement by the different national groups in Upper Canada. Though the names may vary, the basic forms are common to all European peasant traditions. These include: storage chests, tables, benches, chairs, dish dressers, food cupboards, clothes cupboards, beds, cradles, and wall furnishings such as racks, shelves and boxes. More prosperous conditions in some parts of Europe during the eighteenth and nineteenth centuries permitted additional forms of a more formal nature to become part of the vernacular. Thus, we find corner cupboards, desks and chests of drawers included in the vernacular idiom.

Predictably, the vernacular styles of England, Scotland and Ireland are to be found in all parts of the province. Distinctive national and regional characteristics are discernible, as well as the preference of one or another national group for a specific form. In these traditions, basic styles appear which date back as early as the fifteenth century, particularly in chests, tables, benches and cradles. The dish dresser is a somewhat later, but very important, form in the traditional furnishings of each English-speaking group and survives as a major category of Upper Canadian furniture.

The vernacular furniture of Germany, Switzerland and neighbouring Alsace is also the source of distinctive styles and of decorative traditions

which occur in those areas settled by immigrants who came directly to Upper Canada from those parts of Europe. The large wardrobe, or *Schrank*, and the storage chest are two particularly important examples in the furniture tradition of each of these groups. These forms were often made to commemorate special occasions, such as weddings and anniversaries, and may include names and dates in their decoration. Also present were several styles of tables, food lockers, benches and small wall pieces directly related to this rich European tradition. The German craftsmen in Upper Canada were not only highly prolific in the production of their traditional furnishings, but quickly adopted and adapted British and American styles. Even when they did adopt these styles, however, their work was often distinguished by aspects of construction and by traces of the homeland decorative tradition.

Dish dressers, cupboards, storage chests and wardrobes in the Baroque style of rural Poland reflect another source of traditional influence which came to Upper Canada from the shores of the Baltic Sea. As late as the twentieth century, the distinctive styles, construction and painted decoration of this tradition were being produced in remote Canadian communities with little change from that of their earlier prototypes.

The traditional furniture brought from Lower Canada, later Quebec, also served to enrich the vernacular of Upper Canada. The French Canadian traditional style was entirely based on Continental influences from the seventeenth century until the mid-1700s when the British introduced contemporary English influence into the major centres and American influence flowed in from the south. There was a general decline in the expression of traditional French furnishings in Lower Canada in the nineteenth century, reflected, in turn, in French Canadian communities in Upper Canada. In concept and construction, the armoires, chests, cupboards and chairs produced there, however, are clearly in the French tradition.

American Influences

The third category of influence on Upper Canadian furniture, and the most important for direct and continuous impact, came from the United States. Beginning with the arrival of the Loyalists, the American influence grew in importance throughout the years, so much so that during the last quarter of the nineteenth century popular Canadian formal furnishings were to a large degree an extension of current American style. Based originally on the same British and European influences that came directly to Upper Canada, the development and importation of American styles greatly strengthened these influences in Upper Canada, particularly during the nineteenth century.

The Loyalists brought with them the American colonial expression of the eighteenth century British formal styles. These influences are seen in the early chests of drawers, desks, candlestands and other furnishings found in the centres of Loyalist settlement. They also brought the American colonial vernacular which had incorporated British and other European traditional forms and styles from the time of the earliest settlement. Such forms as the slat-back chair and the Windsor chair were European in origin, but were developed to a high degree in the colonies. Other distinctive American variations on traditional utilitarian forms include storage chests, cupboards and beds. Some Upper Canadian furnishings, which are indistinguishable from those made in the eighteenth century New England and New York State countryside, were crafted throughout the southern strip along the St. Lawrence, Lake Ontario and Lake Erie. These areas encompassed the early Loyalist settlements as well as the later American migration during the early 1800s.

Strong American influence continued into the mid-nineteenth century with the development of the American Empire style which was based on the archaeological Classicism of France and the related English Regency styles. The popular American Empire forms were well suited to mechanized production methods, and Upper Canada was an attractive market for aggressive American factories. In the face of competition from these stylish imported furnishings, Upper Canadian craftsmen were quick to adopt both the styles and the new manufacturing techniques. This reaction presaged the eventual dependence of Upper Canadian industry on American technology and design.

Because they allowed the economical production of complex and decorative elements, these techniques were also an integral part of the Victorian styles which became popular in the United States almost at the same time they were current in England. American commercial pressure on the Canadian market continued with the incredible variations on the Rococo, Gothic, Elizabethan and Renaissance revival styles which poured from factories there. These romantic Victorian styles were soon being produced in the new shops and factories that sprang up in all parts of the province. From the mid-century onward, furniture of a formal nature produced in Upper Canada is distinguishable from American examples largely by the absence of stylistic excess. Each of the popular new styles encompassed a wide range of expression, and the conservative Upper Canadians moved more cautiously, since they were still based in a tradition of simplicity.

Other American developments widely adopted in Upper Canada were the American fancy chair and the extensive family of late Windsor seating forms. The fancy chair originated in the delicate painted chairs popularized in England, primarily by Sheraton. Many variations were designed in early American factories where the production of the different parts and their hand-painted and stencilled decoration were developed to a high degree. Similarly, the late American Windsor category included an almost infinite variety of side chairs, armchairs, rocking chairs and benches in the popular arrow-back, rod-back, Boston and other styles. Large numbers of these American-made chairs and chair parts for local assembly were imported into Upper Canada at the beginning of the 1800s, but as early as 1815 chair factories were founded to compete with the prolific American industry. By mid-century, many towns across the province had a chair factory producing these universally popular styles, including many original variations, for its local market.

Of separate importance in stylistic influence from the United States is that of the Pennsylvania-Germans, some of whom arrived as Loyalists, and some of whom, like the Mennonites and Tunkards, were part of the Germanic migration which continued throughout the first half of the nineteenth century. In their self-sufficient communities, they recreated the rural traditions of eighteenth century Pennsylvania. Well-executed furnishings of both a formal and utilitarian nature, protractions of the 18th century Pennsylvania styles, were crafted in the traditional manner in several areas of settlement in the province to the end of the nineteenth century.

Each of these sources of influence was expressed by craftsmen of different levels of skill within the single century that saw the province emerge from the wilderness to become a highly developed region. The body of furniture that was produced, while of modest character, is unique in its compression of diverse influences from different places and times. This is the major theme of the Upper Canadian furniture tradition.

3 The Anglo-American Tradition

A very large portion of all the furniture actually made in Upper Canada was the direct result of the stylistic influences that came from England, Scotland, Ireland and the United States. With the arrival of Loyalist refugees, subsequent immigration from the British Isles and continuous involvement with both older communities, Upper Canada became the point on a triangle which received stylistic influences of a similar kind from south of the border and across the ocean. Furnishings of a formal character made in the new colony were a provincial reflection of the major styles found in the closely related centres of sophistication in both Britain and America. At the utilitarian level, vernacular furniture was made in Upper Canada in basically the same forms that had remained little changed for centuries in Britain – forms that had been transplanted more than a century earlier to the American colonies, to be enriched by American interpretations.

Formal Styles

Throughout the British Empire, London was the hub of furniture fashion where ideas from all parts of the world converged. The rich and fashionable looked to the sophisticated designers and cabinetmakers there for the ultimate in elegance and style, in much the same way that they looked to London for the most fashionable expressions in literature, dress and architecture. In due course, formal furniture styles developed in London were copied in all parts of England, Scotland and Ireland; inevitably, they were also taken across the Atlantic, along with the British vernacular, to become the basis of American colonial taste.

By the end of the eighteenth century, towns like Niagara, York and Kingston, while still remote, were directly involved in this vast communications network. Those members of the early elite who wished to stay abreast of international fashion could easily do so. Nonetheless, it is important to remember that this group of people was very small in Upper Canada at this time. Most of the furniture of a formal character which survives from the first fifty years following the Loyalists' arrival demonstrates a strong conservatism. There is an absence of extravagance and stylish excess and a tendency to prefer styles of earlier times rather than those of current fashion. No matter what the immigrant's social or economic status, existence in the new country sharpened practical instincts, and the harshness of frontier life instilled a yearning for remembered comforts. Meeting unfamiliar challenges in many aspects of this new life, therefore, the immigrant often chose the familiar when finally able to build and furnish a permanent home. Certainly, the furniture styles of eighteenth century England inspired a large portion of the furniture made in the province before 1850, even though many were, by that time, already out of date in London. Marion Macrae and Anthony Adamson in their book on early Canadian architecture, *The Ancestral Roof*, observe that Loyalist Upper Canada was the last stronghold of Georgian architecture;[1] this may be equally true of furniture styles.

The eighteenth century is justly considered the Golden Age of English furniture craftsmanship. It was a period of great creative activity: a highly refined taste found exquisite expression in masterful cabinetmaking technique. Several distinct styles emerged during this period which had a profound impact on the fashionable worlds of Europe and America. These

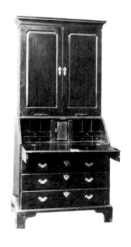

I English – mahogany desk and bookcase, late 18th century. [V. & A.]

styles are associated today with the names of the individual designers: Thomas Chippendale, Robert Adam, George Hepplewhite and Thomas Sheraton. Each of these men incorporated the best of this prolific period with their own brilliant, imaginative ideas.

Many of the very elaborate and elegant ideas conceived by these designers were executed for the grand homes of the wealthy British aristocracy, but manuals of their drawings were also produced and hence copies were made by cabinetmakers in many parts of the world. Although the original designs often specified elaborate carving, delicate inlay and very complex elements, all requiring the skills of the most sophisticated craftsmen, they were above all else masterpieces of form and proportion well suited to simplification by provincial artisans.

As a result, these styles, based as they were on universal concepts of proportion and formalized ornament, came to be the basic vocabulary of craftsmen throughout Britain and the American colonies. Cabinetmakers emigrating to Upper Canada in the early nineteenth century brought with them a sound knowledge of the most popular forms, proportions, ornaments and related construction techniques. Indeed, some may even have carried well-used copies of the manuals which would have provided inspiration for such everyday designs as the pediment for a tall-case clock, the glazing plan for a corner cupboard or the graceful profile for a candlestand pedestal. For example, Chippendale's interpretation of the Rococo style, based on the Queen Anne, appeared in his 1754 pattern book published in London, *The Gentleman and Cabinet-Maker's Directory*. The designs Chippendale illustrates are very elaborate examples, typical of the furniture he produced for his wealthy clients, but he reassures the reader on the title page that they are "calculated to improve and refine present taste and [are] suited to the Fancy and Circumstances of Persons in all Degrees in Life." His instructions mention that the designs may be simplified if desired, "without any Prejudice to the Design."

Chippendale's style is marked by the lively use and graceful combination of "C" and "S" scrolls. He favoured chairs with elaborately carved cabriole legs and ball and claw feet and also those with straight legs and "H" stretchers. The *Directory* illustrates the scrolled pediment on several different furniture forms, while drawings of his chests, desks and presses show many designs for the bracket foot, including the ogee variation. His fret and glazing patterns for bookcases and bureaux and his designs for chair backs demonstrate many Gothic and Chinese motifs which were important facets of the powerful influence Chippendale exerted for more than a century.

The movement away from the flamboyant Rococo style and toward the intellectual Neoclassical is associated with the Scottish architect Robert Adam.[2] Between the 1760s and the 1780s, Adam designed homes and furnishings in the grand manner for a few very wealthy patrons. Adam was dedicated to the idea that architecture and furniture together should express a total, unified design concept. Adam's houses were a highly successful demonstration of this developing mode of thinking. Somewhat later, the Neoclassical style of architecture that he had fostered became popular for homes built in Upper Canada in the second quarter of the nineteenth century.

As in his architectural plans, Adam favoured straight lines which replaced the curved lines of the earlier Rococo style. The integration of architecture and furniture was accomplished by the use of mouldings and other architectural elements to emphasize the structured lines of case furniture. Adam preferred a light and delicate interpretation of Classical decoration which included extensive use of the patera, Greek key, anthemion, fan, Classical urn and cameo motifs. Further, he was instrumental in the rejec-

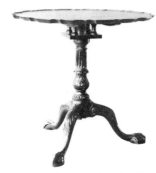

II English – mahogany tripod table, Rococo, second half 18th century, associated with Chippendale. [V. & A.]

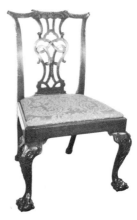

III English – mahogany side chair, Rococo, mid-18th century, associated with Chippendale. [V. & A.]

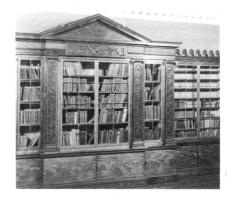

IV English – Croome Court Library designed by Robert Adam in 1764, early Neoclassical. [V. & A.]

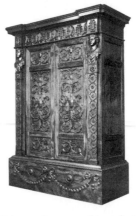

V English – mahogany cabinet designed by Robert Adam for Croome Court about 1764, early Neoclassical. [V. & A.]

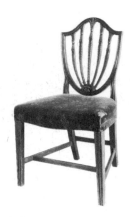

VI English – mahogany shield-back chair, early Neoclassical associated with Hepplewhite, fourth quarter 18th century. [V. & A.]

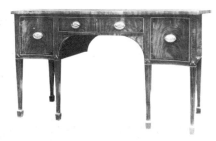

VII English – mahogany sideboard, early Neoclassical associated with Hepplewhite, fourth quarter 18th century. [V. & A.]

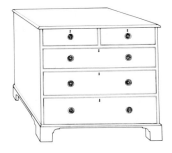

VIII English – chest of drawers, design in Hepplewhite's *Guide* (1794).

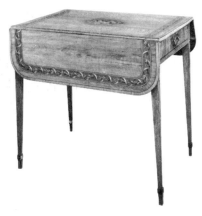

IX English – satinwood Pembroke table painted in grisaille, Neoclassical, late 18th century. [V. & A.]

tion of three-dimensional elements in favour of two-dimensional decoration such as marquetry, inlay and decorative paint. Needless to say, both architectural and furnishing motifs would be in the strictest patterns of Neoclassical harmony, both within and without.

Adam created a brilliant definition of the Neoclassical style, but it was further developed by George Hepplewhite and Thomas Sheraton. With the publication of Hepplewhite's *Cabinet-Maker and Upholsterer's Guide* (London, 1788) and Sheraton's *Cabinet-Maker and Upholsterer's Drawing Book* (London, 1793), the current state of Neoclassical style was summarized and translated into practical furniture. The illustrations in these two books are often quite similar, but some general observations may be made which are pertinent to the much simplified expression of their designs made in Upper Canada.

Hepplewhite favoured the delicate, square, tapering leg for tables and chairs which often terminated in a spade foot, though he was fond of the flared French foot on chests and secretaries. He also incorporated decorative inlay in contrasting woods, combining linear panels with crossbanded borders and decorative panels such as the Prince of Wales feather, medallions, drapery and ears of wheat. His glazing patterns for secretaries and bookcases emphasized circular and geometric designs as well as the Gothic arch. Hepplewhite chairs are distinguished by the frequent use of the shield back.

The most obvious point of departure between Hepplewhite and Sheraton – one that is often given undue emphasis in stylistic discussions – is Sheraton's frequent use of the turned, rounded leg with slim, graceful, often reeded, urn-like shaping. Columns running the full height of the chest or desk were incorporated into case pieces. Sheraton's chairs are characterized by square backs, often composed of bars producing a trellis effect, and he popularized the use of delicately painted decoration on chairs and other forms. Both Hepplewhite and Sheraton introduced new, space-saving, innovative concepts for furnishings to be used in homes of moderate scale.

The early Neoclassical styles gradually replaced the Rococo influence during the last years of the eighteenth and the first decade of the nineteenth century – a period commonly called the Federal in the United States. In Upper Canada, early Neoclassical influence is most visible in the years between 1800 and 1830, but it continued to be evident much later than this, particularly in tables, chairs and cupboards made by country craftsmen. Meanwhile, the French and English Neoclassical styles as they had evolved placed greater emphasis on archaeological accuracy and exotic origin in form and detail. This was inspired by the remarkable discoveries made at Herculaneum and Pompeii and the designs pictured in such books as *The Antiquities of Athens* (London, 1762). The term Regency, sometimes called English Empire, is applied to furniture of this late Neoclassical style.

As with the earlier Neoclassical period, influences from France were strong and several brilliant English designers and craftsmen were involved in the development of the Regency style. It was defined by one man, Thomas Hope, and popularized by another, George Smith. Hope published his *Household Furniture and Decoration* in 1807; it was based on strict Classical principles and intended for the few leaders of taste. On the other hand, in 1808 Smith published *A Collection of Designs for Household Furniture*, the most comprehensive pattern book of Regency style and one that took a more eclectic approach, since it was intended for the use of ordinary craftsmen.

Several new forms emerged during the Regency period which appeared in Upper Canada between 1825 and 1840. The graceful Trafalgar or Grecian chair, patterned on the Classical Greek *Klismos*, became possibly the most

popular style for formal chairs, and was produced in all areas of the province until the end of the nineteenth century. Also associated with the Regency period are the sofa-table, usually seen with trestle ends and supporting stretcher or with pedestal and platform on outward curving feet, and the circular parlour table on a pedestal base. In its more exotic expression, Regency taste included decorative structural elements such as animal paws, swans, lyres, Chinese and Hindu motifs and Classical human figures. These motifs were almost completely ignored by Upper Canadian cabinetmakers, although brass pulls in the shape of lion's heads and brass lion's paw feet were imported and used to enhance simple examples of the style.

The evolution of Neoclassical style in the United States reflected European developments. Known as the American Empire period, the expression of this phase of Classical taste coincided with English Regency. By the 1830s, the influence of American Empire furniture was of great importance in Upper Canada, because in addition to itinerant craftsmen and the circulation of furniture catalogues, a large amount of American-made furniture crossed the border during this time. The situation affected provincial production to such an extent that a visitor to York in 1831 was prompted to say:

> Such is the accumulation of furniture for sale in the Upper Province that the body of cabinetmakers of York, during the last session of the Assembly, petitioned the House to pass an act prohibiting the importation of furniture from the United States.[3]

Initially, these stylish American products were sold primarily in the larger towns to the more prosperous citizens, but later the effects became more widespread. The pressure of imports led to the establishment of furniture factories across the province that were largely reliant on American technology and design. These facts did not escape contemporary notice, and in 1856 the *Daily News* reported that Kingston cabinetmaker William Holgate had imported new equipment for his furniture shop in the form of "an iron lathe and a planing machine from the United States."

The American Empire style encompasses a great variety of stylistic expression. During its early phases, master craftsmen like Duncan Phyfe produced superb furniture using precise Classical principles. By the 1830s, a trend leading away from archaeological exactitude began, resulting in designs that were heavy, bulbous and massively architectural. Ornately carved columns in the Classical orders and large lion's paw feet are the decorative elements typifying this movement. The debasement of Classical form was consistent with contemporary taste in Europe and Britain, and was summarized in George Smith's *The Cabinet-Maker and Upholsterer's Guide*, published in England in 1826. *The Cabinet-Maker's Assistant*, published by the Baltimore architect, John Hall, in 1840, recognized international trends, but at the same time emphasized the use of heavy "C" and "S" scroll elements.

This final and ungainly phase of the American Empire style was pinned to the capability of the newly designed, steam-powered band-saw, because it allowed the economical production of all manner of complex elements. The massive sideboards, chests, secretaries, sofas and other popular Empire forms sat on heavy scrolled feet, while their ogee-shaped fronts displayed variations of the scroll theme. The master of Neoclassical style, Duncan Phyfe, bitterly pilloried these excesses as "butcher furniture," but to meet the demands of popular taste, he too was forced to produce it.[4] These influences moved quickly into Upper Canada, even into the smaller centres, as illustrated by a chest of drawers made, signed and dated 1852 by Thos.

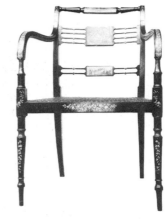

X English – beechwood armchair painted in grisaille and gilding, Neoclassical associated with Sheraton, about 1800. [V. & A.]

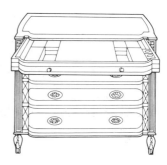

XI English – chest of drawers, design in Sheraton's *Drawing Book* (1791-4).

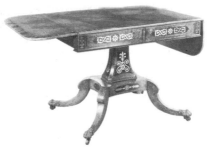

XII English – amboyna and kingwood sofa table, late Neoclassical (Regency), 1816. [V. & A.]

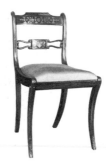

XIII English – Trafalgar or *Klismos* chair in rosewood, late Neoclassical (Regency), early 19th century. [V. & A.]

Darley at Mill Creek (now Odessa) in Lennox and Addington County (Plate 655).

The late Neoclassical period also saw the further development of the American fancy chair. Sheraton had been instrumental in popularizing delicately painted chairs, and the form had become highly desirable during the Regency period. Based on these sources, the American development resulted in a great variety of individual styles. These fancy, painted and stencilled chairs were extremely popular in Upper Canada from 1820 until the end of the century (Plates 365 to 376). A great many of these examples were imported from the prolific American centres, but there is evidence that many were locally made. In 1840, for example, E. Brown & Co. of Kingston advertised,

> direct from their manufactory at Rochester a general assortment of chairs of the most superior materials and workmanship, consisting of curled maple, cane seats, scroll tops, with either plain or banister backs; also imitation rosewood, cane bottom, gilded and bronzed with either slat or roll tops, together with Boston, rocking, sewing, nurse and superior articles of office arm chairs.[5]

While in 1823, C. Hatch & Co., also of Kingston, announced the change of location of their "CHAIR-MAKING BUSINESS in all its various branches! where they intend to keep a constant supply of all kinds of Fancy, Bamboo & Windsor Chairs, also Fancy & Windsor Settees!"[6]

By 1840-1850, the craftsmen of Upper Canada (by then known as Canada West) were producing formal furniture in many styles. Although the more conservative element was still firmly rooted in the eighteenth century idiom, the Regency style was widely adopted in some forms, particularly chairs. Nevertheless, the American Empire style dominated the mainstream of taste in the generation that was now emerging with a desire to express its prosperity.

During this period, Victorian England was wrestling with the momentous changes stemming from the Industrial Revolution. Developments in both social patterns, such as the emergence of a mobile, upward-moving middle class, and production methods, such as the band-saw, routing machines and prismatic lathes, led to new concepts in popularized formal furniture style. Comfort became a major consideration in design, with overstuffed upholstering incorporating the newly designed coil spring. The Victorian era produced stylish, comfortable furniture affordable to those of average means. The dominant theme of popular Victorian furniture was the revival of historical styles. Rococo revival, Gothic revival, Elizabethan revival, Renaissance revival and the somewhat later Eastlake are the major substyles popularly known as Victorian.

J. C. Loudon's *Encyclopaedia of Cottage, Farm and Villa Architecture and Furniture*, published in London in 1833, was one of many publications which provided furniture-makers with examples of the historically based, romantic Victorian styles. Some of these, like Loudon's, incorporated architectural designs from the related historical periods. These new concepts flowed into the mainstream of American taste, because they were quickly adopted by American furniture-makers. New machinery became very important, and the traditional talent and skill of the individual craftsman was confronted by increasingly efficient mass production.

Victorian styles were well established in Upper Canada (Canada West) by 1850. In the last half of the century, the physical face of the province changed dramatically due to the building of "modern" homes and public buildings in the revival styles. Many of these were furnished with the plump, rounded loveseats and ladies' and gentlemen's chairs in the Rococo revival style and the awesome mass of the Renaissance revival bedroom

suites. For those unable to afford the height of style, there were modest "cottage" suites made in the revival and Eastlake styles by the emerging Canadian furniture industry.

Vernacular Styles

Throughout the late eighteenth and entire nineteenth century, a great quantity of everyday furniture was made in all parts of Upper Canada which reflected the vernacular idioms of England, Scotland and Ireland. During the preceding century, these styles had been taken to the American colonies, where, along with traditional influences from other European sources and local developments, a distinct colonial vernacular had evolved.

These traditional furnishings include chests, tables, benches, stools, chairs, dressers, cupboards, desks, beds, cradles and various wall and kitchen utility pieces. Unique cultural factors did produce interesting variations, but the basic forms are common to all European peasant backgrounds. Faced with the need to furnish the first log houses and, later, the permanent country homes built in the last years of the eighteenth century and the first half of the nineteenth in Upper Canada, these time-tested, familiar forms were produced by individual settlers and artisans who had been trained in the homeland craft tradition. In addition to their practical qualities, these traditional forms were aesthetically sound designs for everyday living.[7]

As in the more fashionable types of furnishings, traditional influences had flowed from the early craft expressions in England to the other English-speaking countries throughout the centuries. This movement produced similarities, not only in style, but also in woodworking technique, although the standard of material and workmanship found in England was not so consistently high in less prosperous Scotland and Ireland.

The English standards of excellence were partially due to the highly organized craft guild system (beginning as early as the fifteenth century) which included the Carpenters, the earliest organized craft. The Carpenters were responsible for the conversion of timber into useable forms for the structural members of houses as well as simply formed early furniture. The Joiners came to the fore in the sixteenth century with new techniques involving the cutting and fitting of framed and panelled structures. Specialists within the craft guild framework included the Turner, who produced elements turned on the lathe for buildings and furniture, and the Carver, who decorated the elements in traditional motifs. The Cabinetmakers emerged in the seventeenth century as a result of influences brought from Holland and other parts of Europe. They produced stylish furnishings, incorporating new construction techniques and the use of elegant veneered and inlaid treatments. Although the Cabinetmakers' art was widely accepted, the traditional styles made by the Joiners remained popular, particularly among the lower classes and in the country until the nineteenth century.

Oak was the preferred wood in England for all country furniture, with the occasional appearance of elm, sycamore, ash, beech, birch, chestnut, cedar, walnut, yew and fruitwoods.[8] As the great oak forests dwindled during the late eighteenth and nineteenth centuries, however, some pine was used for furniture,[9] but it was painted and grained to imitate hardwoods. Oak was also used for better traditional furniture in Scotland and Ireland during the early periods, but by the nineteenth century most country furniture was made of painted, less costly and more available soft woods. Similarly, the early use of oak in the American colonies gave way to pine for a large part of the utilitarian furniture made there in the eighteenth century. Therefore, the great virgin pine forests of Upper Canada provided a familiar material of exceptional quality for the Anglo-American

country craftsman. Along with some use of cherry, maple, chestnut, tulip, basswood, hickory, butternut, walnut, birch, ash and oak, it was the principal wood used for vernacular furniture. The heavier lumber, often in widths of three feet and more, elevates these traditional forms into a special category. The use of paint on nearly all softwood pieces was well established in each of the earlier countries, and the universally popular reds, greens, blues, browns and greys were an important dimension of the vernacular style.

In summary, the traditional furniture styles of each of the English-speaking countries absorbed strong influences from England, and differing cultural, social and economic factors produced variations that survived in Upper Canadian communities. These distinct national characteristics are most visible in the furniture made between 1800 and 1840.

Tables

One of the most important forms from the English tradition in Upper Canada is the refectory table. The term itself is taken from the long room, and hence the long table, used for meals in medieval monasteries. The use of a centrally located table was a major point of difference between the English country tradition and that of most Central European countries. The style of these long rectangular tables had evolved from the time of their early use in monasteries and baronial halls right up to the eighteenth century, when they were widely used in English kitchens. The refectory table was also an important element in the American colonial tradition; their appearance there being directly related to English prototypes, although there were strong Germanic and Dutch influences in areas settled by these groups.

Typically, the refectory table has a long rectangular top made up of three or four boards which are fixed directly to the frame. It may have four or six legs joined by medial or box stretchers a few inches from the floor. The early English tables had massive turned and carved legs and carved decoration on the table frieze. The overall scale and character of the design became less massive in later periods; by the seventeenth century the legs may be squared and chamfered and by the eighteenth the carving was often eliminated. From the early period onward, benches were the most common type of related seating, and these included the simple stick-Windsor type, those with trestle ends and the more elaborate joined style.

The concept of a large, centrally positioned table as well as the refectory form were widely adopted in the spacious farm kitchens of Upper Canada. Often called the harvest table, it was the dominant element of kitchen furniture well into the twentieth century. Early Upper Canadian examples have turned or square legs with stretchers, and rare instances are found of a related style which has a trestle base. More typical of Upper Canadian refectory tables, however, are those of lighter construction with square, tapered or turned legs, a much diluted expression of the original form.

In the Irish and Highland Scot vernacular, the large table did not have the same importance as it did in England. Many Irish and Scottish peasant families gathered around the hearth to eat and food was taken from a common bowl. In Ireland,

> because of the focal position of the hearth, the table is pushed against a side wall of the kitchen and in many cases it is seldom moved from there. The idea of the family sitting round a table is alien to Irish tradition; it really belongs with the oven-hearth complex. Often the table is of flimsy construction and may be both small and excessively narrow.[10]

The same is true for the Scots; "It was really when a much later type of cottage could boast a best parlour that the table really became important."[11]

XIV English – oak refectory table, mid-17th century. [V. & A.]

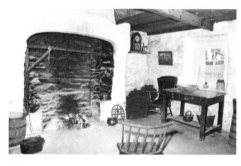

XV Ulster – cottage interior, 19th century. [U.F.T.M.]

As might be expected, the vernacular tables made in Ireland and Scotland are likely to be small and simple. A very popular style in nineteenth century Ireland was a small stretcher-based table with square legs. The distinctive feature of this form is the use of two stretchers in a central position running the length of the table side by side. The central stretchers created an open shelf which was used for the storage of bowls and pots in a convenient position relative to the hearth. On occasion, the "pot shelf" also became a place to rest the coffin during the traditional wake in cottages where space was limited.

A number of these small tables, pot shelf and all, are found in those Upper Canadian areas settled by the Irish. The same design was incorporated into larger tables which are really harvest tables in scale. It is very likely that the hearth-oriented eating tradition did not survive long in the new land; its demise would be brought about by influences from other national groups and the quite different conditions of Canadian life. This is a prime example of the functional modification of a traditional form under pressure from new circumstances. This occurred frequently in the Upper Canadian context and will be discussed in several instances. Out of such developments grew a distinctive furniture vernacular unique to Upper Canada.

The chair-table and bench-table were also significant in the British tradition. This multi-purpose concept is an excellent illustration of the highly functional qualities of traditional or vernacular furnishings. Dating from the sixteenth century,[12] the chair-table provided draft-free seating by the hearthside, storage space below the seat and a table surface when the chair back was put down. It was most common in England in the seventeenth century, but it was still widely used in Ireland in the nineteenth century. Such was its importance in early America, that the occurrence of the chair-table in Upper Canada is more often associated with areas of American settlement than with those of other English-speaking groups.

This is equally true of the sawbuck or "X" stretcher table, an early form in several European traditions in addition to the British. A good number of these tables were made in Canada by immigrants of Germanic origin, while others were made by Americans of British ancestry. In the British tradition, the top boards are fixed directly to the understructure by means of nails, and the understructure itself is simpler than the distinctive German tenoned and pegged stretcher construction.

In some English country kitchens, very large drop-leaf and gate-leg tables were used rather than the common refectory style. These are the prototypes for the long tables with one or two leaves made for Canadian kitchens; they occur largely in centres of English settlement and usually date from the second quarter of the nineteenth century. In the same way, a variety of small stretcher-based tavern tables, four-legged and pedestal candlestands, joint stools, cricket and coaching tables were made in all parts of the province. All have their common origin in the British country tradition.

Chairs and Benches

English vernacular chairs were made in the Windsor, ladder-back and simple country versions of Chippendale, Hepplewhite, Sheraton and Regency styles. Stools and benches in the Windsor style, the joined style and those with trestle ends and shaped skirts were also common seating forms at table or hearthside. Accordingly, similar chairs and benches were widely used in Ireland and Scotland, and distinctive regional variations are found throughout the British Isles. In the Irish cottage, for instance, the three-legged Windsor stool (creepy) was frequently employed, while

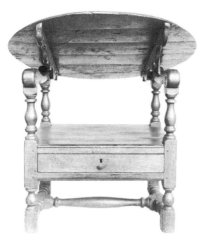

XVI English – oak chair-table, 17th century. [V. & A.]

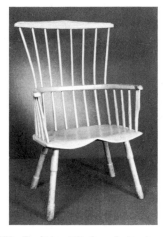

XVII English – Windsor chair, elm seat, painted green, mid-18th century. [V. & A.]

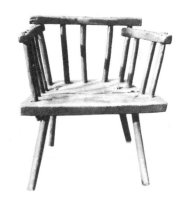

XVIII Irish – primitive armchair, 19th century. [N.M.O.I.]

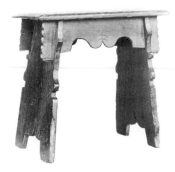

XIX English – oak trestle stool, early 16th century. [V. & A.]

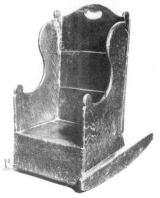

XX English – oak child's rocking chair, 18th century. [G.M.]

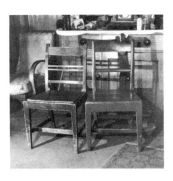

XXI Scottish – country chairs, 19th century [N.M.O.A.O.S]

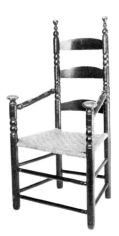

XXII New England – slat-back armchair, first quarter 18th century. [H.D.I.]

simple chairs of Sheraton influence were prevalent in northern England and Scotland.

Surprisingly few chairs were made in Upper Canada directly related to these British styles. Some Windsors and ladder-backs are distinctly British, but these are largely of a primitive character and were made by individuals of limited skills. Children's chairs in the eighteenth century settle-like form are not uncommon, and many stools and benches were made in the typical styles. However, the only British seating form made in significant numbers in Upper Canada, which would suggest the survival of a craft tradition, is the plank-seated country Sheraton style crafted in Lanark and the neighbouring counties. Individual examples of the style are found in other parts of the province, but the Lanark chairs are unique in their numbers and consistent construction details. They are directly related to the Scottish vernacular and are made with typical skill.

The armchairs and side chairs made in the Lanark area possess a wide range of Neoclassical design elements and range from Presbyterian simplicity to a point just short of elegance. The impact of this Scottish tradition on other groups in the area is seen in chairs from nearby French Canadian communities. These are similar, but include elements from the typical French Canadian rustic chair (Plate 1276).

The relative scarcity of Upper Canadian-made chairs inspired by the British vernacular is partially explained by the fact that inexpensive, everyday chairs were readily available in Canadian-made American styles. Writing in 1855, Catherine Parr Traill made this point very nicely:

A dozen of painted Canadian chairs, such as are in common use here, will cost you £ 2.10s. You can get plainer ones for 2s.9d or 3s. a chair; of course you may get very excellent articles if you give a higher price.[13]

These were likely late-Windsor or fancy chairs that had been developed in the United States and were made in large numbers by Upper Canadian craftsmen.

From the earliest American settlements in New England, the ladder-back or slat-back style had been an important form in the American tradition. Many distinctive variations on the early British and Continental prototypes were made throughout the years. It was the most popular chair among the Loyalists and other American settlers in Upper Canada, and it was made in their communities from the first. Expressions of the style took the form of armchairs, rocking chairs and side chairs.

Although comparatively fewer examples of the Windsor style have survived from the early Loyalist period, later variations of it became the most popular in all parts of Upper Canada throughout the nineteenth century. From its earliest beginnings in England, the Windsor was developed to a high degree of functional beauty in eighteenth century America. Some of these handsome early Windsors were brought to the Upper Canadian settlements by the Loyalists. Other examples of the late eighteenth century styles which survive were probably made in towns like Kingston and York at the turn of the century by craftsmen such as Daniel Tiers who was advertising "fan-back and brace-back chairs"[14] for sale in York in 1802. Early in the nineteenth century a wide variety of later Windsor designs began to appear in the United States, including the very popular arrow-back and rod-back styles which incorporated influences from formal Neoclassical styles. These styles were easy to make and became the basis for an incredible number of variations in side chairs, armchairs, rockers, childrens' chairs and benches made in early American factories developed for their production. Many of these Yankee products appeared on the Canadian market, but local shops were soon producing their own sturdy,

painted and stencilled examples. This trend continued throughout most of the nineteenth century. One of the earliest known makers of late Windsor chairs was Chester Hatch of Kingston, who began his prolific operations in 1815 (Plates 252 and 283). In all parts of the province, chairs and benches of the Windsor family were more popular than any other style and account for a large majority of the early seating found today.

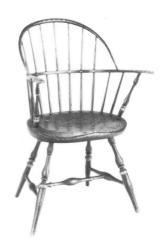

A seat or bed placed near the kitchen hearth was a part of the country tradition in each of the hearth-oriented, English-speaking countries. In the peasant cottage, this might be a box-bed or bed-closet. In more prosperous houses, the high-backed settle offered draft-free seating by the fireside, and a low-backed variety of the form became popular in the eighteenth century. The settle was also widely accepted into the American colonial house, the concept of a kitchen seat or couch establishing itself there just as it had in Britain. Toward the middle of the nineteenth century, elements of the settle and those of the current low-post bed were combined in the kitchen settle or country couch. An early illustration of this form appeared in Loudon's *Encyclopaedia of Cottage, Farm and Villa Architecture and Furniture* (Plate 393). In Upper Canada, too, this aspect of the British tradition survived very strongly, although the early tall settle did not make an appearance. Some examples of the low settle are found which, though somewhat simplified, are related to eighteenth century English style. The country couch was widely adopted by all groups and became a standard item in the kitchen of rural Upper Canada.

In so far as the English-speaking countries are concerned, the settle-bed is unique to the Irish tradition, but it is found in some numbers in Upper Canada. This very functional form is a solid or panelled settle with a box-like seat that folds forward to create a double bed, the mattress and bedding being conveniently stored under the seat when the bed is folded up. Authorities on the Irish folk tradition suggest that the settle-bed was a relatively late addition to the tradition and often occurred as a replacement for other types of beds in the hearthside position.[15] The multi-purpose nature of the settle-bed is illustrated by the following quotation from a survey of Irish country traditions:

> I knew an old cotter who lived in a wee house with just one bay. It served as kitchen, bedroom and parlour. A neighbour went up to his house to get him to work. After knocking at the door he couldn't get in, for he was in bed, and he had sure to wait til he dressed and buckled up the settlebed. C. K. was the dweller's name and he was quite happy for he said, "Och," says he, "I'm not afraid of thieves getting in, for when I let down the settlebed it bars the door.[16]

Settle-beds occurred quite commonly in Upper Canadian Irish settlements. It was probably adopted by their Scottish neighbours, since examples do survive with definite associations with Scottish families, although there is no evidence of the settle-bed in the Scottish homeland tradition. The same form was popular with French Canadians in Lower Canada where it was called a *banc lit*. French Canadian emigration brought it to French settlements in Upper Canada.[17]

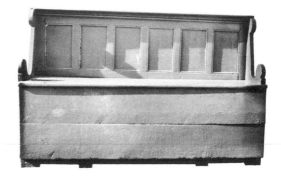

The Irish settle-bed is usually of plain plank construction or simply panelled; but many of those made in Upper Canada are more substantial, incorporating elements of the American Empire style which was at its zenith by the second quarter of the nineteenth century. These stylish additions suggest that the settle-bed may have been used in the Upper Canadian parlour as well as the kitchen.

Dressers and Cupboards

The dish dresser is an important piece in the traditional furnishings of the English-speaking countries. Particularly in small houses and cottages, great

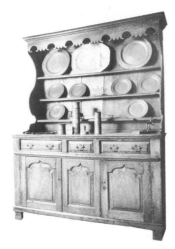

XXV English – oak dish dresser, mid-18th century. [G.M.]

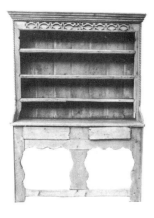

XXVI Irish – dish dresser, 19th century. [N.M.O.I.]

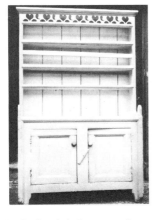

XXVII Irish – dish dresser, 19th century. [N.M.O.I.]

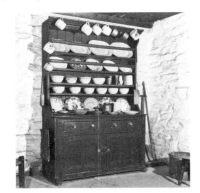

XXVIII Ulster – dish dresser, 19th century. [U.F.T.M.]

emphasis was placed on the utility of individual furniture forms, and the dresser was a functional extension of the hearth. In each of the national traditions, the dresser occupied a prominent position, either facing the hearth or to one side of it. The dresser evolved as a popular form in the British Isles out of the earlier use of plate racks and tin rails placed on the wall over a simple trestle-supported board. This early arrangement has survived in some parts of Ireland and Scotland until the twentieth century.

Many regional variations on the dresser were developed over the years, combining the open racks above with shelves, drawers and cupboards below. With the popular use of decorative china in the eighteenth century, the dresser in England and Wales became less utilitarian, more "polite" and was elevated in station by the addition of design elements from current fashion and excellent joinery. To provide maximum storage space while using the smallest part of the limited floor space, Irish and Scottish dressers were often more vertical in plan than the more horizontal English expressions of the same form. In Ireland,

> The bottom space which in early dressers was always open fronted, but more recently was provided with doors to form cupboards, normally houses larger items like iron pots, kettles, griddles and sometimes also vessels used in butter making. Occasionally these cupboards were used for food storage. However when this low part of the dresser was open fronted, it sometimes held coops of straw, wattle or wood, for hens hatching or possibly for a goose sitting on her eggs.[18]

Just as the craftsmanship of English dressers is distinguished by refinement, so in Ireland it is simple and straightforward. Irish examples seldom reveal dovetailed drawer construction, and the doors may be single boards or simply framed. Characteristic of the Irish dresser are the decorative frieze and upper style details which add a light-hearted quality to these otherwise simple cupboards. The motifs of these charming cut-outs may be the heart, clover, pinwheel or rosette, and they may be taken directly from the folk idiom or they may be naïve interpretations of Neoclassical details. This kind of decorative expression is particularly apparent in the south; in the north the stronger English influence produced a more restrained approach to the design of traditional material.

Scottish joinery, on the other hand, is generally more robust than the Irish, using heavier stock and relying more heavily on the satisfying effects of sound proportions, blown and fielded panels in doors and dresser fronts and simple cornice mouldings and beading to the exclusion of other decorative details. Popular features of some Scottish dressers are a row of small spice drawers and other additions to the dish rack as well as larger drawers in the lower section.

Although they did not figure as prominently as in the British Isles, dish racks and dressers were important early forms in the American colonies. Many American dressers are directly descended from English styles, but others incorporate recognizable Continental influences. While not typical of the colonial period, one simple style that was prevalent in Vermont, New Hampshire and New York was also particularly popular in Upper Canada. This is of slab construction, including the doors which are often just one wide board. The only element of decoration is the neat, moulded cornice (Plate 425).

Dish dressers were widely used in Upper Canada, especially prior to 1840. They are associated with each of the groups of English-speaking immigrants, but they were of particular importance in Irish and Scottish communities. Some of the earliest surviving furnishings are the open dressers, a large proportion of which are found in the Irish and Scottish areas of the eastern counties.

Blind-door cupboards or press cupboards were made in Britain from the

Gothic period onward and they predate the dresser as a traditional furniture element. Early examples are of simple slab construction, enriched by carving typical of the Gothic style. Later presses have panelled doors, fronts and ends, the more sophisticated product of the joiner. The early press was used primarily for the storage of clothing and linens, but closed cupboards of similar design found their way into the kitchen where they were a convenient place for food and utensils. Eighteenth and nineteenth century cupboards of this type were frequently made by country joiners in different sizes, plans and styles according to their intended use. In Ireland during this period, for instance, the press was often given a decorative treatment similar to that on the Irish dresser.

The more formal court cupboard form appeared in the sixteenth century as a tiered sideboard and developed with the addition of cupboards above and below a recessed counter with fitted drawers. This form saw many variations throughout the centuries, from elaborately carved styles with a canopy over the recessed upper cupboards to simple flush-fronted designs combining the same plan and functional elements.

The stylish linen press of the seventeenth and eighteenth century cabinetmakers was copied by country craftsmen throughout the British Isles, and, though it is not a traditional form, it became an important style in the vernacular. Enclosed by two doors, the linen press included drawers below the cupboard space. Even the country examples of this form, which were made of soft wood and grained in hardwood patterns, were given stylish elements such as dentil cornices, bracket feet, quarter columns, shaped door panels and fine hardware.

Many cupboards were made in Upper Canada which are related to the press form. Early examples are frequently of slab construction similar to the Gothic prototypes. Others are framed and panelled, based on centuries-old British Joiners' methods. Rare country pieces are reminiscent of the formal linen press. Another related style, found primarily in the eastern counties, may in fact spring from the court cupboard. These distinctive cupboards have four panelled doors creating an upper and lower cupboard and may possess a row of two or three drawers between the sections. This type of cupboard not only relates to the tradition in its framed and panelled construction, but is also remarkably similar in proportion and plan to some early, flush-fronted court cupboards (Plate 532).

Corner Cupboards and Glazed Dressers

Several developments in English life during the seventeenth and eighteenth centuries were expressed in the furniture vernacular. It has been mentioned earlier that this period, particularly the eighteenth century, was one of intense activity in the creative evolution of formal style and that it produced elegant furnishings for a much wider range of society than previous centuries. It was, in fact, a prosperous period when even the lower classes aspired to some degree of style. One manifestation of a new gentility in those previously thought "rustic" was the growing importance of the parlour or drawing room and the separate dining room. Accordingly, the all-purpose nature of the common-room kitchen began to change. Frequently, the traditional furniture remained in the kitchen or other less public rooms and the parlour received new, more stylish pieces. Several new forms began to appear throughout the country and eventually became basic elements in each of the English-speaking vernaculars.

One of these, the corner cupboard, was widely accepted for the display of the fine china and porcelain so popular during the period. The cupboards were often built in pine as part of the woodwork of the room and painted as part of the overall decoration. The architectural nature of these early cupboards was consistent with current Neoclassical taste; many

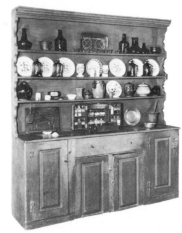

XXIX New England – dish dresser, pine, second half 18th century. [H.D.I.]

XXX Scottish – plate rack, 19th century. [N.M.O.A.O.S.]

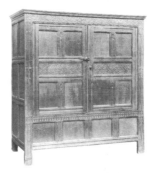

XXXI English – oak press, 2nd quarter 17th century. [V. & A.]

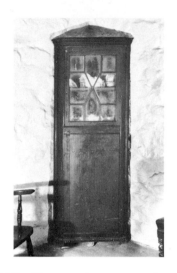

XXXII Ulster – parlour corner cupboard, 19th century. [U.F.T.M.]

were open at the top with shaped shelves and had solid doors on the lower section. Others had glass doors on the upper section glazed in patterns typical of period furniture styles. These were made by cabinetmakers and joiners in mahogany, oak, walnut and fruitwood in addition to the more common pine, and they were intended to be free-standing pieces of furniture. At the cottage level throughout England, Ireland, and Scotland, pleasing vernacular variations of the basic form were used to contain and display the best china and delft in the tiny, seldom-used parlours.[19] The corner cupboard was equally popular in the "best" rooms of colonial America, where current concepts of English elegance were widely followed.

Some measure of Georgian graciousness was the prime objective when the Loyalists and other early immigrants to Upper Canada came to build their Georgian and Neoclassical houses in the first decades of the nineteenth century. The corner cupboard was symbolic of this graciousness, possibly to a greater degree than any other single furniture form, and it was an important focal point in most early houses. Consistent with eighteenth century taste, many of these cupboards were architectural in character and some were built as part of the woodwork by itinerant carpenter-joiners. The Adam-inspired Neoclassical idiom prevailed in the early cupboards, mixed with some elements from Chippendale, Hepplewhite and Sheraton. During the same years, the Scots and Irish made the small, neat cupboards that they well remembered from the tiny, old-country parlours. Most examples of this form were made of pine, painted or grained in the traditional manner; yet some early cabinetmakers, particularly those from England, used walnut, cherry and maple in their simple expressions of eighteenth century formality (Plate 466).

A great many of the early cupboards were made for the formal room in the home, though the space-saving abilities of the form led to its use in more utilitarian contexts. After 1830, quite a few corner cupboards were designed for the kitchen, often replacing the traditional open dresser for everyday storage. These were wider than the early examples and contained drawers for cutlery between the glazed upper section and the solid-doored lower part which provided a generous space for food and cooking utensils. The appearance of the kitchen corner cupboard frequently retained some of the architectonic qualities of the earlier ones, but was less elaborate, with simple glazing and a minimum of detail.

At the same time, the glazed dresser appeared in all parts of Upper Canada; consequently, few open dressers were made after 1840. The glazed dresser was a simple and thoroughly functional evolution of the traditional open dresser, because the glazing protected the contents from dust and dirt. It also had more formal associations and was a comfortable step away from the old ways without breaking continuity. Like the later corner cupboard, the glazed dresser was made largely for the kitchen, though some more refined examples were constructed for the dining room.

Despite the fact that it was entirely derivative in style, the popularity of the glazed dresser in Upper Canada does not appear to have been equalled elsewhere. It did not occur to any significant extent in Britain where, as in most European traditions, the concept was more urban than rural. It appeared but was not widespread in the United States, except in Pennsylvania where it was a major vernacular form. The extent of acceptance in Upper Canada may be partially explained by the influence exerted by early Pennsylvania-German communities. It is likely, however, that the surprising numbers and variations in this category are better explained by the fact that the glazed dresser combined qualities of tradition with those of up-dated function, thereby appealing to thousands of Upper Canadians who were furnishing new homes within a relatively short period of time.

Chests

One of the earliest of British traditional forms, the chest remained a very important facet of the vernacular throughout the centuries. The Gothic-period chest was a simple, six-board construction, supported on trestle-shaped ends, but later, as with the other forms, the organization of the Joiners' Guild caused the framed and panelled variety to become popular. Prior to the eighteenth century, even the common English chests are distinguished by carving, itself an important aspect of country tradition. In the seventeenth century, the basic box form was elaborated by the addition of one or two drawers at the bottom. This variation is called the mule-chest in England. A further variation, the chest-on-chest, was made in two parts, the box chest fitting into a lower structure containing drawers. The final evolutionary stage was the chest of drawers, a form not in widespread use until the eighteenth century. Even then, the simple storage chest maintained its popularity, extending to its execution in a more formal manner by eighteenth century cabinetmakers who employed the dovetailed construction and design elements of current styles. Fine veneers, inlaid decoration, quarter columns and bracket feet were all used to enhance its appearance.

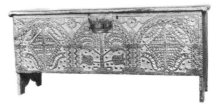

XXXIII English – elm storage chest, dated 1697. [V. & A.]

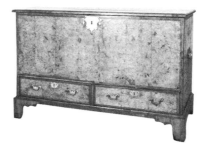

XXXIV English – walnut storage chest, first quarter 18th century. [V. & A.]

Frequently made in Ireland and Scotland, these basic English chest forms were important items in the American vernacular as well. The early trestle-end and later bracket-base types were both popular in the colonies. Box chests with two or three full-width drawers became a significant American country form in the latter part of the eighteenth century. These were similar in appearance to the widely accepted chests of drawers in a countrified Hepplewhite style which incorporated a simple French foot. An important aspect of these American vernacular furnishings was the wide panoply of painted decoration. While primarily based on woodgrain patterns, they were often boldly impressionistic in both form and colour.

The storage chest or blanket box was universally popular in Upper Canada throughout the nineteenth century, most expressions being based on traditional British prototypes. The earliest are of the trestle-end, six-board style which, although elementary in execution, clearly reflects the early English form (Plate 588). Other examples are found in the framed and panelled style, often with the drawers typical of the mule-chest. Only rarely does the chest-on-chest appear. Possibly the most numerous item of Upper Canadian furniture is the six-board chest with bracket base. Its straightforward provincial joinery often makes it rather undistinguished, but some Upper Canadian cabinetmakers did approach eighteenth century English formality through the use of figured maple, cherry and walnut in place of the more common pine. Chests that are otherwise quite ordinary are sometimes elevated by their traditional decoration and woodgraining techniques. Numerous, also, are the tall storage chests with drawers below in the country Hepplewhite style (Plate 608) and those with slender, Sheraton-influenced, turned feet. This last type is particularly common in centres of American settlement.

Beds and Cradles

It is difficult to define the British vernacular bed, other than in broad terms as a tall-post type. Over the centuries, many different styles occurred and various methods of enclosure were used, including testers, curtains, canopies and bed-closets. By the end of the eighteenth century, low-post beds were coming into fashion and the enclosures were often eliminated altogether. The low-post was commonly adopted at the same time in the American colonies, and, while these often reflected the eighteenth century formal styles, a great number of pleasing, turned-post designs were

combined with simply shaped headboards and footboards creating a distinctive vernacular style.

Early British immigrants to Upper Canada, especially those of the prosperous classes, favoured the tall-post form with tester and curtains. Most of these beds were based on the later eighteenth century English styles and had gracefully turned Neoclassical posts and simple headboards. The earlier beds did not include a footboard, and only the footposts were detailed, for those at the head were hidden by the curtains. Later tall-post styles were designed for only a tester and have both foot and head board. These were transitional forms between the early enclosed beds and the low-post type. Very few tall-post beds were made after 1840. Consistent with British and American trends, the most popular Upper Canadian bed was the low-post with footboard, headboard and, often, a blanket rail. The turnings, finial details and headboard designs are typical of those made in the early part of the nineteenth century in the northern United States.

Testers, curtains and other bed enclosures were never widely used in the new country, although some sense of this tradition may have been achieved when the low-post bed was placed under the eaves of the typical Upper Canadian bedroom.

Early British cradles are really miniature versions of the bed, right down to the posts and canopy. In the seventeenth century, the panelled style of the Joiner was the most popular, although many cradles were produced by the Turner with spindles in place of panels between the posts. A similar form was developed in the eighteenth century, but it eliminated the posts by using dovetailed construction for the cradle case. This type was narrower at the base and was shaped to support hoods of different designs. All types were either fitted with rockers or suspended in a trestle-like frame, although the latter was a more sophisticated variant and was not nearly so popular in the country tradition.

Cradles in each of these styles were made in Upper Canada. Nevertheless, examples of the early, posted style are rare, and those of the spindle type are often of late manufacture, dating from the era of the Victorian revivals. Most common are the charming variations of the hooded-box style which were made throughout the first half of the nineteenth century.

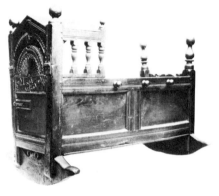

XXXV English – oak cradle, dated 1691.
[V. & A.]

Desks

The desk cannot be considered a truly traditional form, and its early use by the working classes was likely quite limited. By the late eighteenth century, however, it was a common piece of furniture in the modest country homes where literacy allowed the recording of business affairs. The vernacular expression of the desk form evolved from a simple box with a slanted hinged top designed to sit on a table. Later, this box-desk was placed in a frame of more or less table height and became a free-standing piece of furniture. The frame itself might have turned or square legs and often utilized an "H" or box stretcher. More elaborate examples included dividers and drawers in the desk interior as well as drawers in the frame below. This basic style was also used in schools and offices where the legs were lengthened and the user sat at a tall stool. As literacy increased and as the working classes became more prosperous, the desk came to be an important item of domestic furniture which found widespread use throughout the countryside. Influences from the formal bureaux and bureau bookcases were added, leading to a multiplicity of combinations of elements and styles. In a similar way but to a lesser extent, the desk implied the same sort of status as the corner cupboard.

The simple desk was used by each of the English-speaking groups in Upper Canada. It might be found in the kitchen, hallway or in the small

slip-room office that existed in many early houses. The stark simplicity of the early style, based as it was on the English prototype, gave way in later years to the more complex forms and the heaviness of Empire and Victorian styles.

The Hearth and its Furnishings

The importance of the hearth in the British domestic tradition is due to its function as a source of heat, a cooking facility and, as a result, the focal point of social intercourse in the home. The dominance of the hearth in English, Irish and Scottish cottages has already been discussed, but in larger and more elaborate homes that had separate rooms for different activities the more formal hearth also provided warmth, social focus and was the major feature of the room. The mantel shelf provided a convenient place for lighting devices and the display of decorative objects in these rooms, and it eventually evolved into an important and often elegant item of the room's furniture.

This tradition was taken to the American colonies, where great chimneys with multiple hearths were important factors in colonial architecture. Because of its importance as a source of heat in the severe North American climate and the scarcity of stoves during the early years, the open hearth was also adopted by Continental European immigrants whose homeland traditions did not place the same emphasis on it.

Similarly, the idea of the hearth was important in Upper Canada — more so, perhaps, because of colder weather. It was the dominant feature of the first small log cabins and most homes built by American or British immigrants during the eighteenth century and the first three or four decades of the nineteenth. These included a cooking fireplace which often bore the regional stamp of the owner's or builder's homeland. For example, the kitchen fireplace with bake-oven attached is more associated with England than Scotland or Ireland and, hence, was widely used in the American colonies. Beyond the kitchen hearth, most Upper Canadian homes also possessed one or more formal fireplaces in other rooms. The strong traditional emphasis on the hearth prolonged its use by British immigrants, in many cases until the mid-nineteenth century, even though cast-iron stoves offering efficiency were readily available by this time. Immigrants from Europe, on the other hand, were more likely to use a stove, since it was traditionally used in the homeland.

The close relationship between domestic architecture and furniture is often clearly described in the design of the mantelpiece and related cupboards. In Upper Canada, the Neoclassical style followed a short-lived survival of the early Georgian, and it was seen in all areas until the mid-nineteenth century. Individual examples from the 1840s to the end of the century reflect the eclecticism which characterized the mainstream of taste in both furniture and architecture. In the kitchen, the large cooking fireplace and its attendant fittings changed little from the styles of early eighteenth century Britain and America until it was replaced by the cook-stove midway through the nineteenth century.

Many sixteenth and seventeenth century British forms for the fireplace's iron equipment survived well into the Upper Canadian period. Most often made of wrought iron, the firedogs, cranes, trammels, trivets, pots and pothooks, toasters and griddles made for Upper Canadian kitchen hearths follow these early patterns. Cast-iron utensils were not readily available in large numbers until the mid-nineteenth century, and the decorative details of many wrought examples of the smith's art display highly individual expressions as well as regional or national characteristics.

XXXVI English – oak wall box, mid-18th century. [G.M.]

Wall Pieces and Other Traditional Kitchen Items

Particularly at the cottage level in the British tradition, the limited space available in the all-purpose kitchen required well-designed, small, wall-mounted furnishings and containers for specific purposes. Many of these basic forms date from the Middle Ages and are common in the vernacular of most European countries. There are regional variations in style or decoration, of course, but the universal traditional forms remain constant. A list of these forms should include dish racks, salt boxes, knife boxes, spoon racks, pipe racks, candle boxes and shelves. In Upper Canada, such items were often made by the individual settler rather than by a local craftsman, and as a result they are often primitive in execution, more related to folk tradition than furniture craft. A great many of these time-honoured forms were made for Upper Canadian kitchens, doubtless recreating images from the homeland that were clearly etched in the maker's mind. Laymen artisans also carved and shaped such useful wooden objects as bowls, scoops, spoons and ladles as necessity dictated or as found material suggested.

The traditional kitchen required additional utilitarian furnishings which were most often made by craftsmen. The dough box, meal chest, candle dryer, spinning wheel, wool winder, kitchen buffet, preserve cupboard, kitchen washstand and pail bench were all part of the tradition which moved from all parts of the British Isles into the American colonies and, later, into Upper Canada.

During the process of identifying the strong influences from Britain and the United States on the furniture actually made in Upper Canada, it is just as important to observe the differences. Although they are stylistically derivative, Upper Canadian expressions of form and style frequently display their own distinctive characters. This may be the result of provincial simplification, functional adaptation in an altered environment, the different materials that were abundantly available, or simply the expression of that part of human nature that must add something unique and personal to anything that is made.

As in other areas that have been exposed to powerful British or American influence, the Canadian identity is elusive. Perhaps it may be found in adaptability, the altering of basic form and style to suit the special requirements of life in a Canadian environment. In any case, the total impact of influences from the aggregate English-speaking countries, based on forms that were often centuries old, produced a distinct Upper Canadian vernacular expression.

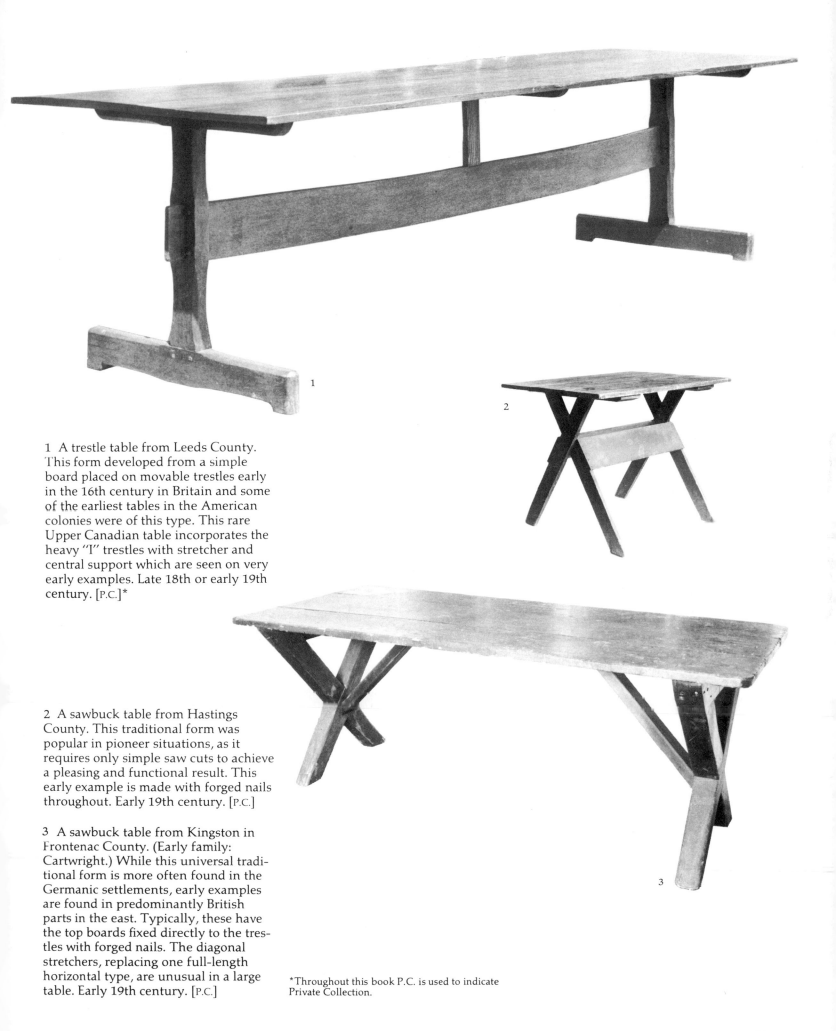

1 A trestle table from Leeds County. This form developed from a simple board placed on movable trestles early in the 16th century in Britain and some of the earliest tables in the American colonies were of this type. This rare Upper Canadian table incorporates the heavy "I" trestles with stretcher and central support which are seen on very early examples. Late 18th or early 19th century. [P.C.]*

2 A sawbuck table from Hastings County. This traditional form was popular in pioneer situations, as it requires only simple saw cuts to achieve a pleasing and functional result. This early example is made with forged nails throughout. Early 19th century. [P.C.]

3 A sawbuck table from Kingston in Frontenac County. (Early family: Cartwright.) While this universal traditional form is more often found in the Germanic settlements, early examples are found in predominantly British parts in the east. Typically, these have the top boards fixed directly to the trestles with forged nails. The diagonal stretchers, replacing one full-length horizontal type, are unusual in a large table. Early 19th century. [P.C.]

*Throughout this book P.C. is used to indicate Private Collection.

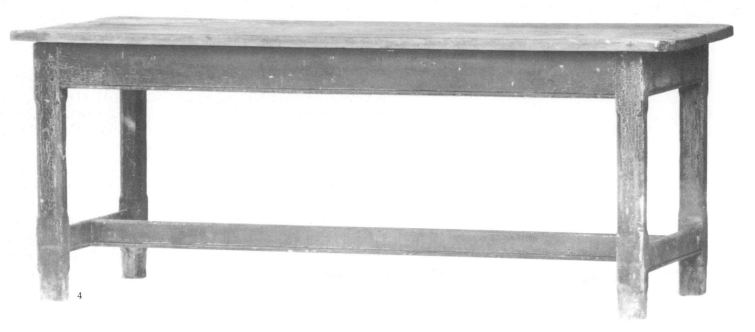

4

4 A kitchen table from York County. The relationship between this example and the mid-17th century English refectory table on page 40 is striking. The chamfered leg detail is seen on many English tables from the 18th and 19th centuries. First half 19th century. [P.C.]

5 A kitchen table from Cavan Township in Durham County. This strong design is directly related to early British refectory table prototypes. While this form was widely made in Upper Canada, it is rare to see the massive character reminiscent of the 16th and 17th century style, which in this example is blended with typical late Empire details in the turnings. Second quarter 19th century. [P.C.]

6 A kitchen table from Simcoe County. This fine example of the refectory form incorporates in its elements the lighter character which is seen in early 18th century examples made in the American colonies. The wide overhang is also a characteristic of the American style. Early 19th century. [P.C.]

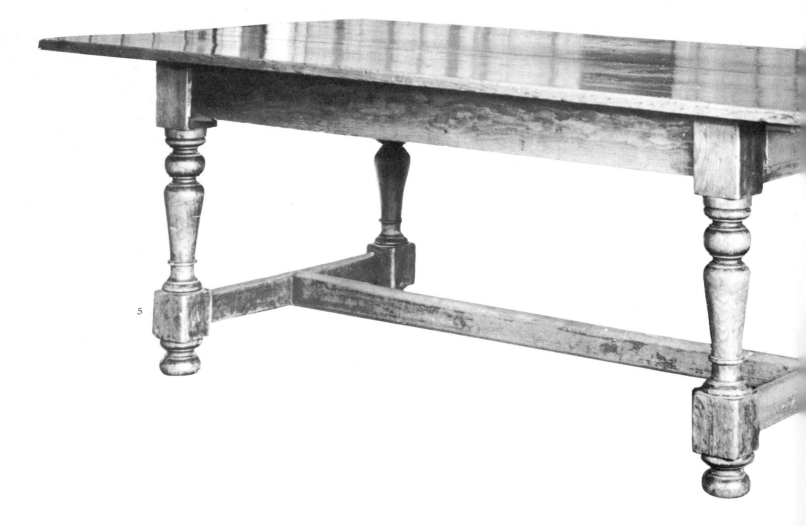

5

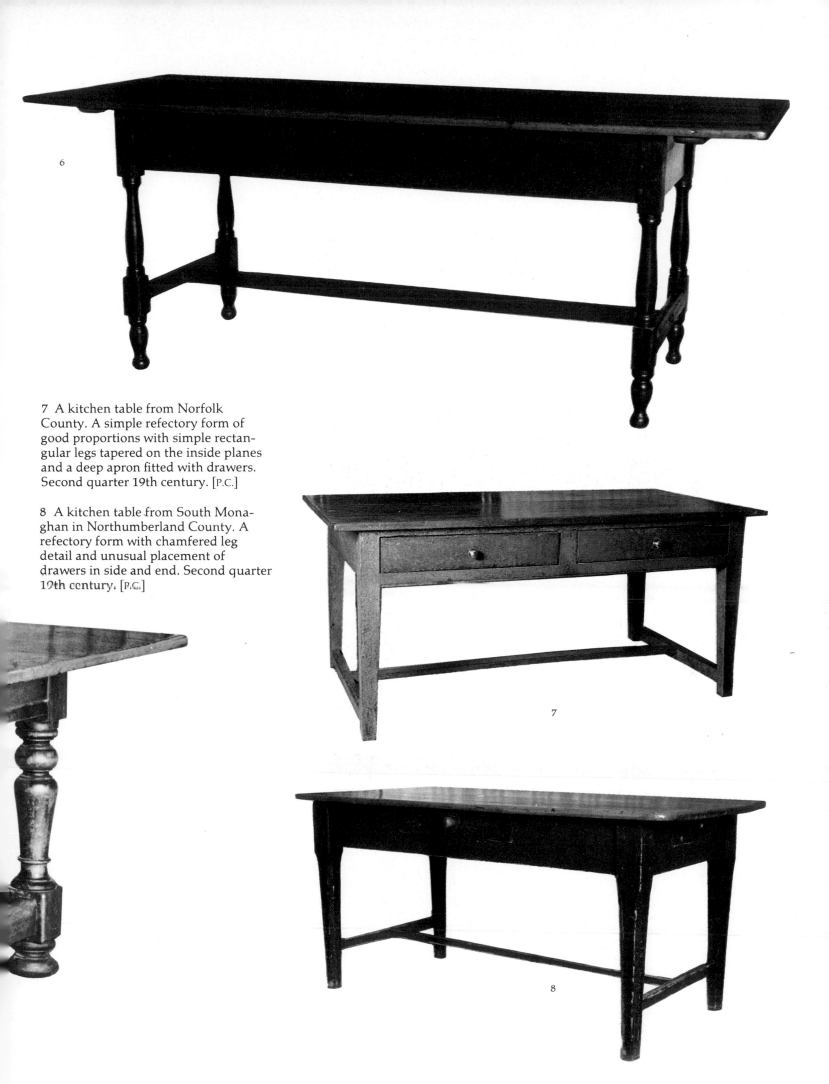

7 A kitchen table from Norfolk County. A simple refectory form of good proportions with simple rectangular legs tapered on the inside planes and a deep apron fitted with drawers. Second quarter 19th century. [P.C.]

8 A kitchen table from South Monaghan in Northumberland County. A refectory form with chamfered leg detail and unusual placement of drawers in side and end. Second quarter 19th century. [P.C.]

6

7

8

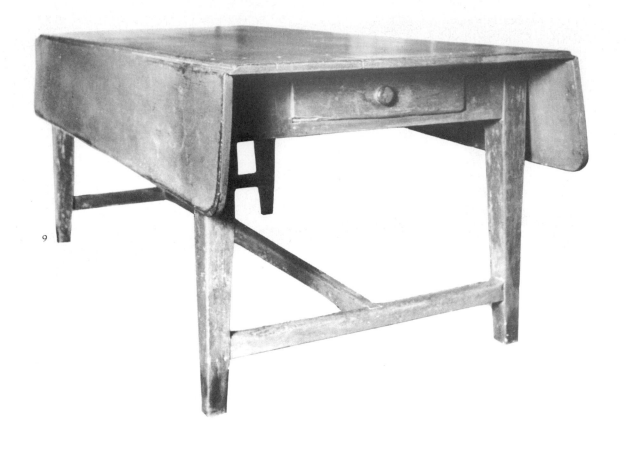

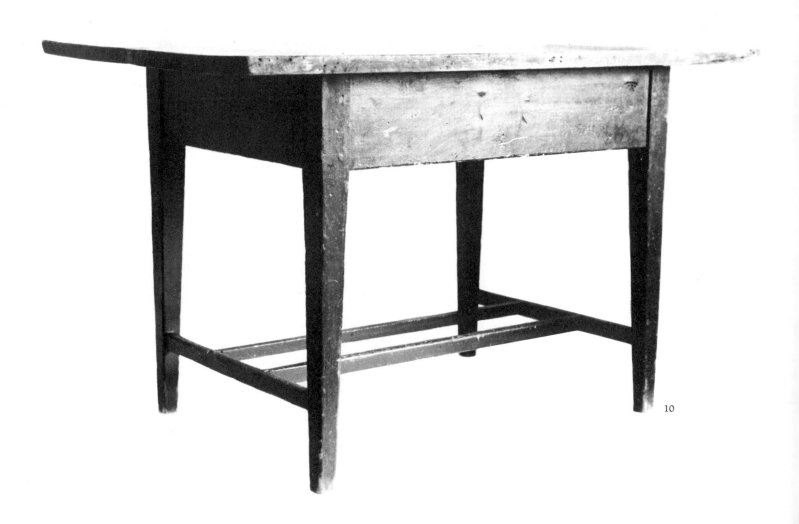

9 A kitchen table from Scarborough in York County. (Early family: Stirling.) This design combines the refectory form with drop-leaves working on rule joints which were popular in large tables, usually of hardwood, made for British country kitchens in the 18th and 19th centuries. Second quarter 19th century. [P.C.]

10 A kitchen table from Durham County. The double stretcher or pot rail identifies this table directly with the Irish cottage tradition. In size and simple construction, this example reflects the prototype. Second quarter 19th century. [P.C.]

11 A kitchen table from Frontenac County. This long, double-leaf design is based on the same British country style as Plate 9. Although simply fashioned, it reflects influences from the Sheraton-Hepplewhite period with the removal of the stretchers and the lighter overall design. Second quarter 19th century. [P.C.]

12 A kitchen table from Toronto. This table survives in the basement kitchen of an early 19th century home. (Early family: Playter.) This development of the refectory form was designed with stretchers on three sides for use primarily as a work table against a wall and includes one drop-leaf and large drawers. Early 19th century. [P.C.]

13 A kitchen table from the central counties. This massive, simply formed stretcher-base design is typical of the refectory tables used in 18th and 19th century kitchens in rural Britain. Second quarter 19th century. [P.C.]

14 A kitchen table from Waterloo County. By the 1860s, variations on the basic design were made in all areas, and they employed a two- or three-board top, a cutlery drawer and turned legs in the Empire style. Third quarter 19th century. [P.C.]

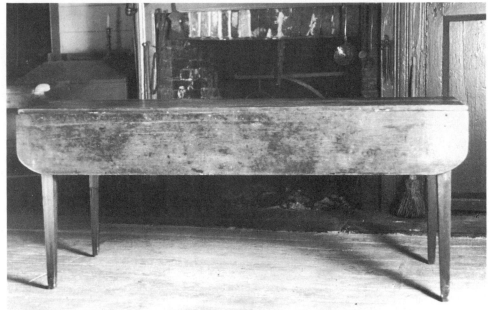

11

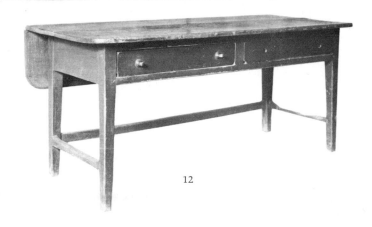

12

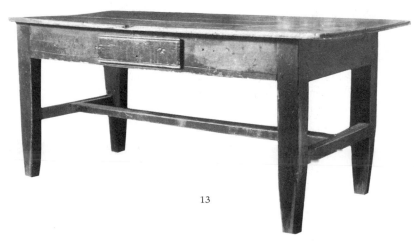

13

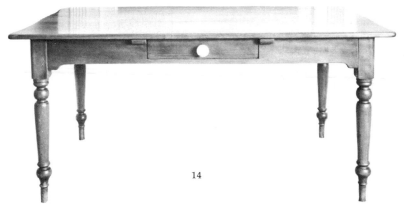

14

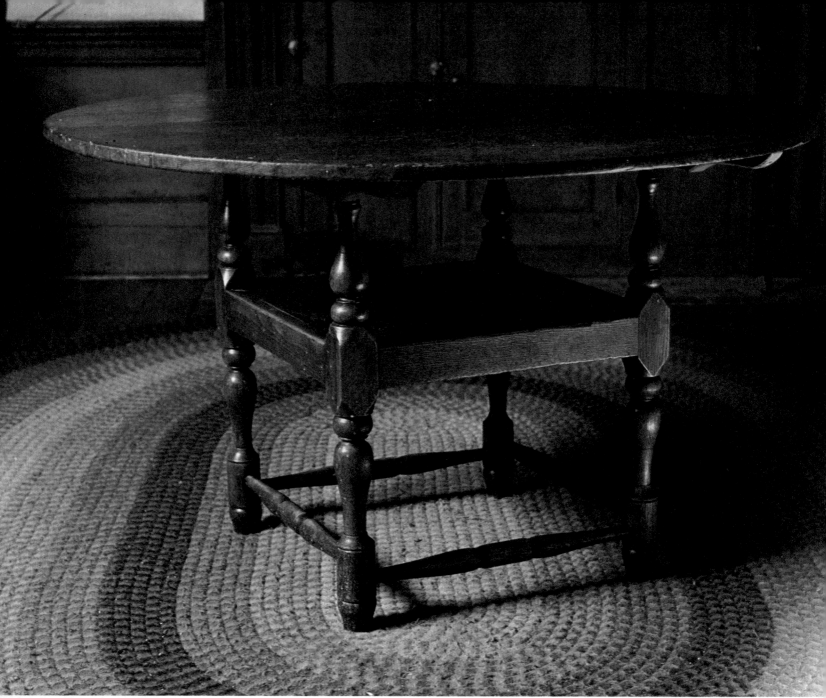

15

15 A chair-table from the Niagara Peninsula. (Early family: Collyer, emigrated from New Jersey in the early 19th century.) The fine, robust turnings and stretchered style seen here are of early character, relating to American examples of the 17th and 18th centuries. This table may well have been brought to Canada as settlers' effects or locally made by a craftsman trained in the earlier tradition. 18th or early 19th century. [P.C.]

16 A chair-table from East Zorra Township in Oxford County. As in the preceding illustration, the complex turnings and fine mortise and tenoned construction in this example are typical of 18th century America. 18th or early 19th century. [P.C.]

17 A chair-table from Prince Edward County. This simple design has a slot in the arm which allows a centred position for the wooden hinge and, as a result, a more stable chair when the top is in the upright position. First quarter 19th century. [P.C.]

18 A chair-table from Elgin County. This is an unusually well-preserved example of late 18th century American vernacular style. Other tables of similar design are known in the same area. First quarter 19th century. [P.C.]

19 A chair-table from Ontario County. This small table was made without the benefit of a lathe, using chamfered posts in place of the traditional turnings. The wooden hinge is created by a dowel running side to side which, with

the addition of a central stretcher, creates a chair back. Second quarter 19th century. [P.C.]

20 A settle-table from Wolfe Island in Frontenac County. This is also a variation on the early British chair-table form. An expert joiner used mortise and tenon and dovetail details and exceptionally heavy stock for the shaped trestles in this impressive example. First quarter 19th century. [P.C.]

21 A settle-table from Lincoln County. As is the case with many examples of the form in Upper Canada, this table was made in an area settled by American Quakers. The top is secured in the table position by pegs in holes at both ends of the cleat and trestle. Second quarter 19th century. [P.C.]

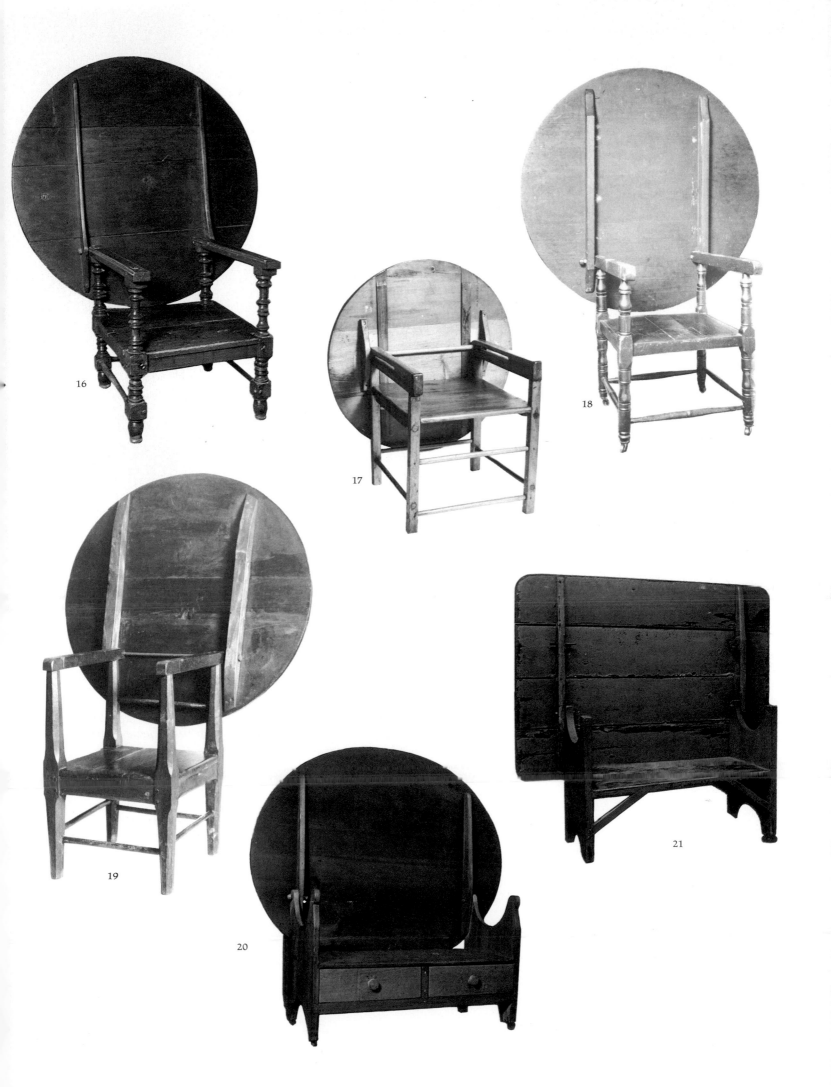

16

17

18

19

20

21

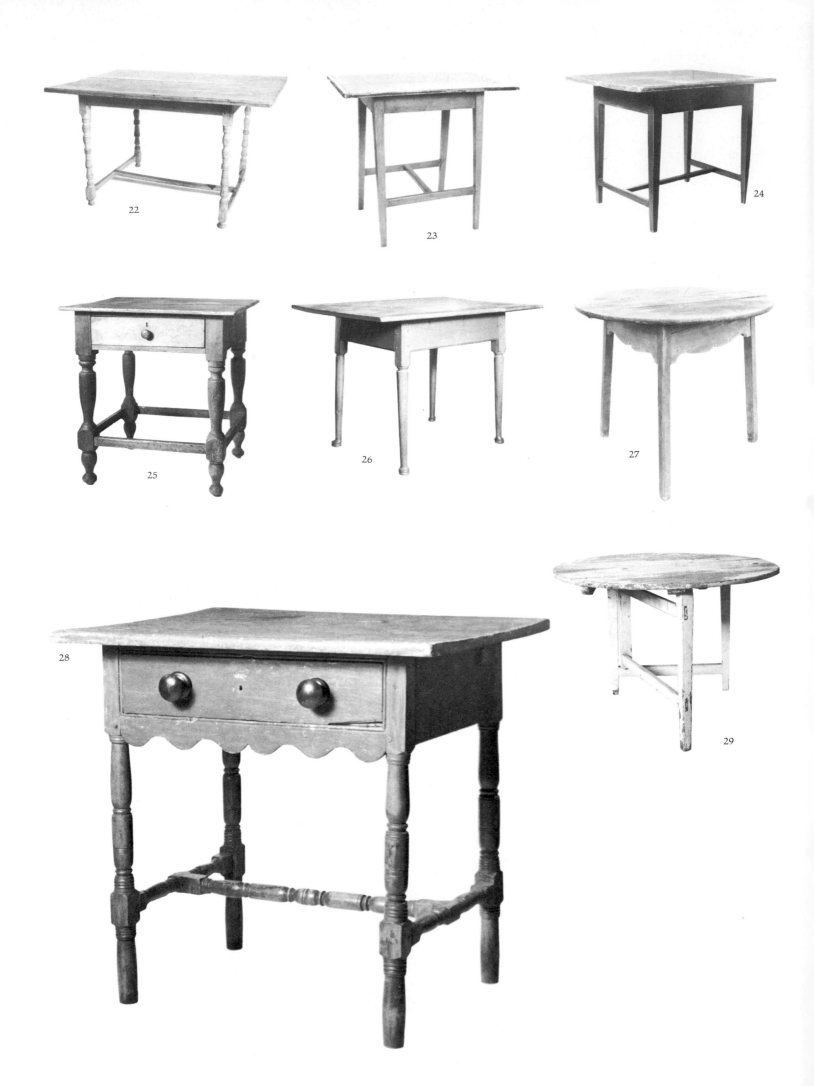

22 A tavern table from Lennox and Addington County. The complex turnings terminating in bun feet are of early 18th century American character, while the simple, slender medial stretcher and lightness of design relate this highly interesting table to the 19th century. First quarter 19th century. [P.C.]

23 A tavern table from the eastern counties. This is a pleasing example of the universally popular square tapered leg style incorporating an "H" stretcher and "bread board" cleats on the one-piece top. First quarter 19th century. [P.C.]

24 A tavern table from Wellington County. Similar to the preceding example, this well-proportioned table retains its original green paint. Second quarter 19th century. [P.C.]

25 A tavern table from Grenville County. This design is soundly based on the 18th century prototype in form, yet the detail and heaviness of the legs are typical of 19th century style. Second quarter 19th century. [P.C.]

26 A tavern table from Prince Edward County. This outstanding early table has simple Dutch or club feet and splayed legs, a provincial expression of the Queen Anne style which was popular in the American colonies in the 18th century. The subtle refinement of the execution is consistent with the style and almost certainly indicates that it originated in an earlier colony. 18th century. [U.C.V.]

27 A three-legged table from Perth County. This form is known in England as a cricket table and was made there from the 17th century. It was also popular in 18th century America. The apron shaped in two cyma curves is a reflection of the Queen Anne period. Second quarter 19th century. [P.C.]

28 A tavern table from the hamlet of Lunenburg in Stormont County. The turned legs and "H" stretcher and the shaped apron are characteristics of 18th century American country style. Early 19th century. [P.C.]

29 A coaching table from Bruce County. This unusual single-gate design folds in the middle for convenient handling. The form originates in 17th century England where it was presumably developed to allow travellers to dine in style by the roadside. Second quarter 19th century. [P.C.]

30 A tavern table from Lennox and Addington County. This fine design is a sensitive simplification of early 18th century American prototypes with its box stretchers and subtle proportions. Late 18th or early 19th century. [P.C.]

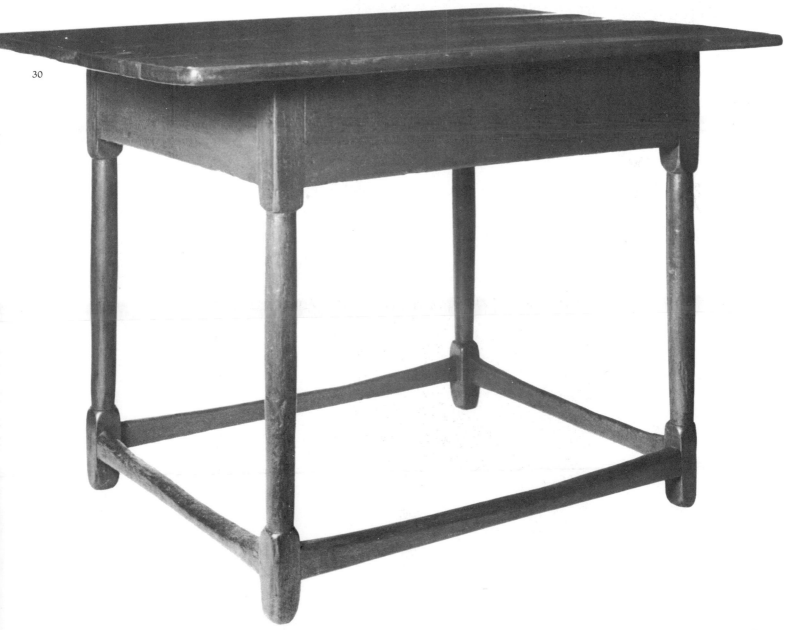

30

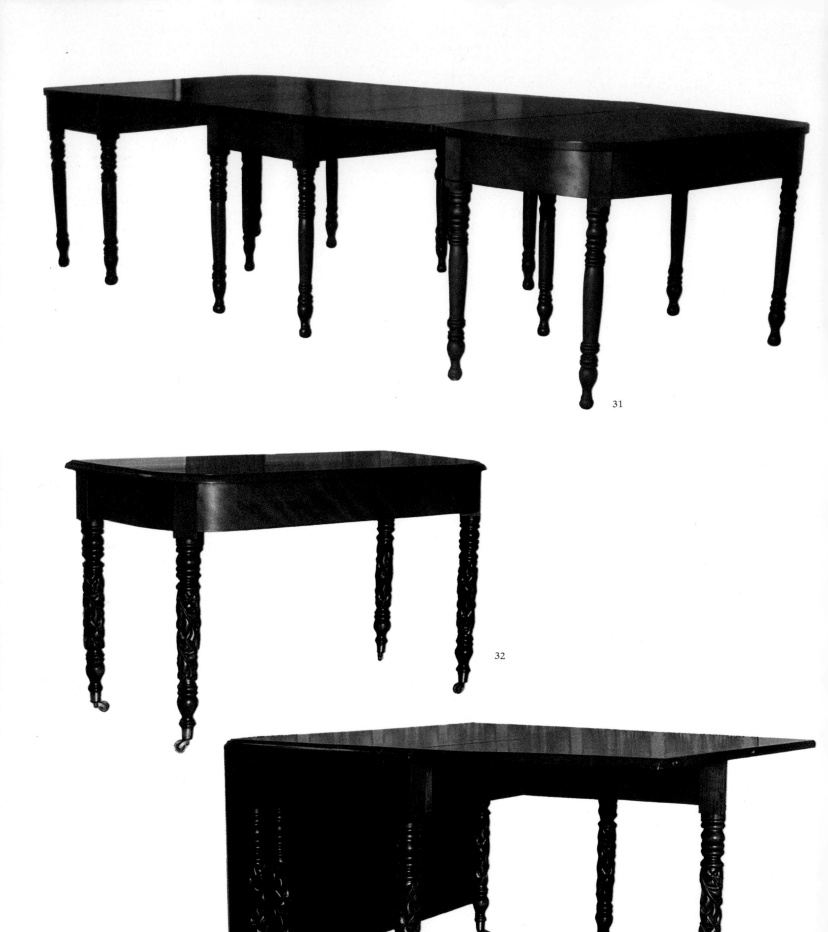

31

32

33

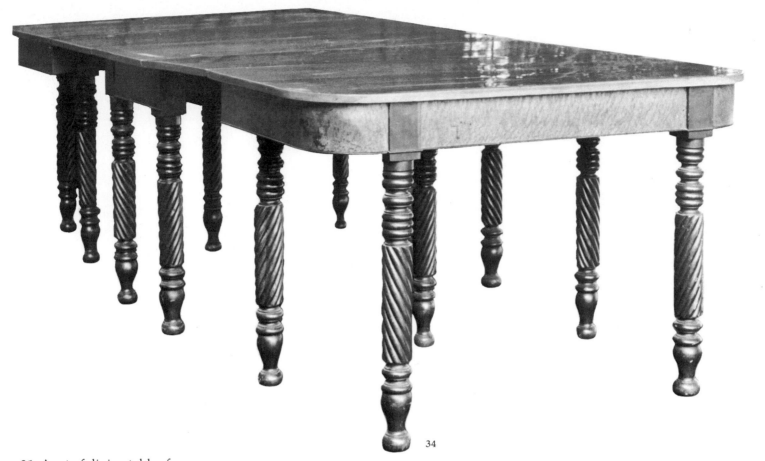

34

31 A set of dining tables from Manchester in Ontario County. (Early family: Christie.) This is a very good example of country formality as expressed in Upper Canada toward the mid-19th century. The three-part table includes a gate-leg centre section and two "D" end sections which may be employed in various combinations. The design is based on the style associated with Sheraton, despite a heaviness in execution which acknowledges the transition to Empire taste as interpreted by a provincial craftsman. Second quarter 19th century. [P.C.]

32, 33 A set of dining tables from Elgin County. This is a well executed example of the Empire style. The acanthus leaf carving and overall heaviness of the design are characteristic. Second quarter 19th century. [P.C.]

34 A set of dining tables from Simcoe County. The heavily detailed leg design and exotic effect of contrasting woods are combined here in a stylish expression of later Empire taste. Second quarter 19th century. [P.C.]

35 A set of dining tables from York County. Labelled, *This table made by Geo. Brooke – made for Mr. Hillory Tay – October 1842.* This conservative example of the Empire style is made of figured maple with rosewood veneer on the curved skirt. 1842. [P.C.]

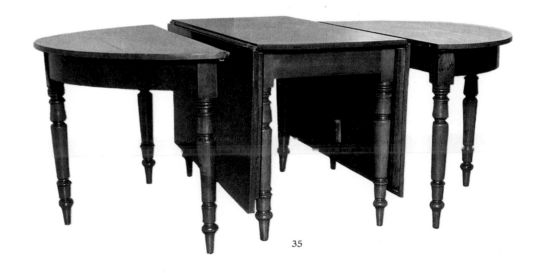

35

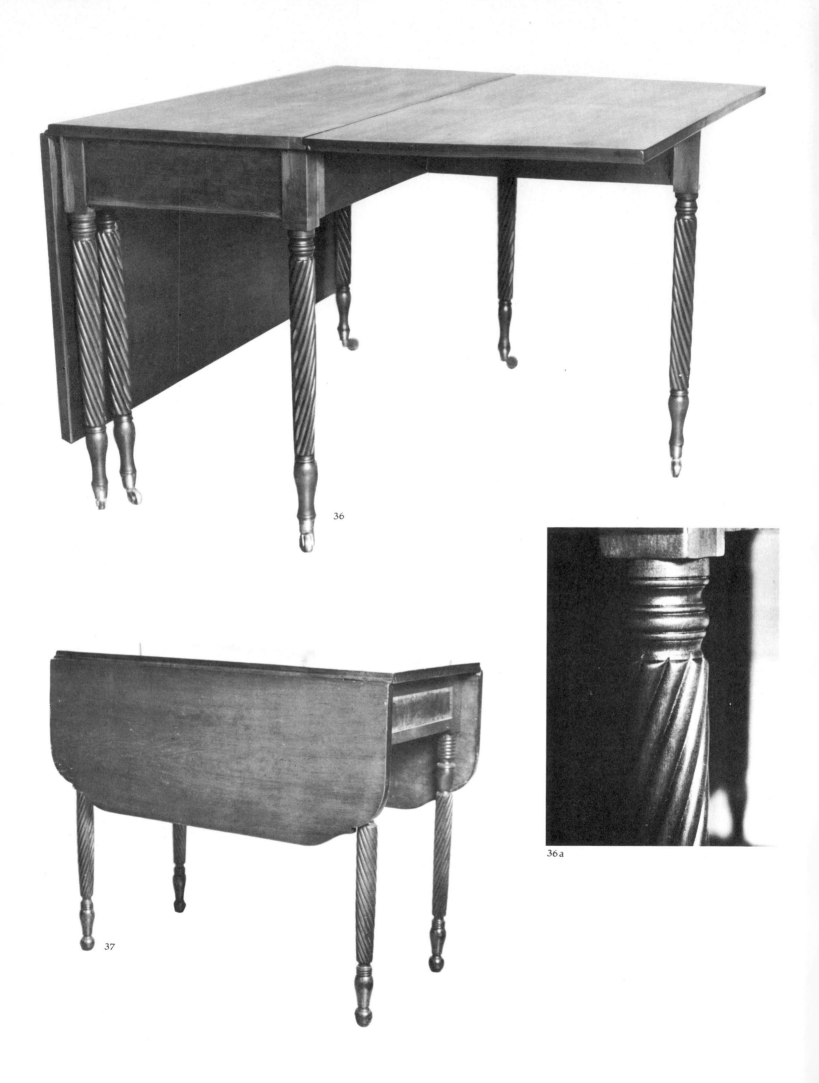

36

36a

37

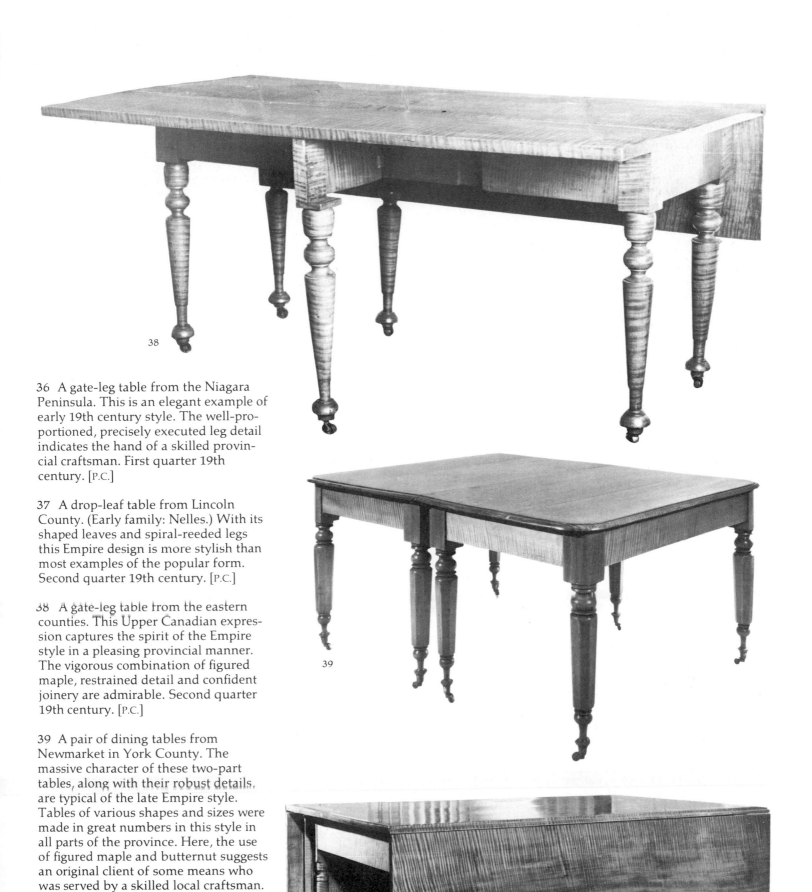

38

39

40

36 A gate-leg table from the Niagara Peninsula. This is an elegant example of early 19th century style. The well-proportioned, precisely executed leg detail indicates the hand of a skilled provincial craftsman. First quarter 19th century. [P.C.]

37 A drop-leaf table from Lincoln County. (Early family: Nelles.) With its shaped leaves and spiral-reeded legs this Empire design is more stylish than most examples of the popular form. Second quarter 19th century. [P.C.]

38 A gate-leg table from the eastern counties. This Upper Canadian expression captures the spirit of the Empire style in a pleasing provincial manner. The vigorous combination of figured maple, restrained detail and confident joinery are admirable. Second quarter 19th century. [P.C.]

39 A pair of dining tables from Newmarket in York County. The massive character of these two-part tables, along with their robust details, are typical of the late Empire style. Tables of various shapes and sizes were made in great numbers in this style in all parts of the province. Here, the use of figured maple and butternut suggests an original client of some means who was served by a skilled local craftsman. Second quarter 19th century. [P.C.]

40 A gate-leg table from Ontario County. This large table is a fine example of Upper Canadian furniture in which magnificent pieces of figured maple are soundly crafted in a re--strained style. The large gate-leg form with deep drop-leaves was a popular English country style from the 17th century. Second quarter 19th century. [P.C.]

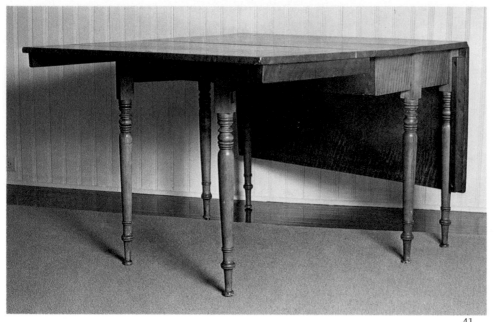

41 A gate-leg table from the eastern counties. The influence of the Sheraton style is reflected in the lightness of the turned leg design, creating a slender urn form. Variations on this style, including degrees of influence from the heavier Empire designs, were made throughout the 19th century in all areas and are an important facet of the Upper Canadian vernacular. Second quarter 19th century. [P.C.]

42 A drop-leaf table from the eastern counties. This well-proportioned design reflects the late 18th century Sheraton style. The use of unusually fine figured maple replaces the elaborate inlaid and veneered techniques of the stylish period examples. First quarter 19th century. [P.C.]

43 A drop-leaf table from Carleton County. A popular element of the Empire idiom, the carved acanthus leaf motif was associated with the height of provincial style. Second quarter 19th century. [P.C.]

44 A drop-leaf table from York County. (Early family: Echhart.) Considered proportions and pleasing figured maple are combined to make this a good example of an Empire style which was made in all areas from 1840 to about 1875. Second quarter 19th century. [P.C.]

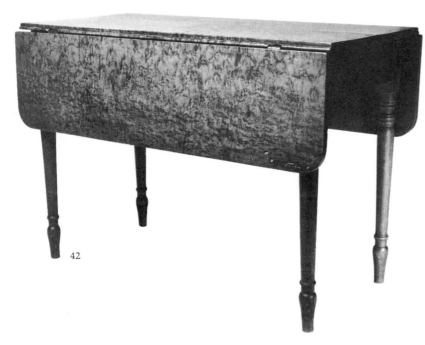

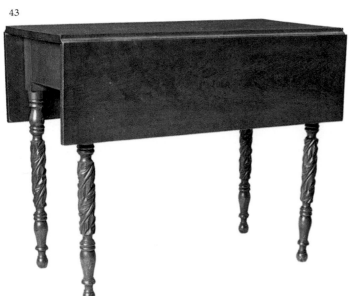

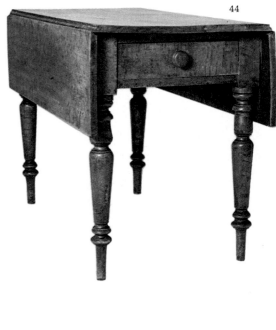

45 A drop-leaf table from Kingston. (Signed, *S. Dale, Kingston, Canada West*; known as a carriage-maker.) This eccentric Empire leg design, combining turned details with a squared section, is often associated with Upper New York State where it was very popular. Further evidence of Empire style is seen here in the veneered, ogee-shaped drawer. Second quarter 19th century. [P.C.]

46 A drop-leaf table from Pickering Township in Ontario County. The strong posture of this simply made table suggests a relationship to the styles of the Chippendale era. Second quarter 19th century. [P.C.]

47 A drop-leaf table from the eastern counties. This small and graceful table retains the spirit of the 18th century Neoclassical period, but the prevailing Empire taste is evident in its heavier design and boldly executed detail. Second quarter 19th century. [P.C.]

48 A gate-leg table from the western counties. This table reflects the form of the stylish card tables of the late 18th century. It is simply made by a country craftsman in the typical Empire-influenced style of the mid-19th century. Second quarter 19th century. [P.C.]

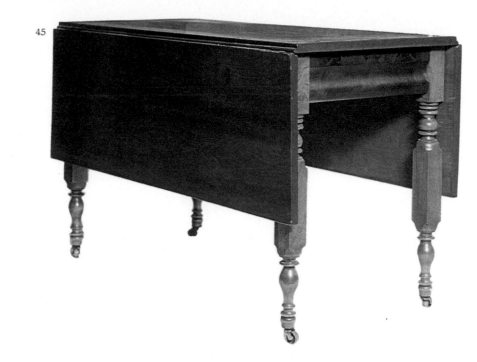

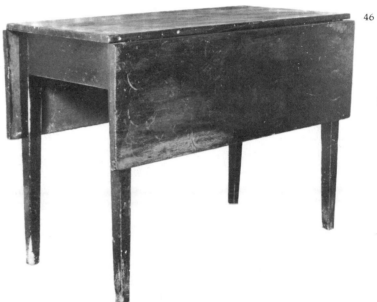

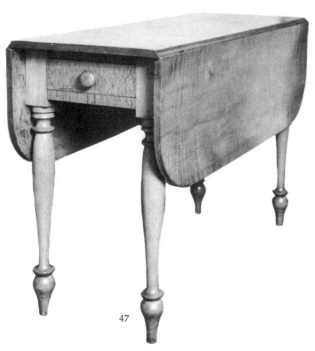

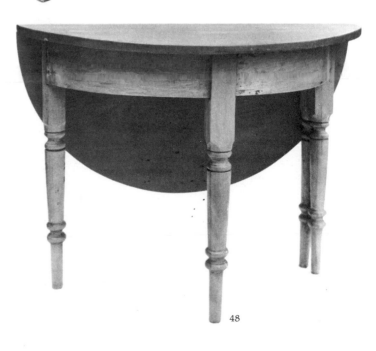

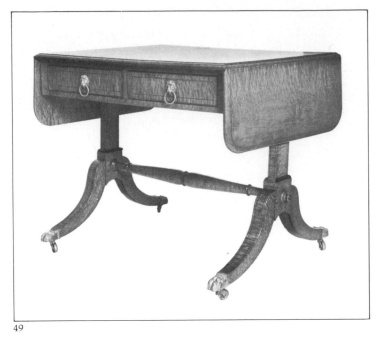

49

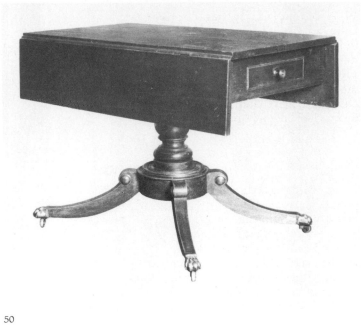

50

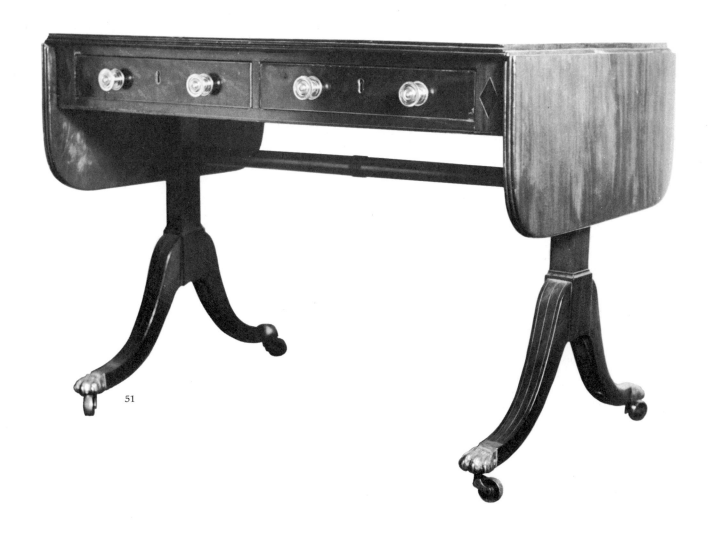

51

49 A sofa-table from Niagara-on-the-Lake in Lincoln County. This fine table in figured maple is of slightly heavier design than Plate 51 and probably is of a later date. The wide moulding of the top and leaf edges is characteristic of later Empire period technique. Second quarter 19th century. [P.C.]

50 A breakfast or parlour table from the eastern counties. This form is associated with the same period as the preceding sofa-tables but was less popular. The unusual example here is made entirely of pine, although the design is quite sophisticated. The exposed dovetail construction of the apron suggests that the maker may have intended to apply veneer which would have been more appropriate. The table retains an early stain and varnish finish. First half 19th century. [P.C.]

51 A sofa-table from Toronto. (Early family: MacDonell.) This graceful form was introduced in Sheraton's time, developing from the Pembroke table, and was popular throughout the Regency period in England and somewhat longer, to the end of the Empire period, in the United States. The Regency example here has a long Toronto history. First quarter 19th century. [P.C.]

52 A drum library table from Kingston. Fitted with drawers in the deep apron, this form was popular in the late 18th and early 19th century, particularly in Britain. This example is of late Neoclassical style. Second quarter 19th century. [P.C.]

53 A drop-leaf table from Oxford County. This exceptionally pleasing small table was made by a skilled and sensitive provincial craftsman well-schooled in the vernacular. Second quarter 19th century. [P.C.]

54 A Pembroke table from Brockville in Leeds County. This simple expression of late 18th century English style is an excellent example of the more stylish furnishings made by provincial craftsmen in Upper Canada for clients of taste and means. First quarter 19th century. [P.C.]

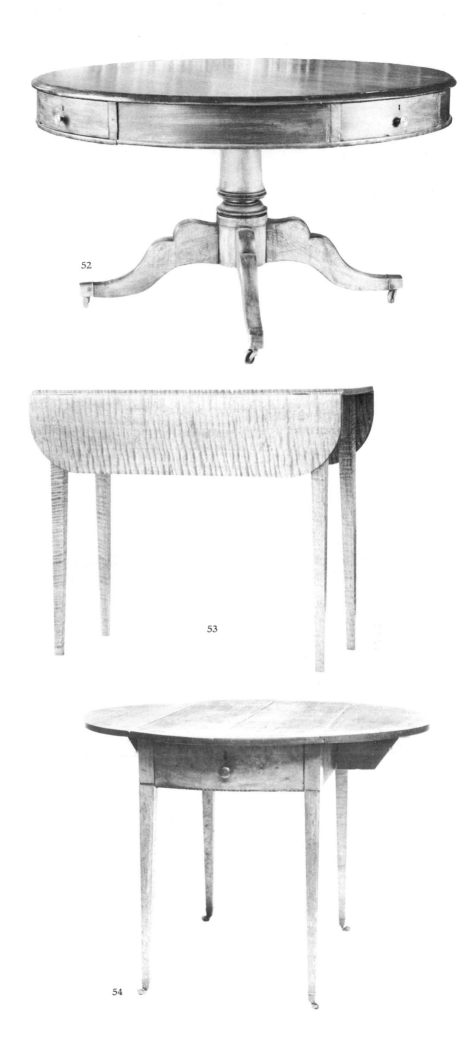

52

53

54

55 A tilt-top parlour table from the eastern counties. Stylish 18th century prototypes for this design have dished tops, often with carving on the edges, pedestal, legs and feet. This provincial survival of the earlier style achieves a light, well-balanced and graceful character with its unusually wide snake feet and simply turned column. First quarter 19th century. [P.C.]

56 A tilt-top parlour table from Northumberland County. The convex form of the tripod legs and the urn-shaped

element in the pedestal were popular features of the late 18th century style, as illustrated by Sheraton. Second quarter 19th century. [P.C.]

57 A tilt-top parlour table from Kingston. A graceful, but sturdily provincial, example of the Sheraton style. Second quarter 19th century. [P.C.]

58 A tilt-top parlour table from Scarborough in York County. The graceful proportions of this example and the use of mahogany suggest a maker of some sophistication, possibly working in York. Second quarter 19th century. [P.C.]

59 A parlour table from Markham in York County. (Early family: Reesor.) From the same area and incorporating similar details as the following example, this smaller table is probably by the same local craftsman. Second quarter 19th century. [P.C.]

60 A tilt-top parlour table from Markham in York County. (Early family: Milne.) The simple, well-proportioned snake feet and urn pedestal are soundly based in 18th century style. Second quarter 19th century. [P.C.]

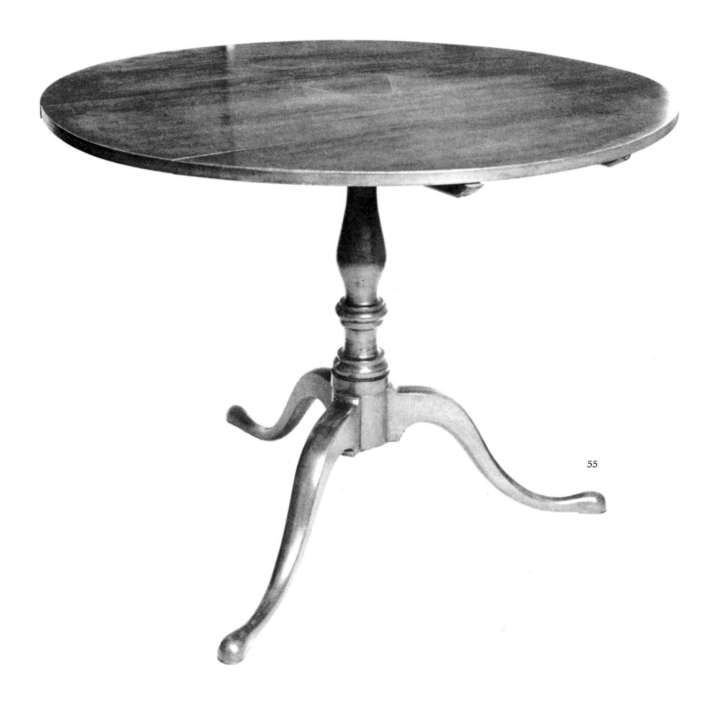

55

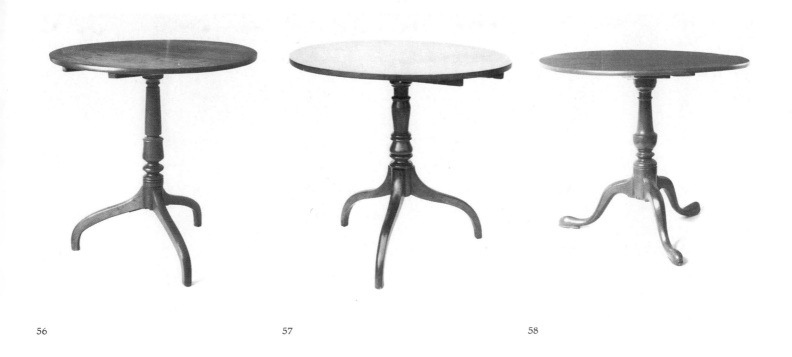

56 57 58

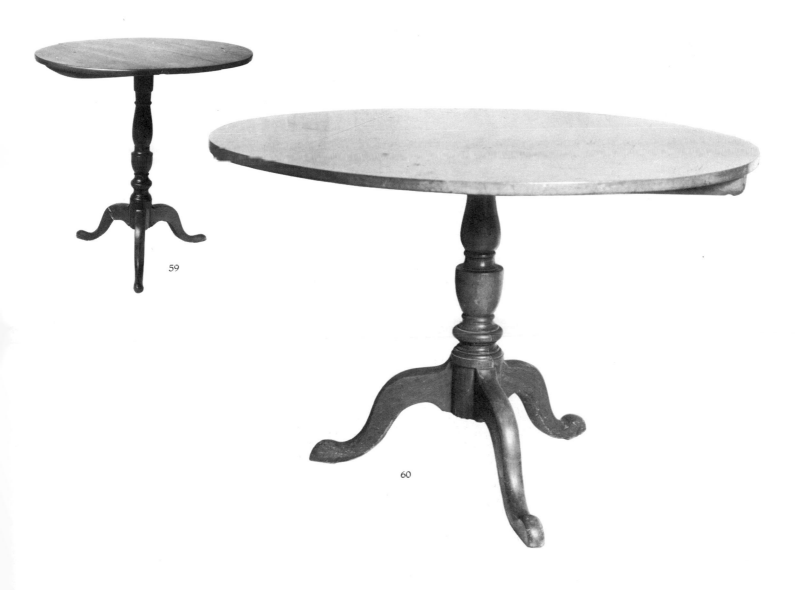

59

60

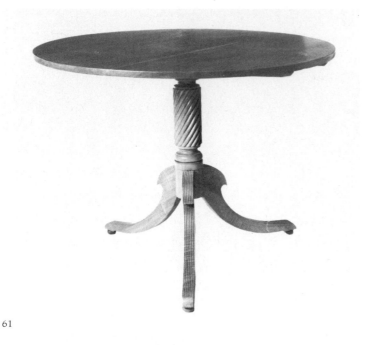

61

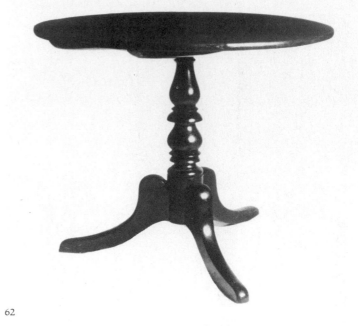

62

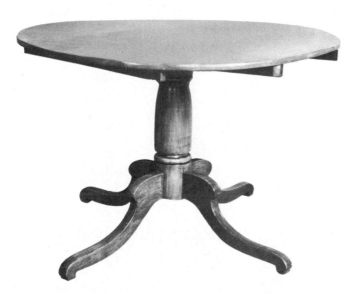

63

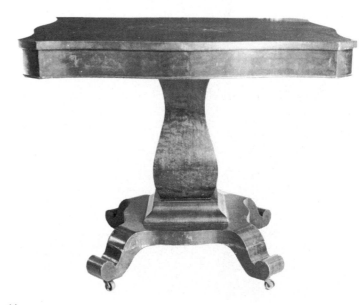

64

61 A tilt-top parlour table from Chippawa in Welland County. The spiral-reeded pedestal and the concave, reeded legs are popular details of late Neoclassical style encompassing the English Regency and the American Empire periods. Second quarter 19th century. [P.C.]

62 A tilt-top parlour table from Norfolk County. (Early family: Arn.) This is a vigorous and romantic interpretation of late Neoclassical style. Second quarter 19th century. [P.C.]

63 A tilt-top parlour table from the eastern counties. Designs incorporating a heavy pedestal or column with three or four feet were popular in the late Empire period. They inspired a wide variety of factory-made pedestal, parlour and dining tables throughout

the last half of the 19th century. Second quarter 19th century. [B.C.P.V.]

64 A parlour table from Napanee in Lennox and Addington County. Typical of late Empire, factory-produced designs, this table was probably made locally in the Gibbard factory. Mid-19th century. [L. & A.C.M.]

65 A card table from Leeds County. The Empire style of this table is not often seen in this form, which was popular from the 18th century until about 1830. It is, however, a good example of its period, incorporating excellent craftsmanship with a pleasing use of figured maple and birch. Second quarter 19th century. [P.C.]

66 A serving table from Frontenac County. This multiple-ring leg design occurs often in the eastern counties, while the panelled end is an unusual detail on tables of Sheraton-influenced style. Second quarter 19th century. [P.C.]

67 A serving table from Hope Township in Northumberland County. (Early family: Moon.) This simple design with shaped apron reflects formal 18th century examples in form and style. Second quarter 19th century. [P.C.]

68 A side table from St. Thomas in Elgin County. This is an honest and satisfying Upper Canadian interpretation of a popular 18th century British form, which includes several drawers, made for use in dining rooms and parlours. Second quarter 19th century. [P.C.]

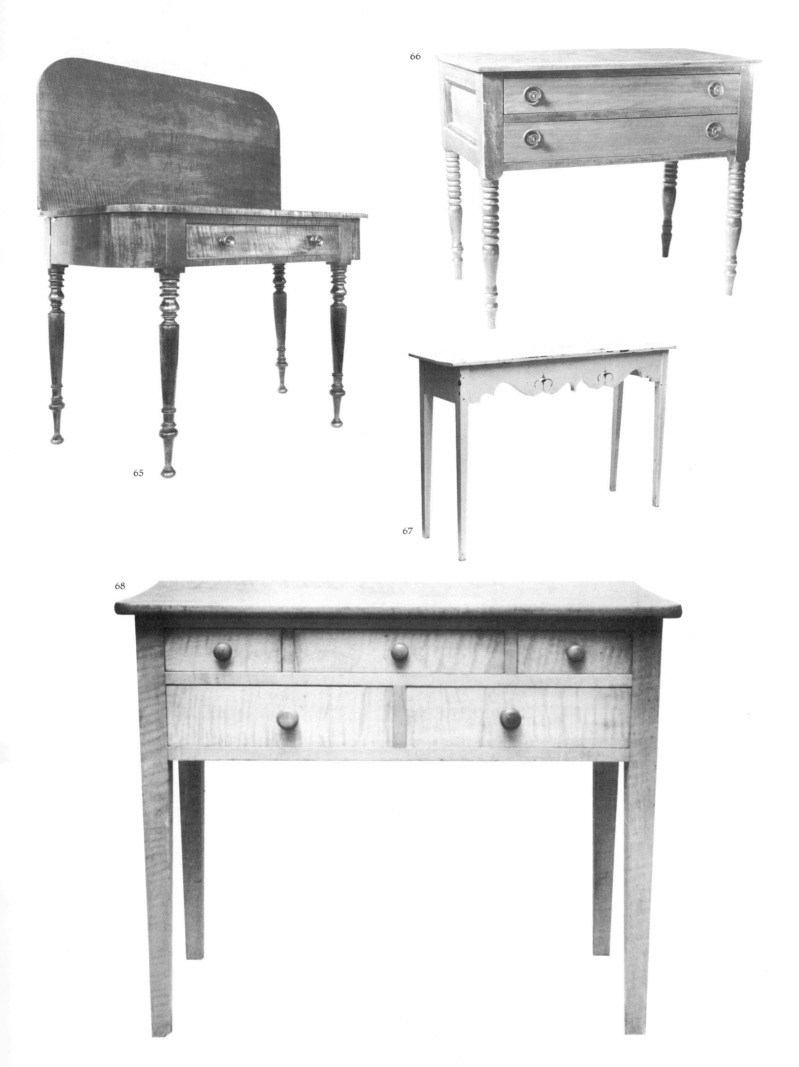

65

66

67

68

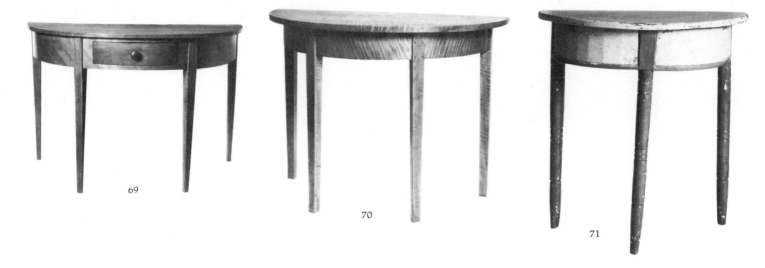

69

70

71

69 A D-end table from the eastern counties. One of a set of tables, this example has long been separated and used as a side table with a drawer fitted to suit its new function. The flame birch top is hand-planed to a pleasing slimness. First quarter 19th century. [P.C.]

70 A parlour side table from the eastern counties. This pleasing example of country craftsmanship reflects the late 18th century styles of the Sheraton and Hepplewhite period in simple joinery. Second quarter 19th century. [P.C.]

71 A parlour side table from the eastern counties. This is a charmingly naïve relative of the following example. First half 19th century. [P.C.]

72 A parlour side table from Toronto. One of a pair, which might be placed together or separate, this table exhibits a highly individual interpretation of the Sheraton style. The inlay-like decoration on the apron is painted and the diamond-pattern panels at the top of each leg are carved. First quarter 19th century. [P.C.]

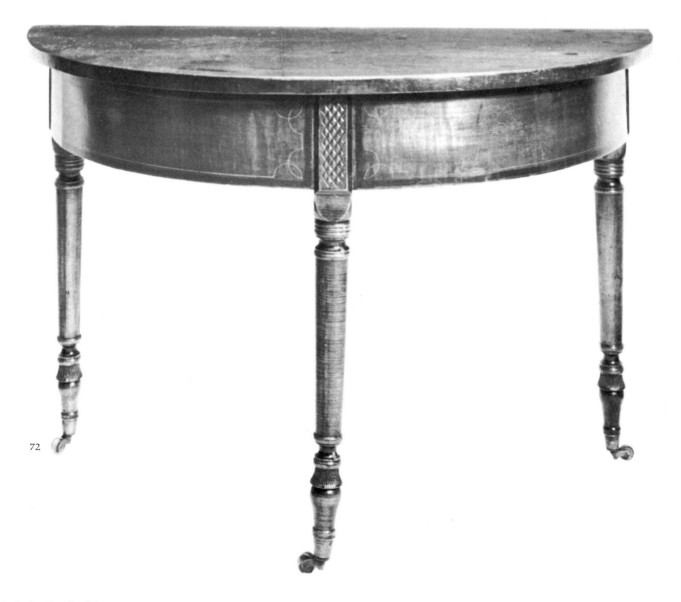

72

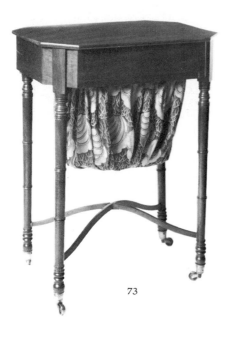

73

73 A work table from Wellington County. (Early family: Passmore.) This fine table with shaped stretchers is typical of those made early in the 19th century in Sheraton-influenced designs and may have been brought from the United States. Unlike more elaborate early examples, the top here is fixed and does not open to provide a sewing box. The bag, which has been restored, is fitted to a slide. First quarter 19th century. [P.C.]

74 A work table from Kingston. Similar to the preceding illustration, this example is fitted with a drawer in front and false drawers at the sides, as well as with a candle slide. The bag and slide are missing. Second quarter 19th century. [P.C.]

75 A work table from Perth in Lanark County. This further example of the popular form includes influences of Empire taste in its more rounded details and rectangular design. Second quarter 19th century. [P.C.]

76 A work table from the eastern counties. A highly competent cabinet-maker produced this fine table of early 19th century style and meticulous detail. The top front drawer is false, allowing smaller drawers on each side above a fixed cock-beaded panel. First quarter 19th century. [P.C.]

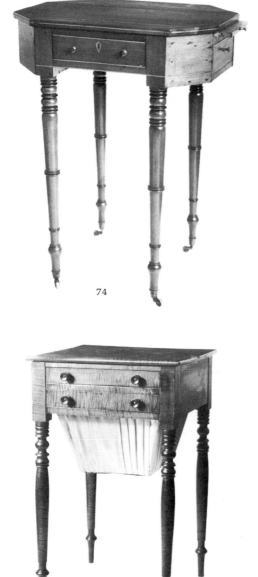

74

75

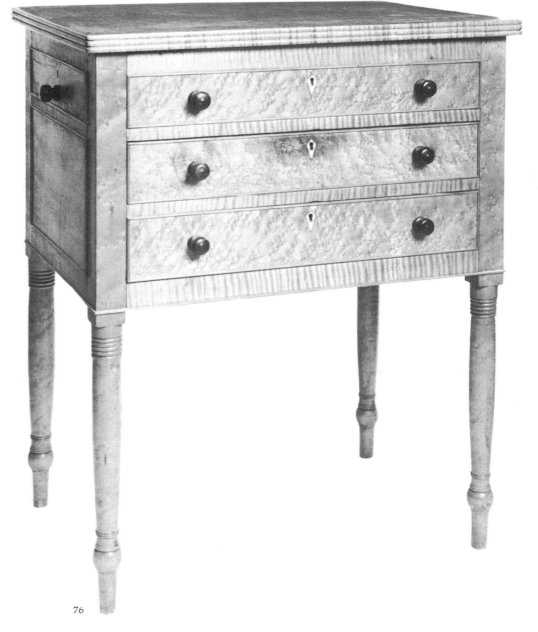

76

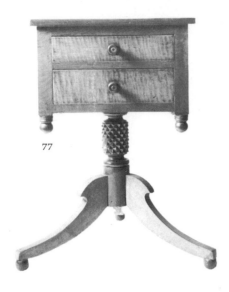

77

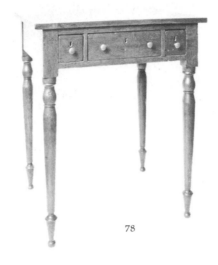

78

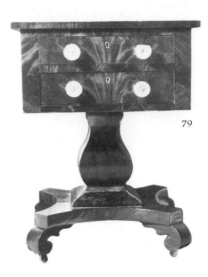

79

77 A work table from Welland County. Of similar style to Plate 80, this design features a pineapple carved column and reeded edges on the legs in a somewhat less sophisticated expression. Second quarter 19th century. [P.C.]

78 A work table from Smithville in Lincoln County. A provincial interpretation of the delicate Sheraton work tables containing drawers for specific materials. Mid-19th century. [P.C.]

79 A work table from the eastern counties. Of late Empire style, this design is typical of those produced in the shops and factories equipped with the newest tools for cutting and shaping the complex elements and the application of veneers. Second quarter 19th century. [U.C.V.]

80 A work table from the eastern counties. This finely crafted table is of late Neoclassical style and might be termed Regency or Empire. The Gothic motif in the contrasting inlaid decoration was introduced to many designs at this time. Second quarter 19th century. [P.C.]

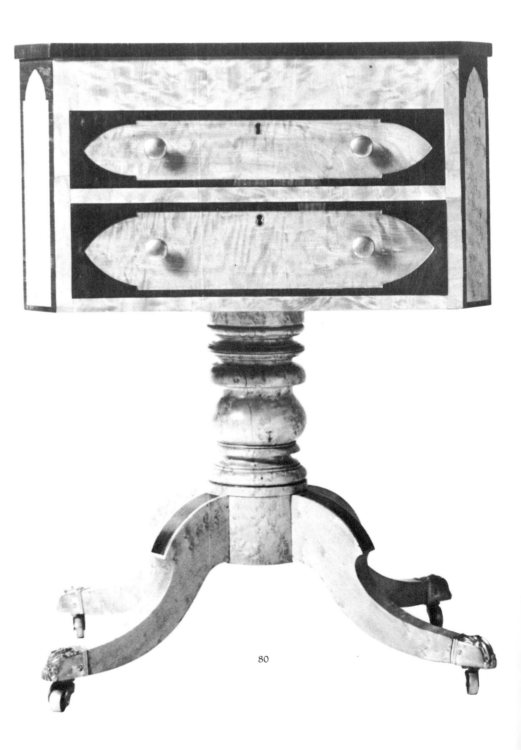

80

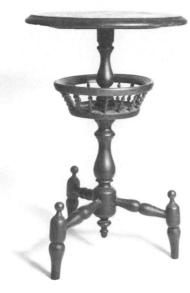

81 A sewing stand from Glengarry County. (Early family: MacArthur.) Several identical examples of this unusual design are known. The spindled basket turns on the column. Mid-19th century. [P.C.]

82 A sewing stand from Adolphustown in Prince Edward County. A decorative variation on the preceding example. The wool basket is turned from the solid. Mid-19th century. [P.C.]

83 A tilt-top candlestand from Kingston. Hepplewhite illustrated designs for tea-trays which were widely imitated in shaped table tops. Second quarter 19th century. [P.C.]

84 A candlestand from the eastern counties. One of a pair in an elegant late 18th century style with dished top. First quarter 19th century. [P.C.]

81

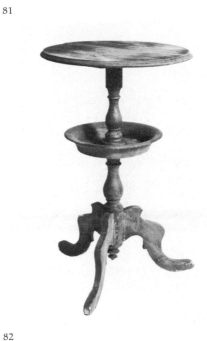

82

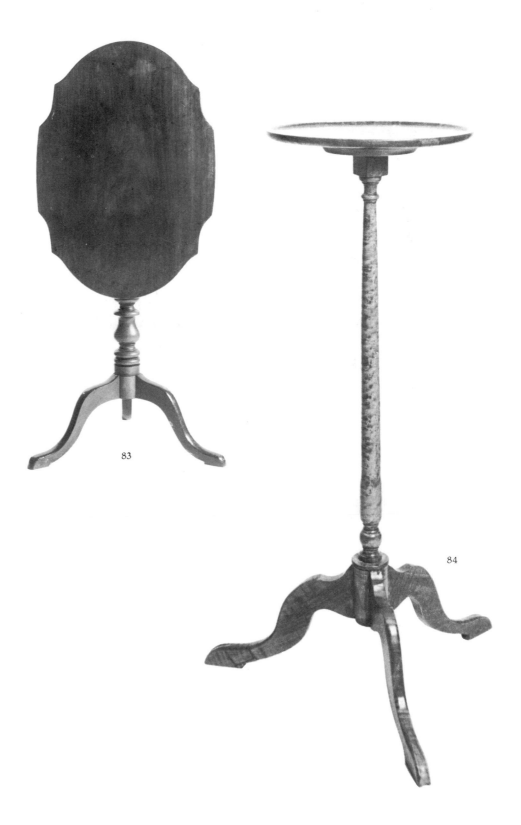

83

84

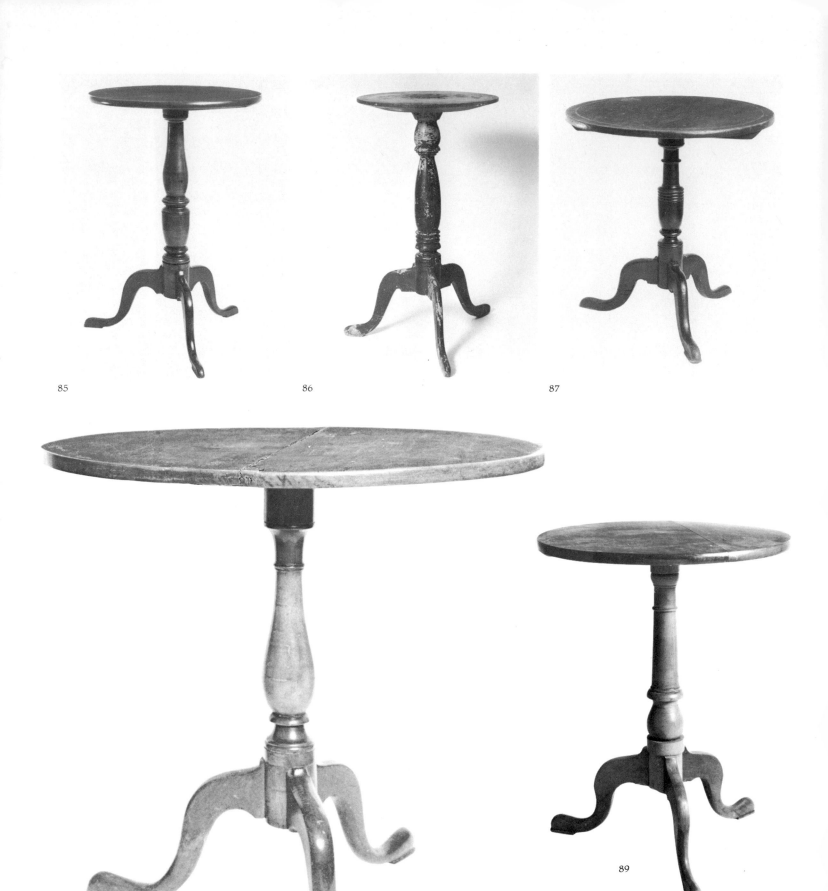

85

86

87

88

89

85 A candlestand from the eastern counties. Some heaviness of 19th century taste is visible in the column design, while the refined snake feet retain an early character. Second quarter 19th century. [P.C.]

86 A candlestand from Hastings County. Exceptionally well-proportioned elevated pedestal with simply executed snake feet. Second quarter 19th century. [P.C.]

87 A candlestand from the eastern counties. This simple, well-proportioned design has a touch of Regency style in painted decoration simulating rosewood with contrasting band inlay. Second quarter 19th century. [P.C.]

88 A candlestand from the eastern counties. A fine provincial development of the snake foot and urn-shaped column. First quarter 19th century. [P.C.]

89 A candlestand from Woodstock in Oxford County. A sound provincial design, signed, *Archibald Elliot – maker – Woodstock, Canada West, Sept. 10th, 1858 – Temperature 125° in the shade, 135° in the sun. Wheat was a good crop this year — sold for $1 a bushel.* 1858. [P.C.]

90 A tilt-top candlestand from the eastern counties. This eccentric table, in fact, mirrors the silhouette of a stylish mid-18th century design with fully developed ball and claw foot. Second quarter 19th century. [P.C.]

91 A candlestand from Milton in Halton County. Similar to the preceding example in inspiration with mid-century turnings and top. Mid-19th century. [P.C.]

92 A parlour table from Markham Township in York County. (Early family: Francey.) This simple, late 19th century table is extraordinary, with the primitive portrait of a Victorian lady painted on top. Late 19th century. [P.C.]

93 A candlestand from Pickering Township in Ontario County. (Early family: Coultice.) A rustic design with Empire influence in the heavy turned column. Second quarter 19th century. [P.C.]

94 A candlestand from Leeds County. A pleasing individual expression of late 18th century influence. Second quarter 19th century. [P.C.]

95 A candlestand from Bath in Lennox and Addington County. (Early family: Amey.) This form was made in the 18th century and might also be called a work-stand. Second quarter 19th century. [P.C.]

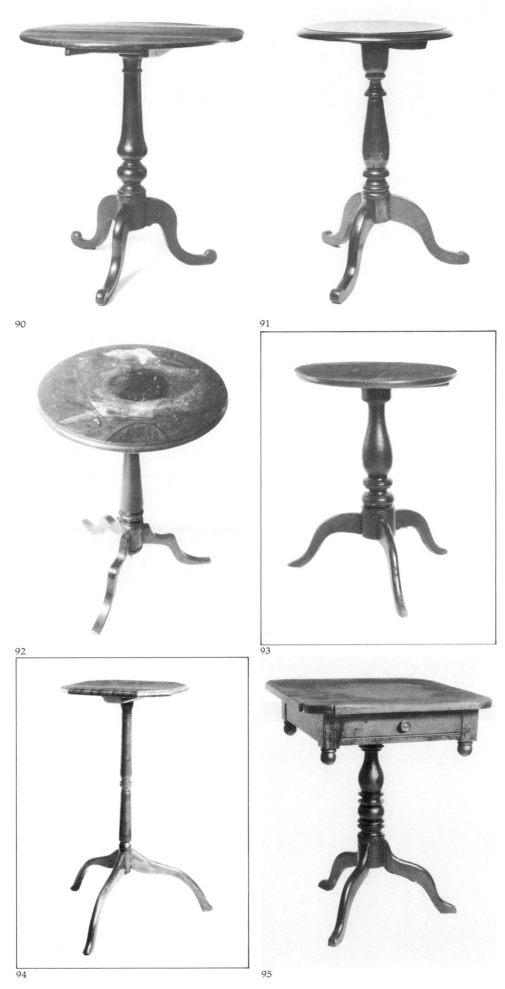

90

91

92

93

94

95

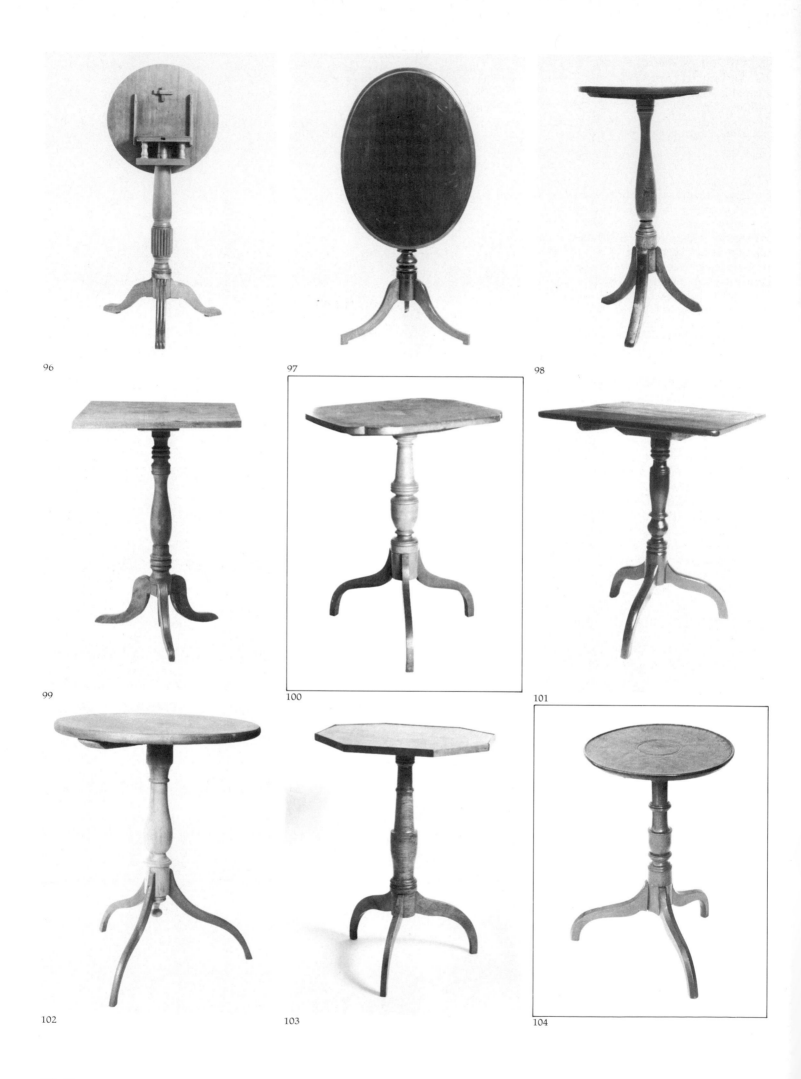

96

97

98

99

100

101

102

103

104

96 A tilt-top candlestand from Hawkesbury in Prescott County. This is a capable articulation of early 19th century Neoclassical style, while the bird-cage feature survives from earlier times. Second quarter 19th century. [P.C.]

97 A candlestand from Perth in Lanark County. This graceful concave-leg profile is another of the designs illustrated by Sheraton. The moulded top was to become popular with the introduction of mechanized tools toward the mid-century. Second quarter 19th century. [P.C.]

98 A candlestand from York County. The column here is unusually graceful. Second quarter 19th century. [P.C.]

99 A candlestand from Frontenac County. Simple, Neoclassical with appropriate, beaded leg detail and well-designed column. Second quarter 19th century. [P.C.]

100 A tilt-top candlestand from Brockville in Leeds County. A Sheraton-inspired design with shaped top and urn-like pedestal. Second quarter 19th century. [P.C.]

101 A tilt-top candlestand from the eastern counties. A well-balanced provincial design with a rectangular top. Second quarter 19th century. [P.C.]

102 A candlestand from Waterloo County. (Early family: Yantzi.) The slim, spider leg was a popular American country style. The turned extension at the base of the column is seen on 18th century designs. Second quarter 19th century. [P.C.]

103 A candlestand from Picton in Prince Edward County. The effect of a dished top is achieved with the applied cock-beaded moulding. Second quarter 19th century. [P.C.]

104 A candlestand from Simcoe County. This pleasing example with a dished top illustrates the survival of 18th century style well past the mid-19th century. Third quarter 19th century. [P.C.]

105 A candlestand from Kingston. The graceful leg employed here was illustrated by Sheraton and widely adopted in provincial designs. Second quarter 19th century. [P.C.]

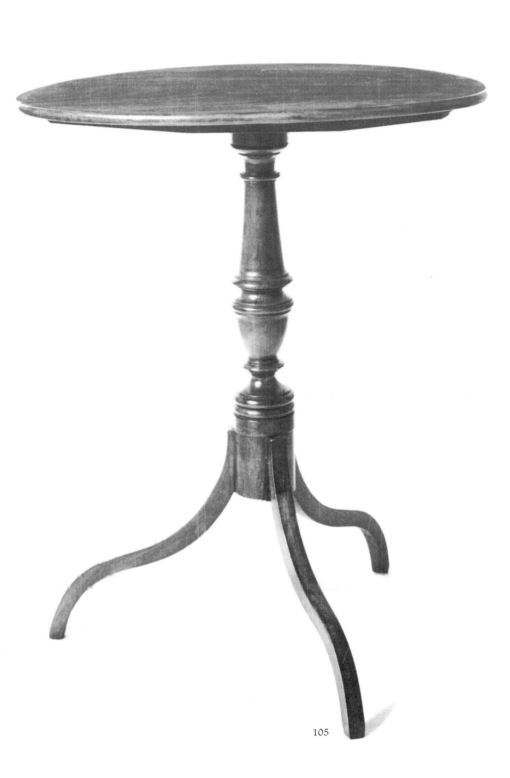

105

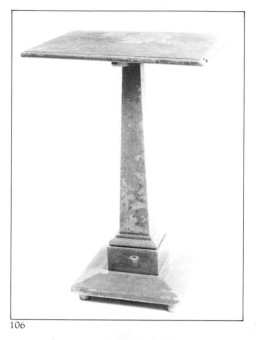

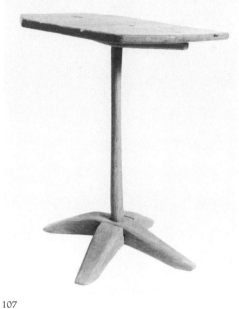

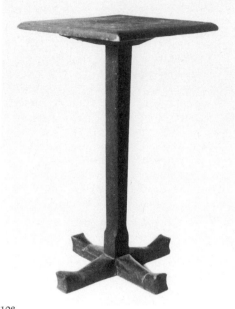

106

107

108

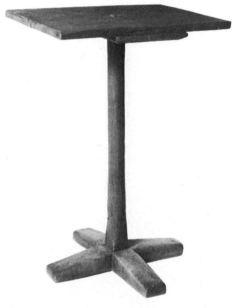

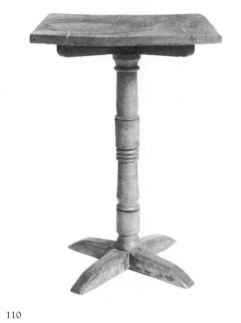

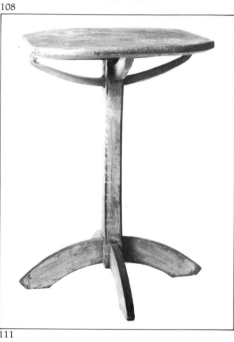

109

110

111

106 A candlestand from Deseronto in Lennox and Addington County. This example of confident provincial joinery is a country relative of Regency style. Second quarter 19th century. [P.C.]

107 A candlestand from Odessa in Lennox and Addington County. A primitive execution of a 17th century stand form. The foot is half-lapped with post pegged through. First quarter 19th century. [P.C.]

108 A candlestand from York County. The unusual, shaped "X" foot is reminiscent of 17th and 18th century examples. The joints, top and bottom, are mortised and tenoned in the traditional manner. First half 19th century. [P.C.]

109 A candlestand from Brussels in Huron County. The feet are half-lapped and the post is mortised and tenoned both bottom and top in this traditional form. First half 19th century. [P.C.]

110 A candlestand from the eastern counties. A pleasing design of 17th and 18th century character with half-lapped and chamfered feet, turned column and "X" support to the top. First half 19th century. [P.C.]

111 A candlestand from Lambeth in Middlesex County. A primitive stand with unique cutout supports to the top. Mid-19th century. [P.C.]

112 A candlestand from the eastern counties. Similar to 17th and 18th century American examples, this stand

is well-crafted with feet tenoned to post and a dished top. First half 19th century. [P.C.]

113 A candlestand from Lennox and Addington County. (Early family: Harrington.) The vigorous detail of the turned column is of an early 18th century character, rather quaintly combined with the slender Windsor legs. Early 19th century. [P.C.]

114 A candlestand from Frontenac County. This Windsor, stool-like design was used in the 18th century and earlier in Britain and the American colonies. Similar examples in maple burl and figured maple were made in the same area in Upper Canada. First half 19th century. [P.C.]

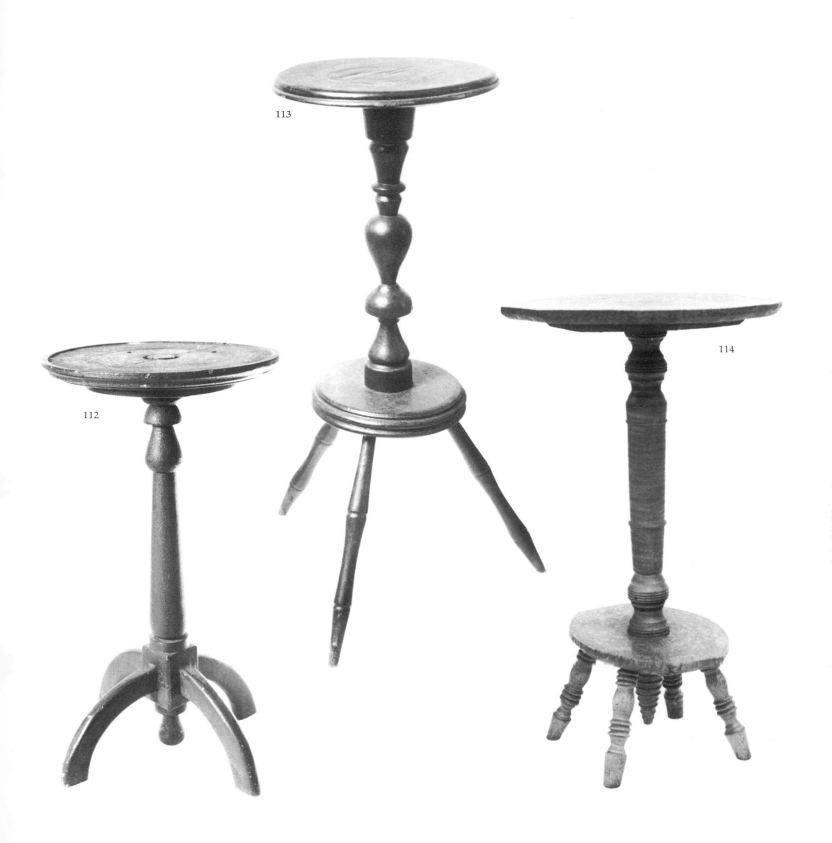

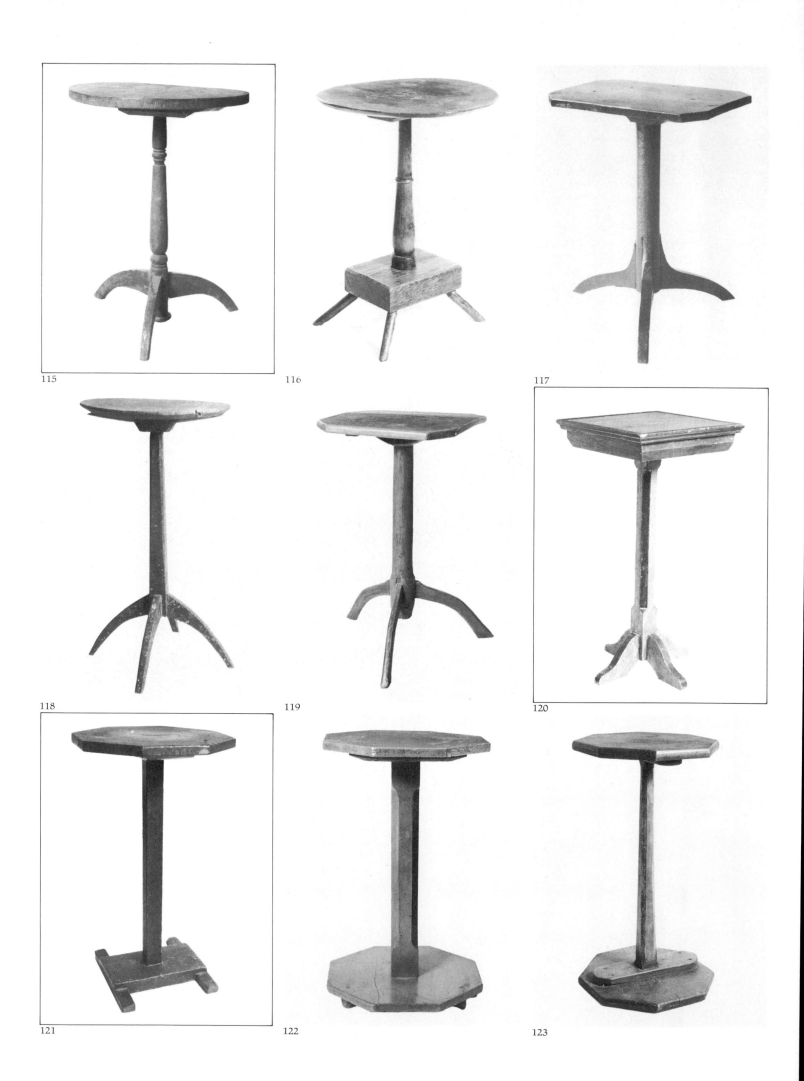

115

116

117

118

119

120

121

122

123

115 A candlestand from Eldorado in Hastings County. A somewhat simpler variation on Plate 114. First half 19th century. [P.C.]

116 A candlestand from Northumberland County. A charmingly rustic execution. Precise dating of such objects is not often possible. First half 19th century. [P.C.]

117 A candlestand from Peterborough County. This simple and rustic example has a distinctly organic character as a result of the unusual shaping of the legs as extensions of the tree-like column. Second half 19th century. [P.C.]

118 A candlestand from Hastings County. A rustic and highly stylized interpretation of a formal candlestand design using sawcut elements throughout. First half 19th century. [P.C.]

119 A candlestand from Leeds County. This is a good example of primitive furniture. The elements are carefully shaped with a spoke shave and the feet are tenoned to the column. First half 19th century. [P.C.]

120 A candlestand from Simcoe County. A country carpenter's concept of style with chamfered post and graphic use of green and yellow paint. Second half 19th century. [P.C.]

121 A candlestand from Pefferlaw in York County. Carefully mortised and tenoned, this design reflects early traditional styles in Britain and America. Second quarter 19th century. [P.C.]

122 A candlestand from Manilla in Victoria County. Identical top and bottom with chamfered post and standing on small round feet. Mid-19th century. [P.C.]

123 A candlestand from Grenville County. The tapered and chamfered post relieves the stark simplicity of this well-crafted example. Second quarter 19th century. [P.C.]

124 A candle table from Northumberland County. (Early family: Burnham.) The applied moulding on the table top creates a slight lip similar to the dished tops of 18th century candlestands. The beaded detail at the lower edge of the moulding is repeated on the apron, adding a note of style to the simple design. Second quarter 19th century. [P.C.]

125 A stand from Northumberland County. The six-legged, turned stand, which has been fitted with a makeshift top at some time, is in fact an 18th century style trivet or plate stand called a "cat" (John Gloag, *A Short Dictionary of Furniture,* pp. 193-94). In Britain, they were made of brass, mahogany and ebony and could be placed by the fireside to keep a plate or tray of muffins or crumpets warm. The example here displays an early Windsor character in the turned parts. First half 19th century. [P.C.]

126 A joint stool or table from Welland County. This simple, but competent, example reflects the splayed-leg form which changed little in the British tradition for three centuries. First half 19th century. [P.C.]

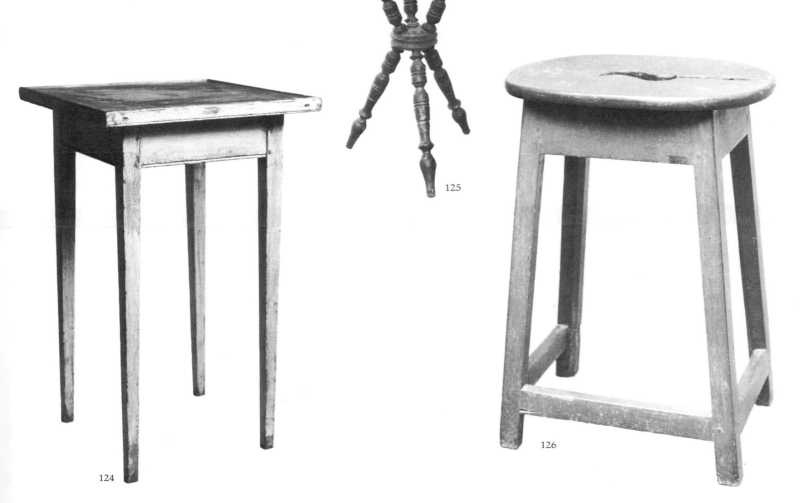

124

125

126

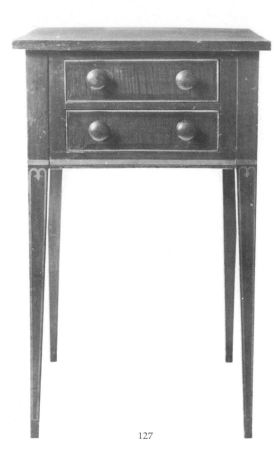

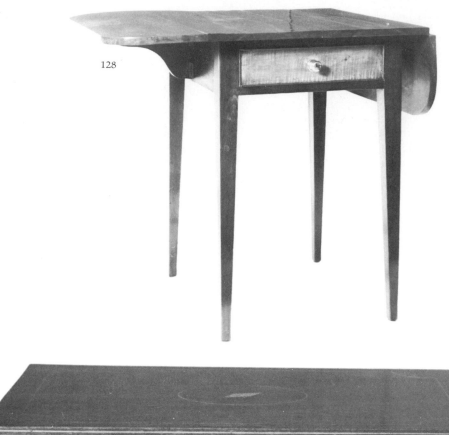

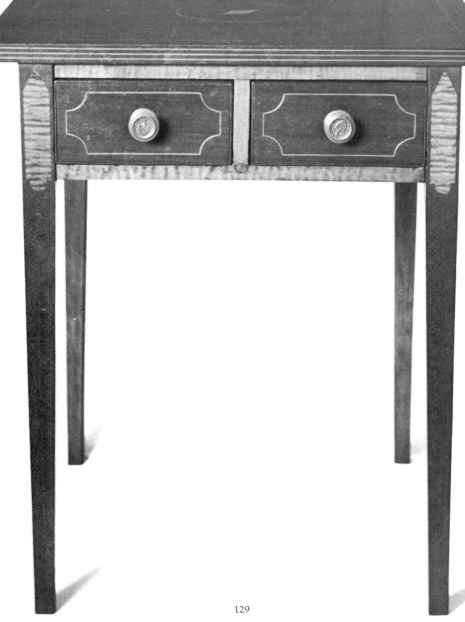

127 A lamp table from Frontenac County. The proportions of this provincial design are particularly fine. Both Sheraton and Hepplewhite illustrated styles which may be the inspiration for this use of the tapered square leg with decorative inlay, as well as banding and cock-beading on the drawer fronts. First quarter 19th century. [P.C.]

128 A lamp table with drop-leaves from Perth in Lanark County. The fine proportions, shaped leaf supports and cock-beaded drawer detail are features of some sophistication in this table of late 18th century style influence. First quarter 19th century. [P.C.]

129 A lamp table from Brantford in Brant County. This is an excellent example of British style survival as produced in the larger Upper Canadian centres. The spirit of late 18th century fashion is captured in walnut with contrasting figured maple inlay of simplified Neoclassical elements. First or second quarter 19th century. [P.C.]

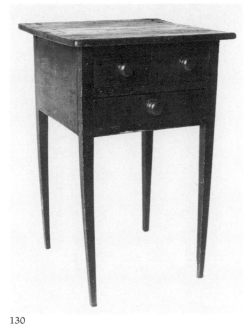

130

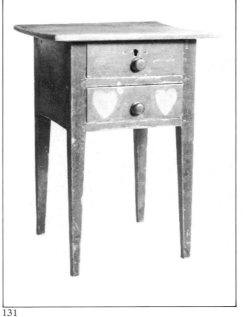

131

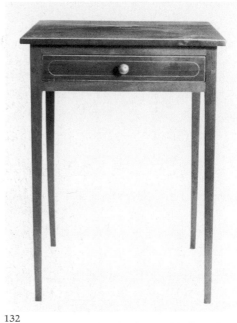

132

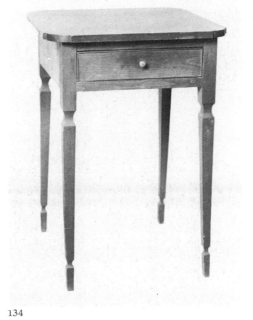

133

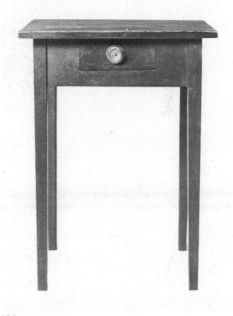

134

135

130 A lamp table from Hope Township in Northumberland County. (Early family: Andrys.) This simplified design is the work of a competent country craftsman. Typically, it is made of several different woods, including a pine top, birch legs and birdseye maple drawer fronts. Second quarter 19th century. [P.C.]

131 A lamp table from Ballyduff in Durham County. This straightforward joinery is elevated from the ordinary by the clearly expressed symbols of affection. Second quarter 19th century. [P.C.]

132 A lamp table from Thorold in Welland County. (Early family: Chrysler.) The survival of Sheraton-Hepplewhite influence is seen in this delicate design with string inlay decoration. Second quarter 19th century. [P.C.]

133 A lamp table from Lincoln County. This is a sound provincial design with shaped top and slightly tapered leg. The varnish and embossed brass pull are original. First quarter 19th century. [P.C.]

134 A lamp table from Winona in Wentworth County. (Early family: Smith.) This design combines the popular Sheraton influence in its shaped top and cock-beaded drawer with an unusual leg profile which may relate to the Louis XVI style as adopted in the Continental German vernacular. Second quarter 19th century. [P.C.]

135 A lamp table from Newburgh in Lennox and Addington County. This pleasing, small stand retains its original varnish finish and embossed brass pull and backplate. First quarter 19th century. [P.C.]

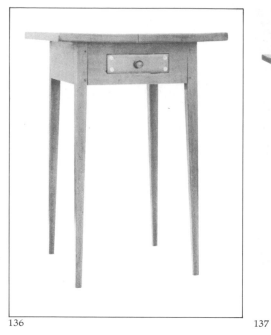

136

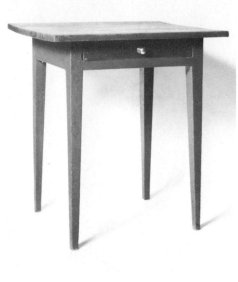

137

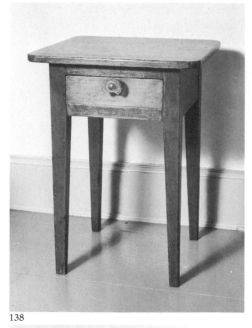

138

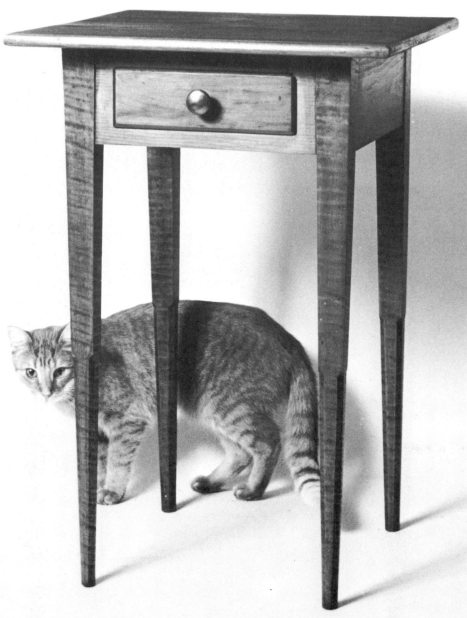

139

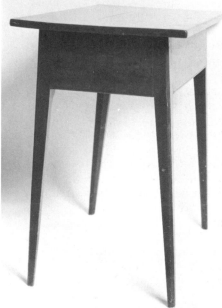

140

141

136 A lamp table from Oxford County. This pleasingly formed table has a small lapped drawer with circular maple inlay. Second quarter 19th century. [P.C.]

137 A lamp table from Lanark County. This sturdy example of this popular style was country-made entirely of pine and painted green. Second quarter 19th century. [P.C.]

138 A lamp table from Renfrew County. This rustic table has some aspirations to elegance with its shaped top and pressed glass pull. First quarter 19th century. [P.C.]

139 A lamp table from Prescott in Grenville County. The chamfered detail at the base of the tapered legs is an unusual feature of this table which combines pine and tiger-stripe maple. First quarter 19th century. [P.C.]

140 A lamp table from the Niagara Peninsula. The splayed legs relate this design to the 18th century American vernacular. The moulded details on the outside of the legs and the chamfer on the inside are noteworthy. First quarter 19th century. [P.C.]

141 A lamp table from Picton in Prince Edward County. Possibly made as a sewing table, this design with one deep drawer is unusual. First quarter 19th century. [P.C.]

142 A lamp table from Trenton in Hastings County. While lacking the characteristic surface decoration, the finely turned and reeded legs, cock-beaded drawer surrounds and elegant proportions of this Sheraton-inspired design make it a fine example of Upper Canadian furniture which retains much of the refinement of the period prototype. First quarter 19th century. [P.C.]

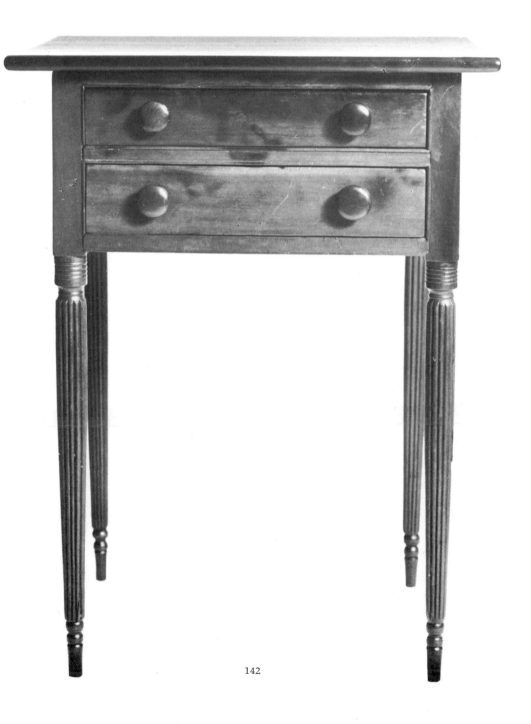

142

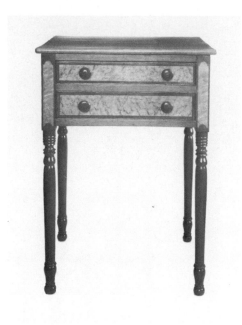

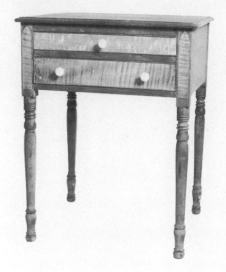

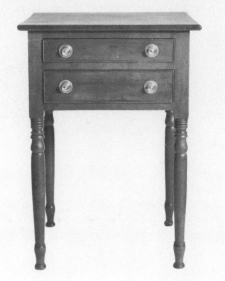

143

144

145

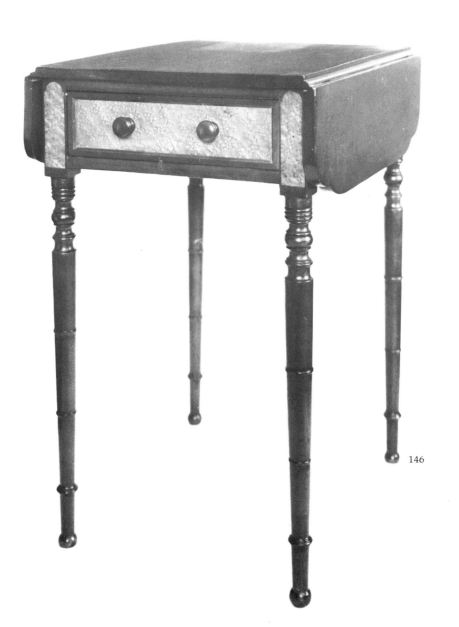

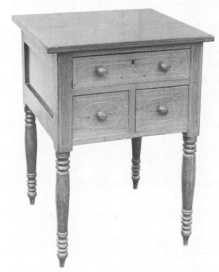

147

146

143 A lamp table from the eastern counties. This finely executed design is of transitional character, combining the form and decorative elements of late 18th century style with slightly heavier leg turnings which are typical of 19th century developments. Second quarter 19th century. [P.C.]

144 A lamp table from Shannonville in Hastings County. In a slightly lighter manner, this example includes similar decorative and construction details to the previous illustration. Note the identical leg design. Second quarter 19th century. [P.C.]

145 A lamp table from Waterloo County. Coming from widely separated areas, the similarity in style and detail between this and the two previous

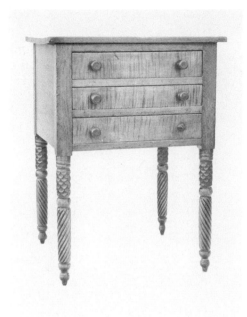

148

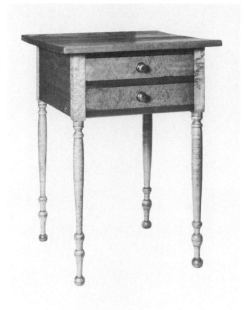

149

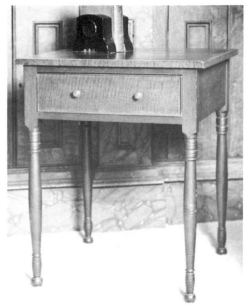

150

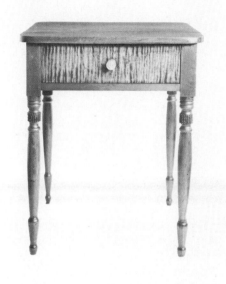

151

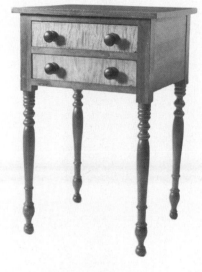

152

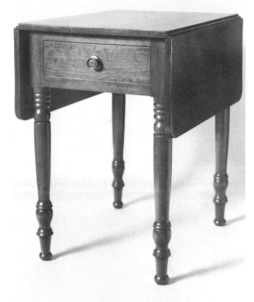

153

examples is interesting and indicates a common design source or an itinerant craftsman. Second quarter 19th century. [P.C.]

146 A lamp table with drop-leaves from the eastern counties. This table with shaped leaves, inlaid veneer decoration, double crossbanding on the drawer front and slim, well-turned legs is a fine provincial interpretation of turn-of-the-century, Sheraton-inspired style. First quarter 19th century. [P.C.]

147 A lamp table from Toronto. String inlay in maple illustrates the tenacity of 18th century influence in this walnut table of stout Empire character. Second quarter 19th century. [P.C.]

148 A lamp table from Oxford County.

Being made of birch, it is unlikely that this table originated in this western area and probably was moved from further east. The handsome spiral-reeded legs are similar in scale, proportion and detail to examples in Sheraton's *Drawing Book*. Second quarter 19th century. [P.C.]

149 A lamp table from Kingston. This design retains the fine legs of early style with unusual ball turnings at the foot. Second quarter 19th century. [P.C.]

150 A lamp table from Halton County. Of Sheraton influence, this larger than average table has particularly good turnings and cock-beaded drawer. Second quarter 19th century. [P.C.]

151 A lamp table from Norfolk County.

The spirit of elaborate Sheraton designs survives in the slender legs with unusual pineapple detail. Second quarter 19th century. [P.C.]

152 A lamp table from the eastern counties. The Empire-influenced vigour of the turned legs is pleasingly reflected in the similarly rounded wooden pulls. Second quarter 19th century. [P.C.]

153 A lamp table with drop-leaves from Preston in Waterloo County. This well-proportioned table of transitional style illustrates the general preference in the western counties for conservative designs executed in one wood rather than the exotic contrasts often found in eastern examples. Second quarter 19th century. [P.C.]

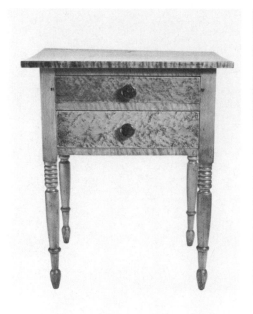

154

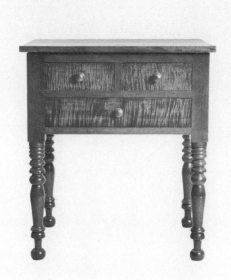

155

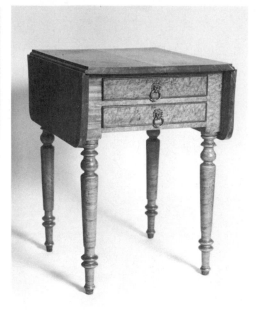

156

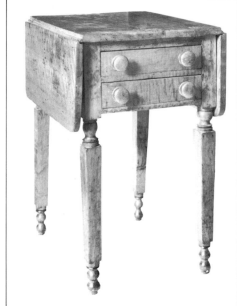

157

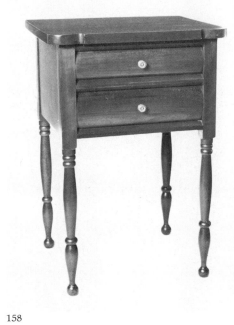

158

154 A lamp table from the eastern counties. The decorative quality of birdseye and figured maple is the major feature of this table of transitional style. Second quarter 19th century. [P.C.]

155 A lamp table from Simcoe County. The trend toward busy, less subtle details was the provincial craftsman's acknowledgment of the new furniture styles in forms which changed little throughout the first half of the 19th century. Second quarter 19th century. [P.C.]

156 A lamp table with drop-leaves from Niagara-on-the-Lake in Lincoln County. This is a well-proportioned and soundly executed example of the restrained Empire style which was favoured by Upper Canadian craftsmen. Second quarter 19th century. [P.C.]

157 A lamp table with drop-leaves from Niagara Falls in Welland County. This squared-leg design is a feature of Empire style which was particularly popular in the northern American states and occurred in Upper Canada primarily where American influence was direct. Second quarter 19th century. [P.C.]

158 A lamp table from Middlesex County. This country design combines the shaped top popularized by Sheraton with convex drawer fronts and turnings of late Neoclassical influence. Second quarter 19th century. [P.C.]

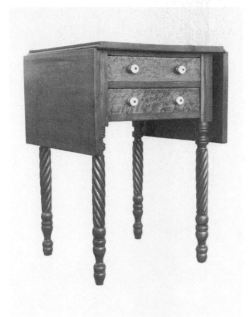

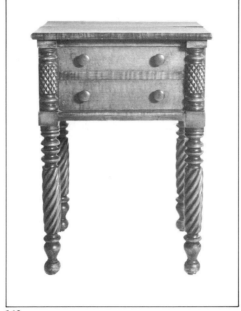

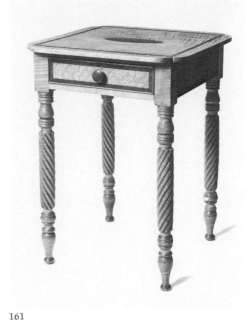

159

160

161

159 A lamp table with drop-leaves from Martintown in Glengarry County. (Early family: Gould.) The deep leaves provide a large table surface which could be used for various purposes in the stylish country parlour. Transitional style. Second quarter 19th century. [P.C.]

160 A lamp table from Markham in York County. (Early family: Milne.) A table of Empire style with unusually energetic detail, including heavy spiral reeding and pineapple motif. Second quarter 19th century. [P.C.]

161 A lamp table from Prince Edward County. This is a well-articulated example of the Empire style and a good illustration of the transition from early, more delicate styles to the robust and heavy. The shaped top, inlay and cock-beading are 18th century details which survived and merged with the Empire influence in Upper Canada. Second quarter 19th century. [P.C.]

162 A lamp table from Frontenac County. The reeded inserts and spiral-reeded leg design are late Neoclassical features which were popular in Britain and America and may be termed Regency or Empire. Second quarter 19th century. [P.C.]

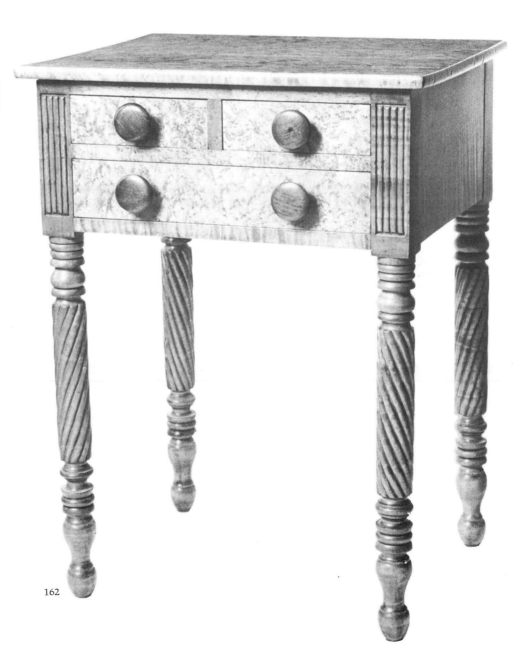

162

163 A lamp table from Waterloo County. The well-articulated club or Dutch foot with pad incorporated in this otherwise typical 19th century vernacular table is a rare occurrence. This feature was popular in Britain and America in the late 17th and early 18th centuries. First half 19th century. [P.C.]

164 A lamp table from Lennox and Addington County. (Early family: Amey.) Complex turnings typical of mid-century with exceptionally good ball feet. Third quarter 19th century. [P.C.]

165 A lamp table from Waterloo County. This is a pleasing example of an Upper Canadian vernacular style which combines early Sheraton-period influences and those of Empire taste. It was made in all areas from 1830 to 1900. Second quarter 19th century. [P.C.]

166 A lamp table from Colborne in Northumberland County. An individual interpretation with unusually deep drawer, beaded details and distinctive legs. Mid-19th century. [P.C.]

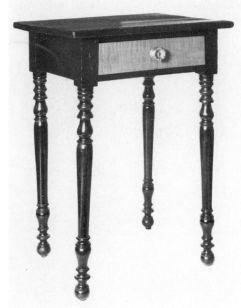

164

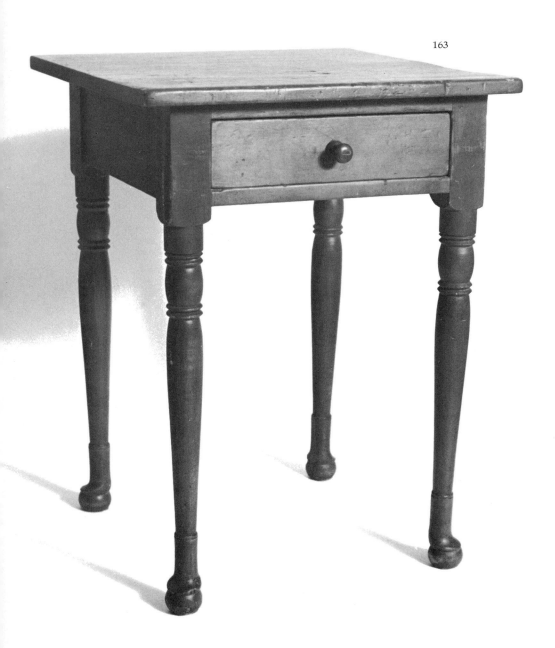

163

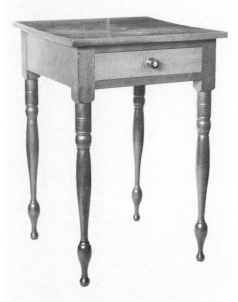

165

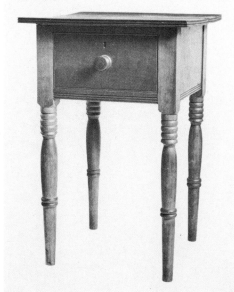

166

167 A washstand from Kingston. A similar bow-front design is illustrated in Sheraton's *Drawing Book* (Plate 42), and the pleasing form was very popular in late 18th and early 19th century Britain. This typically sturdy Upper Canadian example avoids the use of bow-fronted drawers with the addition of a rectangular section which breaks the bow and accepts a simple drawer. Second quarter 19th century. [P.C.]

168 A washstand from Bath in Lennox and Addington County. This stand of Sheraton influence is a fine example of the simple elegance achieved by skilled craftsmen, who modified the elaborate character of sophisticated prototypes to suit the conditions and taste of the new colony. First quarter 19th century. [P.C.]

169 A washstand from Wellington County. Excellent turnings and well-shaped gallery are the major features of this survival of Sheraton style. Second quarter 19th century. [P.C.]

170 A washstand from Napanee in Lennox and Addington County. A simple design with shaped gallery, turned legs and lower shelf was widely adopted in Upper Canada. This stand, with its fitted drawer, illustrates the refined proportions and careful craftsmanship of better early examples. First quarter 19th century. [P.C.]

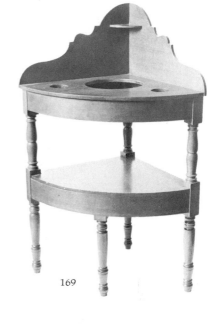
169

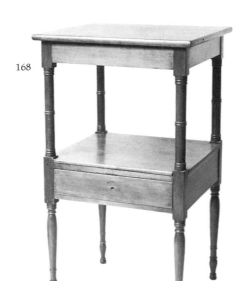
168

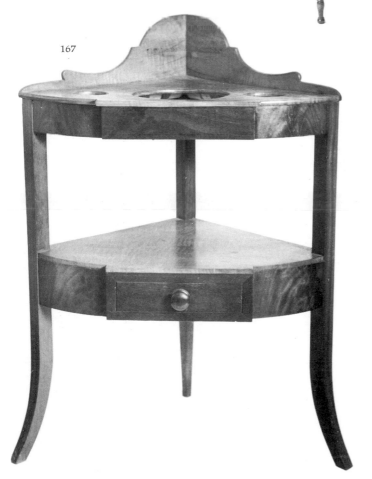
167

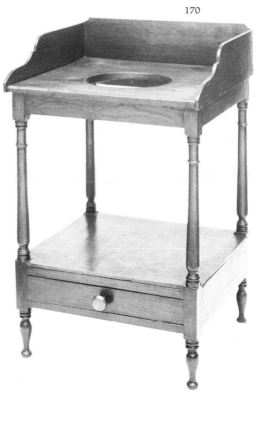
170

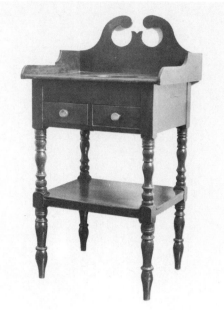

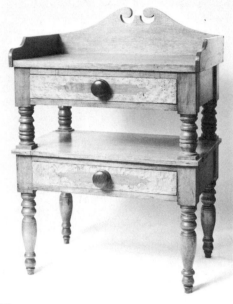

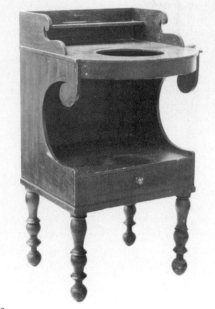

171

172

173

171 A washstand from the eastern counties. An imaginative Upper Canadian craftsman drew at liberty from his vocabulary of British furniture style to create this design. The scrolled pediment is a rather grand addition to the typical early 19th century style which includes later influence in the boldness of the turnings. Second quarter 19th century. [U.C.V.]

172 A washstand from Oak Flats in Frontenac County. The excesses of Empire taste were often rejected by Upper Canadian craftsmen in favour of well-used forms which were executed with a new heaviness and rotundity. Second quarter 19th century. [P.C.]

173 A washstand from the eastern counties. The florid character of late Neoclassical style is neatly summarized in this complex design of scrolls and ogee curves. Second quarter 19th century. [P.C.]

174 A washstand from Portland in Leeds County. This simply made version of the vernacular stand interprets the Empire theme with considerable charm. Second quarter 19th century. [P.C.]

175 A washstand from Lennox and Addington County. This carefully crafted country design pays fleeting homage to a variety of style influences ranging from the early 18th century character of the end apron to the Empire scrolls of the gallery. Second quarter 19th century. [P.C.]

176 A washstand from Leeds County. A mid-century carpenter's sense of style included chamfered legs and extensive applied mouldings painted dark to create the impression of panels. Mid-19th century. [P.C.]

177 A washstand from Lanark County. Stands from the 18th century British cottage tradition are reflected in the simple joinery and shaped aprons of this pleasing example. First quarter 19th century. [P.C.]

178 A washstand from the eastern counties. This rustic design is an admirable personal expression of function. Second quarter 19th century. [P.C.]

179 A washstand from Stormont County. Signed, *John Morrison. Maker. Aultsville. Work made complete to order. 1867.* This maker's strong decorative instincts are apparent in the intricate scrolled gallery, as well as in the graphic elaboration of the signature. 1867. [P.C.]

180 A washstand with cabinet from Oxford County. This design includes the Empire step-back front with a shaped drawer and scrolled gallery. The shaped bracket base is a somewhat insecure memory of earlier style, while the turned towel racks are a mid-century feature. Mid-19th century. [P.C.]

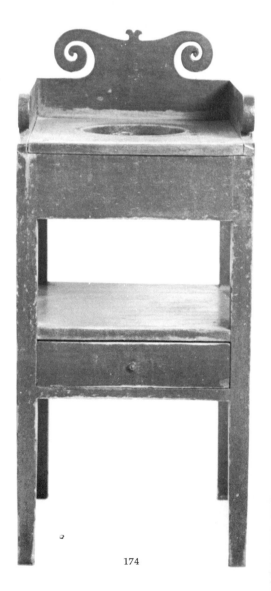

174

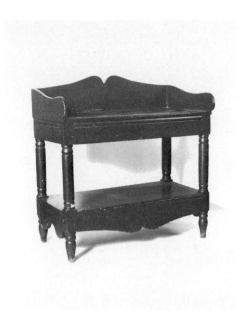

175

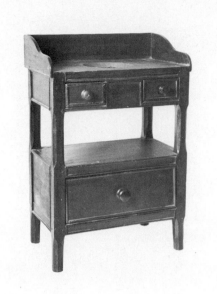

176

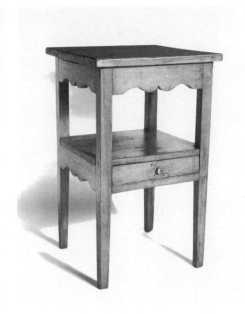

177

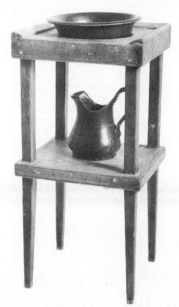

178

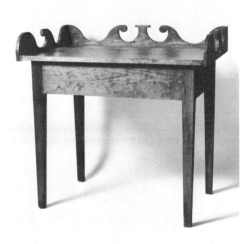

179

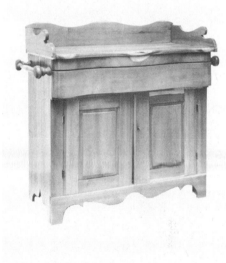

180

179 a

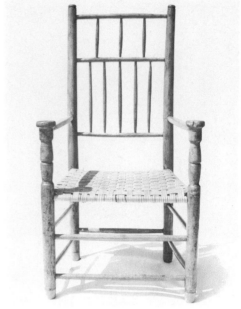

182

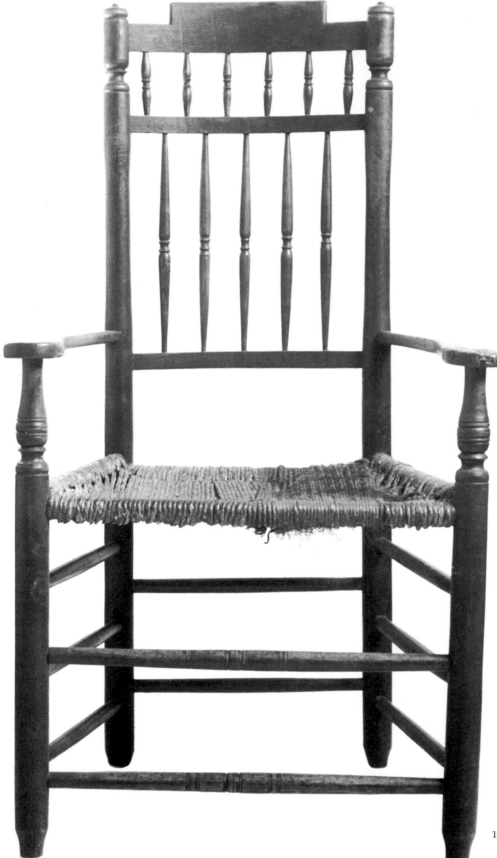

181 An armchair from Williamsburg in Dundas County. Chairs of similar spindle-back form are found in several early traditions. In England, a related style is associated particularly with Lancashire. The Carver chair was popular in the American colonies, and spindled designs were part of the German vernacular. This important Upper Canadian example comes from an area of earliest settlement involving several cultural groups, so that its stylistic ancestry is uncertain. Fourth quarter 18th century or first quarter 19th century. [P.C.]

182 An armchair from Oxford County. A much simpler design than the preceding one; the equal scale of the crest rail to the other back elements is consistent with the American Carver style. First quarter 19th century. [P.C.]

181

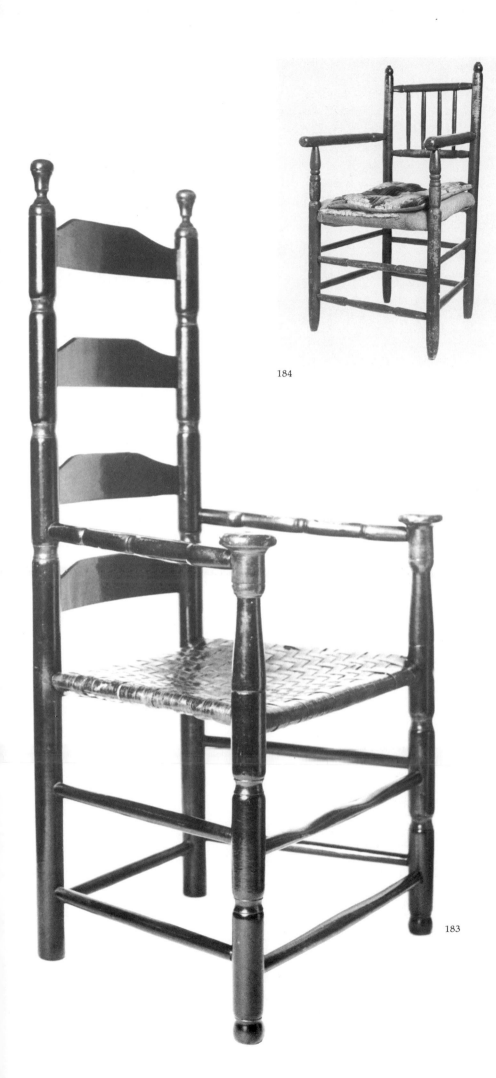

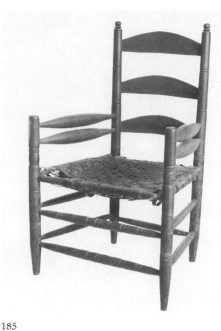

184

185

183 A slat-back armchair from Prince Edward County. (Loyalist family from Hudson River Valley.) This fine chair possesses the most desirable features of early 18th century American proto-types: generous mushrooms, sausage turned posts, bun feet, four shaped splats and good finials. First quarter 19th century. [P.C.]

184 An armchair from Grenville County. (Early family: Eager.) Another American Carver-related design with a low back which was not unusual in the early examples. The extension of the arm turning over the front posts is not a traditional detail. The profile of the front rungs and back rails is typical of early 19th century turning. First quarter 19th century. [P.C.]

185 A slat-back armchair from North-umberland County. The double turning at the arm of this generously proportioned design is unusual. Details of the front rungs, posts and finials are similar to those on chairs made in Rossmount by Davidson (see Plates 204, 206). Mid-19th century. [P.C.]

183

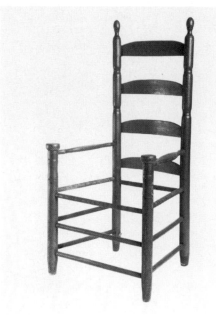

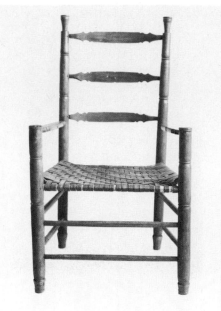

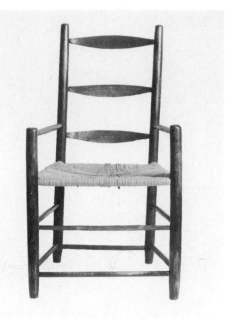

186

187

188

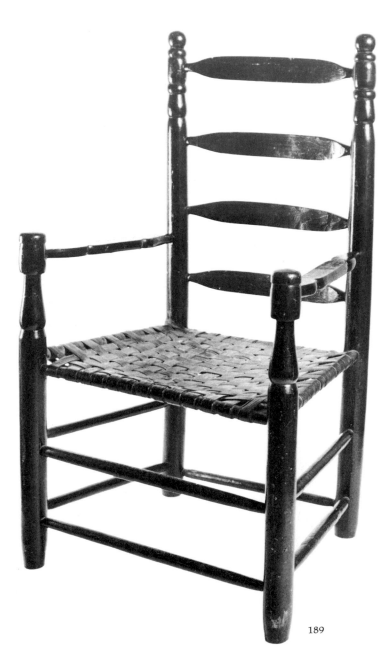

189

186 A slat-back armchair from Lennox and Addington County. A good and very typical example of the slat-back chairs made in large numbers in the eastern counties. The details have lost some of the vigour of the early styles. Second quarter 19th century. [L. & A.C.M.]

187 A slat-back armchair from Kendall in Durham County. This simple design maintains the impression of early examples, and the shaped back splats and arms are curiously similar to the vertical splats in American banister-back chairs of the early 18th century. Second quarter 19th century. [P.C.]

188 A slat-back armchair from Frontenac County. The ultimate simplification of the traditional form, likely made by an individual for his own use. First half 19th century. [P.C.]

189 A slat-back armchair from Lennox and Addington County. The emphasis of turned detail on the upper rear posts is a characteristic of 17th century American styles and is quite unusual in 19th century examples. Second quarter 19th century. [L. & A.C.M.]

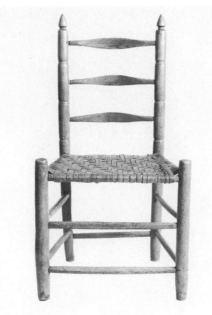

190

190 A slat-back side chair from Frontenac County. A locally made version of the popular 18th century American vernacular chair. First quarter 19th century. [P.C.]

191 A slat-back side chair from Northumberland County. A very typical eastern counties example. Probably by the same maker as Plate 186. Second quarter 19th century. [P.C.]

192 A side chair from Fonthill in Welland County. This unusual design incorporates a delicate Sheraton Windsor back treatment with the typical slat-back form. An added refinement is the slight arching of the back posts. The original seat would likely have been rush. Early 19th century. [P.C.]

193 A slat-back side chair from Lanark County. The wide seat and stark simplicity of this design are found in the very earliest American examples. First quarter 19th century. [P.C.]

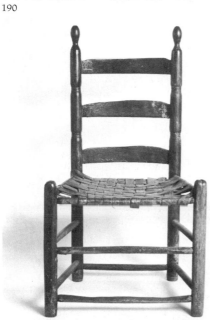

191

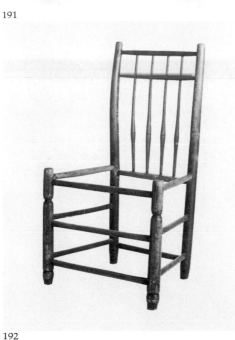

192

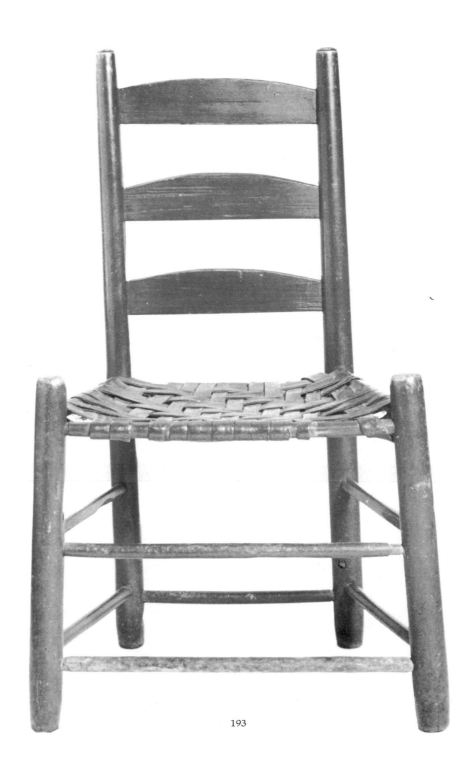

193

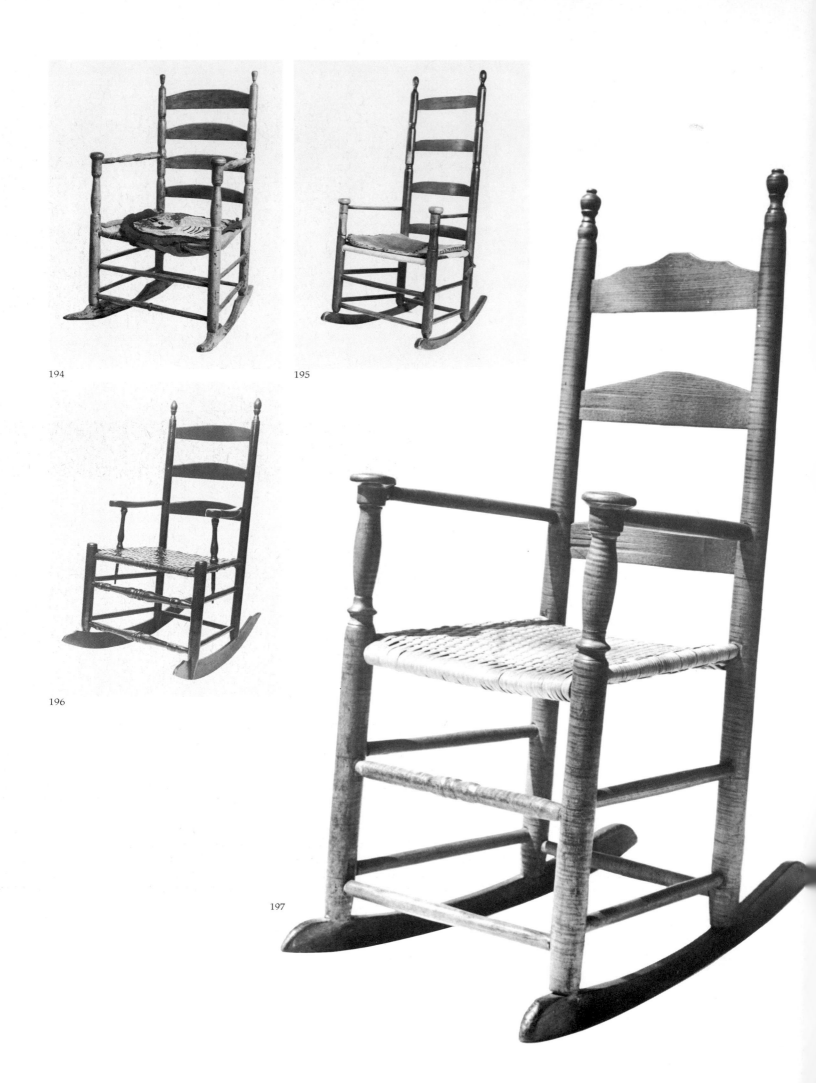

194

195

196

197

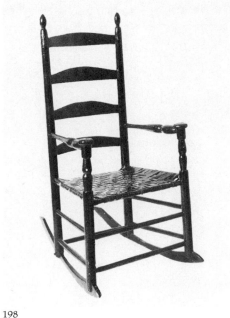

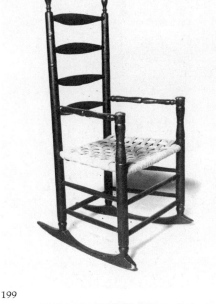

198

199

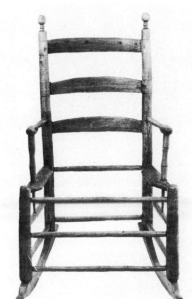

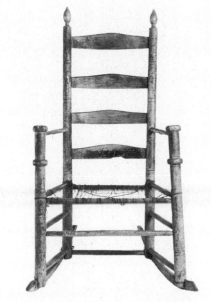

200

201

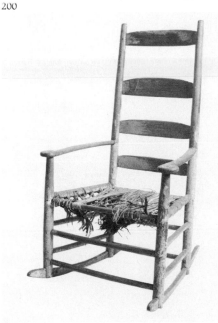

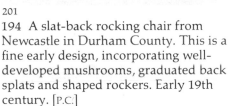

This design includes several characteristics of 18th century style. The step-back arm is associated with the period up to the beginning of the 19th century when full hooped skirts were worn and this feature is often combined with the extension of the supporting spindle to the second stretcher. The robust character of the front stretchers and the post finials is also typical of American slat-backs made in the late decades of the 18th century. Late 18th or early 19th century. [P.C.]

197 A slat-back rocking chair from Middlesex County. Unusually narrow, this beautiful chair surpasses many early examples in the simple perfection of its figured maple turnings, its elongated finials and shaped back splats. First quarter 19th century. [P.C.]

198 A slat-back rocking chair from Markham Township in York County. A well-proportioned chair with simple mushrooms, flame finials and unusual turned arms. Second quarter 19th century. [P.C.]

199 A slat-back rocking chair from the western region. The short, shaped rockers are an early design. First quarter 19th century. [P.C.]

200 A slat-back rocking chair from Lanark County. (Loyalist family.) The step-back arm with posts extending from the first stretcher through the seat rail is an 18th century American characteristic, as are the rocker and finial designs. Late 18th or first quarter 19th century. [P.C.]

194 A slat-back rocking chair from Newcastle in Durham County. This is a fine early design, incorporating well-developed mushrooms, graduated back splats and shaped rockers. Early 19th century. [P.C.]

195 A slat-back rocking chair from Frontenac County. This well-executed chair appears to be by the same maker as the previously illustrated armchair (Plate 186) and side chair (Plate 191). Second quarter 19th century. [P.C.]

196 A slat-back rocking chair from Lincoln County. (Early family: Martin.)

201 A slat-back rocking chair from Lennox and Addington County. A rather eccentric old chair with good early finials and simple mushrooms. The rockers have been added (as was often done) at an early date. Late 18th or first quarter 19th century. [L. & A.C.M.]

202 A slat-back rocking chair from the eastern counties. Several chairs of this design are found in Carleton and neighbouring counties. The arm extends to provide a mushroom-like detail over the front posts. This is a good example of the survival of traditional elements in a modified form. Second quarter 19th century. [P.C.]

202

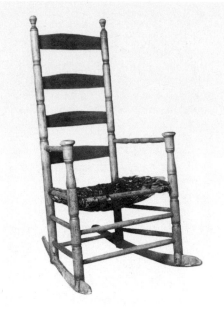

203

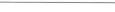

204

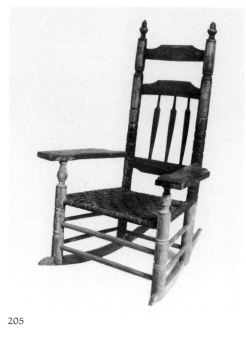

205

203 A slat-back rocking chair from Frontenac County. The survival of several of these well-crafted chairs, incorporating good turnings, well-formed mushrooms and finials, indicates a skilled chairmaker working in the Loyalist settlements in the Kingston area (see armchair, Plate 183). First quarter 19th century. [P.C.]

204 A slat-back rocking chair from Rossmount in Northumberland County. One of several related chairs made by Mr. Davidson in Rossmount. The crisp details of the finial and post turnings and the well-shaped splats are very distinctive and are common to all examples. An unusual subtlety in this chair is the swelling of the rear post to accept the arm, thus avoiding the most important structural weakness in traditional slat-back chair design (see related armchair, Plate 185). Mid-19th century. [P.C.]

205 A slat-back chair from the eastern counties. The maker of this odd chair seems to have tried to capture the impression of an early prototype with his chunky turnings. The use of the same splat design above the arrows and reversed below is seen on early examples of the banister style. Second quarter 19th century. [P.C.]

206 A slat-back rocking chair from Rossmount in Northumberland County. Another chair by Mr. Davidson, a highly skilled and particular craftsman, as seen in the graduated diameter of the rear posts to provide strength in the base and a slender back. The turned detail on all stretcher spindles is also an unusual refinement. Mid-19th century. [P.C.]

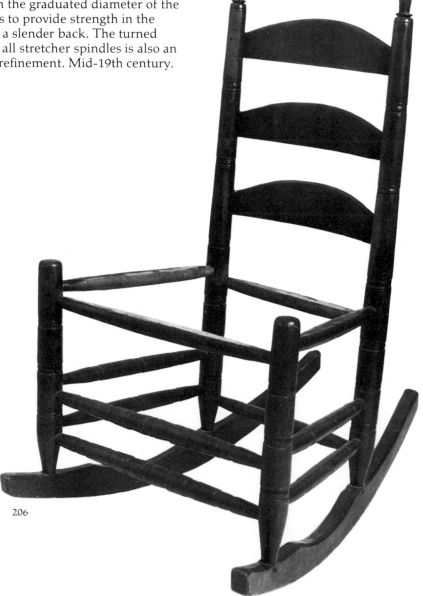

206

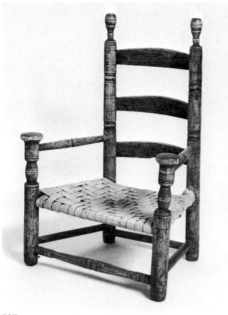

207

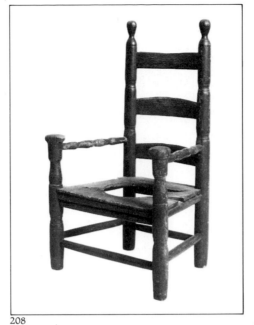

208

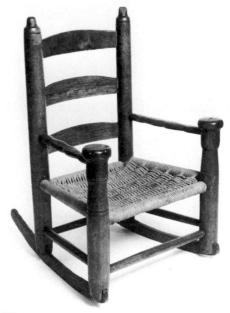

209

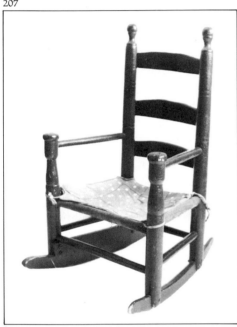

210

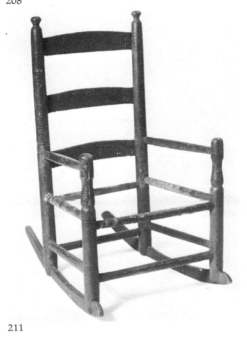

211

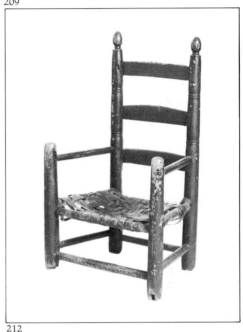

212

207 A child's slat-back armchair from Lennox and Addington County. Good mushrooms and finials of early design. Late 18th or first quarter 19th century. [P.C.]

208 A child's slat-back armchair from Frontenac County. Good early details relate to preceding examples by the same maker (armchair, Plate 183; rocker, Plate 203). Honestly modified. First quarter 19th century. [P.C.]

209 A child's slat-back rocking chair from the eastern counties. The heavy, simple turnings, well-formed mushrooms and nipple finials are characteristic of American chairs dating from the 17th century. The rockers are probably not original, and this early little chair was probably brought from the United States by Loyalists. 18th century. [P.C.]

210 A child's slat-back rocking chair from Frontenac County. The details are simple, but the forms are similar to Plate 208. First quarter 19th century. [P.C.]

211 A child's slat-back rocking chair from Castleton in Northumberland County. The traditional slat-back styles persisted well into the 19th century but the character was often diluted. Second quarter 19th century. [P.C.]

212 A child's slat-back rocking chair from Frontenac County. Used by several generations, the loss of its rockers has not destroyed its simple dignity. Second quarter 19th century. [P.C.]

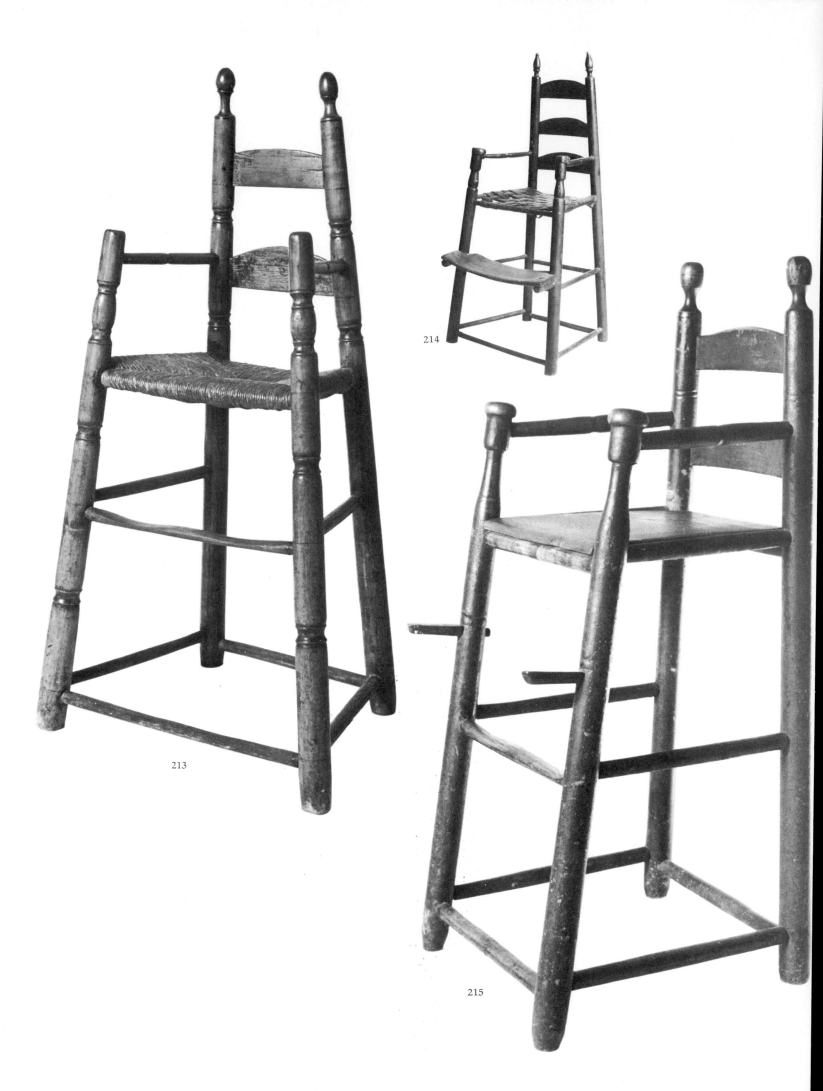

214

213

215

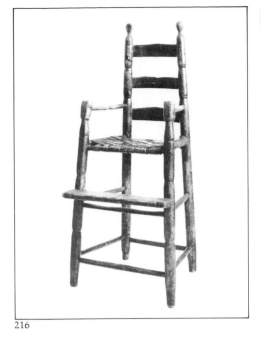

216

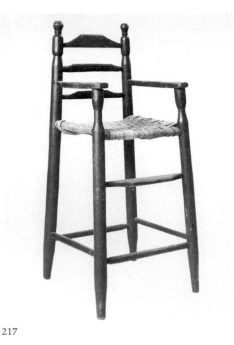

217

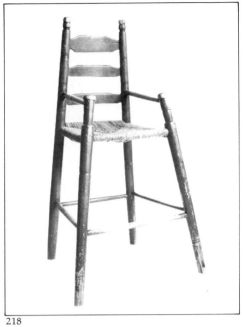

218

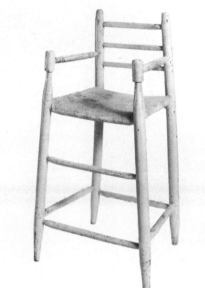

219

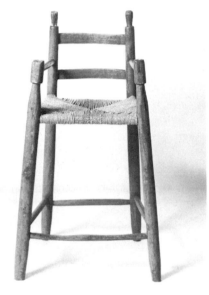

220

213 A slat-back high chair from Frontenac County. The extreme spread of the posts made tipping unlikely and is characteristic of 17th and 18th century prototypes. This excellent example also has very good turnings of early character. 18th century or early 19th century. [P.C.]

214 A slat-back high chair from Hastings County. This is another fine example of the early splayed form with mushrooms and flame finials. Probably 18th century. [P.C.]

215 A slat-back high chair from Gananoque in Leeds County. A very early New England style with original supports for the footrest. Wallace Nutting shows an almost identical example in *Furniture Treasury*. Probably 18th century. [P.C.]

216 A slat-back high chair from Frontenac County. This well-used example relates to the child's armchair (Plate 208) and other locally produced chairs. First quarter 19th century. [P.C.]

217 A slat-back high chair from the eastern counties. A good early form with a simplification of detail often found in 19th century examples. First quarter 19th century. [P.C.]

218 A slat-back high chair from Leeds County. The shaped back splats in reducing widths are typical of better early design, but the single row of stretchers is unusual. First quarter 19th century. [P.C.]

219 A slat-back high chair from Lennox and Addington County. (Early family: Denison.) The influence of 19th century chair design is apparent in the turnings of this much-simplified early form. Second quarter 19th century. [L. & A.C.M.]

220 A slat-back high chair from Lennox and Addington County. Probably by the same maker as the previous example. Second quarter 19th century. [P.C.]

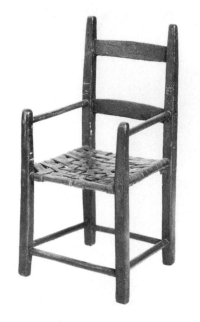

221

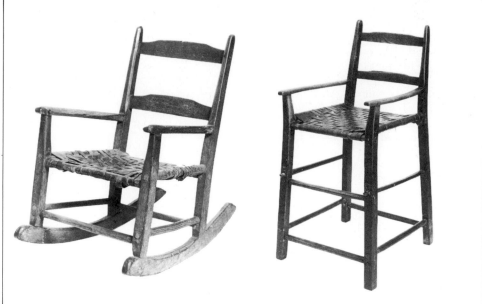

222, 223

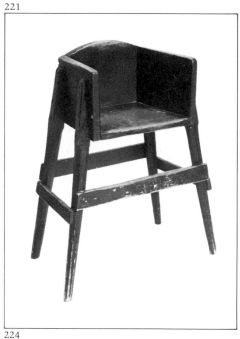

224

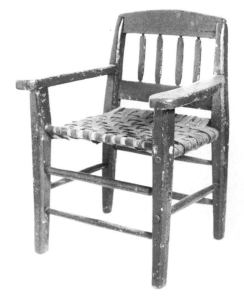

225

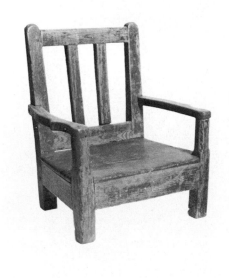

226

221 A child's armchair from Leeds County. A well-fashioned example of the primitive cottage slat-back style found throughout the British Isles. The extension of the rungs through the posts is characteristic. First half 19th century. [P.C.]

222,223 A child's slat-back rocking chair and high chair from Glengarry County. Completely different in

concept from the American slat-back, these examples relate to the British peasant tradition and were probably made by a Scottish immigrant. First half 19th century. [P.C.]

224 A child's high chair, probably from the western counties. A highly practical, individual design which acknowledges tradition only in the splay of the neatly chamfered legs. First half 19th century. [P.C.]

225 A child's armchair from Deseronto in Hastings County. This primitive chair was found on the Indian reservation in the area, but is likely the handiwork of a Scottish or Irish immigrant. First half 19th century. [P.C.]

226 Child's chair from Carleton County. This little chair is related to the traditional country styles of the British Isles. Second quarter 19th century. [P.C.]

227 A corner chair from Madoc in Hastings County. The corner chair was a popular 18th century form in both Britain and America and was often made in pairs. Sometimes they were called courting chairs, presumably as the lady could sit on the gentleman's knee and both would have backs to lean against. One of a pair, this mortised, tenoned and dovetailed example could certainly support this theory. First half 19th century. [P.C.]

228 A child's chair from Stormont County. This is a tiny, primitive example of a traditional British style which was widely used from the 17th century for children's chairs of different sizes. Third quarter 19th century. [P.C.]

229 A reclining chair from Brockville in Leeds County. This fascinating example of ingenuity combines the form of the traditional chair-table with an impression of remembered elegance and comfort. Mid-19th century. [P.C.]

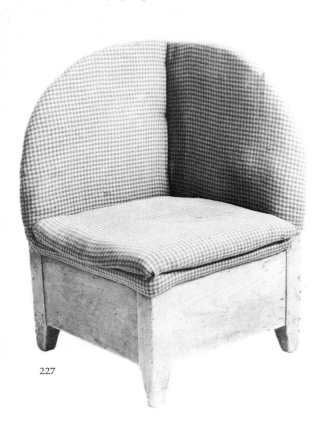

227

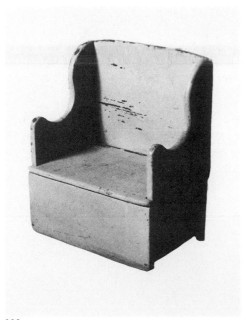

228

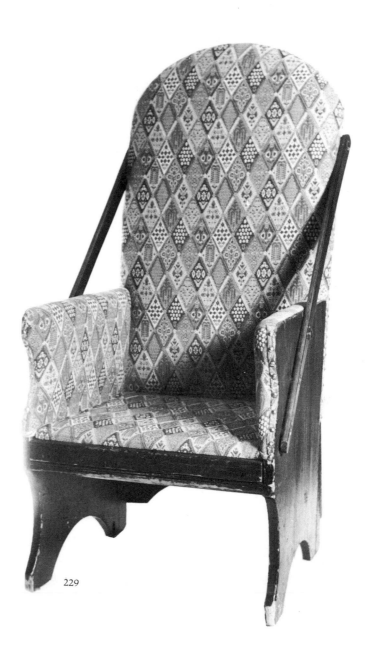

229

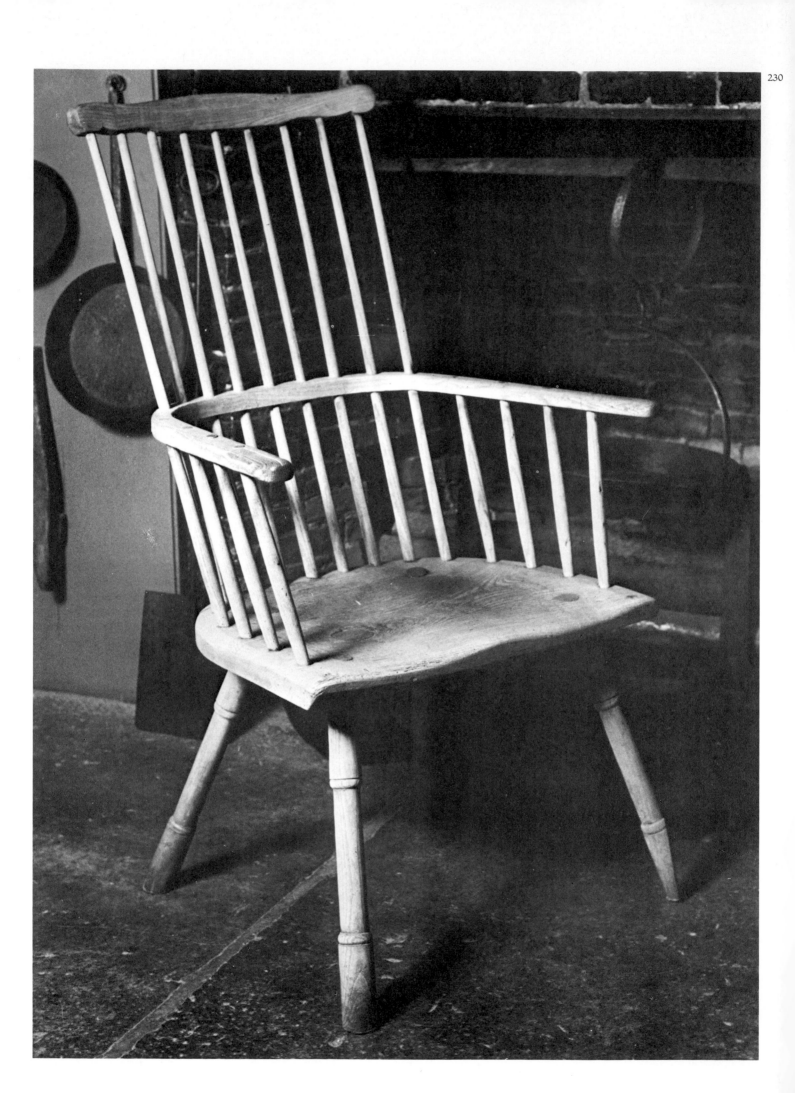

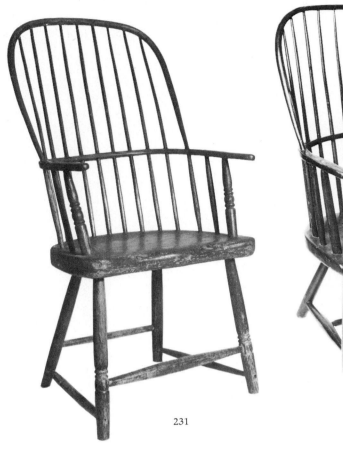

231

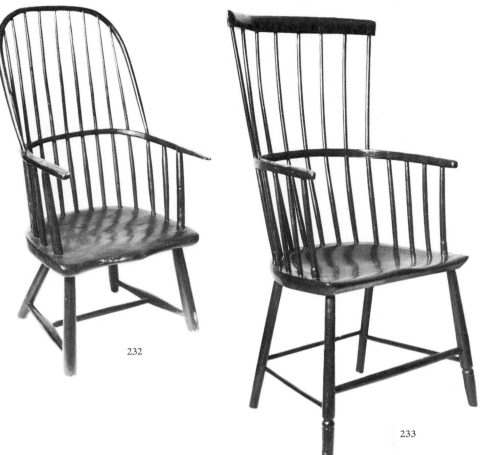

232

233

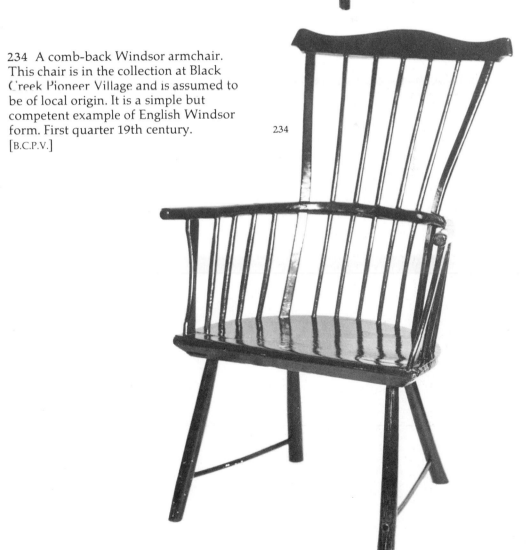

234

230 A comb-back Windsor armchair of unknown origin. This design incorporates typical characteristics of the British country Windsor tradition: simple leg detail without stretchers, legs fitted through the seat, thin plank seat of hardwood, overall heaviness of elements. Late 18th or first quarter 19th century. [U.C.V.]

231 A bow-back Windsor armchair from Markham Township in York County. (Early family: Fowles.) The height of the back and vertical position of the legs at the corners of the wide plank seat suggest an English prototype. Second quarter 19th century. [P.C.]

232 A bow-back Windsor armchair from Scarborough Township in York County. This chair, similar to the preceding example, combines late characteristics in detail with its 18th century form. Second quarter 19th century. [P.C.]

233 A comb-back Windsor armchair from the western counties. Of unusually light construction, this design is reminiscent of 19th century English Windsors. Second quarter 19th century. [P.C.]

234 A comb-back Windsor armchair. This chair is in the collection at Black Creek Pioneer Village and is assumed to be of local origin. It is a simple but competent example of English Windsor form. First quarter 19th century. [B.C.P.V.]

235 A continuous-arm Windsor armchair from Frontenac County. This is a good example of a widely-made 18th century American style in which the pleasantly bulbous turning, shaped seat and beaded, ash arm rail are all typical characteristics. The rarity of such chairs known at this time does not clarify the question of Canadian origin. Fourth quarter 18th century. [P.C.]

236 A continuous-arm Windsor armchair from Renfrew County. Less sophisticated than the previous example, this chair shows deterioration in the character of the turnings, the shaping of the seat and in the overall unity of the design. Fourth quarter 18th century. [P.C.]

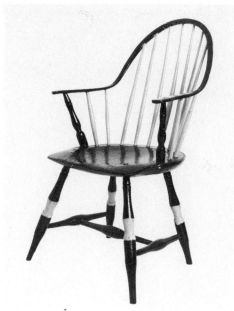

236

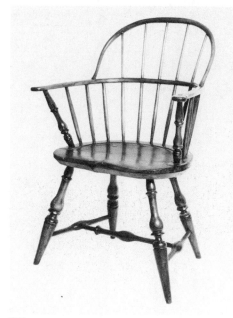

237

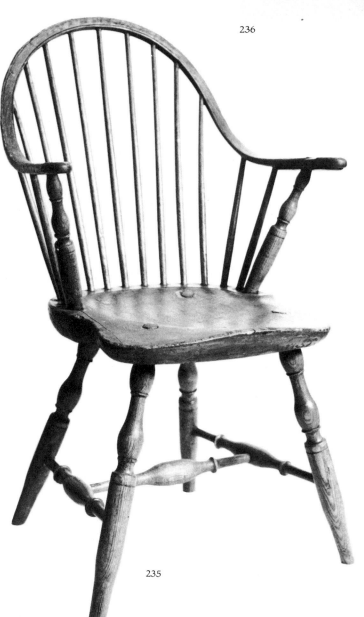

235

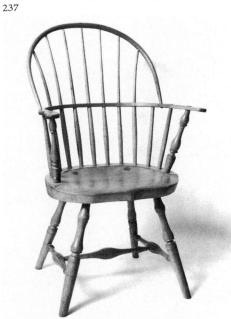

238

237 A bow-back Windsor armchair from Kingston in Frontenac County. This is another popular 18th century American style, and this example indicates a skilled maker, trained in that tradition. Fourth quarter 18th century. [P.C.]

238 A bow-back Windsor armchair from Ivy Lee in Leeds County. A less refined example than the one preceding. The deterioration in the character of the turnings and the shaping of the seat suggest a later date and a provincial origin. First quarter 19th century. [P.C.]

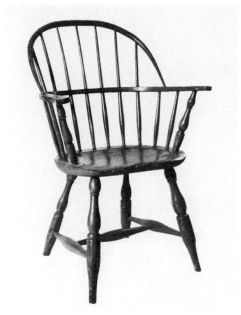

239

240

239 A bow-back Windsor armchair from Bath in Lennox and Addington County. Another countrified example of the handsome American form; the overall heaviness is consistent with frontier taste. First quarter 19th century. [P.C.]

240 A bow-back Windsor armchair from Wellington County. The 18th century form survived in large numbers of chairs that were factory-made throughout the 19th century. While not comparable to early examples, this chair with later 19th century detail is a successful and very practical design for multiple production. Third quarter 19th century. [P.C.]

241 A bow-back Windsor armchair from Kingston in Frontenac County. Attributed by family tradition to Peter Grass, who came to Kingston from New York with his father, Michael, an important Loyalist figure. Six of these chairs were apparently made for six sons and several of these are known to survive. The turnings reflect the influence of 19th century style. First quarter 19th century. [P.C.]

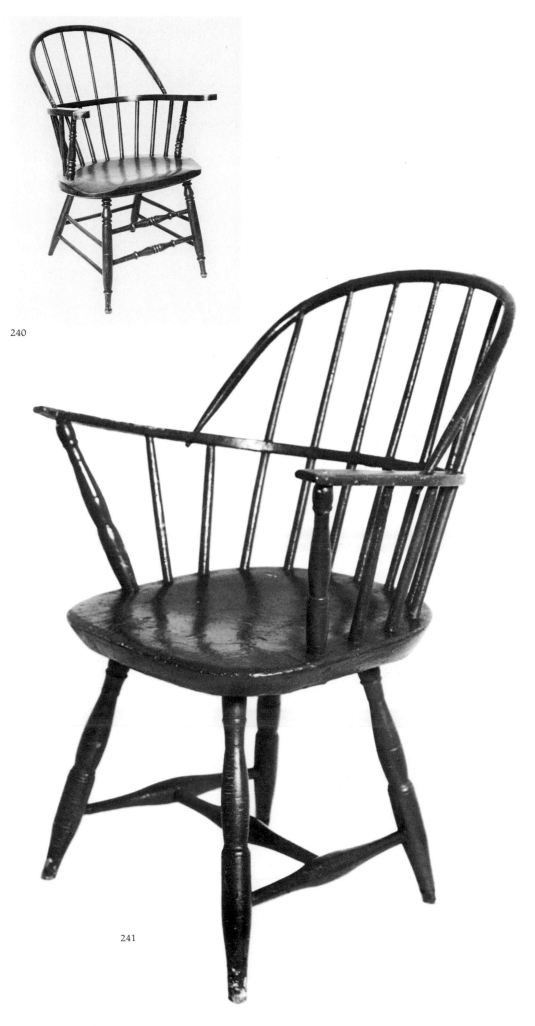

241

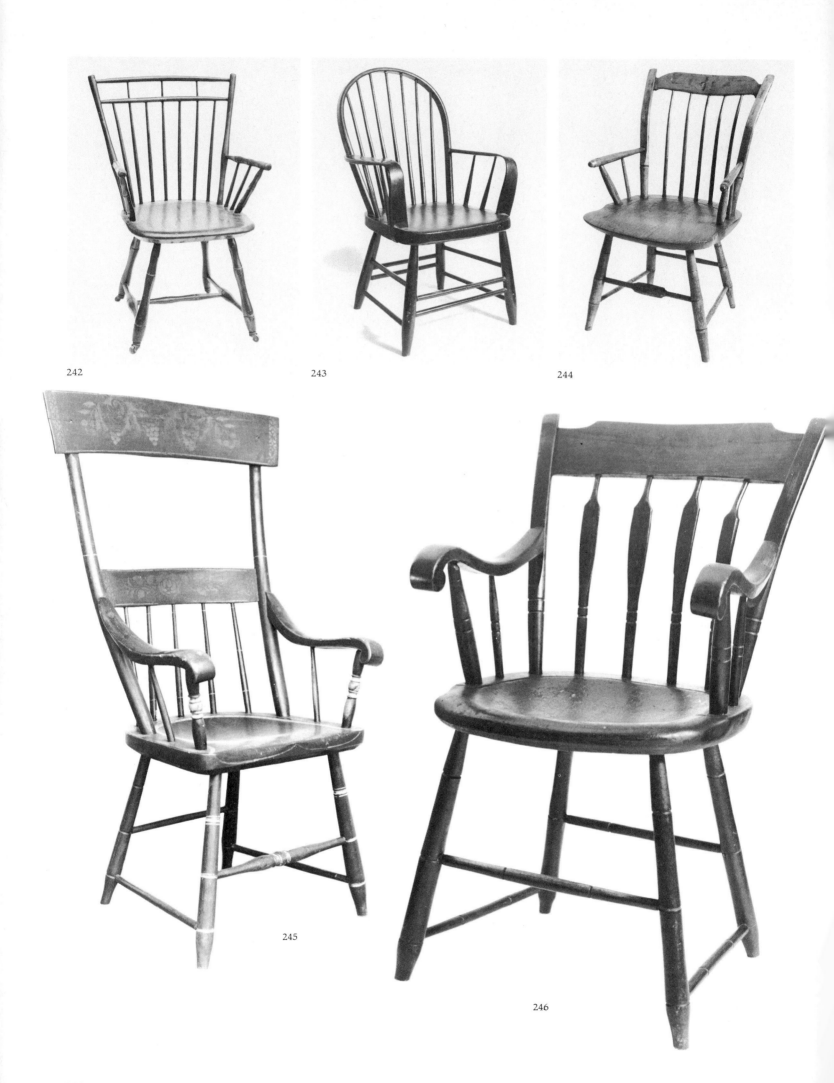

242

243

244

245

246

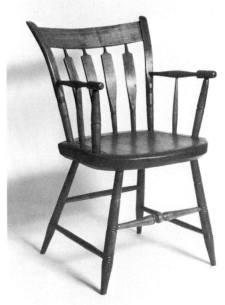

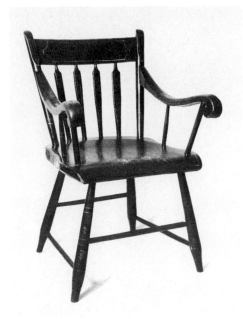

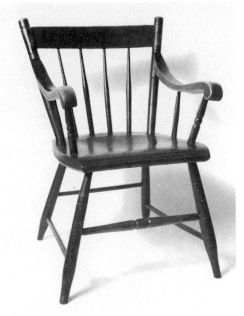

247

248

249

242 A birdcage Windsor armchair from Milton in Halton County. Early in the 19th century influences from Sheraton were accepted in the American Windsor tradition. This example shows a subtle Sheraton character in the design of the back and in the bamboo turnings. First quarter 19th century. [P.C.]

243 A loop-back Windsor armchair from Scarborough in York County. (Early family: David Thompson.) This 19th century Windsor form was quite popular in both armchairs and side chairs and was made in several different locations. The attenuation of the arm to facilitate the curve is an ingenious and pleasing detail. Mid-19th century. [P.C.]

244 A youth's rod-back Windsor armchair from the Niagara Peninsula. The Sheraton influence is apparent here in the low, square back, front stretcher design and the bamboo turnings. First quarter 19th century [P.C.]

245 A Windsor armchair from the eastern counties. The late American Windsor development incorporated influences from current fashion. The broad crest rail in this example as well as the scrolled arm were elements from late Neoclassical style. First quarter 19th century. [U.C.V.]

246 An arrow-back Windsor armchair from the western counties. A fine example of a low-back Windsor armchair form which developed in the early 19th century. The arrow-shaped splat became the distinctive feature of a great variety of designs. Second quarter 19th century. [P.C.]

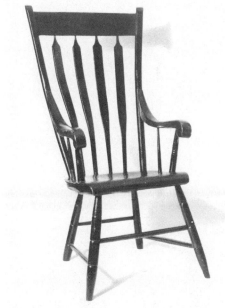

250

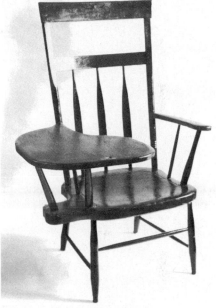

251

247 An arrow-back armchair from Northumberland County. The broad arched arrow splats are particularly well formed in this design, which retains the earlier type of arm and turned front stretcher. Second quarter 19th century. [P.C.]

248 An arrow-back armchair from Guelph in Wellington County. A strong and practical design with a particularly generous arm. This and related chairs from the area have the same proficient striping and painted decoration, as seen in the next example. Second quarter 19th century. [P.C.]

249 A rod-back Windsor armchair from Guelph in Wellington County. Another basic style in 19th century Windsor development which retained

the simply shaped spindles of early Windsor design. Mid-19th century. [P.C.]

250 An arrow-back Windsor armchair from Oshawa in Ontario County. An excellent example of the later American Windsor development, incorporating well-shaped arrow splats, scrolled arms and simple box-stretcher base. Second quarter 19th century. [P.C.]

251 A writing-arm Windsor chair from Middlesex County. This unusual chair combines the typical 19th century arrow-back and box-stretcher base with the broad writing arm and supporting structure found on 18th century American examples. Mid-19th century. [P.C.]

252 A low-back Windsor armchair from Kingston in Frontenac County. Stamped, HATCH. (Chester Hatch was a Kingston chairmaker 1815-1851.) The collared, low armchair was another of the basic 18th century American styles which was modified to become a popular 19th century form. This example is a transitional phase which combines the basic form of the early style with the overall heaviness and simplified turnings that characterize the many variations which followed. Second quarter 19th century. [P.C.]

253 A low-back Windsor armchair from Lennox and Addington County. The raked angle of the back in this well-balanced design survives from the early Windsors. The roll at the seat front is shaped from the solid. Second quarter 19th century. [P.C.]

254 A low-back Windsor armchair from Adams Mills in Lanark County. The deep, arched collar, well-shaped seat and scrolled details on arm and seat front are particularly pleasing features of this well-turned design. Second quarter 19th century. [P.C.]

255 A low-back Windsor armchair from Cornwall in Stormont County. The repetition of the vigorous spindle detail in the back and front legs is a simple but effective design feature. This chair retains its multi-coloured striping and stencilled decoration. Second quarter 19th century. [P.C.]

256 A low-back Windsor armchair from Belleville in Lennox and Addington County. Another example of continuity in unusually decorative turning detail. The sculptured character of the collar and seat are excellent features of this design. Second quarter 19th century. [P.C.]

257 A low-back Windsor armchair from the Niagara Peninsula. The well-shaped collar and detailed spindles add an air of refinement to this sturdy design. Second quarter 19th century. [P.C.]

258 A low-back Windsor from Perth in Lanark County. One of a set of chairs made for the Perth Town Hall which was built in 1863. Later examples show the simplification brought about by mechanized volume production and lack the fluid character of those individually made. Third quarter 19th century. [P.C.]

259 A low-back Windsor armchair from Napanee in Lennox and Addington County. One of a set of chairs from the Court House built in 1864. The addition of the comb, inspired by early Windsors, was a popular feature in late examples. Probably from the Gibbard factory. Third quarter 19th century. [P.C.]

260 A low-back Windsor armchair from Whitney in Peterborough County. (Signed, *Fuller – Whitney C.W.*) This form did not escape the epidemic of spool turnings which spread with Victorian taste. Third quarter 19th century. [P.C.]

261 A low-back Windsor armchair from Glengarry County. Popularly called a captain's chair, this American design was made by the thousands in all parts of the country. This many-bobbled version retains its painted decoration. Third quarter 19th century. [G.C.M.]

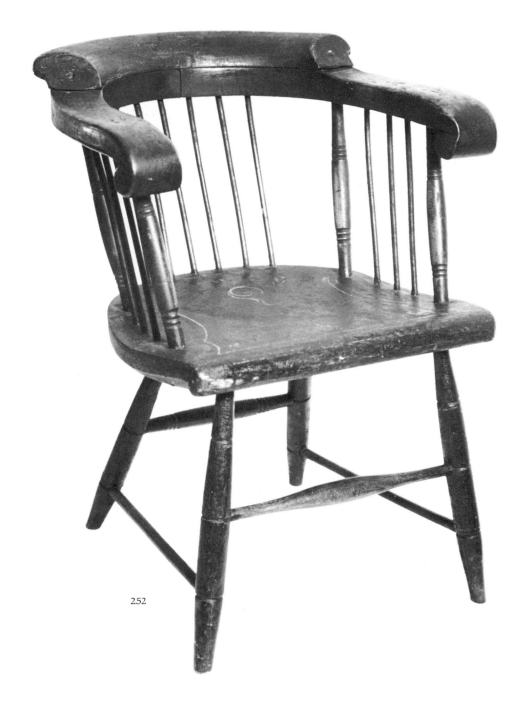
252

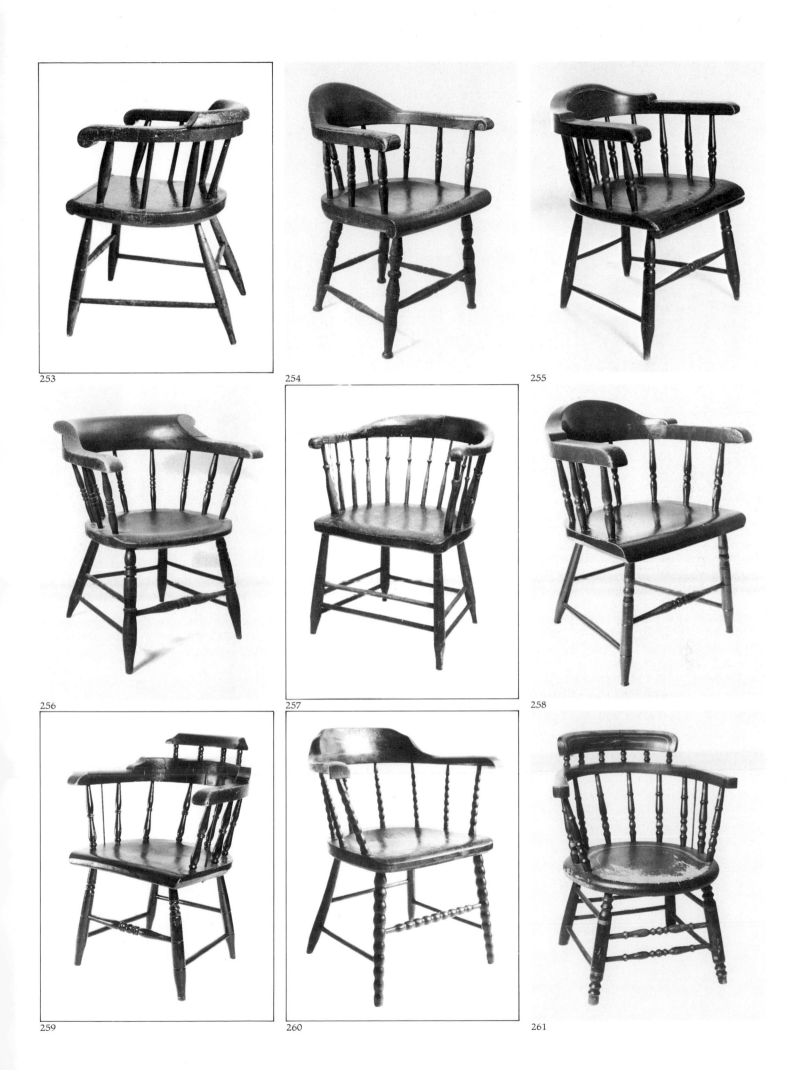

253

254

255

256

257

258

259

260

261

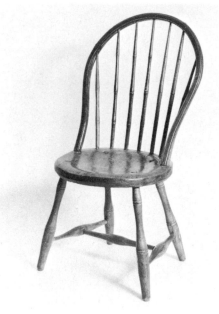

262

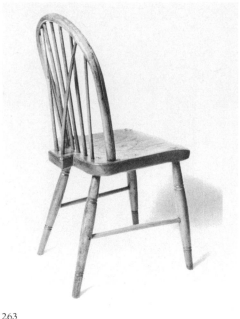

263

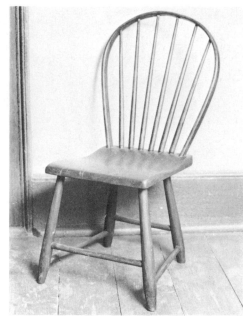

264

262 A loop-back Windsor side chair from Martintown in Glengarry County. This is a very individual interpretation of the popular form, particularly the circular seat and overall sturdiness. First quarter 19th century. [P.C.]

263 A brace-back Windsor side chair from Goderich in Huron County. This chair was made by a British craftsman for military use in Canada and bears the British Ordinance mark. It is typical of English country Windsor style with its simple seat, heavy loop and absence of front and rear stretchers. First quarter 19th century. [P.C.]

264 A loop-back Windsor side chair. This late Windsor style was very popular and was made in several widely separated areas. Mid-19th century. [P.C.]

265 A loop-back Windsor side chair from Carleton County. This Windsor design with a Sheraton influence in its bamboo turnings was popular in late 18th century America. The bulbous "H" stretcher and graceful beaded loop are details found on better examples. Chairs of this type are found in some numbers in the eastern counties which may or may not indicate their local manufacture. Late 18th or early 19th century. [P.C.]

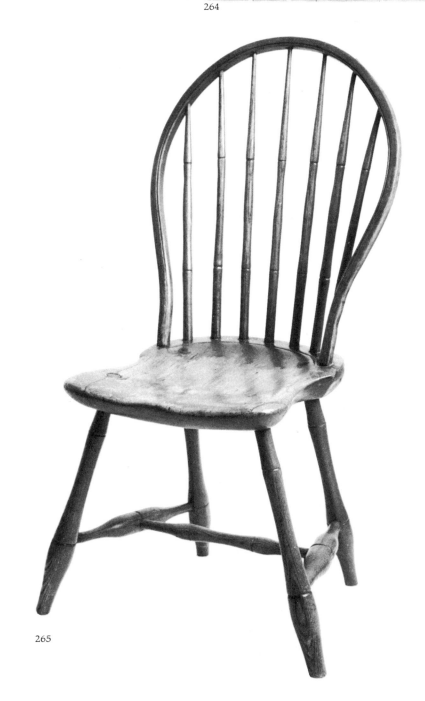

265

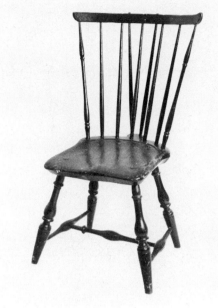

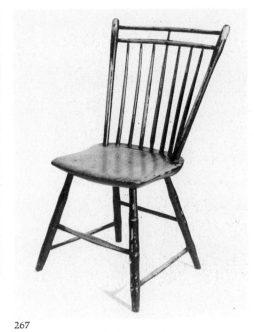

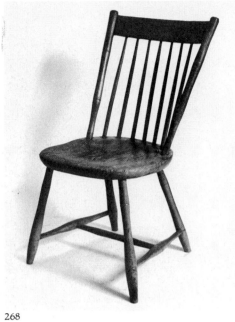

266 267 268

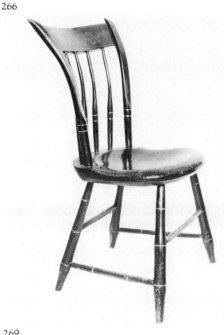

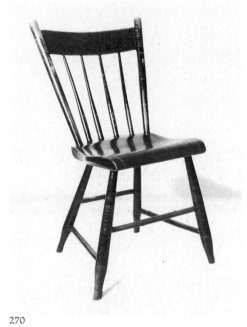

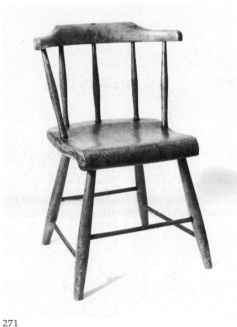

269 270 271

266 A braced, fan-back Windsor side chair from Carleton County. This was also a popular American Windsor style in the 18th century. Examples from Upper Canada are very rare, and are likely to have been brought at an early date from the American colonies or Lower Canada. Fourth quarter 18th century. [P.C.]

267 A birdcage Windsor side chair from the Niagara Peninsula. Sheraton influence produced this early 19th century Windsor style. This is a relatively simple version of the form which often is very delicate with a graceful sweep to the back and bamboo turnings throughout. First quarter 19th century. [P.C.]

268 A rod-back Windsor side chair from Lanark County. The Sheraton-influenced Windsors inspired a large number of variations. This transitional example retains the earlier "H" stretcher-base design with the squared spindle back. First quarter 19th century. [P.C.]

269 A rod-back Windsor side chair from Prince Edward County. This chair includes several features of better late Windsor design: well-arched back, dished seat and bamboo legs. Other examples of this design are known from the same area. Second quarter 19th century. [P.C.]

270 A rod-back side chair from Guelph in Wellington County. Somewhat later than the preceding example, this chair has the straight back and overall simplification that was favoured by large-volume factories. The painted decoration identifies this chair with previously illustrated armchairs (Plates 248, 249). Mid-19th century. [P.C.]

271 A rod-back Windsor side chair from the eastern counties. This very unusual design is reminiscent of British cottage Windsors in form, but the elements are typically North American. Second quarter 19th century. [P.C.]

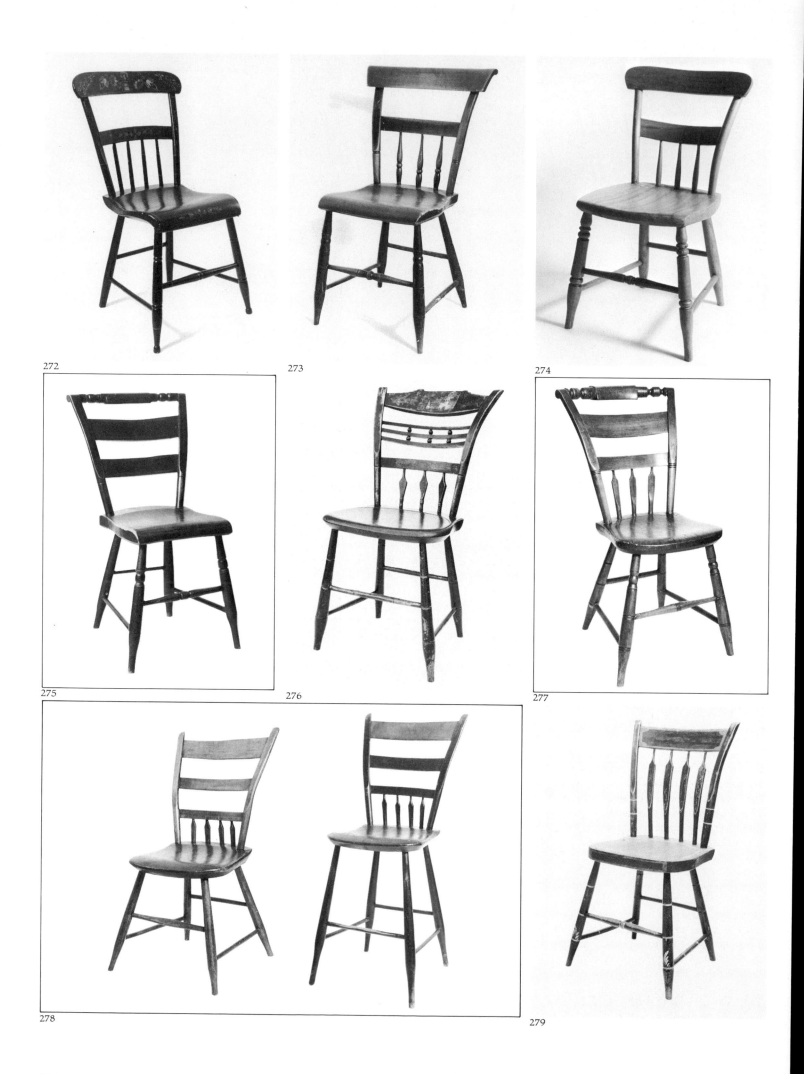

272

273

274

275

276

277

278

279

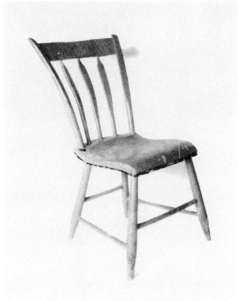

280

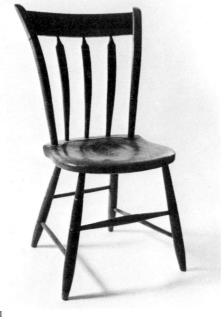

281

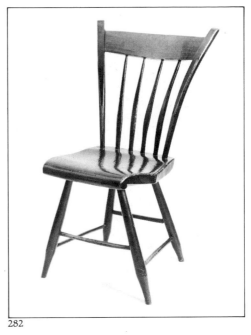

282

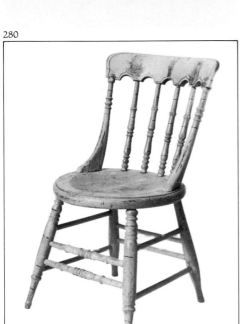

283

272 A chicken coop side chair from Lennox and Addington County. Influences from the more formal American fancy chair styles were combined with the late Windsor developments. In this example the wide crest rail, detail of legs and stretcher and stencilled decoration produce what might be called a fancy Windsor. Second quarter 19th century. [L. & A.C.M.]

273 A chicken coop Windsor side chair from Lanark County. This design includes the rolled crest rail and arched back which, in addition to pleasing late turning detail, make it a good example of the style. Second quarter 19th century. [P.C.]

274 A rod-back Windsor side chair from Almonte in Lanark County.

(Signed, *Field, Almonte;* Charles E. Field was a cabinetmaker there in the 1860s.) This well-made, late chicken coop has lost the crispness of earlier designs. Third quarter 19th century. [P.C.]

275 A pillow-back Windsor side chair from Guelph in Wellington County. This is another example of the overlap of Windsor and fancy chair styles. The pillow crest rail and wide back rails are from the fancy style, while the seat, base and overall form are typically late Windsor. Second quarter 19th century. [P.C.]

276 A Sheraton Windsor side chair from Amherstburg in Essex County. This handsome Windsor shows a strong Sheraton or American fancy chair influence in its complex back design and decoration. First quarter 19th century. [P.C.]

277 An arrow-back Windsor side chair with pillow from the eastern counties. This excellent design was almost certainly painted and decorated originally. It is an unusually good example of late Windsor form and detail. First quarter 19th century. [P.C.]

278 An arrow-back side chair and desk chair from Carleton County. These chairs found in the same area are likely by the same local maker. The desk chair is not often found and was likely a special order which was based on the maker's standard side chair design. Second quarter 19th century. [P.C.]

279 An arrow-back Windsor side chair from the Niagara area. The arrow-shaped splat was the most popular

single feature of the late Windsor style. This better-than-average example has four splats, usually indicating an earlier date than those with three. Second quarter 19th century. [N.H.S.M.]

280 An arrow-back Windsor side chair from Napanee in Lennox and Addington County. (Signed, *Gibbard.*) The Gibbard factory in Napanee is one of the earliest that is still in operation. An early Gibbard advertisement offers: "Sofas, Sideboards, Bureaus, Centre and Dining Tables, What Nots, Fancy, and Common Stands, Hair Cloth, Fancy Cane Seat, Windsor, and Small Chairs for Children, etc." Second quarter 19th century. [P.C.]

281 An arrow-back Windsor side chair from Kingston in Frontenac County. Stamped, HATCH. The turning detail in the legs, front stretcher and rear post are similar to the Hatch low-back Windsor in Plate 252. Second quarter 19th century. [P.C.]

282 An arrow-back Windsor spinning chair from Waterloo County. A chair designed for use at the spinning wheel. The legs are set back and the front corner is shaped to allow convenient access to the wheel. Second quarter 19th century. [P.C.]

283 A gunstock Windsor side chair from Seaforth in Huron County. One of a large number made for the Seaforth Opera Hall in 1877. Still basically a Windsor form, the gunstock is much adorned to suit the Victorian taste for fussiness. Fourth quarter 19th century. [P.C.]

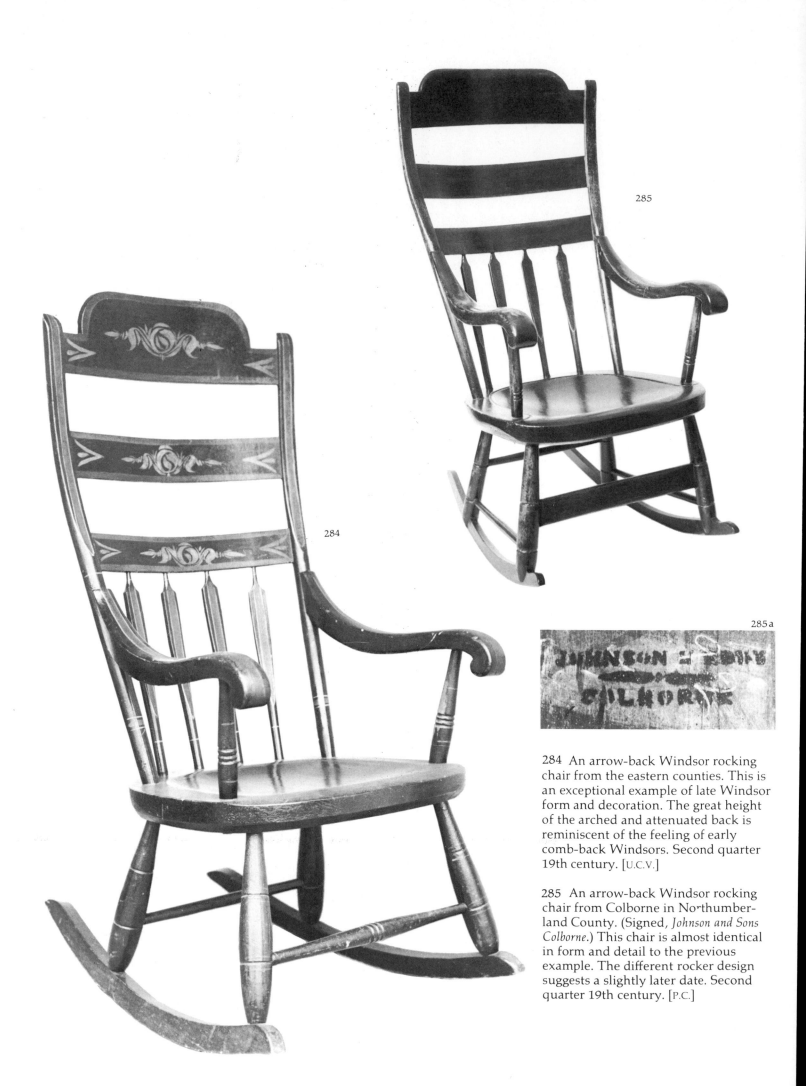

284 An arrow-back Windsor rocking chair from the eastern counties. This is an exceptional example of late Windsor form and decoration. The great height of the arched and attenuated back is reminiscent of the feeling of early comb-back Windsors. Second quarter 19th century. [U.C.V.]

285 An arrow-back Windsor rocking chair from Colborne in Northumberland County. (Signed, *Johnson and Sons Colborne*.) This chair is almost identical in form and detail to the previous example. The different rocker design suggests a slightly later date. Second quarter 19th century. [P.C.]

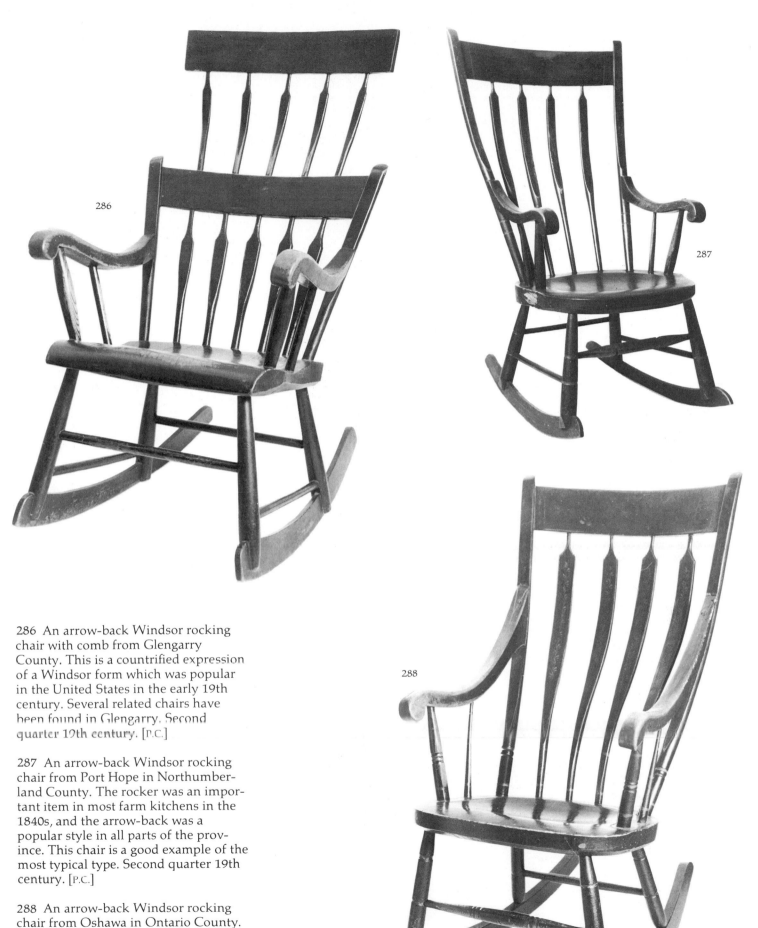

286 An arrow-back Windsor rocking chair with comb from Glengarry County. This is a countrified expression of a Windsor form which was popular in the United States in the early 19th century. Several related chairs have been found in Glengarry. Second quarter 19th century. [P.C.]

287 An arrow-back Windsor rocking chair from Port Hope in Northumberland County. The rocker was an important item in most farm kitchens in the 1840s, and the arrow-back was a popular style in all parts of the province. This chair is a good example of the most typical type. Second quarter 19th century. [P.C.]

288 An arrow-back Windsor rocking chair from Oshawa in Ontario County. A striking example of the variations which occurred on the basic form. The high position of the arms is unusual and reflects the graceful line of the arrow-shaped splats. Second quarter 19th century. [P.C.]

289 A loop-back Windsor rocking chair from Huron County. This design combines a distinctly English Windsor character in its flat loop and heavy arm bow with a seat and base that are typical of locally made, late-American Windsors. Second quarter 19th century. [P.C.]

290 An arrow-back Windsor rocking chair from Frontenac County. Most rockers have a relaxed character, but tension is the impression created by this design with its inward-bowed back and alert stance. Second quarter 19th century. [P.C.]

290

291

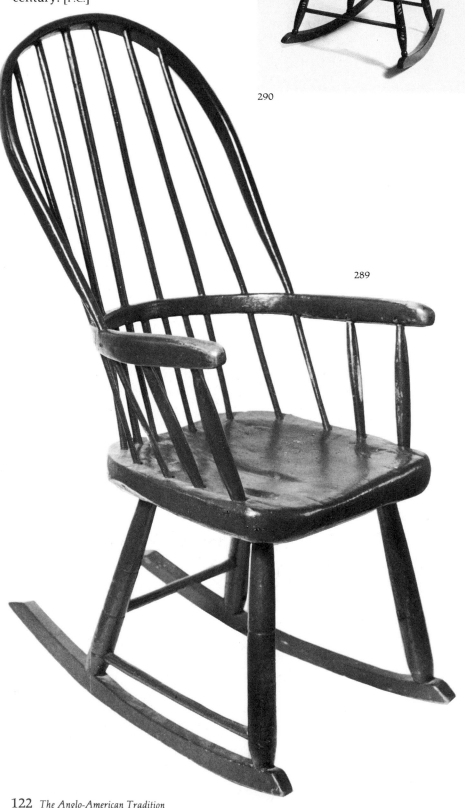

289

292

291 An arrow-back Windsor rocking chair from Frontenac County. The turned Sheraton-type arm and bamboo detail in the front stretcher suggest a slightly earlier date for this well-decorated chair than for most arrow-back rocker designs. First quarter 19th century. [P.C.]

292 An arrow-back Windsor rocking chair from York County. The splayed legs, well-shaped seat and tall straight back in this example are strongly influenced by the 18th century Windsors. The shaped rockers are an added refinement. Second quarter 19th century. [P.C.]

293 An arrow-back Windsor rocking chair from Napanee in Lennox and Addington County. This chair belonged

293

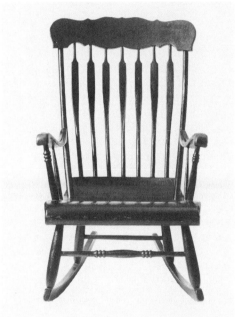

294

to the Gibbard family and was made in the Napanee factory. It is a late example of the arrow-back type. Third quarter 19th century. [P.C.]

294 An arrow-back Windsor rocking chair from Schomberg in York County. This exceptionally generous chair takes the prize for number of arrows. The rolled seat and shaped crest rail are found on many rockers of the late rod-back, Boston variety. Third quarter 19th century. [P.C.]

295 A rod-back Windsor rocking chair from Oxford County. The Boston rocker style is one of the most success-ful designs based on the flowing "S" scroll which fascinated 19th century furniture designers. Mid-19th century. [P.C.]

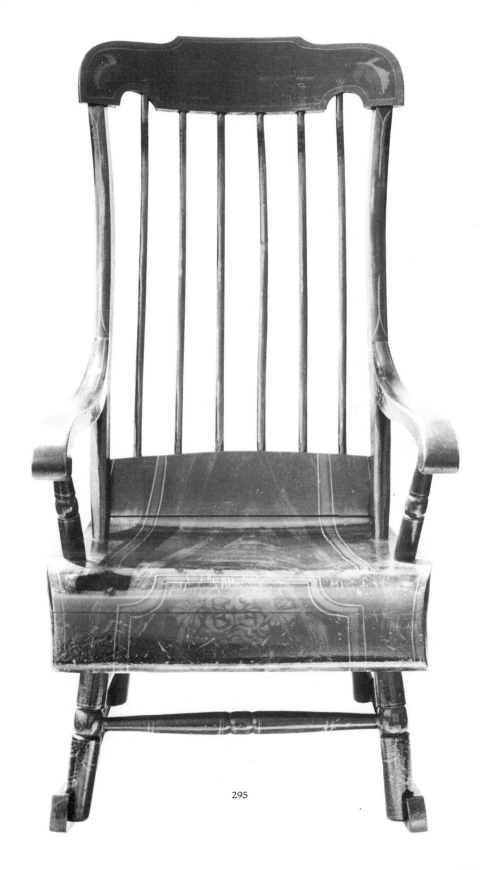

295

296 A rod-back Windsor rocking chair from Dunnville in Haldimand County. This is an outstanding example of the universally popular Boston rocker, a Windsor form with strong influences from the Empire style. The shaped crest rail, rolled arm and seat, and stencilled decoration are typical features. Mid-19th century. [P.C.]

297 A rod-back Windsor rocking chair from Leeds County. This is a transitional style, retaining the shaped rockers and rounded seat of earlier character combined with the broad crest rail and scrolled arms of the later period. Second quarter 19th century. [P.C.]

298 A rod-back Windsor rocking chair from Frontenac County. This is an unusual transitional design which is strongly related to the 18th century comb-back Windsor form with elements from the Boston rocker style superimposed. Several identical examples are known in the area. Second quarter 19th century. [P.C.]

299 A rod-back Windsor rocking chair from Kingston in Frontenac County. A transitional design with the crest rail and arms of the Boston style, but retaining the earlier type of seat. This is an unusually large and well-proportioned example. Second quarter 19th century. [P.C.]

300 A rod-back Windsor rocking chair from Kemptville, Grenville County. The widely splayed base and crisp scrolls give this simply-made chair its own distinct personality. The rolled seat is shaped from one piece. Mid-19th century. [P.C.]

301 A rod-back Windsor rocking chair from the eastern counties. A highly romantic craftsman created this voluptuous Empire design with an unusual understanding of the human form. Numerous chairs of this general character are found along the Ottawa River near the eastern border and may include influence from French Canada. Second quarter 19th century. [P.C.]

302 An arrow-back Windsor rocking chair from Dunvegan in Glengarry County. This is a very typical example of the popular bedroom rocker. Second quarter 19th century. [G.C.M.]

303 An arrow-back Windsor rocking chair from Leeds County. The unusually high, built-up seat and back and the forward placement of the rear posts are unusual features. Second quarter 19th century. [P.C.]

304 An arrow-back Windsor rocking chair from Napanee in Lennox and Addington County. This nursing rocker has an unusually high back and low seat. The similarity of design and decoration to the Gibbard chair illustrated earlier (Plate 293) suggests the same maker. Third quarter 19th century. [P.C.]

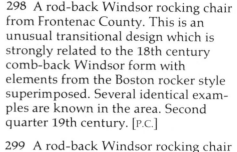
296

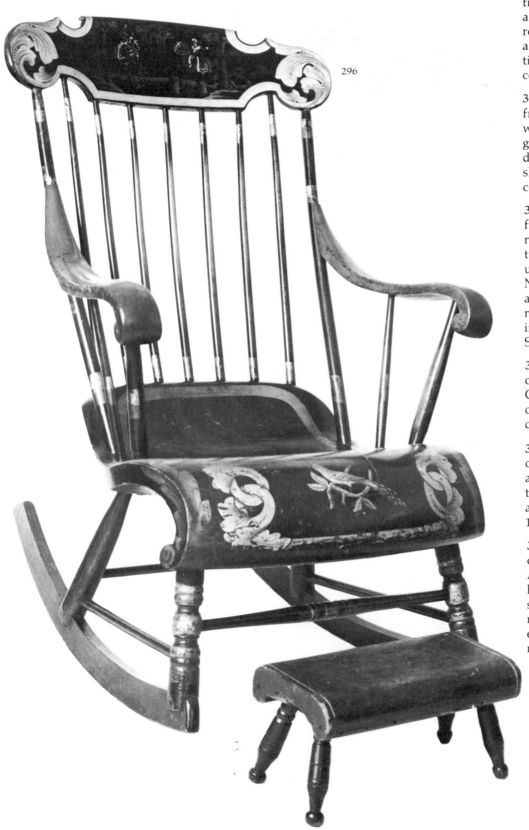

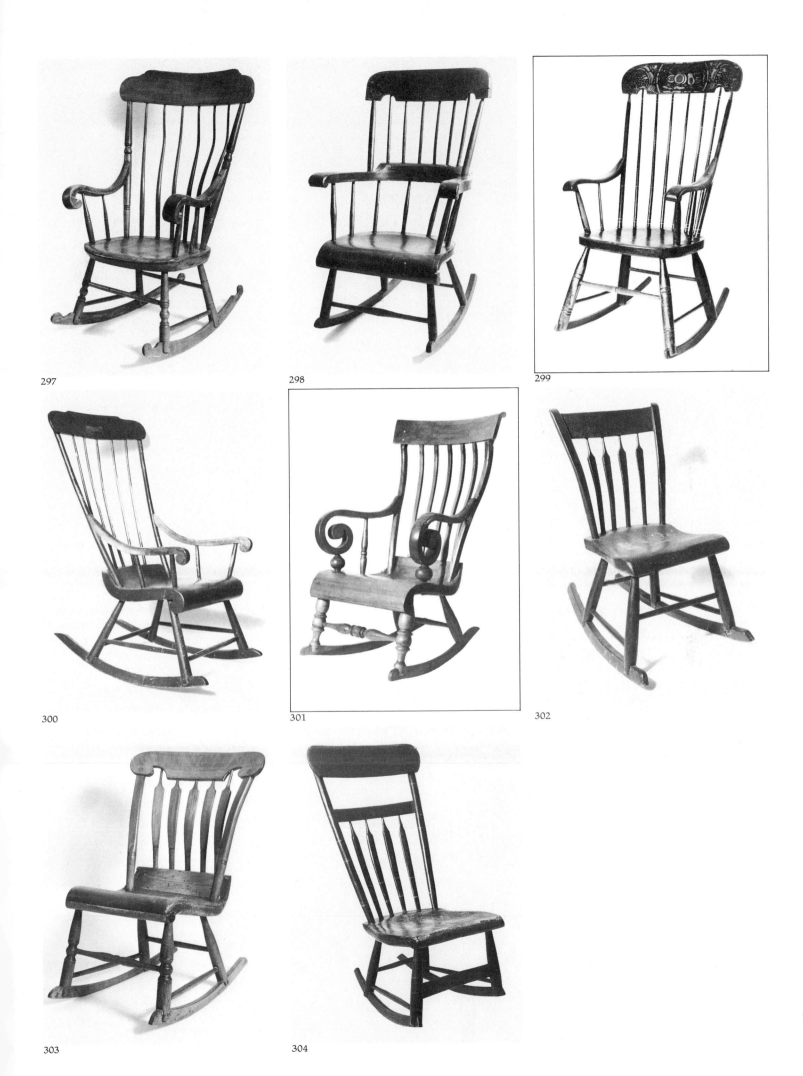

297

298

299

300

301

302

303

304

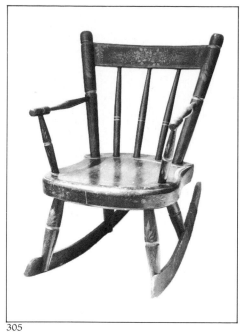

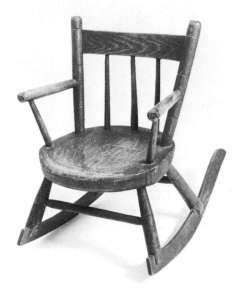

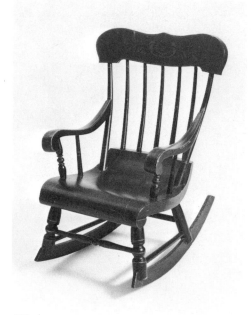

305

306

307

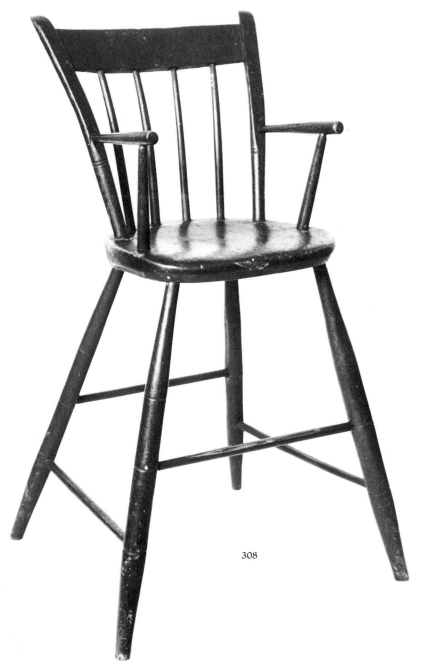

305 A child's rod-back rocking chair from Oxford County. (Early family: De Long.) The stencilled decoration on this little rocker is unusually delicate. Second quarter 19th century. [P.C.]

306 A child's rod-back Windsor rocking chair from Peterborough County. The widely splayed legs and chunky seat have an early Windsor character. Second quarter 19th century. [P.C.]

307 A child's rod-back Windsor rocking chair from Waterloo County. A well-designed example of the popular Boston rocker style in reduced proportions. Mid-19th century. [P.C.]

308 A rod-back Windsor high chair from the eastern counties. A well-balanced design with simple Sheraton Windsor elements. Second quarter 19th century. [P.C.]

308

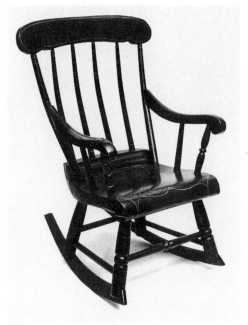

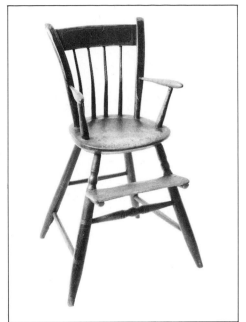

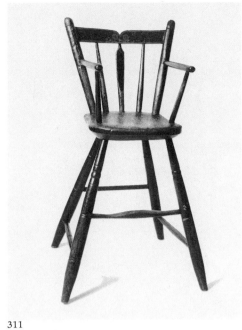

309

310

311

309 A youth's rod-back rocking chair from Markham in York County. (Early family: Reesor.) The popular rocker styles were made in different sizes for all ages. Third quarter 19th century. [P.C.]

310 A rod-back Windsor high chair from the eastern counties. Particularly good turnings and shaped seat are seen in this well-executed design, which has its original foot ledge. Second quarter 19th century. [P.C.]

311 A Windsor high chair from the eastern counties. An individual expression of the Sheraton Windsor style with shaped crest rail and combined rod- and arrow-back elements. Second quarter 19th century. [P.C.]

312 A bow-back Windsor child's chair from Napanee in Lennox and Addington County. Unlike most of the previous examples, this little pot chair is distinctly English in style. Further evidence of a British maker is the method of extending all rods completely through the elements which they join. First quarter 19th century. [L. & A.C.M.]

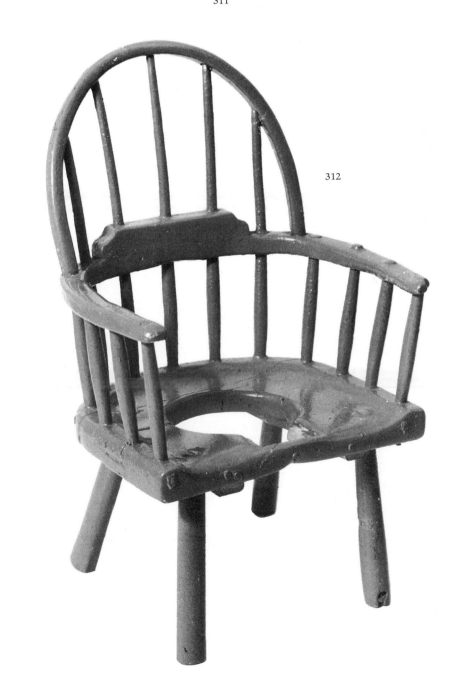

312

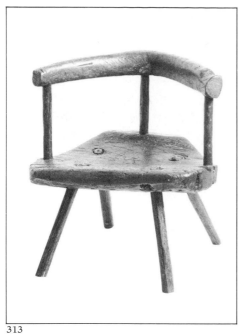

313

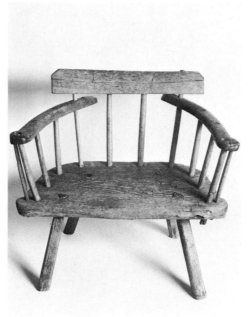

314

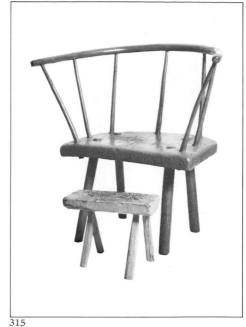

315

313 A stick-Windsor armchair from the eastern counties. This primitive Windsor is an unusually organic and sculptural example of a form that was prevalent in the peasant cottage throughout Britain and in frontier circumstances in America. Late 18th century or first quarter 19th century. [P.C.]

314 A stick-Windsor armchair from York County. This sturdy example is a primitive but soundly constructed version of a distinctly Irish country style. The broad crest rail and the corner spindle set through the arm at the rear are characteristic details. See prototype on page 314. 19th century. [P.C.]

315 A stick-Windsor armchair from London in Middlesex County. The stool is from Oakwood in Victoria County. While of primitive construction, this design surpasses pure function and creates some impression of the grace inherent in traditional Windsor design. The stool is a traditional cottage form. First half 19th century. [P.C.]

316 A stick-Windsor armchair from Kingston in Frontenac County. Many sophisticated Windsor designs do not match the fragile elegance of this rustic example. It is thoroughly sophisticated in concept, but honestly primitive in material and execution. The American bow-back is the prototype. First half 19th century. [P.C.]

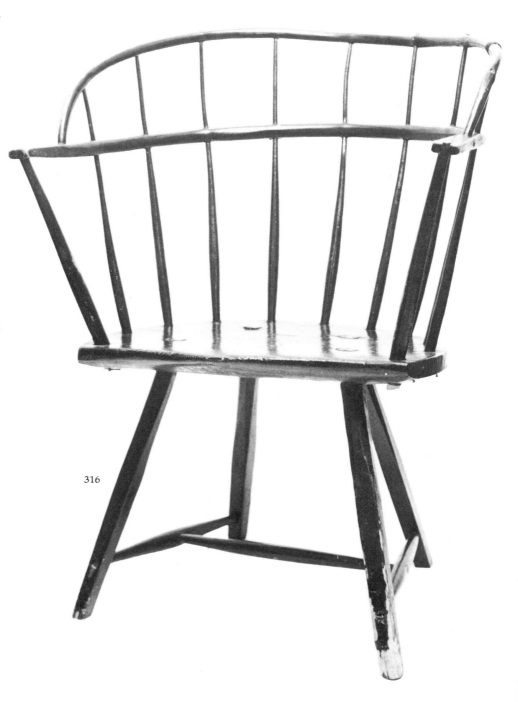

316

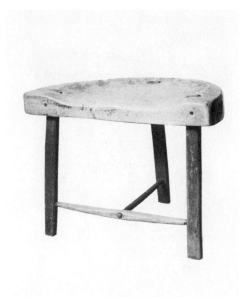

317

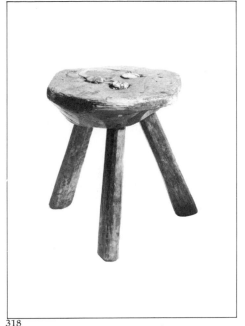

318

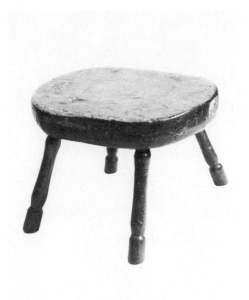

319

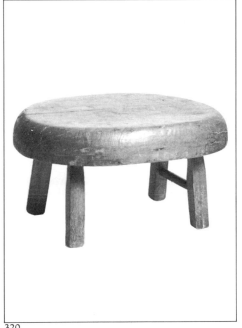

320

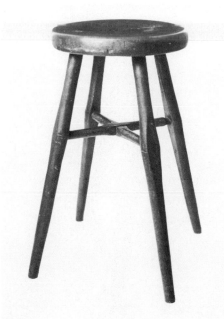

321

322

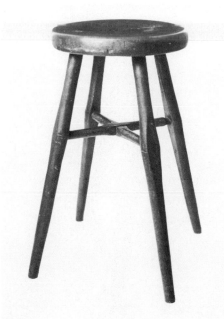

323

317 A Windsor stool from the eastern counties. A simple design of primitive construction, probably used for spinning or weaving. First half 19th century. [P.C.]

318 A Windsor footstool from Ontario County. (Early family: Squelch.) A primitive example in the British cottage tradition. First half 19th century. [P.C.]

319 A Windsor footstool from Ontario County. The simple leg turnings are reminiscent of those on English country Windsor chairs. First half 19th century. [P.C.]

320 A Windsor stool from the eastern counties. A stoutly primitive example

with a stretcher at one end which presumably serves as a handle. First half 19th century. [P.C.]

321 A Windsor stool from Ontario County. This stool shares the character of locally made late Windsor chairs. Second quarter 19th century. [P.C.]

322 A Windsor stool from Lincoln County. The Windsor turnings have an English character. First half 19th century. [J.H.M.O.T.T.]

323 A Windsor high stool from Waterloo County. A fine example of a simple form. The swelling of the legs to accept the stretcher is a detail seen on early American Windsor chairs. Second quarter 19th century. [P.C.]

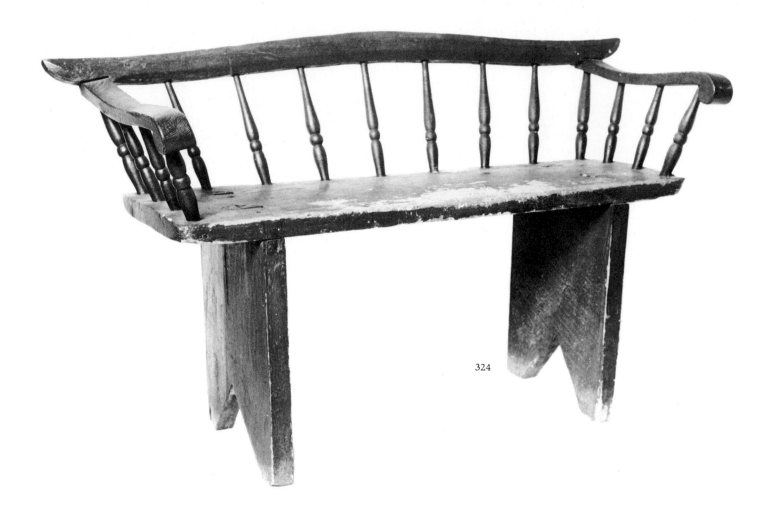

324

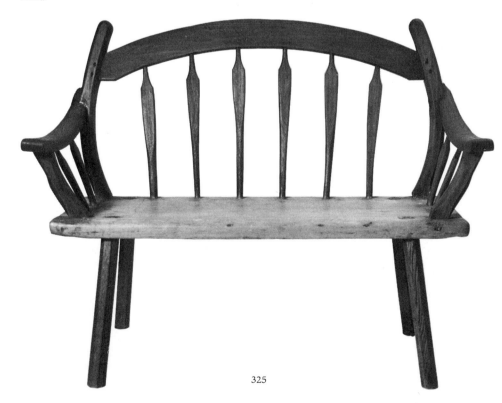

W. McLEOD.
CARRIAGE MAKER.

325 a

325

324 A rod-back Windsor wagon seat from Lucan in Huron County. The arms and spindles of this design are typical late Windsor elements, but the gently arched line of the extended crest rail is a highly individual variation on the style, as are the sturdy bootjack-shaped legs which are mortised through the plain seat. Family tradition suggests that this seat was used in the home, on the wagon, as well as taken to the benchless local church. Mid-19th century. [P.C.]

325 An arrow-back Windsor wagon seat from Lancaster in Glengarry County. (*Made by W. McLeod – Carriage Maker.*) This unique Windsor design is the product of a skilled and inventive craftsman. The arrow-shaped splats are borrowed from contemporary chair design, the seat and legs are country Windsor, while the complex arms and bowed back relate to carriage construction. Second quarter 19th century. [P.C.]

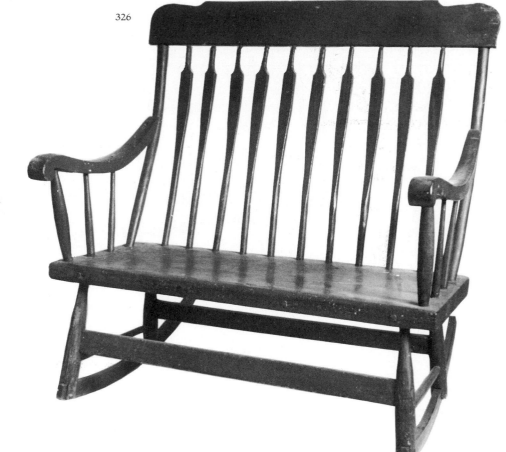

326

326 An arrow-back Windsor rocking bench from the eastern counties. This two-seated rocker is a rare example of a rather romantic concept, whether we call it a narrow bench or a wide chair. The style is a combination of typical late Windsor chair elements. Second quarter 19th century. [P.C.]

327 A settee from the eastern counties. While not a conventional Windsor form, this example is an interesting contrast to the following examples, because it is a British country style, rather than the popular late American Windsor style. Second quarter 19th century. [M.I.C.]

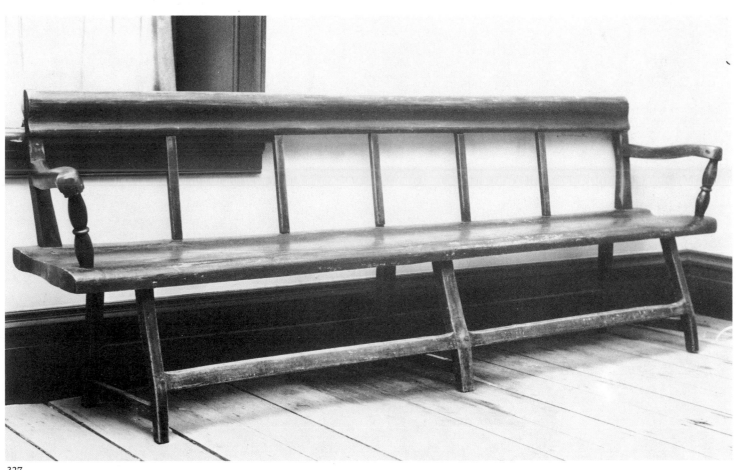

327

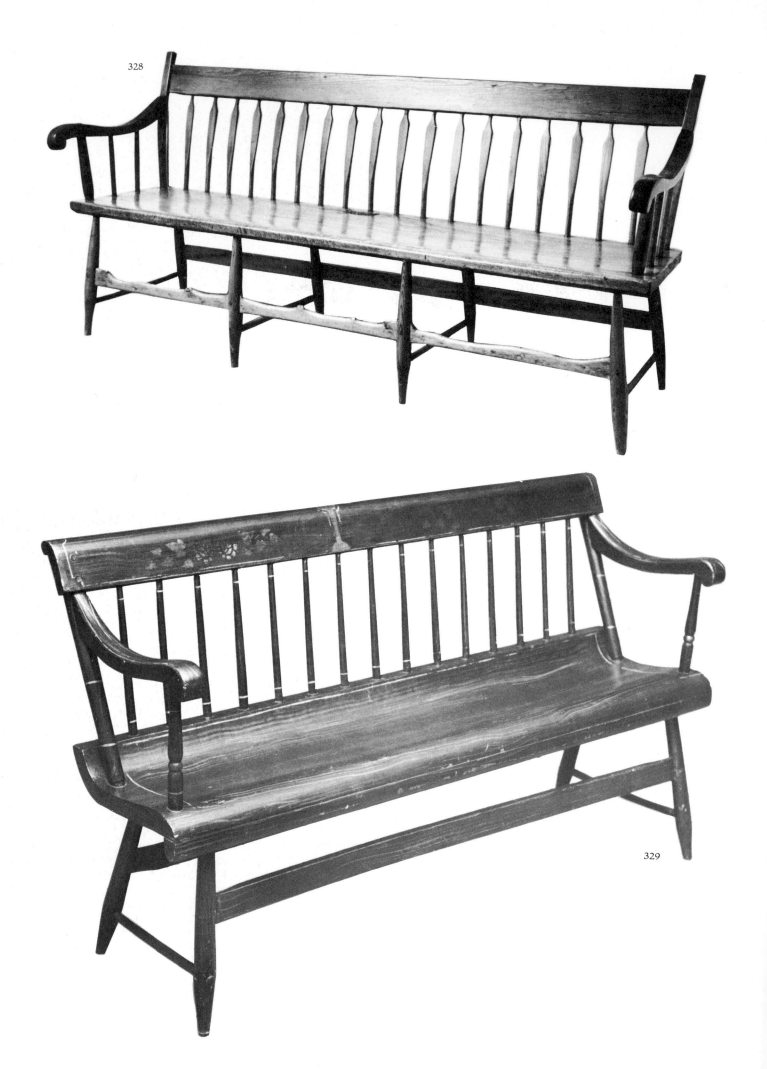

328

329

328 An arrow-back Windsor settee from Northumberland County. This settee is generously proportioned with typical details of the later Windsor category. Second quarter 19th century. [P.C.]

329 A rod-back Windsor seat from Bruce County. Later Windsor designs are often narrower than the early ones and were intended as secondary seating in hallways, porches and public locations. This example is well-formed and retains its original stencilled decoration. Second quarter 19th century. [P.C.]

330 A rod-back Windsor settee from Hawkesbury in Prescott County. The deeply shaped seat, scrolled crest rail and arm are combined with tautly arched back spindles to create an unusually striking late Windsor design. Second quarter 19th century. [P.C.]

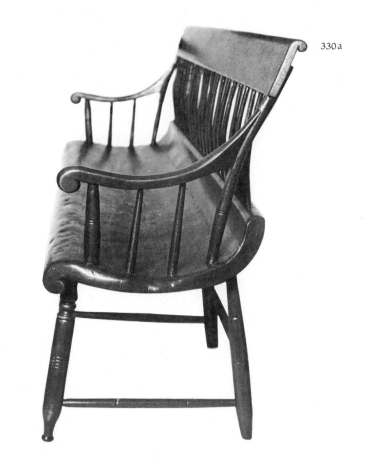

330a

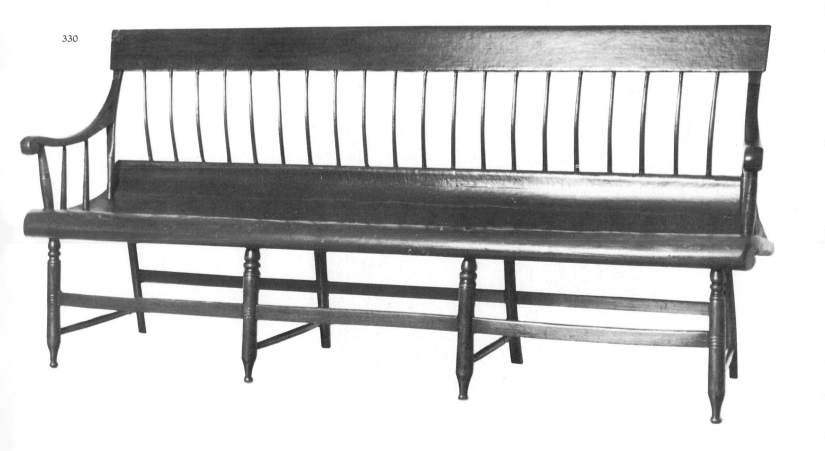

330

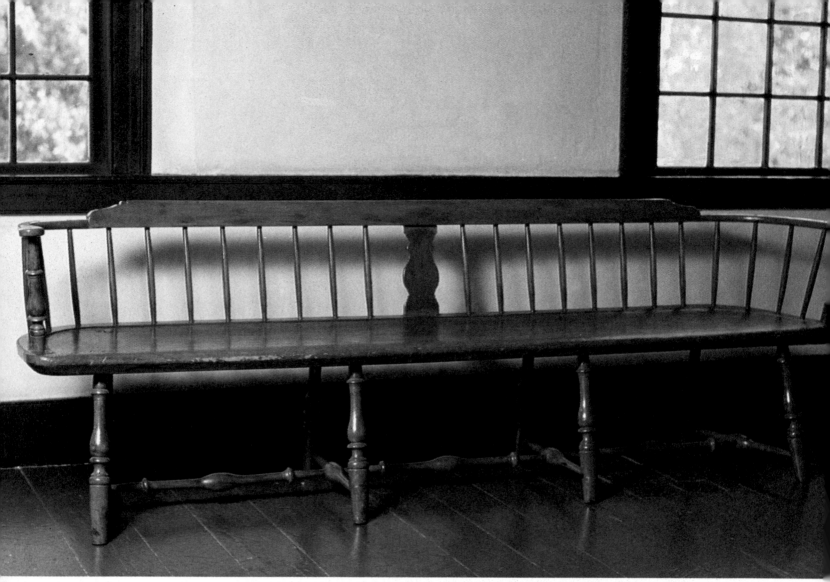

331

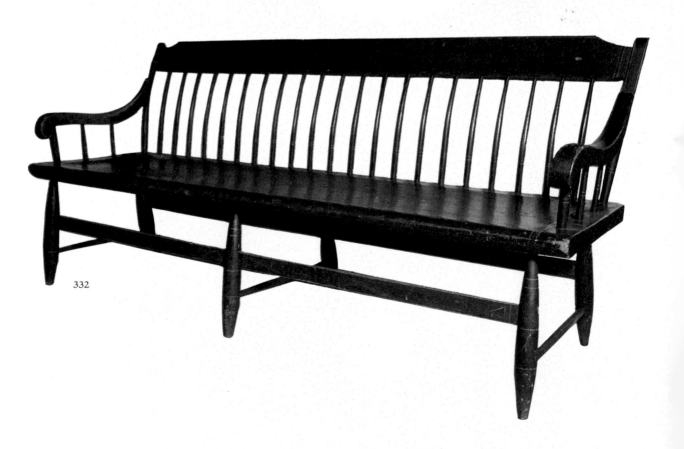

332

331 A low-back settee from Prescott in Grenville County. For the most part, this fine design is typical of American Windsor style of the last quarter of the 18th century. However, the soft character of the turnings suggests a later date and the urn-shaped back splat and chair-like crest rail are popular elements of Neoclassical influence consistent with early 19th century trends. These features suggest that this unusual example may have been made by a provincial craftsman as late as 1825. Early 19th century. [U.C.V.]

332 A Windsor settee from Dunvegan in Glengarry County. (Early family: Macmillan.) This design retains the generous scale of the earlier form with the broad crest rail, scrolled arms and flat stretchers of late Windsor style. Second quarter 19th century. [G.C.M.]

333 A Chippendale-style side chair from Kingston in Frontenac County. One of a pair, the "H" stretcher base, unadorned back splat and crest rail are seen in country Chippendale chairs made in England and Lower Canada in the last decades of the 18th century. The survival of this early style in Upper Canada is very rare. Late 18th century. [P.C.]

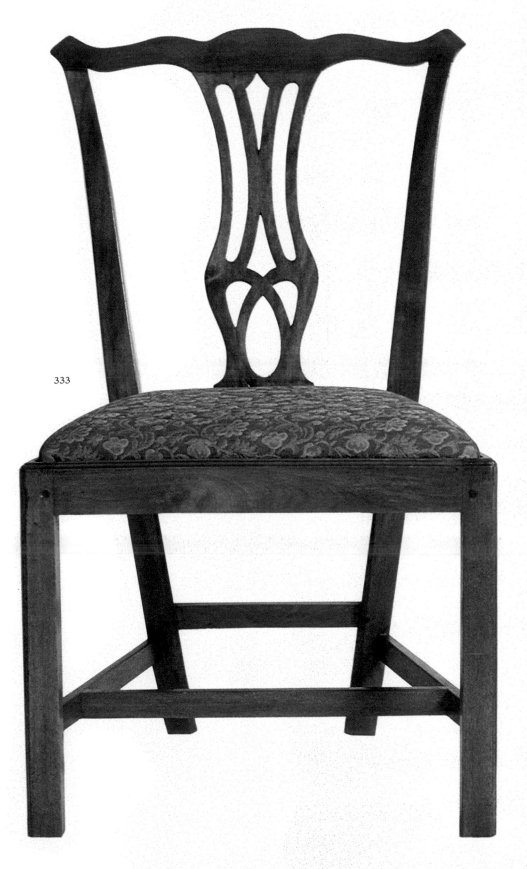

333

334 An upholstered easy chair from Pakenham in Lanark County. Upholstered chairs with elaborate wings to protect the user from draughts were popular in Britain from the mid-18th to mid-19th century. This crisp, simple design is based on that tradition and, like most locally made examples, acknowledges 19th century country taste in its turned front legs. Second quarter 19th century. [P.C.]

335 Sheraton-style side chairs from Port Hope in Northumberland County. The square back and design of the splat are characteristic of the Sheraton style in a highly individual provincial expression. First quarter 19th century. [P.C.]

336 A Hepplewhite-style easy chair from Carleton Place in Lanark County. A design in George Hepplewhite's *The Cabinet-Maker and Upholsterer's Guide* may well have been the inspiration for the competent provincial craftsman who made this example of a form which was rarely used in Upper Canada. First quarter 19th century. [P.C.]

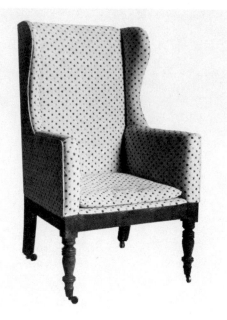

334

335

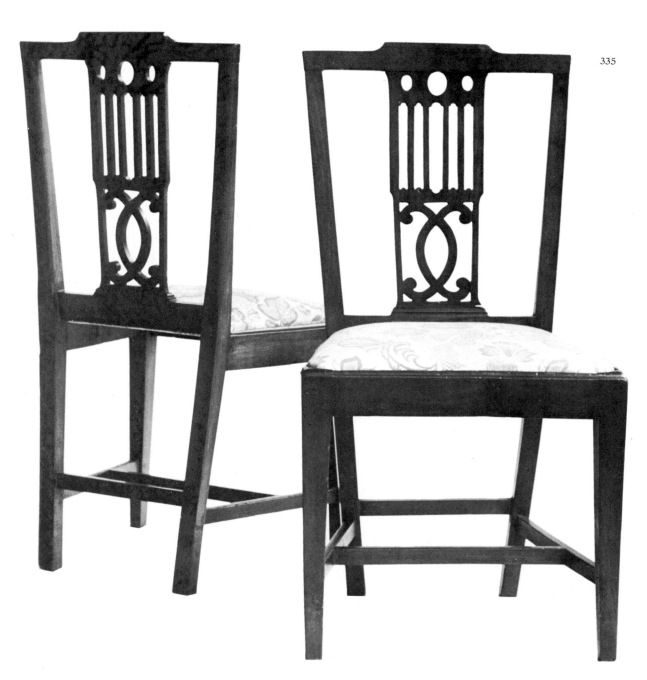

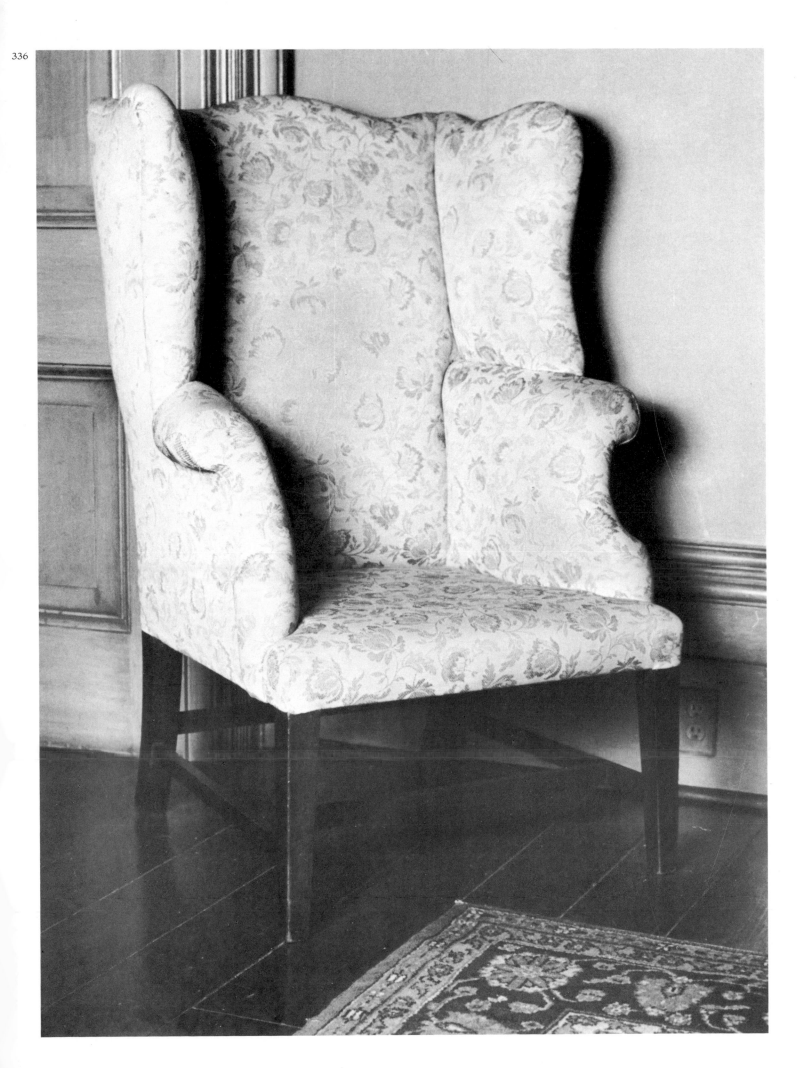

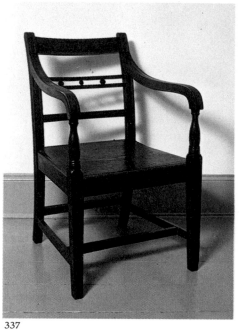

337

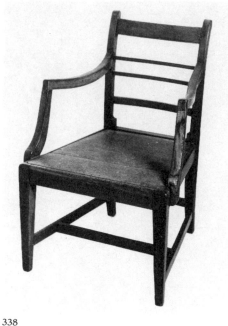

338

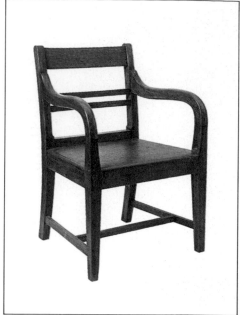

339

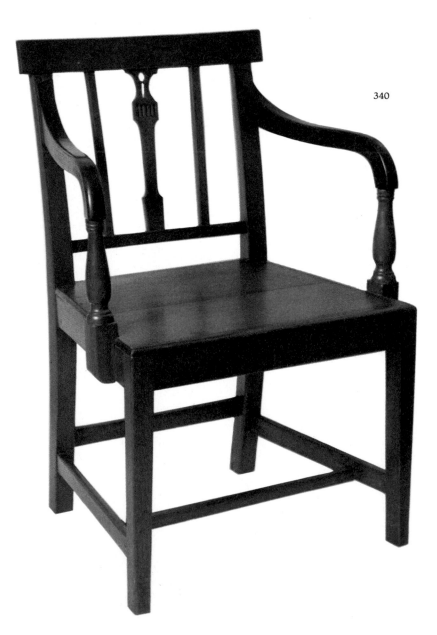

340

337 An armchair from Carleton Place in Lanark County. (Early family: Yuill.) The ball and reeded details in the chair back were popular elements in country expressions of the Neoclassical style, particularly in the north of England and Scotland. Second quarter 19th century. [P.C.]

338 An armchair from Lanark County. A simpler variation with beaded horizontal back elements. Second quarter 19th century. [P.C.]

339 An armchair from Lanark County. The continuous flow of the front leg into the arm is a concept which was favoured in 18th century Neoclassical designs. Second quarter 19th century. [P.C.]

340 An armchair from Perth in Lanark County. The beaded back spindles and stiles, carved splat and arm post turnings are Sheraton in character, while the heavy crest rail suggests a Regency influence. Second quarter 19th century. [P.C.]

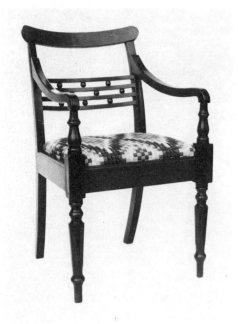

341

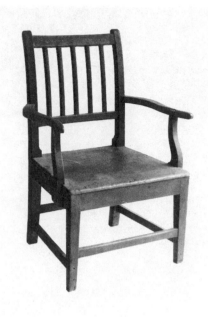

342

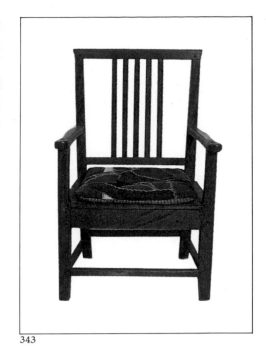

343

341 An armchair from the eastern counties. One of a pair, the slightly heavier turnings, hexagonal legs and applied crest rail are Regency characteristics. The upholstered seat and absence of stretchers in the base take these chairs out of the country category. Second quarter 19th century. [P.C.]

342 An armchair from near Lanark Village in Lanark County. Another 18th century arm design. The moulded detail just above the seat, where the leg reduces in thickness to allow a more delicate back, is typical of 18th century chair design. Second quarter 19th century. [P.C.]

343 An armchair made in Lanark County, attributed to Wallace Fallbrooke. This chair is larger than most in this group and achieves a Georgian character with a few simple details. Second quarter 19th century. [P.C.]

344 An armchair from the Ottawa Valley. The well-executed arms are more ambitious than most in this group of chairs, and this basic shape is found in many 18th century designs. The square back is typical country Sheraton. One of a pair of chairs. Second quarter 19th century. [P.C.]

344

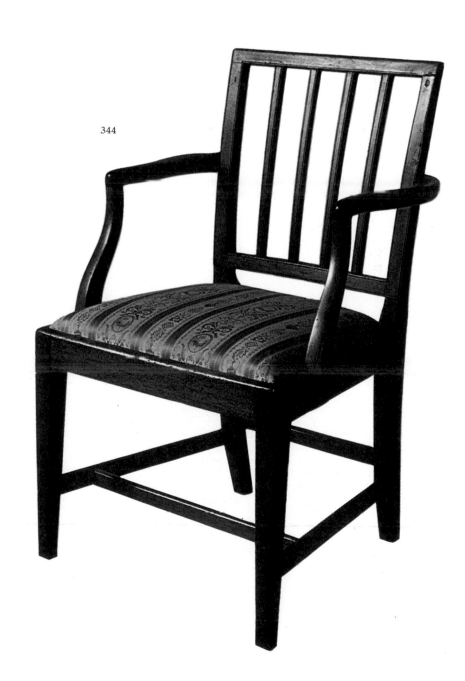

345 A side chair and armchair from Wellington County. From the same Scottish tradition as the Lanark examples, these chairs are of slightly heavier design and the broad back rail reflects early 19th century style. Second quarter 19th century. [P.C.]

346 A commode chair from Chippawa in the Niagara Peninsula. The Sheraton-style arm approaches sophistication while the rest of the design is sturdily country. The seat has been replaced. Second quarter 19th century. [P.C.]

347 A commode chair from Lanark County. This chair is a most unusual example of the Lanark group. The swayed back, button feet and arm design have a distinct Jacobean character. Second quarter 19th century. [P.C.]

348 A side chair from Carleton County. A Regency influence is evident in the horizontal organization of the back and the shaped centre rail. Second quarter 19th century. [P.C.]

349 A side chair from Woodstock in Oxford County. An unusually robust example of country Regency style. Second quarter 19th century. [P.C.]

350 A side chair from Battersea in Frontenac County. One of a set of four, this chair has little pretence to style other than the beading of the Sheraton-inspired back elements and the chamfered corners of the front legs. Second quarter 19th century. [P.C.]

351 An armchair and side chair from Sutton West in York County. Late 18th century influences in the design of the backs and arms are combined here with the simple straight leg of country Chippendale style. Second quarter 19th century. [P.C.]

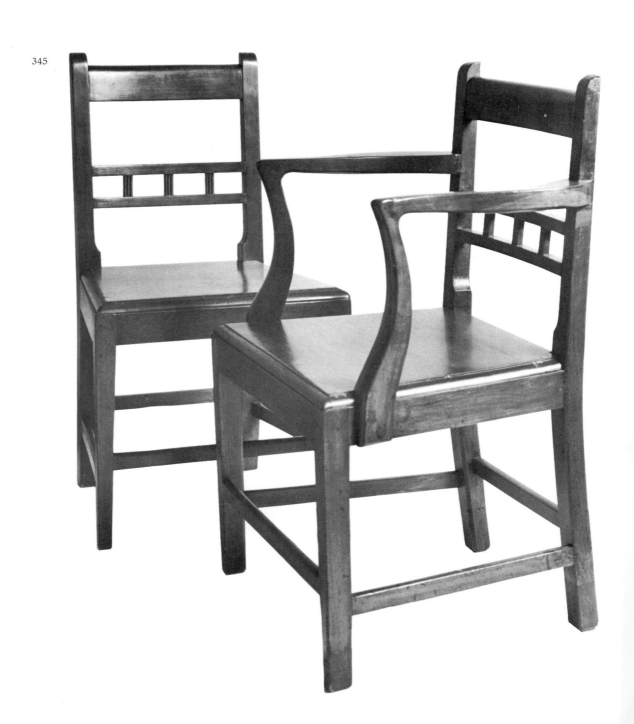

345

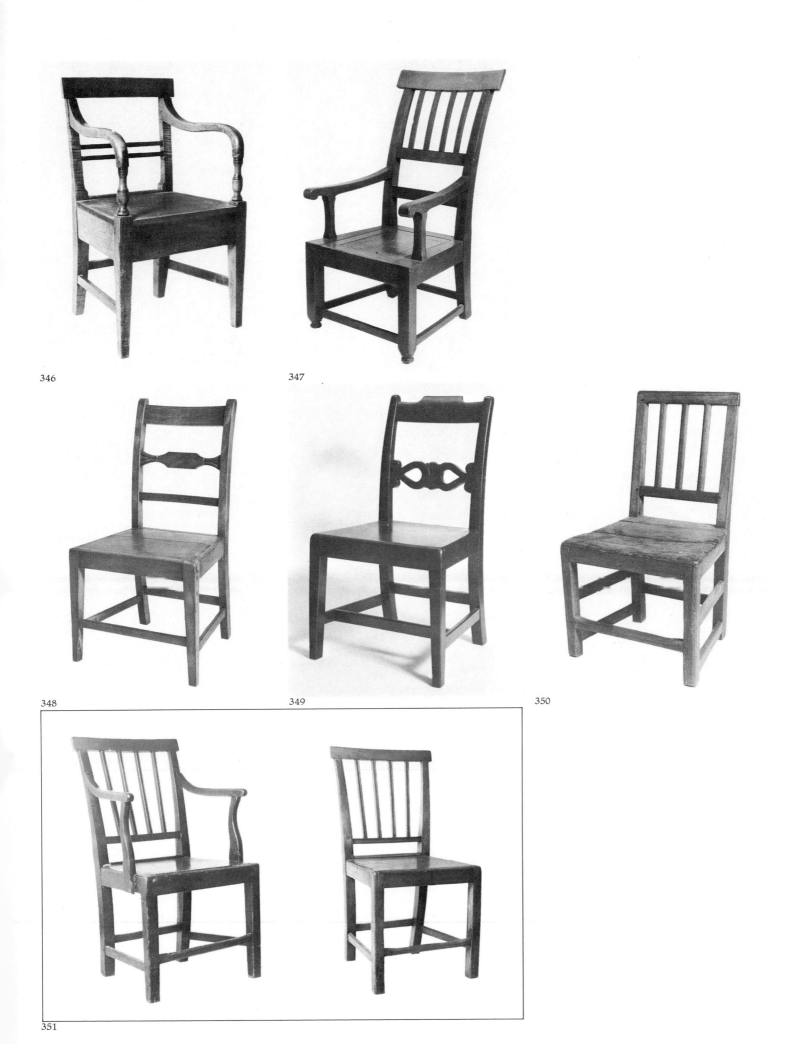

346

347

348

349

350

351

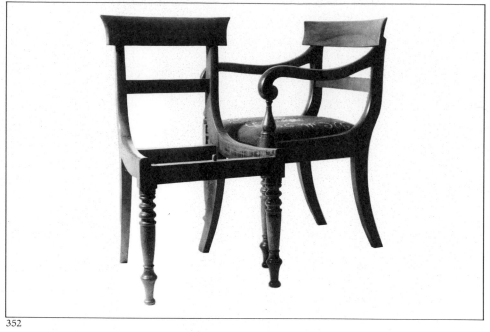

352

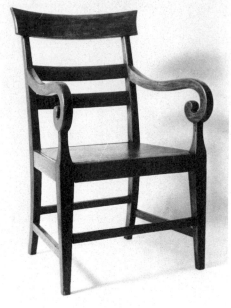

353

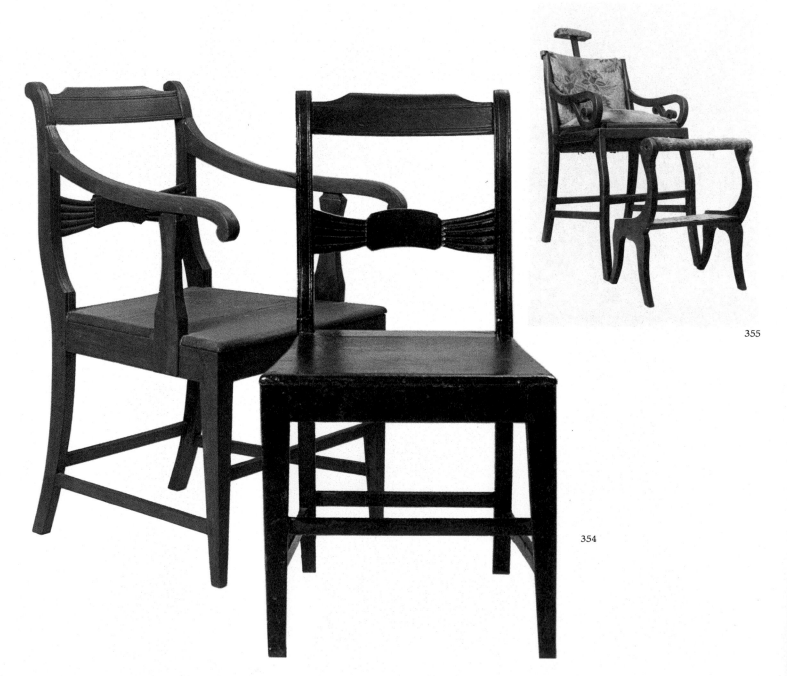

355

354

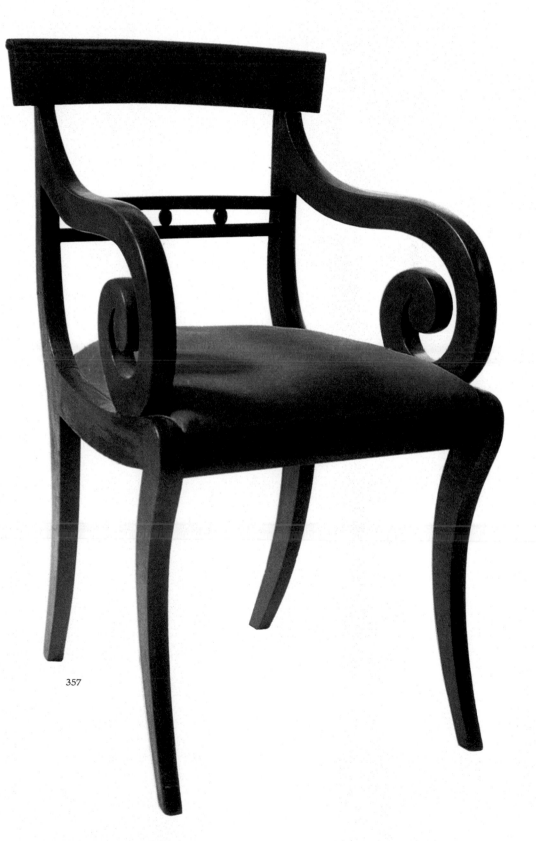

357

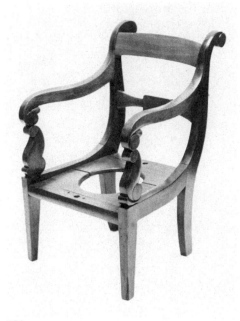

356

357 An armchair from Kingston in Frontenac County. Stamped, HATCH. This graceful Regency style was often called a Trafalgar or Waterloo chair and was quite popular in Upper Canada. Chester Hatch advertised Waterloo chairs as well as other styles as early as 1816 in the *Kingston Gazette*. First quarter 19th century. [P.C.]

352 A side chair and armchair from Perth in Lanark County. The use of turned front legs with the graceful *Klismos* rear legs and back was a popular British style in the early 19th century and was widely adopted in Upper Canada. Second quarter 19th century. [P.C.]

353 An armchair from Lanark County. The scrolled arm and wide back rail of the Regency style are combined with the typical Lanark form. Second quarter 19th century. [P.C.]

354 A side chair and armchair from Glengarry County, attributed to Alexander McEwen. The basic country form assumes a Regency character due to Grecian influences in the shaped back, scrolled arm and broad back rails. Second quarter 19th century. [P.C.]

355 A barber's chair and footrest from MacDonald's Corners in Lanark County. The sweeping curves of this locally made barber's chair and stool illustrate the wide popularity of the Classical styles. Second quarter 19th century. [P.C.]

356 A child's commode chair from Lincoln County in the Niagara Peninsula. Attributed to George Carlisle, this charming and stylish little chair is a very individual interpretation of the Regency style. The design of the single-piece front leg and arm is effective. Second quarter 19th century. [N.H.S.M.]

358 An armchair and side chair from Niagara. These chairs and the preceding example were based on a classical prototype, the Greek *Klismos* which had concave legs, front and rear, and a shallow concave back rest. Second quarter 19th century. [P.C.]

359 A side chair from Frontenac County. The marriage of the *Klismos* form with the Empire back, cane seat and stretchers resulted in design incongruities which, however, did not discourage its popularity. Figured maple was often used in better examples of the style. Second quarter 19th century. [P.C.]

360 A rocking chair from St. Catharines in the Niagara Peninsula. Stiffly Classical, these caned rockers provided competition, in some areas, for the universally popular Boston rocker. Third quarter 19th century. [P.C.]

361 A side chair from Hastings County. Occasionally the rich colour and pattern of figured maple was used as the decorative element in the fancy chair style in place of the typical painting and stencilling. This well-designed chair includes the slightly flared front legs which often distinguish good early examples. First quarter 19th century. [P.C.]

362 A side chair from Lennox and Addington County. The Classical Grecian form with its Empire additions was cleverly designed as a series of components so that endless variations were possible by changing one or two elements. Manufacturing efficiency had become an important criteria of furniture design. Third quarter 19th century. [L. & A.C.M.]

363 A side chair from Lennox and Addington County. This pleasingly decorated chair is also typical of thousands produced in local factories. The simple *Klismos* shape introduces yet another variation to the broad "fancy" category. Third quarter 19th century. [P.C.]

364 A side chair from Dundas in Wentworth County. The sculptured quality in the back of this example of the popular style suggests the hand of a talented individual craftsman rather than a production approach. The Gothic motif in the design was another dimension of Victorian style. Third quarter 19th century. [P.C.]

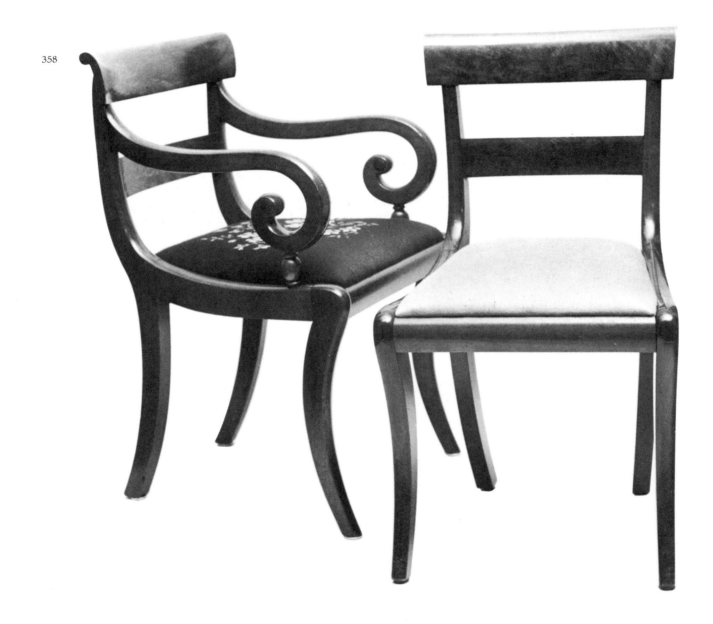

358

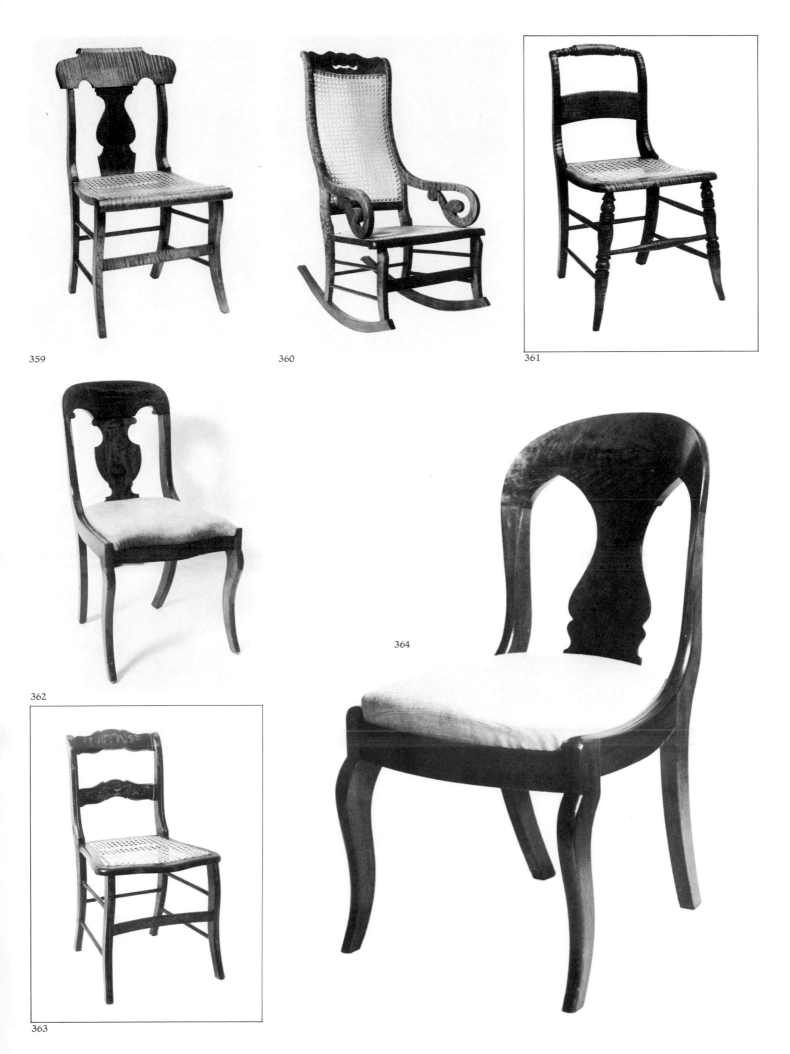

359

360

361

362

363

364

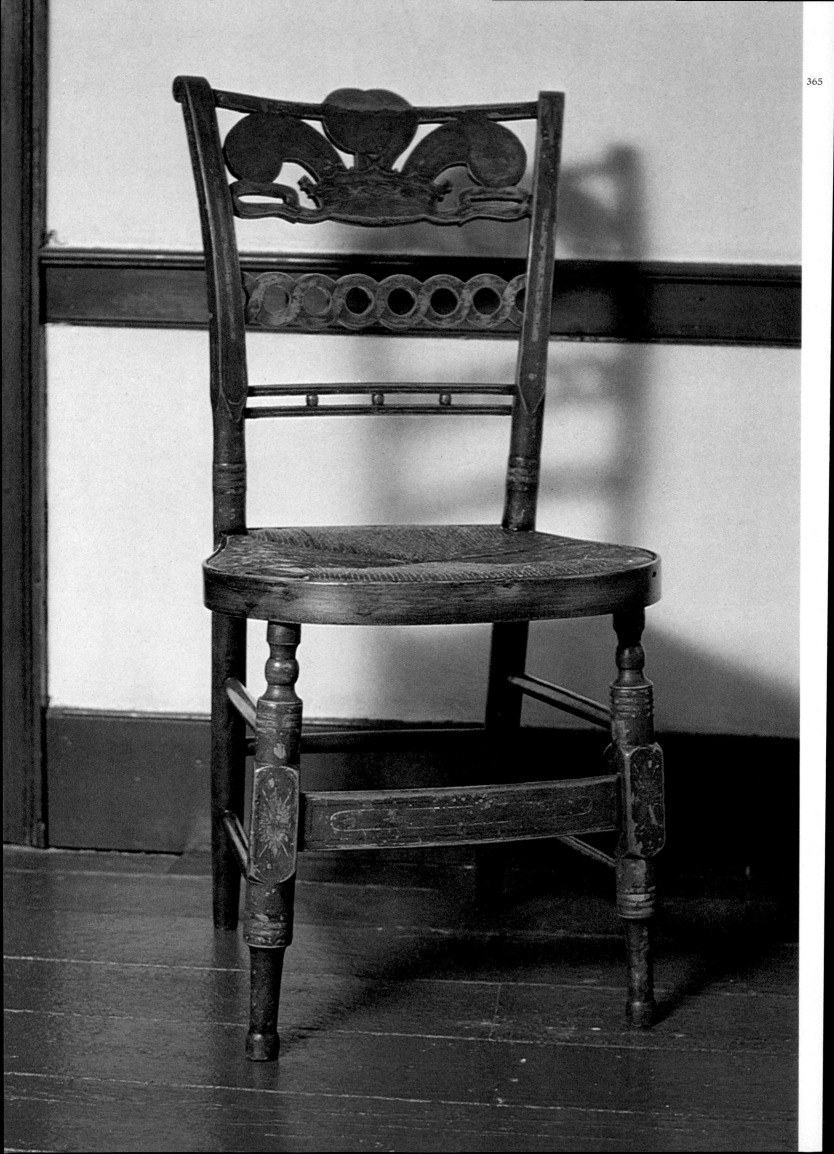

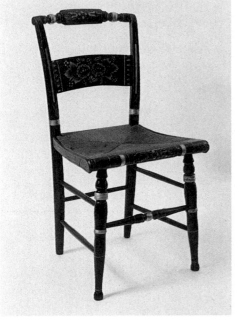

366

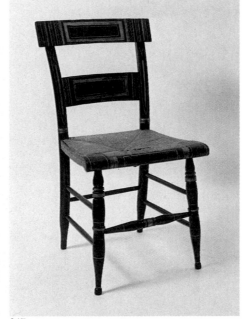

367

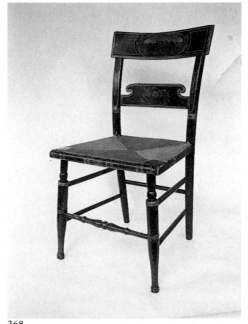

368

365 A side chair from Belleville in Hastings County. One of a set of six, this chair retains its original hand painted decoration and is an exceptionally fine example of the American fancy chair as it developed from the influence of Sheraton's elegant designs. The Prince of Wales feather motif was a favourite in the late 18th and early 19th century, as were the guilloche and bead. First quarter 19th century. [U.C.V.]

366 A side chair from Lennox and Addington County. This popular style is often called Hitchcock, since a Connecticut maker by that name made and marked great quantities of this pleasing form. Second quarter 19th century. [L. & A.C.M.]

367 A side chair from Lennox and Addington County. For those who could not afford the elaborately decorated products, a great variety of simple decorative concepts were devised which could be quickly done with limited skills. Second quarter 19th century. [L. & A.C.M.]

368 A side chair from Cobourg in Northumberland County. One of a set of four, the design of this chair includes characteristics of the Empire style in the shaped splat and broad crest rail. The typical romantic landscape and floral paintings were the work of a competent artist. Interestingly and possibly coincidentally, it is known that the noted Canadian painter, Paul Kane, had some association with an early chair-making family in Cobourg. Second quarter 19th century. [P.C.]

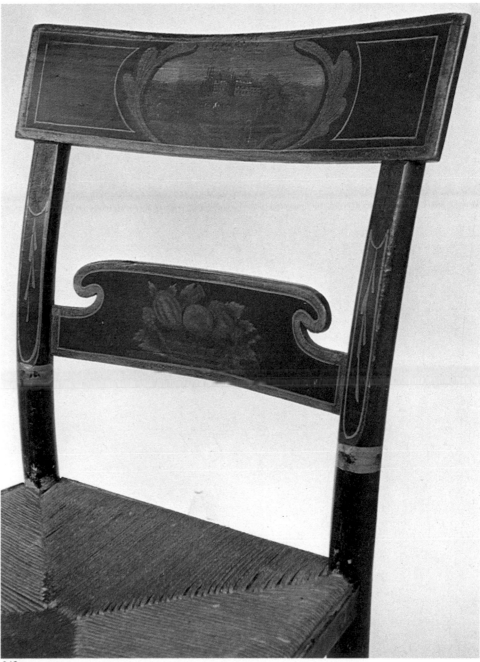

368a

369 An armchair from the eastern counties. The rolled crest rail and deeply scrolled arms are style elements which became popular early in the 19th century. The multi-coloured stencilled cornucopia was a favourite motif in the American fancy chair style. First quarter 19th century. [P.C.]

370 An armchair from Toronto. There were many variations and combinations of similar design elements in the great quantity of fancy chairs made between 1810 and 1850. The rolled crest rail, rounded rush seat and flat front stretcher indicate an early date of manufacture. First quarter 19th century. [P.C.]

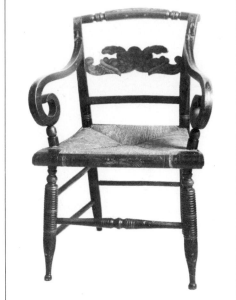

369

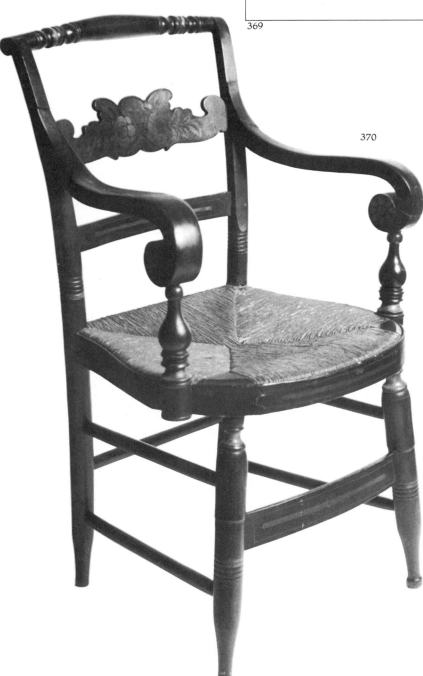

370

371 A side chair from Prince Edward County. The urn-shaped back splat and scrolled crest rail are Empire influences married to a late Windsor form, including bamboo detailed legs. Second quarter 19th century. [P.C.]

372 A side chair from Kingston in Frontenac County. Stamped, HATCH. There is no indication that this locally made chair was decorated, although Chester Hatch advertised "All kinds of Ornamental Painting, gilding and varnishing" as early as 1815. In style, this example is typical of the fancy chairs of the 1850s. Second quarter 19th century. [P.C.]

373 A side chair from Peterborough. (Signed, *J. K. Paterson – Peterborough – 1857*.) This hybrid style was painted and grained to simulate figured maple and striped to achieve a very fancy effect. 1857. [P.C.]

374 A side chair from Cobourg in Northumberland County. (The chair is signed *Clench Factory – Coburg [sic]*, a company listed in *The Mercantile Agency Reference Book (And Key) For the Dominion of Canada, January 1875*, under the heading of "Cabinetmakers.") The design is typical of the mid-century product of chair factories in towns in all parts of the province. It has an obvious stylistic relationship with the American fancy chair family. Third quarter 19th century. [P.C.]

375 A side chair from Cobourg in Northumberland County. (Signed, *G. Stephens – Coburg [sic]*; listed in the 1875 directory as "Cabinetmakers".) This design is contemporary with the previous example, but includes the shaped splat of the Empire styles. Third quarter 19th century. [P.C.]

376 A side chair from Ernestown in Lennox and Addington County. (Early Loyalist family: Peter Amey.) One of a set of six, example of the Sheraton-inspired style assumes a stoutly provincial character as a result of the square rush seat and the dark varnish which was applied at an early date over the original pale cream colour. Second quarter 19th century. [P.C.]

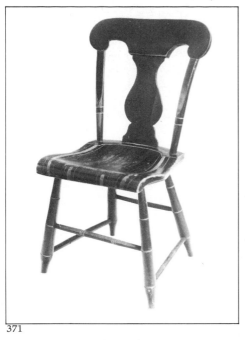

371

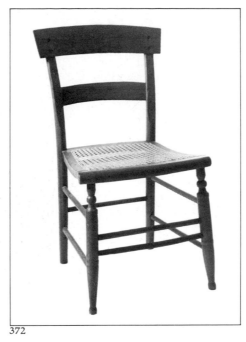

372

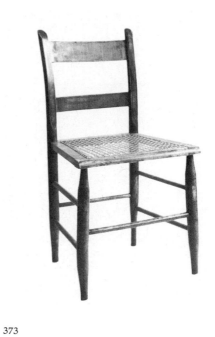

373

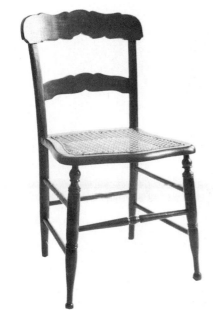

374

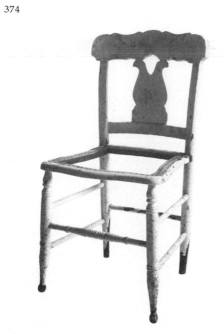

375

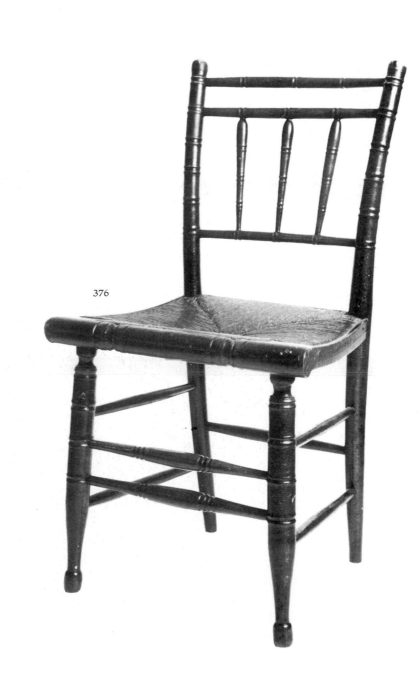

376

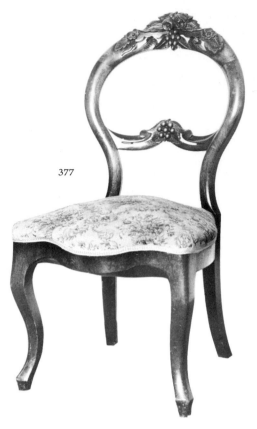

377

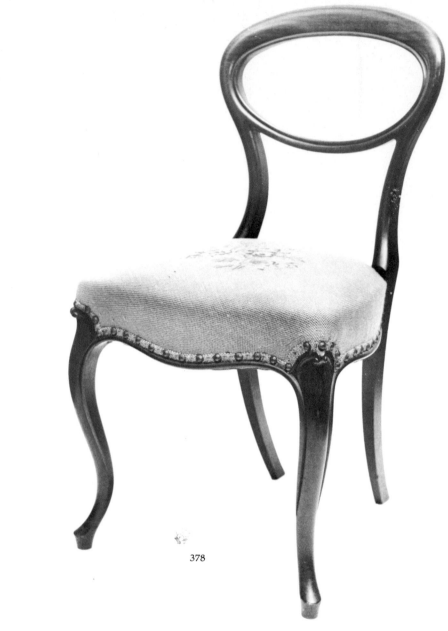

378

377 A Rococo revival side chair from Picton in Prince Edward County. (Early family: McCuaig.) This stylish chair was probably made in the immediate area in a shop equipped with relatively sophisticated mechanical tools. Mid-19th century. [P.C.]

378 A Rococo revival side chair from Woodstock in Oxford County. (Attributed to Alexander White, joiner.) One of six, this elegant example of Victorian style illustrates the high standard of individual craftsmanship that survived in the face of mechanized production at the mid-century. Second quarter 19th century. [P.C.]

379 A rocking chair from Scugog Island in Ontario County. This and other related chairs are attributed locally to a maker named Dunn. This is possibly a unique design. It is related to the popular Boston rocker in the form of the understructure, rolled seat, rounded crest rail and Empire-influenced, urn-shaped splat. Third quarter 19th century. [P.C.]

380 A side chair from Scugog Island in Ontario County. Side chairs of this style are attributed to Mr. Dunn, as is the preceding rocker. Similar Empire influence was incorporated here in an unusually sturdy and well-crafted kitchen chair. Third quarter 19th century. [P.C.]

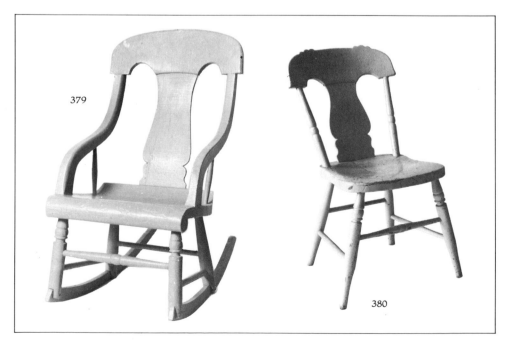

379

380

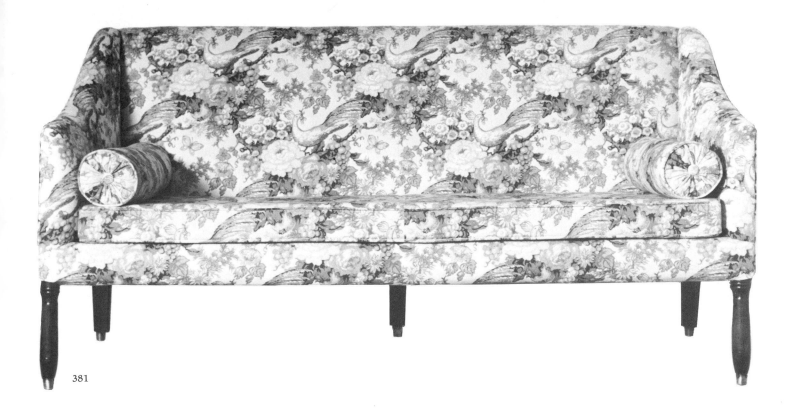

381

381 A sofa from Prescott in Grenville County. From the home of Rev. Robert Blakey, first rector of the Anglican Church at Augusta. The chest of drawers in Plate 634 is from the same home. The handsome design is a provincial interpretation of the popular Sheraton sofa. Second quarter 19th century. [P.C.]

382 A sofa from Kingston. Examples of this Sheraton style are rare in Upper Canada, because the later Neoclassical forms were introduced early in the 19th century. This design is soundly 18th century in form, but the heavy Empire character of the turned leg and arm elements suggests a date of manufacture as late as 1840. Second quarter 19th century. [P.C.]

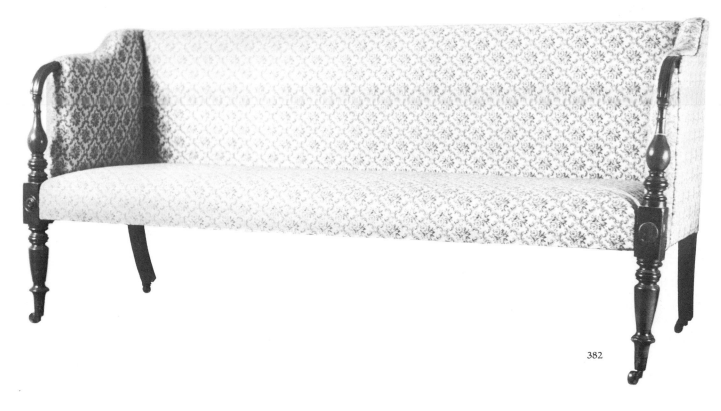

382

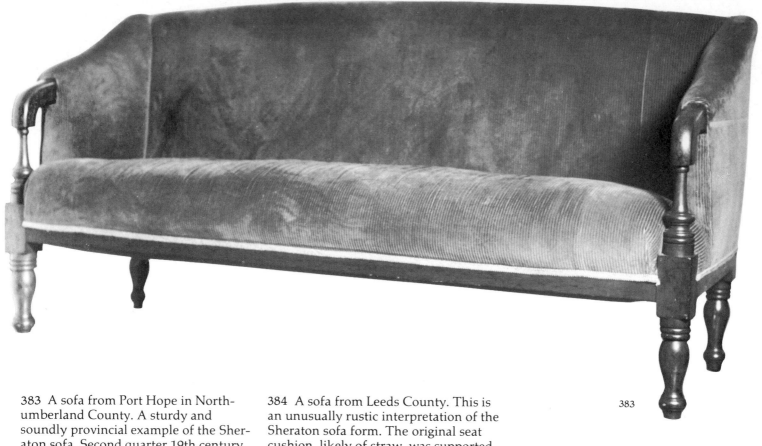

383 A sofa from Port Hope in Northumberland County. A sturdy and soundly provincial example of the Sheraton sofa. Second quarter 19th century. [P.C.]

384 A sofa from Leeds County. This is an unusually rustic interpretation of the Sheraton sofa form. The original seat cushion, likely of straw, was supported on rope as in British settles of the late 18th and early 19th century. Second quarter 19th century. [P.C.]

383

384

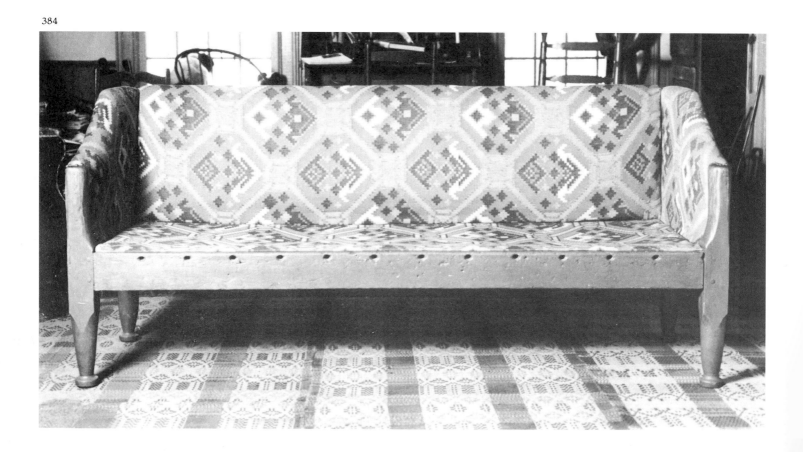

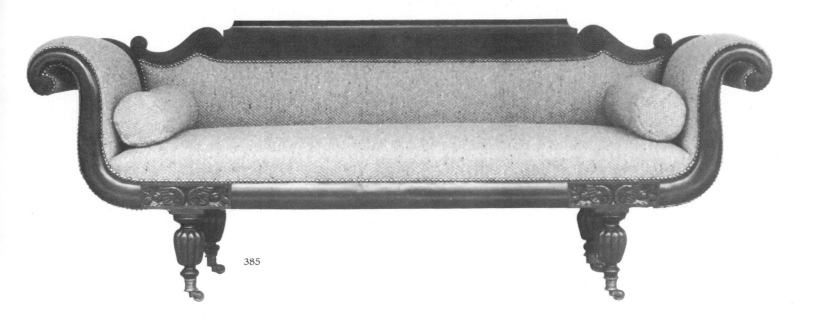

385

385 A sofa from Ontario County. This is a fine graceful late Neoclassical design. The slender rolled arm, carved Classical decoration and shaping of the legs are seen in Regency designs, particularly those illustrated by the Nicholsons in *The Cabinet Maker, Upholsterer and Complete Decorator* in 1826. Second quarter 19th century. [P.C.]

386 A sofa from Kemptville in Grenville County. Simple when compared to the exotically carved examples of the American Empire sofa imported from stylish centres south of the border, or those of the Regency style from Britain. The spiral-reeded legs and diagonal-reeded inserts were favoured details in Upper Canada. Second quarter 19th century. [P.C]

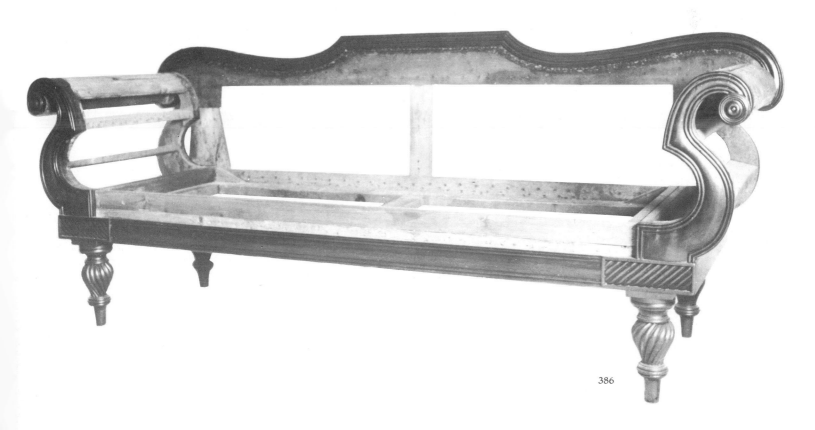

386

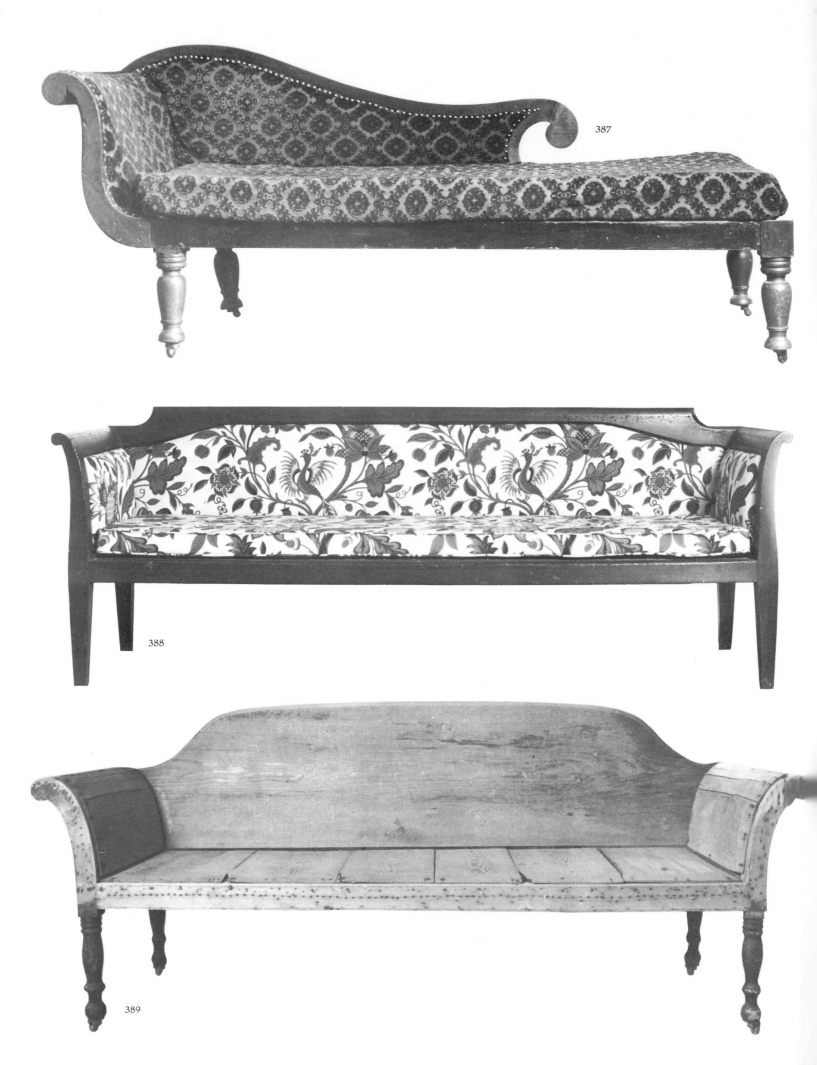

387

388

389

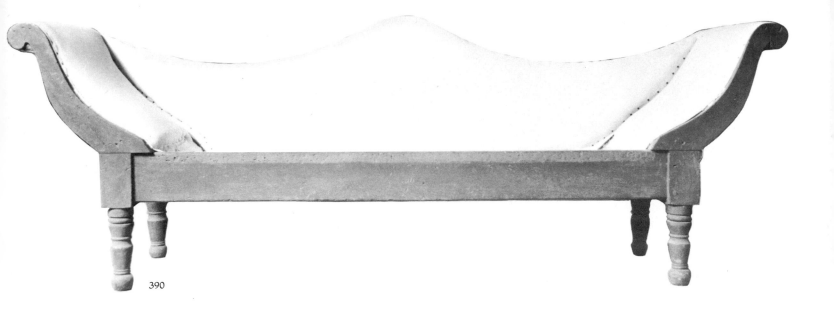

390

387 A couch or lounge from the western counties. Based on Grecian prototypes, this form was popular in the stylish Regency parlours in England, as well as those of Empire style in America. In this country version, of sound basic design, the Neoclassical decoration of stylish examples is typically ignored. Second quarter 19th century. [P.C.]

388 A sofa from Niagara-on-the-Lake in Lincoln County. This provincial design also reflects the styles of the Sheraton period in the lightness and the integration of the elements, with later Neoclassical influence apparent in the scrolled shaping of the arm. First quarter 19th century. [P.C.]

389 A sofa from Hastings County. The straightforward construction of this country design is clearly seen, during restoration, with the straw stuffing and upholstery removed. In style, it is a hybrid of Sheraton and later Grecian style, expressed with admirable simplicity. First quarter 19th century. [P.C.]

390 A sofa from Tillsonburg in Oxford County. Attributed to a maker known locally as "Long Coffin" Tom Warden. This naïve design of considerable charm successfully weds an 18th century camel back with exaggerated arms of the universal Grecian influence. Second quarter 19th century. [P.C.]

391 A sofa from Oshawa in Ontario County. Variations on the Neoclassical theme were numerous. This example, which includes the universal scrolled arm, owes much to the newly acquired band-saw in the elaboration of the Classical sabre leg and the sweeping curves of its Rococo-influenced backboard. Mid-19th century. [P.C.]

391

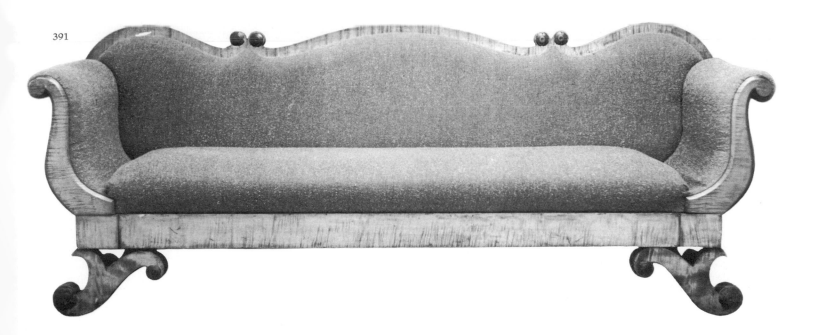

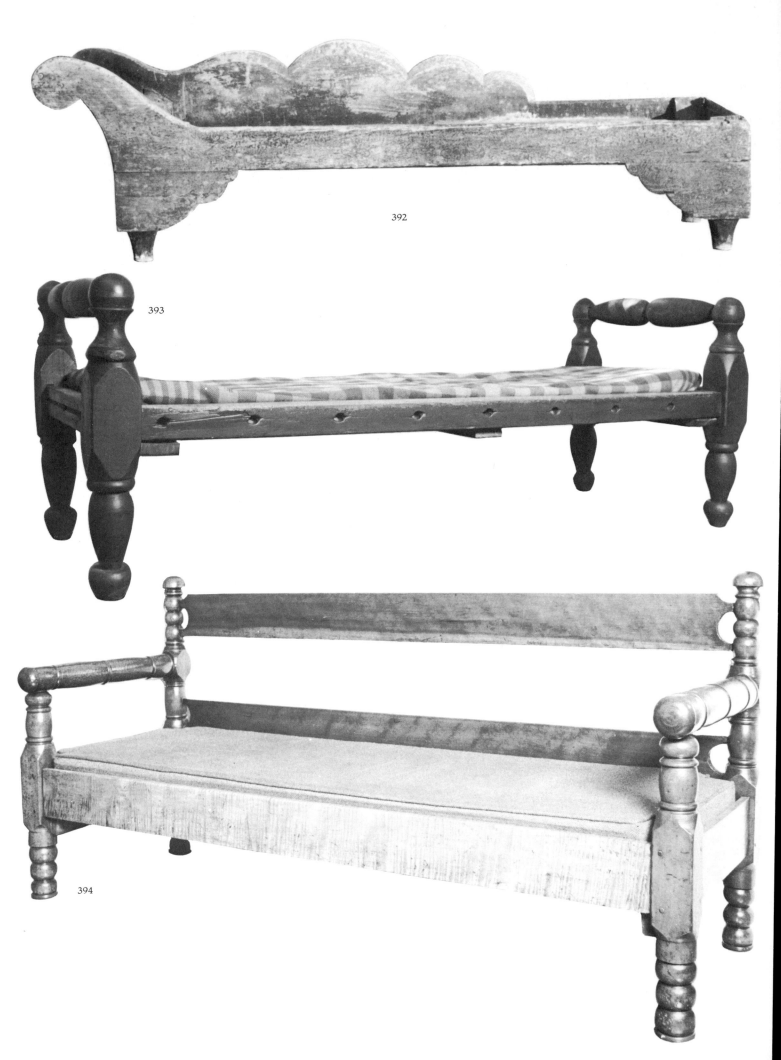

392

393

394

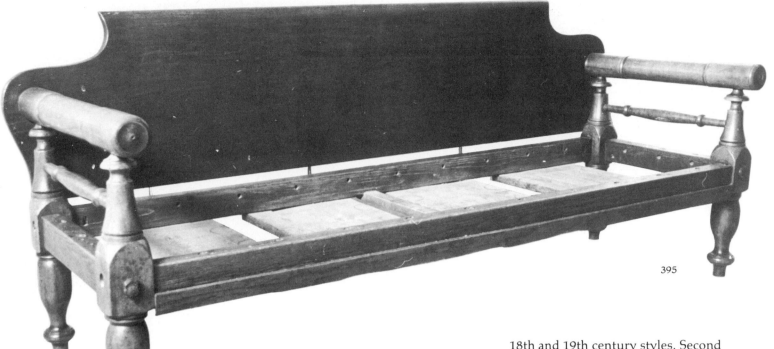

395

392 A couch or lounge from Halton County. The elegant Neoclassical lounge form inspired many simply crafted kitchen couches. Second quarter 19th century. [P.C.]

393 A couch from Lanark County. In his 1833 *Encyclopedia of Cottage, Farm and Villa Architecture and Furniture*, John Loudon illustrated a bench of this form, recommended for porch or hall use. The very individual character of the turnings in this Lanark example produces a well-integrated design which is superior to the prototype. Second quarter 19th century. [P.C.]

394 A settee from Middlesex County. The bed-like bench in the previous illustration is the basis for a wide variety of settees, settles or country couches which were very popular in Upper Canada. Most of these have backs which relate them to the British low-back settle which was made in the 18th and 19th century styles. Second quarter 19th century. [P.C.]

395 A settee from Peterborough County. This and other related examples are attributed to a maker named Hutchinson. Here, the simply shaped backboard produces a form strongly reminiscent of the panelled-back British settles, many of which also used rope to support the seat mattress. Second quarter 19th century. [P.C.]

396 A settee from the eastern counties. A complex backboard is reflected in the design of turned spindles in the arms. Second quarter 19th century. [U.C.V.]

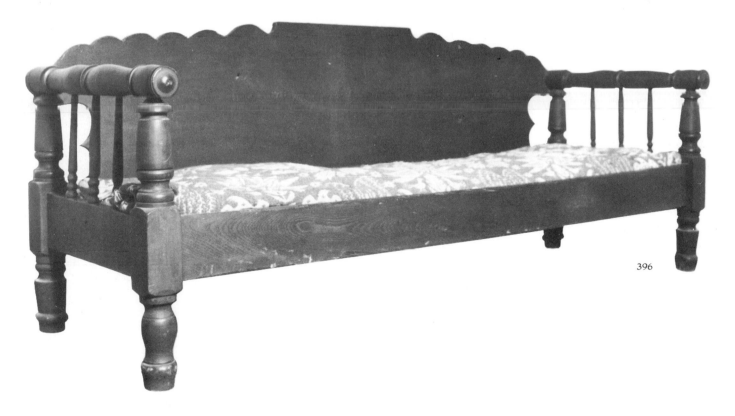

396

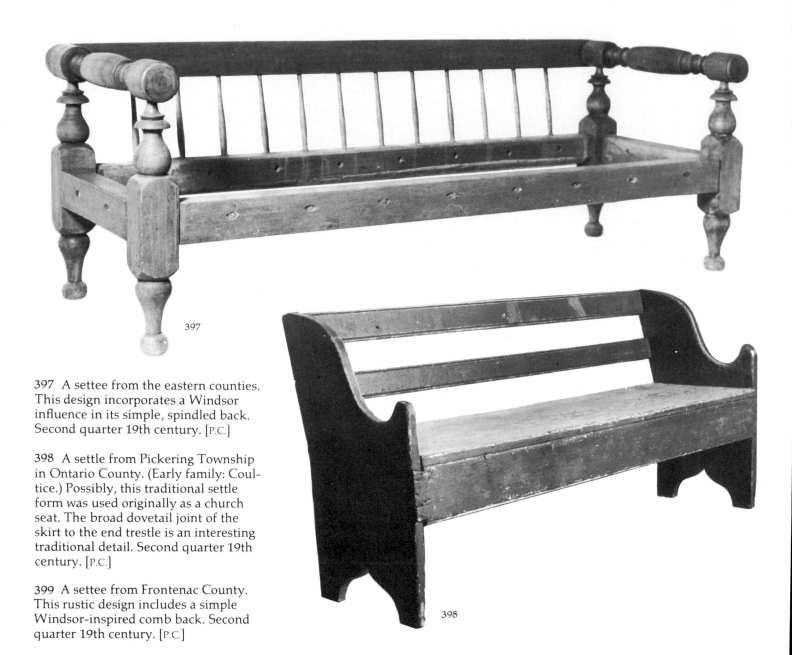

397 A settee from the eastern counties.
This design incorporates a Windsor
influence in its simple, spindled back.
Second quarter 19th century. [P.C.]

398 A settle from Pickering Township
in Ontario County. (Early family: Coul-
tice.) Possibly, this traditional settle
form was used originally as a church
seat. The broad dovetail joint of the
skirt to the end trestle is an interesting
traditional detail. Second quarter 19th
century. [P.C.]

399 A settee from Frontenac County.
This rustic design includes a simple
Windsor-inspired comb back. Second
quarter 19th century. [P.C.]

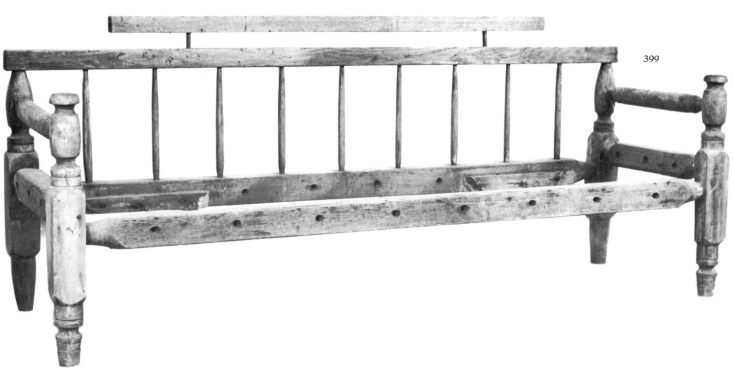

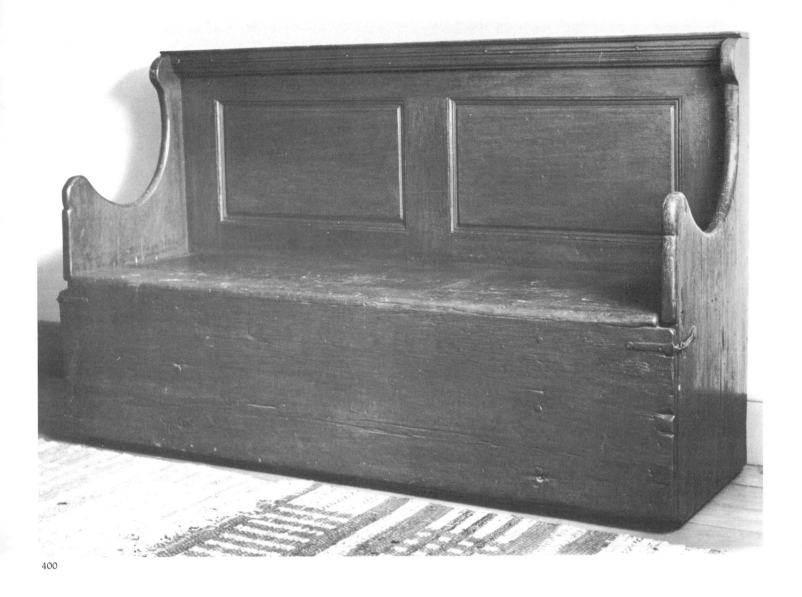

400

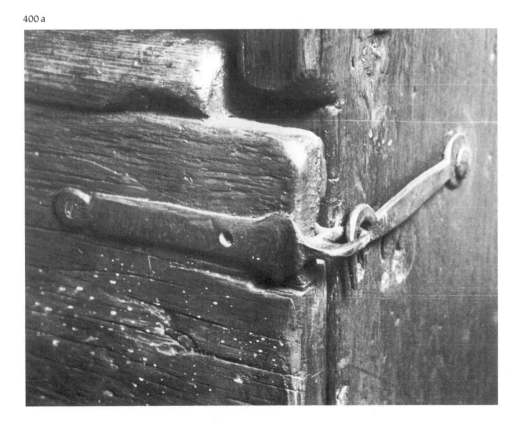

400 a

400 A settle-bed from Lanark County. As has been mentioned earlier, the settle-bed came to Upper Canada from the Irish tradition, but was likely taken into the Scottish tradition as well. This fine example combines the panelled style of the traditional British settle with the seat which drops forward to make a box-like bed. The forged-iron hardware is noteworthy. First quarter 19th century. [P.C.]

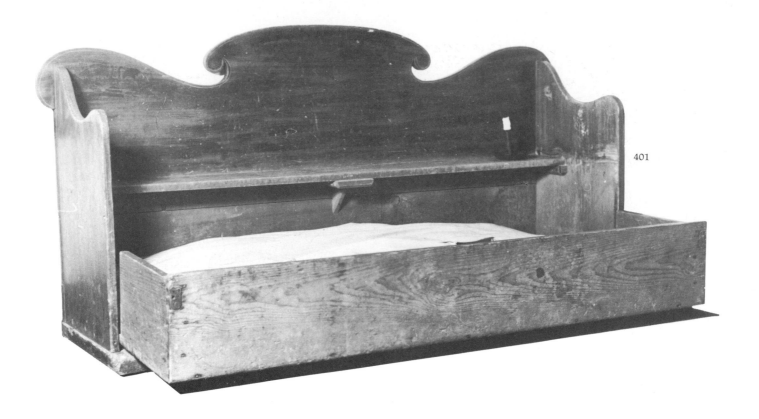

401

401 A settle-bed from Glengarry County. This functional design provides a narrow shelf for the candle, etc., when the seat is put down to form the bed. A strong Empire influence is seen in the shaped backboard and in the stencilled and linear decoration. Second quarter 19th century. [U.C.V.]

402 A settle-bed from Lanark County. This structure is almost Gothic in character as a result of the unusual thickness of the single boards from which the simple elements are formed. The scroll of the backboard suggests an Empire influence. Second quarter 19th century. [P.C.]

402

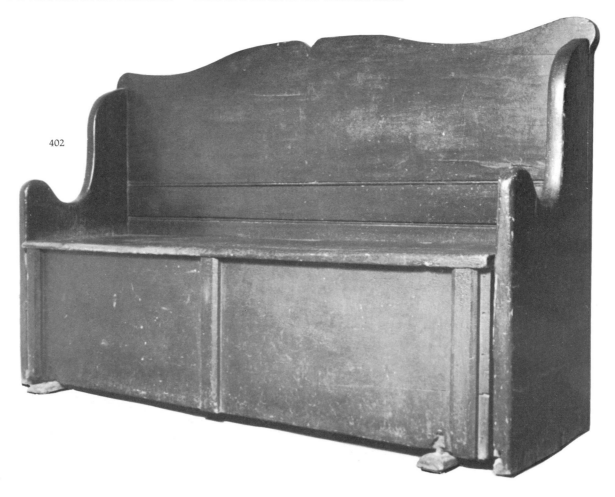

403

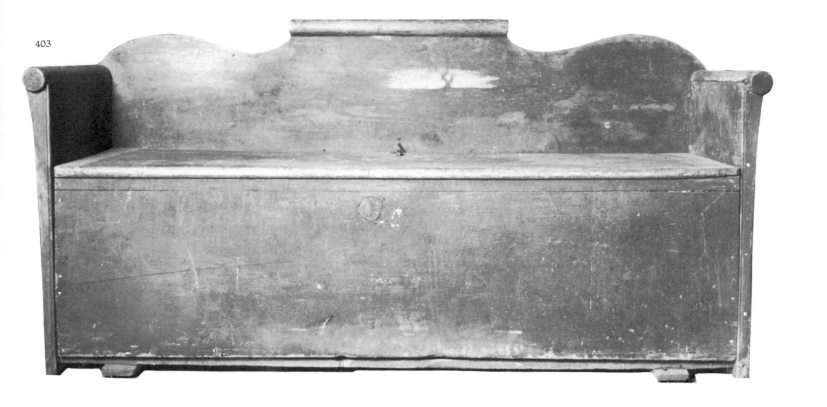

403 A settle-bed from Caledon in Peel County. This form is rarely found in the western counties. Of simple construction, this design incorporates influence from contemporary bed design in the graceful shaping of the backboard and the roll element in the back and the subtly shaped arms. Second quarter 19th century. [P.C.]

404 A settle-bed from Renfrew County. Of framed and panelled construction, this design of sturdy traditional character sits on a shoe foot which was widely used in Scotland and Ireland to raise furnishings from the damp floors. Second quarter 19th century. [P.C.]

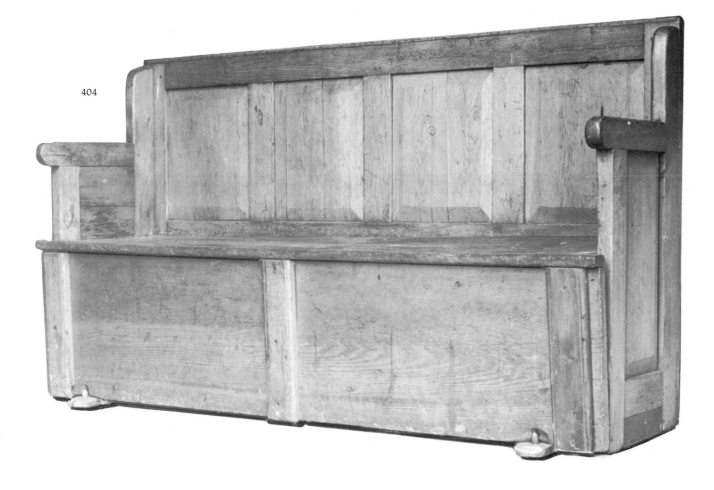

404

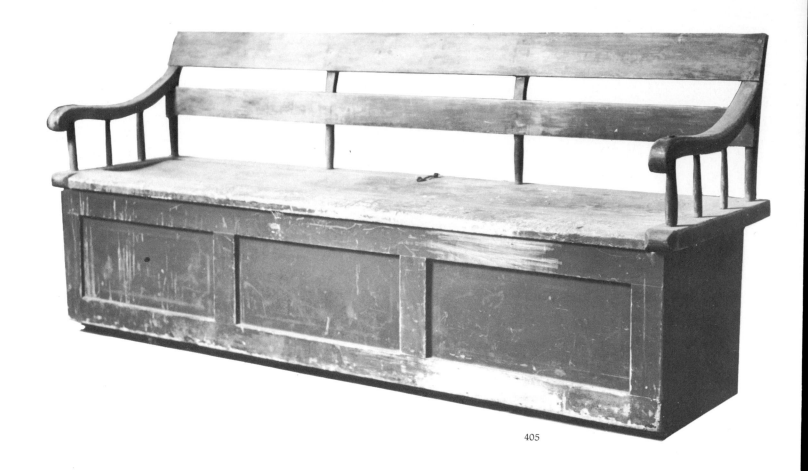

405

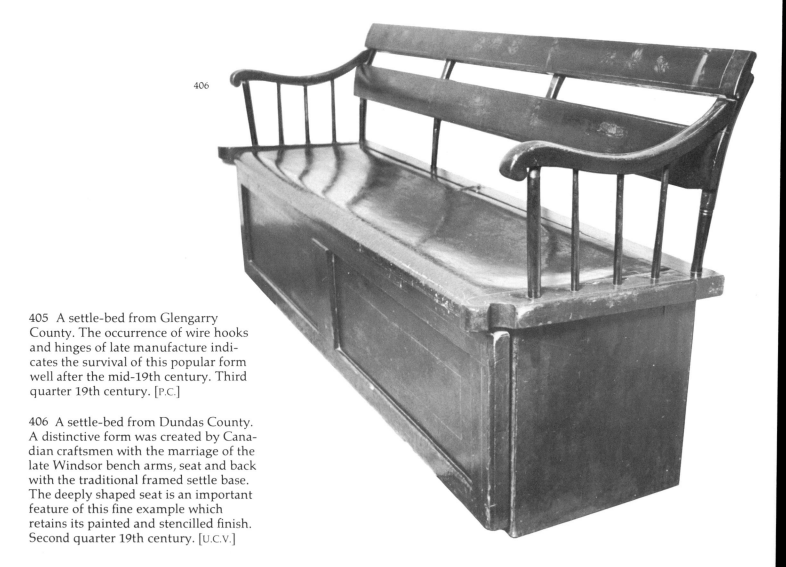

406

405 A settle-bed from Glengarry County. The occurrence of wire hooks and hinges of late manufacture indicates the survival of this popular form well after the mid-19th century. Third quarter 19th century. [P.C.]

406 A settle-bed from Dundas County. A distinctive form was created by Canadian craftsmen with the marriage of the late Windsor bench arms, seat and back with the traditional framed settle base. The deeply shaped seat is an important feature of this fine example which retains its painted and stencilled finish. Second quarter 19th century. [U.C.V.]

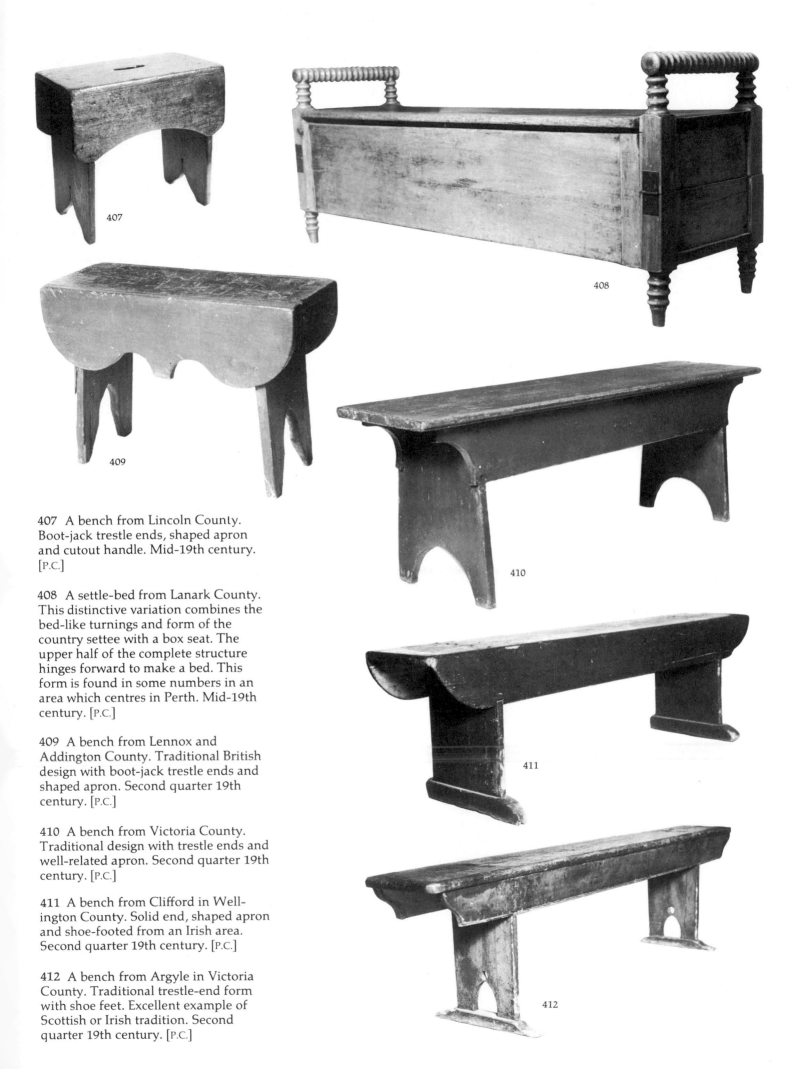

407 A bench from Lincoln County. Boot-jack trestle ends, shaped apron and cutout handle. Mid-19th century. [P.C.]

408 A settle-bed from Lanark County. This distinctive variation combines the bed-like turnings and form of the country settee with a box seat. The upper half of the complete structure hinges forward to make a bed. This form is found in some numbers in an area which centres in Perth. Mid-19th century. [P.C.]

409 A bench from Lennox and Addington County. Traditional British design with boot-jack trestle ends and shaped apron. Second quarter 19th century. [P.C.]

410 A bench from Victoria County. Traditional design with trestle ends and well-related apron. Second quarter 19th century. [P.C.]

411 A bench from Clifford in Wellington County. Solid end, shaped apron and shoe-footed from an Irish area. Second quarter 19th century. [P.C.]

412 A bench from Argyle in Victoria County. Traditional trestle-end form with shoe feet. Excellent example of Scottish or Irish tradition. Second quarter 19th century. [P.C.]

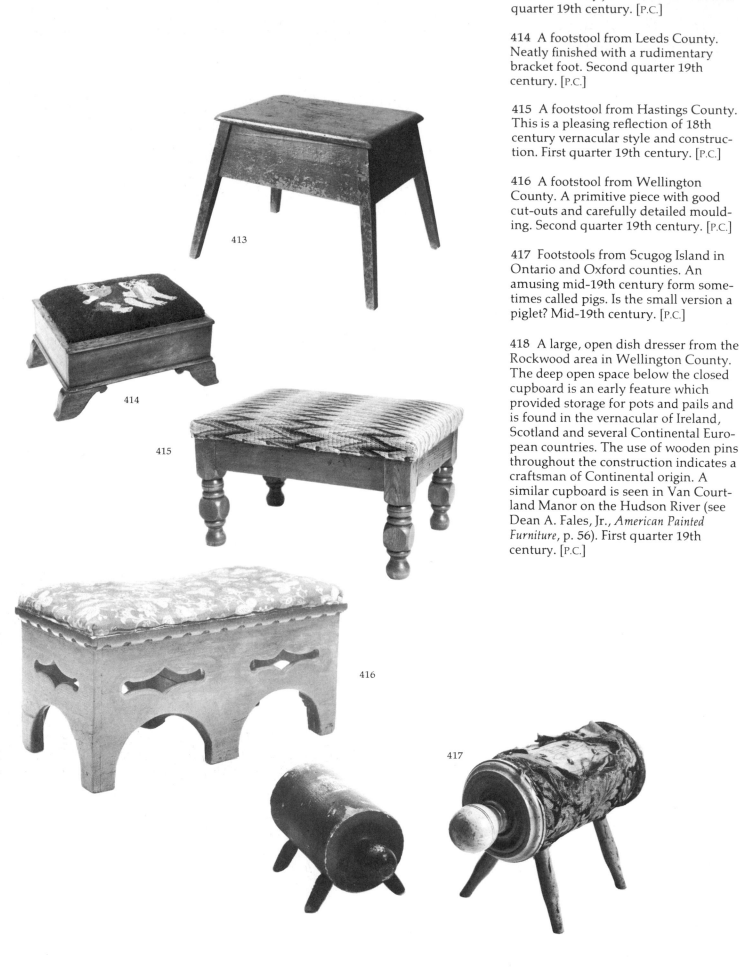

413 A footstool from Prince Edward County. This splayed-leg form of mortise and tenon construction is reminiscent of early jointed stands. Second quarter 19th century. [P.C.]

414 A footstool from Leeds County. Neatly finished with a rudimentary bracket foot. Second quarter 19th century. [P.C.]

415 A footstool from Hastings County. This is a pleasing reflection of 18th century vernacular style and construction. First quarter 19th century. [P.C.]

416 A footstool from Wellington County. A primitive piece with good cut-outs and carefully detailed moulding. Second quarter 19th century. [P.C.]

417 Footstools from Scugog Island in Ontario and Oxford counties. An amusing mid-19th century form sometimes called pigs. Is the small version a piglet? Mid-19th century. [P.C.]

418 A large, open dish dresser from the Rockwood area in Wellington County. The deep open space below the closed cupboard is an early feature which provided storage for pots and pails and is found in the vernacular of Ireland, Scotland and several Continental European countries. The use of wooden pins throughout the construction indicates a craftsman of Continental origin. A similar cupboard is seen in Van Courtland Manor on the Hudson River (see Dean A. Fales, Jr., *American Painted Furniture*, p. 56). First quarter 19th century. [P.C.]

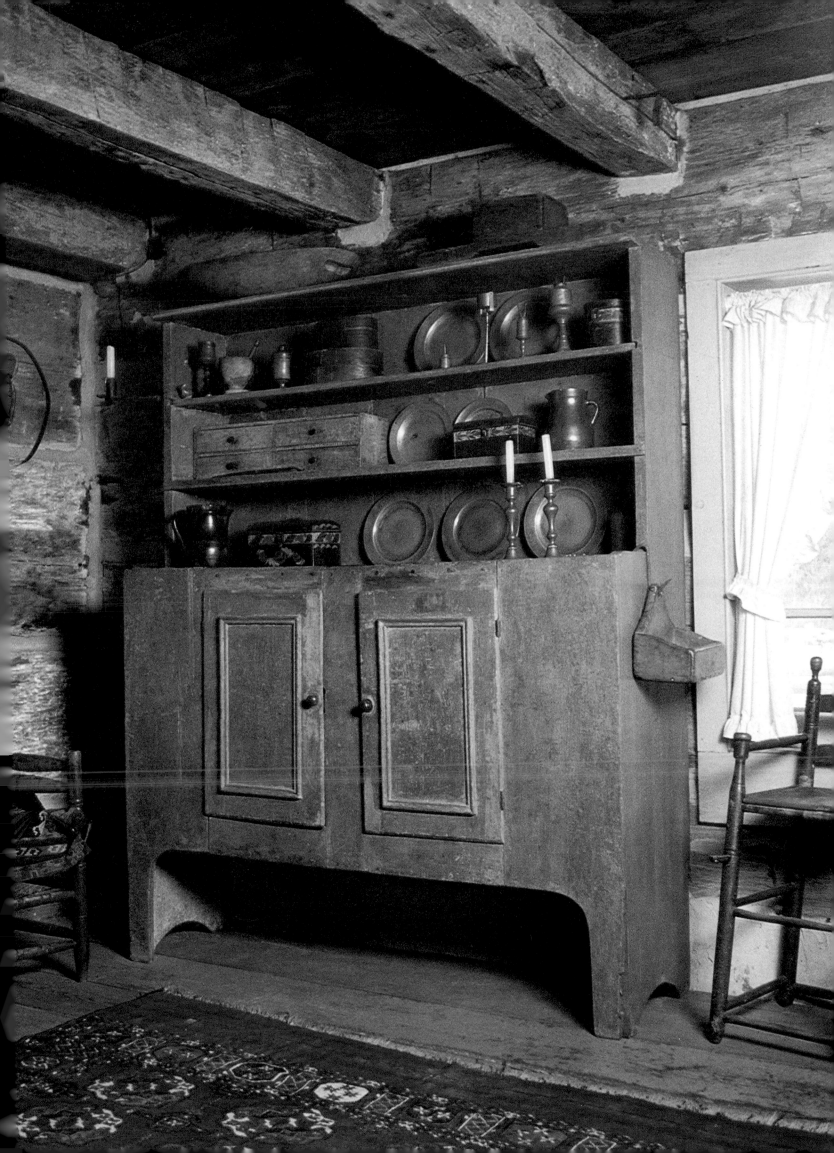

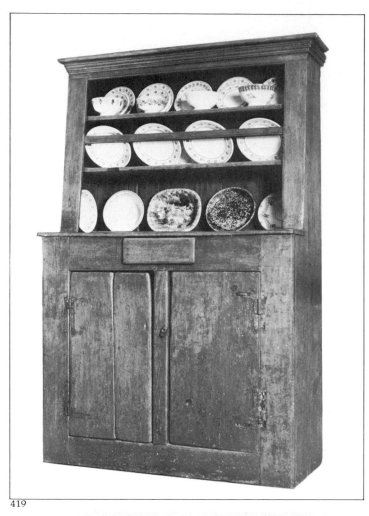

419

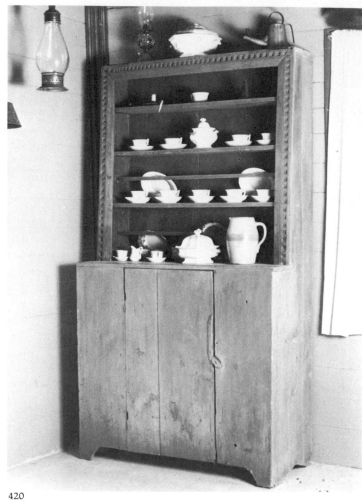

420

419 An open dish dresser from Montague Township in Lanark County. The canting of the upper dish rack section is an early feature often seen on 18th century New England cupboards, and the scars of early "HL" hinges are visible. First quarter 19th century. [P.C.]

420 A small, open dish dresser from Frontenac County. This cupboard also has the canted dish rack. It is of primitive construction with vigorous chip-carved, dentil detail in the facia board. First half 19th century. [P.C.]

421 An open dish dresser from Westport in Leeds County. The maker of this large cupboard was not likely trained in the making of vernacular furnishings. The workmanship and detail are unusually refined and meticulous, and the overall impression is one of formality. Second quarter 19th century. [P.C.]

421

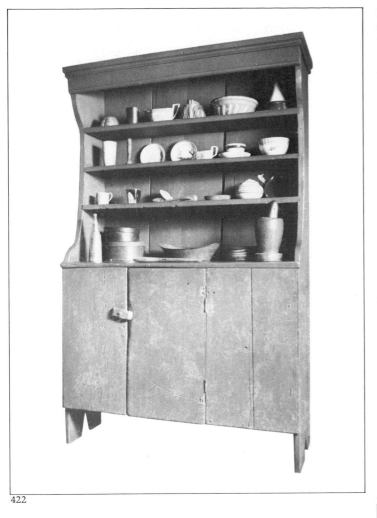

422

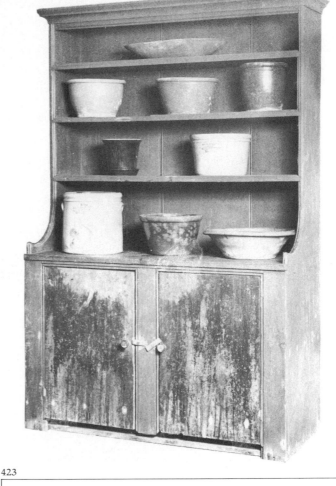

423

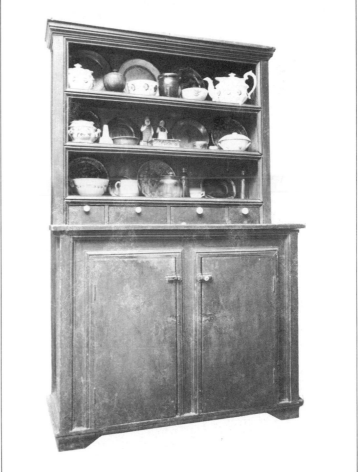

424

422 An open dish dresser from the eastern counties. The distinctive shaping of the dish rack is often seen on early New England dressers. The unusually thick boards and primitive construction are typical of homemade cupboards from the early period. First quarter 19th century. [U.C.V.]

423 An open dish dresser from Cookstown in Simcoe County. A pleasant example of the British tradition as it was often expressed in the northern American colonies. Second quarter 19th century. [P.C.]

424 An open dish dresser from the Little Lake area in Oxford County. This cupboard is traditional in concept, but the execution is highly individual. The buildup of mouldings, completely hiding the basic structure, is amateurish in approach while rather skilfully done. The use of cherry is also unusual and suggests a winter project by a handy immigrant farmer who had carefully saved some lumber for the purpose. Second quarter 19th century. [P.C.]

425 An open dish dresser from York County. A cupboard which is typical of many made in the New England colonies in style and decoration. Second quarter 19th century. [P.C.]

426 An open dish dresser from Westport in Leeds County. As was often the case, this cupboard had glass doors added some time after it was made when they became popular. Second quarter 19th century. [P.C.]

427 An open dish dresser from Leeds County. An early date and the hand of a skilled old country joiner are evident in this simple piece, with its fine moulded details which are cut into the structural elements rather than applied as mouldings in the later manner. First quarter 19th century. [P.C.]

428 An open dish dresser from Zephyr in Ontario County. This vigorous design incorporates several early Anglo-American features, including the elevated foot, the deeply chamfered door panels, the "S" scroll profile at the counter ends and the understated cornice. First quarter 19th century. [P.C.]

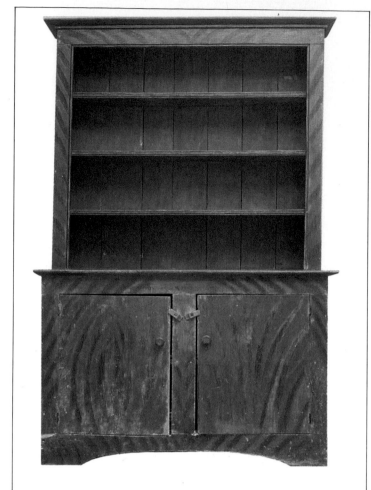

425

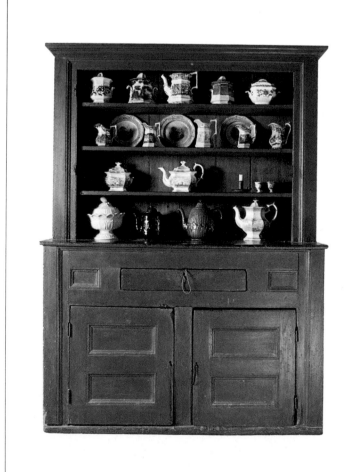

426

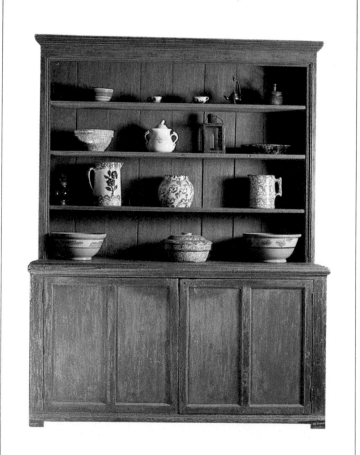

427

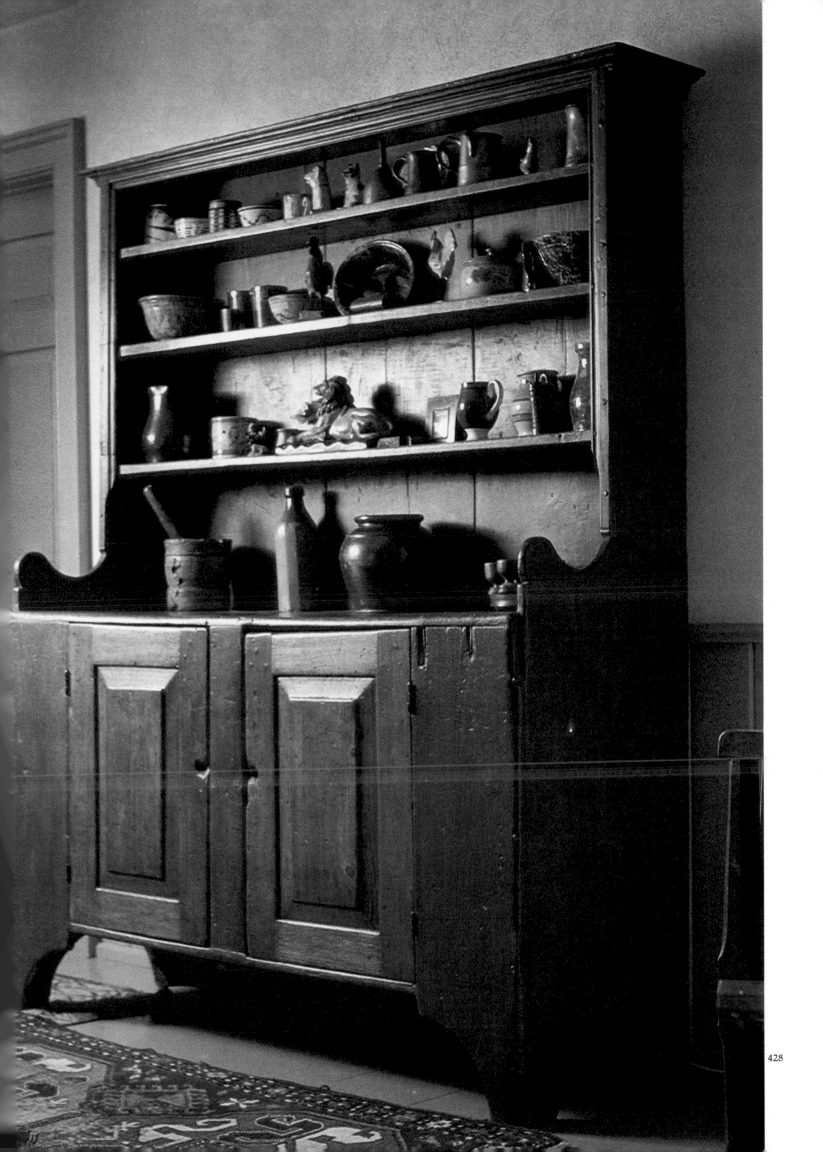

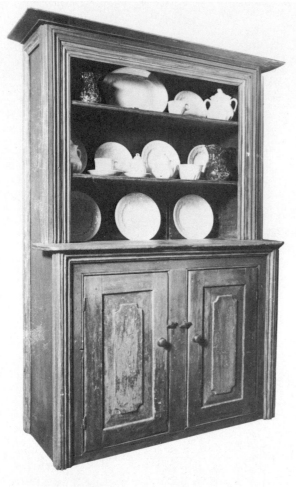

429

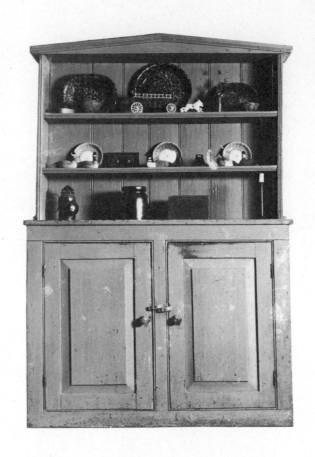

430

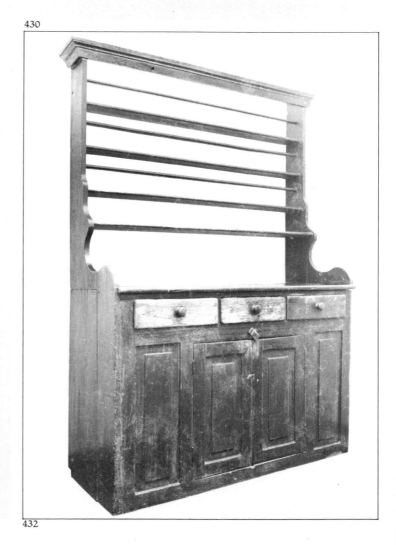

431

432

429 An open dish dresser from the Blairton area in Peterborough County. (Early family: Russell.) The simple traditional form becomes stylish with the rather extravagant use of architectural mouldings. Second quarter 19th century. [P.C.]

430 An open dish dresser from Fenella in Northumberland County. The elementary Classical pediment is an unusual addition to a traditional form. The wide backboards have flush bead details between the joints to give the impression of narrow boards which were more familiar to British craftsmen. Second quarter 19th century. [P.C.]

431 An open dresser from Enterprise in Frontenac County. This strong, simple cupboard is rescued from dourness by its unusual and almost playful Rococoish bracket base. Second quarter 19th century. [P.C.]

432 An open dresser from Lobo Township in Middlesex County. This rare example of northern English or Scottish regional style was found in an early log house. It was made without backboards, a characteristic of many British dressers. Of various woods, the counter is walnut and shows evidence of many scrubbings. Second quarter 19th century. [P.C.]

433 An open dresser from York County. This very large cupboard is typical of those found in large farm houses in Scotland and England. It is an evolution from the wall-mounted dish rack with some purely functional working surface below. The utilitarian nature of the piece is disguised by its rather refined detail and execution. Second quarter 19th century. [P.C.]

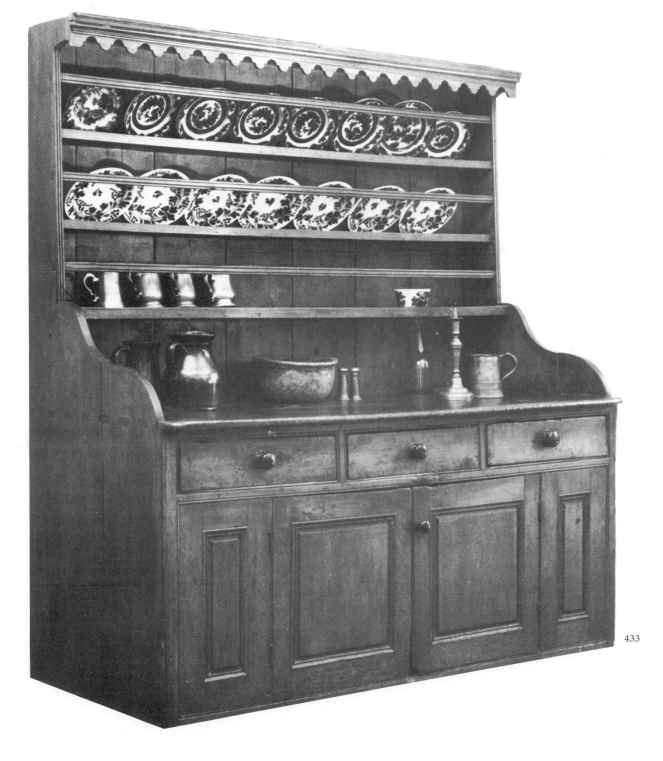

433

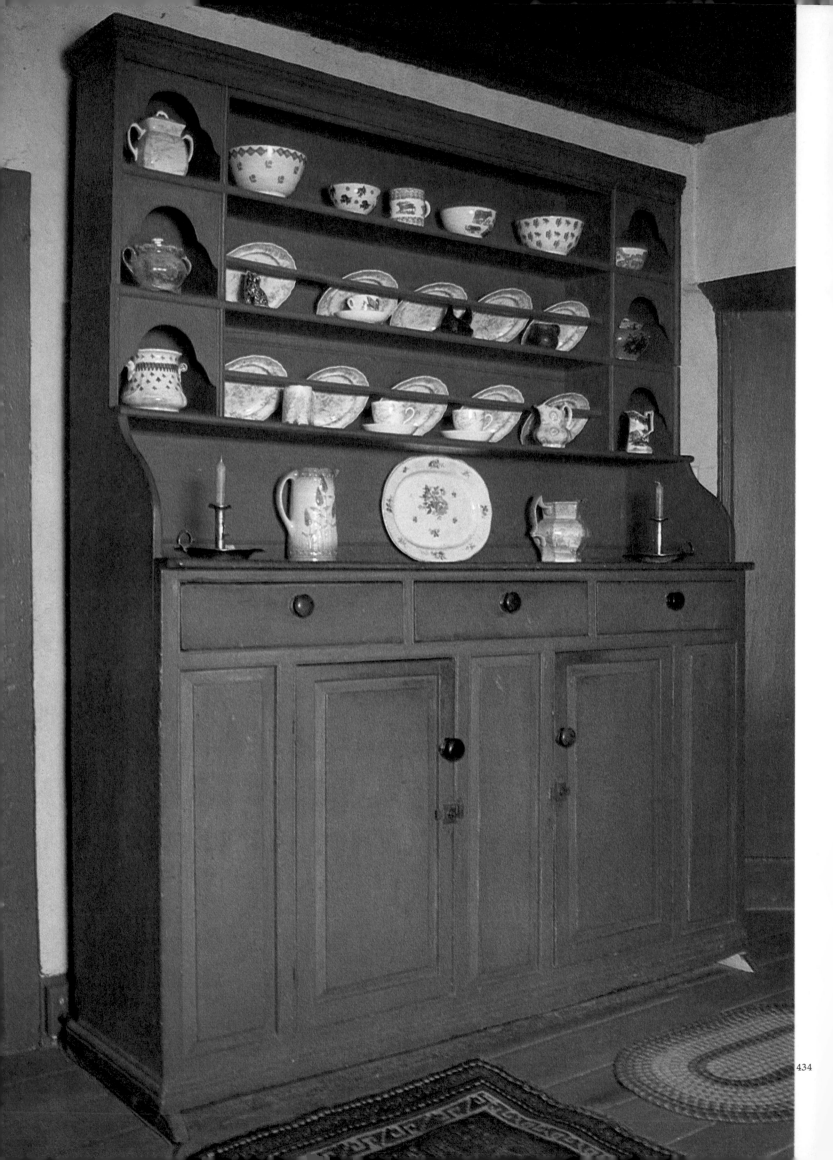

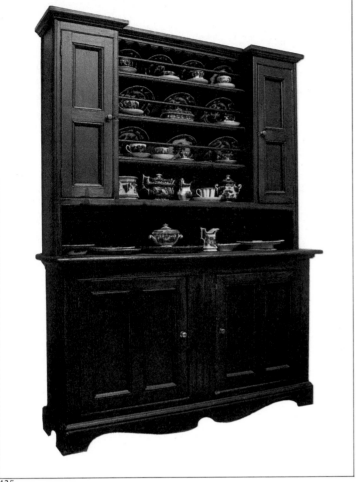

435

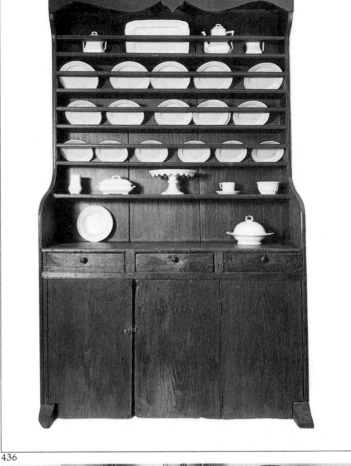

436

434 An open dish dresser from Glengarry County. This fine Scottish vernacular cupboard sat beside the open hearth in the early home of Robert Dewar. Family tradition indicates that it was made by a Mr. McNaughton. First quarter 19th century. [P.C.]

435 An open dish dresser from Stormont County. Similar in concept to the preceding cupboard, this design combines the traditional dish rack with closed cupboards in the upper section and a very convenient counter surface below. First quarter 19th century. [P.C.]

436 An open dish dresser from Mara Township in Durham County. The tall, hooded and shoe-footed form is typical of the Scottish vernacular. The simple construction is refined by the careful beading of the shelves, plate rails, sides, etc. Second quarter 19th century. [P.C.]

437 An open dish dresser from Douro Township in Peterborough County. Found in the early log home of the Sheenan family, it is an excellent example of the traditional Irish dresser, with a nicely articulated Neoclassical cornice and frieze. First quarter 19th century. [P.C.]

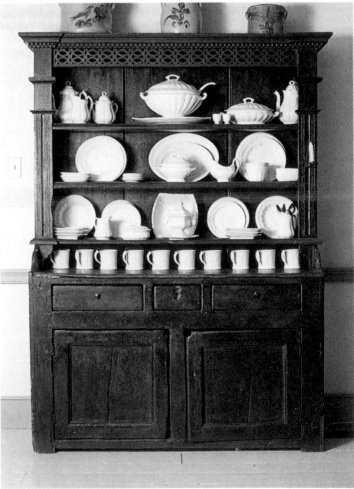

437

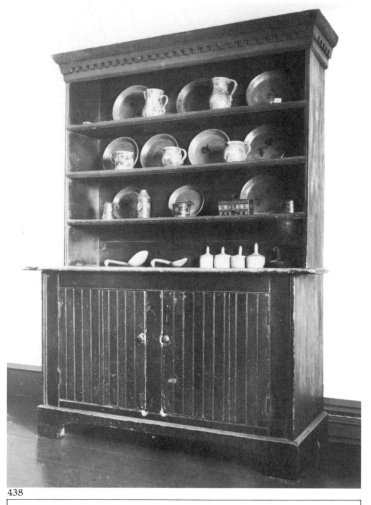

438

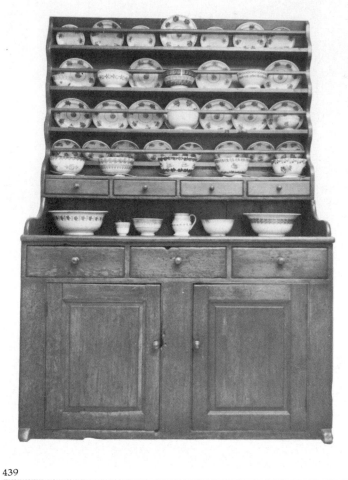

439

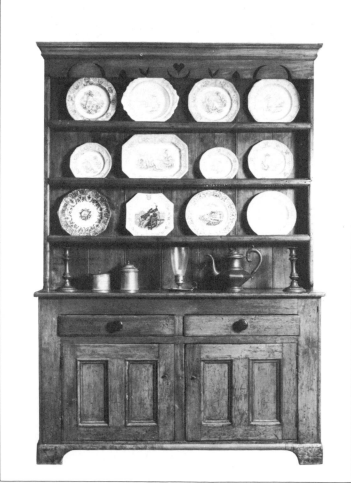

440

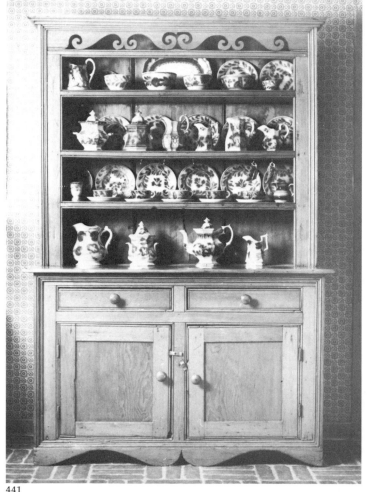

441

438 An open dish dresser from Erin in Wellington County. It is not surprising that this large and robust dresser comes from an area of Scottish settlement. It is distinguished from many of similar form by the precision of the dentil cornice, the finely drawn mouldings of the dish rack, the beading of the single-board doors and by its satisfying proportions. Second quarter 19th century. [P.C.]

439 An open dish dresser from Lanark County. This is also a distinctly Scottish vernacular cupboard. The plate rack is a separate unit sitting on the base and includes a row of spice drawers. The shoe foot and simple, competent joinery overall are typical of the Scottish country tradition. First quarter 19th century. [P.C.]

440 A dish dresser of unknown origin. The simple detail overall, decorative frieze, vertical proportion and low cupboard section are all characteristic of the Irish traditional form. The importance of the dish rack is clearly stated in this example. Second quarter 19th century. [P.C.]

441 An open dresser from Ontario County. The maker of this well-proportioned cupboard had a nice decorative sense as seen in the pleasingly Rococo frieze and graceful bracket base. He was also fond of his beading plane which produces an unusually active linear effect. Second quarter 19th century. [P.C.]

442 An open dish dresser from Summerstown in Glengarry County. While this form is typical of northern Ireland, the reeded frieze and fine moulding details throughout are English influences. First quarter 19th century. [P.C.]

443 An open dish dresser from the Woodville area in Victoria County. Typical early Irish form and construction. Second quarter 19th century. [P.C.]

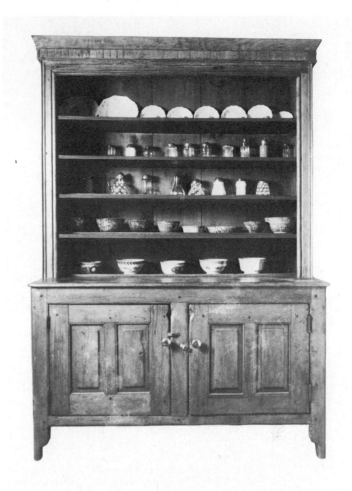

442

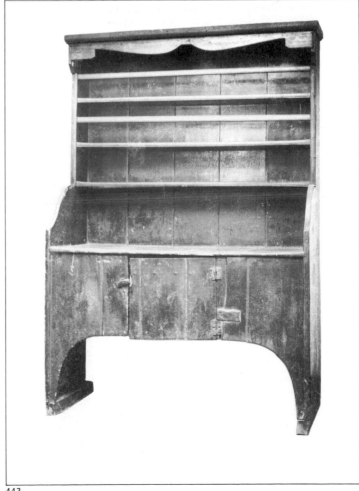

443

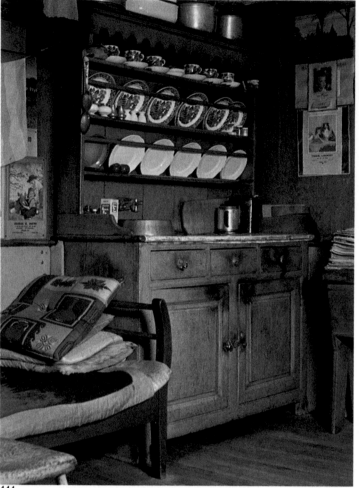

444

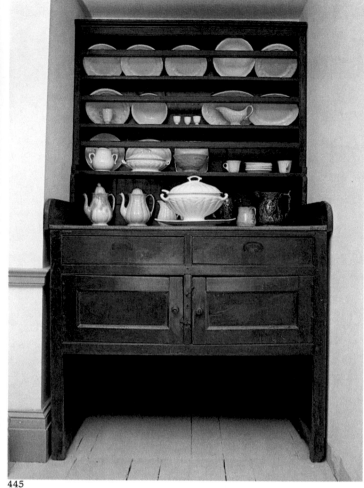

445

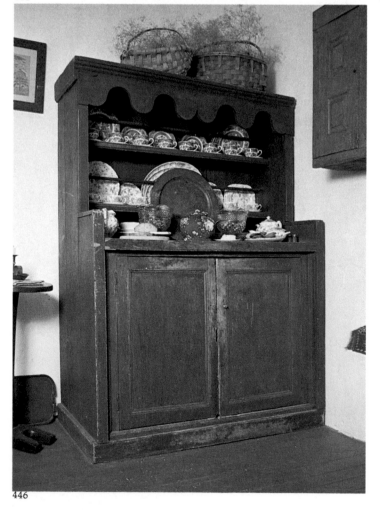

446

444 A dish dresser from Lanark County. This dresser is typically Irish in form and detail. Interestingly, it remains in daily use in a Scottish home where it has been for at least two generations. The arrangement of furnishings in the room mirrors the tradition with a huge cookstove replacing the hearth as the focal point. Second quarter 19th century. [P.C.]

445 An open dish dresser from Lanark County. This large, functional dresser incorporates several elements of the Irish vernacular style – the large rack, the open storage space at the floor and the generous counter surface – but it may have been made for an inn or similar utility kitchen rather than for a home. Second quarter 19th century. [P.C.]

446 An open dish dresser from Balderson in Lanark County. At first glance, this cupboard has a naïve folk charm, resulting from the unusually exuberant scalloped frieze and the squat proportions. Closer examination reveals very proficient technique in the lower section. Likely it was modified to fit a new location, but the result is entirely charming and consistently Irish. Second quarter 19th century. [P.C.]

447 A glazed, architectural corner cupboard from Lennox and Addington County. This fine Neoclassical cupboard is, in spite of early alterations, a marvellous piece of architectural furniture. It was built about 1825 as part of the woodwork of a house which still stands near Napanee. A number of related cupboards are found in the area, which suggests the activity of a local or itinerant builder who worked in the area for a relatively short period. The alteration to the cupboard entablature occurred when it was moved from the original house to another built on the same farm in the 1880s. To preserve the architectural integrity of the cupboard, it was made deeper to conform with the higher ceilings in the later building. The redesigned entablature, while entirely different in style and not as refined in execution as the original work, was done carefully and with an instinctive sense of design which is not entirely unsuccessful. The cupboard incorporates a number of outstanding details. The cornice is well articulated and correct. The double-reeded columns on either side of the piece are beautifully drawn and well proportioned in the overall design. The use of the popular fan motif is pleasing, as is the subtle repetition of the 8-sided door panel shape in the glazing plan. First quarter 19th century. [P.C.]

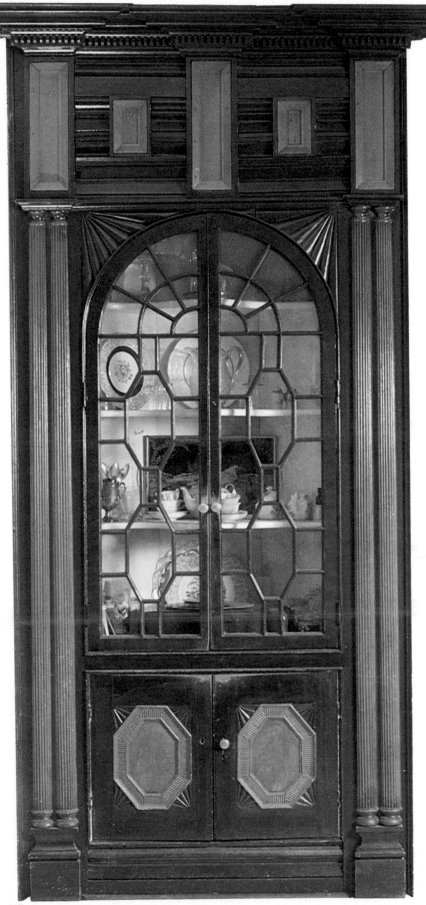

447

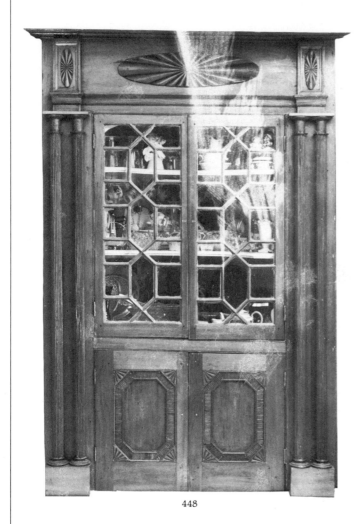

448

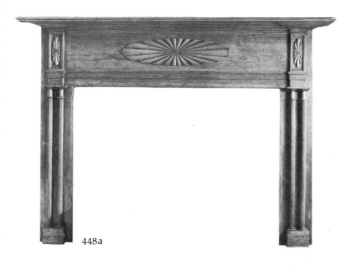

448a

448b

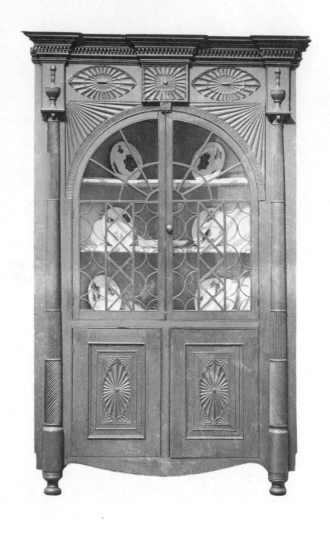

449

448 A glazed, architectural corner cupboard and mantelpiece from Lennox and Addington County. Another example of Napanee Neoclassical. These elements are all that remain of what must have been a very striking interior in a modest farm home which has unfortunately been modernized. The glazed doors on the cupboard conceal the typical shaped shelves and an interior arch with the radiating fan detail in the corners, supported on small, fluted pilasters. The proportions of the cupboard are not as successful as those of the mantel, which is a good example of provincial craftsmanship. First quarter 19th century. [P.C.]

449 A corner cupboard from Frontenac County. Exhibiting similar technique and detail as the preceding examples, this cupboard is impressive in its Neoclassical complexity. The turned feet are extensions of the columns, in the Sheraton manner, and are consistent with the shaped skirt. First quarter 19th century. [C.D., R.O.M.]

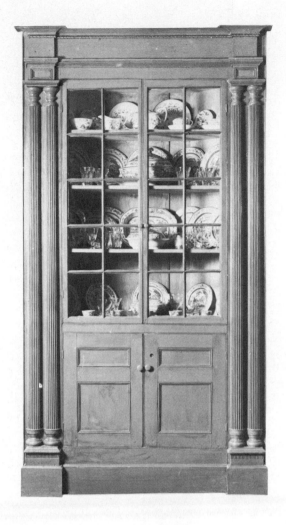

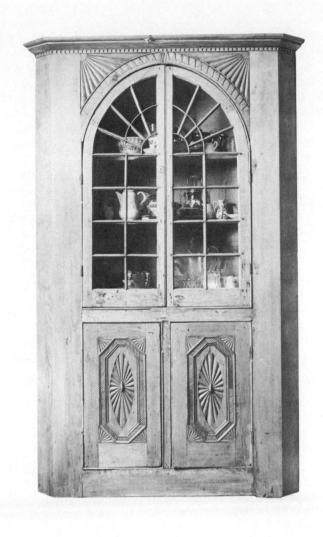

451

450 A glazed, architectural corner cupboard from Frontenac County. The split columns on this piece are similar to the full columns on the earlier examples and, although the overall design is much simpler, it may also be by the same maker. The crisp geometry of the rectangular glazing in the upper doors is reflected in the lower doors and in the entablature. One wonders if the subtle reeding in the plinth to the split columns was repeated in the original cornice which is missing. First quarter 19th century. [U.C.V.]

451 A glazed, architectural corner cupboard from Frontenac County. Possibly by the same maker as the preceding piece, this one has lost part of its cornice and had some restoration to the glass doors. It is a simpler design, but displays the flattened sunburst and the saw-tooth detail around the door arch as additional elements in this maker's impressive vocabulary of Neoclassical motifs. First quarter 19th century. [P.C.]

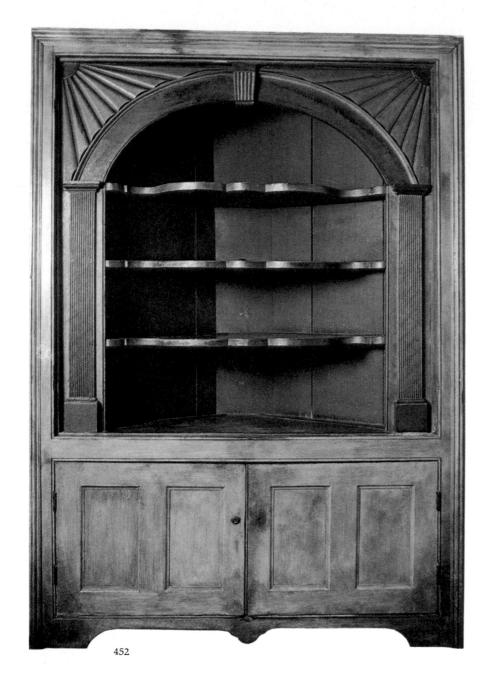

452

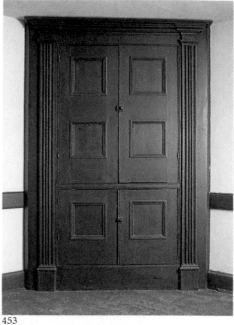

453

453 a

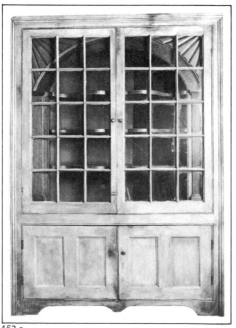

452 a

452 A glazed corner cupboard from York County. (Early family: Duncan.) This large cupboard is a rare example of the survival of 18th century style. The exterior is simple; its panelled doors below a deep glazed section reflect the plan of earlier times. A single moulding, similar to architectural woodwork of the period, frames the facade. The interior presents a boldly executed Neoclassical arch with keystone, reeded pilasters and fan details. Second quarter 19th century. [P.C.]

453 An architectural corner cupboard and mantelpiece from Peel County. Part of the woodwork of the modest 1830 home of Lewis Bradley, a Loyalist from Georgia. This design includes Neoclassical pilasters and cornice with simple panelled doors in a plan which reflects 18th century British and American architectural cupboards. The interior shelves are shaped in the traditional manner. Second quarter 19th century. [P.C.]

454 A glazed, architectural corner cupboard from the Napanee area in Lennox and Addington County. Possibly by the same Napanee craftsman as the earlier group, it illustrates another level of interpretation and in its own way is successful. The moulded and reeded pilasters are correctly scaled as is the built-up cornice. The single disappointing detail is the lack of alignment between the mullions and shelves in the door glazing. First quarter 19th century. [M.W.M.]

455 A glazed, architectural corner cupboard from Frontenac County. This

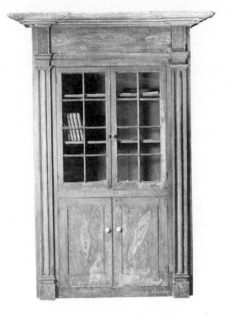

454

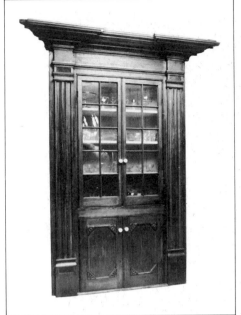

455

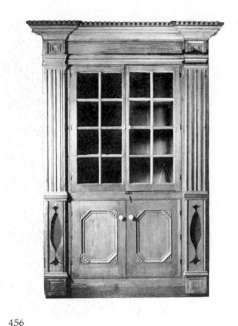

456

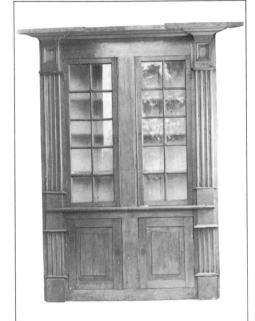

457

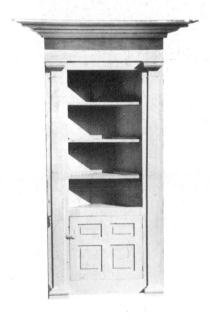

458

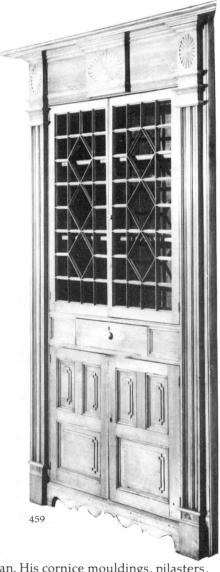

459

and the following three cupboards are stylistically related to the earlier group, but do not have the same refinement or confidence. This may indicate different craftsmen working at a later date. Second quarter 19th century. [P.C.]

456 A glazed, architectural corner cupboard from Kingston. This cupboard illustrates the trend to heaviness which accompanied the later developments in the Neoclassical style. Second quarter 19th century. [P.C.]

457 A glazed, architectural corner cupboard from Kingston. A departure from Classical principles with its complex pilaster arrangement and the breaking of the entablature by the upper doors. Second quarter 19th century. [P.C.]

458 An open, architectural corner cupboard from Kingston which was made for an early Loyalist family by the name of Orser. This cupboard relates to Neoclassical prototypes in several ways in which the preceding examples do not. Its small scale, open upper section and single lower door are typical features of many earlier English and American designs. Although simple in execution, the overall proportions are good and the shaping of the pilaster is remarkably subtle. First quarter 19th century. [P.C.]

459 A glazed corner cupboard from Peterborough County. The survival of Neoclassical style in Upper Canada was not exclusive to the Napanee-Kingston area. This imaginative provincial craftsman combined a much later cupboard arrangement, including a waist-high drawer, with the Classical plan. His cornice mouldings, pilasters, sunburst motifs, geometric glazing, shaped panels and Rococo skirt are well executed, but the total effect suffers from lack of continuity. Second quarter 19th century. [C.D., R.O.M.]

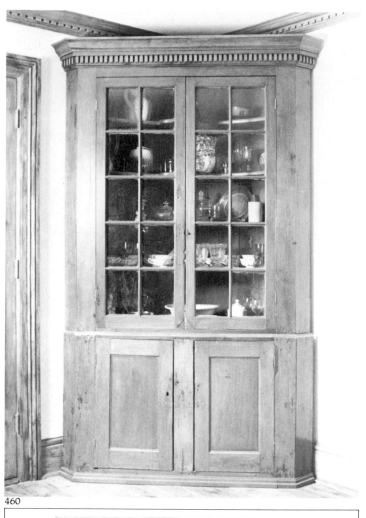

460

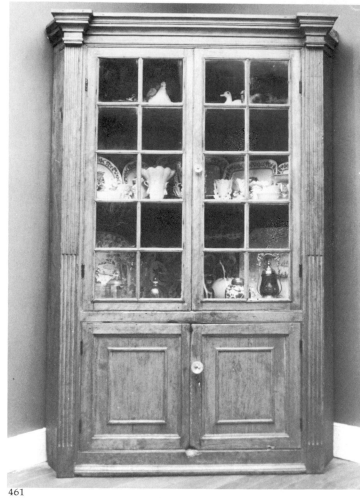

461

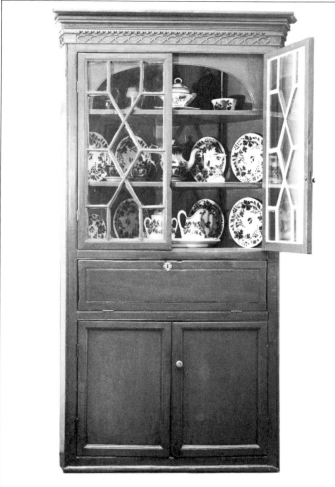

462

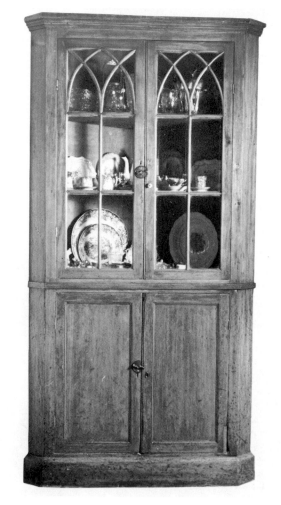

463

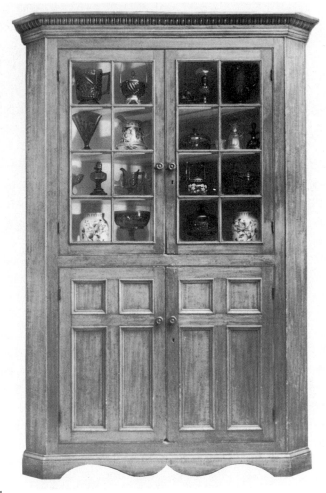

464

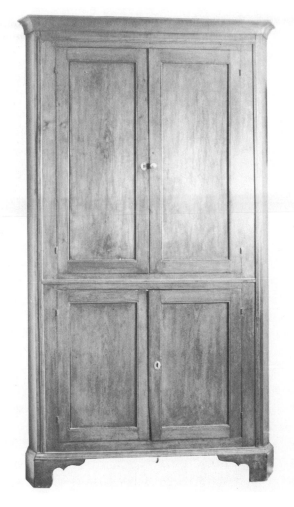

465

460 A glazed corner cupboard from London in Middlesex County. The dentil detail in the cornice, the deeply shaped shelves and the subtle detail of the lower doors place this well-proportioned hardwood cupboard clearly in the Georgian tradition. First quarter 19th century. [P.C.]

461 A glazed corner cupboard from Cornwall in Stormont County. The maker of this cupboard was well schooled in late 18th century English style. The cornice and pilaster design is sophisticated (Hepplewhite illustrated a similar detail in Plate 54, 1794 edition), and the overall restraint is admirable. First quarter 19th century. [P.C.]

462 A glazed cupboard from Georgetown in Halton County. The outstanding feature of this piece is the provincial expression of a Chippendale cornice and frieze. The interior arch, glazing and simple joinery are typically country British. The horizontal cupboard below the glazed section may have been intended for letters and documents or possibly for the storage of pastries. Second quarter 19th century. [P.C.]

463 A glazed corner cupboard from Lanark County. The graceful Gothic motif in the glazing of this cupboard is associated with the Hepplewhite style and was almost as popular in Upper Canada as the Chippendale design in the preceding example. The well-considered proportions, simple detailing and brass hinges and escutcheons suggest that this country craftsman was trained in the British tradition. Second quarter 19th century. [P.C.]

464 A glazed corner cupboard from Lanark County. This piece retains the simple formality of the British country parlour cupboard in its Neoclassical cornice, fine glazing and bracket base and at the same time reflects the more spacious rooms in the Upper Canadian houses with wide, generous proportions. Second quarter 19th century. [P.C.]

465 A blind-doored corner cupboard from the Niagara Peninsula. The simple cavetto cornice, understated details and moulded bracket base are combined in this cupboard with good proportions. An unusual and inventive locking device for the upper doors employs a wedge-shaped wooden piece which fits a similar mortice in the door. First quarter 19th century. [P.C.]

The Anglo-American Tradition 183

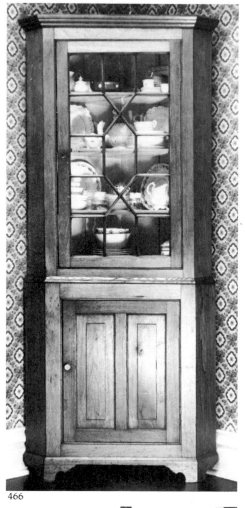

466

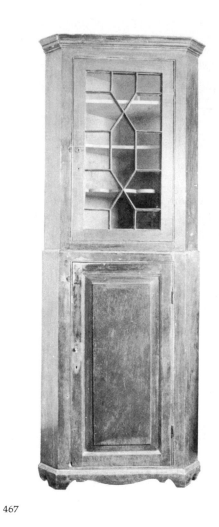

467

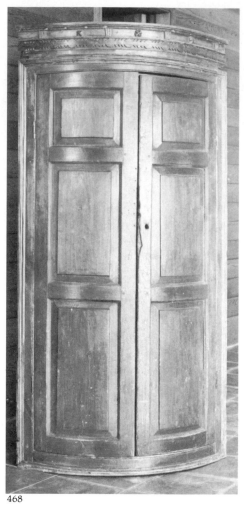

468

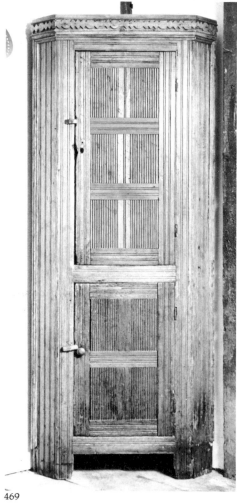

469

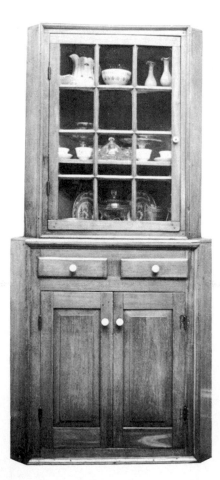

470

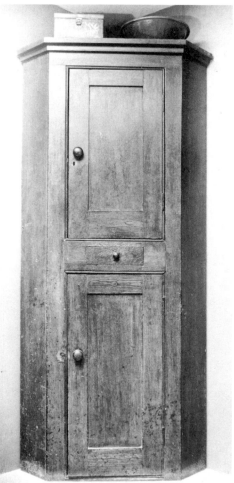

471

466 A glazed corner cupboard from Paris in Brant County. The diminutive size and simple Georgian style of this cupboard are typical of those made for parlours throughout the British Isles in the late 18th and early 19th centuries. The simple cornice mould, Chippendale-inspired glazing and bracket base were basic elements of countrified formality. Second quarter 19th century. [P.C.]

467 A glazed corner cupboard from an early log house in Poland, Lanark County. From the same parlour tradition as the previous cupboard, this one has a sturdy character to its joinery which often identifies a Scottish craftsman. First quarter 19th century. [P.C.]

468 A blind-doored corner cupboard from Glengarry County. A very unusual variation on the small parlour cupboard theme is this piece with its bowed front. This rather sophisticated and demanding approach is inconsistent with the naïve Neoclassical cornice and frieze and the very plain interior. First quarter 19th century. [P.C.]

469 A blind-doored corner cupboard from Glengarry County. The similarity in the moulding profiles as well as the cornice and interior details suggest the same maker for this cupboard and the preceding one. The complex linear pattern created by the beading plane is an effective provincial concept of surface enrichment. First quarter 19th century. [P.C.]

470 A glazed corner cupboard-on-cupboard from the eastern counties. This small, two-piece cupboard is less formal than the previous examples, with a simple picture frame style and step-back form. First quarter 19th century. [P.C.]

471 A blind-doored corner cupboard from Lanark County (fourth generation of Norris family). A small parlour cupboard without pretence to style other than woodgrain decoration. Second quarter 19th century. [P.C.]

472 A corner cupboard from Glencoe in Middlesex County. This charming and practical design is the original concept of a careful, but untrained, craftsman. Second quarter 19th century. [P.C.]

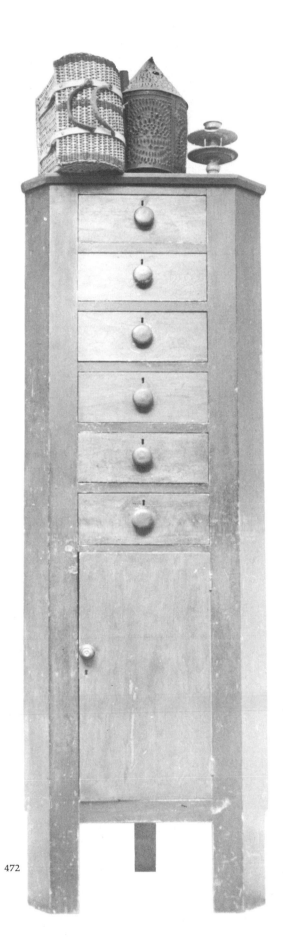

472

473 A glazed corner cupboard from Leeds County. This cupboard is an excellent example of the marriage of 18th century British style and 19th century Upper Canadian practicality. The well-executed elements of Georgian formality have been skilfully integrated in a plan which provided an unusually deep closed storage space and cutlery drawers, as well as the traditional glazed china cupboard. Second quarter 19th century. [P.C.]

474 A glazed corner cupboard from Lanark County. This is a vigorous provincial interpretation of late 18th century style. The simply decorative glazing plan, shaped panels on doors and drawers and the elevated bracket base are pleasing features. Second quarter 19th century. [P.C.]

475 A glazed corner cupboard from York County. Attributed to William Thompson of Scarborough. In spirit, this capably crafted, free-standing cupboard is 18th century. The built-up cornice, chamfered panels and caricatured treatment of the bracket feet illustrate the influence of the Empire style and late Neoclassical architectural detail on provincial craftsmen. Second quarter 19th century. [P.C.]

476 A glazed corner cupboard from the Cornwall area in Stormont County. The large utilitarian scale of this cupboard is disguised by the use of simple design elements from formal furniture style and by the decorative combination of hardwoods. The turned foot became popular for large case pieces in the 1830s. Second quarter 19th century. [C.C.]

477 A glazed, architectural corner cupboard from Prince Edward County. Another expression of the tradition of architectural corner cupboards, this design is based on the simple panels which might have been used on interior window and door frame returns and in wainscoting. First quarter 19th century. [P.C.]

478 A blind-doored, architectural corner cupboard from Prince Edward County. This cupboard was built for the parlour or dining room of an early home. While it is of the 18th century in concept, the style and detail are those of architectural woodwork of the second quarter of the 19th century. Second quarter 19th century. [P.C.]

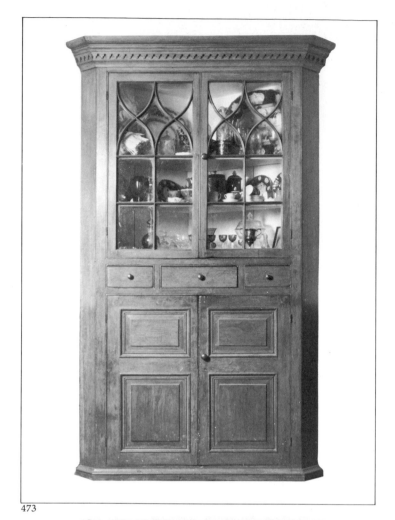

473

474

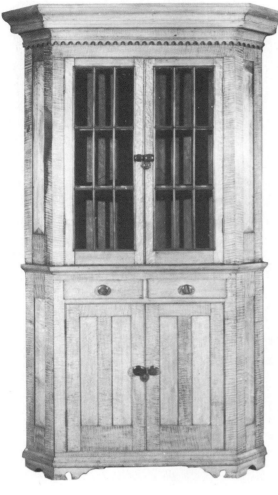

475

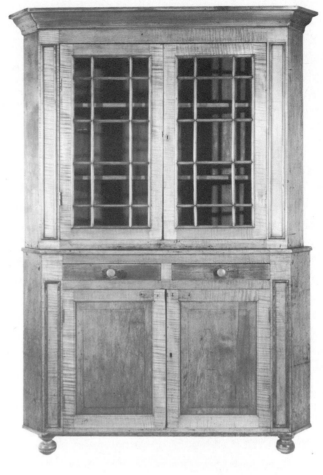

476

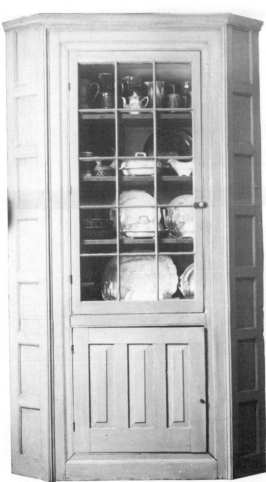

477

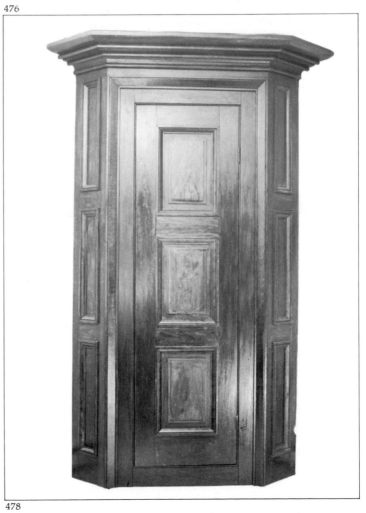

478

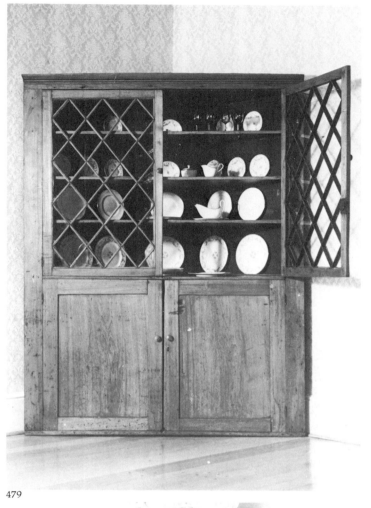

479

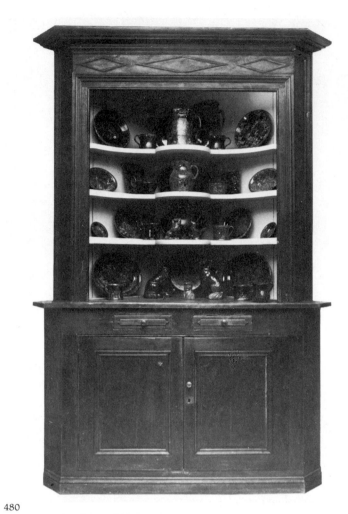

480

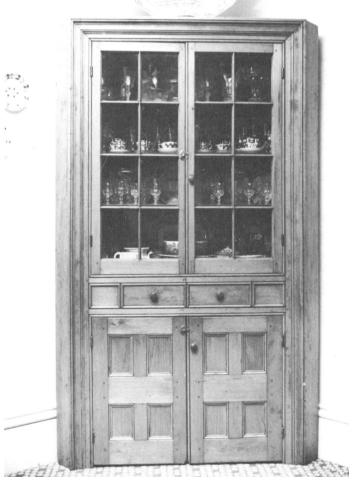

481

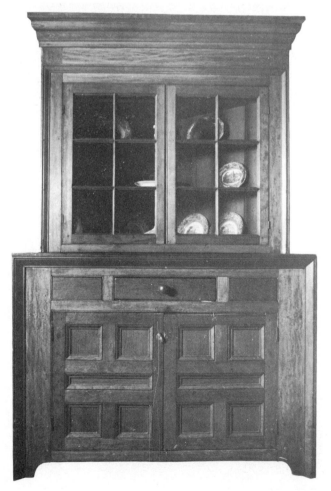

482

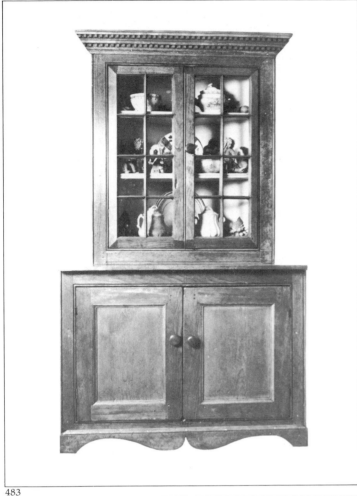

483

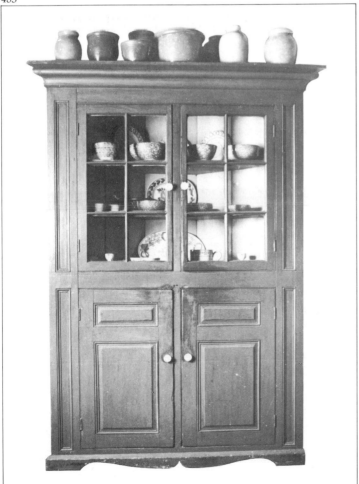

484

479 A glazed, architectural corner cupboard from Cardinal in Grenville County. While purely functional, this simple design achieves an air of formality through the use of a popular 18th century glazing plan. First quarter 19th century. [P.C.]

480 An open, architectural corner cupboard from the Kingston area in Frontenac County. This very large, one-piece cupboard combines ideas from several periods. The open upper section with shaped shelves is a carry-over from the 18th century, which is given some-what secondary importance to the lower buffet section with its convenient serving shelf. As with many of the cupboards in this category, it was likely made by an architectural joiner rather than one trained in furniture-making. Second quarter 19th century. [P.C.]

481 A glazed, architectural corner cupboard from Bloomfield, Prince Edward County. This is a later architectural style in which the elements are framed with the same moulding used for the doors and windows in the room. Second quarter 19th century. [P.C.]

482 A glazed corner cupboard-on-cupboard from the far eastern counties. Unlike the related two-piece designs illustrated, which attempt to integrate the upper and lower cupboards in a unified concept, this example was clearly intended as a functional buffet with dish storage of secondary importance. The smaller scale of the framing and facia mouldings on the upper cupboard is an interesting example of intuitive design. Second quarter 19th century. [U.C.V.]

483 A glazed corner cupboard-on-cupboard from Hamilton in Wentworth County. The stark functionalism of this design is pleasantly softened by the simple dentil cornice and the shaped bracket base. Second quarter 19th century. [P.C.]

484 A glazed corner cupboard from Mono Road in Peel County. An honest, functional kitchen cupboard which relates to the British tradition in its details and construction. Second quarter 19th century. [P.C.]

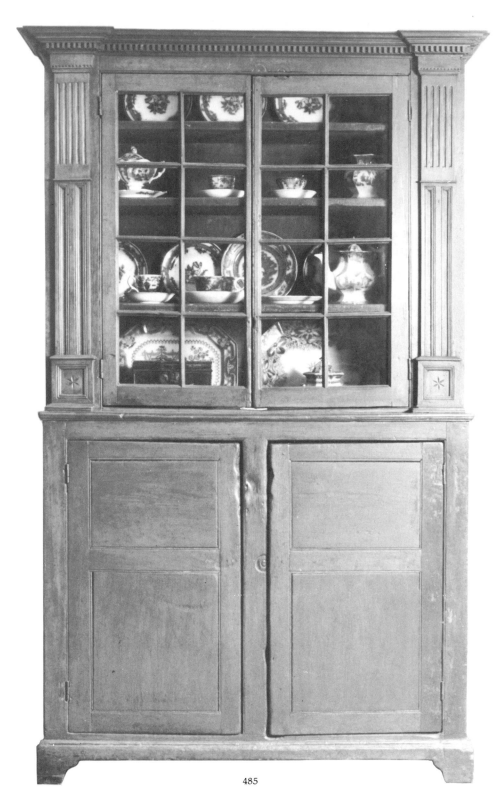

485

485 A glazed dish dresser from North Lancaster in Glengarry County. The formal proportions and well-articulated Neoclassical detail of this dresser connect it with glazed bureaux in 18th century British parlours. The starkly simple lower storage section expresses its function with little concern for the overall style. Second quarter 19th century. [P.C.]

486 A glazed dish dresser from Portland in Leeds County. Made by Richard Byington for the Polk family, this is a very personal expression by a competent country craftsman who had an elementary vocabulary of Neoclassical style. The repetition of the diamond motif in the frieze, glazing and door panels is a pleasing naïve concept. The overhang of the drawers in the buffet section suggests influence from the Empire style, while the decorative theme overall is Georgian. Second quarter 19th century. [P.C.]

487 A glazed dish dresser from the eastern counties. This large, one-piece, architectural cupboard is based on the wall cupboards that were built into rooms in 18th century houses in Britain and America. It is related in style to the Neoclassical corner cupboards which were more popular in Upper Canada, and was likely made by a joiner who produced the woodwork for the home. Second quarter 19th century. [P.C.]

488 A glazed dish dresser from Lambton County. An unusually large cupboard, with simple architectural mouldings providing its style feature. Family tradition indicates that it stood in the parlour where it may have displayed the best china, or perhaps been used for books. Second quarter 19th century. [M.I.C.]

489 A glazed dish dresser from Leeds County. In "as found" condition and awaiting careful restoration, this cupboard is an important example of vernacular furniture. That it was almost certainly made by an Irish immigrant is indicated by the characteristic combination of Neoclassical architectural form, with a light-hearted application of naïve decorative elements and those such as the heart and sun which have traditional associations. Second quarter 19th century. [P.C.]

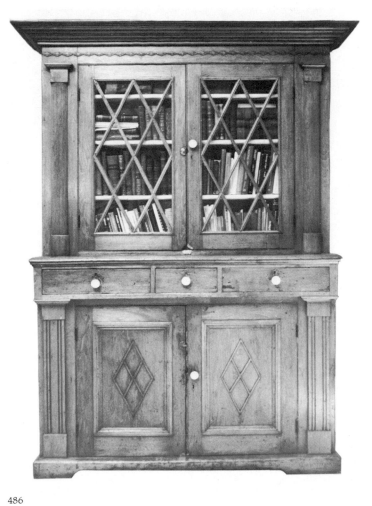

486

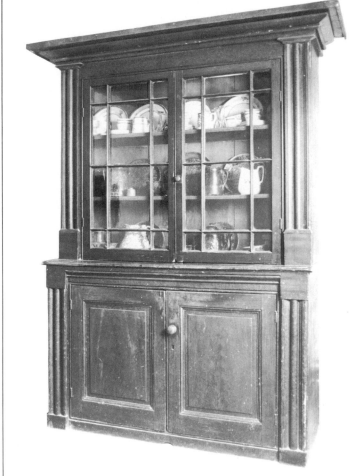

487

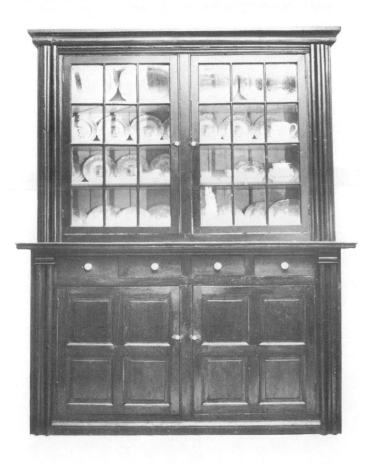

488

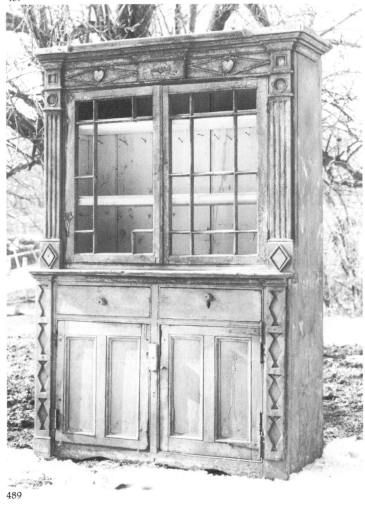

489

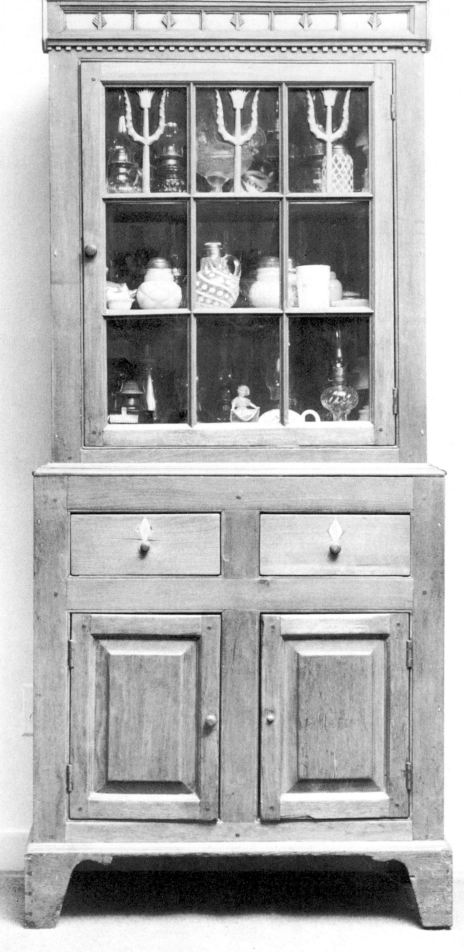

490 A glazed parlour cupboard from Caledon East in Peel County. From the same house and probably by the same maker as Plate 494. In provincial terms, this design captures the Neoclassical feeling of Adam and Hepplewhite with its decorative frieze and glazing. Second quarter 19th century. [P.C.]

491 A glazed dish dresser from Lanark County. Family legend attributes this cupboard to an Irish craftsman named Quinn in the Perth area. It is another graphic example of the development of the concept of the glazed dresser through the marriage of the traditional open dresser (including the plate rails) and a stylish parlour form which, in this case, is a Georgian glazed secretary. The confident craftsmanship exhibited in this piece suggests a maker who could produce either type of furniture on request. Second quarter 19th century. [P.C.]

492 A glazed dish dresser from Belle-ville in Hastings County. In the face of the often ungainly Empire and Victo-rian styles, crisp Georgian simplicity retained a place in Upper Canadian taste as seen in this mid-century dres-ser. The bun feet and simple joinery are typical of the products of cabinet shops in the 1860s, while the proportions, glazing and cornice survive from the 18th century. Third quarter 19th century. [P.C.]

493 A glazed parlour cupboard from the Prescott area in Grenville County. The single-door design of this simple architectural style wall cupboard is unusual and probably reflects the popular corner cupboard form. Second quarter 19th century. [P.C.]

494 A glazed dish dresser from Caledon East in Peel County. This vigorous design illustrates clearly the evolution of the glazed dresser to combine the functional counter and storage of the traditional open dresser with the stylish formality of the glazed bureau. The hand of a skilled cabinetmaker is visible in the refined Chippendale-influenced glazing, the crisp door construction and the dovetailed bracket base. Second quarter 19th century. [P.C.]

490

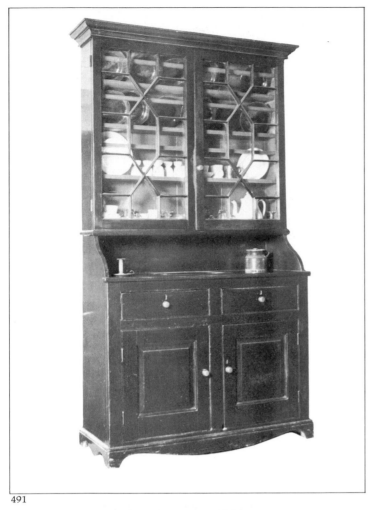

491

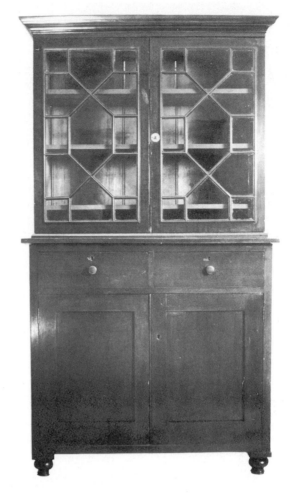

492

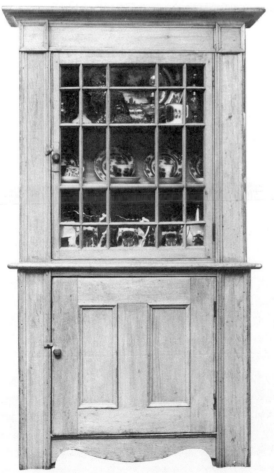

493

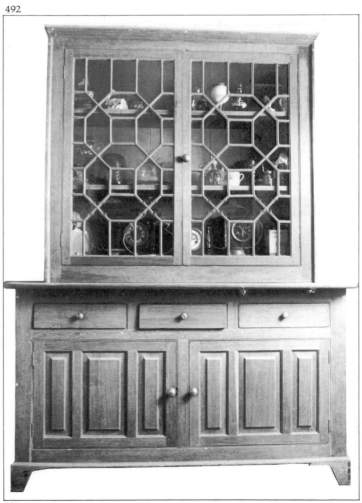

494

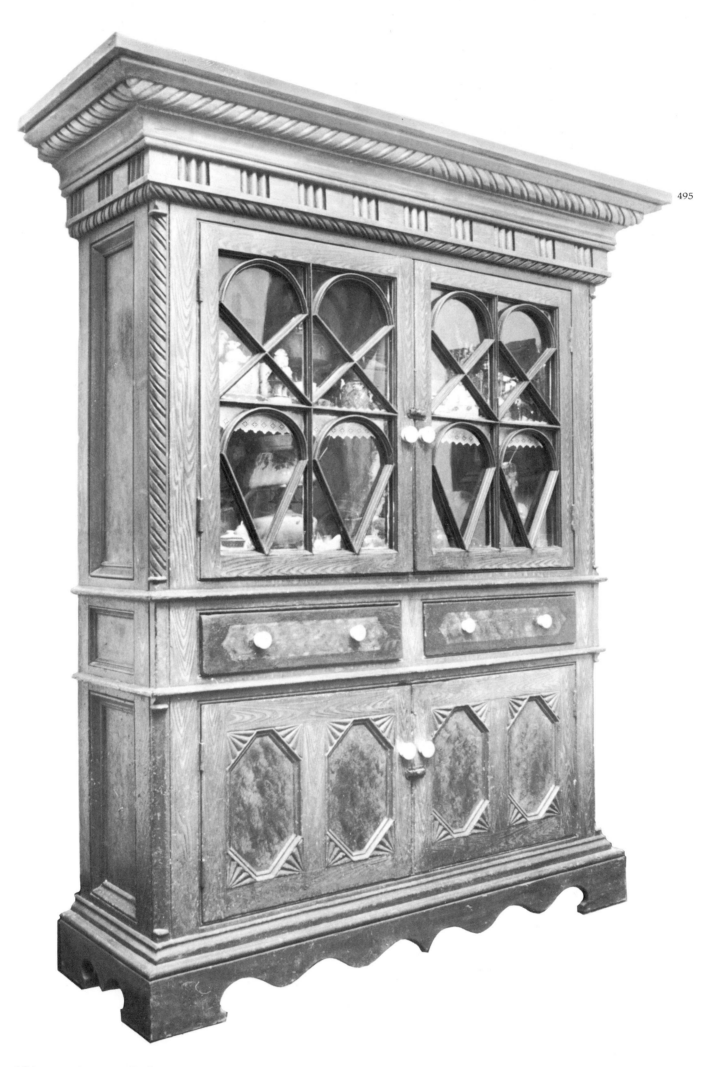

495

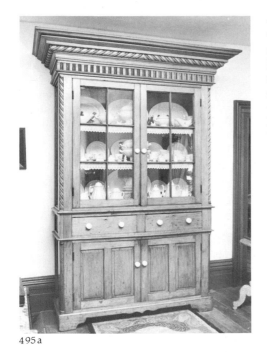

495 This unique group of furnishings, which share an unusually epic scale and character, was made for a modest farmhouse at Mono Mills in Simcoe County (Speers family), an area of Scottish settlement. The details shared by all three pieces comprise a vigorous and highly personal interpretation of the 18th century Neoclassical idiom executed with a confidence typical of British country joinery. The same elements were used throughout the woodwork of the remarkable house for which these furnishings were made, achieving a unified architectural concept in the spirit of Robert Adam. Second quarter 19th century. [P.C.]

495a

495b

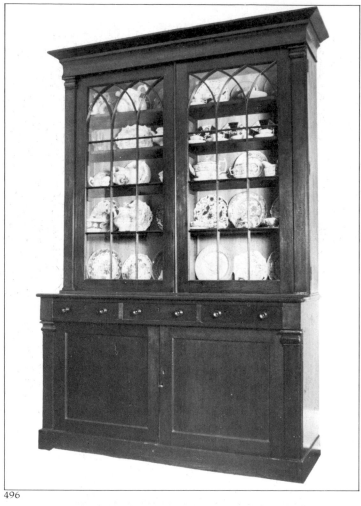

496

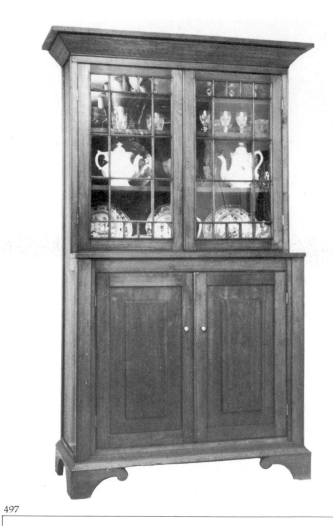

497

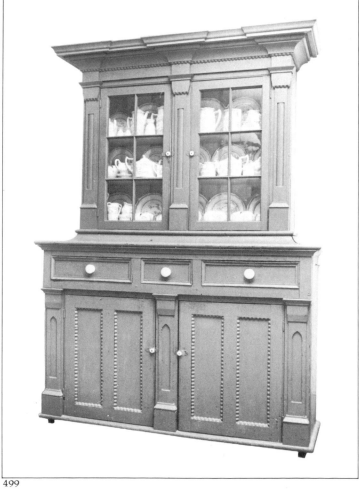

498

499

496 A glazed dish dresser from Perth in Lanark County. Made for "Ingle Va," an early Perth home, and attributed to David Hogg, who is a known Perth cabinetmaker. This large dresser is more formal than most Upper Canadian examples and retains influences from the 18th century in its glazing while the proportions and restrained pilaster treatment are typical of the late Neoclassical styles. Its relationship to the mantelpiece, from the same house, in Plate 779 is interesting. Second quarter 19th century. [P.C.]

497 A glazed dish dresser from the London area in Middlesex County. Another example of country formality on a Georgian theme. Second quarter 19th century. [P.C.]

498 A glazed dish dresser from Brantford in Peel County, made for a nephew of Thomas Carlyle. Similar in period to the preceding design, this dresser design is more flamboyant and typical of late Neoclassical style. The egg and dart motif as seen in the cornice and base was a favourite of the period and was illustrated by Smith in 1808. Second quarter 19th century. [P.C.]

499 A glazed dish dresser from Campbellville in Halton County. Conceived on a monumental scale, this dresser is soundly based on Neoclassical architectural principles, while the beaded mouldings, Gothic elements in the lower pilasters and projecting section encompassing the drawers are typical characteristics of Empire furniture. Mid-19th century. [P.C.]

500 A glazed dish dresser from Perth in Lanark County. It is one of several related pieces by a skilled provincial cabinetmaker which are known in the same area. The use of drawers throughout in the lower section was not a popular form in Upper Canada and occurs primarily in Scottish settlements. This design is based on Georgian influences with its refined proportions, Chippendale glazing pattern and slim, reeded pilasters in the manner of Sheraton. The cornice is well executed on Classical principles but is heavy, indicating the maker's awareness of more contemporary trends. Second quarter 19th century. [P.C.]

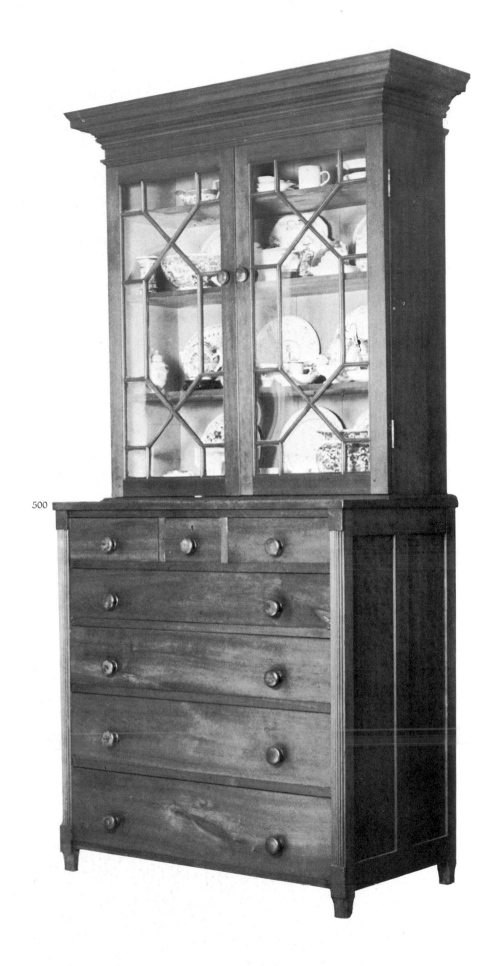

500

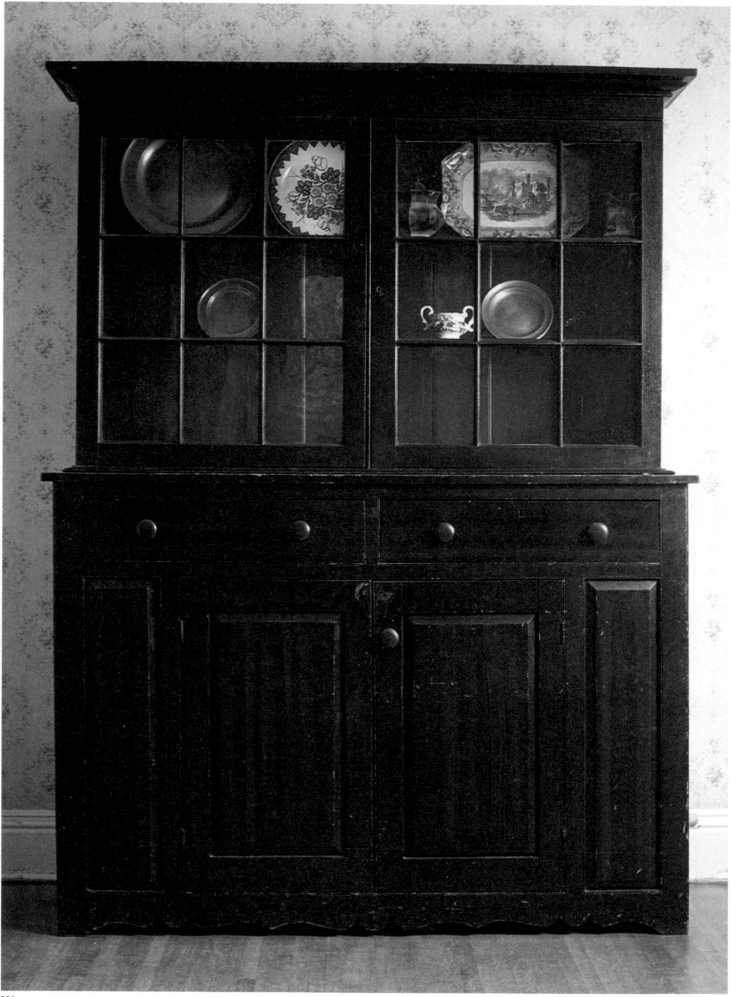

501

501 A glazed dish dresser from Stanley's Mills in Peel County. Signed, *W. P. Linfoot, Maker, March 1862.* This exceptional example of country furniture includes many details which are typical of provincial British craftsmanship. The moulding profiles are based on Classical prototypes, all frame edges are finished with a single beaded detail, the panels are raised and chamfered and the glazed doors are mounted edge to edge. The direct relationship to the traditional open dresser is also apparent. Third quarter 19th century. [P.C.]

502 A glazed dish dresser from Prince Edward County. The cornice and set-back of the lower cupboard in this simple design are details from the late Neoclassical styles which have been added to the typical utilitarian form by a confident craftsman. First quarter 19th century. [P.C.]

503 A glazed dish dresser from Seabright in Durham County. (Early Scottish family: Graham.) The outstanding feature of this large cupboard is the painted decoration on the lower doors and drawers. These floral groupings are naïve in both composition and execution, suggesting that they were done by a family member. Since there is no precedent for this type of decoration in the Scottish tradition, it was likely inspired by the memory of painted or inlaid formal furniture which was popular in Britain at the end of the 18th century. The design and construction of the cupboard suggest a Scottish maker of limited skill. Third quarter 19th century. [C.F.C.S., M.O.M., N.M.O.C.] .

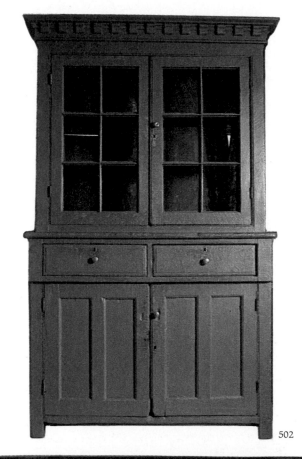

502

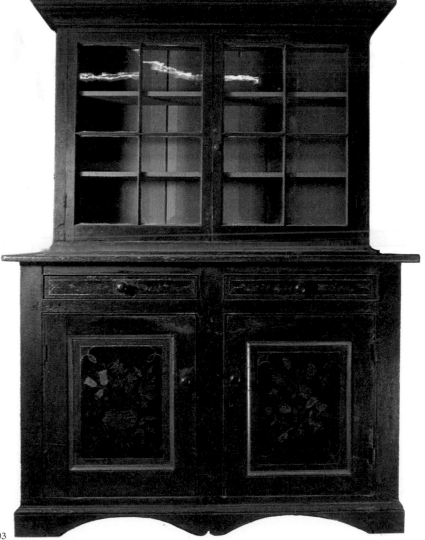

503

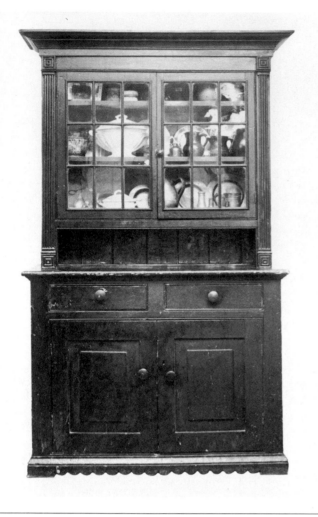

504

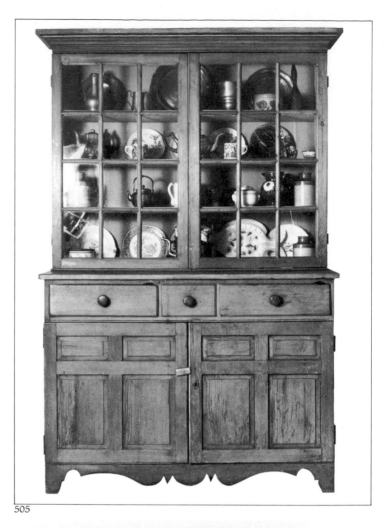

505

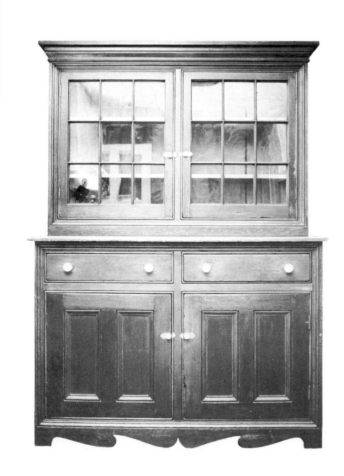

506

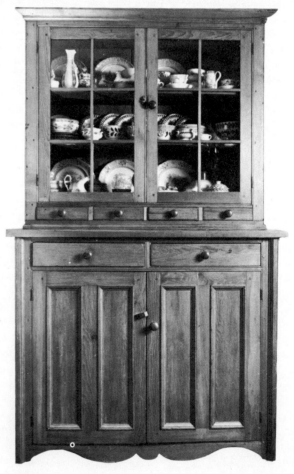

507

504 A glazed dresser from Durham County. The formal proportions and rather refined detail of this design assume a Regency character with the addition of restrained reeded pilasters and corner pieces. The pie shelf is not often seen in British-style cupboards. Second quarter 19th century. [P.C.]

505 A glazed dresser from Markham Township in York County. This design, with upper and lower doors mounted directly to the frame, and its vertical proportions and the shaped bracket base related directly to case pieces of the Hepplewhite and Sheraton periods, suggests a British-trained craftsman. However, the lapped drawer construction and the placement of two wide and one narrow drawer is typical of Pennsylvania-German furniture in the Markham area. The flow of influence from one cultural group to another was probably not unusual in the early communities, but is not often as clearly defined as in this example (see related design in Plate 518). Second quarter 19th century. [P.C.]

506 A glazed dish dresser from Beamsville in Lincoln County. The pure functionalism of this design is enriched by an unusual moulded frame surrounding both the top and bottom cupboards and by a shaped bracket base which has a hint of Empire style in its florid scrolls. Second quarter 19th century. [P.C.]

507 A glazed dish dresser from Blackstock in Durham County. The proportions and layout of this dresser, including the row of spice drawers, are often seen in traditional Scottish open dressers. Second quarter 19th century. [P.C.]

508 A glazed dish dresser from Simcoe County. This simple one-piece dresser is typical of those found in centres of later settlement by the British groups. Second quarter 19th century. [P.C.]

509 A glazed dish dresser from Lansdowne in Leeds County. The design basis for many Upper Canadian dressers as well as corner cupboards was the architectural built-in wall cupboard which was popular in 18th century British and American rooms. In this large example, the traditional dresser form has been framed with mouldings which likely matched those of the room for which it was made. Second quarter 19th century. [P.C.]

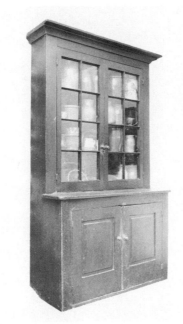

508

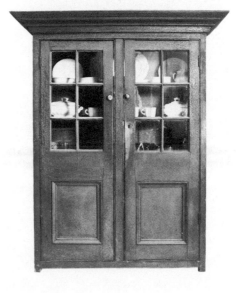

509

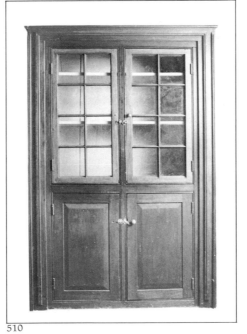

510

511

510 A glazed cupboard from Kingston in Frontenac County. This simple kitchen cupboard is typical of many made in the eastern counties which were similar to the earlier built-in type, but were made as movable pieces of furniture. First quarter 19th century. [P.C.]

511 A glazed cupboard from Raglan in Ontario County. (Early family: Harden.) This very functional kitchen cupboard employs architectural doors and mouldings in a unique design which was likely the product of a joiner-builder. Second quarter 19th century. [P.C.]

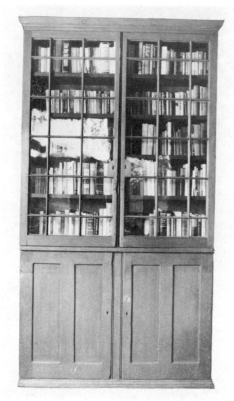

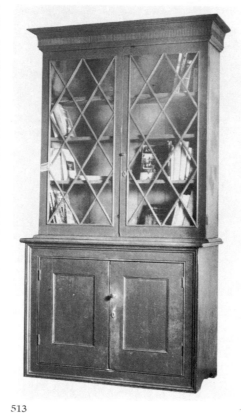

512

513

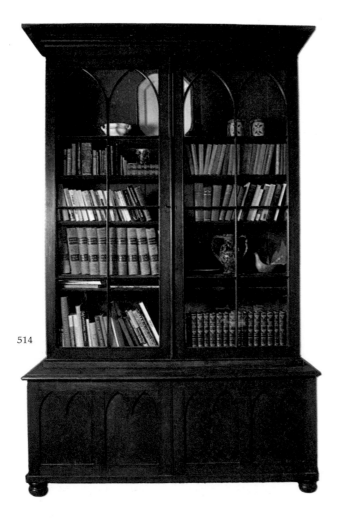

514

512 A glazed bookcase from the eastern counties. Even in this starkly simple execution, the Georgian bookcase form is elegant. Typically, the shelves are adjustable to accommodate different-sized books. First quarter 19th century. [P.C.]

513 A glazed bookcase from Bolton in Peel County. The deep glazed cupboard with movable shelves for books above a low closed section was a popular form which attracted the skills of each of the 18th century English designers. This pleasing country interpretation owes something to Hepplewhite in its reeded frieze and lattice glazing pattern. Second quarter 19th century. [P.C.]

514 A glazed bookcase from Brant County. More stylish than the earlier examples, this bookcase incorporates many typical features of the Georgian designs, some of which included smaller cupboards, set back on either side, and called breakfronts. The Gothic motif was a favourite of Hepplewhite, but became very popular in Victorian style, as did the flat bun-shaped feet, which place this piece later than would otherwise be indicated. Mid-19th century. [P.C.]

515 A glazed library bookcase from Caledon East in Peel County. While strongly architectural in character, this large cupboard was made as a piece of movable furniture and was found in a small log house which survived from the early settlement period in the area. The concept is clearly based on the stylish and popular 18th century British glazed bookcase which included many combinations of glazed upper cupboards with drawers and closed cupboards in the lower section, made as free-standing furniture or as architectural woodwork. The Gothic element repeated in the glazed and panelled doors and the roundels in the moulded frame are typical architectural elements of the 1840-1860 period. The drawers in the 18th century prototype were used for the storage of prints and maps. As with many pieces of early furniture, it is fascinating to speculate on the people and circumstances involved with its first years. Mid-19th century. [P.C.]

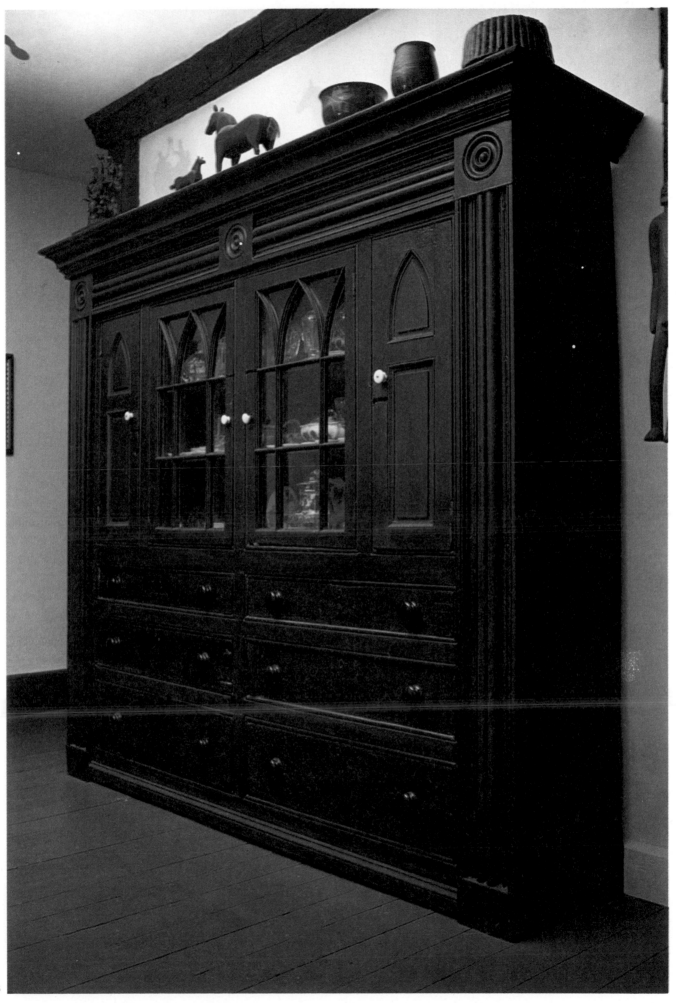

515

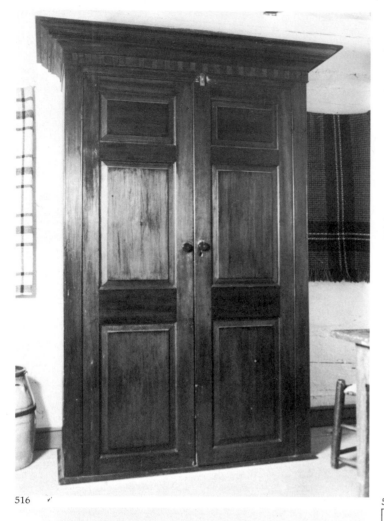

516

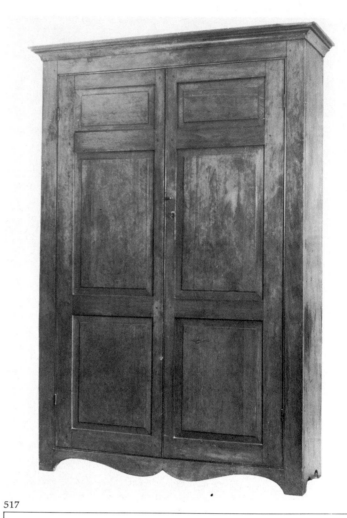

517

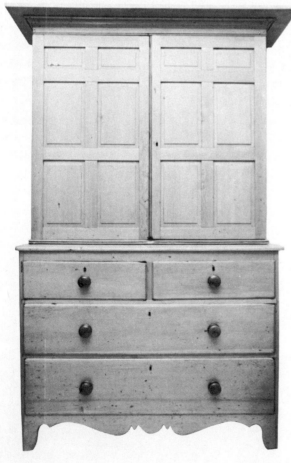

518

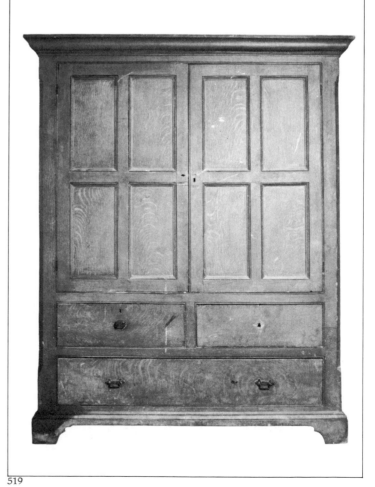

519

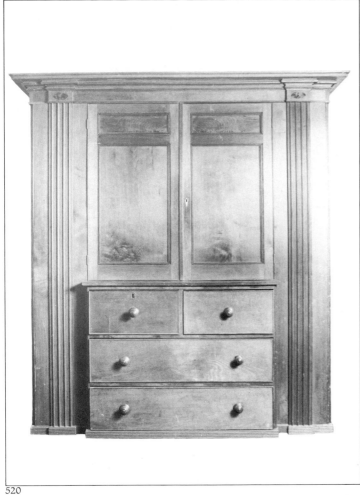

520

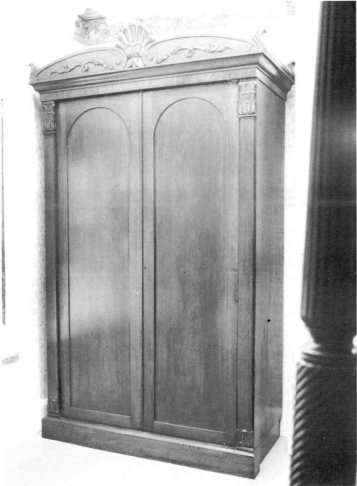

521

516 A storage cupboard from Lunenburg in Stormont County. Fitted with shelves for storage of linens, this traditional press or cupboard has the unusually exaggerated cornice with reeded frieze of the Neoclassical style which was so popular in the eastern counties. First quarter 19th century. [U.C.V.]

517 A storage cupboard from Brantford in Brant County. This piece was listed as a press in an 1849 inventory of the furnishings of "Myrtleville," home of the Good family. Similar to the previous example in form, it is of simpler construction and style and is likely of a later date. Second quarter 19th century. [P.C.]

518 A linen press from Scarborough Township in York County. (Early family: Devenish.) This pleasing provincial design relates to late 18th century British examples. Similarities in style and construction to Plates 505 and 557 from the same area indicate one maker. Second quarter 19th century. [P.C.]

519 A wardrobe from Scarboro Township in York County. The wardrobe also developed in 18th century England from the early press form including drawers below the closed cupboard with hooks or rods for hanging clothes. The typical wardrobe is wider than the linen press and is made in one piece. The bracket base, chamfered corners and simple cornice on this well-balanced design indicate a craftsman well-schooled in the British vernacular. The skilful painted finish simulating oak is most interesting, as most English country wardrobes were made of that wood. Second quarter 19th century. [P.C.]

520 A linen press from Toronto. This walnut press was made for the Grange, early home of the Boulton family. It reflects the Neoclassical style of the house built in 1817. The details of its entablature and pilasters are repeated on several mantelpieces in the home. First quarter 19th century. [G.C., A.G.O.]

521 A wardrobe from Toronto. Also from the Grange, this wardrobe is based on a more complex design in George Smith's *The Cabinet-Maker's and Upholsterer's Guide*, published in 1828. The Grecian motif in the pediment and pilasters is typical of the Regency style. First quarter 19th century. [G.C., A.G.O.]

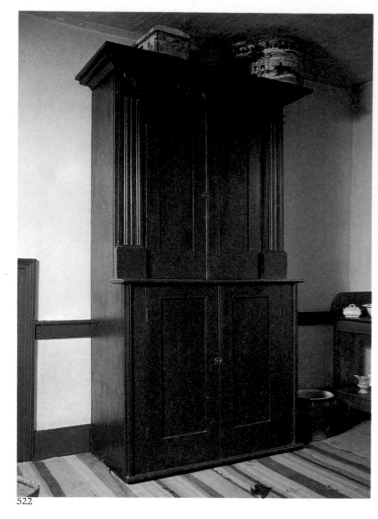

522

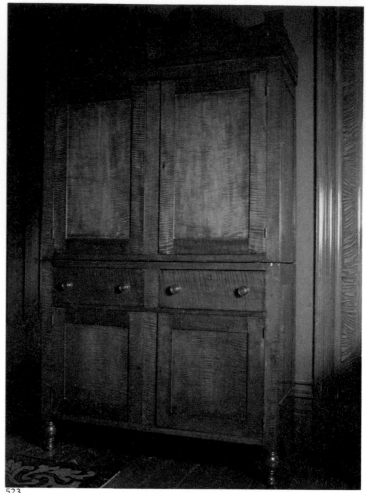

523

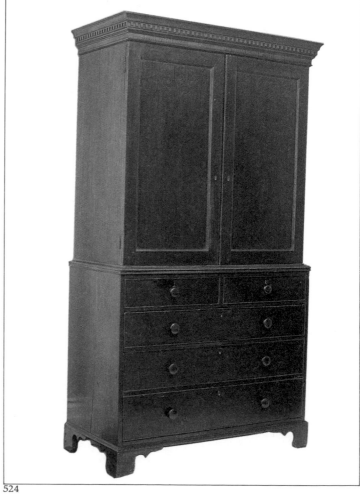

524

522 A storage cupboard from Merrickville in Grenville County. The Neoclassical entablature and pilasters which elevate this design from simple functionalism are found on many pieces of Upper Canadian furniture made in the first decades of the 19th century. However, the unassuming refinement seen in this example and the applied leaf motif combine to provide an unusually pleasing result. Second quarter 19th century. [U.C.V.]

523 A storage cupboard from Niagara-on-the-Lake. The scrolled pediment and turned feet seen on this stylish cupboard of figured maple were popular design elements in Britain and America in the early 19th century. First quarter 19th century. [P.C.]

524 A linen press from Stoney Creek in Wentworth County. (Early family: Jones.) In form and detail this refined design in walnut and figured maple is typical of presses made in the British Isles in the late 18th and early 19th centuries. The dentil cornice, door construction, cock-beaded drawers and bracket feet are characteristic features of the period and indicate an immigrant craftsman of considerable sophistication. First quarter 19th century. [N.P.C., B.H., S.C.]

525 A linen press from Waterloo County. The addition of a set of drawers to the traditional press form dates from the early 18th century when the stylish London cabinetmakers developed the convenient concept for the elegant homes of the period. By the late 18th and early 19th centuries, the related country styles were popular throughout Britain. This unusual single-door example is typical of British country–Georgian style and technique. The painted finish suggests a fine mahogany veneer. Second quarter 19th century. [P.C.]

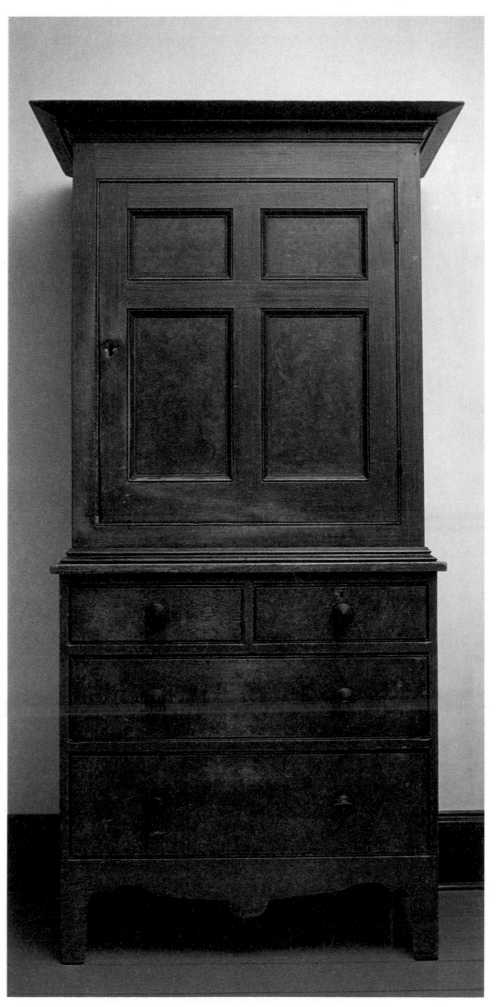

525

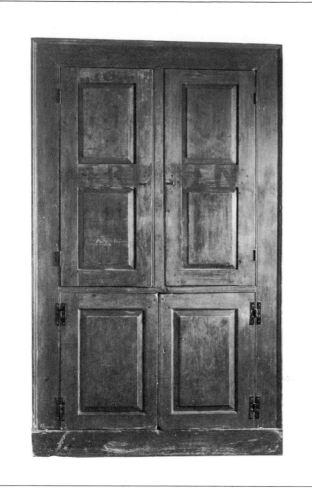

526

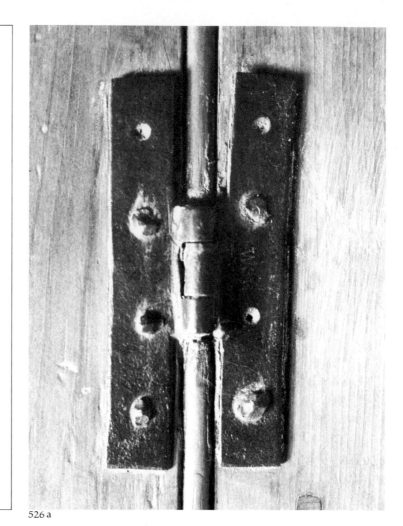

526 a

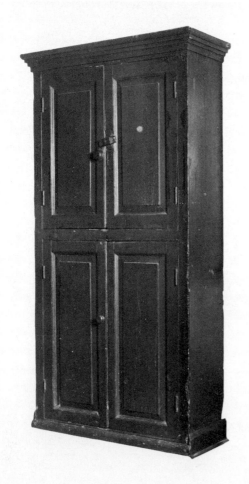

527

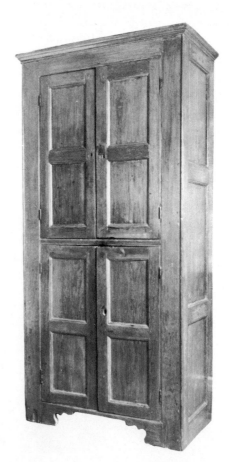

528

526 A kitchen cupboard from Frontenac County. The blind-doored, built-in cupboard found in 18th century British and American houses was included in some early Canadian rooms. More often, the same simple form was made as a movable piece of furniture. The "H" hinges indicate an early date of manufacture. First quarter 19th century. [P.C.]

527 A kitchen cupboard from Lanark County. In the Irish and Scottish country tradition, the everyday dishes and utensils were often kept in the blind-doored cupboard or press while the better china was visible on the open dresser. First quarter 19th century. [P.C.]

528 A kitchen cupboard from Lanark Village in Lanark County. Cupboards or presses of this simple panelled style were particularly popular in the traditional furnishings of the Irish kitchen. Second quarter 19th century. [P.C.]

529 A kitchen cupboard from Lonsdale in Hastings County. The elementary, Classical cornice, moulded door panels and unusually heavy construction suggest that the maker of this robust cupboard was a builder of houses. Second quarter 19th century. [P.C.]

530 A kitchen cupboard from Lanark County. The suggestion of Classical style in the fluted mock pilasters and the shaped door panels add a pleasing element of style to this simple cupboard. Second quarter 19th century. [P.C.]

531 A storage cupboard from Mariposa Township in Victoria County. This unusually small variation on the traditional theme was likely made for a particular location where space was limited. The well-designed, dovetailed bracket base, well-balanced cornice, chamfered corners and precise door construction produce a most pleasing result. Second quarter 19th century. [P.C.]

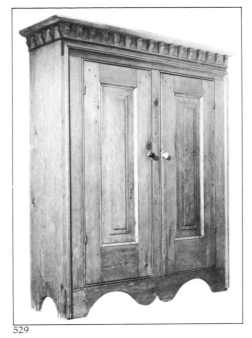
529

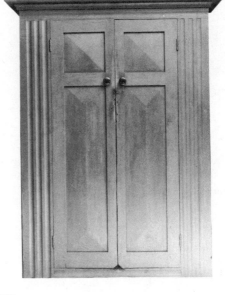
530

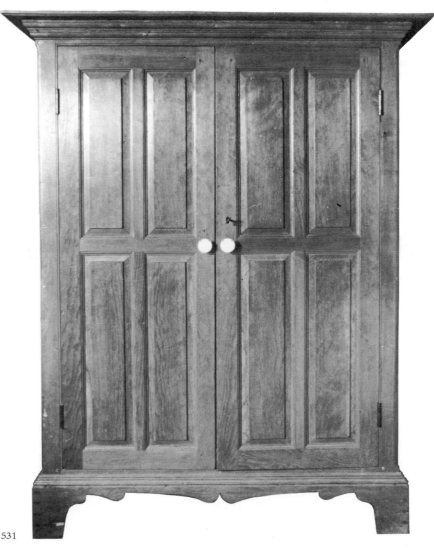
531

532 A kitchen cupboard from Frontenac County. This cupboard and those which follow may be distant relatives of the 17th and 18th century court cupboard. Simplified to eliminate the set-back and canopy usually associated with the early form, these framed and panelled cupboards are similar in plan and function. Second quarter 19th century. [P.C.]

533 A kitchen cupboard from Woodville in Victoria County. The well-articulated Neoclassical detail elevates this example of the simple form from the utilitarian category. Like most of these cupboards, it comes from an area of predominantly Irish settlement. Second quarter 19th century. [P.C.]

534 A dish cupboard from Frontenac County. This is a more formal example of this recurring eastern counties form with panelled ends, dentil cornice and an interior arch. This feature is frequently seen on British corner cupboards; however its occurrence in wall cupboards suggests an Irish craftsman. Second quarter 19th century. [P.C.]

535 A kitchen cupboard from Horning's Mills in Grey County. This cupboard comes from a later centre of Irish settlement but retains the same form as those from the eastern counties. Often, these pieces have been relegated to outbuildings as indicated by the typical "as found" condition of this example. Second quarter 19th century. [P.C.]

536 A storage cupboard from Sunderland in Ontario County. (Family: Shier-Rynard.) The simple, confident articulation of the Neoclassical style apparent in this cupboard is repeated in the detail of the house for which it was made. Although the original family was Germanic, this piece, in style and technique, suggests the work of a skilled housebuilder of British or American origin. Second quarter 19th century. [P.C.]

537 A storage cupboard from Frontenac County. The traditional press form was used for the storage of clothing and food. This free-standing piece incorporates rather countrified Neoclassical architectural entablature and pilaster elements which were popular in the early 19th century. The chip-carved detail in the frieze and centre rail is an old technique which is rarely found in Upper Canada. First quarter 19th century. [P.C.]

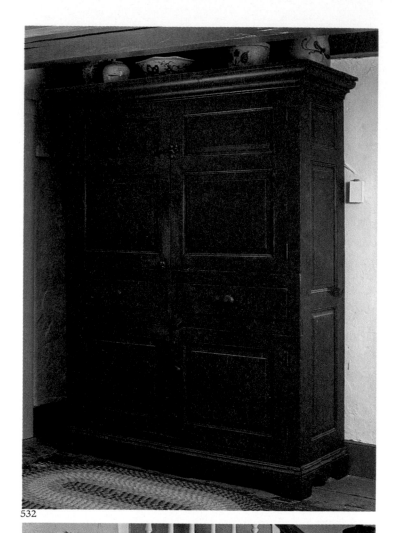

532

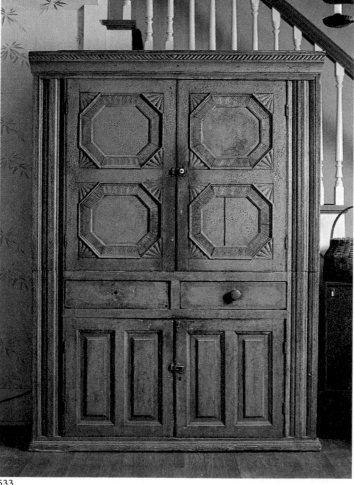

533

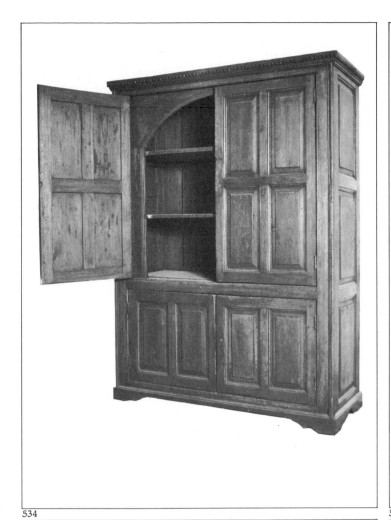

534

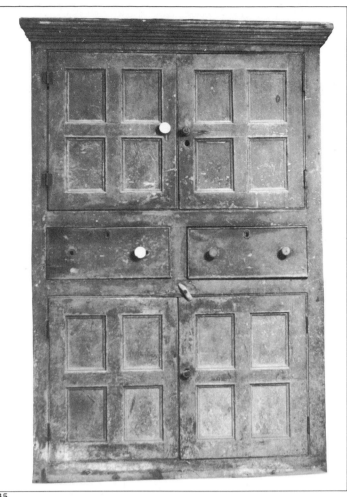

535

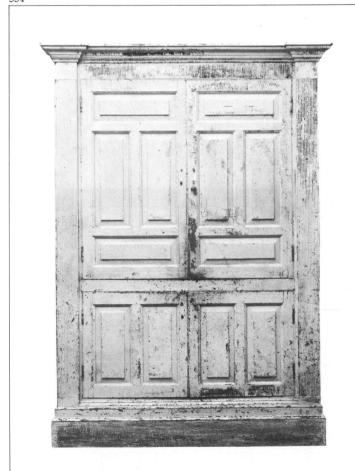

536

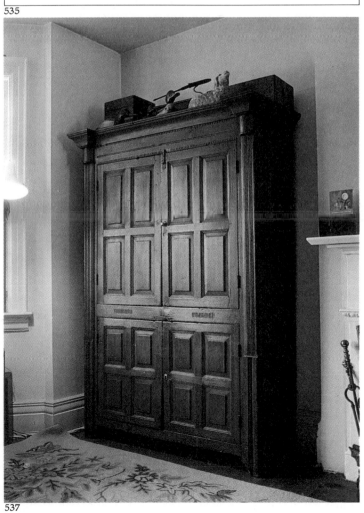

537

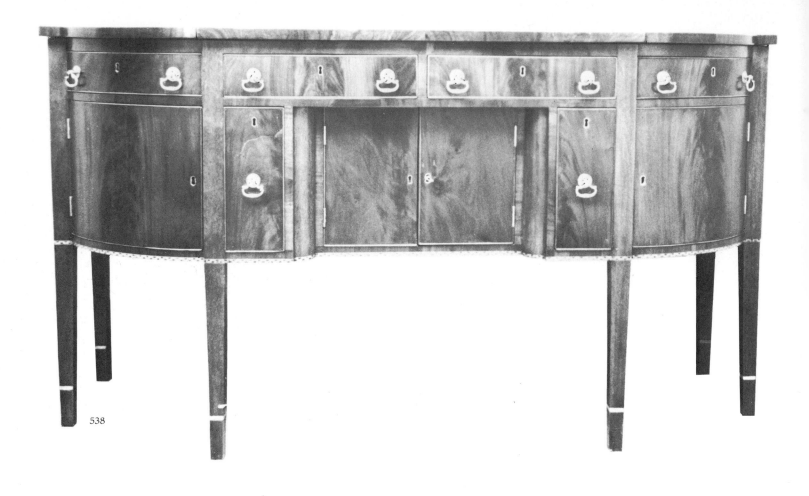

538

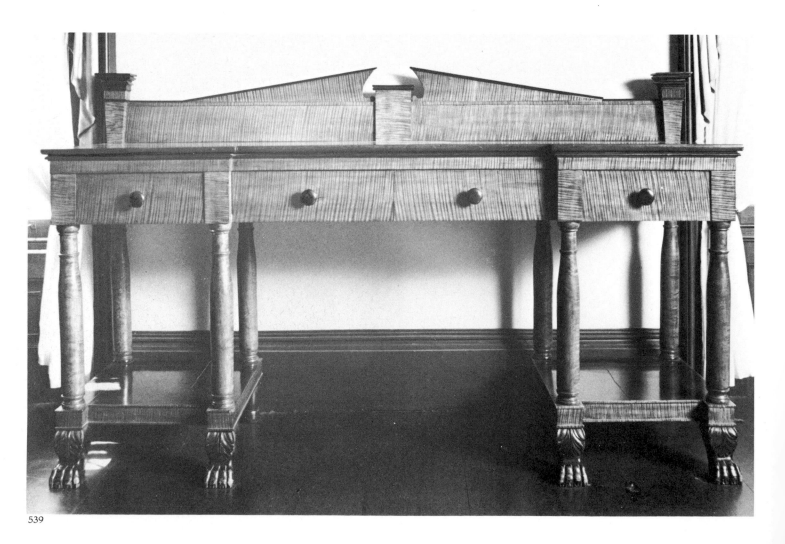

539

538 A Sheraton-style sideboard from Hamilton in Wentworth County. As with many examples of earlier furniture, little is known about the origin of this sideboard other than its survival in an area where it is equally probable that it was locally made or brought across the border from New York State at an early date. It is a proficient rendition of the style, with a slight heaviness in the vertical elements and relatively simple inlaid decoration suggesting a provincial craftsman. First quarter 19th century. [P.C.]

539 A Regency-style sideboard from Toronto, made for Beverley House, the Toronto home of Chief Justice, Sir John Beverley Robinson. Thoroughly British, this design is a very individual interpretation of proper Regency form and motif. A weakness in the supporting columns is unfortunate, but the superb workmanship and careful selection and placement of the finely figured maple represents the better standards of Upper Canadian craftsmanship. First quarter 19th century. [G.C., A.G.O.]

540 An Empire style sideboard from Frontenac County. This design incorporates a suggestion of earlier influence in the overall restraint, yet the heaviness, contrasting wood pattern and bold spiral reeding are solidly Empire. Second quarter 19th century. [P.C.]

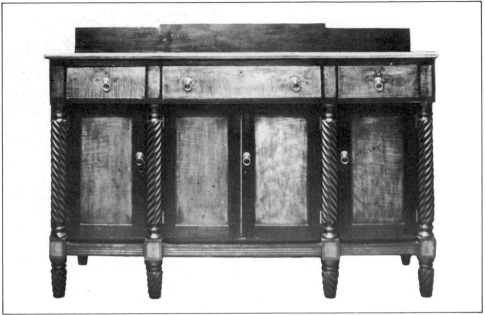

540

541 A provincial Sheraton-style sideboard from Merrickville in Grenville County. The shaping of the sideboard top to define the vertical elements, the turned leg and arched central feature are inspired by Sheraton's more elaborate designs, while the simplification and sturdiness of the execution is typical of British country craftsmanship in the early 19th century. The occurrence of rather stylish furnishings with strong influence from the late 18th century English styles is not unusual in areas settled by British military personnel whose tastes were somewhat sophisticated. First quarter 19th century. [P.C.]

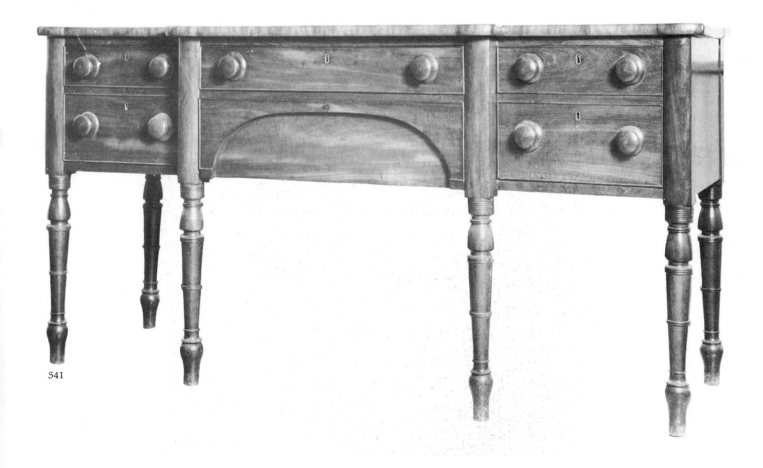

541

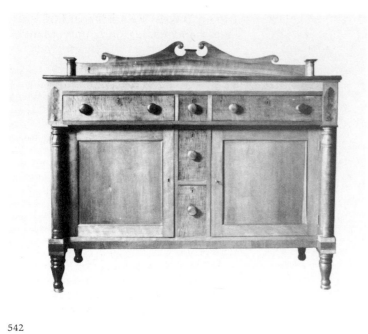

542

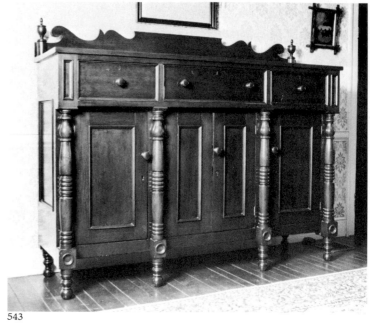

543

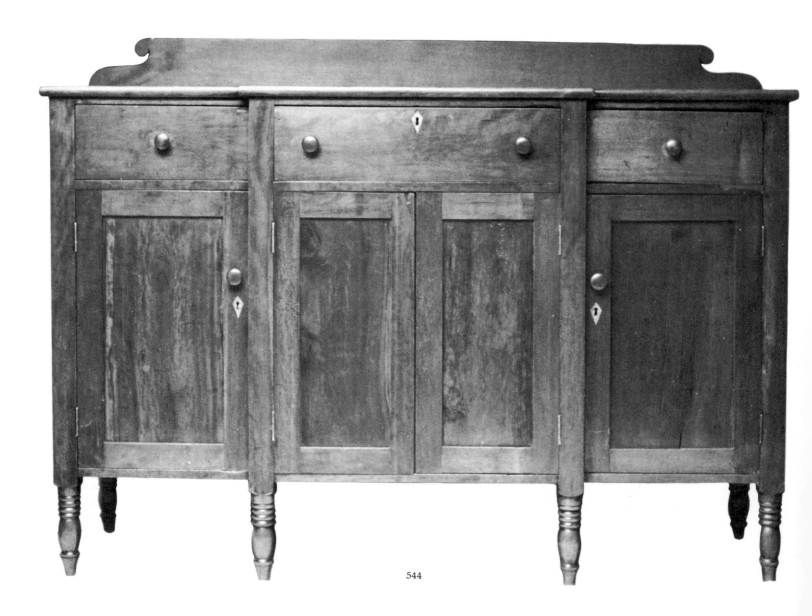

544

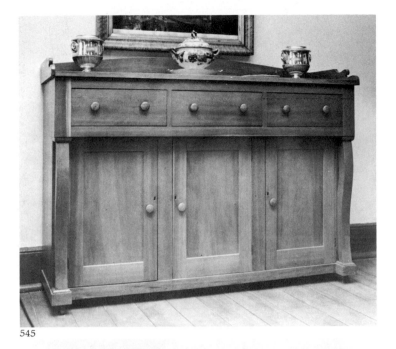

545

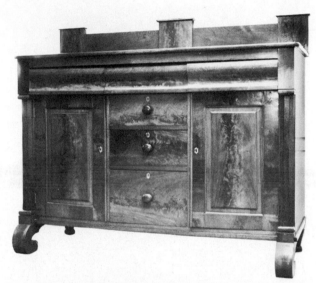

546

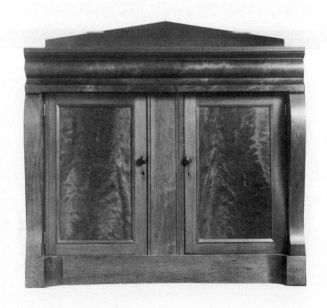

547

542 An Empire-style sideboard from Lennox and Addington County. Many Upper Canadian craftsmen approached the flamboyant Empire style with some reluctance, as illustrated here in the familiar 18th century scrolls of the backboard, the neatness of the columns and the quiet use of contrasting woods. The arrangement of drawers, including those for wine storage in the lower section, is also a carry-over from earlier styles. Second quarter 19th century. [P.C.]

543 An Empire-style sideboard from Burlington in Wentworth County. Typically Empire in plan and scale, this design has a hint of Sheraton in the character of the turned columns and finials. Walnut was a favoured wood of country furniture-makers in the western counties and was seldom combined with any other. Second quarter 19th century. [P.C.]

544 A sideboard from Welland County. (Early family: Patterson.) This is a transitional design incorporating the plan and mass of American Empire style with slender legs, restrained detail and an overall lightness which relate to earlier, Sheraton-influenced examples. Second quarter 19th century. [P.C.]

545 An Empire-style sideboard from Trafalgar Township in Halton County. (Early family: James Mason.) This conservative expression of the Empire style is unusually serene in its simple material and absence of the more typical eccentricities. The solid gallery is a pleasant country interpretation of the spindled, bracketed and mirrored designs which are seen on more stylish examples. Second quarter 19th century. [H. N. & M.E.P.]

546 An Empire-style sideboard from St. George in Brant County. (Early family: Nixon.) The heavy, scrolled feet, ogee drawer fronts and chimney-pot design of the backboard are design elements popularized by John Hall in his *The Cabinetmaker's Assistant* (1840). Like many examples from this period, this sideboard is beautifully crafted using fine, figured walnut veneers. Second quarter 19th century. [P.C.]

547 An Empire-style sideboard from Kingston in Frontenac County. Made to fit an alcove in a Kingston home dating from the 1840s, this small sideboard is a restrained interpretation of the Empire style of the John Hall variety. Second quarter 19th century. [P.C.]

548 An Empire-style sideboard from Port Robinson in Welland County. While the previous example illustrates the rather sophisticated technique of a mid-century cabinet shop with up-to-date equipment for applying veneers and producing delicate mouldings and decorative elements, this sideboard is typical of the survival of traditional joinery in the period and is likely the product of a small local shop. The addition of the two drawers at the top is an unusual feature more often seen on contemporary chests of drawers. Mid-19th century. [P.C.]

549 An Empire-style sideboard from Chatham in Kent County. This sideboard was beautifully made by "Fraser Smith & Co., Upholsterers, Undertakers, Dealers in and Manufacturers of Cabinet Wares, Chairs, etc., King St. Chatham C.W." The style is basically Empire with the overhung ogee drawers and turned columns running into the foot on each side; however, the spool turning of the columns and the decorative treatment of the doors suggest an influence from the slightly later Elizabethan revival style which became very popular at the mid-century. Mid-19th century. [C.C.]

550 A Victorian-style sideboard from Hamilton. Newly available routing equipment produced the elaborately carved flora and fauna motifs which frequently adorn quite simple forms. Mid-19th century. [P.C.]

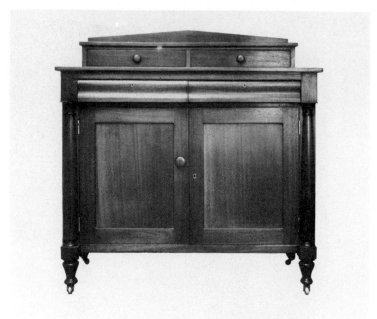

548

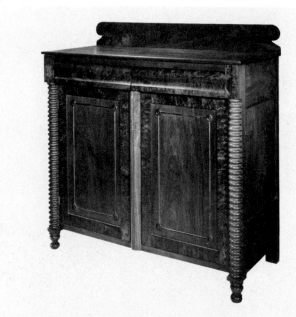

549

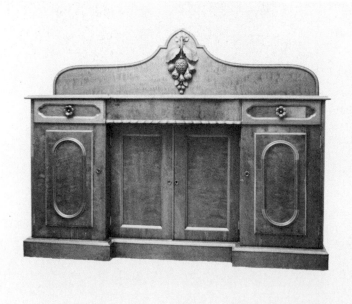

550

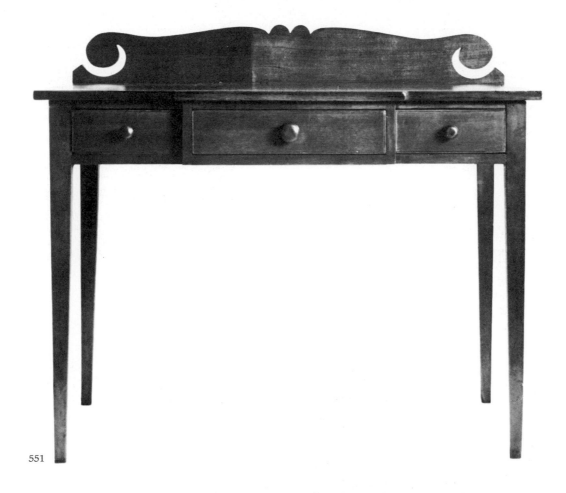

551

551 A serving table from the Niagara Peninsula. The broken-front feature sets this design apart from the simple tapered-leg table design which was a basic element in the 19th century North American vernacular and suggests an influence from a Sheraton or Hepplewhite prototype. The shaped backboard is another example of the wildfire influence of the Empire style. Second quarter 19th century [P.C.]

552 A country sideboard from Prescott in Grenville County. No doubt the maker of this charming small sideboard remembered an earlier example of the Hepplewhite or Sheraton style and there is a touch of Empire in the profile of the gallery. Second quarter 19th century. [P.C.]

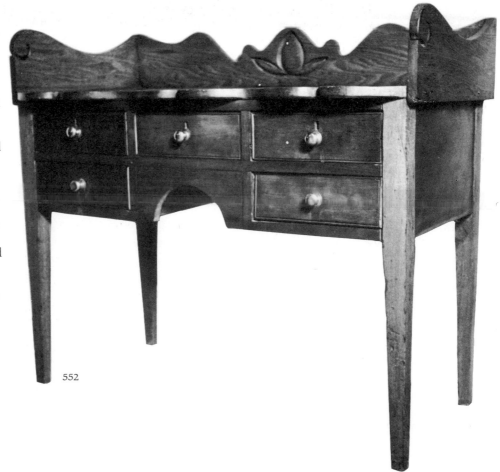

552

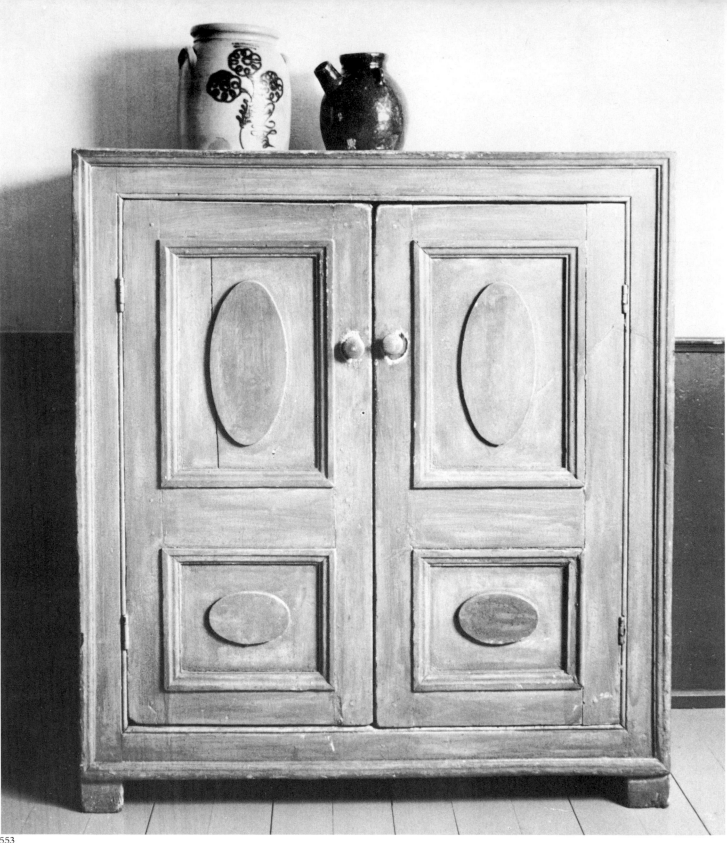

553

553 A kitchen sideboard from Arthur in Wellington County. The raised oval panels in the doors add an air of formality to this practical design. Second quarter 19th century. [P.C.]

554 A kitchen sideboard from Utica in Ontario County. The Empire scrolls quickly became part of the country joiners' vocabulary. Second quarter 19th century. [P.C.]

555 A kitchen sideboard from Middlesex County. The shoe foot was used in British country furniture, particularly in Ireland and Scotland, to raise the cupboard from the damp earth or ceramic floor. In this example, it is combined with multiple panels and egg and dart mouldings to create a decorative kitchen piece. Second quarter 19th century. [P.C.]

556 A kitchen sideboard from Lincoln County. (Early family: Lymburner.) This utilitarian design incorporates stylish Empire characteristics in the shaped backboard with chimney pot ends and in the elaborate woodgrained and striped painted finish. Second quarter 19th century. [P.C.]

557 A kitchen sideboard from Markham Township in York County. Here, the shaped base, simple French foot, flush-mounted panelled doors and lapped drawers indicate the same craftsman at work as in the glazed dresser (Plate 505). Both pieces come from early farms in northwest Markham. Second quarter 19th century. [P.C.]

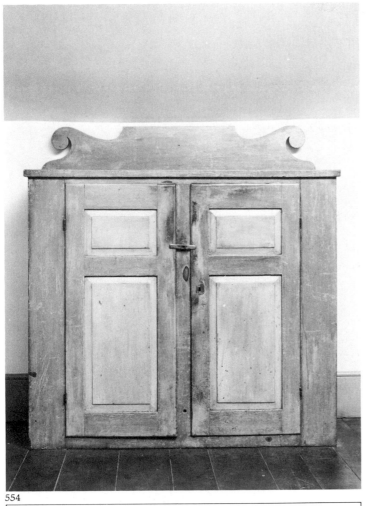

554

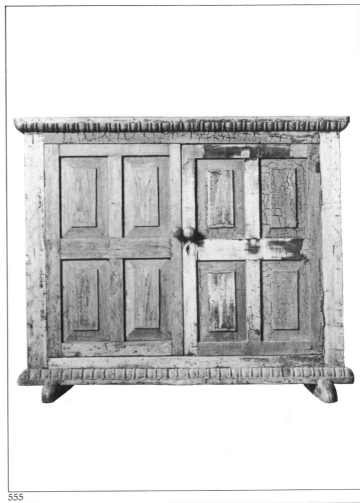

555

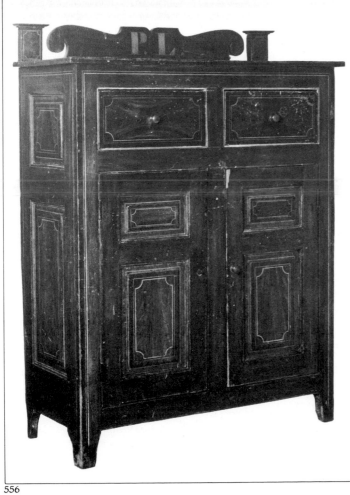

556

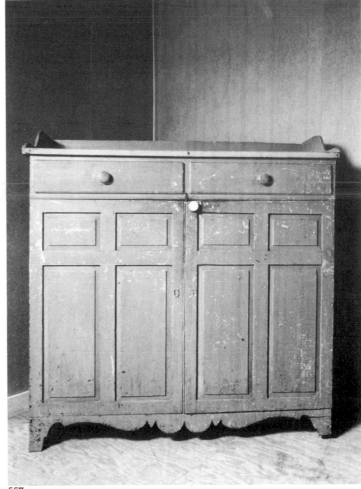

557

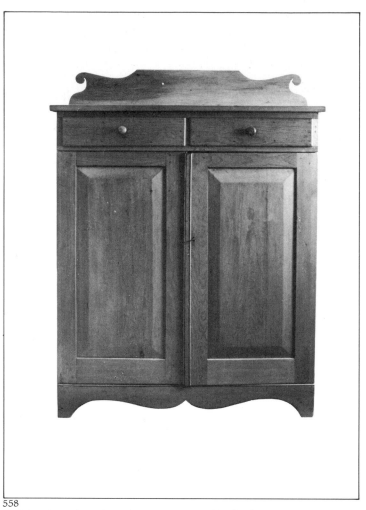

558

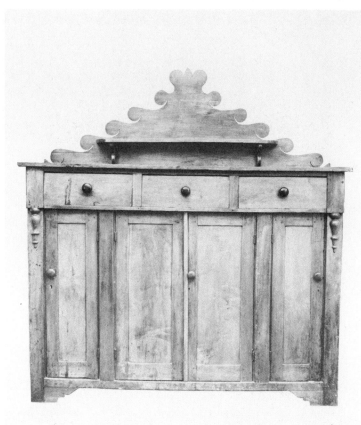

559

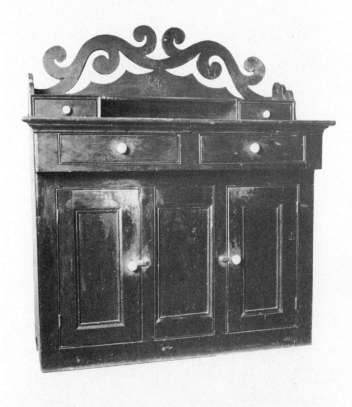

560

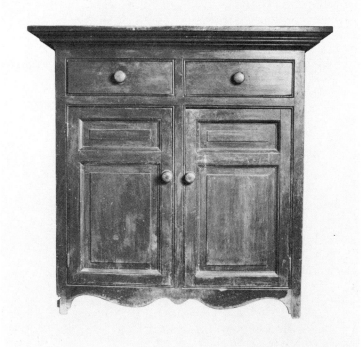

561

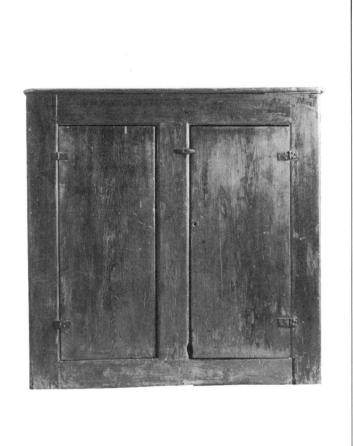

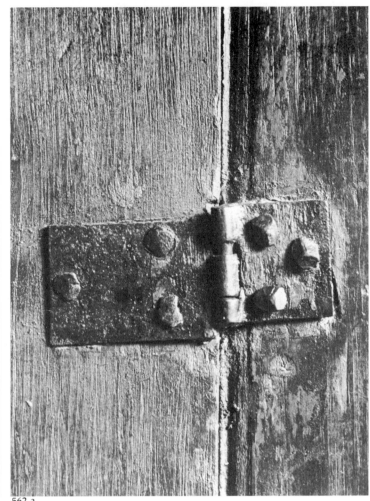

562

562 a

558 A kitchen sideboard from Markham Township in York County. This cupboard comes from the same area as the previous one and includes similar drawer construction, flush-mounted doors and a related bracket base. The deep chamfer on the door panels is unusual, as it was most often turned to the inside with a simple or fielded panel exposed. Second quarter 19th century. [P.C.]

559 A kitchen sideboard from Claremont in Ontario County. This country maker had a basic idea of the elements and style of a formal Empire sideboard which were happily overpowered by his forceful creative urge. Mid-19th century. [P.C.]

560 A kitchen sideboard from Simcoe County. Country craftsmen occasionally adopted Empire motifs with naïve charm and great enthusiasm. Third quarter 19th century. [P.C.]

561 A kitchen sideboard from Oxford County. This pleasing example of country joinery includes cock-beading around drawers and doors. The scale of the bead detail is designed to hide the cast hinge which is set into it. Second quarter 19th century. [P.C.]

562 A preserve cupboard from the eastern counties. This early cupboard is simple, but not of primitive construction. A skilled joiner carefully mortised and tenoned and pinned the frame and moulded the door openings. The hinges are hand-forged. Late 18th or early 19th century. [P.C.]

563 A cutlery tray from Durham County. A vernacular design of fine character with heart-shaped handle cut-out. Second quarter 19th century. [P.C.]

563

564 A dough box from the eastern counties. This is a nicely crafted small box for bun dough. A wooden scoop from the eastern counties and a wooden cookie cutter crafted to a knife edge from Frontenac County. First half 19th century. [P.C.]

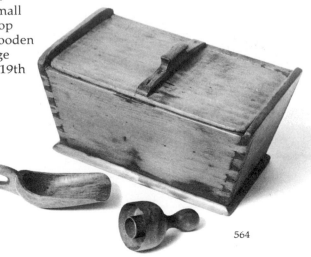

564

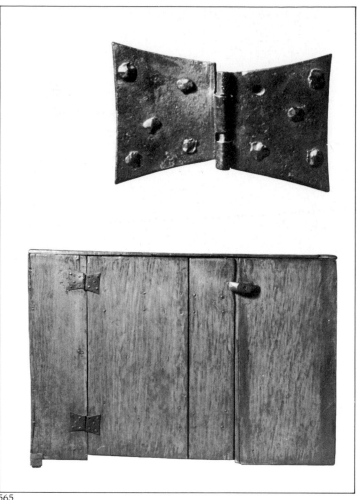

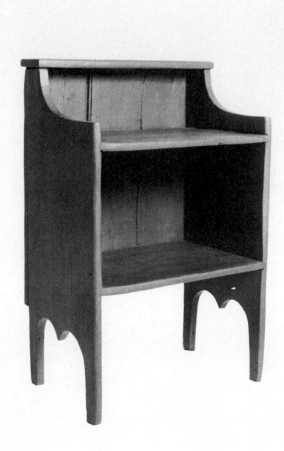

565

566

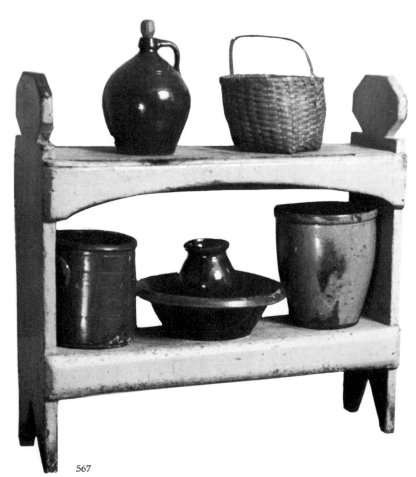

567

565 A pail cupboard from Grenville County. A very early primitive piece with butterfly hinges. Late 18th century or early 19th century. [P.C.]

566 A pail bench from Prince Edward County. Second quarter 19th century. [P.C.]

567 A pail bench from Lennox and Addington County. Second quarter 19th century. [P.C.]

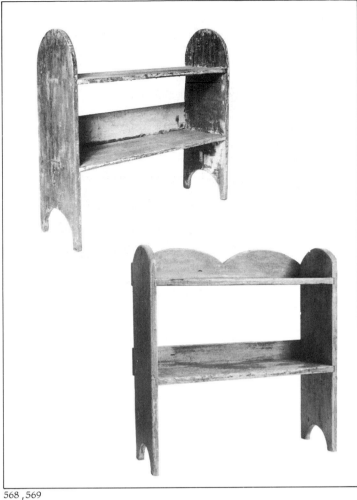

568 ,569

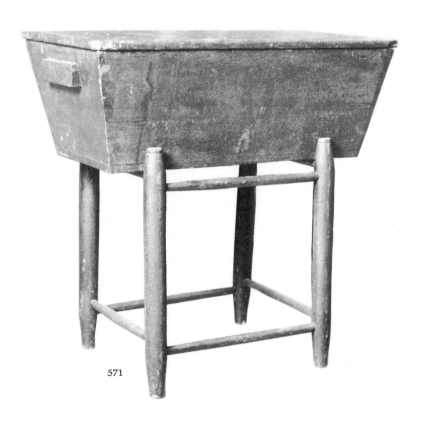

570

568 A pail bench from Prince Edward County. Mortised construction. Second quarter 19th century. [P.C.]

569 A pail bench from the eastern counties. Second quarter 19th century. [P.C.]

570 A dough box from Lennox and Addington County. Neatly dovetailed. Second quarter 19th century. [L. & A.C.M.]

571 A dough box from Lennox and Addington County. The box can be removed from the stand and placed near the warmth of the fire. Second quarter 19th century. [L. & A.C.M.]

571

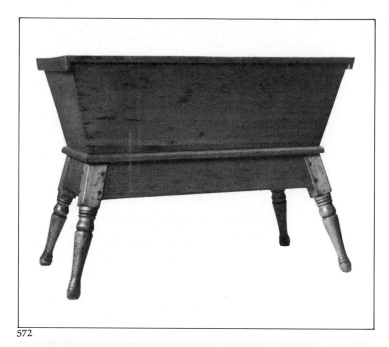

572

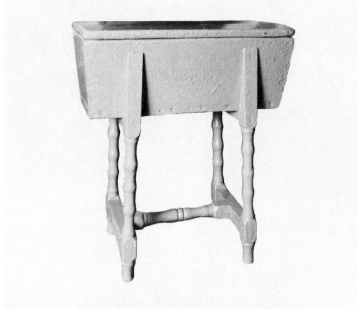

573

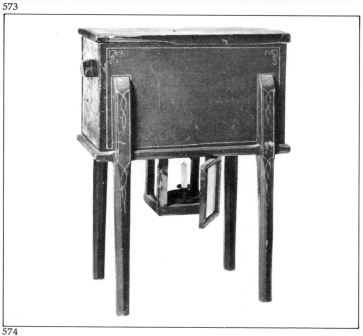

574

572 A dough box from the eastern counties. The tapered, dovetailed box with splayed, turned legs was a common design from 18th and 19th century Britain. Second quarter 19th century. [P.C.]

573 A dough box from Lennox and Addington County. A turned "H" stretcher base of early character. Second quarter 19th century. [P.C.]

574 A dough box from Lennox and Addington County. A rare and possibly unique design. The candle below provided the desired warmth for the dough to rise. Third quarter 19th century. [P.C.]

575 A wall cupboard from Simcoe County. The simple detail and single raised and chamfered panel produce an unusually pleasing result. Second quarter 19th century. [P.C.]

576 A wainscot corner cupboard from Lennox and Addington. Designed to sit on the wainscot rail, this large hanging cupboard incorporates rather primitive Neoclassical fan motifs. Second quarter 19th century. [P.C.]

577 A corner cupboard from York County. Style was of no concern to the maker of this functional piece. Second quarter 19th century. [P.C.]

578 A candle rack from Carleton County. An 18th century form cleverly fashioned to incorporate a tree crotch in the tripod base. Early 19th century. [P.C.]

579 A set of pewter candle moulds in frame from Northumberland County. 18 pewter moulds. Early 19th century. [P.C.]

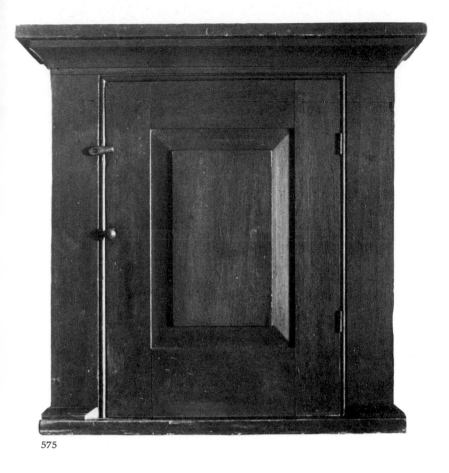

575

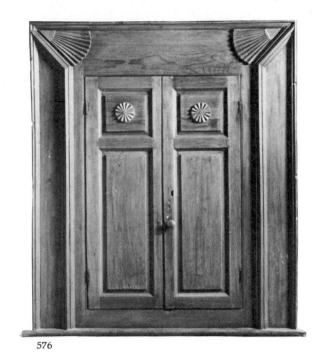

576

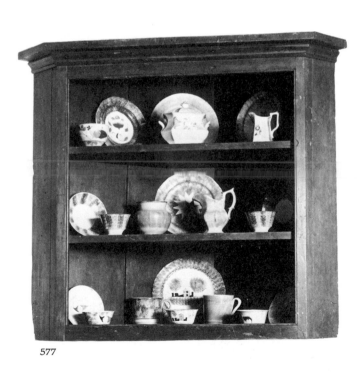

577

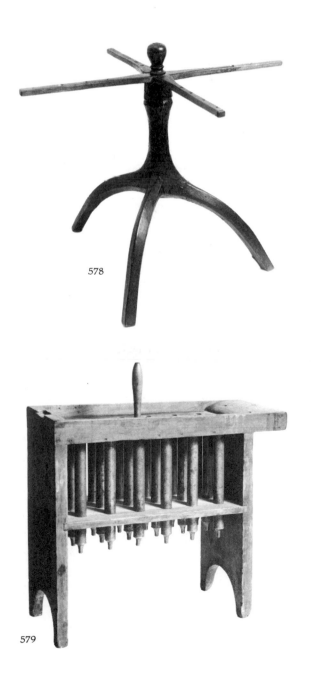

578

579

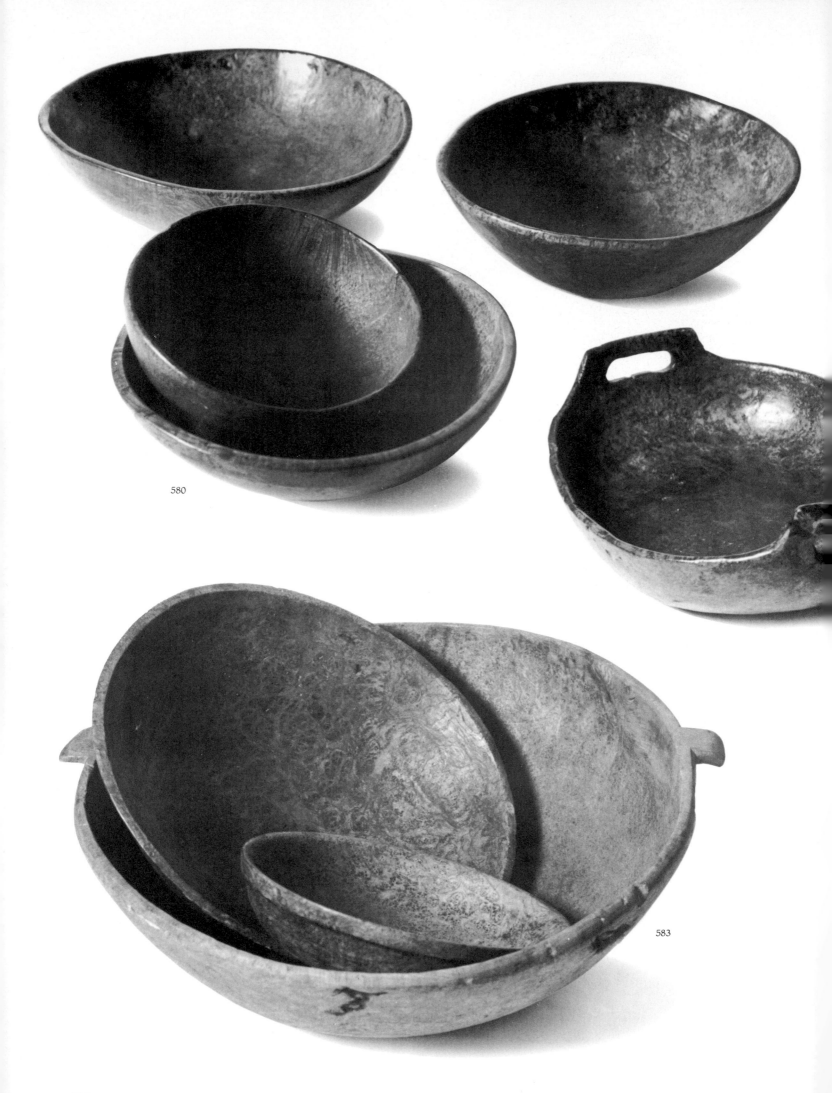

580

583

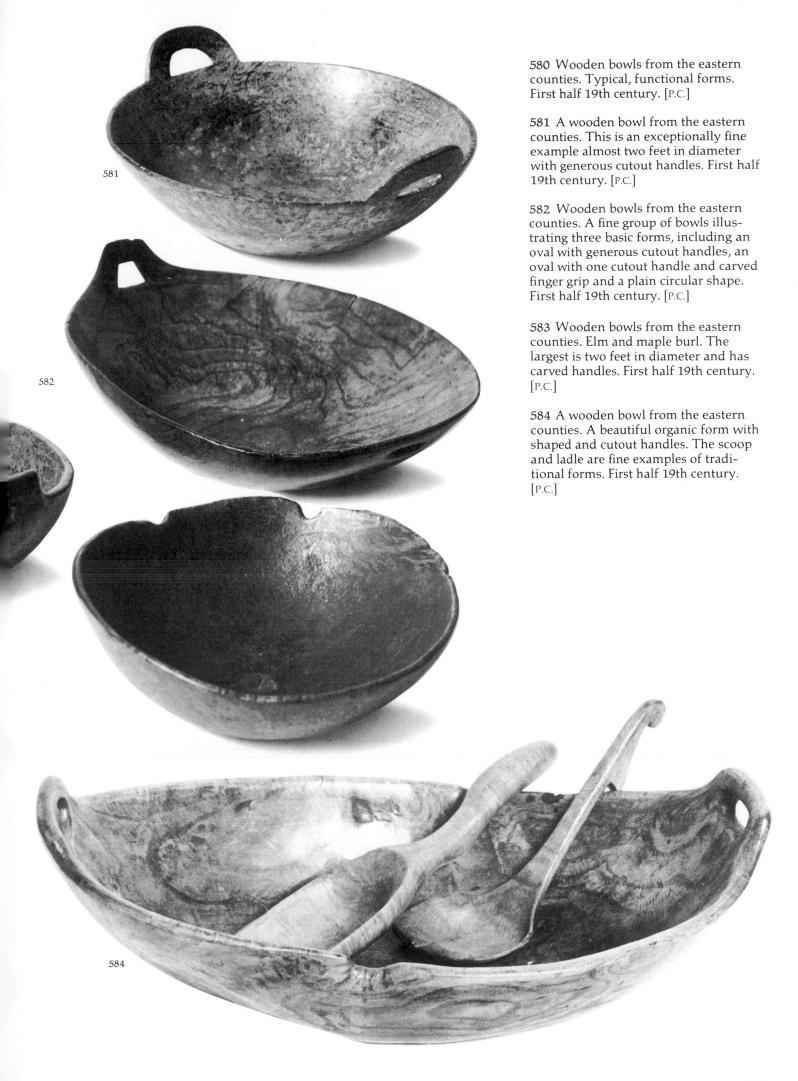

580 Wooden bowls from the eastern counties. Typical, functional forms. First half 19th century. [P.C.]

581 A wooden bowl from the eastern counties. This is an exceptionally fine example almost two feet in diameter with generous cutout handles. First half 19th century. [P.C.]

582 Wooden bowls from the eastern counties. A fine group of bowls illustrating three basic forms, including an oval with generous cutout handles, an oval with one cutout handle and carved finger grip and a plain circular shape. First half 19th century. [P.C.]

583 Wooden bowls from the eastern counties. Elm and maple burl. The largest is two feet in diameter and has carved handles. First half 19th century. [P.C.]

584 A wooden bowl from the eastern counties. A beautiful organic form with shaped and cutout handles. The scoop and ladle are fine examples of traditional forms. First half 19th century. [P.C.]

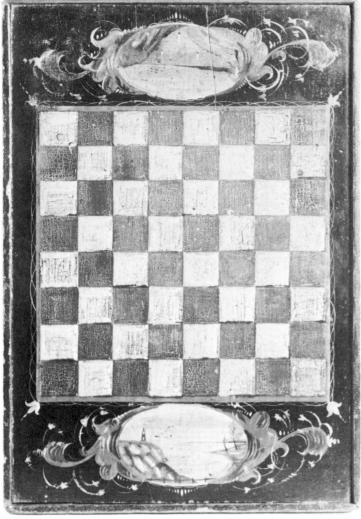

585

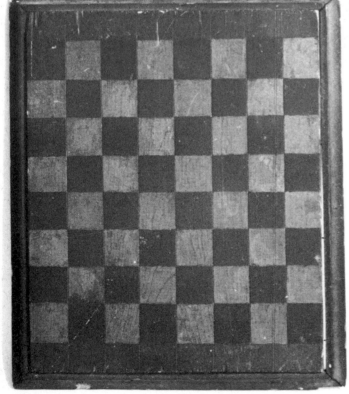

586

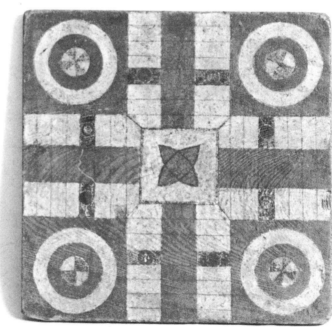

587

585 A checker board from Port Dover in Norfolk County. Decorated with professional facility, incorporating landscape vignettes which appear to be local scenes. Mid-19th century. [P.C.]

586 A checker board from Belleville in Hastings County. A pleasing design using colour contrasted with natural wood. 19th century. [P.C.]

587 A parchesi board from Newtonville in Durham County. A strong graphic design, carefully rendered. 19th century. [P.C.]

588

588 A storage chest from Leeds County. The prototype for this simple Upper Canadian chest is found in the British tradition of medieval times. Many of the earliest chests were of this practical form. This example is of lapped joint construction secured by hand-forged nails. There were no hinges. First quarter 19th century. [P.C.]

589 A storage chest from Pickering Township in Ontario County. This is a rare example of a framed and panelled chest which, while important in the British tradition, was seldom used in Upper Canada. Second quarter 19th century. [P.C.]

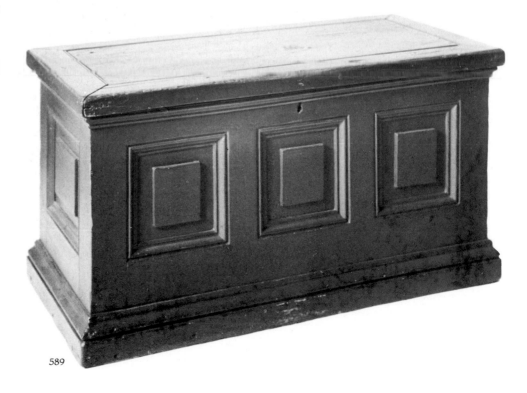

589

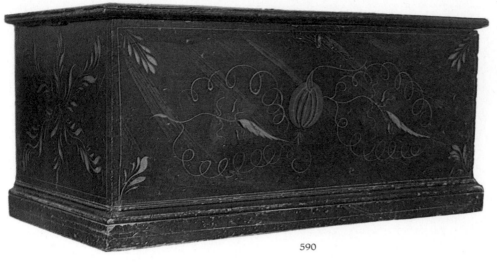

590

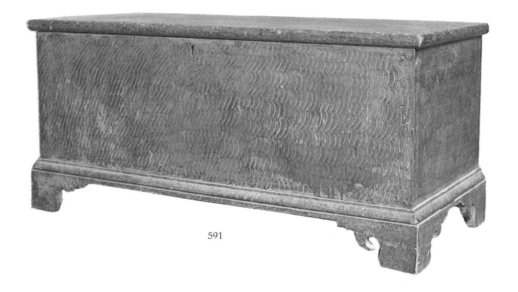

591

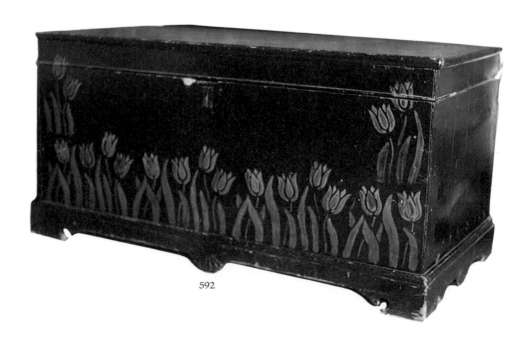

592

590 A storage chest from Prince Edward County. The sophisticated calligraphic character of this painted decoration suggests the hand of a professional painter. Second quarter 19th century. [P.C.]

591 A storage chest from Elgin County. This six-board chest is dovetailed and stands on a well-formed bracket base of 18th century style. The painted decoration is an impressionistic wood grain combed through a dark overpaint. Second quarter 19th century. [P.C.]

592 A storage chest from Leeds County. This simple design is removed from the ordinary by the stencilled tulips which are stylized in a manner reminiscent of a quilt pattern, and the bracket base is enriched with a small fan motif. Second quarter 19th century. [P.C.]

593 A storage chest from York County. This is an unusually dramatic example of abstract decoration using a sponge or putty on the thinned, dark overpaint. Second quarter 19th century. [B.C.P.V.]

594 A storage chest from Elgin County. The moulded bracket base here is an unusual stylization of 18th century designs. Of note also is the visual impact of the original painted decoration employing a repeated dab technique. Second quarter 19th century. [P.C.]

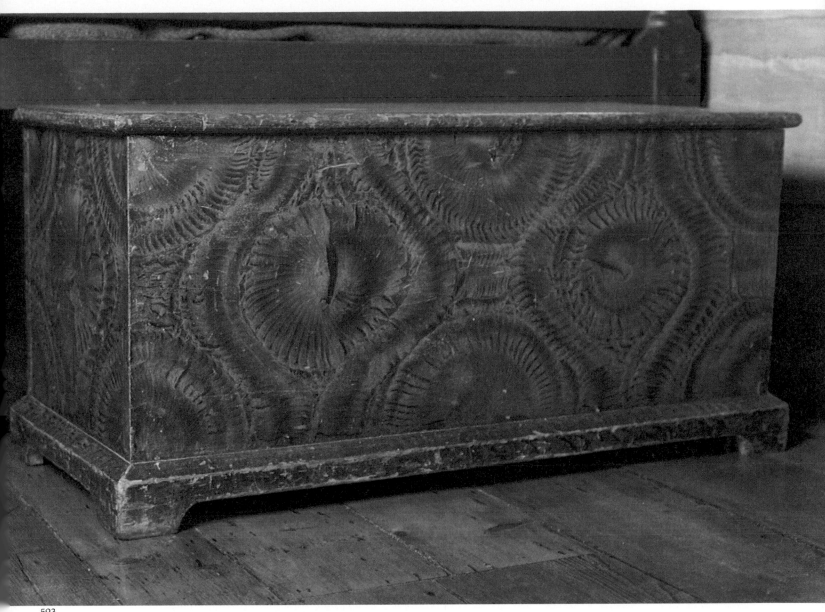

593

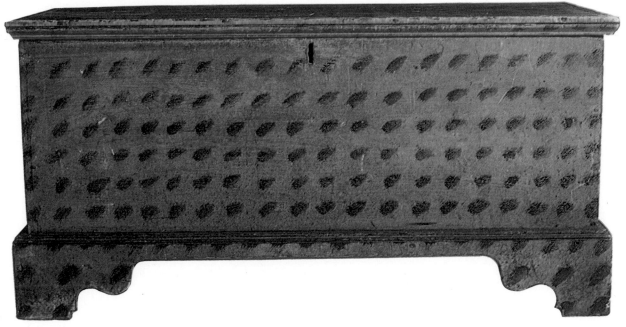

594

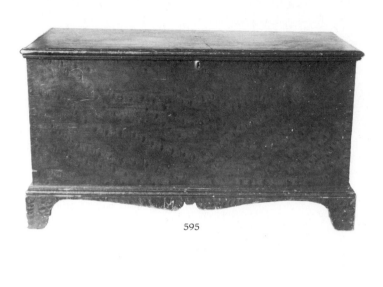

595

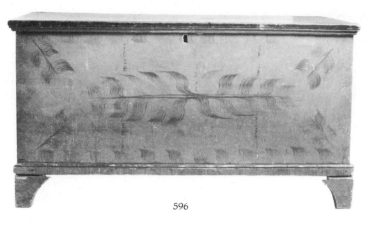

596

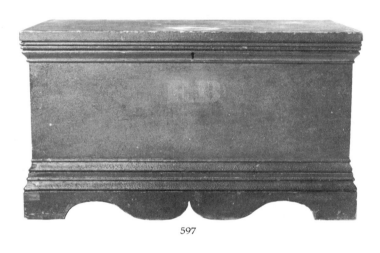

597

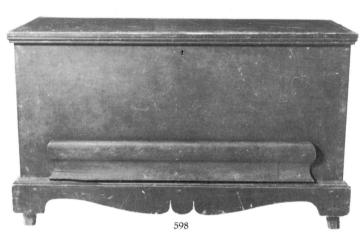

598

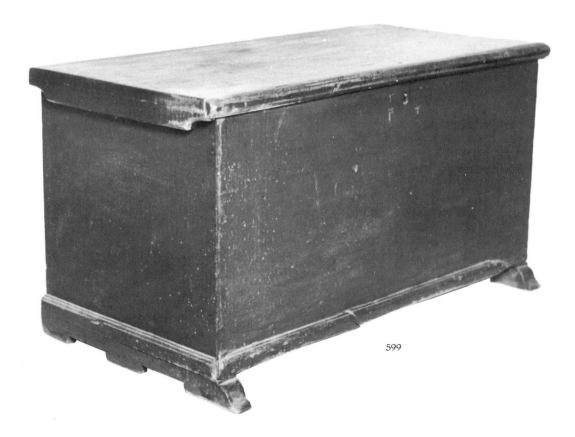

599

595 A storage chest from York County. The shaped and moulded bracket base on this well-crafted six-board chest was a popular 19th century vernacular style based on late 18th century formal influence. Second quarter 19th century. [P.C.]

596 A storage chest from the western counties. The decorative effect of a feather painted leaf motif is the major feature of this simple six-board form. Second quarter 19th century. [P.C.]

597 A storage chest from Brockville in Leeds County. This six-board chest with shaped bracket base is set apart from the average by the multiplicity of moulded details and the decorative rendering of the owner's initials. Second quarter 19th century. [P.C.]

598 A storage chest with drawer from Hastings County. This country craftsman added a touch of Empire style to a basic vernacular design in the form of a heavy ogee-shaped drawer. Second quarter 19th century. [P.C.]

599 A storage chest from Peterborough County. (Early family: McFarlane.) The shoe foot replaces the more typical bracket type in this six-board chest, suggesting an Irish or Scottish maker. First quarter 19th century. [P.C.]

600 A storage chest with drawers from Ontario County. This framed and panelled chest with two drawers below was a popular British joiner's style in the 17th and 18th centuries and is called a mule chest there. Upper Canadian examples are extremely rare. First quarter 19th century. [P.C.]

601 A storage chest with drawers from Grey County. This example of the traditional British panelled chest style is not of the early type incorporating the heavy corner posts. Here, the framing is butt-joined at the corner with a reel and dart quarter column insert. Mid-19th century. [P.C.]

602 A storage chest with drawers from Oxford County. The elevation of the bracket base and the well-defined profile of the feet are the major features of this walnut chest. A cleated top, fine dovetailing and scratch-beaded drawer detail are combined by a skilled craftsman well schooled in 18th century style. Possibly of American origin. Early 19th century. [P.C.]

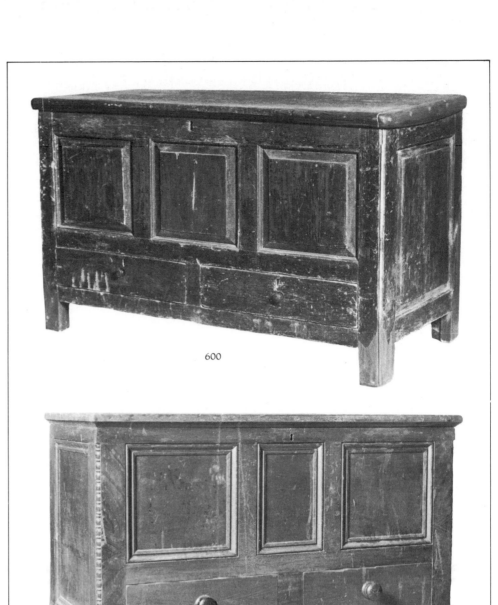

600

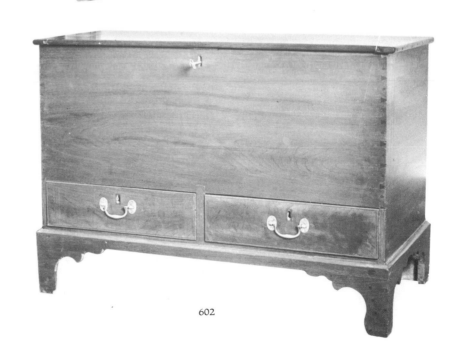

601

602

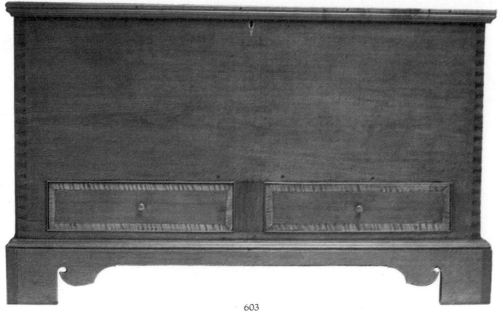

603

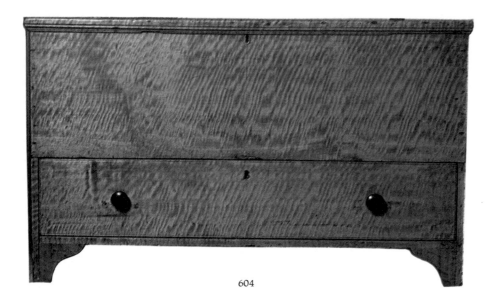

604

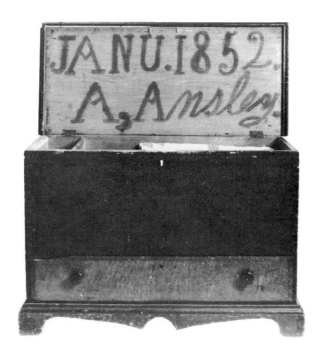

605

603 A storage chest with drawers from the Niagara Peninsula. (Early family: Smith.) This example is removed from the utilitarian category by the hand of a skilled cabinetmaker. The style and details, including crossbanding, cockbeading, inlaid escutcheon and well-defined bracket foot, reflect 18th century British and American designs of formal character. An identical chest may be seen in the collection at Black Creek Pioneer Village. First quarter 19th century. [P.C.]

604 A storage chest with drawer from the eastern counties. Although this chest is of simple butt-joint construction, the decorative quality of figured maple, finely drawn mouldings and beaded drawer successfully create provincial formality. Second quarter 19th century. [P.C.]

605 A storage chest with drawer from Newburg in Lennox and Addington County. (Signed and dated.) Some pretence to style is apparent in the use of butternut and birdseye maple in this chest of common design. 1852. [P.C.]

606 A chest-on-chest from Amherst Island in Lennox and Addington County. This is a rare example of early form, style and traditional joinery. The boarded, lift-top chest with false drawers fits into the moulded reveal of the lower section of stile and rail construction. As is seen on some panelled British chests supported on heavy corner styles, a bracket base has been applied. A similar example is illustrated in Jean Palardy, *The Early Furniture of French Canada*, Plate 22. First quarter 19th century. [P.C.]

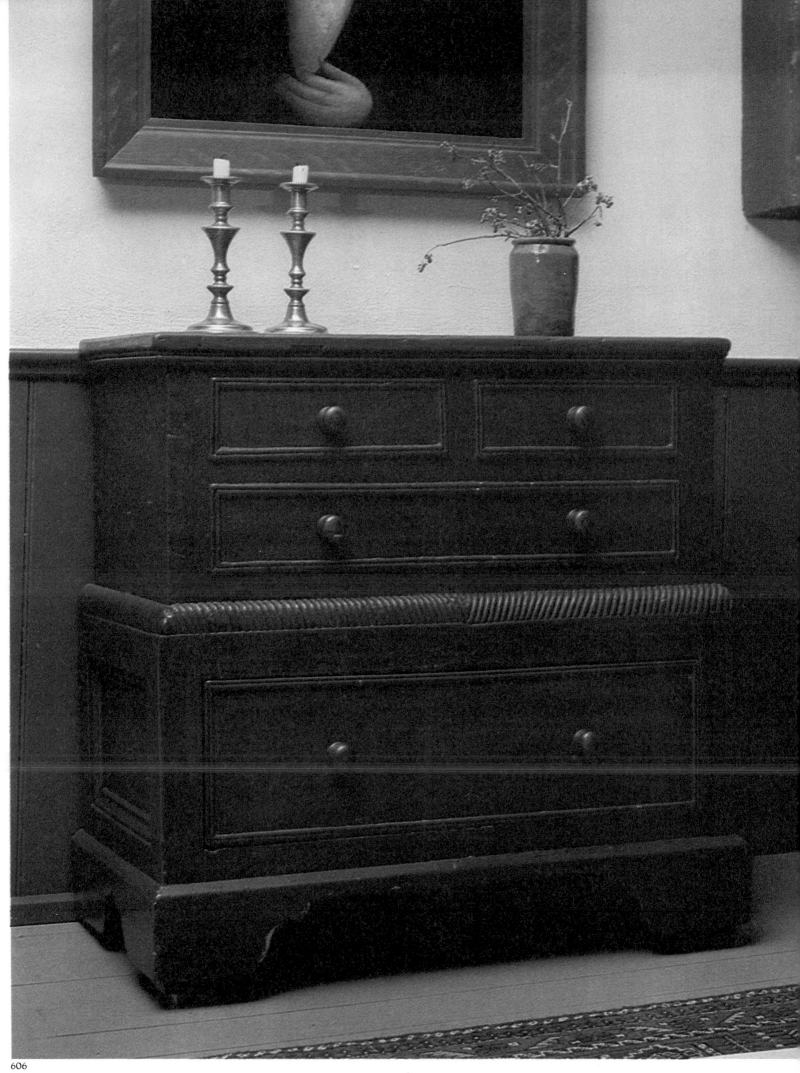

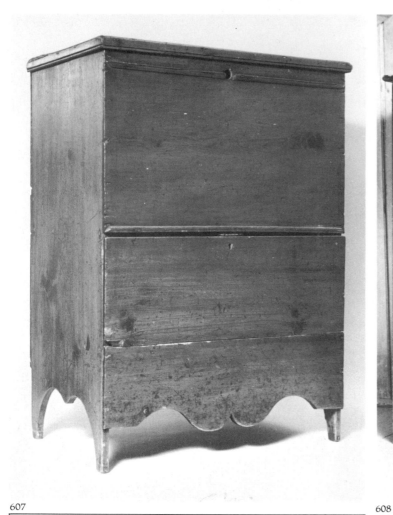

607

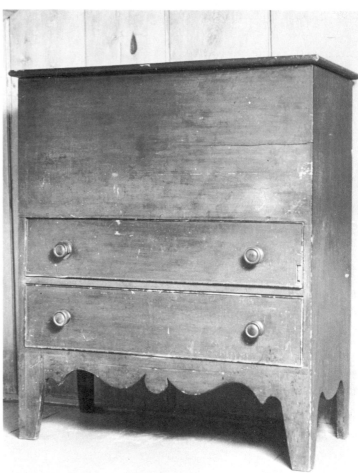

608

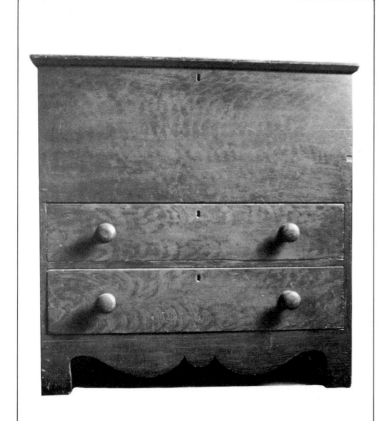

609

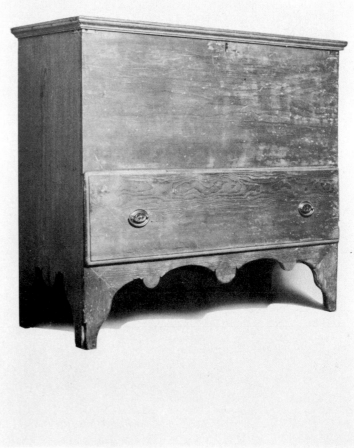

610

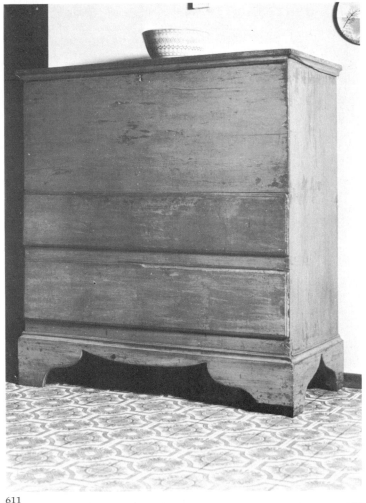

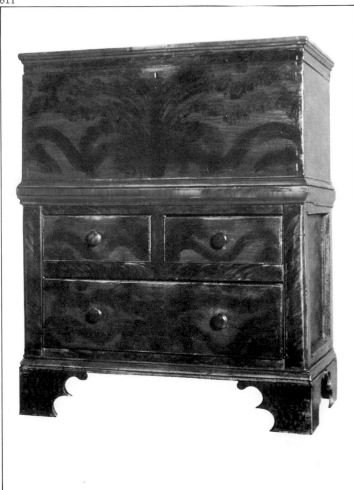

611

612

607 A storage chest with drawer from the eastern counties. This is a carpenter's development of the simple bootjack trestle chest design. The feet on the unusually deep apron board have been damaged from an early date. First quarter 19th century. [P.C.]

608 A storage chest with drawers from Lanark County. This is a country version of late 18th century style with shaped skirt and a simple elevated French foot. A popular style in the United States, it occurs in Upper Canada as a result of influence and immigration from the south. Second quarter 19th century. [P.C.]

609 A storage chest with drawers from the eastern counties. Typically, this simple bracket-front chest is painted to suggest an exotic wood grain. Second quarter 19th century. [U.C.V.]

610 A storage chest with drawer from Hastings County. Signed, *Cornelius Wawn, 1825.* The chest with drawers below is an early transitional form which led to the chest of drawers in the British tradition and was a popular form in early America. This example, with nicely shaped bracket base and lipped drawer, is typical of late 18th and early 19th century New England country style. 1825. [P.C.]

611 A storage chest with drawers from Lanark County. This is a strong vernacular design with a well-shaped bracket base and lapped drawers. First quarter 19th century. [P.C.]

612 A chest-on-chest from Waterloo County. This example combines the same form and construction characteristics as Plate 606, but is considerably larger, with three drawers below. The bracket foot is an interesting caricature of earlier style. Second quarter 19th century. [P.C.]

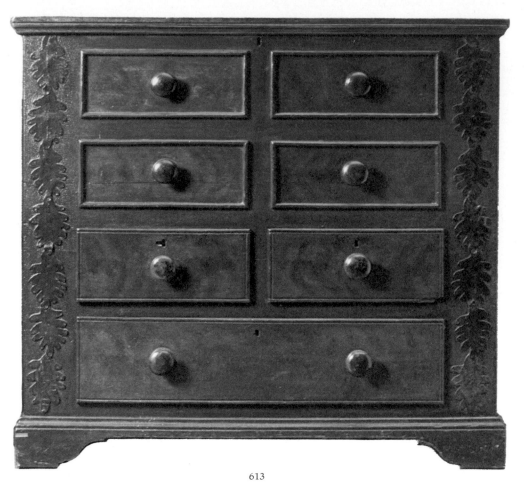

613

613 A storage chest with drawers from Lanark County. The top drawers on this unique folk-decorated, lift-top chest are false, with mouldings and painted wood grain creating the illusion. The lower drawers are lipped with scratch-beaded detail. The major feature is the subtle, painted decoration and the repeated oak leaf applique which is of leather. Second quarter 19th century. [P.C.]

614 A storage chest with drawers from Prince Edward County. The upper two drawers are false in this well-crafted chest which has a good bracket base and cock-beaded drawers. It retains its exceptional painted finish which imitates figured maple with walnut crossbanding and string inlay. Second quarter 19th century. [P.C.]

615 A storage chest with drawers from Frontenac County. Provincial craftsmen adapted the reeded detail of 18th century Neoclassical style with some enthusiasm. Here, reeded panels are placed in alternate directions to lighten this large chest with bracket foot. Second quarter 19th century. [P.C.]

616 A storage chest with drawers from Stevensville in Welland County. (Early family: White.) This austere design is appealing for its precise craftsmanship and the quality of carefully selected cherrywood. The lapped-drawer detail and dovetailed bracket feet are admirable features. Early 19th century. [P.C.]

617 A storage chest with drawer from Leeds County. This chest illustrates a high standard of traditional provincial joinery. It is of stile and rail construction, with panelled ends and a fixed panel matching the detail of the functional drawer in front. The inset quarter columns and richly moulded and dovetailed bracket base complete a pleasing reflection of 18th century style. Second quarter 19th century. [P.C.]

618 A storage chest with drawer from Uxbridge in Ontario County. The popular influence of the Sheraton style is seen in many related examples of this framed and panelled chest, standing on slender turned feet. This one retains its original two-colour paint. Second quarter 19th century. [P.C.]

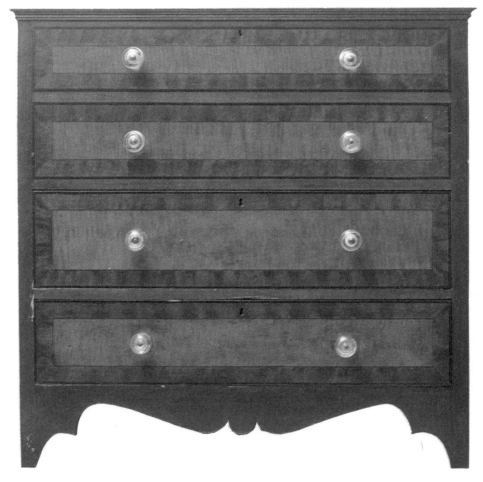

614

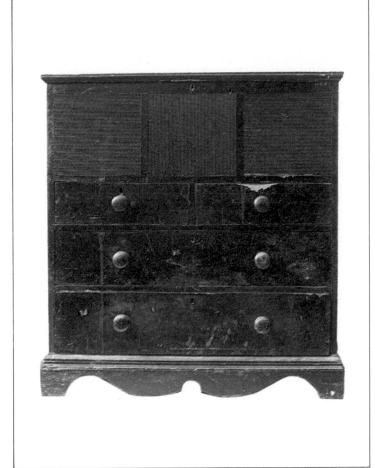

615

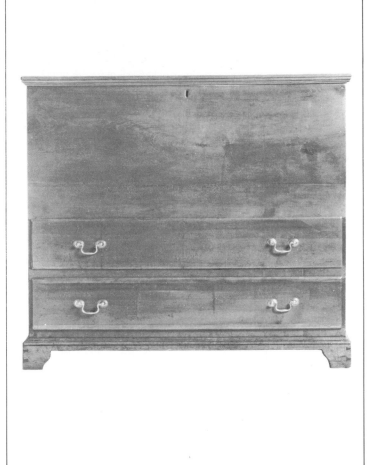

616

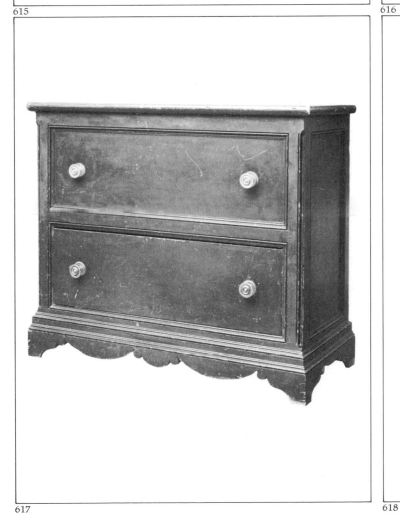

617

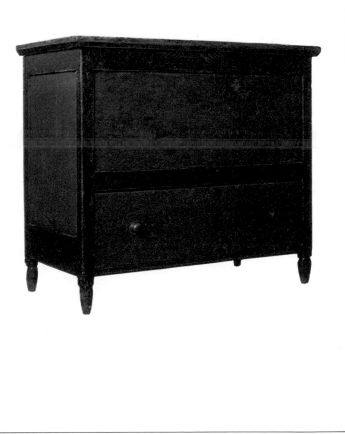

618

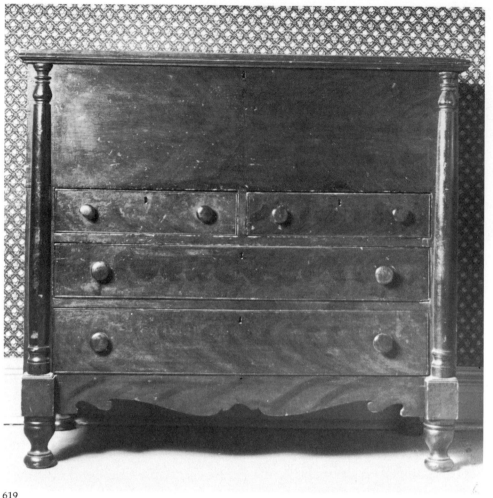

619

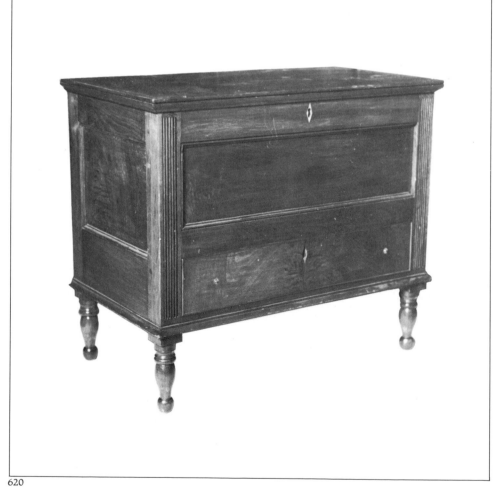

620

619 A storage chest with drawers from Kingston. This example is set apart from the ordinary with split columns and turned feet of Neoclassical style. Second quarter 19th century. [P.C.]

620 A storage chest with drawers from Wentworth County. (Early family: Easterbrooke.) This is a more formal example of the Sheraton-influenced style than the preceding one and is made of walnut with reeded stiles and ivory escutcheons. Second quarter 19th century. [P.C.]

621 A box from Welland County. Inscribed, *Susan Gainer, February 15, 1873*. This charming decoration, both inside and outside, employs a repeated pattern of the same elements which appear to have been transferred as in block printing. 1873. [P.C.]

622 A box from the Niagara Peninsula. Similar to Plate 628, this one is made of tulipwood rather than pine. Several identical boxes have survived in this area. First quarter 19th century. [P.C.]

623 A box from Norfolk County. Probably intended for documents, this decorative example is a chest form in miniature with a shaped bracket base. Mid-19th century. [P.C.]

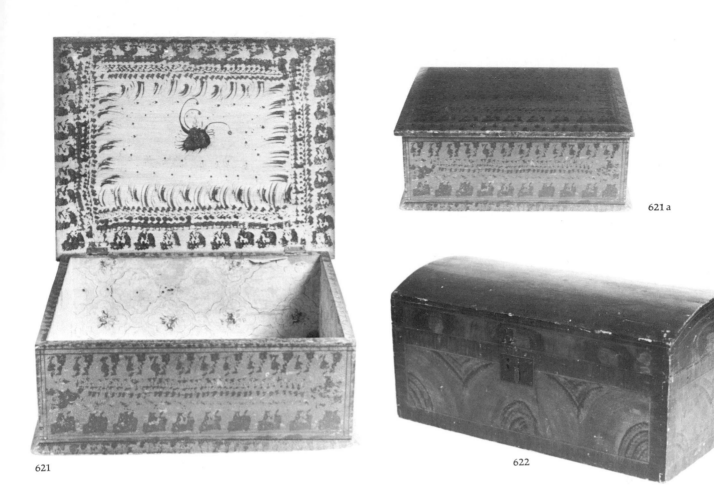

621

621a

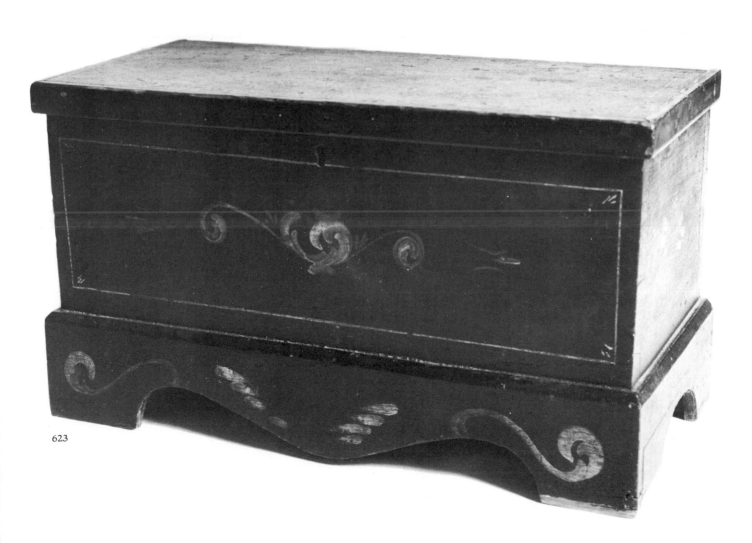

622

623

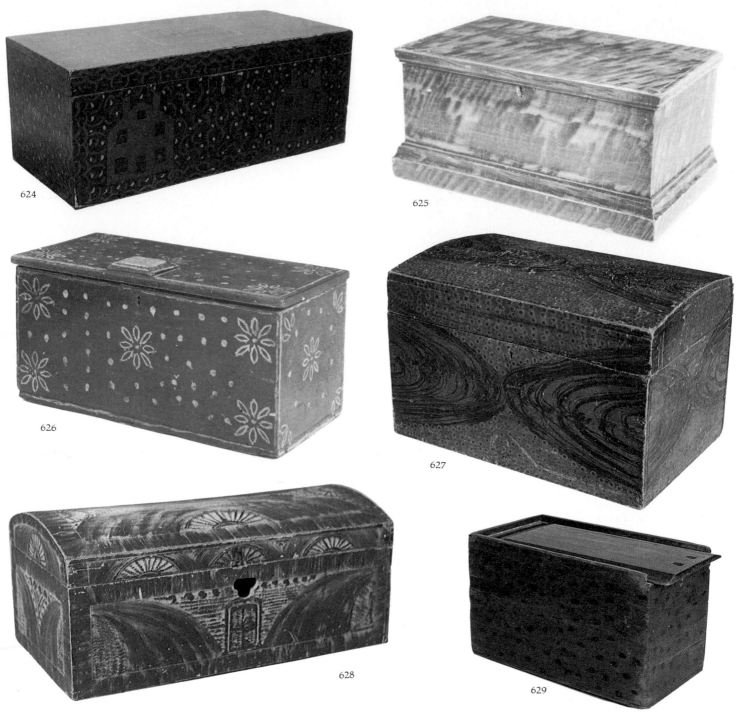

624 A box of unknown origin. This charmingly decorated piece, incorporating houses, abstract brushwork, initials and date, was part of the well-known early collection of Joseph Bauer. Dated 1845. [P.C.]

625 A box from the eastern counties. This is a pleasing example of smoke graining accomplished by passing a lighted candle over partially dry varnish applied to an undercoat of light paint. Second quarter 19th century. [P.C.]

626 A storage chest from Lennox and Addington County. The simple folk decoration on this chest, while early, is not the original finish. Second quarter 19th century. [P.C.]

627 A box from the Niagara Peninsula. A simple, domed-top form decorated with feather painting and simulated birdseye maple pattern. Second quarter 19th century. [P.C.]

628 A box from the Niagara Peninsula. (Early family: Secord.) Domed-topped boxes of this type are found in all areas which received immigrants from the United States, where they may have originated. This dramatically decorated example has traditional associations with the Secord family. First quarter 19th century. [P.C.]

629 A storage box from Mara Township in Ontario County. This large box retains its original black on red painted finish. First half 19th century. [P.C.]

630 A chest of drawers from Carrying Place in Prince Edward County. This well-balanced chest of the Hepplewhite style is made of birdseye maple and cherry with mahogany crossbanding. The popularity of two drawers at the top, as illustrated by Hepplewhite, appears to have been greater in Britain than in America and may indicate craftsmen of British origin for this and similar chests. First quarter 19th century. [P.C.]

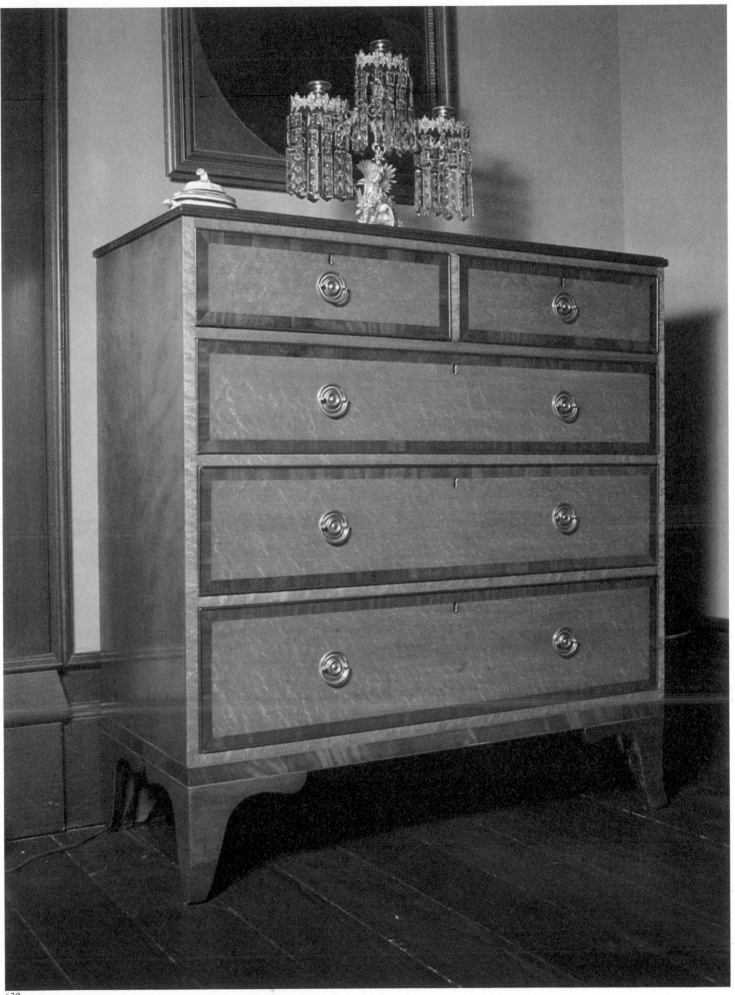

630

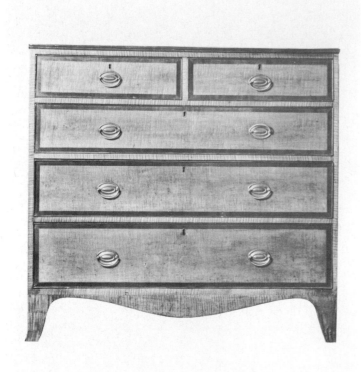

631

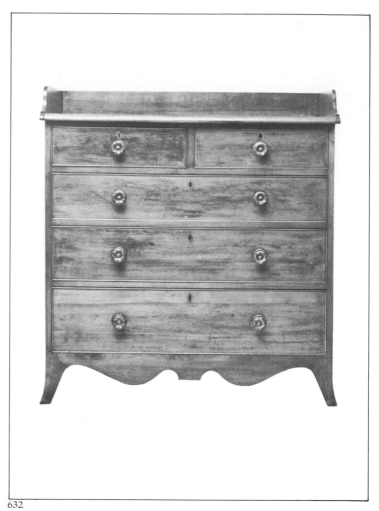

632

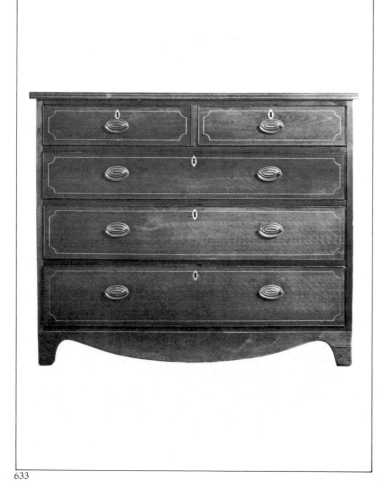

633

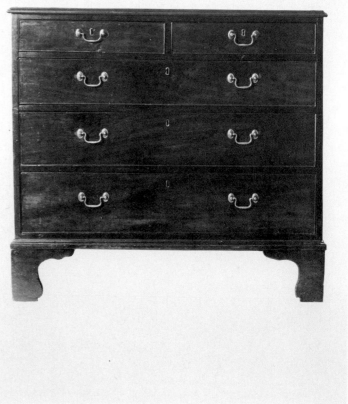

634

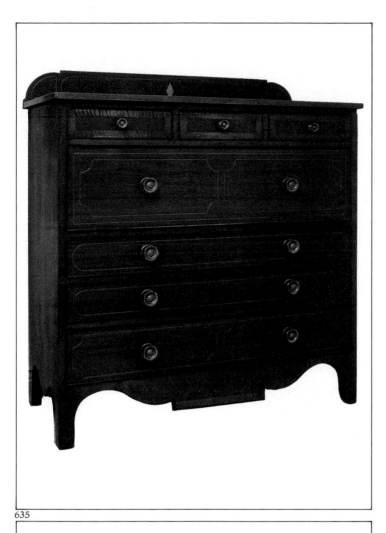

635

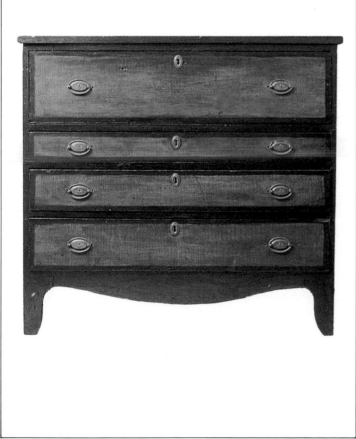

636

631 A chest of drawers from the eastern counties. This is a fine example of the flared, French foot style associated with Hepplewhite, in figured maple and mahogany inlay. The cross-banding and cock-beaded drawer detail are important parts of the style as interpreted by skilled craftsmen. First quarter 19th century. [P.C.]

632 A chest of drawers from Leeds County. Less sophisticated in execution than the two examples before, this design is well proportioned with a pleasing splay to the flared foot and a well-shaped apron. The gallery is a country feature, more practical than stylish. First quarter 19th century. [P.C.]

633 A chest of drawers from Penetanguishene in Simcoe County. The use of walnut with string inlay of contrasting maple suggests that this chest may have been made in the western counties or the Niagara Peninsula. The back is papered with an 1851 edition of the *British Army Dispatch*. First quarter 19th century. [N.P.C., B.H., S.C.]

634 A chest of drawers from Grenville County. From the home of Rev. Robert Blakey, first rector of the Anglican Church at Augusta. The sofa in Plate 381 is from the same home. The major feature of this soundly crafted chest is the bracket feet in a design which was widely used throughout the Hepplewhite and Sheraton periods. The cock-beading on the drawer fronts is a consistent detail. First quarter 19th century. [P.C.]

635 A chest of drawers from Hamilton. The addition of a backboard and the arrangement of the upper drawers are later influences on a design that is primarily based on late 18th century style. Other pieces demonstrating the same transitional characteristics, with similar inlay decoration and distinctive base pediment, are found in the Niagara area. See Plate 241, *The Furniture of Old Ontario*, by Philip Shackleton. Second quarter 19th century. [P.C.]

636 A chest of drawers from Glengarry County. In this country version of the popular French foot style, painted wood grain has been used with simulated crossbanding to create an impression of formality and refinement. Second quarter 19th century. [P.C.]

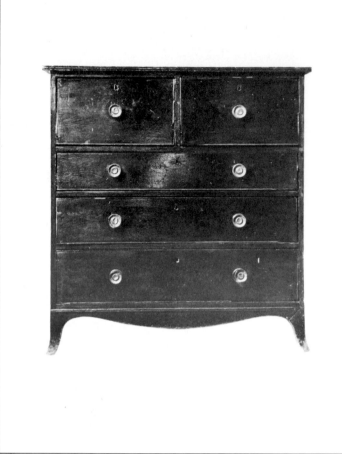

637

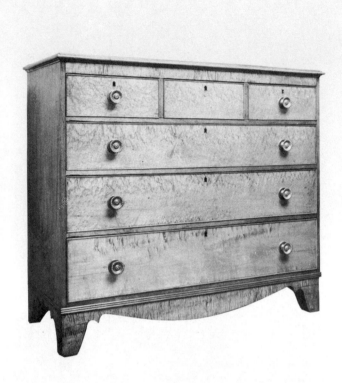

638

637 A chest of drawers from Renfrew County. This is a pleasing example of country style in which the deep bonnet drawers of later influence have been added to a crisply simple rendering of an 18th century design. Second quarter 19th century. [P.C.]

638 A chest of drawers from the eastern counties. The influence of early style and technique is still clearly evident in this finely crafted chest. However, the wider, heavier proportions and the arrangement of the three upper drawers are consistent with 19th century developments. Second quarter 19th century. [P.C.]

639 A chest of drawers from Toronto. The cock-beading, reeded stiles, reeded feet and upper drawer arrangement seen here were early 19th century features, particularly of the late Regency style in Britain. This chest is made of cherry with walnut veneer only on the top and frieze. The top centre drawer is inlaid with cross-grained cherry. Second quarter 19th century. [P.C.]

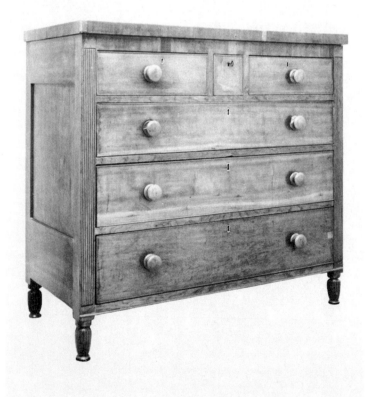

639

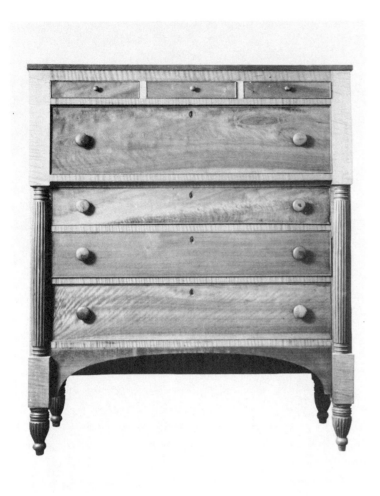

640

640 A chest of drawers from Thorold in Welland County. This fine example of Upper Canadian cabinetmaking is a very individual interpretation of late Neoclassical style. The character of the decorative elements in the form of reeded split columns and feet and the shaped apron probably indicates the hand of a British immigrant craftsman. Second quarter 19th century. [P.C.]

641 A chest of drawers from the eastern counties. The major feature of this impressive maple chest is the finely articulated acanthus leaf columns which visually support the broken front. Second quarter 19th century. [P.C.]

642 A chest of drawers from Lincoln County. (Early family: Smith.) This is a sophisticated example of the late Neoclassical style. The columns incorporate the popular spiral reeding and pineapple details, and the chimney-pot backboard was widely employed in stylish pieces of the period. Rarely found on Upper Canadian furniture is the bowed-front feature of the lower drawers, a carry-over from 18th century style requiring more than average skill. Second quarter 19th century. [P.C.]

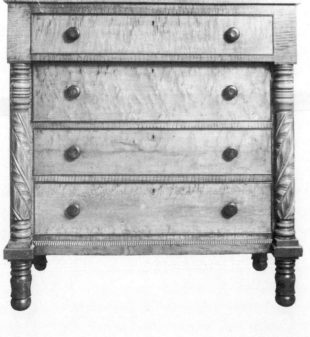

641

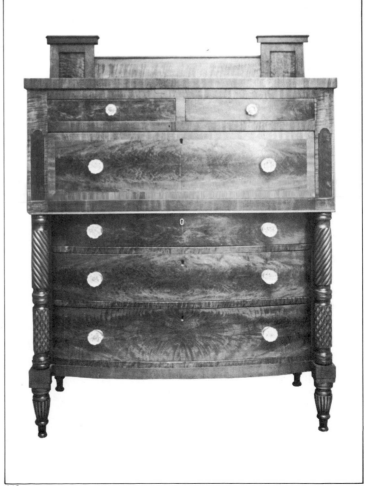

642

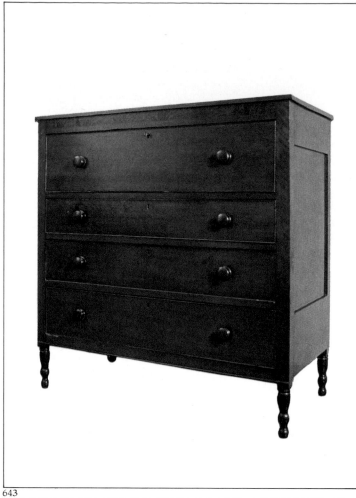

643

643 A chest of drawers from Norfolk County. This cherry chest of Sheraton influence is an unusually fine example of a style which was popular in the western counties. The proportions are refined and the detail is subtle, with a single decorative feature provided by an inlaid panel of mahogany veneer on the frieze. Second quarter 19th century. [P.C.]

644 A chest of drawers from Lyn in Leeds County. This is a satisfying provincial design of Sheraton influence with vigorously detailed columns at each corner and shaped top. The figured maple drawers are cock-beaded. First quarter 19th century. [P.C.]

645 A chest of drawers from Middleville in Lanark County. The functions of washstand and chest are handsomely combined in this design with its boldly scrolled gallery. Second quarter 19th century. [P.C.]

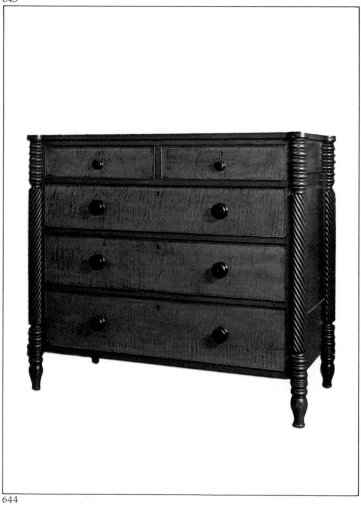

644

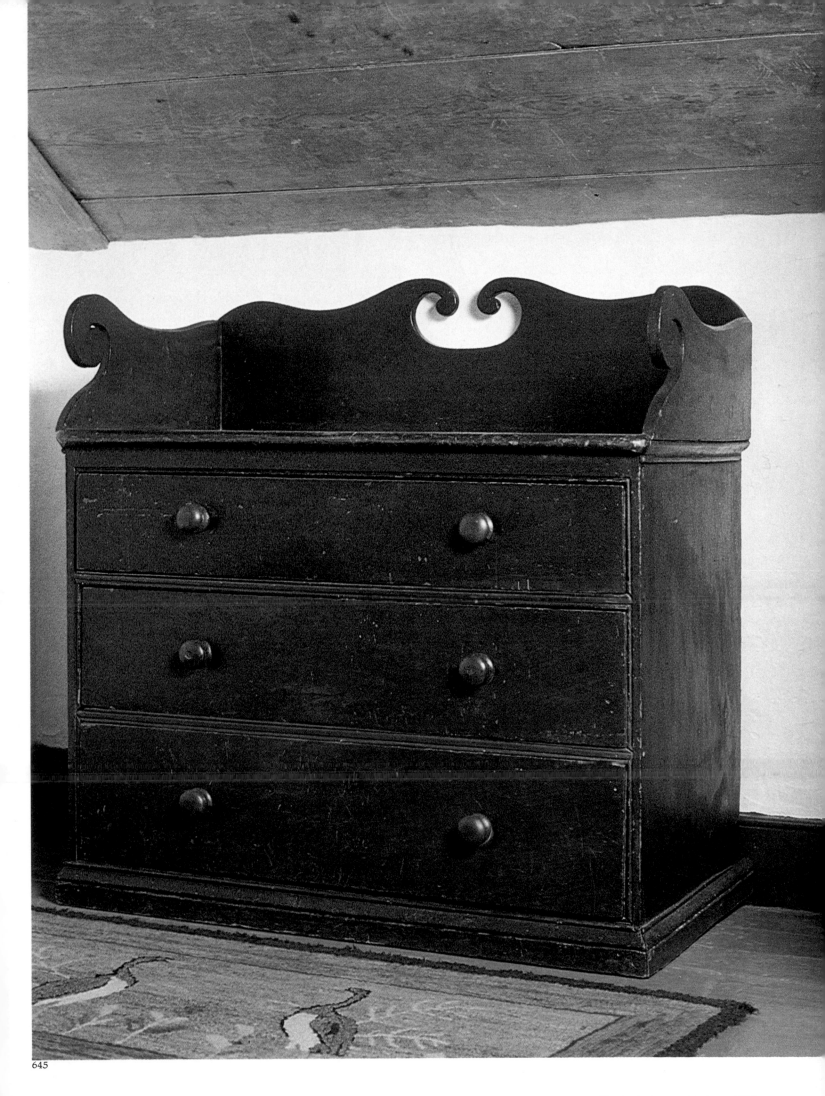

645

646 A chest of drawers from Glengarry County. (Early family: Dingwall.) The occurrence of several chests with galleries in the eastern counties stems from the vernacular of the British groups. In this example, the complex scrolls of the gallery are repeated in the apron. Second quarter 19th century. [P.C.]

647 A chest of drawers from the eastern counties. The decorative quality of figured maple and a highly individual interpretation of early style and detail are combined here to produce a very pleasing example of vernacular furniture. Second quarter 19th century. [P.C.]

648 A chest of drawers from Frontenac County. This is a country craftsman's individual interpretation of Empire style. The unification of the decorative scroll with the frame stile is a unique and sophisticated concept. Mid-19th century. [P.C.]

649 A chest of drawers from the eastern counties. The tasteful combination of fine figured maple with walnut crossbanding relates this design to the Georgian tradition, while the upper drawer arrangement and the bun feet were popular elements of provincial British style in the early Victorian period. Second quarter 19th century. [P.C.]

650 A chest of drawers from Leeds County. Well-crafted in figured and birdseye maple, this chest is transitional, retaining a Georgian simplicity in the drawer plan and overall proportions with the addition of heavy Empire-influenced feet and scrolled backboard. Second quarter 19th century. [C.C.]

651 A chest of drawers from Brant County. An inventory of the furnishings of "Myrtleville," the Brantford home of the Good family, made in 1849 lists "2 walnut chests." This small walnut chest of restrained Empire style is almost certainly one of these items. Second quarter 19th century. [P.C.]

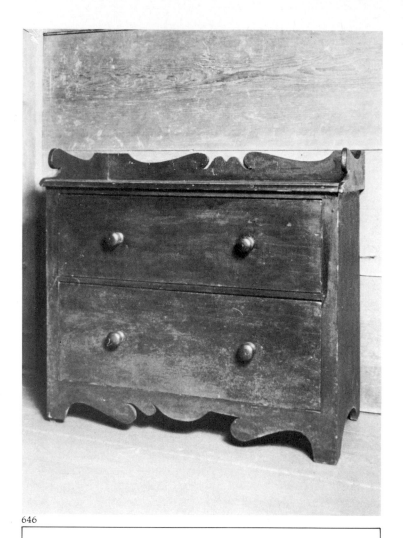

646

647

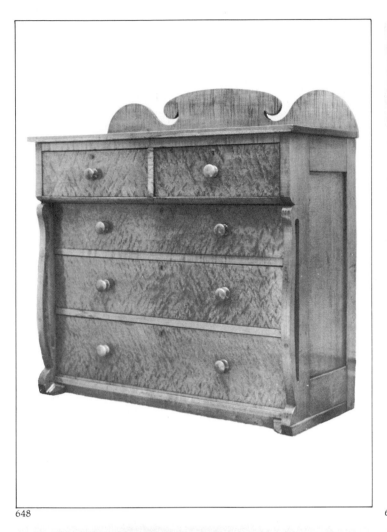

648

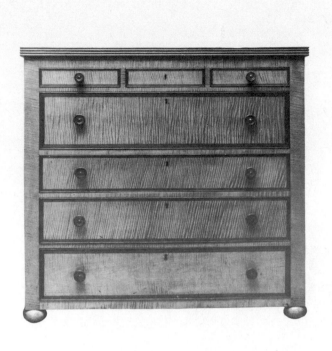

649

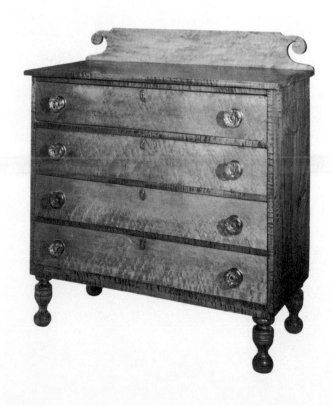

650

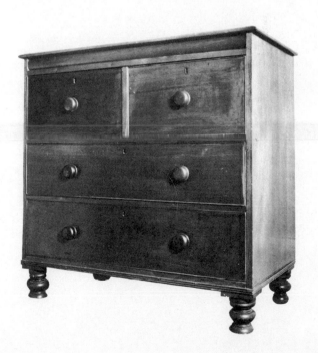

651

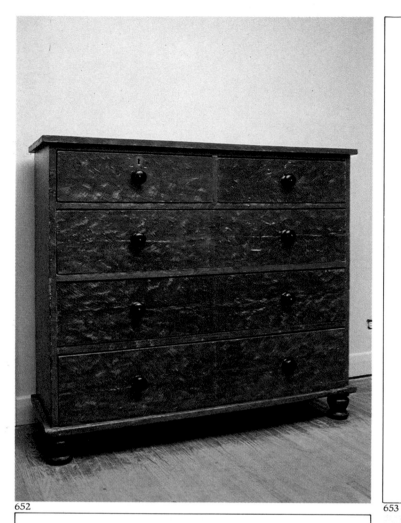

652

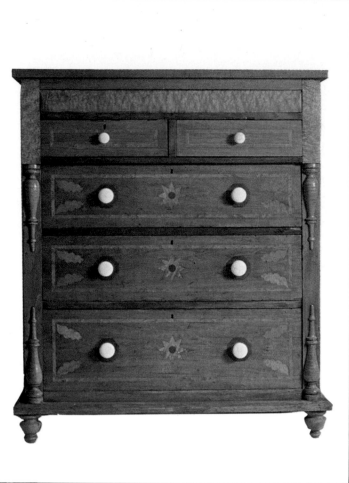

653

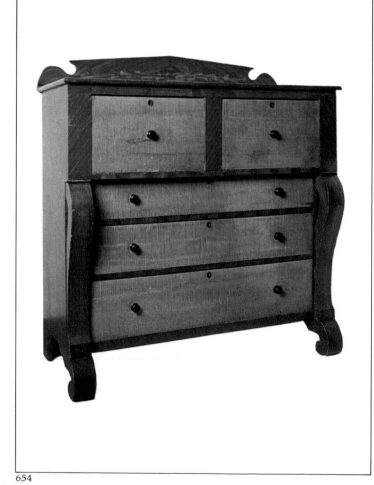

654

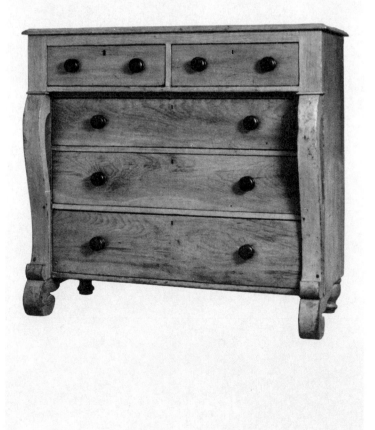

655

652 A chest from Simcoe County. (Early family: Wyant.) Country joiners often ignored the elaborate Empire styles in favour of a simple form standing on heavy turned feet. These were often painted with impressions of exotic woodgrain patterns. Second quarter 19th century. [P.C.]

653 A chest of drawers from Valentia in Victoria County. This design is a curious composition of conflicting elements and the obvious determination of the maker to produce a "special" piece of furniture. The step-back style with split turnings is soundly Empire, while the tall, vertical proportions are rarely seen with that style, and the top panel of birdseye maple is a secret

drawer which can only be opened through one of the two small drawers below. The most endearing feature, however, is the inlaid decoration of folk character, including leaves, stars and crossbanding. Third quarter 19th century. [P.C.]

654 A chest of drawers from Woodstock in Oxford County. Equally typical of country Empire style, this design with the heavy scrolled elements is also enhanced by its masterful painted decoration suggesting rosewood and figured maple. Mid-19th century. [P.C.]

655 A chest of drawers from Odessa in Lennox and Addington County. Signed on each drawer, *Thos. D. Darley, Mill Creek* [now Odessa] *1852*. This inscription establishes a time frame for countless similar examples of country Empire style. 1852. [P.C.]

656 A chest of drawers from Waterloo County. This very typical country American Empire chest is elevated from the ordinary by its exceptional painted and stencilled decoration. A dramatic feather-painted impression of crotch-grain mahogany is combined with ebonized split columns stencilled in gold. Mid-19th century. [P.C.]

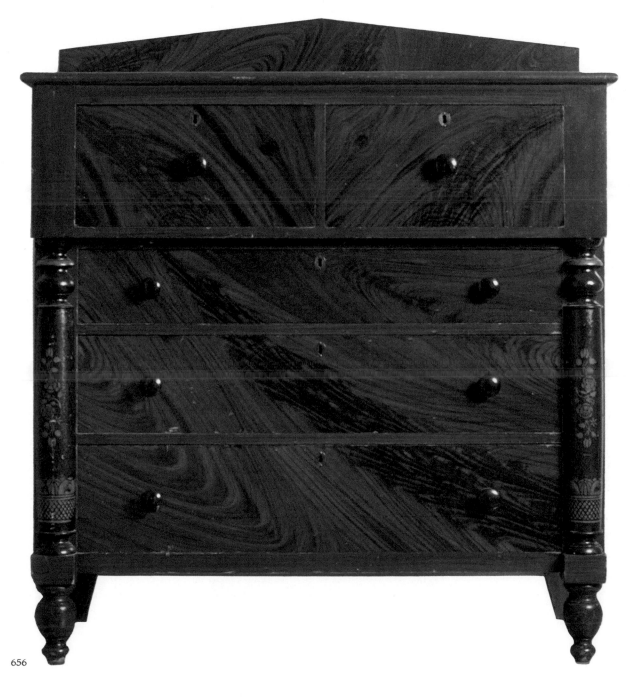

656

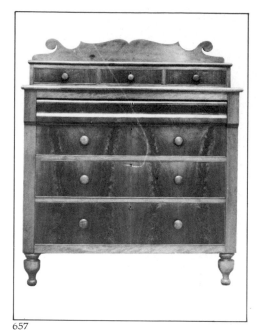

657

657 A chest of drawers from Ontario County. This and the following chests are examples of the inexpensive furnishings made by local shops and factories in the last half of the 19th century. Here, we see the popular addition of small drawers above a tastefully simple form with an ogee section and cock-beaded drawers veneered in crotch-grained walnut. Third quarter 19th century. [P.C.]

658 A chest of drawers from Napanee in Lennox and Addington County. Labelled, *John Gibbard,* etc. (see label). This design is a composite of contemporary features, including a busy scrolled backboard, ogee-shaped upper drawers, rounded corners, shaped brackets to castored feet and walnut veneer overall. Fourth quarter 19th century. [L. & A.C.M.]

659 A chest of drawers from Farmersville in Leeds County. Signed, *W. Shipman, Farmersville, Oct. 22, 1877.* Variations on this unpretentious design were made in great numbers in all parts of the newly named Province of Ontario. 1877. [P.C.]

660 A desk from York County. Retaining the classic 18th century form, this design assumes a sturdy late Neoclassical character with the use of simple, reeded quarter columns and inverted turnip-shaped feet. It is confidently crafted in solid cherry and figured maple with some mahogany veneer on the interior fittings. Second quarter 19th century. [P.C.]

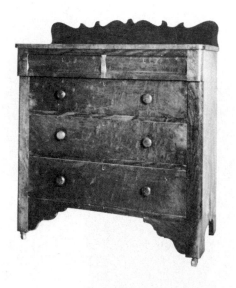

658

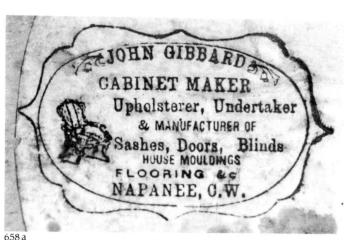

658 a

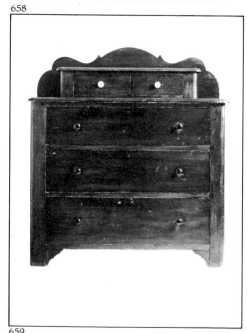

659

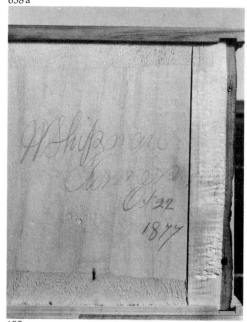

659 a

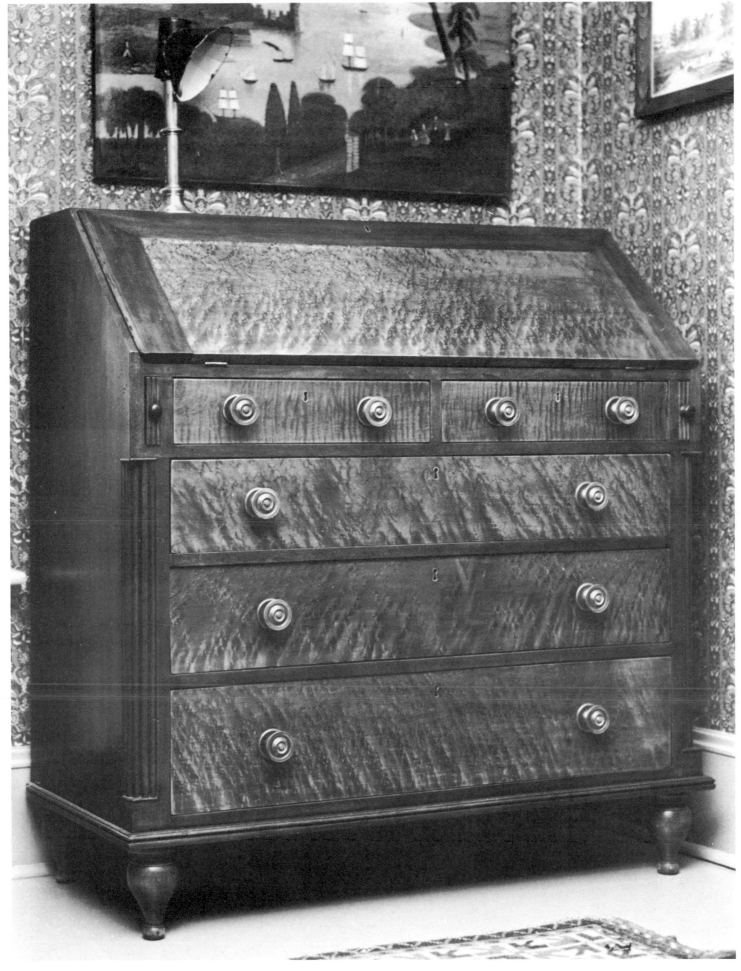

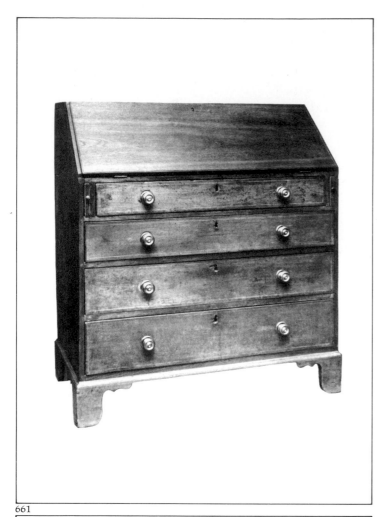

661

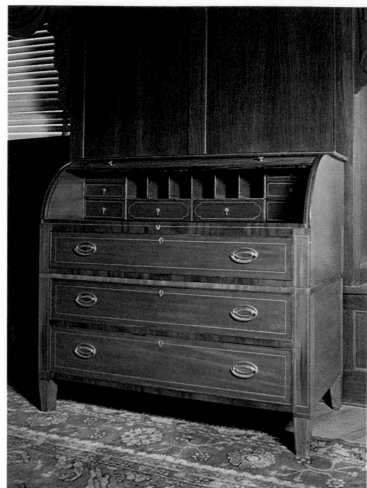

662

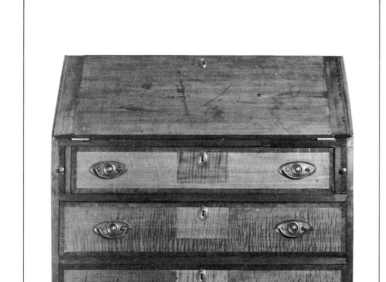

663

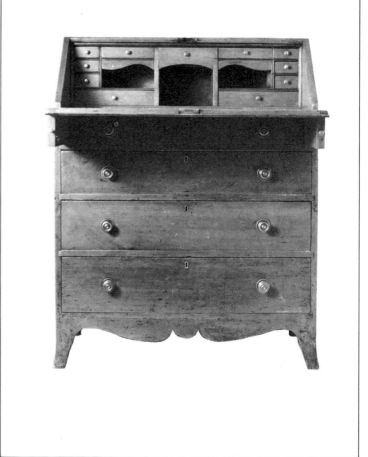

664

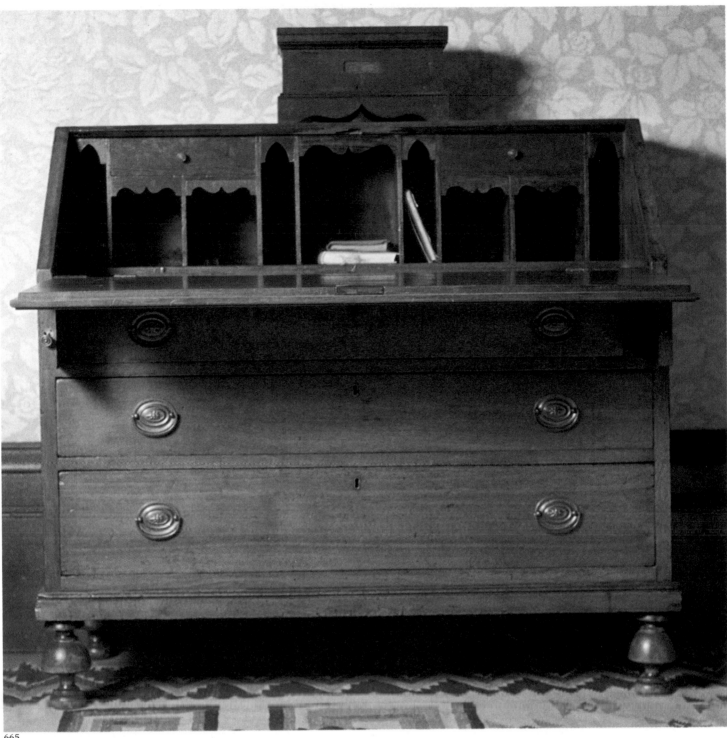

665

661 A slant-front desk from Niagara-on-the-Lake in Lincoln County. This desk of late 18th century style is made of walnut with maple string inlay and cock-beaded drawers. Late 18th or early 19th century. [P.C.]

662 A cylinder desk from Toronto. The cylinder fall was a popular feature of late 18th and early 19th century British design. Sheraton illustrates a cylinder desk and bookcase in his *Drawing Book* (1791-94). Other details of this large two-part desk are consistent with this period, including the extensive string inlay decoration, cock-beaded drawers and the use of contrasting veneers over-

all. First quarter 19th century. [P.C.]

663 A slant-front desk from Stormont County. Combining birch and figured maple, this is a sound provincial execution of late 18th century style. The drawers are crossbanded in walnut and the delicate inlay on the apron is of walnut and maple. Late 18th or early 19th century. [P.C.]

664 A slant-front desk from the western counties. Country-made, entirely of pine, this desk is of late 18th century style with its major feature being the nicely flared foot and shaped apron. This Hepplewhite-inspired style

was popular in all degrees of sophistication in the American states, as well as in Upper Canada wherever American influence prevailed. First quarter 19th century. [P.C.]

665 A slant-front desk from York County. This is a rare example of the revival of early 18th century style in Upper Canada. While the construction details suggest a date of manufacture close to the mid-19th century, the proportions, design of foot and interior treatment indicate more than a superficial interest in the early style. Second quarter 19th century. [P.C.]

666 A butler's desk from Brantford in Brant County. (Early family: Leeming.) While the form and plan is typical of late Neoclassical style, an impression of earlier prototypes is created by the diminutive scale and restrained use of inlaid and carved decoration. The reeding and leaf motif as well as the foot are integral to the stile, illustrating a high level of craftsmanship overall. Second quarter 19th century. [P.C.]

667 A slant-front desk from North-umberland County. This is a robust provincial recollection of 18th century style. The bracket base is simplified with a charming heart cut-out in the base pediment. The broad, crossbanded inlay, in contrasting figured maple, creates a strong horizontal pattern with the similar width of the drawer rails. Second quarter 19th century. [P.C.]

668 A butler's desk from the eastern counties. The extensive reeding and delicate rosettes effectively relieve the mass of this late Neoclassical style design. The feet have been restored in an appropriate form, but the originals may have reflected the reeded theme. Second quarter 19th century. [P.C.]

669 A butler's desk from Kingston. This stylish example of Empire style is very typical of furnishings made in New York State and may well have been imported at an early date. It is made of cherry, figured and birdseye maple, with some use of mahogany veneer. Second quarter 19th century. [P.C.]

670 A writing desk from Oxford County. Attributed by family tradition to a Mr. Lee. This is a competent country craftsman's version of the delicate Sheraton writing desks that were popular in the early 19th century. They inspired many countrified variations, and often included a tambour enclosure to the upper cabinet. In this example, the panelled front drops to provide a writing surface and to expose the interior shelves and cubicles. Second quarter 19th century. [P.C.]

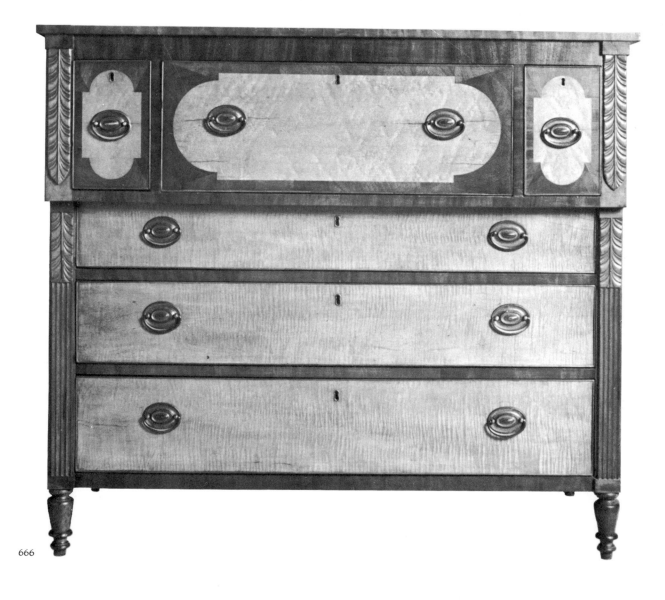

666

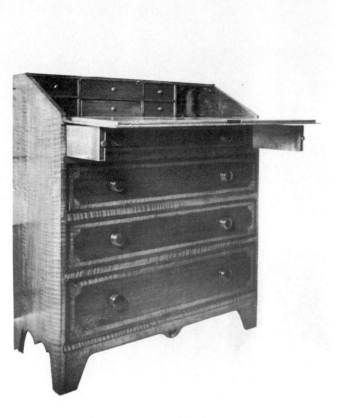

667

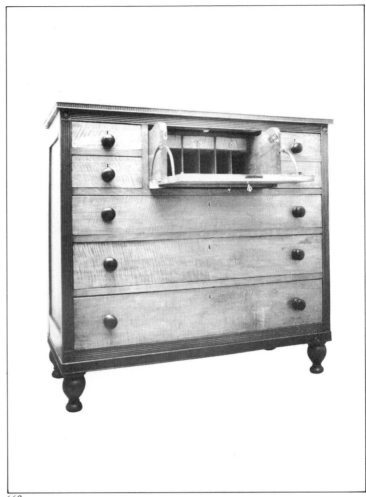

668

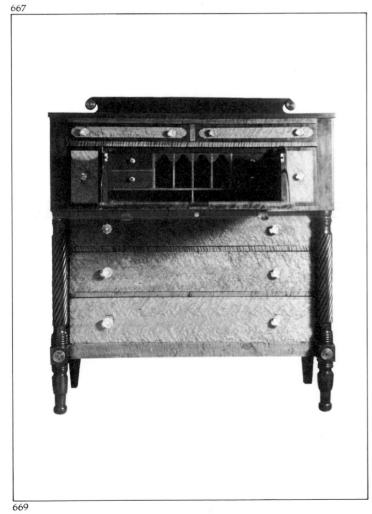

669

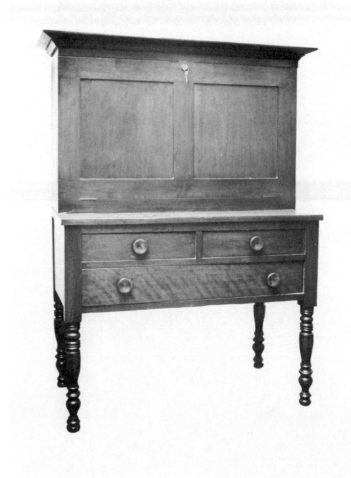

670

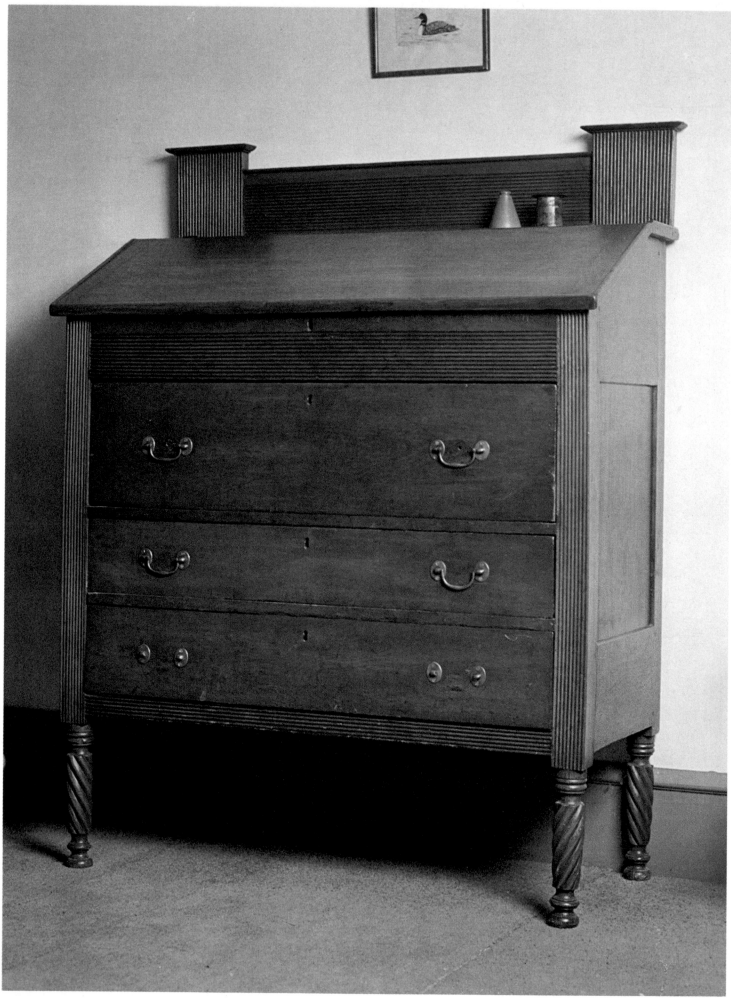

671 A lift-top desk from Kingston. With admirable restraint, this large stand-up desk evokes the Regency-Empire style with spiral-reeded legs, reeded stiles and rails and the chimney-pot backboard. Second quarter 19th century. [P.C.]

672 A drop-front desk from Lennox and Addington County. Signed, *Wm. Amey, Maker, Ernsttown, Nov. 2, 1860.* This unpretentious adaptation of the stylish Empire butler's desk style is an ingenious and useful, if not entirely beautiful, piece of country furniture. The workmanship is indifferent, but the effect is one of curious charm. 1860. [P.C.]

673 A slant-front desk from Prince Edward County. Nothing is superfluous in this pleasing example of early 19th century vernacular design. Even the well-shaped feet are turned as integral parts of the frame stiles. Second quarter 19th century. [P.C.]

674 A lift-top desk from Stouffville in York County. This soundly crafted, stand-up desk combines a neat, dovetailed bracket base and simple early form with some stylish Empire flourishes in the gallery and upper drawers stepped over split finials. Second quarter 19th century. [P.C.]

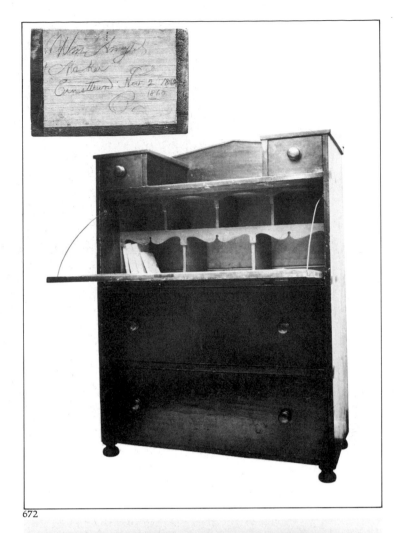

672

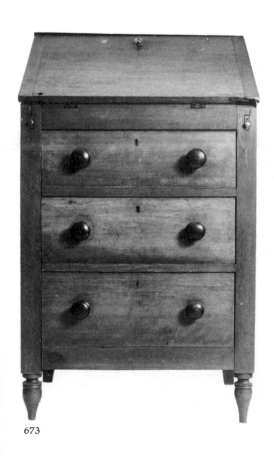

673

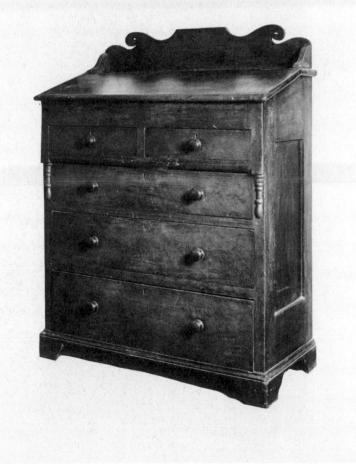

674

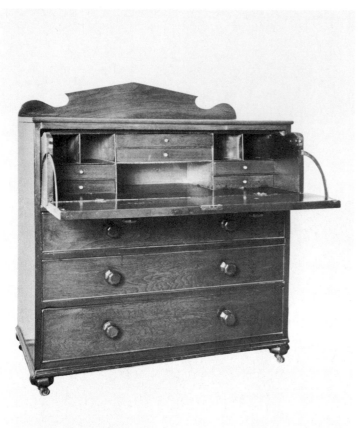

675

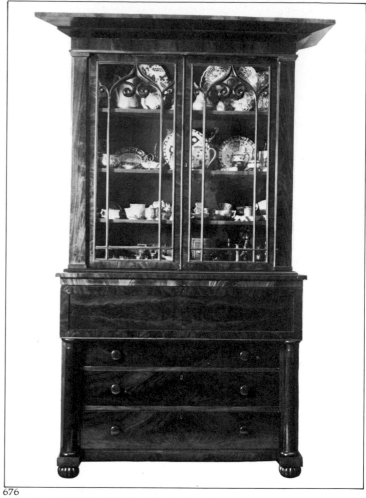

676

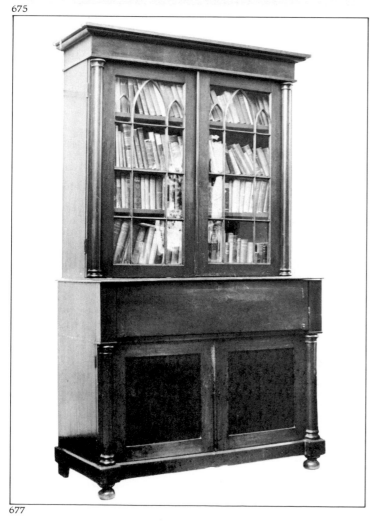

677

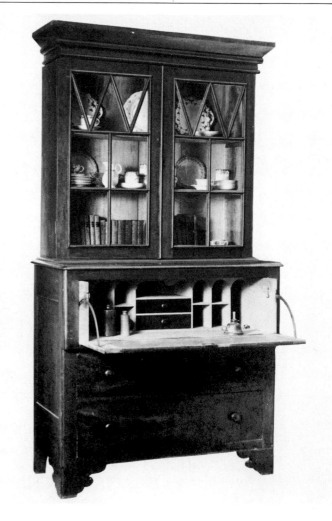

678

675 A butler's desk from Huron County. The small-scale, simple refinement of the interior and distinctively shaped pulls and bun feet strongly relate this desk to provincial British examples from the late Regency or early Victorian period. Mid-19th century. [P.C.]

676 A secretary from Kingston. Of late Neoclassical style, this is an excellent example of the stylish furniture made in the major centres toward the mid-19th century. The craftsmanship overall is admirable and the treatment of the Gothic glazing motif is clearly the work of an artisan of exceptional skill. Second quarter 19th century. [P.C.]

677 A secretary from Queenston in Lincoln County. (Early family: Hamilton.) Of similar character to the preceding example, this piece is less grand and is fashioned in a more provincial manner from local walnut in the solid, with very limited use of mahogany veneer. The 1808 pattern book by George Smith placed emphasis on the Gothic motif as seen in the glazing plans of these two designs. Second quarter 19th century. [P.C.]

678 A secretary from Napanee in Lennox and Addington County. Similar in style and technique to labelled examples by Gibbard in Napanee, this secretary is a good illustration of late 19th century, factory-made furniture which retains some elements of Georgian style. Third quarter 19th century. [L. & A.C.M.]

679 A secretary from Leeds County. This design is based directly on Sheraton-influenced secretaries which were popular in America throughout the Federal period. This is particularly apparent in the fine character and proportions of the low, glazed bookcase fitted with three small drawers. The style overall is ponderous late American Empire with typically heavy columns supporting the overhung shaped upper drawer. Second quarter 19th century. [P.C.]

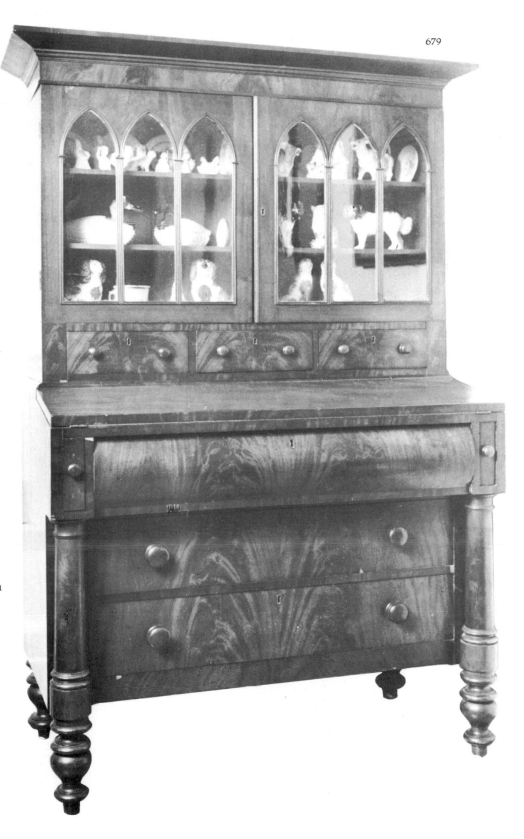

679

680 A desk-box from Picton in Prince Edward County. This simple form occurs among the earliest furnishings in the British tradition. The example here is joined by dovetails at the corners and decorated with linear brushwork. Second quarter 19th century. [P.C.]

681 A lift-top desk on frame from Prince Edward County. The desk-box was also placed in a table-like frame from an early date, producing another traditional form which was executed in many different styles throughout the centuries. This is an exceptionally fine example of the stretcher-based style which was widely adopted throughout Britain and America in the late 17th and early 18th centuries. First quarter 19th century. [N.H.S., F.G.]

682 A lift-top desk from Welland County. The desk-box was united with the frame, producing the functional form seen here. This starkly simple desk in walnut with straight, square legs and stretcher and fitted with a flush drawer, simply beaded, is similar to those made of oak for 18th century British farmhouses. First quarter 19th century. [P.C.]

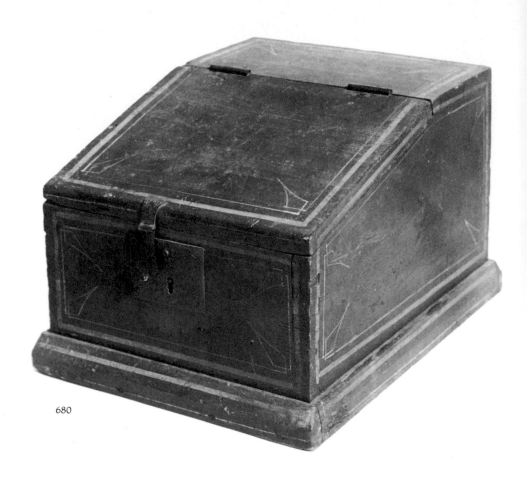

680

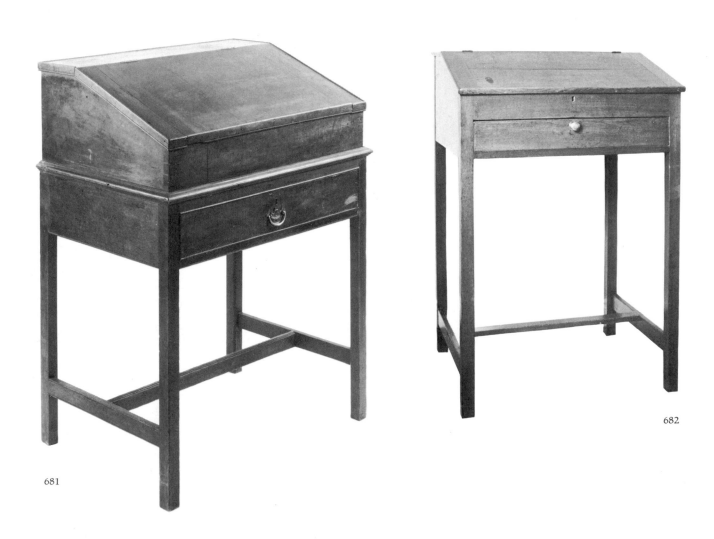

681

682

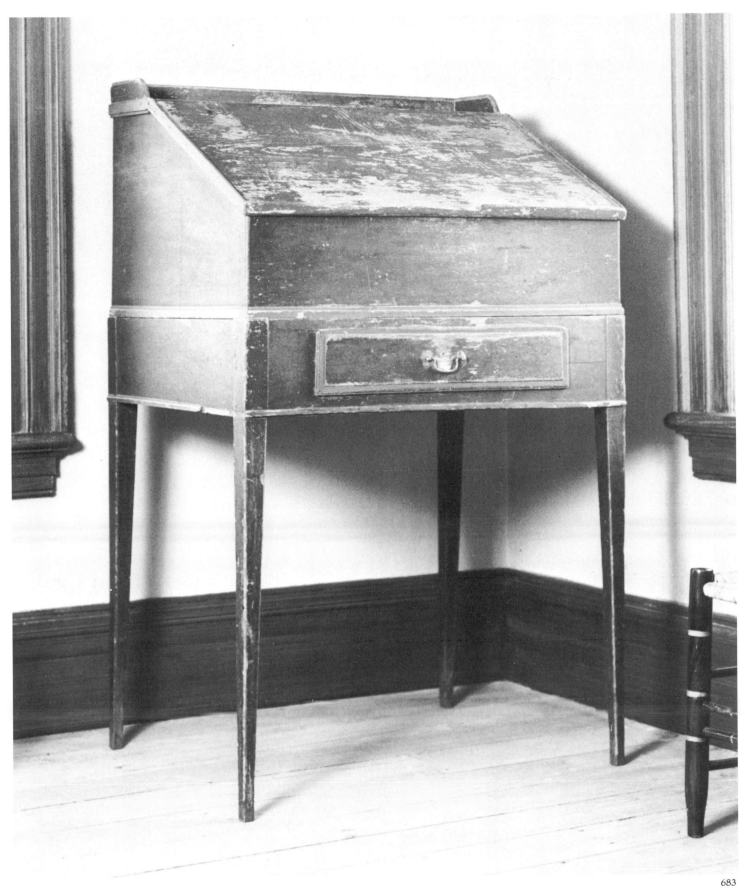

683

683 A lift-top desk-on-frame from
Prince Edward County. This very tall
desk has a deep box fitted with cubicles
and drawers. It is an unusually refined
country design, reflecting influences
from late 18th century formal style in
its fine proportions and subtle detail.
First quarter 19th century. [P.C.]

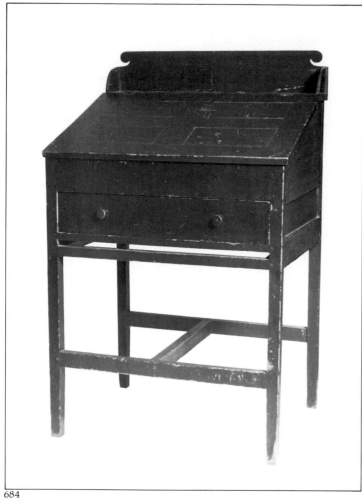

684

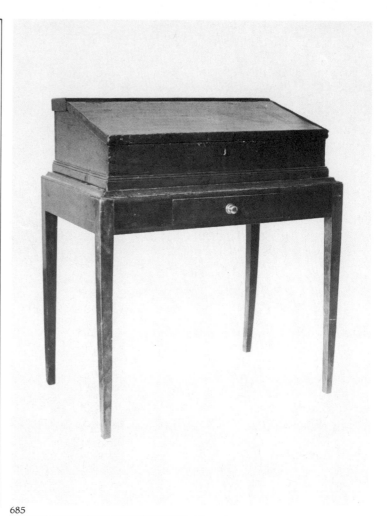

685

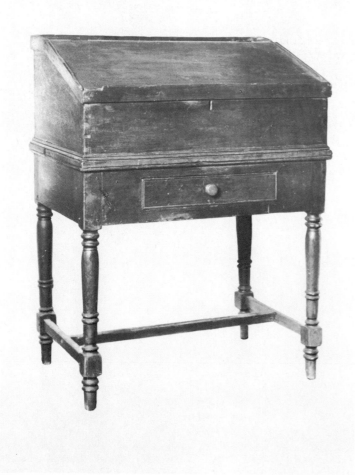

686

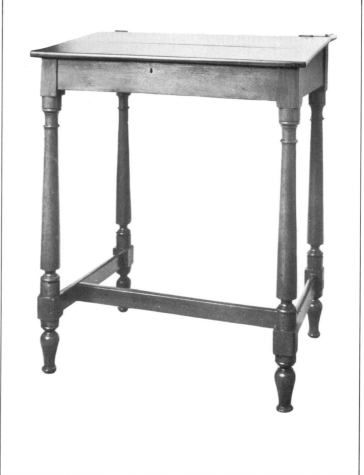

687

684 A lift-top desk from Northumberland County. This dramatic design includes an Empire influence in the scrolled gallery. The lid is framed and flush-panelled and a convenient slide was originally fitted below the drawer. The reversed "H" stretcher arrangement is unusual. Second quarter 19th century. [P.C.]

685 A lift-top desk-on-frame from Peterborough County. The two pieces are visually united with well-considered moulding details in this design executed in butternut and birch. Second quarter 19th century. [P.C.]

686 A lift-top desk-on-frame from Aylmer in Elgin County. The turned legs with "H" stretcher and generous proportions of the box and frame apron relate this desk to those made in the American colonies in the early 18th century. The details of the turnings and mouldings, however, indicate that this rare Canadian example of the early form was made as late as 1850. Mid-19th century. [P.C.]

687 A lift-top desk from Halton County. This handsome walnut desk of traditional form was made for the small office of an early farmhouse that includes many features of 18th century English country homes. Second quarter 19th century. [P.C.]

688 A lift-top desk from Erin in Wellington County. This pleasing design is more formal than most and is directly related to tables of the period. The graceful turned legs and gallery are a simplification of Sheraton influences. Second quarter 19th century. [N.P.C., B.H., S.C.]

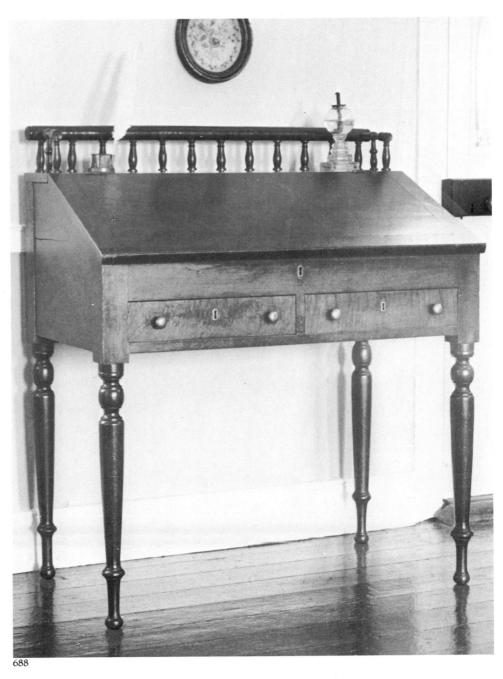

688

689 A lift-top desk-on-pedestal from Prince Edward County. This distinctive and functional form is particularly associated with the Shaker communities in several northeastern American locations. This piece is neatly fashioned in figured and birdseye maple. Second quarter 19th century. [P.C.]

690 A lift-top desk from York County. The unusual height, double drawers and panelled ends make this a dramatic example of this popular style which reflect the design of tables throughout the middle and late years of the 19th century. Second quarter 19th century. [P.C.]

691 A lift-top desk-on-frame from Waterloo County. The upper drawers are non-functional but important to the visual appeal of this example of the popular desk-on-frame form. Second quarter 19th century. [P.C.]

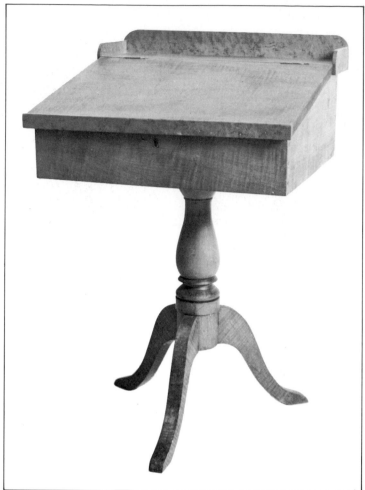

689

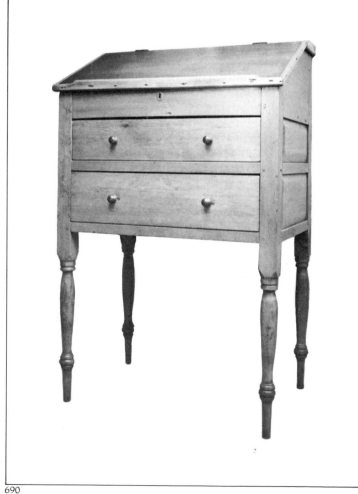

690

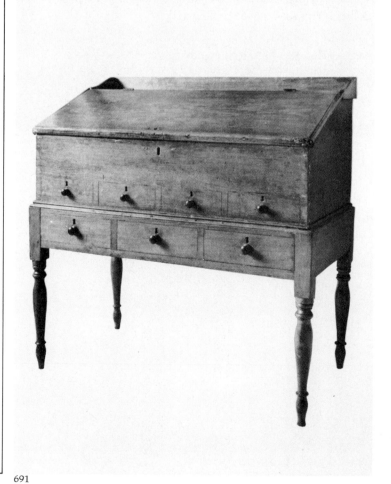

691

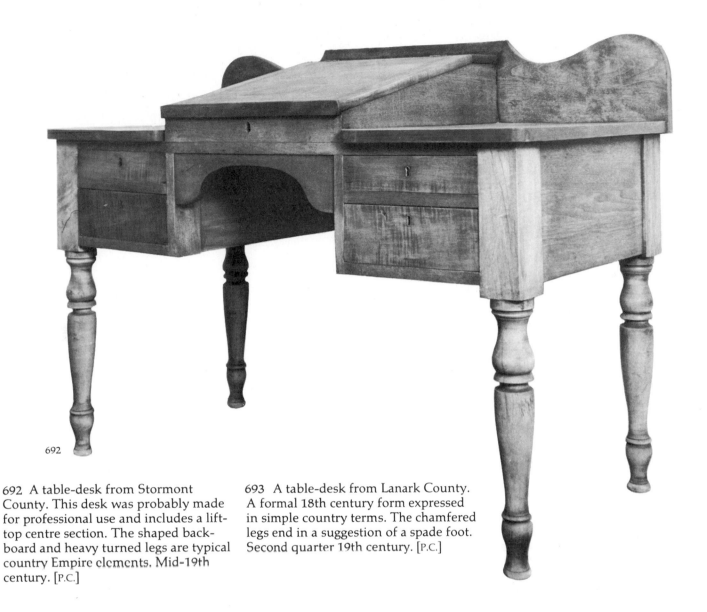

692

692 A table-desk from Stormont County. This desk was probably made for professional use and includes a lift-top centre section. The shaped backboard and heavy turned legs are typical country Empire elements. Mid-19th century. [P.C.]

693 A table-desk from Lanark County. A formal 18th century form expressed in simple country terms. The chamfered legs end in a suggestion of a spade foot. Second quarter 19th century. [P.C.]

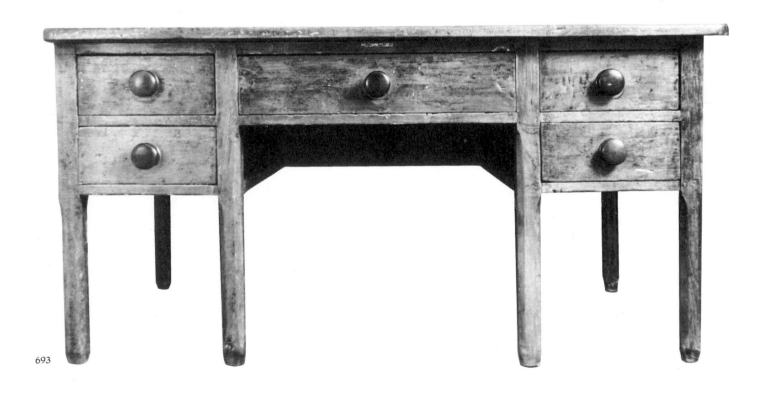

693

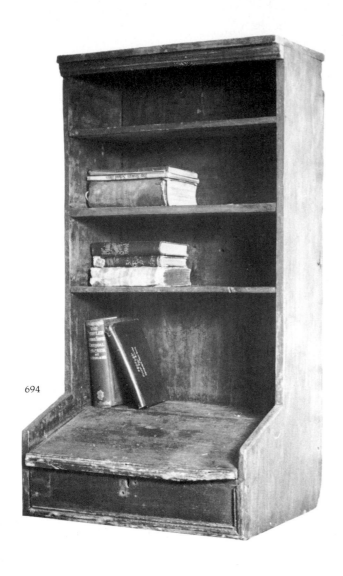

694

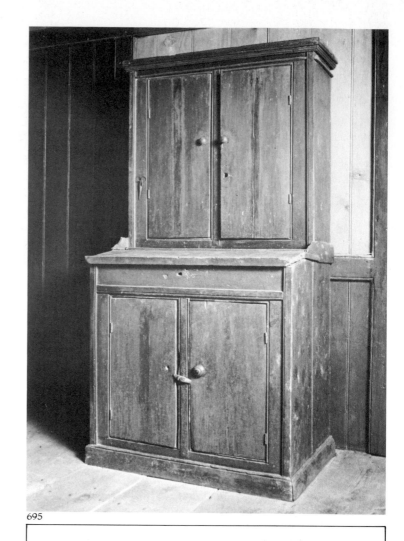

695

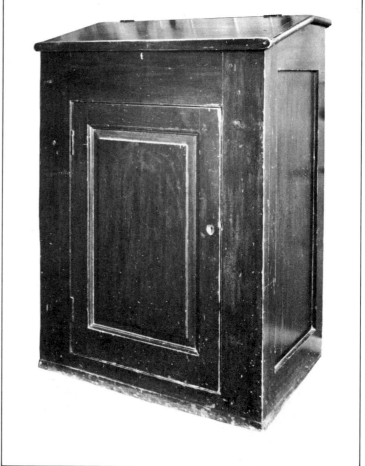

696

694 A hanging secretary from Ontario County. This very practical form is certainly rare and may be a unique solution by a country craftsman to a particular requirement. Second quarter 19th century. [P.C.]

695 A secretary from Poplar Hill in Middlesex County. The occurrence of formal furniture concepts in primitive execution provides some fascinating objects. Here, an ambitious, do-it-yourself carpenter remembered the basic elements of a Georgian secretary when he fitted the upper cabinet with shelves and cubicles. Under the writing surface are three drawers and a sliding panel to a secret compartment. Second quarter 19th century. [P.C.]

696 A lift-top desk from Markham in York County. This unusual desk has a nicely painted interior fitted with drawers and cubicles. The exterior is enriched by panelled ends and a single door with a blown panel and moulded frame. Second quarter 19th century. [P.C.]

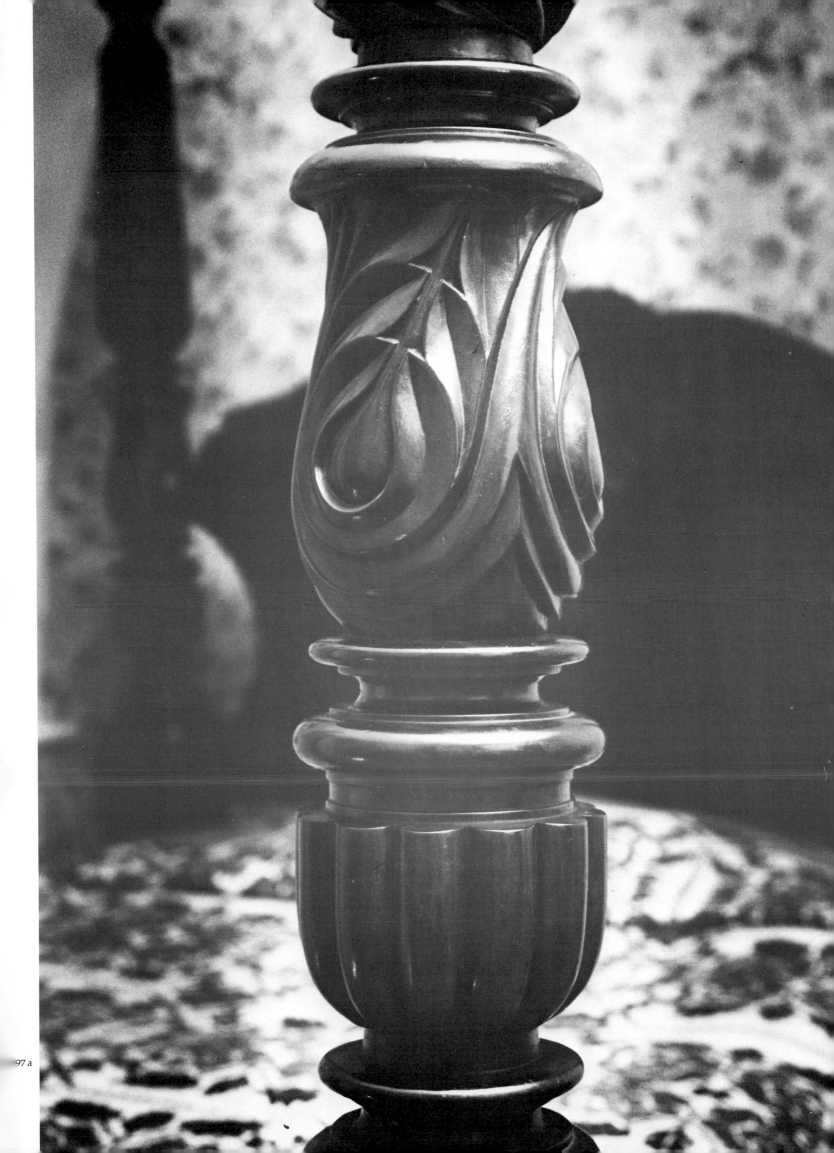

697 A high-post bedstead from Napanee in Lennox and Addington County. This massive English Empire bed is thought to have been made for a local lumber baron by John Gibbard in the early years of his furniture-making operations. While unsubstantiated, the attribution is probable, since Gibbard was a skilled woodcarver of moulds for iron foundries in England and Lower Canada. The craftsmanship is of a high order (see detail, page 271). Second quarter 19th century. [P.C.]

698 A high-post bedstead with tester from St. Catharines in Lincoln County. The acanthus leaf motif, carved here in the heavy foot-posts, was widely employed in stylish examples of late Neoclassical design. The head-posts and headboard are simple. First quarter 19th century. [U.C.V.]

699 A high-post bedstead from Northumberland County. This is a restrained example of the Sheraton-inspired style with reeded posts and turnings of some refinement. The low, simple footboard is a transitional stage developing from earlier styles which had only head-boards. First quarter 19th century. [P.C.]

700 A high-post bedstead from Ontario County. (Early family: McArthur.) The pencil-post style, which was popular in 18th century America, is a rarity in Upper Canada. This example is of primitive character with heavy chamfered posts and simple head and foot boards. Second quarter 19th century. [P.C.]

701 A high-post bedstead with canopy from Frontenac County. The posts of this design are lighter than the previous examples, expressing Sheraton and Empire influences in a vigorous and busy provincial manner. Second quarter 19th century. [P.C.]

702 A high-post bedstead from Sydenham in Frontenac County. The graceful configuration of the posts is based on Sheraton style which the country craftsman has modified to create a heavier Empire character. Second quarter 19th century. [P.C.]

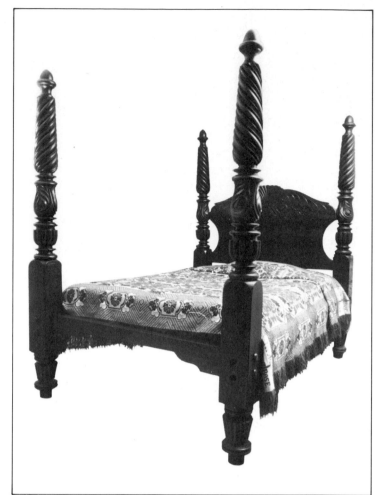
697

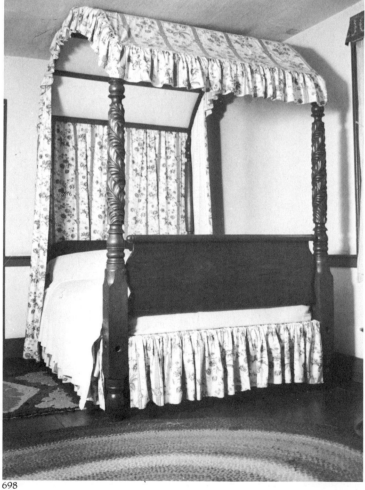
698

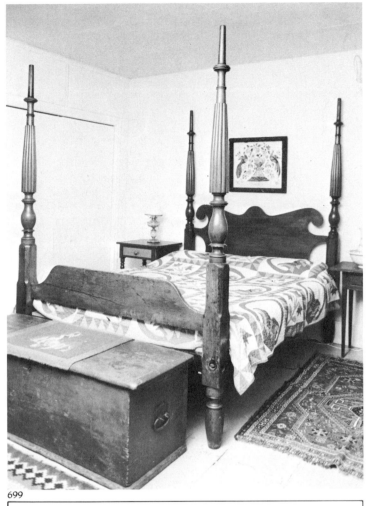

699

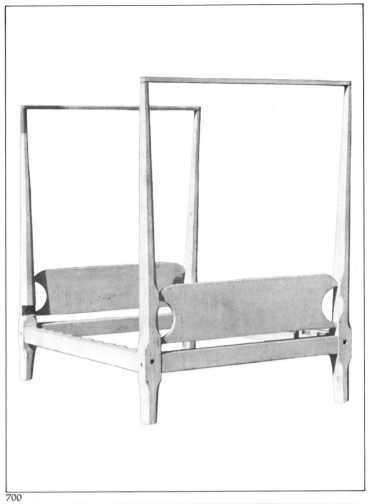

700

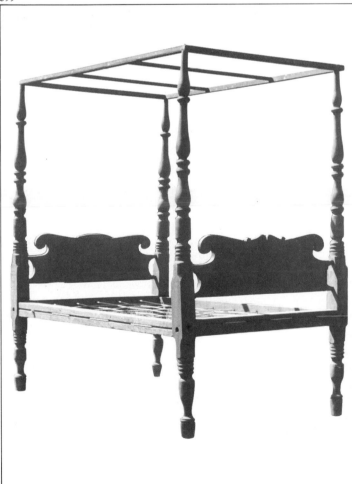

701

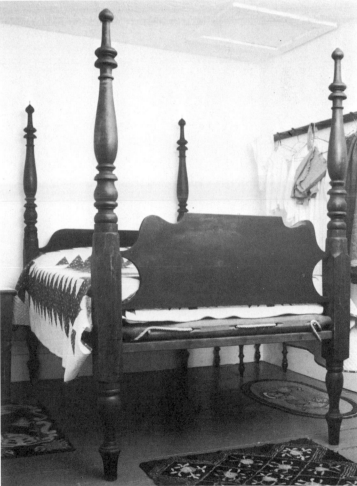

702

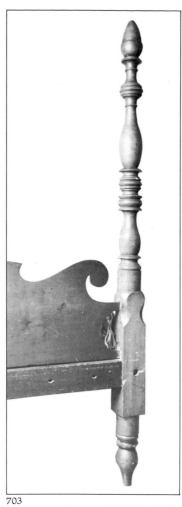

703

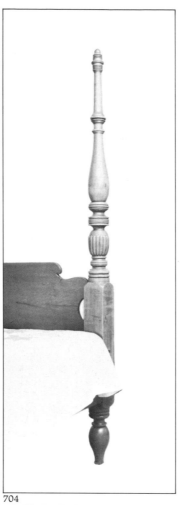

704

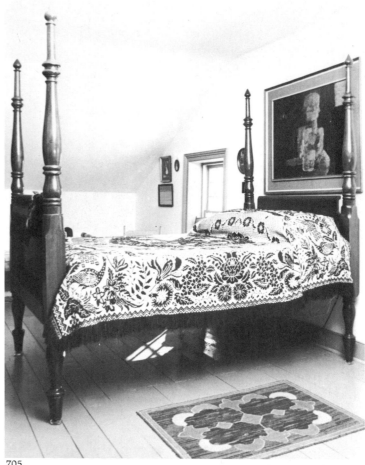

705

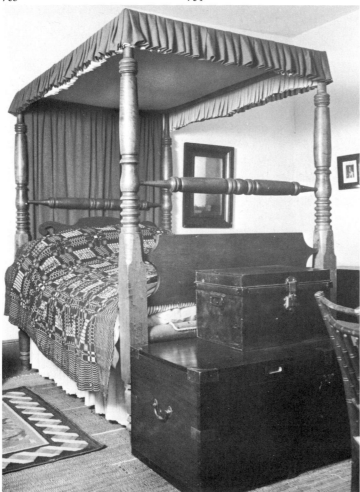

706

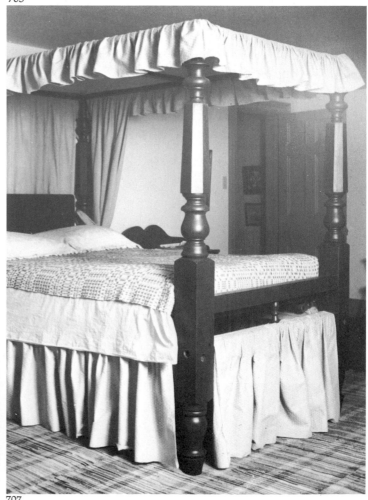

707

703 A high-post bedstead from Elgin County. (From the Talbot Estate.) This is another robust provincial example of style in transition to the heavy Empire taste. The acorn finial was a popular feature on early 19th century beds. Second quarter 19th century. [P.C.]

704 A high-post bedstead from Brampton in Peel County. This Sheraton-influenced design retains the slender form of period examples. The complexity of finely executed turnings is typical of later 19th century interpretations by provincial craftsmen. Second quarter 19th century. [P.C.]

705 A high-post bedstead from Leeds County. In this design, the posts are unusually tall. Like many provincial examples of Sheraton influence, the heavy, turned details obscure the elegant line of the basic form. Second quarter 19th century. [P.C.]

706 A high-post bedstead with canopy from Peel County. (Early family: Silverthorne.) This well-crafted Empire-style bed was clearly intended to impress with the use of finely figured maple and the addition of blanket rolls at the head and foot. This feature is more common on low-post beds and is rarely included at both ends. Second quarter 19th century. [H.N. & M.E.P.]

707 A high-post bedstead with canopy from the eastern counties. This design is a departure from the typical heavy Empire style in its short, squat proportions, which are reminiscent of English canopy beds of the 16th and 17th centuries. Mid-19th century. [P.C.]

708 A field bedstead with tester from Leeds County. The lower posts of the field bed accommodate the high-arched tester. This example is a simple version of Empire style with identical head and foot boards. The bedsteps are noteworthy and were an important accessory to many pre-mid-century beds. Second quarter 19th century. [P.C.]

709 A French bedstead from Kingston. Advertisements from the 1830s in centres like Kingston mention "French beds in mahogany." Also called sleigh beds, these stylish alternatives to posted beds were widely adopted in America from the French Empire style. This rather massive example, in mahogany veneer over pine, is one of a pair said to have belonged to Sir John A. Macdonald. Second quarter 19th century. [P.C.]

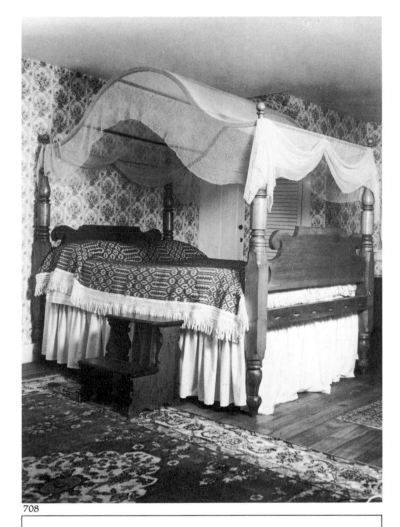
708

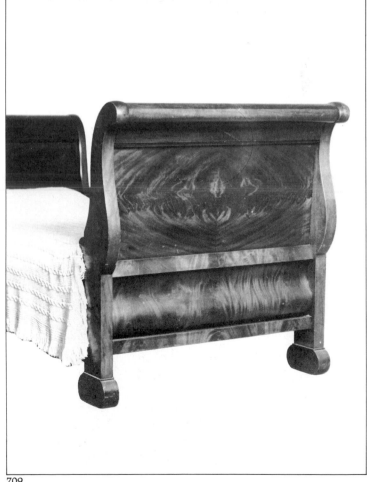
709

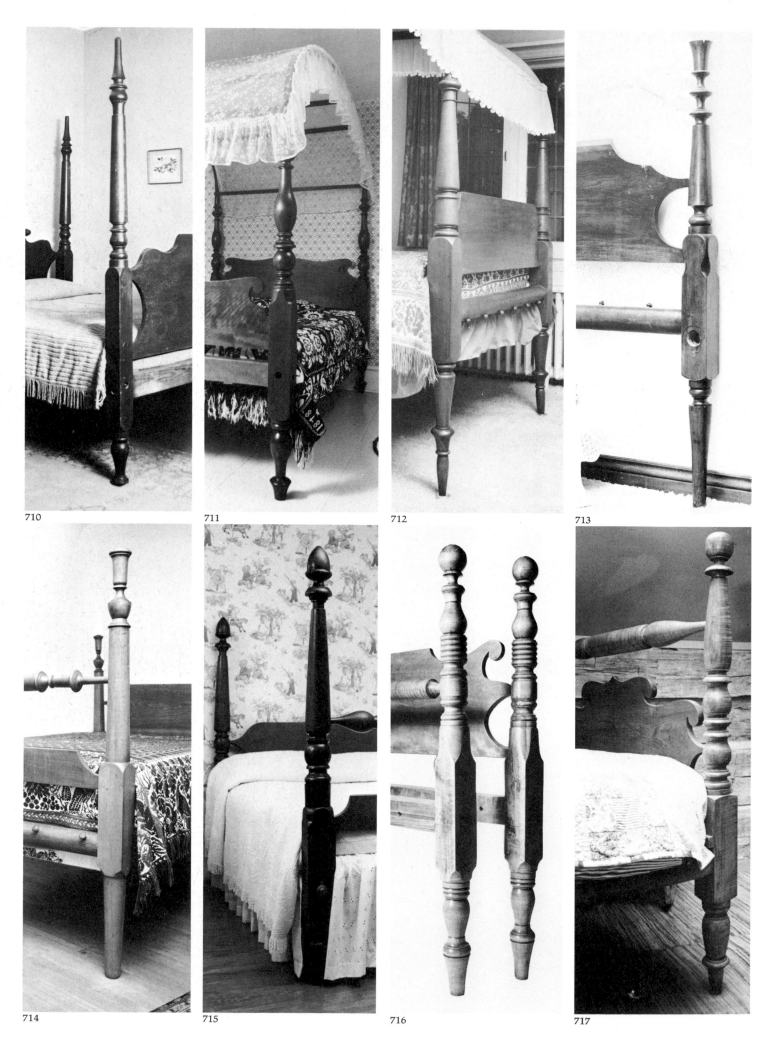

710

711

712

713

714

715

716

717

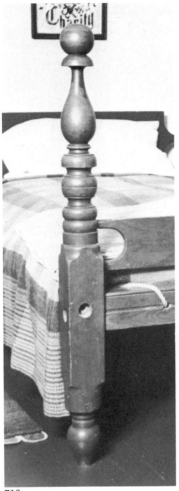

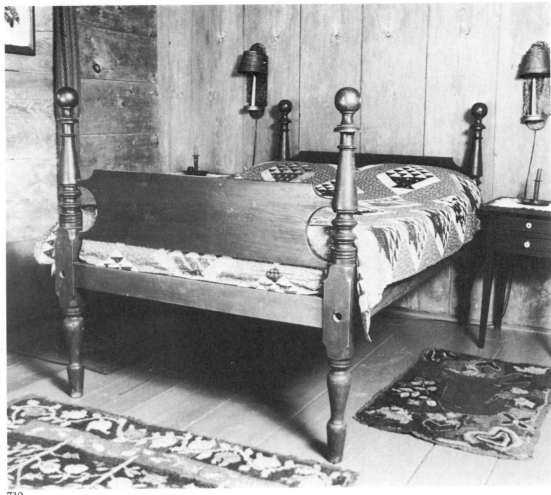

718

719

710 A high-post bedstead from Brant County. The slender, cylindrical posts and the deep boards are elements of 18th century style which survive in this simple provincial design. Second quarter 19th century. [P.C.]

711 A field bedstead with tester from the Niagara Peninsula. This is a provincial impression of the Empire style with pleasingly rotund details. Second quarter 19th century. [P.C.]

712 A field bedstead with tester from the western counties. The unusually slender foot in this Empire design creates a somewhat insecure elevation. Second quarter 19th century. [P.C.]

713 A low-post bedstead from Elgin County. This design is typical of the

period just prior to the mid-19th century, showing the large wooden screw detail which secured the rails and the pegs for roping. Second quarter 19th century. [P.C.]

714 A low-post bedstead from the western counties. This is a simple country design incorporating the popular blanket roll at the foot. Second quarter 19th century. [P.C.]

715 A low-post bedstead from Middlesex County. This sound, country-Empire design has a well-shaped blanket roll and acorn finials. Second quarter 19th century. [P.C.]

716 A low-post bedstead from the eastern counties. This is an exceptionally pleasing example of the popular

Empire style with cannon ball finials. Second quarter 19th century. [P.C.]

717 A low-post bedstead from the western counties. A variation on the cannon ball design with a blanket rail and scrolled footboard. Second quarter 19th century. [P.C.]

718 A low-post bedstead from the eastern counties. This is a sturdy variation on the cannon ball design. The roping is visible. Second quarter 19th century. [P.C.]

719 A low-post bedstead from Perth in Lanark County. (Early family: Watson.) A well-designed post with cannon ball finial. The head and foot boards are identical. Second quarter 19th century. [P.C.]

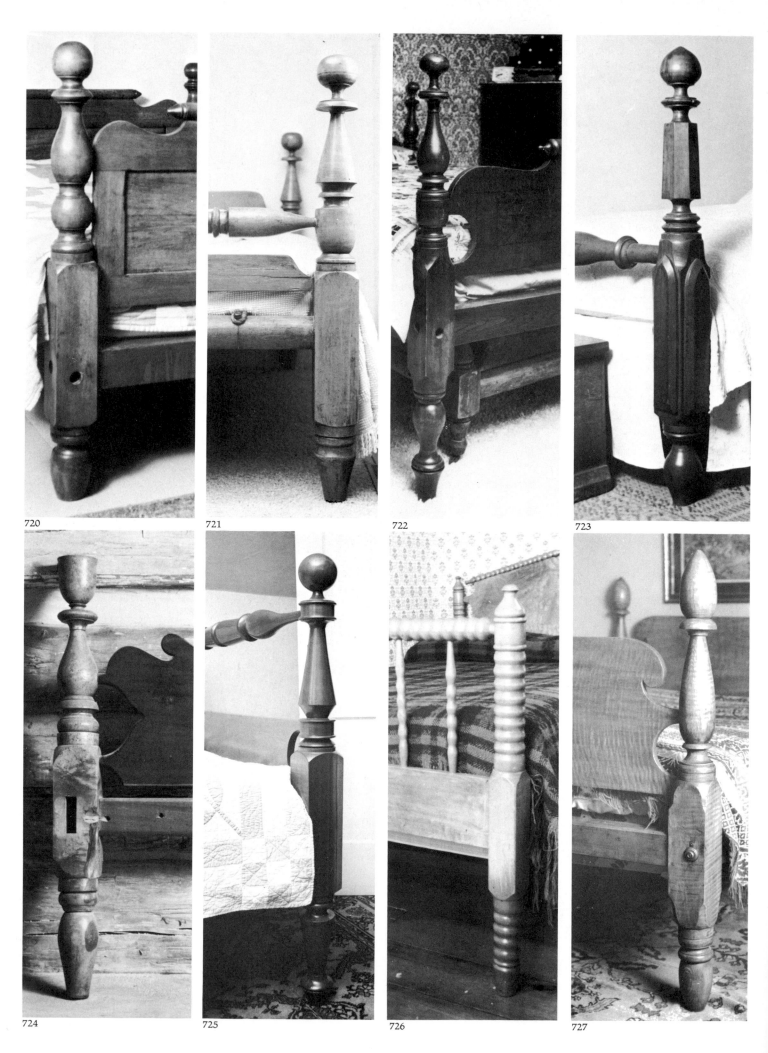

720 721 722 723

724 725 726 727

720 A low-post bedstead from Lanark County. Simple, stout cannon ball posts with matching panelled head and foot boards. Second quarter 19th century. [P.C.]

721 A low-post bedstead from Brant County. Country-Empire design with cannon ball finial and turned blanket roll. Second quarter 19th century. [P.C.]

722 A low-post bedstead from MacDonald's Corners in Lanark County. Mushroom finials and deeply cut details are incorporated here with head and foot boards which are painted in exotic wood grains suggesting inlaid panels. The trundle bed below is of a similar style and was pulled out at night for the children. Second quarter 19th century. [P.C.]

723 A low-post bed from the eastern counties. This is a more stylish example than most shown here. The applied panels create a heavy Gothic impression, although the basic design is typical of contemporary provincial Empire style. Second quarter 19th century.[U.C.V.]

724 A low-post bedstead from Elgin County. These well-shaped, figured maple posts were turned on a horse-powered lathe by Mack Carter, an early Elgin County woodworker. Second quarter 19th century. [P.C.]

725 A low-post bedstead from Waterloo County. This is an unusual cannon ball design with angular elements in place of the more familiar rounded effect. Second quarter 19th century. [P.C.]

726 A low-post bedstead from Elgin County. Spool turnings, a simple expression of the Elizabethan Revival style, were combined in a variety of designs and mass produced in local factories across the province. Still, examples such as this one in figured maple were made by individual craftsmen. Third quarter 19th century. [P.C.]

727 A low-post bedstead from St. Catharines in Lincoln County. The large acorn finials are the major feature of this design, made entirely in figured maple. Second quarter 19th century. [P.C.]

728 A low-post bed from Lennox and Addington County. This rustic example was likely made as a kitchen bed. The simple, chamfered-post style is similar to those of the cottage tradition in Scotland and Ireland. Second quarter 19th century. [P.C.]

729 A trundle bed from Paisley in Bruce County. Designed to slide under the full-size bed for daytime storage, the trundle bed reflects its style in the simple turned elements which in this case include a blanket rail. Second quarter 19th century. [P.C.]

730 A child's bed from the central counties. This soundly crafted bed is typical of those made by country joiners for children. There is little concern for style, but a real consideration of function is evident in the sturdy construction and in the way harsh elements have been excluded and the edges of posts and headboard softened by caps. Mid-19th century. [P.C.]

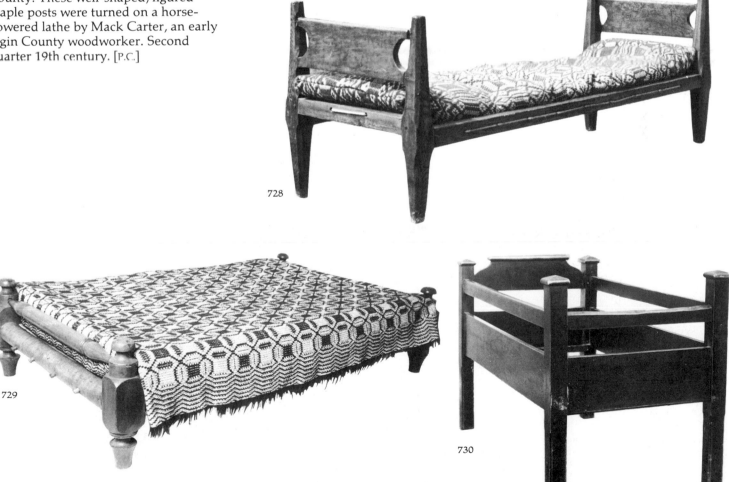

728

729

730

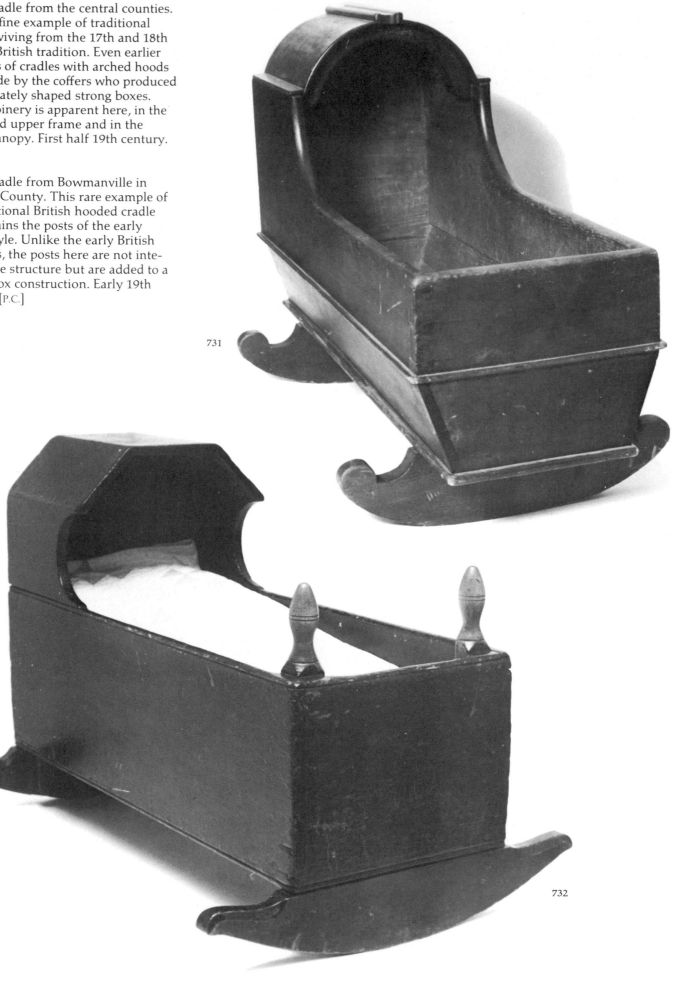

731 A cradle from the central counties. This is a fine example of traditional form surviving from the 17th and 18th century British tradition. Even earlier examples of cradles with arched hoods were made by the coffers who produced the intricately shaped strong boxes. Skilled joinery is apparent here, in the dovetailed upper frame and in the arched canopy. First half 19th century. [P.C.]

732 A cradle from Bowmanville in Durham County. This rare example of the traditional British hooded cradle form retains the posts of the early joined style. Unlike the early British examples, the posts here are not integral to the structure but are added to a typical box construction. Early 19th century. [P.C.]

731

732

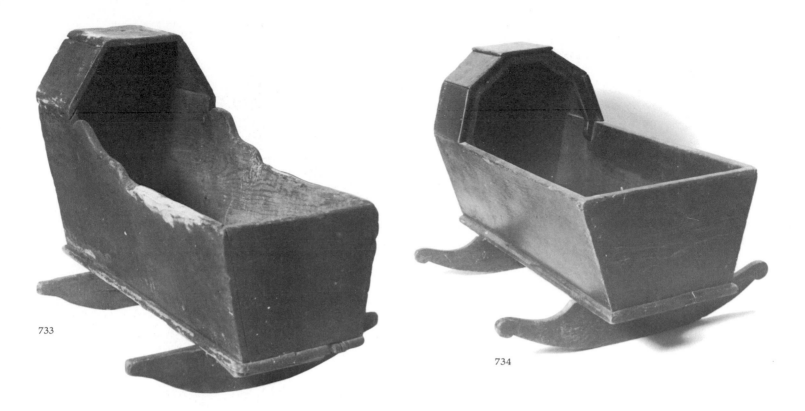

733

734

733 A cradle from Lanark County. The shaped sides are pleasing features in this simple traditional design of lapped construction. First half 19th century. [P.C.]

734 A cradle from Perth in Lanark County. (Early family: James.) Some skill is exhibited in the complex construction of the hood. First half 19th century. [P.C.]

735 A cradle from Beeton in Simcoe County. (Early family: Watson.) The canted hood here is carefully designed with compound angles, and the box is dovetailed. The original red and black graining is retained. Second quarter 19th century. [P.C.]

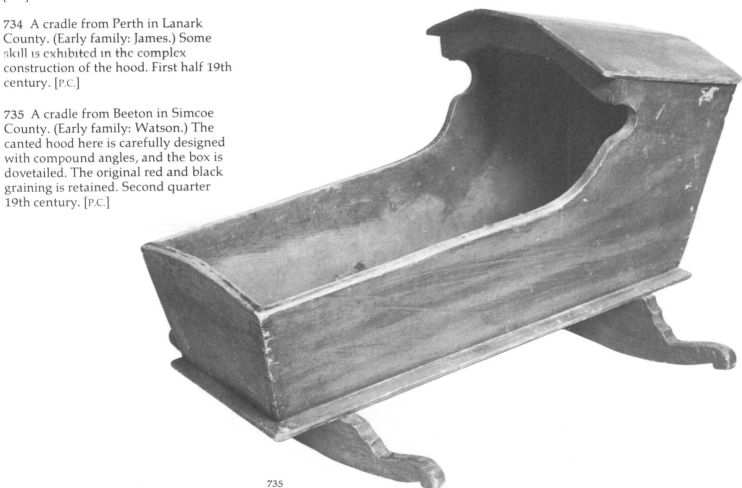

735

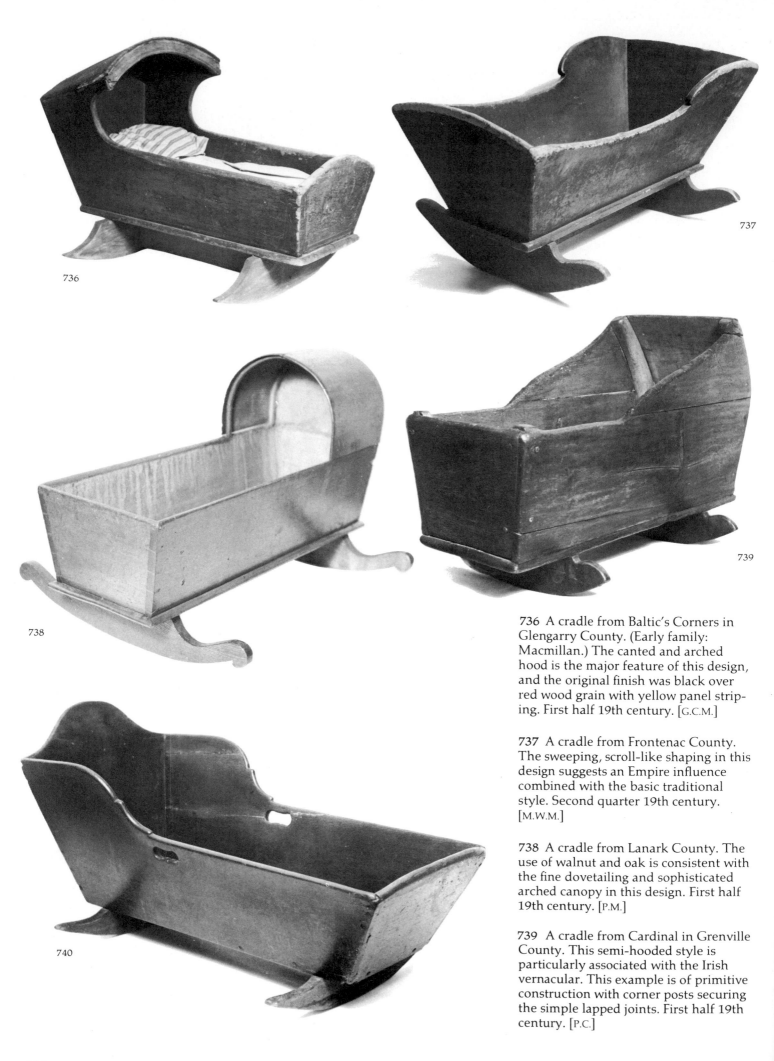

736 A cradle from Baltic's Corners in Glengarry County. (Early family: Macmillan.) The canted and arched hood is the major feature of this design, and the original finish was black over red wood grain with yellow panel striping. First half 19th century. [G.C.M.]

737 A cradle from Frontenac County. The sweeping, scroll-like shaping in this design suggests an Empire influence combined with the basic traditional style. Second quarter 19th century. [M.W.M.]

738 A cradle from Lanark County. The use of walnut and oak is consistent with the fine dovetailing and sophisticated arched canopy in this design. First half 19th century. [P.M.]

739 A cradle from Cardinal in Grenville County. This semi-hooded style is particularly associated with the Irish vernacular. This example is of primitive construction with corner posts securing the simple lapped joints. First half 19th century. [P.C.]

740 A cradle from Lincoln County. The simple refinement of design and construction relates this cherry cradle directly to 18th century American and English examples. First half 19th century. [P.C.]

741 A cradle from Fenelon Falls in Victoria County. This design, based on the late Windsor, arrow-back chair, is most unusual, although cradles of Windsor construction were common in the American colonies. The black over red graining and remnants of stencilled decoration are retained. Second quarter 19th century. [H.N. & M.E.P.]

742 A cradle from Cartwright Township in Durham County. This simple furniture construction reflects the early turned and posted cradles from the British tradition combined with rustic, stick-Windsor technique. First half 19th century. [P.C.]

743 A cradle from Prince Edward County. Stamped, HATCH. This prolific Kingston chairmaker included a variety of chair-like elements in this unique Windsor design. The similarity of this cradle and the Hatch low-back armchair in Plate 252 is noteworthy. Second quarter 19th century. [P.C.]

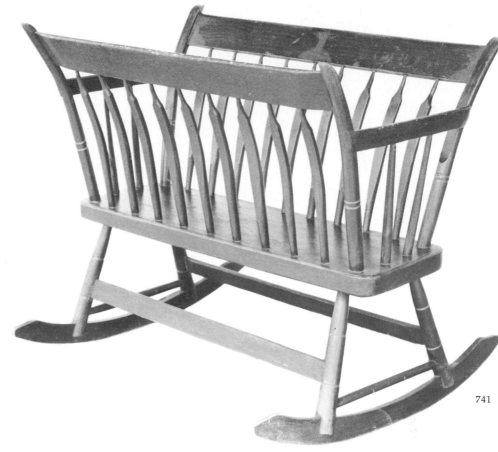

741

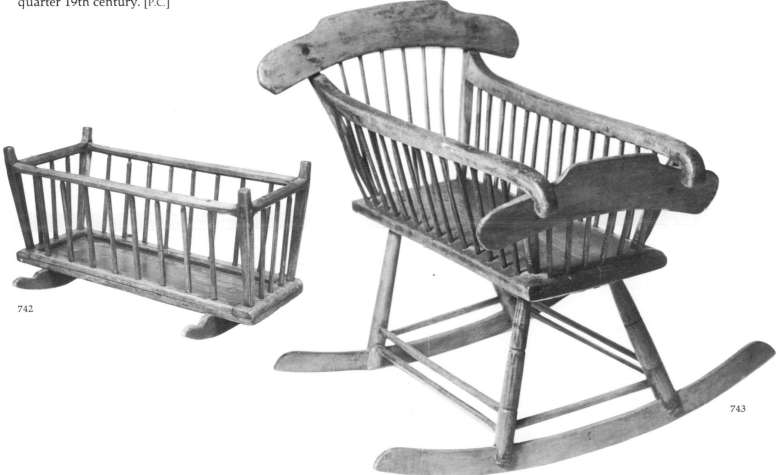

742

743

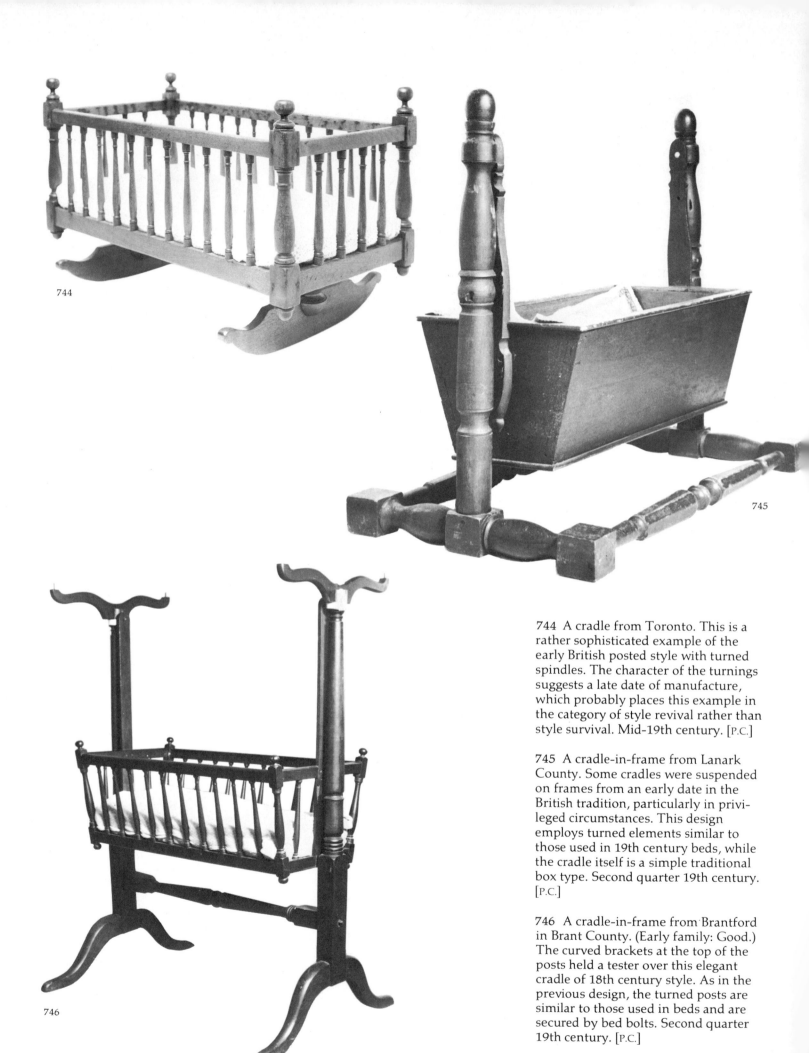

744 A cradle from Toronto. This is a rather sophisticated example of the early British posted style with turned spindles. The character of the turnings suggests a late date of manufacture, which probably places this example in the category of style revival rather than style survival. Mid-19th century. [P.C.]

745 A cradle-in-frame from Lanark County. Some cradles were suspended on frames from an early date in the British tradition, particularly in privileged circumstances. This design employs turned elements similar to those used in 19th century beds, while the cradle itself is a simple traditional box type. Second quarter 19th century. [P.C.]

746 A cradle-in-frame from Brantford in Brant County. (Early family: Good.) The curved brackets at the top of the posts held a tester over this elegant cradle of 18th century style. As in the previous design, the turned posts are similar to those used in beds and are secured by bed bolts. Second quarter 19th century. [P.C.]

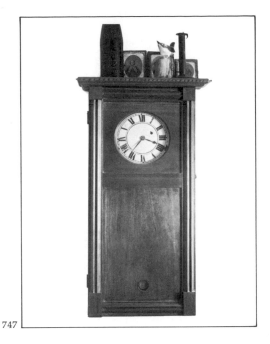

747

747 A wall-clock from the eastern counties. The movement from an American banjo clock has been fitted to a cherrywood case of unique design by a local craftsman. Certainly the inspiration for the neatly Classical style was the architectural wall mirrors of the period. Second quarter 19th century. [P.C.]

748 A tall-case clock from Cornwall in Stormont County. Signed, *W. Smith 1832*. As with many Upper Canadian clocks, this movement was brought from Britain and fitted with a case locally. The design of this well-crafted cherry case combines a provincial mixture of 18th century features, including an arched and scrolled pediment with colonettes on each side of the face, reeded quarter columns on the lower case and a simply shaped foot and apron. 1832. [U.C.V.]

749 A tall-case clock from Huron County. Family tradition suggests that this clock case was made by an early family member. The movement is American and the slender cherry case is typical of those made in the United States in the early 19th century, with arched and scrolled pediment, plain quarter columns and bracket base. A most unusual feature is the cast owl finials. Early 19th century. [P.C.]

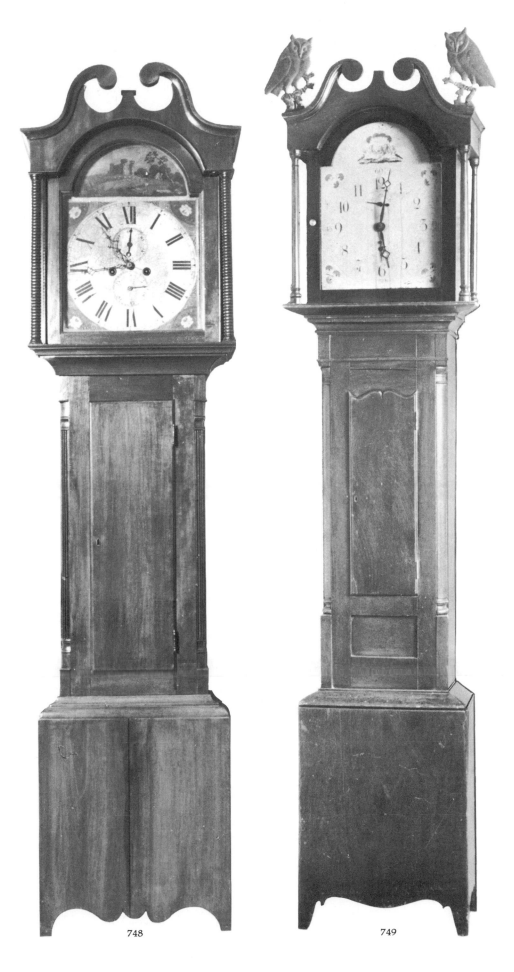

748

749

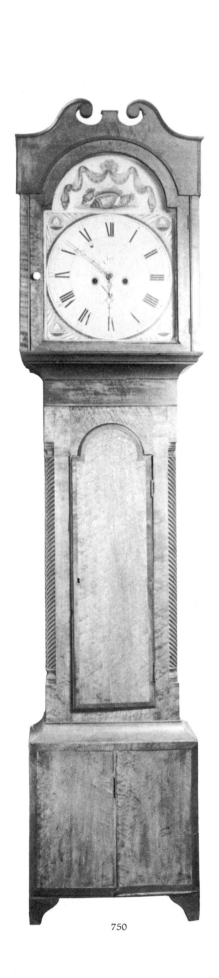

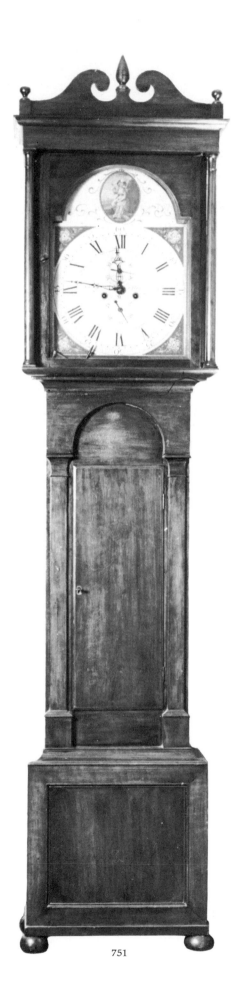

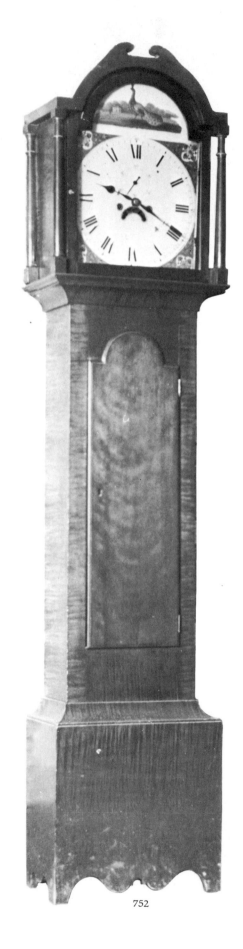

750

751

752

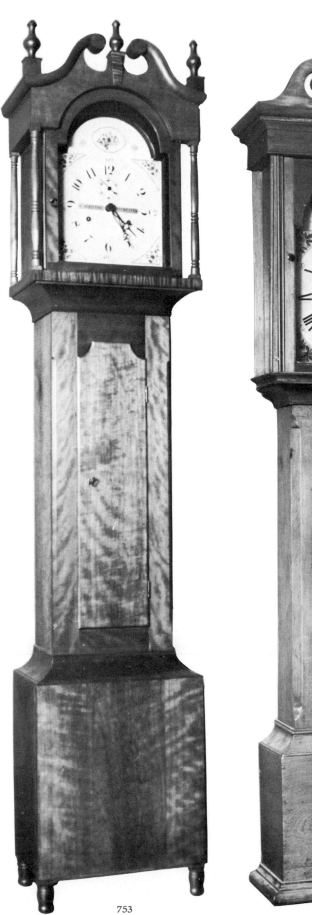

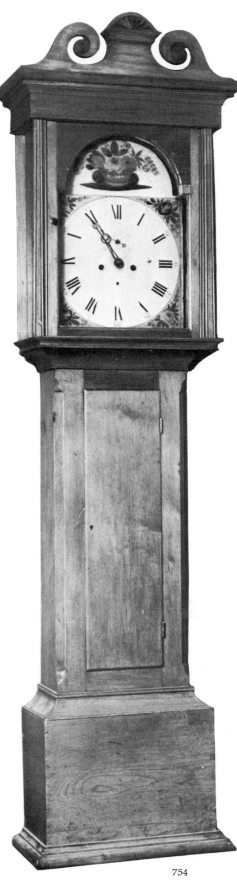

750 A tall-case clock from Lanark County. A Scottish movement is fitted to this case, which exhibits a high level of provincial craftsmanship. The restrained design includes a scrolled pediment, arched door and spiral reeded quarter columns. The use of figured maple, birdseye maple and mahogany with crossbanding of cherry reflects the decorative character of stylish late 18th century British furnishings. Early 19th century. [P.C.]

751 A tall-case clock from Perth in Lanark County. (Early family: Mr. Bell, who was the first Presbyterian minister in the area.) A Scottish movement is fitted in this cherrywood case which combines a scrolled pediment and colonettes with Neoclassical pilasters and arch on the lower case. The flat, bun feet are common on early 19th century British furnishings. Second quarter 19th century. [P.M.]

752 A tall-case clock from Morrisburgh in Dundas County. The movement is British in this cherry and figured maple case, which is a provincial expression of 18th century style influence. The pediment is a rather awkward stylization of the arched scroll form, while the sturdy colonettes, arched lower door and bracket base are handled with confidence. Early 19th century. [U.C.V.]

753 A tall-case clock from Toronto. The movement is by R. Whiting, the prolific Connecticut clockmaker whose products found their way in considerable numbers to Upper Canada. The case with scrolled pediment and standing on turned feet is typical of 19th century provincial American examples and may have been brought with the works intact or made locally. Second quarter 19th century. [P.C.]

754 A tall-case clock from the Niagara Peninsula. British movement. The rather grand scale and squat proportions of this design reflect the character of some stylish 18th century examples. The massive hood incorporates scroll and fan details in the pediment and simple beaded colonettes. The corners of the lower case are chamfered with lambs-tongue stops. Early 19th century. [P.C.]

753

754

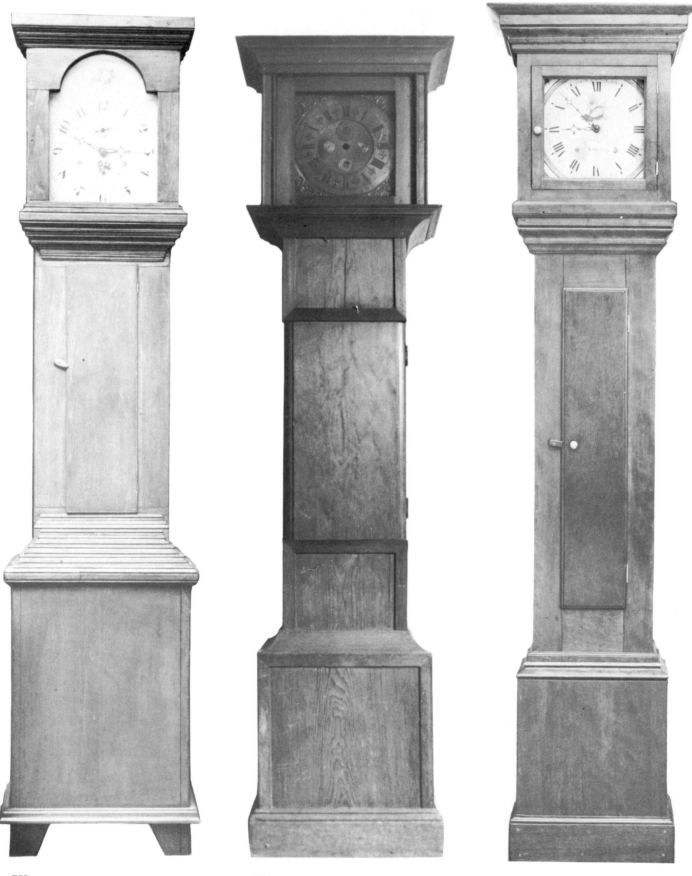

755

756

757

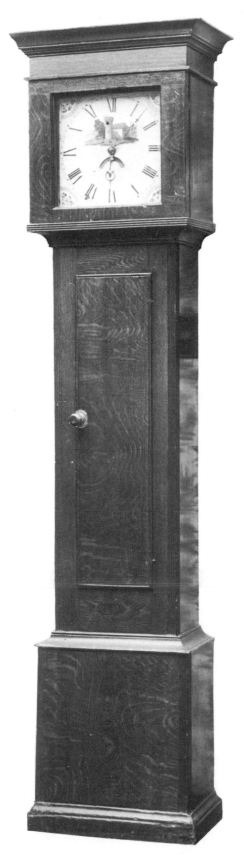

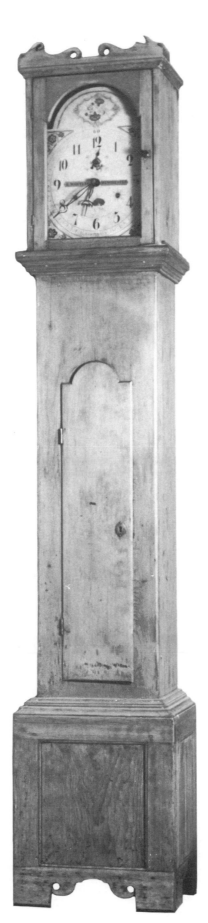

755 A tall-case clock from Claremont in Ontario County. Although the arched shaping of the movement by R. Whiting suggests a scrolled pediment design for the case, this country craftsman achieved a pleasing result featuring complex moulding arrangements on a simple box-like case. Second quarter 19th century. [P.C.]

756 A tall-case clock from Belleville in Hastings County. The small, square, brass-faced movement is of an early 18th century British type, and the square hood pine case is of a similarly early style. The addition of flat mouldings to the front of the case creates a panelled effect and the original finish was a painted facsimile of walnut or mahogany. Early 19th century. [P.C.]

757 A tall-case clock from Middlesex County. This simple rectangular design in cherrywood is similar to English cottage clocks of the early 18th century. The movement is British, with a circular face of a later date which is somewhat at odds with the remembered case design. Second quarter 19th century. [P.C.]

758 A tall-case clock from Durham County. (Early family: Osbourne.) This survival of 18th century British style is elevated from the simple country category in the restrained refinement of the detail, which includes finely drawn mouldings and reeding at the base of the hood and at the vertical edges of the case front. The present painted finish of some age reflects the English affection for oak; however, the original paint was blue-green. The movement is British. Early 19th century. [P.C.]

759 A tall-case clock from Simcoe County. Another Whiting movement has been employed here in a design which relates to early British and American examples in its great height and slender rectangular form. The pediment is a rustic interpretation of mid-18th century Rococo style, as is the bracket base. Early 19th century. [P.C.]

758 759

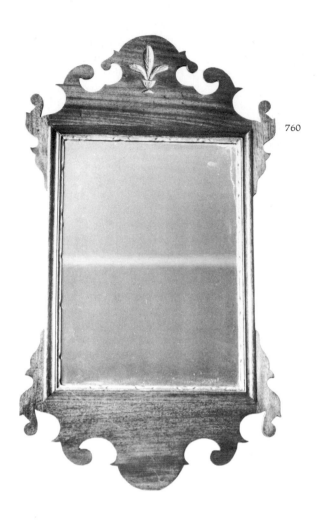

760

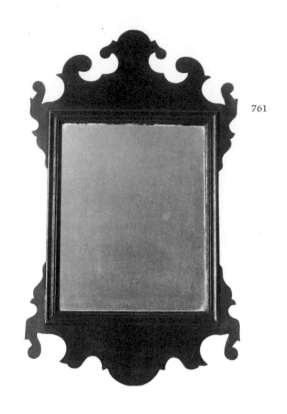

761

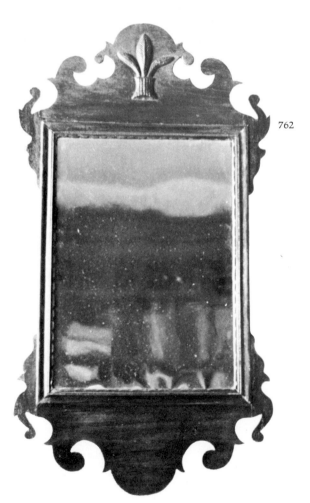

762

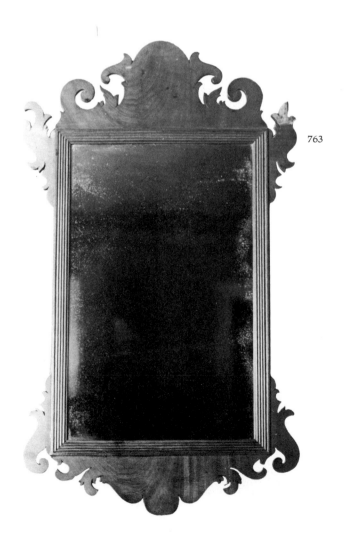

763

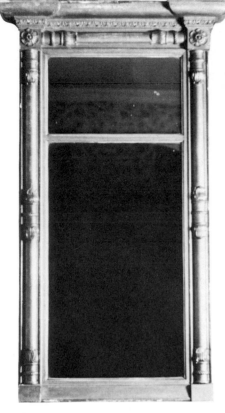

764

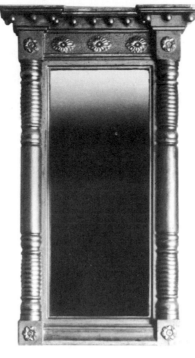

765

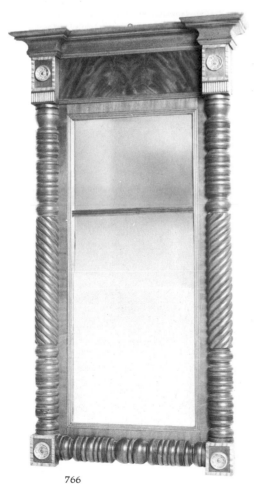

766

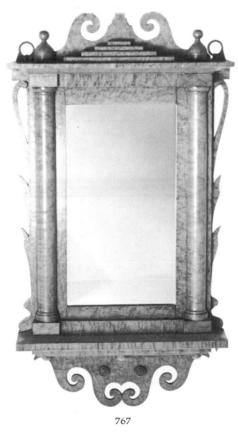

767

760 A fretwork mirror from St. Catharines in Lincoln County. Simple provincial examples of the Chippendale design such as this are occasionally found, particularly in areas of British settlement. No doubt, some of these arrived as treasured effects from England or America. However, local cabinetmakers advertised "looking glasses of all descriptions" which probably included this popular style survival. Late 18th or early 19th century. [P.C.]

761 A fretwork mirror from the Niagara Peninsula. Small mirrors of mahogany on pine identical to this example are occasionally found in early settlements. In *The Pine Furniture of Early New England,* Russell Kettell states that they were made in great numbers in the American colonies in the early 18th century. It is not known whether those found in Canada are part of this early group or were made locally in the 19th century. 18th or early 19th century. [P.C.]

762 A fretwork mirror from Carleton Place in Lanark County. Similar to Plate 760, in fact likely cut from the same pattern. Late 18th or early 19th century. [P.C.]

763 A fretwork mirror from Prince Edward County. This is a more complex variation on the popular Chippendale style than the earlier examples, but of similar provincial character. Late 18th or early 19th century. [U.C.V.]

764 An architectural mirror from Perth in Lanark County. (Early family: Matheson.) While this architectural form was developed in the Sheraton period, the example here incorporates less refined elements of American Empire style. Early 19th century. [P.M.]

765 An architectural mirror from the eastern counties. This design reflects the heavy, robust character of furniture of the late American Empire style. It retains its original gilt on gesso finish. Second quarter 19th century. [P.C.]

766 An architectural mirror from the Niagara Peninsula. This fine American Empire design combines turned and spiral-reeded walnut columns with delicate reeded mouldings in mahogany around the mirror. Second quarter 19th century. [P.C.]

767 A mirror from the eastern counties. This is a rather fanciful combination of the fretwork and architectural styles. The result is distinctly Empire. Second quarter 19th century. [P.C.]

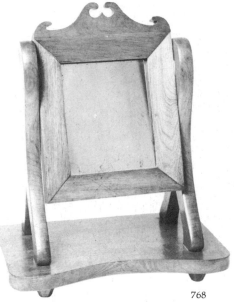

768

768 A mirror in stand from Waterloo County. This is a pleasing interpretation of American Empire style by a cautious country craftsman. Second quarter 19th century. [P.C.]

769 A mirror from the western counties. This naïve interpretation of Queen Anne style is neatly crafted in walnut. First half 19th century. [P.C.]

770 A mirror from Deseronto in Hastings County. A precious fragment of mirror preserved in a rustic frame which suggests a Queen Anne influence. Early 19th century. [P.C.]

771 A mirror from Clarke Township in Durham County. Signed, *J. Noden.* A purely functional design of primitive execution. Late 19th century. [P.C.]

772 A mirror from Prince Albert in Durham County. A simple moulding of birdseye maple. Mid-19th century. [P.C.]

773 A hand mirror from Hastings County. Crafted from a single piece of pine, this inventive design seems to have been created to make use of a fragment of mirror. First half 19th century. [U.C.V.]

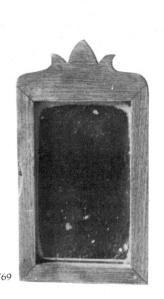

769

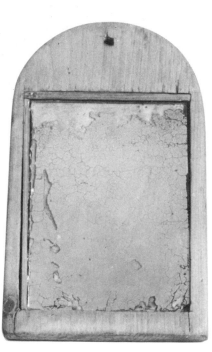

770

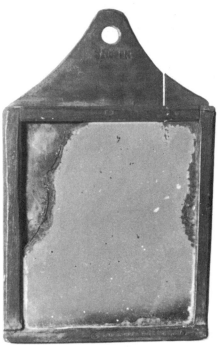

771

772

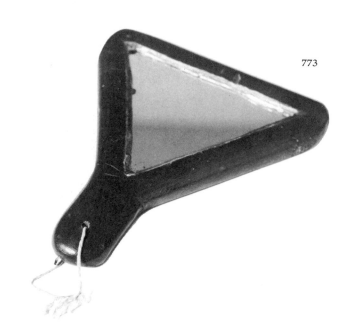

773

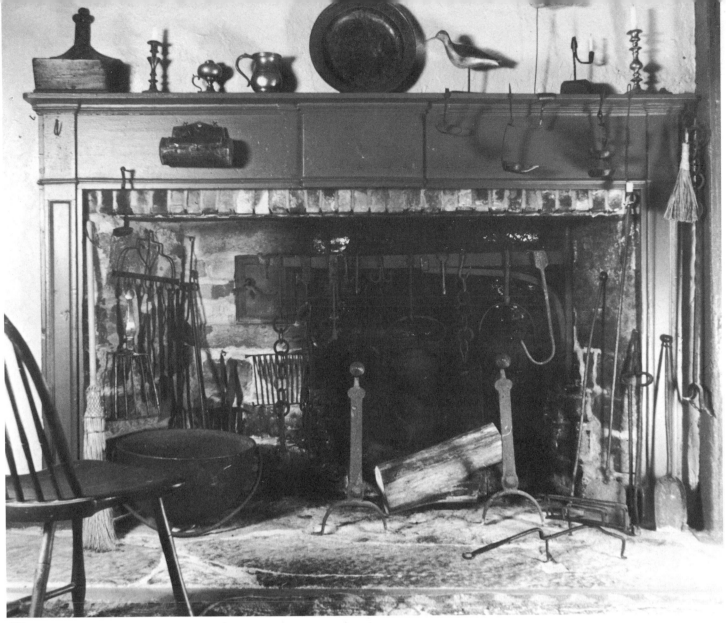

774

775

774 A kitchen hearth in Frontenac County. A typical early 19th century hearth of a British immigrant, incorporating the bake oven on one side within the pine mantelpiece. The fine collection of forged-iron accessories is largely from the eastern counties. Second quarter 19th century.

775 A parlour mantelpiece from Lincoln County. This is a rare example of Upper Canadian woodwork in both the finely detailed Neoclassical mantelpiece and the panelled wall in the British tradition. Both are related to 18th century American examples. First quarter 19th century.

776

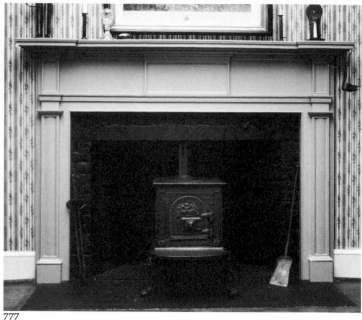

777

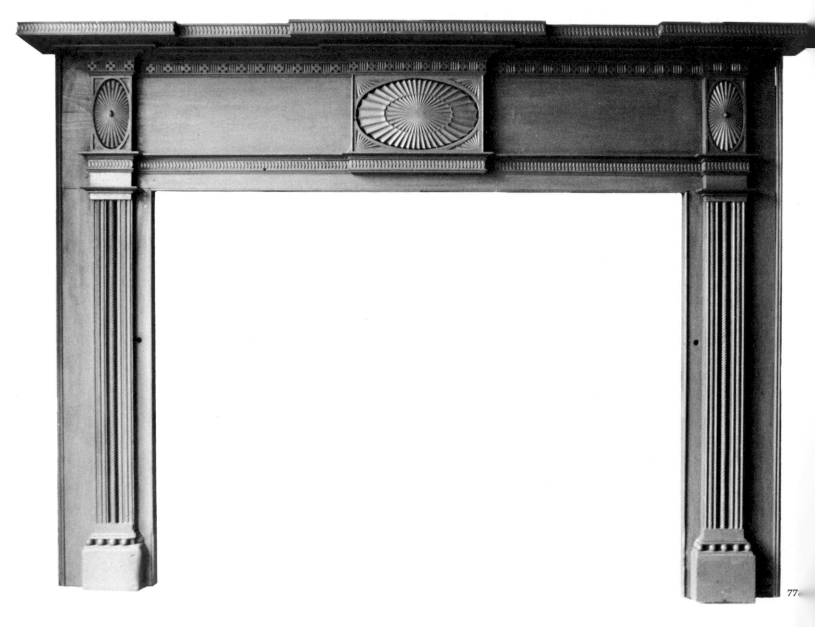

77

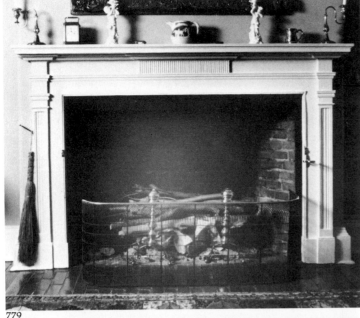

779

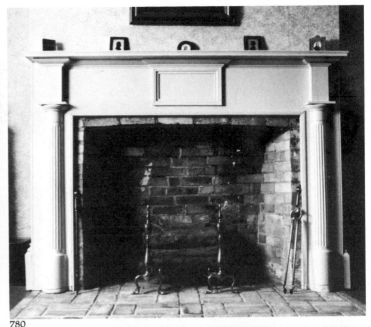

780

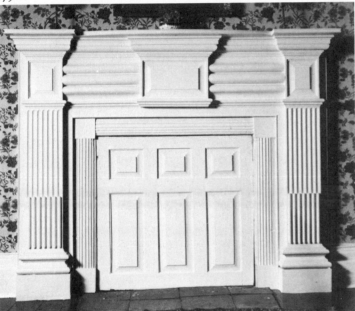

781

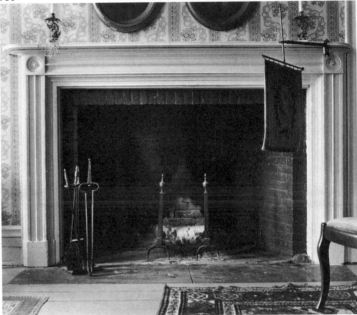

782

776 A mantelpiece from Frontenac County. The Neoclassical style as expressed by a country builder in which reeding is the basic motif. First quarter 19th century.

777 A mantelpiece from Lincoln County. Neoclassical style with convex, reeded pilaster detail. The cast-iron stove is placed in the hearth, as was commonly done to provide more efficient heat. It is a rare example from the early Normandale foundry. Second quarter 19th century.

778 A mantelpiece from Lincoln County. This sophisticated design includes a variety of delicately carved Neoclassical motifs which were obviously created by a craftsman of unusual skill. Typically, the wood is pine, and the original colour would have been deep rose madder. First quarter 19th century.

779 A mantelpiece from Perth in Lanark County. A central panel of fluting is repeated in the pilaster of this restrained Regency design. First quarter 19th century.

780 A mantelpiece from Brant County. Fluted columns are the major feature of this Regency design. Second quarter 19th century.

781 A mantelpiece from Perth in Lanark County. A robust heaviness relates this fluted and reeded design to the Scottish-Georgian style of the Matheson house for which it was made. Second quarter 19th century.

782 A mantelpiece from Lennox and Addington County. This simple design surrounds the doors, windows and hearths of many houses built in the 1825-1850 period. Second quarter 19th century.

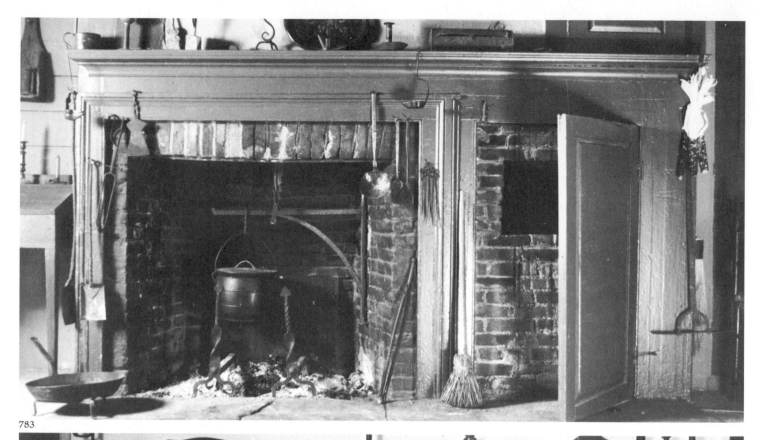

783

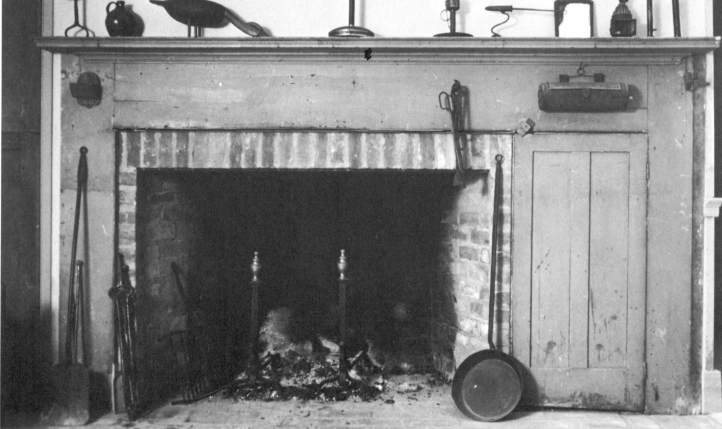

784

783 A kitchen hearth from Lennox and Addington County. This fireplace, with bake oven and chimney cupboards, is in a modest home built for a British immigrant about 1825. First quarter 19th century.

784 A kitchen hearth from Cobourg in Northumberland County. This kitchen mantel was moved from the early home of the Clinch family, who were chair-makers. It is a typical early 19th century mantelpiece, enclosing the bake oven with a panelled door. Second quarter 19th century.

785 A pair of andirons from the Niagara Peninsula. Cast iron. Common design in western area. Possibly Van Norman Foundry. 19th century. [P.C.]

786 A pair of andirons from the Niagara Peninsula. Goose neck, octagonal finial, penny feet. 19th century.[P.C.]

787 A pair of andirons from the southwestern counties. Goose neck, chamfered shaft. 19th century. [P.C.]

788 A pair of andirons from the eastern counties. Crook neck with octagonal finial. 19th century. [P.C.]

789 A pair of andirons from Cooksville in Peel County. From "Cherryhill House" (1817). Goose neck, octagonal finial, penny feet, shield-shaped shaft. 19th century. [P.C.]

790 A pair of andirons from Lanark County. Ring top with decorated shaft. 19th century. [P.C.]

791 A pair of andirons from Prince Edward County. Ball finial and chamfered shaft. 19th century. [P.C.]

792 A pair of andirons from Grey County. Ram's head design. 19th century. [P.C.]

793 A single andiron from Perth in Lanark County. Fine scroll. 19th century. [P.C.]

794 A single andiron from Victoria County. Pigtail design, penny foot. 19th century. [P.C.]

795 A pair of andirons with spit rod from Markham Township in York County. Unusual spike top, possibly for roasting. 19th century. [P.C.]

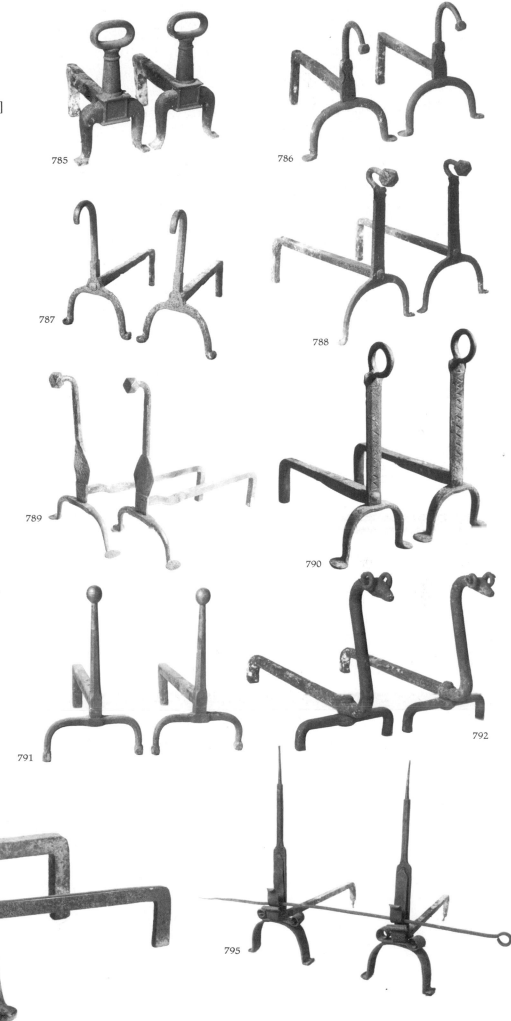

785

786

787

788

789

790

791

792

793

794

795

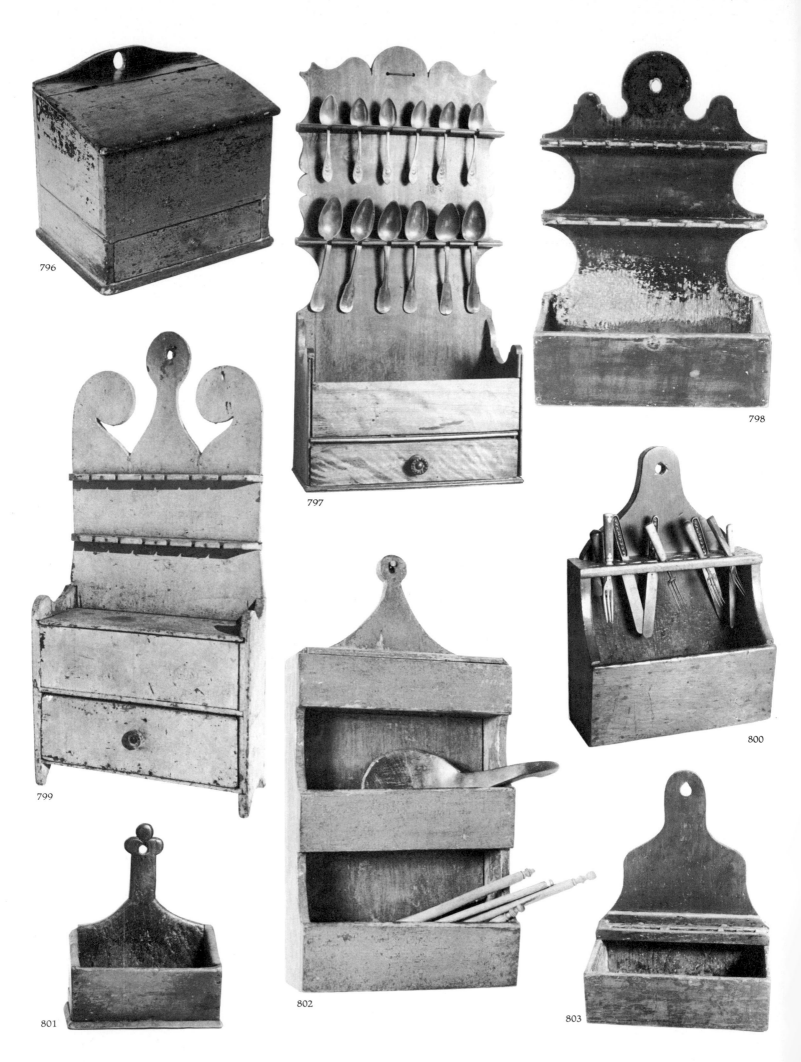

796

797

798

799

800

801

802

803

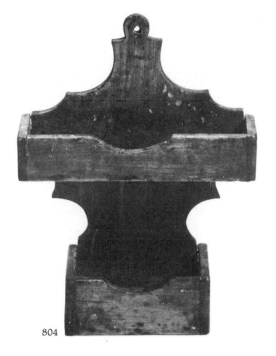

804

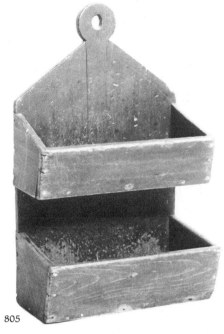

805

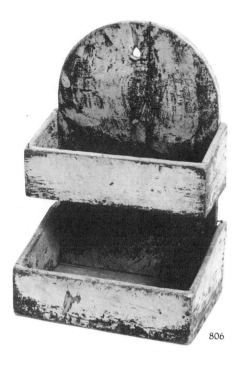

806

796 A wall box from Waterloo County. This was a universally popular form for the storage of candles and other lighting materials. Dovetailed construction. Second quarter 19th century. [P.C.]

797 A wall box with spoon rack from Lanark County. The refined character of this birch wall piece is reminiscent of 18th century English examples. First half 19th century. [P.C.]

798 A wall box with spoon rack from Dundas County. This is an exceptionally good design of early character. First half 19th century. [P.C.]

799 A wall box with spoon racks from Hastings County. This distinctive traditional design includes a slide-top box as well as a drawer in the lower section. Second quarter 19th century. [P.C.]

800 A wall box with knife rack from Frontenac County. A functional traditional form. First half 19th century. [P.C.]

801 A wall box from the eastern counties. The shaped backboard functions as a handle or for hanging. Mid-19th century. [P.C.]

802 A wall box from Shannonville in Hastings County. A simple design with two trays and a box with lid. Second quarter 19th century. [P.C.]

803 A wall box with knife rack from Camden East in Lennox and Addington County. A variation on the traditional form. Second quarter 19th century. [P.C.]

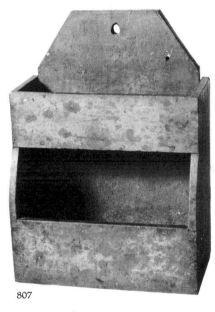

807

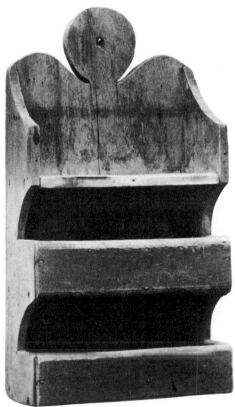

808

804 A wall box from the eastern counties. A two-tiered design with fret-cut backboard and shaped fronts to the trays. Mid-19th century. [P.C.]

805 A wall box from the eastern counties. Two tiers with canted trays. Mid-19th century. [P.C.]

806 A wall box from Lanark County. A simple design with two tiers. Second quarter 19th century. [P.C.]

807 A wall box from Pickering in Ontario County. A two-tiered design with solid, shaped sides. Mid-19th century. [P.C.]

808 A wall box from Simcoe County. (Early family: Katt.) A strong traditional design with two trays and a shelf. Second quarter 19th century. [P.C.]

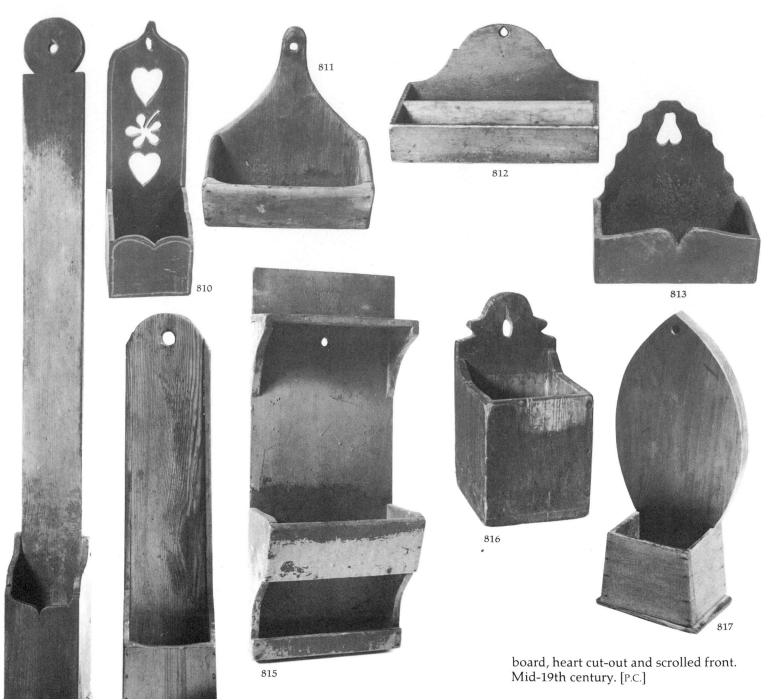

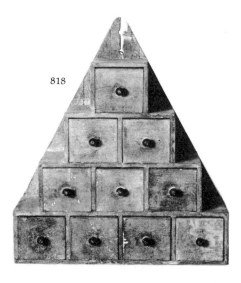

809 A knife box from Lanark County. An unusually tall back for knife scouring. Mid-19th century. [P.C.]

810 A wall box from Ontario County. The cutout decoration includes a five-leaf clover motif and the universal hearts. Mid-19th century. [P.C.]

811 A wall box from Lennox and Addington. A simple tray which was never painted or stained. Mid-19th century. [P.C.]

812 A wall box from Simcoe County. Nicely shaped back and divided tray; may be taken from the wall to table. Second half 19th century. [P.C.]

813 A wall box from the eastern counties. A simple tray with shaped back-board, heart cut-out and scrolled front. Mid-19th century. [P.C.]

814 A knife box from Durham County. Traditional tall back for knife scouring. Mid-19th century. [P.C.]

815 A wall box from Renfrew County. An unusual design which includes two trays and a shelf. Second half 19th century. [P.C.]

816 A wall box from Ontario County. One deep bin, probably used for salt. Mid-19th century. [P.C.]

817 A wall box from Durham County. Unusual canted tray and shaped back. Mid-19th century. [P.C.]

818 A set of spice drawers from Harlem in Leeds County. A highly graphic form. Other examples from the village are known. Mid-19th century. [P.C.]

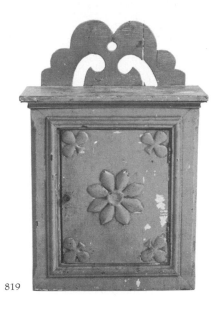

819

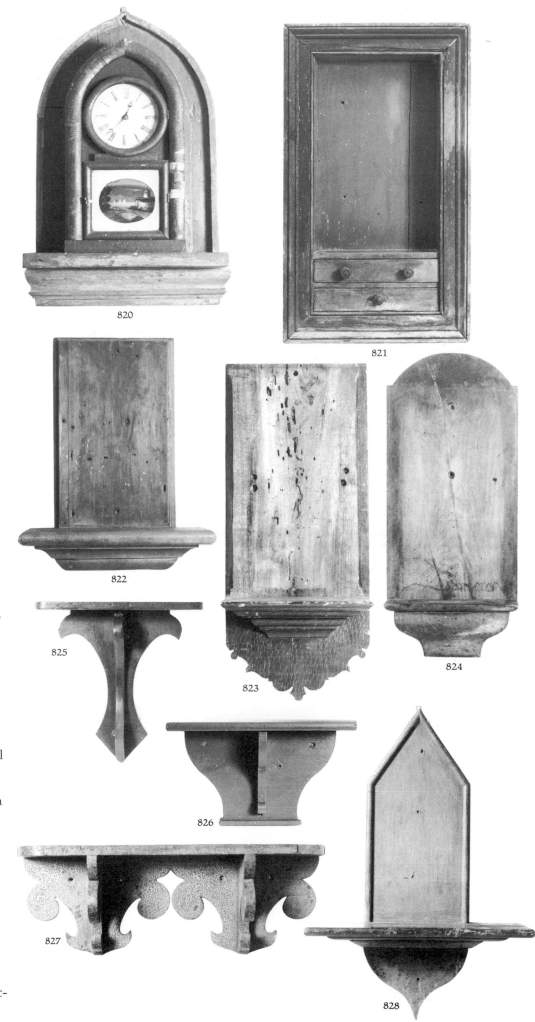

819 A wall box from Coe Hill in Hastings County. This charming wall piece provides a shelf and a small cabinet. Floral and clover carved decoration. Second half 19th century. [P.C.]

820 A clock shelf from Wellington County. Made for historic Rockwood Academy. Mid-19th century. [P.C.]

821 A clock shelf from Lanark County. The addition of drawers adds greatly to the interest of this architectural design. Mid-19th century. [P.C.]

822 A clock shelf from Ontario County. A sound combination of cavetto and ovolo mouldings. Second quarter 19th century. [P.C.]

823 A clock shelf from Frontenac County. The influence of a Chippendale mirror is seen in the delicate scrolls. Second quarter 19th century. [P.C.]

824 A clock shelf from Huron County. A refined use of the ogee profile. Mid-19th century. [P.C.]

825 A clock shelf from Peterborough County. Pleasing repetition of a graceful line. Mid-19th century. [P.C.]

826 A clock shelf from Scugog Island in Ontario County. (Early family: Fralicks.) A restrained use of the "S" curve in both backboard and supporting bracket. Mid-19th century. [P.C.]

827 A clock shelf from Victoria County. A decorative repetition of a stylish Prince of Wales plume motif. Mid-19th century. [P.C.]

828 A clock shelf from Wellington County. This pleasing design was evidently created for a steeple or Gothic-style clock. Mid-19th century. [P.C.]

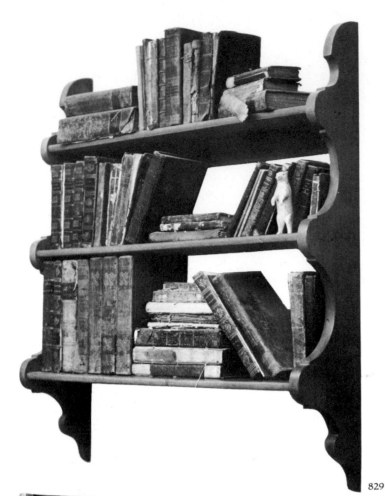

829

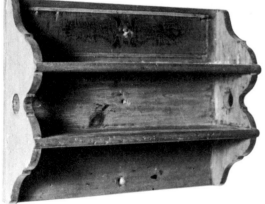

830

831 A spinning wheel from the eastern counties. A double-treadle, double-wheel style designed to work at a much higher speed than the common type. Similar in concept to the chair wheels of Connecticut origin and rare in Upper Canada. First half 19th century. [U.C.V.]

832 A spinning wheel from Scugog Island in Ontario County. A walking wheel, used in all parts of Upper Canada for the spinning of wool. First half 19th century. [S.S.H.M.]

833 A spinning wheel of unknown origin. A typically European style variously called a castle wheel, German wheel, visiting wheel, parlour wheel and cottage wheel. 18th or early 19th century. [P.C.]

834 A spinning wheel from Whitby in Ontario County. This double-spindle type is often called a gossip or lovers' wheel, because it could be used by two spinners at the same time. However, some accomplished spinners could use both hands to double their production. First half 19th century. [P.C.]

835 A spinning wheel from Amherstburg in Essex County. Signed, *Alexr McIntosh, 1814*. Alexander McIntosh made spinning wheels in Pictou County, Nova Scotia (Burnham and Burnham, *Keep Me Warm One Night*, p. 32, Fig. 16). This wheel, of a Scottish type, was brought to Upper Canada by an early immigrant from the Maritime province, possibly a Loyalist. First half 19th century. [P.C.]

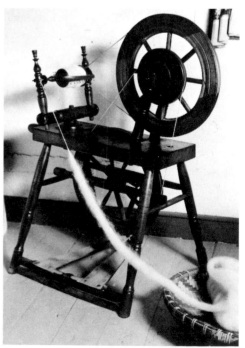

831

829 A wall shelf from the eastern counties. This is a handsome example of vernacular design. Early 19th century. [U.C.V.]

830 A wall shelf from York County. The profile of the scalloped side pieces is a detail which occurs in the British tradition from the 17th century. This small shelf is decorated with multi-coloured stencils and striping. Second quarter 19th century. [P.C.]

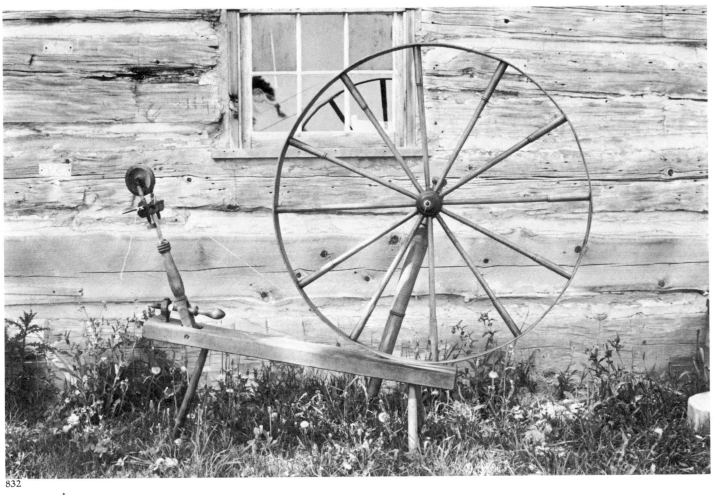

832

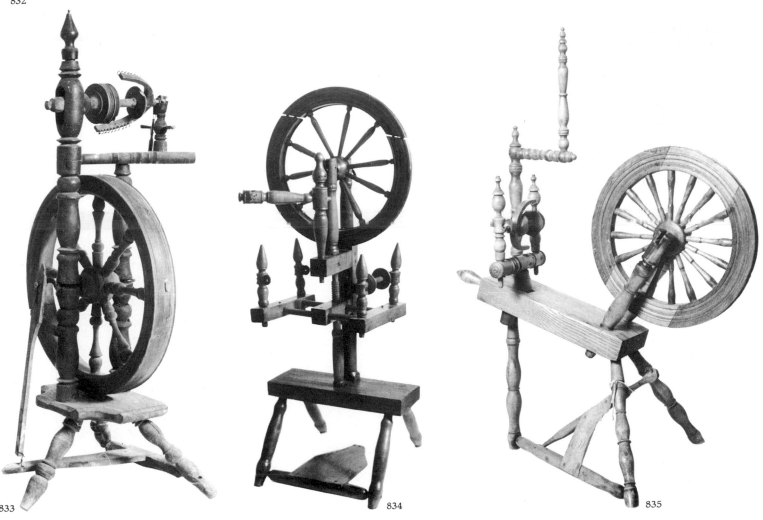

833

834

835

836 A swift from Frontenac County. A barrel or squirrel-cage swift used for transferring the skeins to bobbins for the weaver or balls for the knitter. First half 19th century. [M.W.M.]

837 A yarn reel from Frontenac County. Used for forming skeins of a standard length; this type is commonly found in Quebec. First half 19th century. [M.W.M.]

838 A swift from Waterloo County. From a Pennsylvania-German home, this early and unusual style includes a wooden cup for holding the uncompleted ball of yarn. First half 19th century. [P.C.]

839 A clock reel from Milbrook in Durham County. This reel is used in forming skeins of a standard length. The length of the skein is measured by a wooden gear mechanism. First half 19th century. [P.C.]

840 A swift from Frontenac County. A very early style in which the upright members can be placed in different positions to hold skeins of varying lengths. First half 19th century. [M.W.M.]

841 A hackle from Frontenac County. Used in preparing the flax for spinning into linen yarn. This is an early traditional form often brought as immigrants' effects. 18th or early 19th century. [M.W.M.]

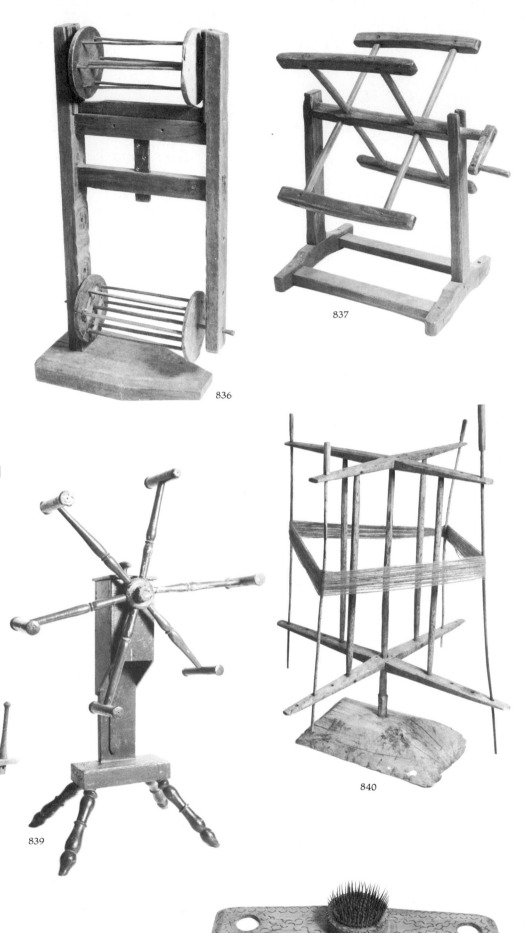

837

836

840

839

838

841

4 The Germanic Tradition

Significant numbers of Germans were among the first Loyalist refugees who entered the region that was to become Upper Canada. Initially, these people, mostly Palatinate[1] Germans, came to the Niagara region from the Mohawk Valley in New York State and squatted on lands opposite Fort Niagara as early as 1780. The farms they established were soon productive and a valued source of produce for the military establishments. Members of Butler's Rangers, disbanded after the American Revolutionary War, also took lands in the Niagara area, and many of these had German and Huguenot backgrounds. In the years that followed, the first family groups of Pennsylvania-Germans arrived, establishing the precedent for the later major migration.

With the cessation of hostilities in 1783, soldiers from Sir John Johnson's Loyalist Corps, the King's Royal Regiment of New York and Major Edward Jessup's Rangers were the first settlers in the eastern areas along the St. Lawrence. The First Battalion of the Royal Yorkers settled in the Cornwall area, and the Second Battalion was located on the Bay of Quinte. Many of these soldiers were German. A small number of Hessian soldiers, direct from Europe, also settled around the Bay of Quinte, although the vast majority were Palatinate Loyalists from the Mohawk Valley. In 1792, Mrs. Simcoe commented on her travels through the Cornwall area en route to Niagara that, "There are many Dutch and German farmers about here whose houses and grounds have a neater and better appearance than those of any other people."[2]

Yet another German group arrived in York County in 1794, this one led by an Austrian aristocrat, William von Moll Berczy. Originally, Berczy had organized the group in Germany with an eye to settling in New York State, but, meeting difficulties there, he made arrangements with Governor Simcoe for lands in Upper Canada. There were, apparently, other German settlers in the York area, since Mrs. Simcoe observed earlier that year that, "The weather was so pleasant we rode to the bottom of the Bay, crossed the Don which was frozen and rode to the Peninsula, returned across the marsh which is covered with ice and went as far as the Settlements which are near 7 miles from the camp. There appeared some comfortable Log Houses inhabited by Germans and some by Pennsylvanians."[3]

Very little evidence of these early settlements survives in the way of furniture. In the eastern areas, rare objects are found with distinct German characteristics, yet there does not appear to have been a substantially developed German folk tradition at that time. Since many of these early settlers were from military backgrounds, they may not have been exposed to a traditional Germanic environment. Others had lived in America for some time, where their folk traditions may have been diluted by exposure to other national groups and, doubtless, were affected by the different conditions of the new land.

In the Niagara area, Germanic influence from the early years is similarly elusive, apart from the distinct Pennsylvania-German tradition that was planted there by the first groups of "Plain Folk" and grew in importance in several areas of the province in the following years. The survival of the Pennsylvania-German tradition for so many years is due to the strong religious convictions of the Mennonites, Dunkards and others, which set them apart from the mainstream of society and its diluting influences.

It was not until somewhat later, during the 1820s and continuing into the 1860s, that immigration directly from Germany, Alsace and Switzerland brought a European Germanic tradition. In several areas of settlement of the province, this strong tradition produced distinctive furniture styles and other folk crafts. Although many of these same Continental elements were retained in the Pennsylvania-German vernacular as well, other influences incorporated there resulted in many quite different forms. Thus, within the Germanic tradition in Upper Canada there are two distinct branches, each of which produced a sizable body of important material.

The Pennsylvania-Germans

Shortly after he was granted the governorship of the lands to be known as Pennsylvania in 1681, William Penn initiated a campaign to attract immigration from the rich agricultural areas of the Netherlands, southern Germany and Switzerland. Many of the skilled artisans and farmers of these regions were members of pacifist religious groups with a history of persecution. Penn, a Quaker, felt a strong empathy for these people and shrewdly concluded that they would make excellent settlers for his new colony.[4] Large-scale immigration from these areas included people from the Mennonite, Amish, Quaker, Dunkard, Moravian and Schwenkfelder religious groups. In addition to these "plain" people, there were Lutherans, Huguenots and members of the German Reformed Church.

By the early eighteenth century, southeastern Pennsylvania was becoming highly developed and prosperous as a result of the diligence and skill of these immigrants. Also involved were Quakers from Holland, England, Wales and other early American colonies. This development included a highly sophisticated community of furniture-makers, clockmakers, potters, carvers, pewterers and silversmiths. In total, there was a rich craft community, encompassing not only the traditional peasant expression of the various homelands, but also the most formal developments from the centres of fashion, particularly Holland and England.

The philosophy of the Plain Folk rejected ostentation in all things. This was, nevertheless, rationalized with the production, in Philadelphia and other major towns, of some of the most elegant objects in colonial America. Formal furniture crafted in eighteenth century Pennsylvania incorporated the prevailing mannerisms of the William and Mary, Queen Anne, Chippendale and Neoclassical styles. Some of the Philadelphia craftsmen had learned their skills in London, Edinburgh and Dublin, and they made furniture in these styles which is distinguishable from that of other centres by its restraint and delicate grace.

By the 1760s, the distinctive Philadelphia Chippendale style was reaching its peak in the creation of the highboy form. Expressions of the Chippendale vocabulary also took the form of lowboys, low and high chests, desks, secretaries, chairs, tables and clock cases. With exquisite carving, working in imported mahogany as well as native hardwoods, the Philadelphia cabinetmakers executed the ball and claw foot, fluted column, broken arch pediment and shaped apron on pieces that were organized into admirable symmetry. These elegant forms were created for the Georgian mansions of the worldly and wealthy citizens of Philadelphia.

Still, the Chippendale style, albeit somewhat simplified, was expressed by provincial German craftsmen in furniture for prosperous rural homes. At the same time, these skilled craftsmen made more utilitarian cupboards, tables, chairs, wardrobes, chests and cradles in styles remembered from their European origins. As one might expect, some recognizable influence from current fashion was often mixed with these traditional forms.

In the same rural communities, the art of manuscript illumination was an important focus of religious fervour and a means of transmitting basic

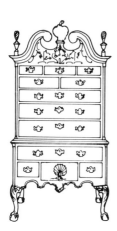

XXXVII Pennsylvania – high chest of drawers, Philadelphia Chippendale, 1765-1780.

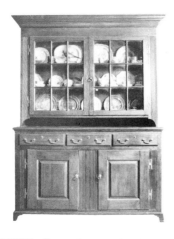

XXXVIII Pennsylvania – glazed, walnut, dish dresser, late 18th century. [P.C.]

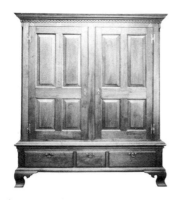

XXXIX Pennsylvania – walnut wardrobe, dated 1793. [P.C.]

Germanic thought. Called *Fraktür*, it was taught in the denominational schools that dotted the countryside. While basically religious in motivation and centred in the Continental German tradition, this art form developed its own unique character in Pennsylvania. That is, the symbols and illustrative motifs underwent considerable stylization and also emerged as decorative motifs in ironwork, needlework, textiles, pottery, architecture and furniture.

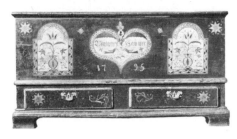

XL Pennsylvania – dower chest, dated 1795. [P.C.]

From a composite of the traditional styles of Germanic Europe, the influences of eighteenth century English formal styles and the unique local decorative vocabulary,[5] a distinct Pennsylvania-German vernacular style was formed. This style was at the zenith of its power when the first Pennsylvania-Germans moved to the Upper Canadian frontier in the 1780s. Their pacifist beliefs and allegiance to Britain as the legitimate power had led to recriminations from the American patriots, and some came to Upper Canada for reasons of loyalty to the Crown, or because they disapproved of conflict. Some were more concerned with their religious freedom in the new republic, but the majority came because of the availability of land. A major concern of the prosperous older generation was the establishment of their families on good land, and Pennsylvania could no longer satisfy this need. Possibly influenced by the dramatic success of development in Pennsylvania a century earlier, Governor Simcoe welcomed the Germans and their skills and advertised free land to suitable settlers in the Philadelphia newspapers.[6]

Throughout the last decade of the eighteenth century and the early years of the nineteenth, large numbers of Pennsylvanians, including family and religious groups, established their traditional patterns in the Upper Canadian hinterland. Early immigration included Mennonites, Dunkards, Moravians, Quakers and Lutherans. Their communities were soon flourishing. Almost completely self-sufficient, they neither required nor sought contact with the outside world. This characteristic is of great importance in explaining the surprising degree of survival of their eighteenth century craft traditions, including furniture styles, throughout the nineteenth century. The German settlements possessed all the elements of the earlier communities in Pennsylvania. Potters, weavers, smiths and cabinetmakers were soon providing the necessities for their communities. The styles employed were familiar ones from Montgomery, Bucks, Berks, Lancaster and Somerset counties in Pennsylvania.

The materials they found in abundance were also familiar, in particular pine, cherry, maple and the much-favoured black walnut. In *The Trail of the Black Walnut*, G. Elmore Reaman has observed that the Pennsylvania Germans selected their land with a keen eye for the potential yield of the virgin forest.[7] They were particularly satisfied to find areas where the black walnut flourished, because this indicated the presence of the limestone soil they preferred for farming. In any event, walnut and cherry were certainly the hardwoods most often selected by provincial Pennsylvania-German cabinetmakers.

The map on page 19 shows that there were several Pennsylvania-German settlements of varying size in Upper Canada. Each one constituted an important facet of the Germanic tradition; three of them – the Niagara Peninsula, and York and Waterloo counties – attracted large-scale immigration and, because of this, evolved as clearly defined craft communities. The earliest established of these was the Niagara Peninsula, where early settlement centred in Lincoln, Welland and Haldimand counties and spread west along the shores of Lake Erie. The villages of Jordan and neighbouring Vineland were important supply centres, and craftsmen in this area of the Niagara settlement in particular became the focal point of a very distinct and cohesive furniture tradition.

The Lincoln County cabinetmakers produced a variety of formal furniture forms in the Chippendale and Neoclassical styles, as interpreted in rural Pennsylvania during the last decades of the eighteenth century. Of particular note are the linen presses, low chest, high chests, blanket chests, desks, cupboards, beds, tables and tall-case clocks. Niagara furniture of this type is characterized by excellent workmanship and sound traditional Pennsylvania-German construction techniques. The well-proportioned drawers are dovetailed, the mouldings are finely drawn and often secured with wooden pegs rather than nails, drawers and doors are lapped. Details from the Pennsylvania Chippendale style, quarter columns (plain and reeded), straight bracket and ogee bracket feet, are used with admirable restraint. Neoclassical influence is occasionally seen in reeded cornice and frieze details, reeded door panels and facia inserts. Walnut is most often found in this family of related pieces, with the occasional appearance of cherry, maple or pine. Veneers, inlay or decorative effects are not used, other than the frequent use of ebonizing on mouldings, columns, feet, and drawer or door laps where it appears in carefully considered emphasis of the overall design (Plate 937).

Pennsylvania vernacular expressions of more utilitarian furnishings were also crafted in the Niagara community. This family is made up of dressers, cupboards, tables, blanket chests, chairs, benches and cradles. Pine was the wood most often chosen for these pieces, though it is not unusual in Niagara to find everyday objects in walnut or cherry, for instance in the form of fine, stretcher-based kitchen tables, blanket chests and cradles. The pine pieces are painted in the universally popular reds, greens, blues, greys and browns, or in woodgrained effects which are subdued in colour and subtle in execution. Considering the relatively high degree of survival of the Pennsylvania furniture tradition, it is surprising that few Niagara painted pieces have decorative elements of any kind and the use of colour is, for the most part, subdued.

Even after 1850, some of the formal furniture made in this area retains its single-minded focus on the Chippendale style of eighteenth century Pennsylvania, despite the occasional use of Neoclassical elements from somewhat later in the century. There is, nevertheless, considerable deterioration in the refinement of both detail and proportion. By the 1860s, influences from the Empire and Victorian styles regularly occur in forms which are still basically eighteenth century in concept.

In all the early Niagara furniture, there is an unmistakable crispness, lightness and simple refinement of proportion which plainly reveals makers of some sophistication. This furniture is sometimes found today in settlements further west as well as in York and Waterloo counties, a dispersement caused by migration from the earlier settlement and intermarriages among German families. In any location, the Niagara personality cannot be mistaken. Several names are associated with the Jordan-Vineland complex of cabinetmakers: Jacob Fry, John Grobb, Israel Moyer (the painter), Daniel Zimmerman, Jacob Houser and Albert Lane.[8] Their works are not often signed, yet most of these makers are represented by clearly marked examples which establish individual idiosyncrasies and will provide a basis for much-needed further research.

The second centre of Pennsylvania-German settlement important for the study of Upper Canadian furniture was in York County. During the first years of the nineteenth century, Dunkards from Somerset came to Vaughan Township and Mennonites from Lancaster and Bucks settled in Markham. These communities gradually expanded northward into King, Whitchurch and Uxbridge, where Quakers from Pennsylvania also settled. Each of these locations was the centre of a closely knit religious group, established very much along the lines of its Pennsylvania origin. As in Niagara, these centres

had craftsmen of all kinds among their citizens, and all the traditional folk crafts were practised in the homes well into the twentieth century.

The German cabinetmakers there created a wide range of furniture in the Pennsylvania styles, but the major emphasis was on utilitarian forms. Most common are glazed and blind-doored cupboards, corner cupboards, blanket chests, chests of drawers, desks, tables, benches and cradles. York County Pennsylvania-German furniture is usually made of pine and only infrequently appears in cherry, walnut, butternut or maple. Pine pieces are painted in the traditional colours; some are decorated with highly imaginative woodgrain and impressionistic effects. Individual pieces may utilize different techniques and exotically patterned combinations. Vermilions, cadmiums, ochres and oranges are contrasted with blacks and umbers. A few examples are to be found of decoration displaying geometric symbols from the Pennsylvania tradition.

Relatively little furniture of a formal character was produced in these York communities. One important exception, however, is a small group of related pieces – secretaries, chests and presses – in the Pennsylvania Chippendale style that were made at Sharon in the northern part of the county. This was the home of the Children of Peace, a religious sect that separated from the main body of Quakers in that area. The Sharon furniture is finely crafted in figured maple, walnut and pine in a rather robust expression of the style, quite distinct from that of Niagara, although it uses the same vocabulary. These pieces are attributed to a single maker by the name of John Doan, who emigrated from Bucks County in 1806 and who was associated, through his brother Ebenezer, with the building of the beautiful Sharon Temple.

Chests of drawers are found in some numbers in York County that possess formal characteristics of eighteenth century origin. This derivation is evident in the overall plan and may extend to lapped drawers and quarter columns. Many of these pieces reveal Empire influences in their cornice boards, turned feet and other details. Blanket chests were also a popular form, particularly the dovetailed, six-board type or those that stood on moulded bracket bases, many of which had drawers. Among these chests are some of the most dramatic examples of York painted decoration (Plates 1108, 1109).

The most important category of Pennsylvania-German influence from the Markham-Vaughan complex is the numerous early glazed and blind-doored cupboards. They are consistent in form with eighteenth century Pennsylvania cupboards: generously proportioned, clean linear cornices and mouldings and fine glazing details. Later cupboards make use of Victorian and Empire elements and other features from nineteenth century fashion, with only a hint of traditional style remaining.

It is evident from these indications that the furniture-makers in the German centres of York County were exposed to strong currents from the mainstream of furniture style. Unlike the Niagara craftsmen, they worked in widely separated locations and dealt with several non-Germanic commercial communities. It would also appear that the Markham and Vaughan religious groups were more progressive and, perhaps, more willing to admit intrusions from outside sources. As a result, while some exceptional examples of the Pennsylvania-German style do survive, these influences did not last nearly as long in York as they did in Niagara and the style is not nearly so cohesive.

Waterloo County is the third repository of Pennsylvania tradition in Upper Canada. Here, immigration from the state began at the start of the nineteenth century and continued until after 1850. Waterloo attracted several different groups of Mennonites in addition to Dunkards and Lutherans, largely from the Pennsylvania counties of Montgomery and Lancaster.

Waterloo was the nucleus of the Pennsylvania-German settlement that radiated into neighbouring Perth, Wellington and Oxford counties during the early period. Somewhat later, many Waterloo Mennonites moved northward into Huron, Grey and Bruce counties. Both in numbers and geographical area, the Waterloo community is the largest of the three Pennsylvania-German settlements. The Waterloo Mennonites, particularly those of the Old Order, have maintained their traditional way of life to a much greater degree through the years than the other two communities, and they created a vast quantity of furniture in a comparatively pristine Pennsylvania-German style, carrying on into the twentieth century.

Also important are the many Waterloo examples of Anglo-American styles that demonstrate a strongly Germanic accent in decoration or construction. Some of these pieces were made by Continental German craftsmen who settled in the area, but who were never directly involved in the Pennsylvania tradition.

As in York County, the most common Pennsylvania-German styles in Waterloo are the glazed cupboard and the related corner cupboard. The typical Waterloo cupboard is often of late manufacture and is a distinctly regional expression of the eighteenth century Pennsylvania prototype (Plate 976). These cupboards are so numerous and so similar that, if the facts did not indicate otherwise, one might conclude that they were all made by one incredibly productive craftsman. In fact, many were factory made. Most often made of pine, they are occasionally elevated into a special category by boldly coloured and executed painting in both realistic and abstract woodgrain patterns. Others achieve an air of formality through the use of cherry with ebonized details. Individual, usually early, examples of these same forms, including those with blind doors, are much more robust examples of the eighteenth century Pennsylvania style. Often, these are painted in bold combinations of vermilion, pumpkin, ochre, viridian and umber. Rare examples are painted with floral and other decorative motifs from the Pennsylvania tradition. Still other exceptional pieces reveal Classical influences in the architectural nature of their cornices, friezes, pilasters and glazing patterns, all of which are consistent with late eighteenth and early nineteenth century trends in the Pennsylvania tradition.

Another Pennsylvania form unique to the Waterloo area in Upper Canada is the scrolled-pediment corner cupboard. Cupboards of this type are typically massive in scale but finely crafted in pine, cherry or figured maple. With rare exceptions, the heavy columns, "C" and "S" scroll elements and ogee mouldings of the Empire style have been superimposed on the eighteenth century Chippendale style (Plate 984). A like deterioration of this classic style took place in early nineteenth century Pennsylvania, suggesting that this group of Waterloo cupboards was made by immigrants of a relatively late date.

There is a wide variety of formal styles visible in Waterloo case pieces, like chests of drawers, tall chests, chest-on-chests, desks and secretaries. Rare examples from the 1800-1835 period reflect the provincial Pennsylvania expression of the Neoclassical styles of the American Federal period (Plate 1136). More representative are the rather stoutly proportioned chests and desks which are simply framed with panelled ends and standing on turned feet, or valiantly supporting the pillars and scrolls of the Empire style. For their more formal pieces, cherry was the favoured wood of the Waterloo craftsmen, figured maple occasionally being employed for decorative contrast.

Several table forms from the Pennsylvania vernacular occur in some numbers in the Waterloo area. In the early period, the sawbuck table, in various sizes but usually made of pine, was used for dining as well as food

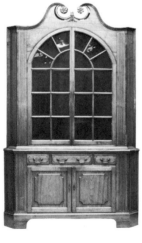

XLI Pennsylvania – scrolled arch, walnut, corner cupboard, late 18th century. [W.P.M.M.H.]

preparation. Serving the same dual function was the more typical Waterloo peg-top kitchen table. It has turned legs in the late Neoclassical form, a deep skirt with two or three drawers and a widely overhanging top which is cleated and secured to the base with removable wooden pegs (Plate 856). Again, cherry was the favoured wood, though some were made in pine, maple, walnut and oak. While the eighteenth century Pennsylvania prototypes of this form are stretcher-based and have more refined details in their turnings, the construction and the basic silhouette survive in Waterloo (Plate 858).

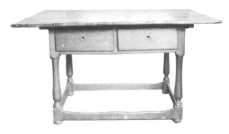

XLII Pennsylvania – walnut table, late 18th century. [P.F.M.O.L.V.]

Also strongly associated with the Waterloo area is the ladies' sewing or work table. Even though this form occurs in other areas, the numerous Waterloo pieces are identifiable by their sturdy, late Classical turned legs, wide top overhang, lapped drawers and painted decoration. Some Waterloo work tables are found with decorative inlay or with the ladies' names central to the decoration. The practice of creating furniture personalized by special decoration to commemorate weddings, anniversaries and other special occasions is Continental German in origin. Accordingly, these Waterloo work tables may originate in either the Pennsylvania or German tradition.

Similarly, the wardrobe, or *Schrank*, is a Continental form which was popular in eighteenth century Pennsylvania. These carefully constructed and highly functional storage pieces occur in considerable numbers in the Waterloo area. Many reflect the regional styles of Germany, Alsace or Switzerland; others reveal the English influences so widespread in Pennsylvania. These last pieces are lighter and less massive than the Continental styles, and may involve restrained Neoclassical cornice and moulding details, quarter columns and bracket feet.

A wide variety of everyday furniture, strongly influenced by the Pennsylvania vernacular, was made in each of the Pennsylvania-German communities of the province. Hanging corner cupboards with the distinctively shaped tail have been found in York and Waterloo. The dry sink and dry-sink cupboard are forms that are almost exclusive to the German communities, but they are particularly numerous in Waterloo County. Pail cupboards, pail benches and seating benches were also popular everyday furnishings made throughout the nineteenth century in traditional styles.

Chairs crafted in the three major centres are variations on the Pennsylvania ladder-back style. In Niagara, chairs associated with the name Springer have Classically influenced vertical spindles in a simple ladder form. Some armchairs, rockers and side chairs are found there in a more pristine eighteenth century Pennsylvania style, and they have deep arched splats and excellent turnings. In the Markham area, a very austere ladder-back was made in which the splats are turned and shaved, rather than cut from flat material in the standard method. In Vaughan, Peter Cober turned side chairs with a subtle Pennsylvania flair for the Dunkard community there. The Jacob Hailer factory in Kitchener also produced ladder-back chairs with Pennsylvania characteristics, despite the fact that Hailer himself had immigrated from Baden in the Rhineland.

Beds found in these communities have very low, simple turned posts in a mid-eighteenth century style and are likely to be made of walnut. Cradles of almost identical design and dovetailed construction are found in each of the areas. Distinctive features of this pleasing cradle design are the heart-shaped, cutout handles and the generous rockers ending in a graceful scroll. Several vernacular designs occur in knife boxes, shredding boards, wrought-iron utensils and other small objects, and it is often in these that the decorative motifs of the Pennsylvania tradition are most clearly expressed.

Continental Germans

The immigrants who arrived in Upper Canada directly from Europe in the period between 1825 and 1860 were part of the large migration to North America from southern Germany, Alsace and Switzerland that had begun a century or more earlier. Religious, political and economic reasons had motivated the earliest groups, but those who came to Upper Canada during this latter period arrived primarily in search of land. For the most part, they emigrated from agricultural areas near the Rhine, such as the Palatine, Baden, Württemburg and German-speaking Alsace and Switzerland. Individuals and small groups came from other parts of southern Germany, particularly Hesse and Bavaria, often joining those from the Rhineland.

G. Elmore Reaman has made an important observation that outlines German migration patterns:

> One racial characteristic has been an important factor with the Swiss and Palatinate Germans; when they migrate, they tend to do so in groups of twenty or more families. This has several advantages — the group is large enough to keep up morale, and it provides a variety of occupational training which when used on a co-operative basis has a high economic value.[9]

In Upper Canada, Continental German groups of this nature were attracted to areas already settled by the Pennsylvania-Germans. As a result, Waterloo and Perth counties and some neighbouring townships developed a strong German character. Within this total Germanic community, different religious and regional groups retained their identities, an ability reflected in the make-up of villages throughout the area. In this respect, there is a noticeable similarity to the great agricultural regions of the Rhineland, where countless villages provide religious and cultural foci for their immediate areas. This was an important factor in the survival of German folk traditions in Upper Canada.

As the map on page 19 shows, other groups settled across the Lake Erie shore in Welland, Norfolk and Haldimand and on to the western border; later, others moved northward into the newly surveyed areas of Huron, Grey and Bruce counties. Some of these settlements were probably not so cohesive from the beginning, and some have all but disappeared in the face of influences from their English-speaking neighbours. Yet furnishings in the traditional Continental styles are found in each of these areas.

One of these isolated groups came from the region of Hesse-Cassel in 1834. The group settled in Simcoe County which was then just opening up for settlement and was a considerable distance from other German centres. Originally Lutherans, these people became members of the Dunkard sect through association with the Pennsylvania-Germans in distant Markham Township. Eventually, this small, isolated group became the nucleus of a strong religious community which survives to this day.

A separate migration brought Germans from the northeastern state of Brandenburg to Renfrew County during the late 1850s and continuing into the 1860s. Parts of this group moved into the northern part of Lennox and Addington County as well. (At the same time and likely as a result of the same immigration promotion, Poles from neighbouring homeland areas also settled in Renfrew.) The remote location of these northern communities demanded a high level of self-sufficiency among the immigrant groups; hence, elements of their folk tradition were retained into the twentieth century. Many distinctive furniture forms were crafted in these Continental German communities, and, since most of the immigrants were from rural backgrounds, these forms are of the eighteenth and nineteenth century German peasant furniture tradition.

In addition to the traditional forms, the immigrant craftsmen brought with them a high level of competence in carpentry and joinery. These

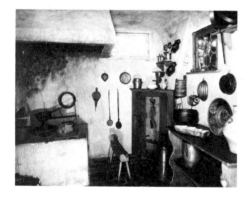

XLIII German – kitchen, 18-19th century. [H.S.V.S.]

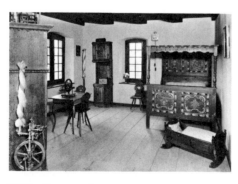

XLIV German – farmhouse interior (*Stube*), 18-19th century.

German skills are usually identifiable in the design of dovetails, lapped-drawer construction and the use of wooden pins instead of nails when securing mouldings and backboards.

As in most of Europe, the German tradition encompassed tables, benches, chairs, cupboards, *Schränke* of various types, beds, cradles and small wall pieces. These basic furnishings are found in a multiplicity of styles, some of which have regional associations. Even greater variety exists in the styles and types of decoration. This important aspect of the Continental European folk tradition includes both painted and carved decoration in many styles, motifs and distinctive colour preferences which vary from one area to another. Like the Pennsylvania-Germans, their Continental brothers also placed great importance on traditional furnishings created to commemorate special occasions. In such pieces, names, initials and dates are often central to the decorative scheme.

Although the decoration of country furniture was still widely practised in Germany, Alsace and Switzerland in the mid-nineteenth century, only rare examples of traditional, Upper-Canadian-made furniture forms possess these decorative elements. These are seen in rudimentary carved and painted elements as well as names, initials and dates. The strongest thread of continuity from the decorative tradition, however, appears in the frequent occurrence of paint techniques simulating woodgrain patterns which are often bolder in colour and execution than typical examples from other national groups. The rich combinations of vermilion and black, vermilion and ochre, and green and ochre are often very similar to the background treatments seen on elaborately decorated European pieces.

Much less evidence is seen of continuity from that part of the German furniture tradition which was based on the use of unpainted hardwoods with surface carving. There was, however, some furniture made with cherry and figured maple, and it is evident that great care was taken in selecting the woods so that some decorative effect was achieved by their natural qualities. Other hardwood pieces employed simple decorative elements inlaid in woods of contrasting colours. One wonders why the more complex decoration, certainly an integral part of the Old World tradition, would have all but disappeared in Upper Canada, even though the styles survived so clearly.

The traditional German house and the lifestyle of its occupants differed markedly from those in the English-speaking countries, and the differences are visible in the basic furnishings. The kitchen is arranged and furnished entirely for the activities related to the preparation of food. The most important element is the raised and hooded hearth which is always in a corner position in the room. The hearth is purely functional and is not important as a source of warmth or a centre of family activity. Some kitchens may have a table for eating which is also positioned in a corner with benches against the walls. Additional benches or chairs are placed on the room side of the table. Other furnishings, such as dressers, *Milchschränke*, pail benches, *Küchenschränke*, wall racks, wall boxes and small wall cupboards, are arranged for convenience relative to the cooking hearth.

Family life was centred in a separate room (*Stube*) which contained the large cast-iron or ceramic stove which was in popular use in Germany from the sixteenth century onward. Chairs or a sitting bench with back and arms were positioned near the comfort of the stove. This room might also contain the traditional table and bench arrangement in one corner and the best bed in another. Depending on the economic level of the family, there might be an elaborate open or glazed cupboard for the display of the better china, a *Schrank* for storage of clothing, a storage chest, a wall cupboard, a clock, a spinning wheel or a cradle.

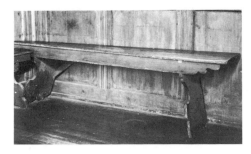

XLV German – bench, 19th century. [H.S.V.S.]

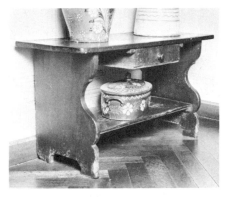

XLVI Alsatian – bench, 19th century. [M.A.D.S.]

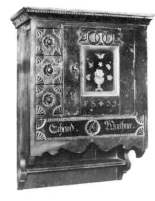

XLVII German – hanging cupboard, dated 1835. [H.G.W.G.]

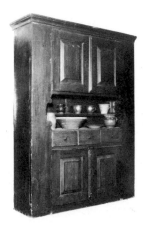

XLVIII German – dish cupboard, 1845. [H.S.V.S.]

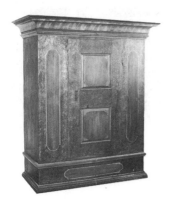

XLIX German – *Schrank*, dated 1790. [H.S.V.S.]

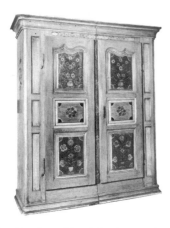

L Alsatian – *Schrank*, Louis XV and XVI influences, dated 1817. [M.A.D.S.]

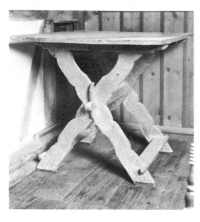

LI German – table, 19th century. [T.D.W.]

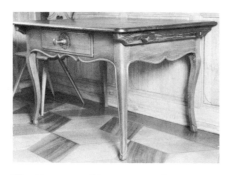

LII Alsatian – table, Louis XV influence, 18th century. [M.A.D.S.]

Possibly the most important of these traditional forms is the *Schrank*, which displays an impressive variety of individual and regional folk expressions in design and decoration. Most numerous is the *Kleiderschrank*, made for the storage of clothing; it is found in various sizes and plans, including those with one door, two doors and some with drawers in the lower part. The large *Schränke* are made in sections, and secured by wooden pegs so that they can be dismantled for moving. *Schränke* were also made combining doors and drawers for use in the kitchen (*Küchenschränke*) and for the storage of dairy products (*Milchschränke*). The *Milchschrank* had an open grill section in the door which allowed ventilation for the contents.

Many examples of the *Schrank* are found in Germanic communities in Ontario. Most of these are of the wardrobe type and in styles that are typical of later examples in Germany, Alsace and Switzerland. The interior plans are identical to the European prototypes: one side is fitted with pegs for hanging clothes, while the other side is divided by shelves and drawers for smaller articles. A few Upper Canadian *Schränke* are of a more formal character, constructed of hardwoods and employing elements from the fashionable Beidermier style (Plate 1024). The *Milchschrank* was more prevalent in the northern parts of Germany than in the south. This was reflected in Upper Canadian communities, with most examples of this form originating in Renfrew County which was settled by immigrants from the Baltic region.

The open dish dresser is seldom found in Germanic communities in Upper Canada, although it was a popular form in the European tradition. Perhaps in place of this, the glazed cupboard and those with solid doors were widely adopted. As in the British tradition, the glazed cupboards had more formal associations in Germany and were not found among average rural furnishings. The enclosed cupboards made in Waterloo and Perth counties by Continental immigrants are frequently similar to the Pennsylvania-German style; both combine the horizontal mass, deep pie shelf and decorative emphasis of panels with English influences in glazing, plan and other Neoclassical details. The principal exception to this is the group of glazed and open cupboards from Renfrew County which are directly related to European prototypes from the northern areas (Plates 999, 1001).

The traditional German concept of tables and benches was retained to a large extent in Upper Canadian farm homes. Out of the several different vernacular table forms that are found in Germany, the sawbuck or "X" trestle type was favoured in the earlier German settlements. These tables do not duplicate the complex shaping of the "X" trestle elements found in European examples. But they are identical in other details, such as the construction of the tops on shaped cleats, the use of pegs to secure the top to the base and the central stretcher tenoned through the trestle. The French Louis XV style is seen in tables which have a cabriole leg, adding a stylish element to otherwise typical draw tables or peg-top forms. Similar tables may have a square, tapered leg with horizontal fluting just below the skirt in the Louis XVI style. Both of these styles were made in Upper Canada and occur in dining tables and the smaller lamp tables, work tables and writing desks.

The traditional use of benches for seating was likely quite widely retained in Germanic Upper Canada, at least in the kitchens, for a great many of the well-constructed trestle-end styles survive today. The extensive use of benches as the principal seating form is further indicated by the fact that only a very few chairs have been found which reveal traditional German styles. These include the primitive stick-Windsor, the simple slat-back and the most widespread vernacular style of Central Europe which has a simple plank seat and back with tapered legs fitted into cleats under the seat. The only known examples of the typical German plank chair come

from the remote Renfrew community. Early German craftsmen such as Jacob Hailer did produce chairs which were primarily in a slat-back style suggesting a strong influence from the United States, particularly Pennsylvania. This type of early mass production doubtless made inexpensive chairs available to all the communities, thus discouraging the survival of traditional styles.

The German tradition contains a number of storage chest styles, many of which are common to all the Central European countries. Among these, the domed trunk, the framed and panelled style and the simple six-board type are the most prevalent. Each of these styles is found with either the bracket base or standing on square or turned feet. Their surface decoration displays a great variety of carved and painted motifs, applied mouldings and pilasters. The storage chest is particularly important in the German folk tradition as an object commemorating a girl's wedding. Often, these dower chests work in her name, initials and the date of marriage in the highly decorative painted treatments. Small chests and chest-like boxes are also significant in this tradition. Many of these are in the domed-top form and are exquisitely decorated with various folk motifs in both paint and inlay.

Storage chests made in the Germanic communities of Upper Canada are mostly in the six-board style and the domed-trunk type. These chests frequently reflect the decorative emphasis seen in their European forbears in colourful abstract and woodgrain patterns to which initials, names and dates are sometimes added. Very rare examples have decorative schemes made up of floral or geometric motifs (Plate 1098).

A general observation that can be made about Continental German traditional storage chest styles is that they frequently display strength, complexity and elevation in their bracket bases. This is in marked contrast to the lower, simpler and more subtle character of ordinary British styles, and is often the only point of difference in otherwise similar forms. Generally, these characteristics are also visible in chests made by Pennsylvania-Germans, although in the Pennsylvania style the profile of the bracket is likely to be of eighteenth century English origin.

The typical bed in the Continental German tradition is a box-like, four-posted form with solid or panelled headboard, footboard and tester. Low beds with similar solid head and foot boards, but using deep-shaped side rails, are also seen. These are probably a later development. The high-post form did not survive into Germanic Upper Canada; however, a few of the low type are found, particularly in sizes appropriate for children (Plate 1189). Most beds surviving in the Germanic communities are of the low-post type, with turnings that are indicative of the Pennsylvania-German style. Characteristics of the traditional, Continental German cradle were retained. However, while the Continental style is usually constructed of panels fitted to posts with turned finials, most Upper Canadian examples achieve a similar silhouette by dovetailed board construction.

The intuitive decorative creativity and careful craftsmanship of the German folk tradition are often displayed in small pieces of wall furniture and other utilitarian items. The making and decoration of these objects, possibly as a gift or to commemorate a family occasion, were undertaken with great care and affection. Although many of these small forms are common to most European traditions, distinctive German examples are discovered of wall racks, salt boxes, spoon racks, spoon trays, wall cupboards, wood and iron utensils, spinning wheels, hackles and picture and mirror frames. This highly personalized aspect of the tradition survived to a high degree in the Upper Canadian communities.

Examples of this survival come, for instance, from Waterloo and Perth counties, where ladies' work tables are found that are inlaid with hearts, stars and geometric motifs, or with painted, sometimes personalized, deco-

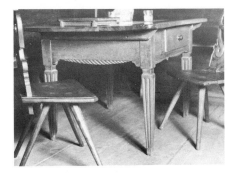

LIII Alsatian – table, Louis XVI influence, 19th century. [M.A.D.S.]

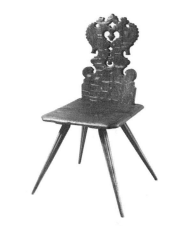

LIV German – chair, 19th century. [G.N.M.]

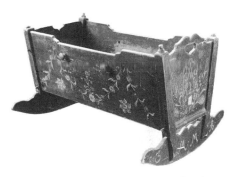

LV German – cradle, dated 1831. [G.N.]

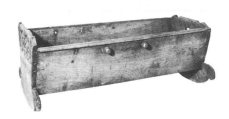

LVI Swiss – cradle, 18th century. [S.L.]

LVII German – stool, 19th century. [H.S.V.S.]

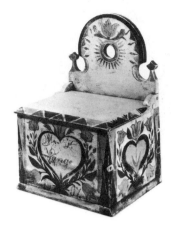

LVIII German – salt box, dated 1907. [G.N.]

ration. In each of the German communities, hackles, cabbage shredders and other utensils were either carved or cut out in distinctly German motifs. Similarly, picture and mirror frames, wall shelves and wall boxes are often unique and highly individual expressions of traditional forms and recurring decorative themes. Spinning wheels and related equipment were made in each of the communities, and a distinctive style of flax wheel is found in Renfrew County, stamped with the name Leonhard.

The importance of the aggregate Germanic tradition, both Pennsylvanian and Continental, which was brought to Upper Canada by a sizable percentage of its original settlers, is not often given sufficient notice in popular historical works. These highly practical people were not inclined to engage in activities placing them in the political, religious or economic spotlight. Indeed, many consciously shunned acknowledgment of their contributions to Upper Canadian society, because of religious conviction. Nevertheless, the impressive range of furnishings of all types and other objects pictured here, when combined with accomplishments in agriculture, architecture, manufacturing and many areas related to early development, produces overwhelming evidence of the central importance of Germanic heritage to the Upper Canadian milieu.

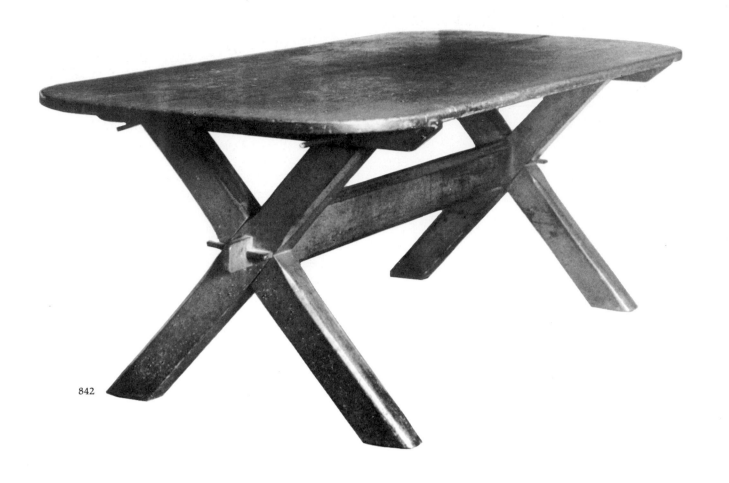

842

843

842 A sawbuck table from New Dundee in Waterloo County. This is an excellent example of the traditional Germanic table as it was made in Upper Canada by both Pennsylvania and Continental German immigrants. The cleated top, which is attached to the understructure with removable pegs, and the tenoned central stretcher are construction details which were employed in that tradition for several centuries. Second quarter 19th century. [P.C.]

843 A sawbuck table from Drumbo in Oxford County. The proportions of this table are more related to the Continental tradition than the longer examples. The horizontal stretchers are fixed to the trestles with one broad dovetail and the crossed stretchers are tenoned. The top is finished with a wooden-pinned, breadboard cleat. Second quarter 19th century. [P.C.]

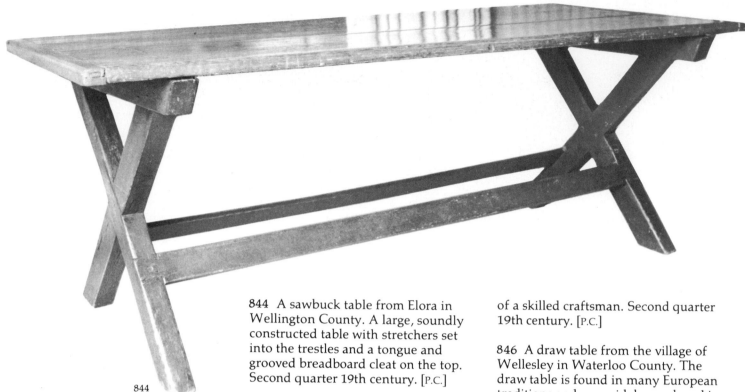

844

844 A sawbuck table from Elora in Wellington County. A large, soundly constructed table with stretchers set into the trestles and a tongue and grooved breadboard cleat on the top. Second quarter 19th century. [P.C.]

845 A sawbuck table from Vineland in Linçoln County. (Early family: Moyer.) This exceptionally large table was probably used only at harvest time or for other large gatherings. Its light construction would allow it to be moved and stored. It is of simple design, but its construction illustrates the confidence

of a skilled craftsman. Second quarter 19th century. [P.C.]

846 A draw table from the village of Wellesley in Waterloo County. The draw table is found in many European traditions and was widely employed in Germany. The top boards run the depth of the table and are secured by cleats running lengthwise to which they are mortised. When the draw leaves are extended at either end, the length of the table is almost doubled. Second quarter 19th century. [P.C.]

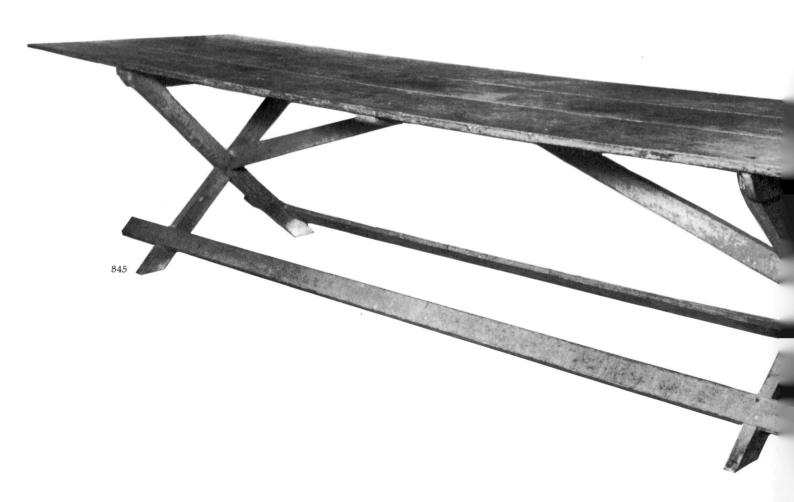

845

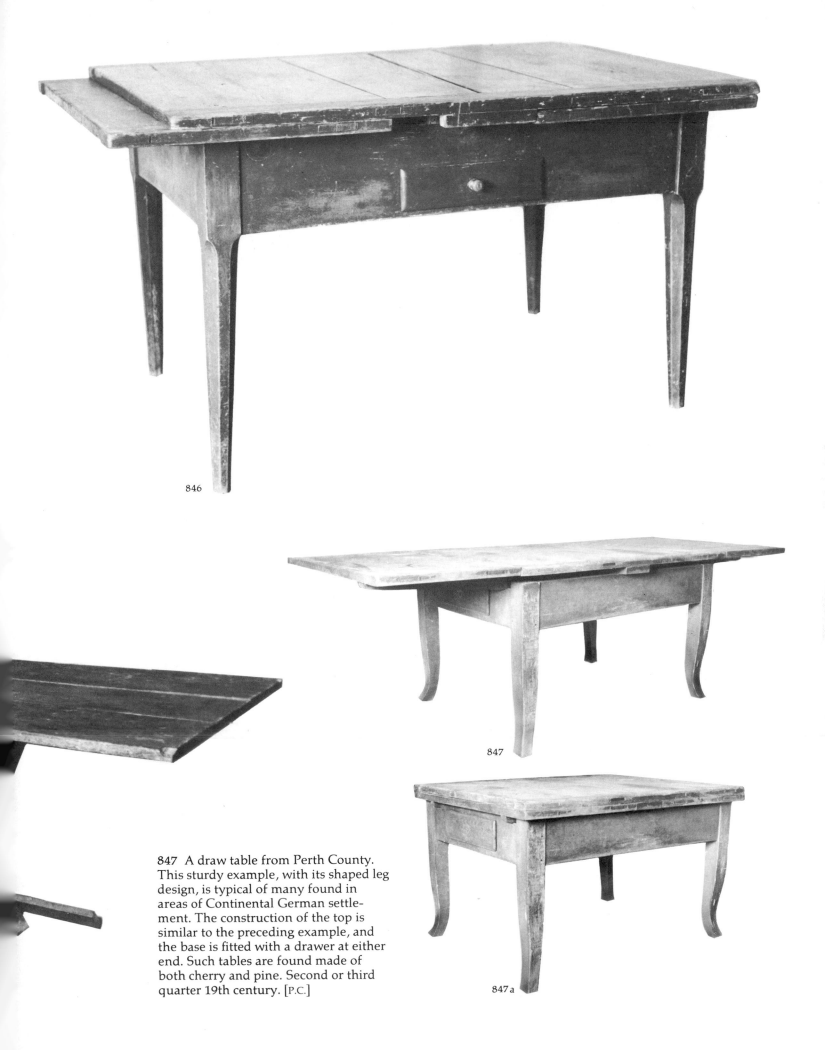

846

847

847 A draw table from Perth County. This sturdy example, with its shaped leg design, is typical of many found in areas of Continental German settlement. The construction of the top is similar to the preceding example, and the base is fitted with a drawer at either end. Such tables are found made of both cherry and pine. Second or third quarter 19th century. [P.C.]

847a

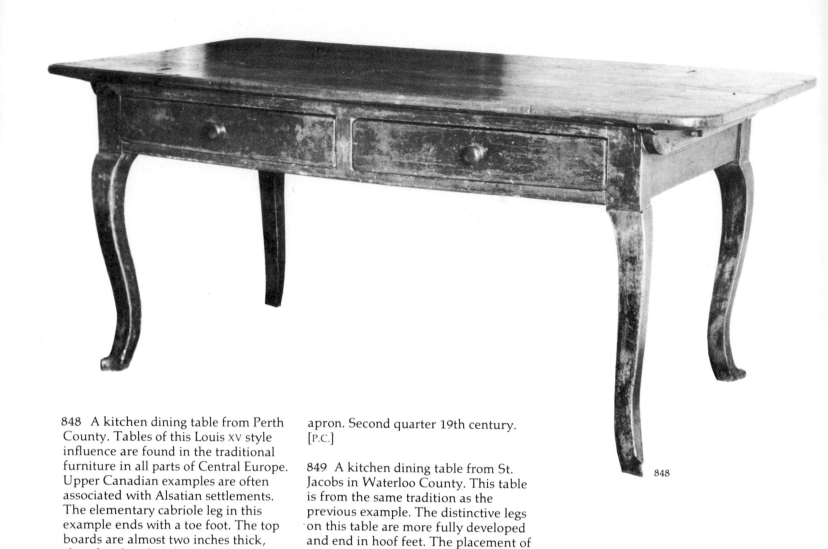

848 A kitchen dining table from Perth County. Tables of this Louis XV style influence are found in the traditional furniture in all parts of Central Europe. Upper Canadian examples are often associated with Alsatian settlements. The elementary cabriole leg in this example ends with a toe foot. The top boards are almost two inches thick, chamfered at the edges to lighten the effect, and are fitted to a shaped and moulded cleat which is pegged to the apron. Second quarter 19th century. [P.C.]

849 A kitchen dining table from St. Jacobs in Waterloo County. This table is from the same tradition as the previous example. The distinctive legs on this table are more fully developed and end in hoof feet. The placement of drawers in the apron is consistent with European examples. Second quarter 19th century. [P.C.]

848

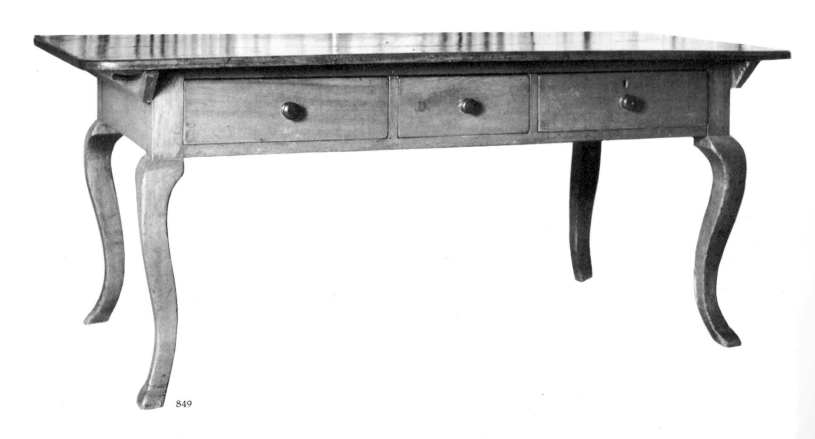

849

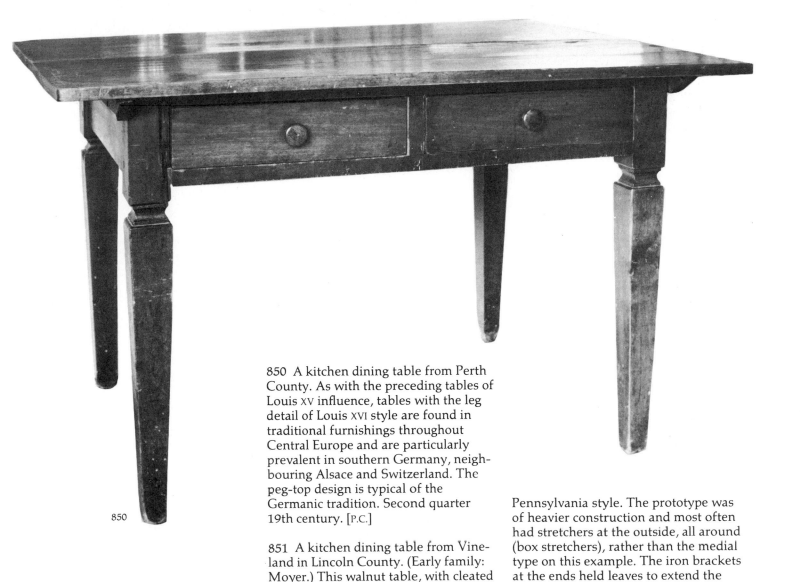

850

850 A kitchen dining table from Perth County. As with the preceding tables of Louis XV influence, tables with the leg detail of Louis XVI style are found in traditional furnishings throughout Central Europe and are particularly prevalent in southern Germany, neighbouring Alsace and Switzerland. The peg-top design is typical of the Germanic tradition. Second quarter 19th century. [P.C.]

851 A kitchen dining table from Vineland in Lincoln County. (Early family: Moyer.) This walnut table, with cleated top, multiple drawers and stretcher base, is a survival of the 18th century Pennsylvania style. The prototype was of heavier construction and most often had stretchers at the outside, all around (box stretchers), rather than the medial type on this example. The iron brackets at the ends held leaves to extend the length in the manner of the draw table. Second quarter 19th century. [P.C.]

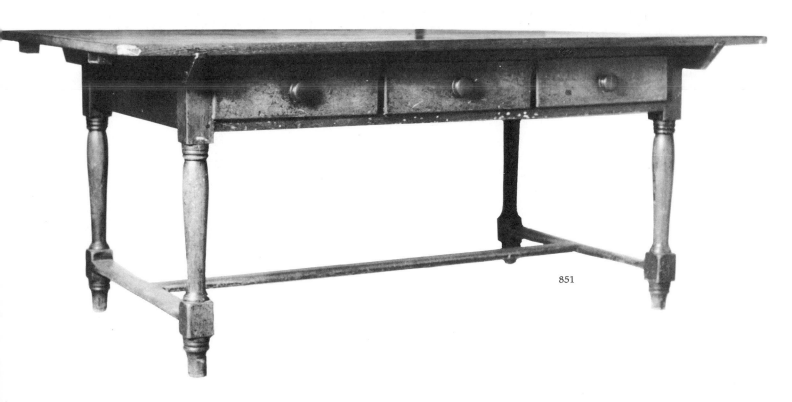

851

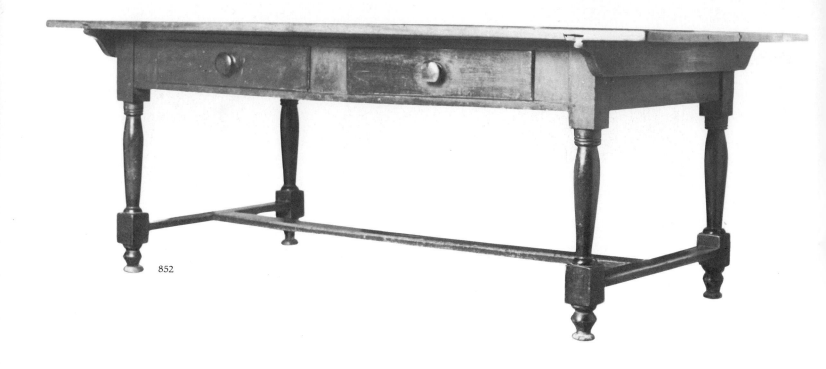

852

852 A kitchen dining table from Vineland in Lincoln County. (Early family: High.) Probably by the same maker as the previous example, this two-drawer table retains its original varnish stain. Second quarter 19th century. [P.C.]

853 A kitchen dining table from Jordan in Lincoln County. This table, like the preceding example, is directly from the Pennsylvania tradition, but is likely somewhat earlier, having box stretchers and a heavier skirt with two large drawers. The stretchers are covered with a wrapping of velvet to prevent the scuffing of busy feet. The last turning of the legs has been replaced by castors. First quarter 19th century. [J.M.O.T.T.]

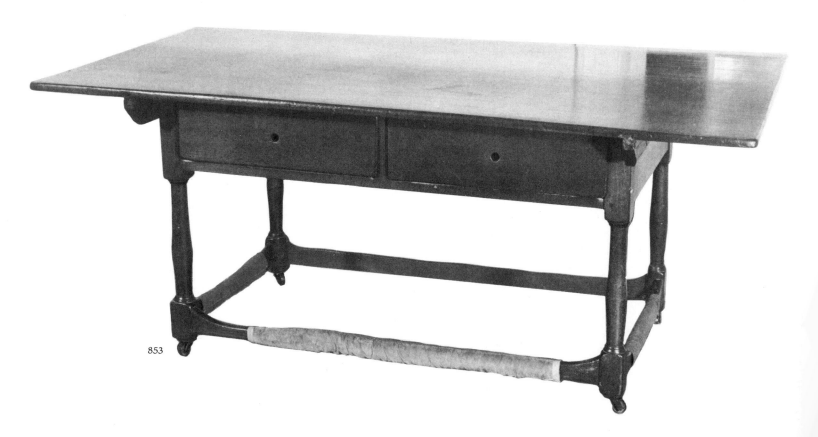

853

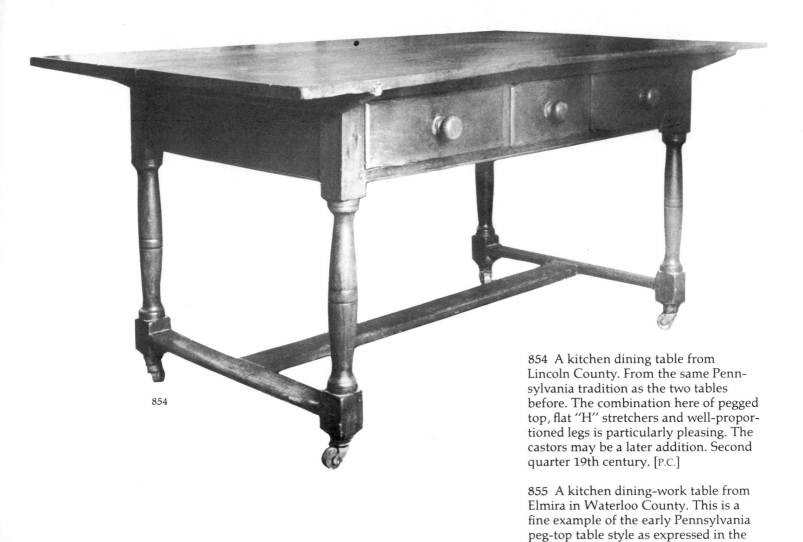

854

854 A kitchen dining table from Lincoln County. From the same Pennsylvania tradition as the two tables before. The combination here of pegged top, flat "H" stretchers and well-proportioned legs is particularly pleasing. The castors may be a later addition. Second quarter 19th century. [P.C.]

855 A kitchen dining-work table from Elmira in Waterloo County. This is a fine example of the early Pennsylvania peg-top table style as expressed in the Waterloo area. Surviving with the table is the seating bench of traditional Germanic style and construction. Second quarter 19th century. [P.C.]

855

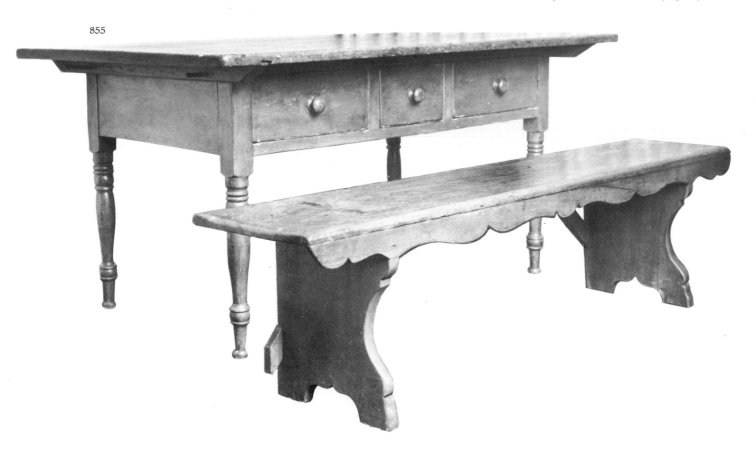

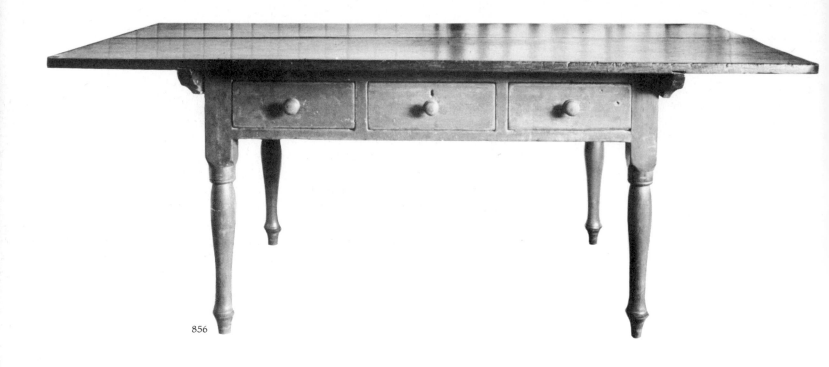

856

856 A kitchen dining table from Waterloo County. (Early family: Gerber.) This Waterloo peg-top has an unusually wide overhang at the ends to allow comfortable seating all around. The detail shows the typical cleat and peg which allowed the removal of the top for cleaning. Second quarter 19th century. [P.C.]

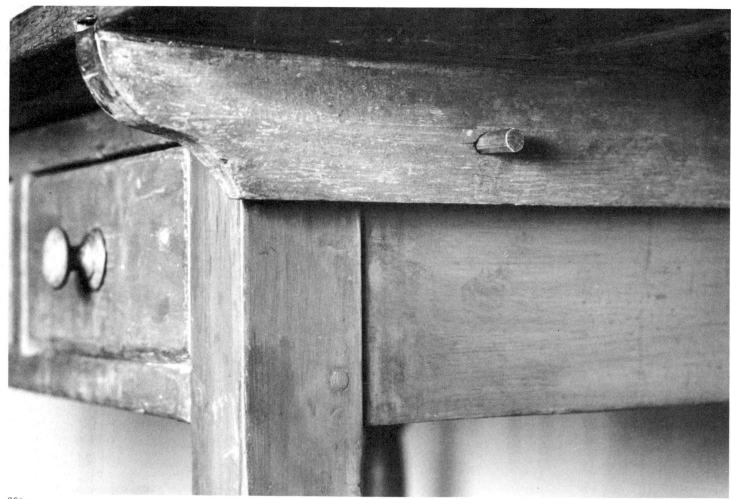

856 a

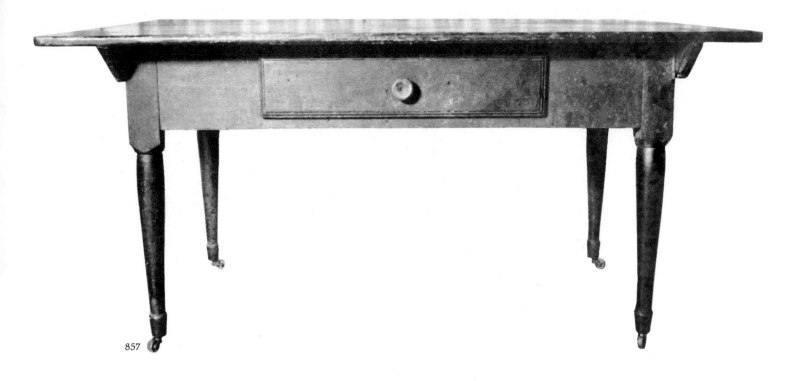

857

857 A kitchen dining table from Vaughan Township in York County. (Signed, *J.S. 1881*; possibly by Jacob Snider who made furniture for the Dunkard community in the area.) This table is soundly based on the early Pennsylvania style with its peg-top, moulded and lapped drawer and simply turned legs. The absence of stretchers is consistent with most Upper Canadian designs. The late date with the signature is an important example of the surprising survival of the traditional styles in the Germanic centres. 1881. [P.C.]

858 A kitchen dining table from the Waterloo County area. This two-drawer peg-top table relates more directly to traditional Germanic examples in its size and proportions than do the larger preceding pieces. It is made entirely of cherry which was a much favoured wood of the Germanic craftsmen in this area. Mid-19th century. [P.C.]

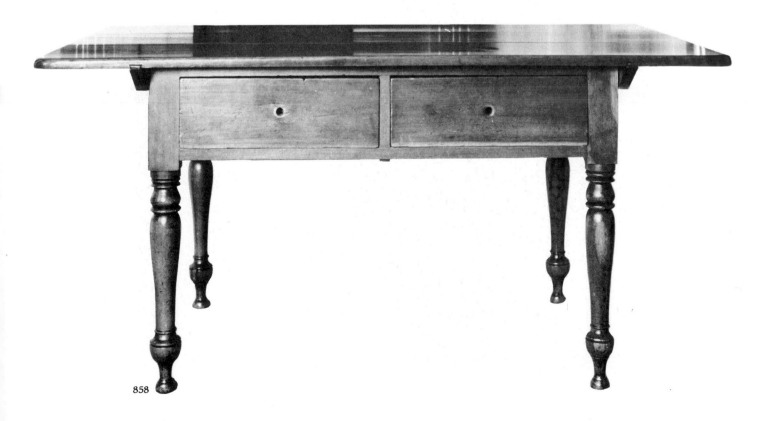

858

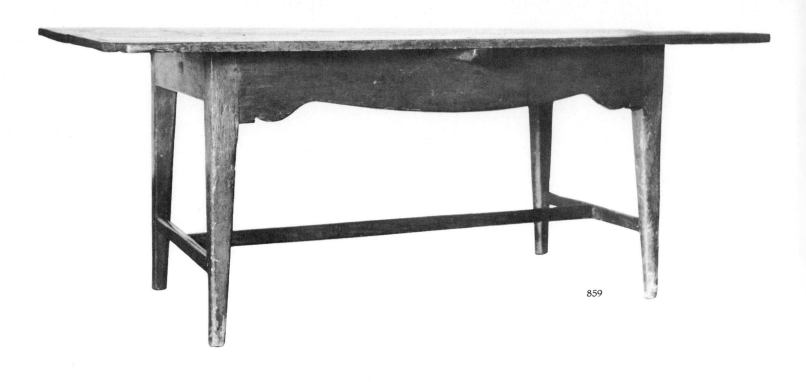

859

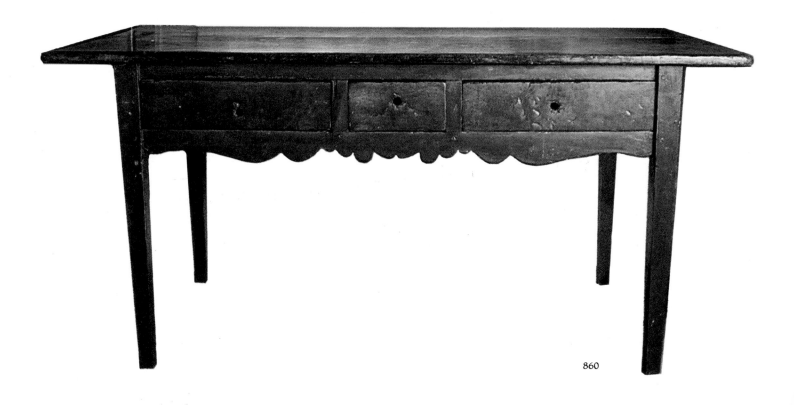

860

859 A kitchen dining table from Burford in Brant County. This table departs from the tradition in the simple stretcher base, but retains a distinctly Germanic character in the wide overhang of the top and the shaped apron. Second quarter 19th century. [P.C.]

860 A kitchen dining table from Markham in York County. This typical Upper Canadian table form reflects the Germanic tradition in its deep, shaped apron and arrangement of two wide drawers flanking a narrow one. Second quarter 19th century. [P.C.]

861 A kitchen work table from York County. A simple utility table with a single-board top, breadboard cleats and lapped drawer. Second quarter 19th century. [P.C.]

862 A kitchen work table from Markham in York County. The deep apron is a typical Germanic characteristic on this table, which has a single board top. Second quarter 19th century. [P.C.]

863 A kitchen work table from Elmira in Waterloo County. This is an exceptional example of Germanic country craftsmanship and characteristic detail. Second quarter 19th century. [P.C.]

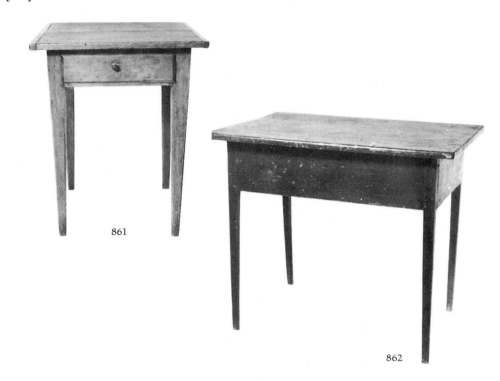

861

862

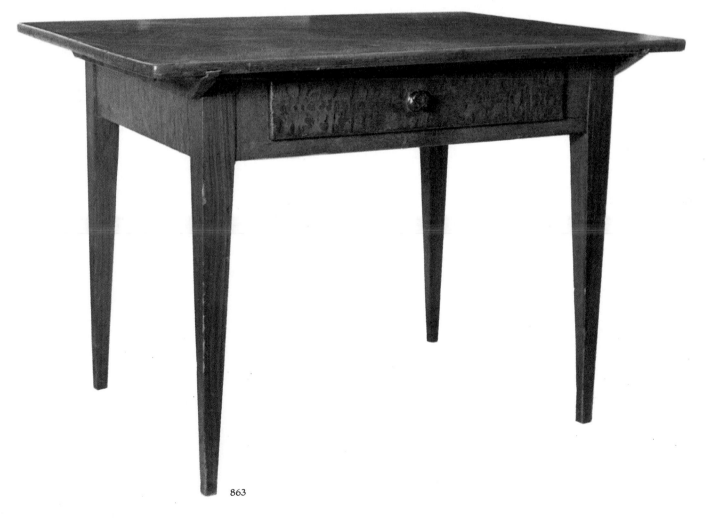

863

864 A ladies' work table from Waterloo County. This design survives from the tradition of the Rhineland. It is a fine example of the small furnishings which were made with great care and affection in the German tradition to commemorate weddings, anniversaries and other important events. The linear and geometric inlay in contrasting woods is also an aspect of German traditional furnishings in some areas, while painted decoration was common in others. Second quarter 19th century. [P.C.]

865 A lamp table from Baden in Waterloo County. This eccentric design is of Germanic character and was probably made by an individual handyman rather than by a trained craftsman. Second quarter 19th century. [P.C.]

866 A lamp table from Logan Township in Perth County. The moulded top and style of the woodgrain decoration suggest a late date for this example of the cabriole leg style from an Alsatian farm home. Third quarter 19th century. [P.C.].

867 A work table from Linwood in Waterloo County. A soundly constructed example of rural Continental Germanic style. The peg-top is not often found on tables of this size and suggests a kitchen purpose. Mid-19th century. [P.C.]

868 A lamp table from Hanover in Grey County. A somewhat more complex interpretation of the Louis XVI influence than the preceding example. Mid-19th century. [P.C.]

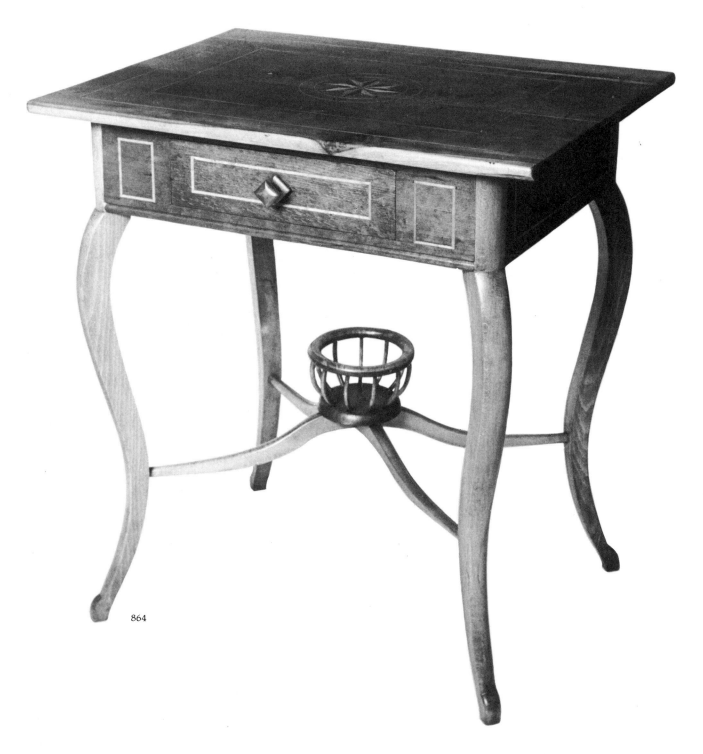

864

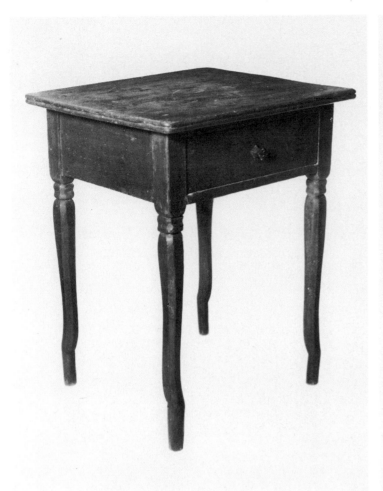

865

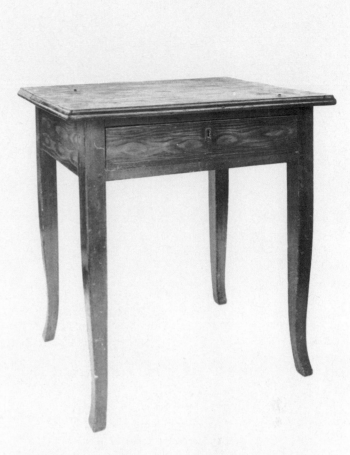

866

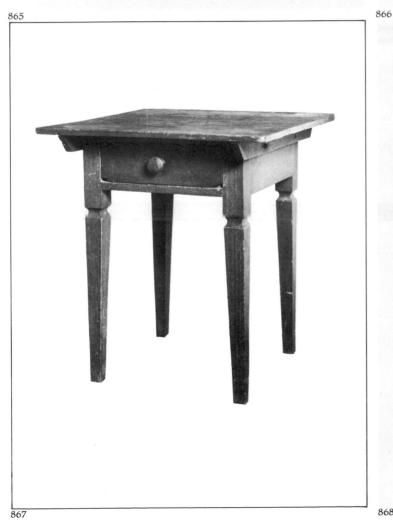

867

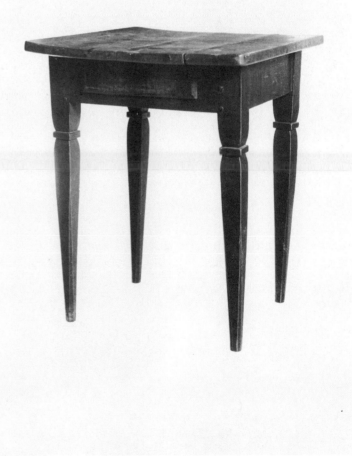

868

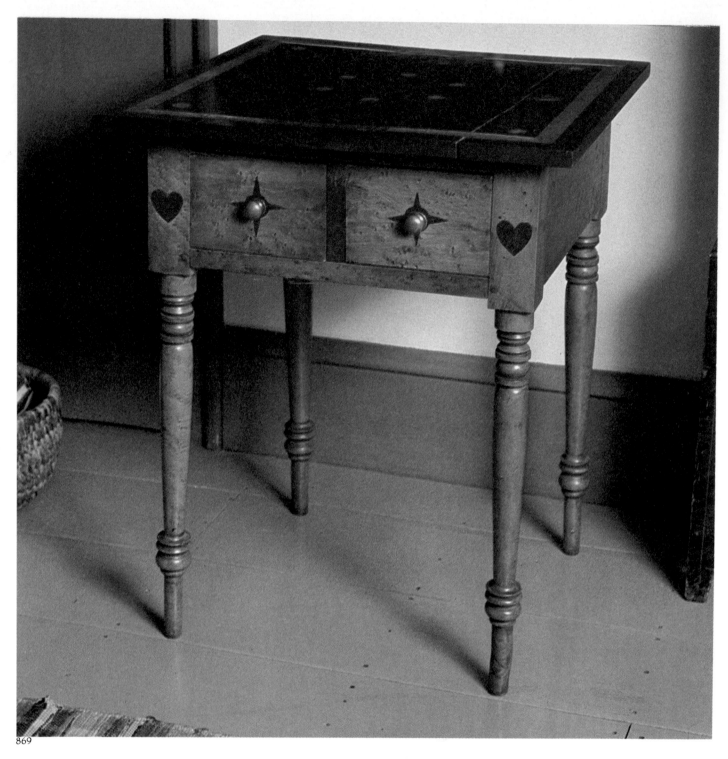

869

869 A ladies' work table from Erbsville in Waterloo County. This outstanding table, while typical of the 19th century American vernacular style, is soundly based in the Germanic tradition of Europe and Pennsylvania. The multiple-drawered ladies' work table was a favourite form, to be carefully fashioned and decorated as a gift for a special occasion. The use of inlay for the heart and star decorative elements suggests a craftsman trained on the Continent. Second quarter 19th century. [P.C.]

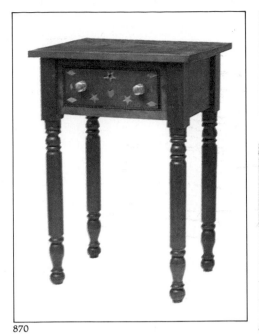

870

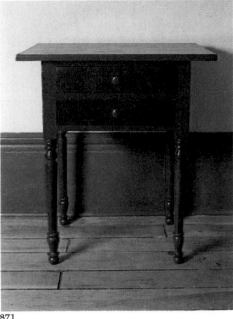

871

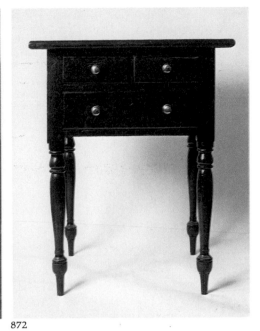

872

870 A lamp or work table from Erbsville in Waterloo County. This table is from the same family (Schaefer/Schweitzer) as the previous example and the similar decorative motif and character of craftsmanship may indicate one maker. Second quarter 19th century. [P.C.]

871 A ladies' work table from Waterloo County. (Carved on front, *Anna S. Zehr – 1887*.) The carving of the name and date on this table is an important aspect of the Germanic tradition and indicates its origin as a gift for a special occasion. While the style would suggest a mid-19th century Waterloo area product, the date clearly establishes another example of the survival of early styles in that area. 1887. [P.C.]

872 A ladies' worktable from Waterloo County. This well-proportioned table is a good example of the typical Waterloo area style, carefully crafted in pine. It retains the original stain and varnish finish. Mid-19th century. [P.C.]

873 A lamp table from Waterloo County. The well-formed cabriole leg on this table is a common element of Louis XV influence in the vernacular furniture of the Rhineland. Further evidence of that tradition is seen in the geometric painted decoration which in the homeland would likely have been inlaid in contrasting woods. Second quarter 19th century. [P.C.]

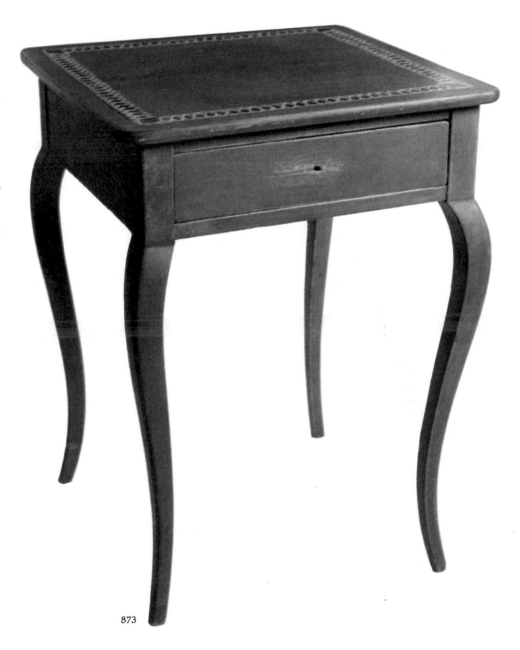

873

874 A ladies' work table from the Wellesley area in Waterloo County. (Early family: Bost.) The silhouette of the turned leg in this neatly crafted small table bears an interesting similarity to that of the typical Continental shaped leg of Louis XVI influence (Plate 868). Mid-19th century. [P.C.]

875 A ladies' work table from Waterloo County. Many large, multi-drawered work tables were made in the Germanic communities in the Waterloo area. This example is elevated by a fine painted woodgrain finish and stencilled decoration. Mid-19th century. [P.C.]

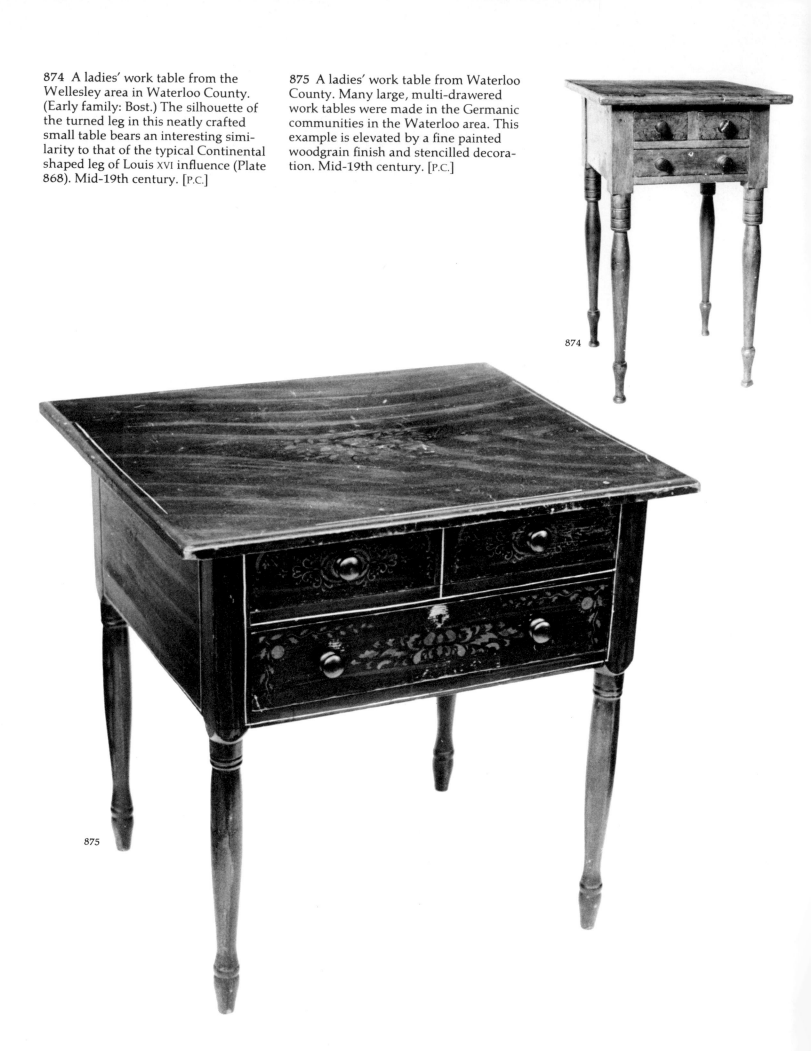

874

875

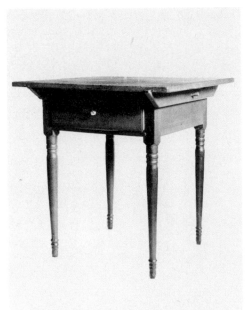

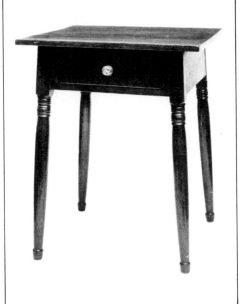

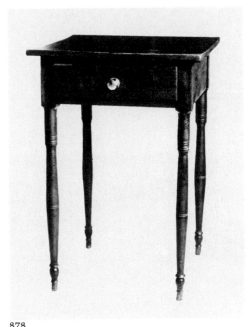

876

877

878

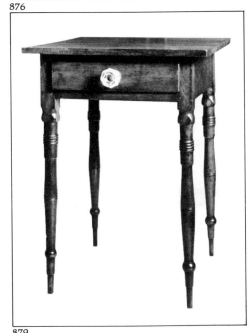

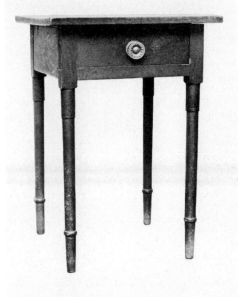

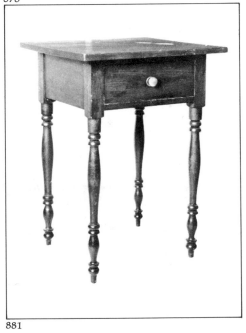

879

880

881

876 A work table from Wellesley in Waterloo County. (Early family: Amos Leis.) The cleated peg-top and lapped drawer are typical Germanic details in this table. The removable top suggests that the table was used in the kitchen. Mid-19th century. [P.C.]

877 A lamp table from Cheapside in Haldimand County. The splayed leg seen on this table is found in earlier Pennsylvania designs as well as in the Continental German vernacular. Second quarter 19th century. [P.C.]

878 A lamp table from Selkirk in Haldimand County. This design includes a pleasing example of the Sheraton influence in the turned legs as well as the lapped drawer, which was widely employed by Germanic craftsmen. Second quarter 19th century. [P.C.]

879 A lamp table from the Niagara Peninsula. The unusual upper detail in the well-turned, splayed leg is seen in a related table in other local examples. Second quarter 19th century. [P.C.]

880 A lamp table from Lincoln County. Signed, J.F., and possibly made by Jacob Fry, a known cabinetmaker. This simple design has a subtle refinement which sets it apart from the average. First quarter 19th century. [P.C.]

881 A lamp table from Wellesley in Waterloo County. (Early family: Kohner.) The Germanic craftsmen adopted the popular Anglo-American styles and expressed them with considerable flair. Mid-19th century. [P.C.]

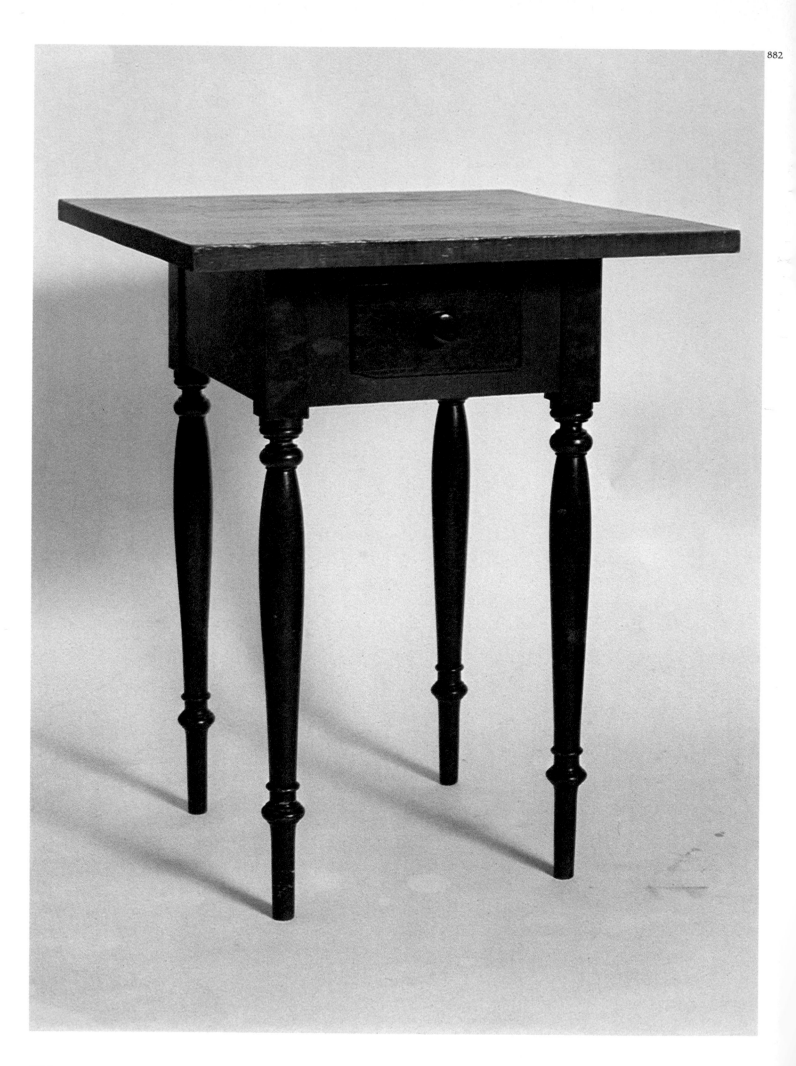

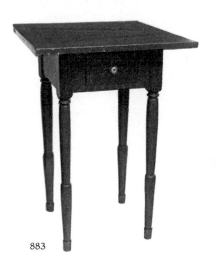

883

882 A lamp table from Stouffville in York County. (Signed, *Geo. Barkey, Ringwood – Durham County*.) The Barkeys were a furniture-making family in the Markham area. The wide overhang of the top and the small, lapped drawer in this table are elements from the Pennsylvania tradition. The painted decoration is of the highly proficient character seen on many Markham area pieces. Mid-19th century. [P.C.]

883 A lamp table from Markham in York County. The similarity in style and painted decoration to the preceding table, as well as interwoven family connections, indicate that this table is also a Barkey product. The attenuation just below the line of the apron in the detail of the turned legs is a distinctive and unusual feature. The drawer is not dovetailed, but is butt-joined and nailed. Mid-19th century. [P.C.]

884 A tea table from Vaughan Township in York County. (Early family: Snider.) Of simple provincial design, this table is a fine example of sound Germanic craftsmanship. The butterfly-shaped cleats joining the tongue and grooved top boards are characteristic details. Second quarter 19th century. [P.C.]

885 A lamp table from Perth County. This is an unusual design of pleasing country character. The striking combination of painted wood grain and banding is an important part of its charm. The drawer front is mitred to fit precisely against the sides of the understructure. Mid-19th century. [P.C.]

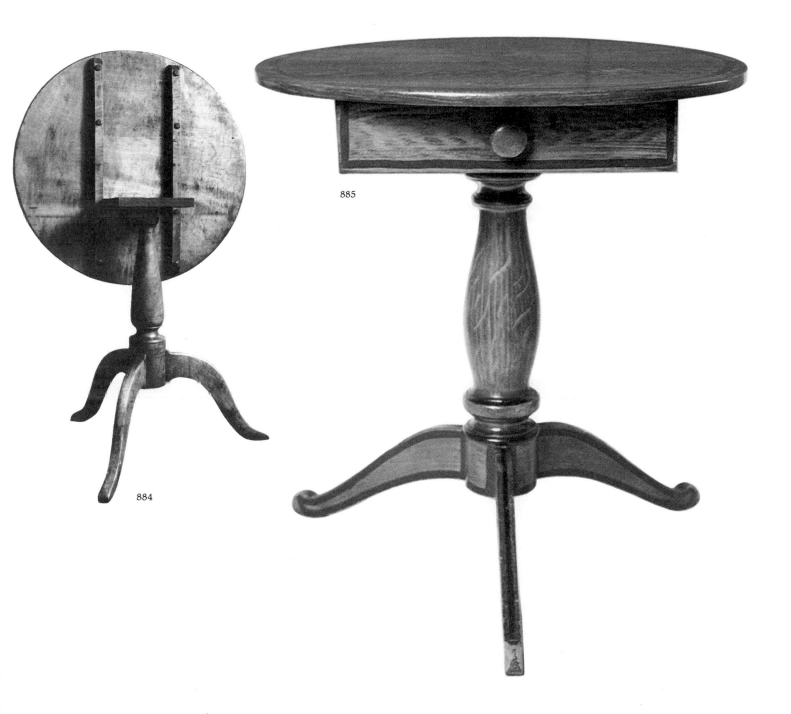

885

884

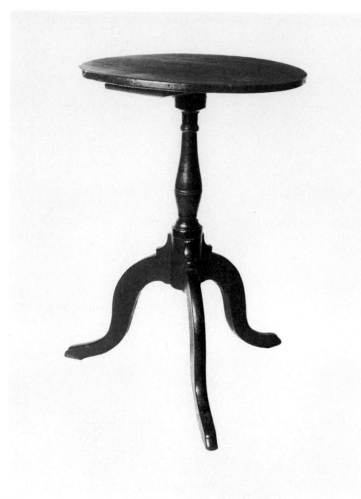

886

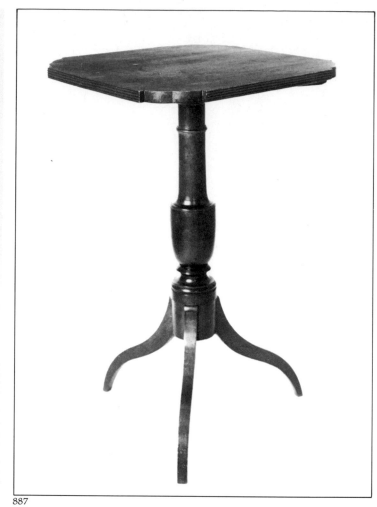

887

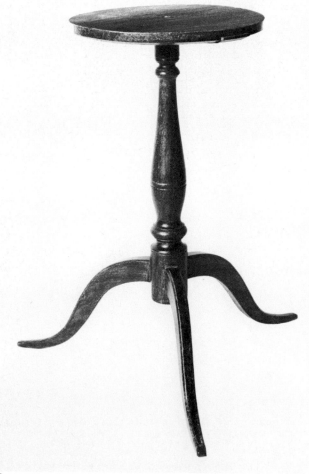

888

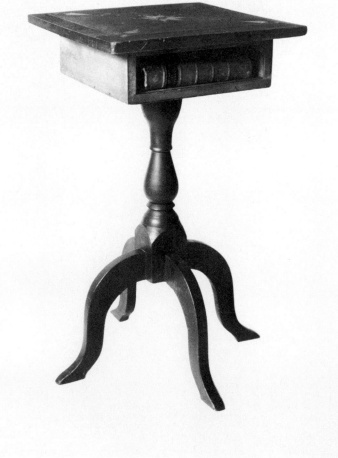

889

886 A candle table from Pelham Township in Welland County. (Early family: Wilson.) This excellent country design suggests a maker trained in the 18th century Pennsylvania tradition. The simple hoof feet on the legs are not often found on 19th century products, and the shaped brackets at the top of the legs are well considered both structurally and visually. The slender simplicity of the turned column is seen in other Lincoln County examples of Pennsylvania style. First quarter 19th century. [P.C.]

887 A candle table from Campden in Lincoln County. Of Sheraton-influenced style, this table is somewhat heavy in the proportions of its urn-shaped column, a detail consistent with late expressions of 18th century designs. The reeded detail on the edges of the shaped top was a favourite of Lincoln County craftsmen. Second quarter 19th century. [P.C.]

888 A candlestand from Vineland in Lincoln County. (Early family: Kline Moyer.) This fine example of Germanic craftsmanship is well designed for its purpose, with an unusually wide and stable tripod. The simple grace of the column relates to that on the candlestand illustrated earlier (Plate 886). First quarter 19th century. [P.C.]

889 A lamp table from Louth Township in Lincoln County. (Early family: Fretz.) A charming and quaint design of individual character. The simply shaped legs have a suggestion of the hoof foot and the pine inlay on the top includes an eight-pointed star and arrow motifs. Mid-19th century. [P.C.]

890 A candle table from Campden in Lincoln County. A very unusual form with distinctly Germanic style influences in the widely overhung top and the extreme splay of the legs. First quarter 19th century. [P.C.]

891 A washstand from the St. Clements area in Waterloo County. As with many examples of furniture made in centres of Alsatian settlement, this design reflects the influence of Louis XVI style in its form and in the tambour enclosure and simple leg detail. Second quarter 19th century. [P.C.]

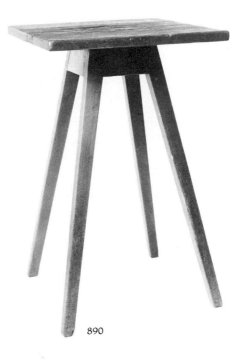

890

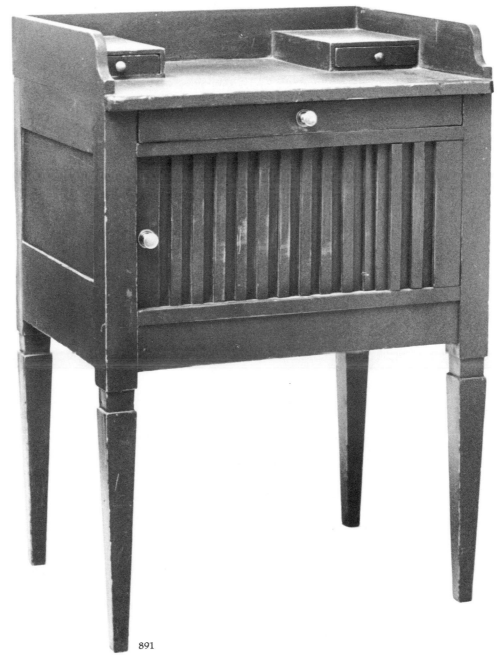

891

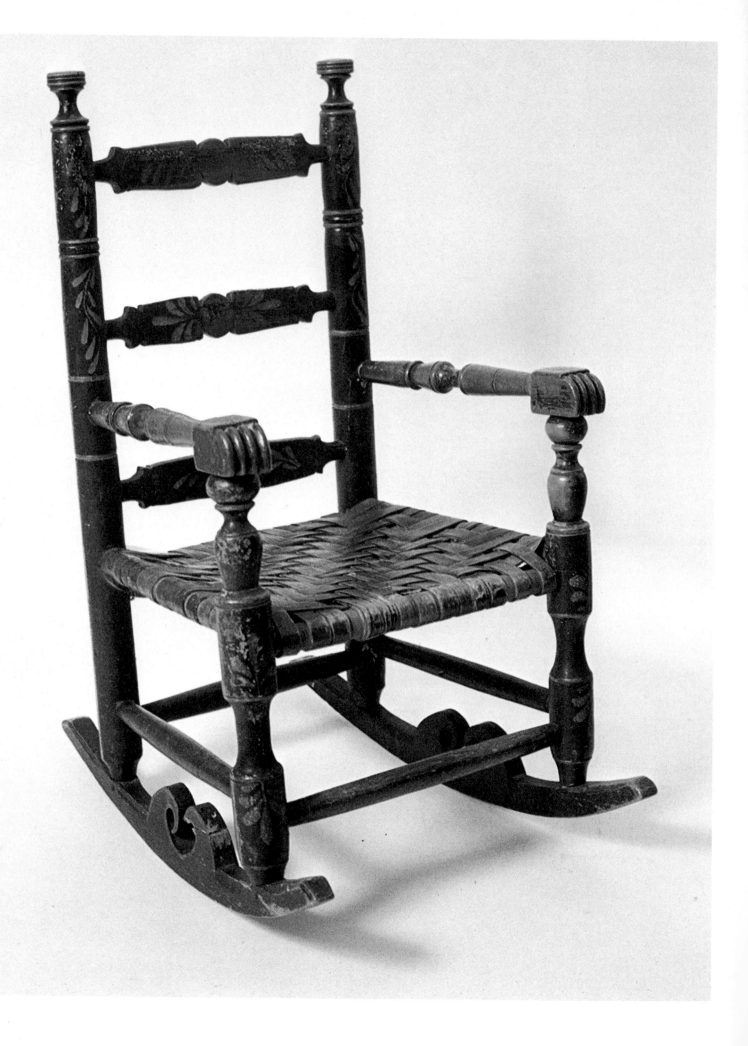

892

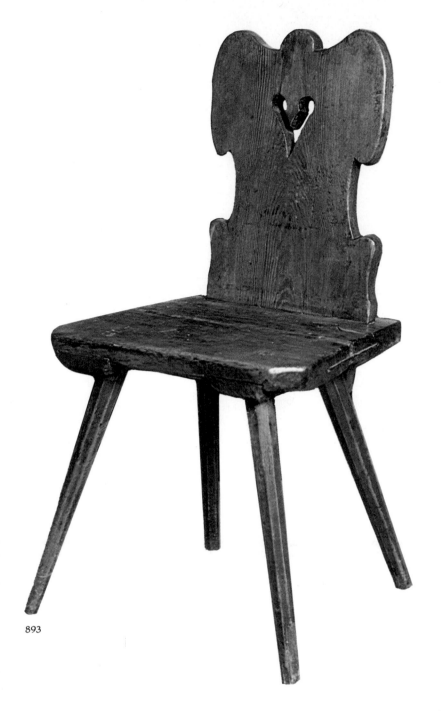

893

893 a

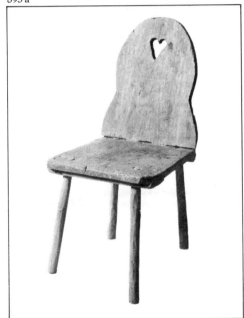

894

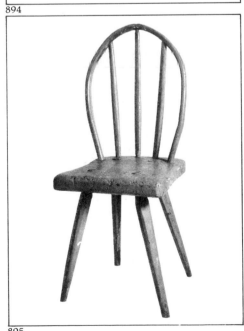

895

892 A child's rocking chair from Lennox and Addington County. The unusually shaped rockers, back splats, carved arms and heavy turnings identify this chair with the Continental German tradition. The painted decoration is, however, typical of the style widely used in the United States and Upper Canada in the early 19th century. First half 19th century. [L. & A.C.M.]

893 A side chair from Palmer Rapids in Renfrew County. (Early family: Boehme.) This is one of the rare examples of the most typical Continental German traditional chair form which survive in Upper Canadian settlements. The shaped and pierced back mortised through the seat and the seat cleats with simple chamfered legs set in are details common to European examples. Third quarter 19th century. [P.C.]

894 A side chair from Palmer Rapids in Renfrew County. Of simpler design than the previous example, this chair is attributed by family tradition to August Boehme. The understructure is slightly different, in that the seat cleats go from side to side and the stick legs are set in through cleat and seat. Third quarter 19th century. [P.C.]

895 A side chair from Golden Lake in Renfrew County. A simple stick-Windsor chair from a German settlement which incorporates similarities to the preceding traditional plank chairs in style and technique. Third quarter 19th century. [P.C.]

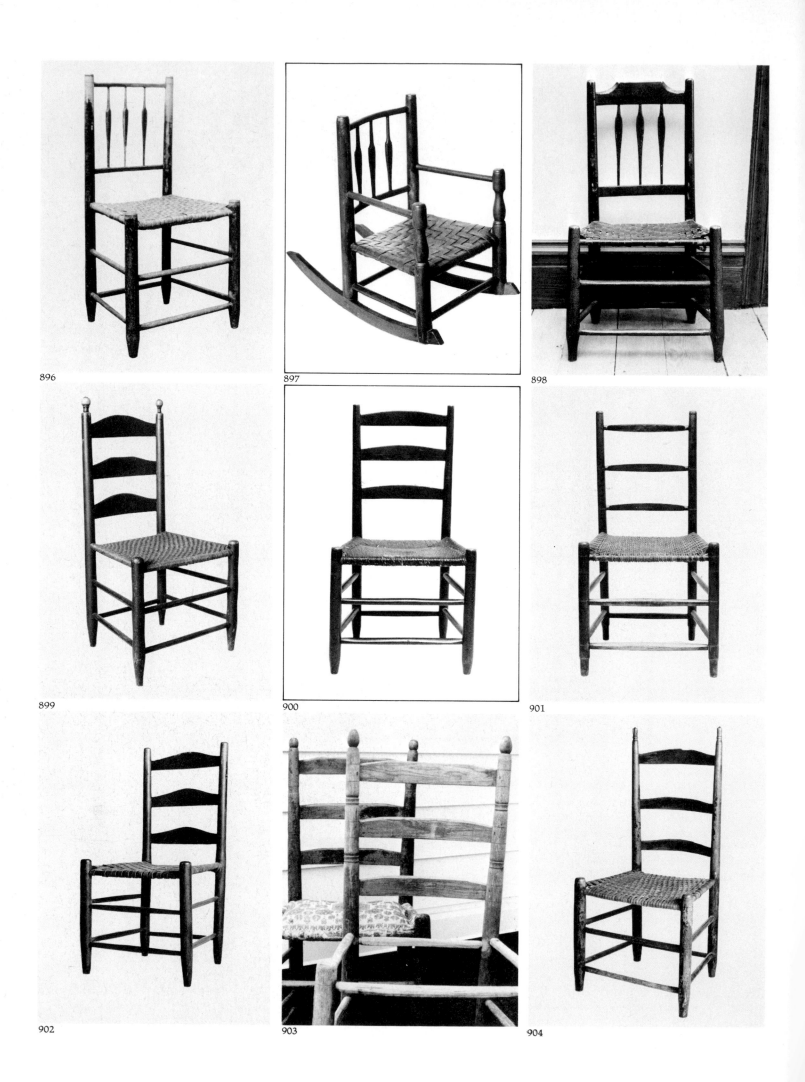

896

897

898

899

900

901

902

903

904

896 A side chair from the Niagara Peninsula. Many chairs of this Sheraton-influenced style are found in the Niagara area and are associated with the name Springer, a local family which is supposed to have included chairmakers in the early period. Further research is required to establish the location and nature of this early industry. Second quarter 19th century. [P.C.]

897 A child's rocking chair from Lincoln County. The distinctive Springer style in another form. Second quarter 19th century. [P.C.]

898 A side chair from the Niagara Peninsula. This design incorporates the same Sheraton influence in the arrow splat-back as the typical Springer chair preceding. It is of heavier construction, with a shaped crest rail similar to those found on Pennsylvania slat-backs. Second quarter 19th century. [P.C.]

899 A slat-back side chair from the Niagara Peninsula. A well-designed chair with Pennsylvania style arched splats, good finials and unusually shaped front legs. Second quarter 19th century. [P.C.]

900 A slat-back side chair from Kitchener in Waterloo County. Made in the Jacob Hailer factory, established in 1832. Hailer was from Baden in southern Germany, although this simple style and others attributed to this early factory include influences from the Pennsylvania tradition. Second quarter 19th century. [P.C.]

901 A slat-back side chair from Markham Township in York County. A number of these elegantly simple chairs have survived in Markham. The distinctive feature is the back splats shaped from a round turned spindle. This example retains the delicate linear decoration on the splats and front legs. Second quarter 19th century. [P.C.]

902 A slat-back side chair from the Niagara Peninsula. The deep, arched back splats are a feature of many simple chairs made in the Niagara area, reflecting the earlier Pennsylvania styles. The swelling in the rear post to accept the seat spindle is typical of practical Germanic craftsmanship. Second quarter 19th century. [P.C.]

903 Slat-back chairs from Roblin in Lennox and Addington County. These simply detailed chairs survive in the home of early chairmaker Henry

Walwraith, who made and sold many of similar design throughout the neighbouring counties. Henry Walwraith emigrated from Pennsylvania in the 1840s. Second quarter 19th century. [P.C.]

904 A slat-back side chair from Lincoln County. (Early family: Honsberger.) The accentuated finials of early character place this otherwise typical design in a category of special interest. Early 19th century. [P.C.]

905 A slat-back rocking chair from Dunnville in Haldimand County. The five arched back splats of reducing depth and distinctively shaped arms relate this chair to the 18th century Pennsylvania tradition. Early 19th century. [P.C.]

906 A slat-back rocking chair from the Niagara Peninsula. This is an exceptionally vigorous interpretation of the 18th century Pennsylvania slat-back style, incorporating five well-shaped splats, strong finials and front spindle, shaped arms and rockers. A larger gentleman's chair of identical design also survives. Early 19th century. [P.C.]

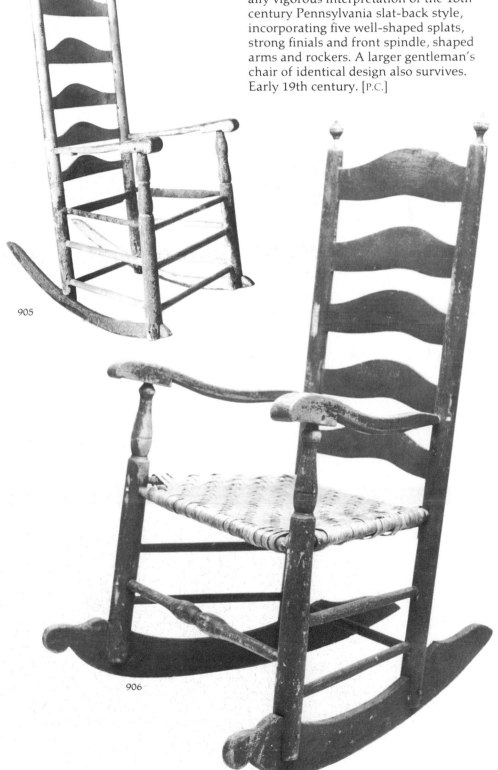

905

906

907 A rocking chair from Burford in Brant County. This Boston-type rocker has an unusually generous back splat and well-shaped seat. The painted decoration includes birds, leaves and strawberries reflecting the Pennsylvania German decorative tradition. Mid-19th century. [P.C.]

908 A slat-back rocking chair from Lincoln County. (Early family: Rittenhouse.) This individual expression combines elements of the traditional slat-back with shaped back posts associated with late Windsor style. The turned and shaped arms are unusual. Second quarter 19th century. [P.C.]

909 A slat-back rocking chair from the Niagara Peninsula. This is a somewhat simpler version of the Pennsylvania slat-back than the preceding examples, with interesting arm detail and unusually generous rockers. Early 19th century. [P.C.]

910 A slat-back rocking chair from the Niagara Peninsula. (Early family: Spiece.) A companion nursing rocker to the preceding example. Early 19th century. [P.C.]

911 A slat-back rocking chair from Gainsborough Township in Lincoln County. (Early family: Crown.) A sturdy, well-crafted survival of the Pennsylvania style retaining its original decoration. Second quarter 19th century. [P.C.]

912 A slat-back chair from Norfolk County. A well-crafted country chair almost certainly by the same maker as the preceding rocker. Second quarter 19th century. [P.C.]

913 A slat-back rocking chair from Vaughan Township in York County. Made by Peter Cober, who produced chairs for the Dunkard community in Vaughan. The broad back splats and well-shaped finials survive from the earlier Pennsylvania style. Second half 19th century. [P.C.]

914 A side chair from Vineland in Lincoln County. (Early family: Beamer.) Empire-influenced, painted fancy chairs with deep crest rail and broad urn-shaped back splat were popular in Pennsylvania and the style is found occasionally in the Upper Canadian communities. Second quarter 19th century. [P.C.]

915 A side chair from Lyn in Leeds County. Signed, *S. Haskin – Lyn.* Little is known about the background of the chairmaker, S. Haskin; however, this well-decorated, Empire-influenced design with broad crest rail and distinctively shaped back splat is typical of those produced in Pennsylvania, as are other signed examples of his products. The painted figured maple finish with striping and leaf decoration is exceptionally well executed. Second quarter 19th century. [U.C.V.]

916 A side chair from Iroquois in Dundas County. The late Neoclassical character of this design is seen in southern Germany and other parts of central Europe. It is a tentative hypothesis that this example, which is one of a set and is certainly North American, has associations with the Germanic element which survives in this eastern county. Early 19th century. [U.C.V.]

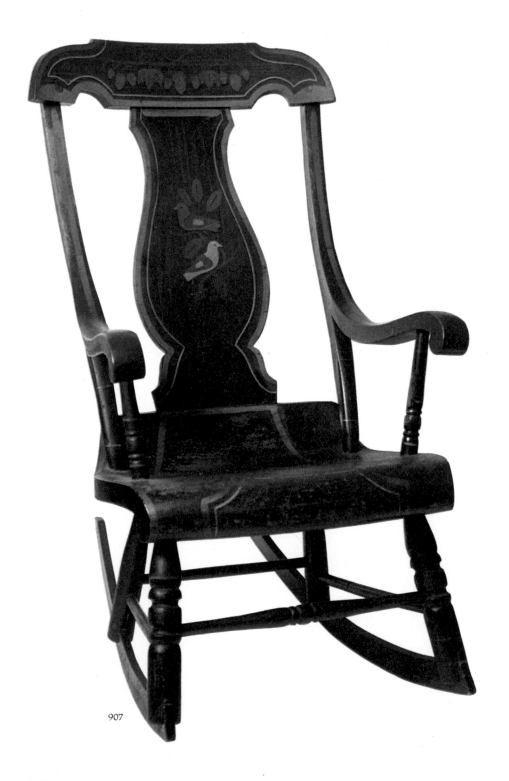

907

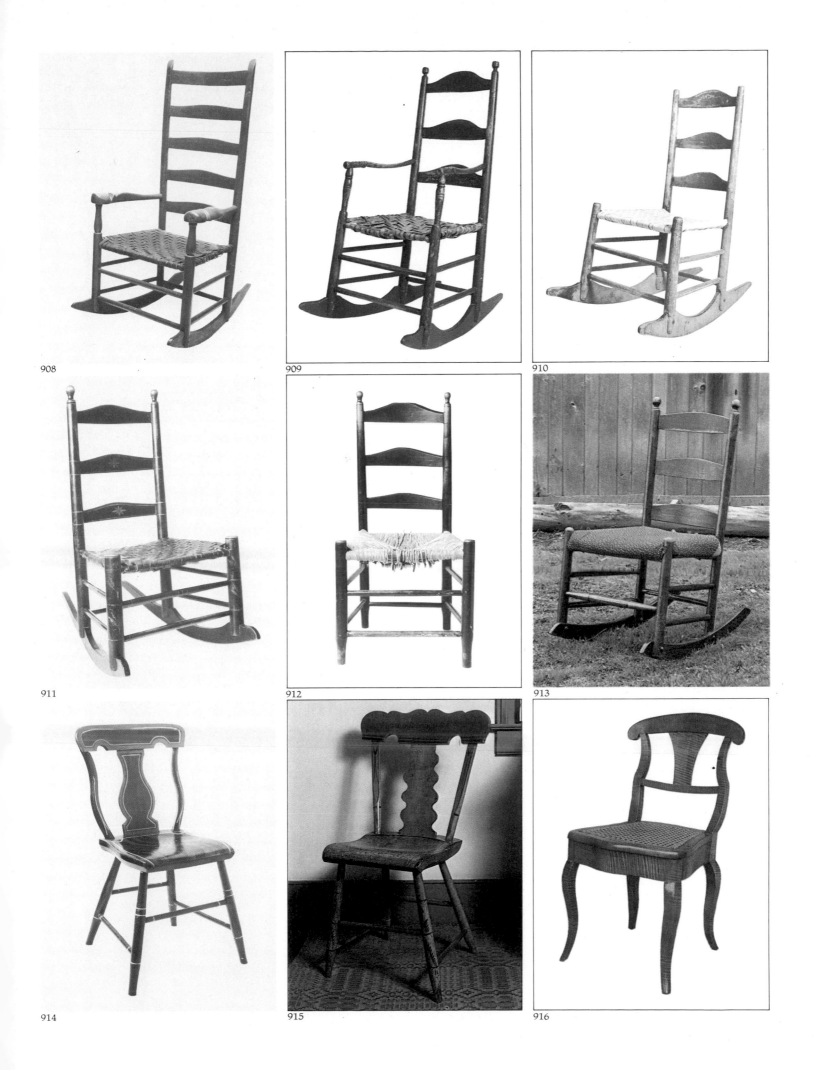

908

909

910

911

912

913

914

915

916

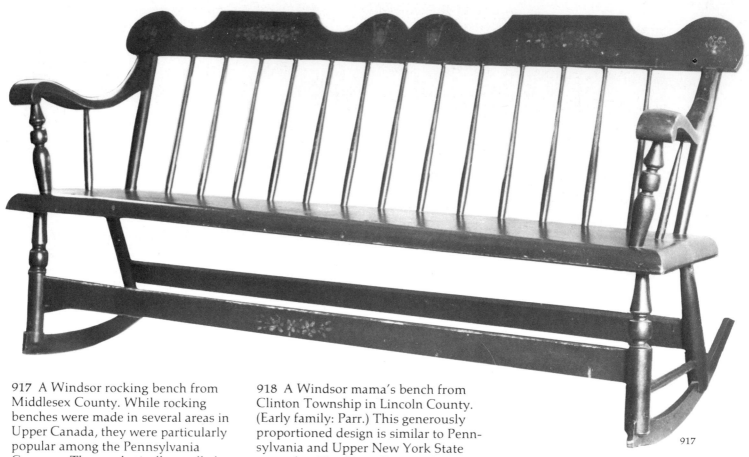

917 A Windsor rocking bench from Middlesex County. While rocking benches were made in several areas in Upper Canada, they were particularly popular among the Pennsylvania Germans. The emphatically scrolled crest rail, wide seat and extended rockers on this example are typical of those made in Germanic Pennsylvania and Ohio. Mid-19th century. [P.C.]

918 A Windsor mama's bench from Clinton Township in Lincoln County. (Early family: Parr.) This generously proportioned design is similar to Pennsylvania and Upper New York State examples. The "fence" secured the baby while the mother rocked or worked nearby. Mid-19th century. [P.C.]

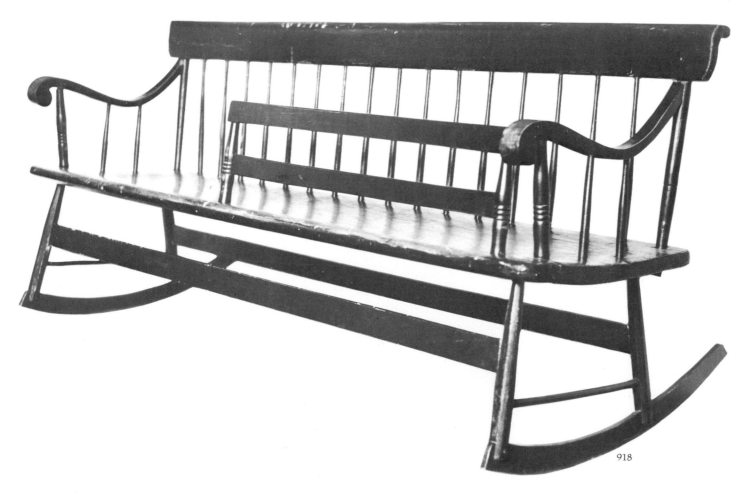

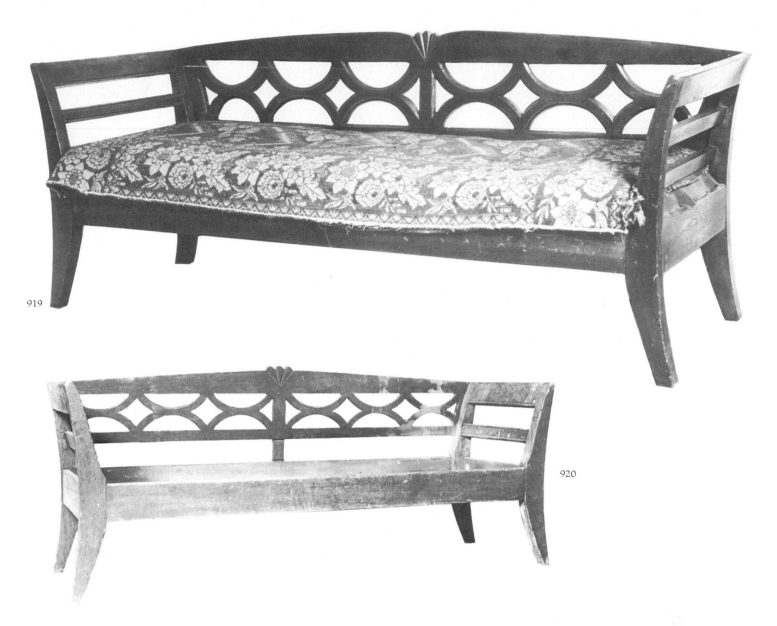

919

920

919 A sofa from Ardock in Frontenac County. Made by a German immigrant, Alois Schwager, as a wedding gift for his sister. The vigorous Germanic vernacular design is Neoclassical in influence and is an outstanding example of the survival of the tradition. Late 19th century. [P.C.]

920 A sofa from Ardock in Frontenac County. Alois Schwager also made this sofa, which is slightly simpler than the preceding piece and with minor variations in detail. Late 19th century. [P.C.]

921 A daybed from Erbsville in Waterloo County. This simple design is

from the European Germanic vernacular which encompassed influences from the universally popular Neoclassical style early in the 19th century. It is the competent product of an Alsatian or southern German craftsman. Second quarter 19th century. [P.C.]

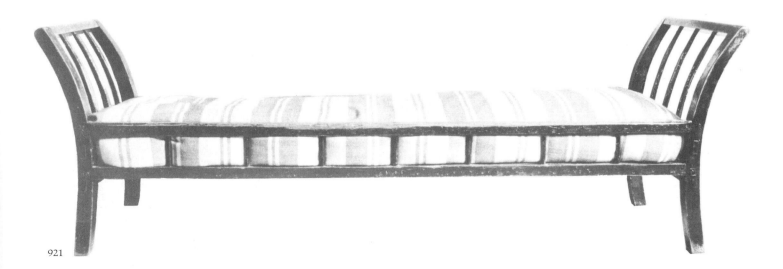

921

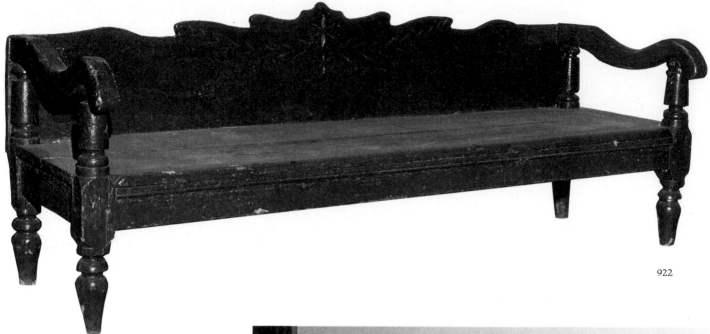

922

922 A sofa or settle from Germanicus in Renfrew County. (Early family: Raglan.) The popular Canadian country couch was likely the basis for this design, which includes a distinctly Germanic character in the shaping of the back and the arms, as well as in the roundel and leaf motif of the carved decoration. Late 19th century. [C.F.C.S., M.O.M., N.M.O.C.]

923 A sitting bench from Petersburg in Waterloo County. The bench with arms was a common form in the Continental German tradition and occurred in various styles, including spindled types. This example is soundly crafted using mortise and tenon construction throughout. Mid-19th century. [P.C.]

924 A stool from Waterloo County. A traditional form with Germanic scrolled and scalloped shaping. 19th century. [P.C.]

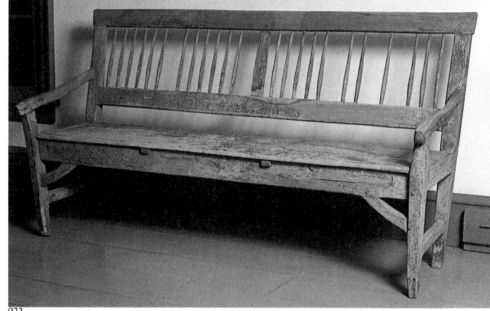

923

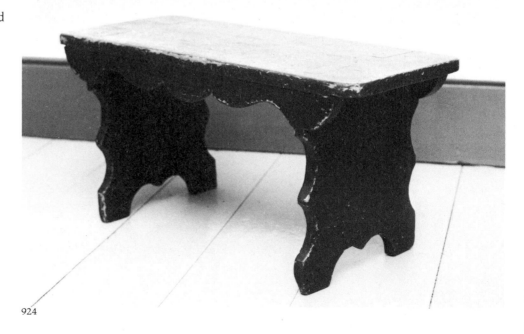

924

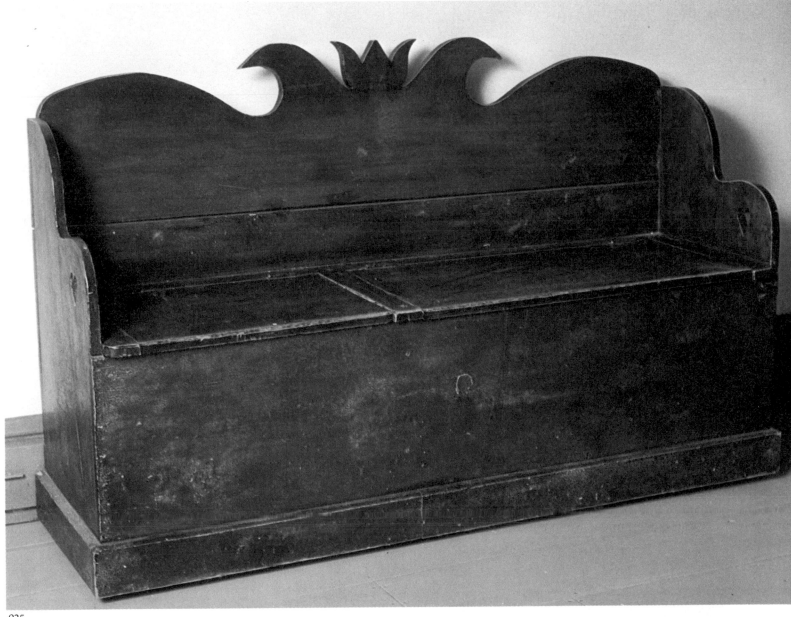

925

925 A bench-chest or *Truhenbank* from Waterloo County. This is a rare Canadian example of a form which was popular in the 18th and 19th century Continental German tradition. Useful storage space is provided under the seat which lifts. The tulip motif in the back and the hearts in the shaped arms were popular Germanic folk motifs. Last half 19th century. [P.C.]

926 A bench from the western counties. This settle-like bench may have been made for use in a meeting house or for domestic use. Second quarter 19th century. [P.C.]

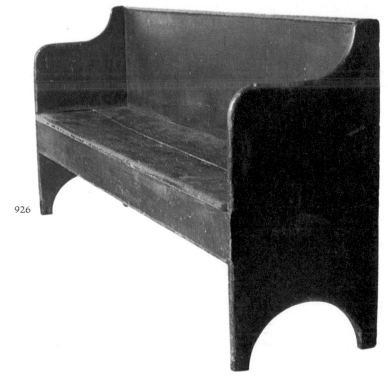

926

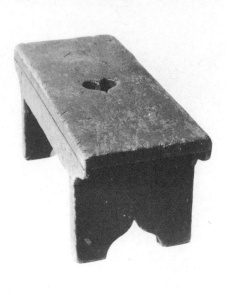

927

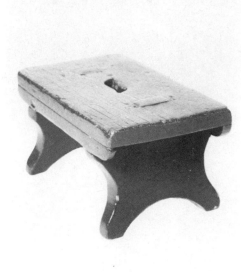

928

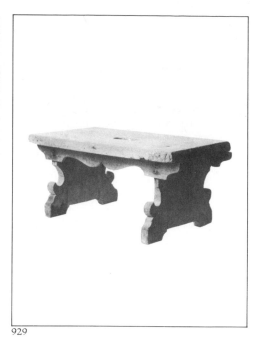

929

927 A stool from Waterloo County.
A traditional form with a heart-shaped
cut-out. 19th century. [P.C.]

928 A stool from Waterloo County.
A traditional form with trestle end
mortised through the top and typical
Germanic "S" scroll cut-out. 19th
century. [P.C.]

929 A stool from Smithville in Lincoln
County. A traditional form with
Germanic scrolled and scalloped shap-
ing. 19th century. [P.C.]

930 A footstool from Muskoka. A
decorative example of primitive charac-
ter. Fourth quarter 19th century. [P.C.]

931 A footstool from Bruce County.
Carefully crafted with mitred corners,
this simple design has a Gothic charac-
ter. 19th century. [P.C.]

932 A pair of stools from Renfrew
County. (Early family: Luloff.) Made by
an early family member. The form and
construction are typical of the Conti-
nental German country tradition and
relate to the common plank chair.
Second half 19th century. [P.C.]

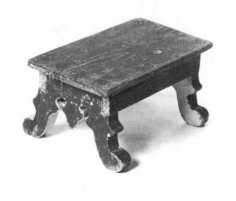

930

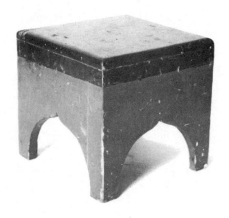

931

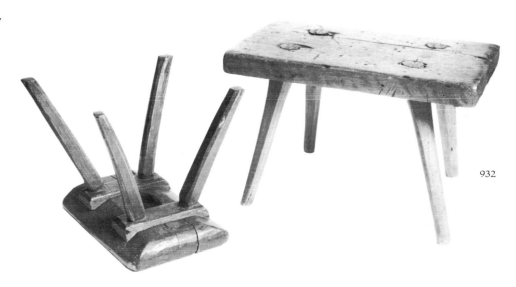

932

933 A bench from Selkirk in Haldi-mand County. (Early family: Winger.) A very graphic Germanic form with splayed trestle ends of spade shaping. 19th century. [P.C.]

934 A kitchen bench from Renfrew County. The simple trestle bench was a basic element in the Germanic tradition. 19th century. [P.C.]

935 A kitchen bench from Waterloo County. This example of the traditional form has three trestles, typically mortised and tenoned through the seat. 19th century. [P.C.]

936 A kitchen bench from Markham Township in York County. Traditional benches of great length were made for use on porches and for seating large groups on special occasions. 19th century. [P.C.]

933

934

935

936

937

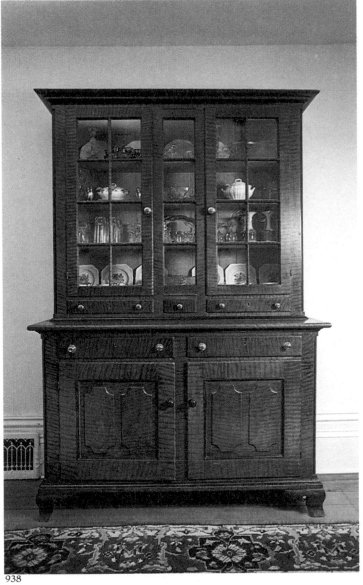

938

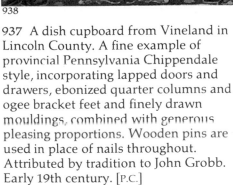

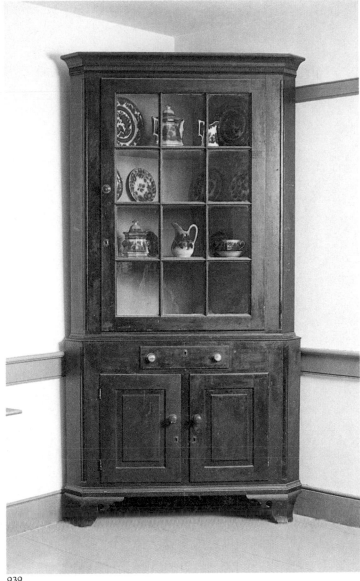

939

937 A dish cupboard from Vineland in Lincoln County. A fine example of provincial Pennsylvania Chippendale style, incorporating lapped doors and drawers, ebonized quarter columns and ogee bracket feet and finely drawn mouldings, combined with generous pleasing proportions. Wooden pins are used in place of nails throughout. Attributed by tradition to John Grobb. Early 19th century. [P.C.]

938 A glazed dish dresser from Vineland in Lincoln County. (Early family: Grobb.) Clearly by the same maker as the previous example and similar in detail; the proportions are appropriately more formal in this glazed cupboard. The effect of figured maple has been created by the use of stain or dye. The glazed panel between the upper doors is a feature of many 18th century Pennsylvania designs, as are the narrow drawers above the counter ledge. Early 19th century. [P.C.]

939 A glazed corner cupboard from Lincoln County. (Early family: Honsberger.) Sharing details of design and craftsmanship with the preceding examples, this cupboard is also directly related to 18th century Pennsylvania prototypes. The deep, single, glazed door above a short lower cupboard with two blind doors and a drawer was a popular early plan. The Neoclassical reeded frieze below the cavetto cornice moulding is seen on other Lincoln County pieces. Early 19th century. [P.C.]

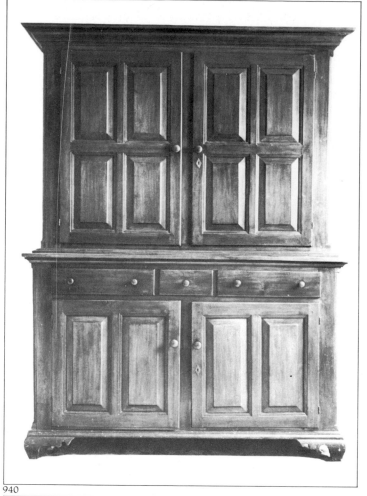

940

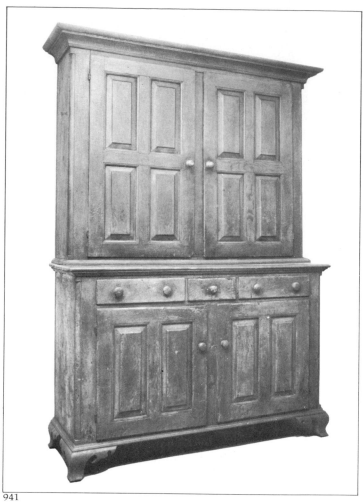

941

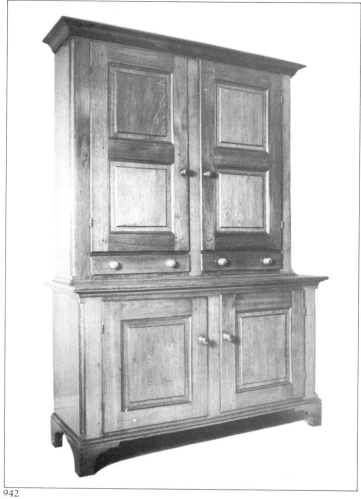

942

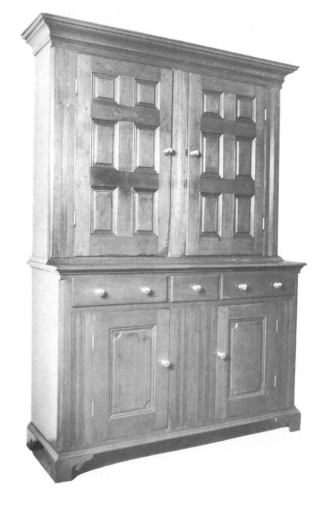

943

940 A dish cupboard from Lincoln County. A striking cupboard, related in many details to the preceding examples and almost certainly by the same hand or shop. The major feature of this design is the rich effect of the deeply chamfered door panels. Deterioration has lowered the feet by about two inches. Early 19th century. [P.C.]

941 A dish cupboard from Haldimand County. Almost identical to the preceding illustration, this cupboard was made of pine rather than walnut. Both cupboards are fitted with spoon holders on their upper shelves. Early 19th century. [P.C.]

942 A dish cupboard from Lincoln County. This cupboard comes from the early home of a descendant of Jacob Fry, and family tradition states that it was made by him for his son, Henry. The absence of drawers in the lower section gives this design a formal character. The craftsmanship throughout is of a high order, which is pleasingly illustrated by the dovetailed bracket foot. Early 19th century. [P.C.]

943 A dish cupboard found in Dunnville in Haldimand County. The use of panels as the major decorative feature in this design is a Germanic characteristic which is seen in the Pennsylvania tradition as well as in that of the homeland. The use of brass hinges on this piece is unusual on Niagara furnishings and these are signed, *J. B. 654*. Early 19th century. [P.C.]

944 A dish cupboard from Dunnville in Haldimand County. A fine early cupboard of 18th century design. The fluted detail on the structural elements of the cupboard front and the flush, beaded door panels illustrate the influence of British style on the Pennsylvania vernacular. The pie shelf is a typical feature of Germanic cupboards. First quarter 19th century. [P.C.]

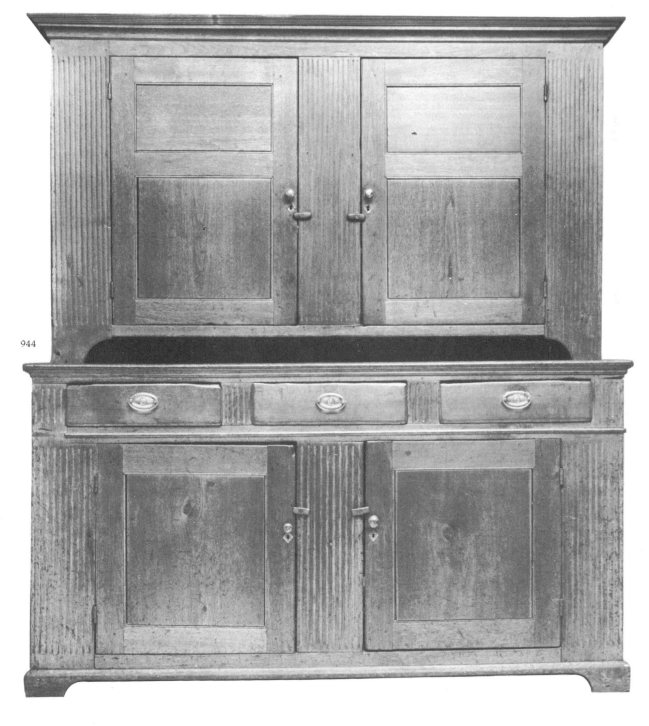

944

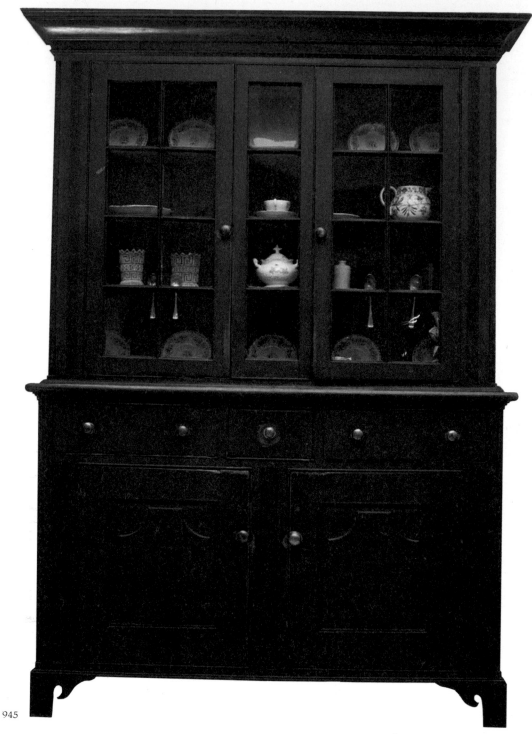

945

945 A glazed dish dresser from Clinton Township in Lincoln County. This cupboard is generously scaled, and, although it is made entirely of pine, its detail is highly refined. Details include a reeded frieze, quarter columns and inserts in the cupboard front. The use of flush-fitted doors and drawers, while not unique, is less common in this group of furnishings than the more typically Germanic lapped type. Early 19th century. [P.C.]

946 A storage cupboard from Lincoln County. A simple but elegant design in which a reeded frieze below the cavetto cornice moulding and spiral-reeded quarter columns are the only decorative features. The form is more related to the popular linen press, in the absence of a counter shelf, than to other dish cupboards made in Lincoln County. First half 19th century. [P.C.]

947 A glazed dresser from Lincoln County. This handsome design relates to the preceding cupboard in the treatment of the cornice, quarter columns and lower cupboard plan. The addition of drawers to the glazed upper dresser and the wide generous ogee bracket feet are details seen on early Pennsylvania examples. First half 19th century. [P.C.]

948 A dish cupboard from Welland County. This design relies entirely on careful proportions and the subtle linear quality of the simple mouldings. The finish and hardware are original. Second quarter 19th century. [N.P.C., B.H., S.C.]

949 A dish cupboard from Wainfleet Village in Welland County. This is a very early example of the recurring Pennsylvania style in the Niagara area. While understated in terms of decorative detail, it is finely proportioned and executed by a very capable craftsman. The rare rat-tail hinges, remains of brass bale hardware and flush, beaded-panel door construction are evidence of its early date. First quarter 19th century. [P.C.]

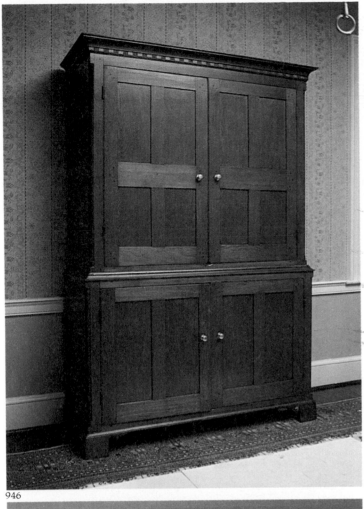

946

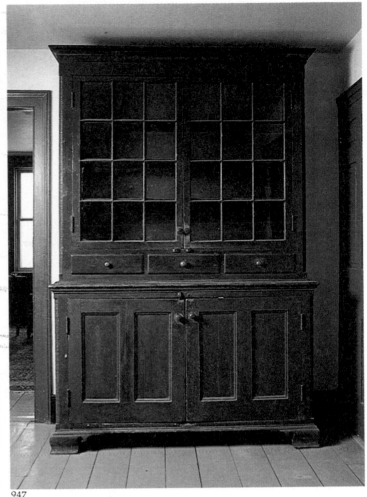

947

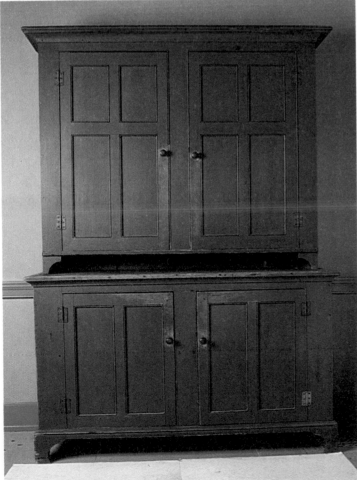

948

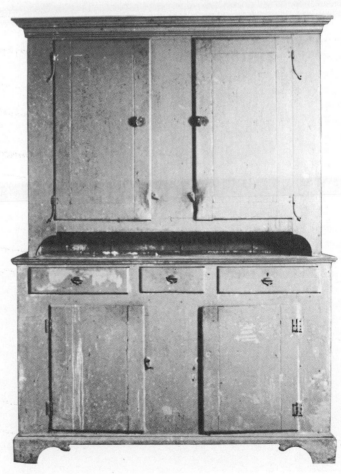

949

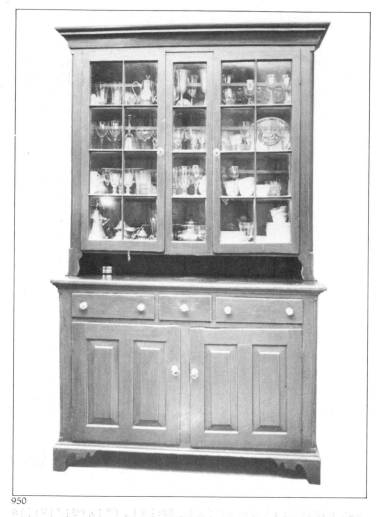

950

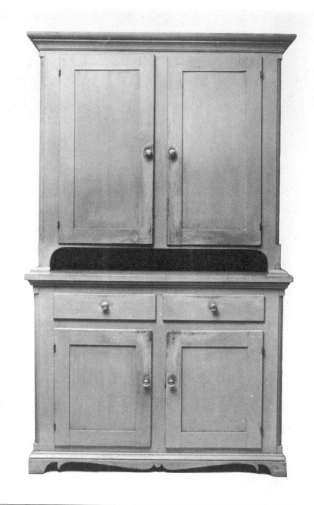

951

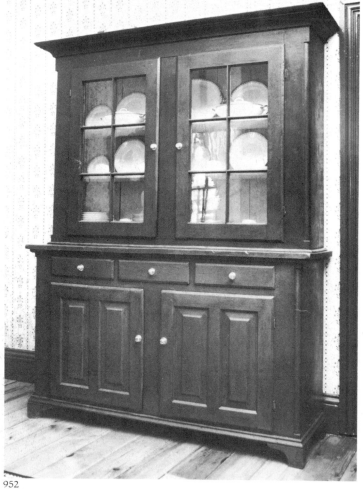

952

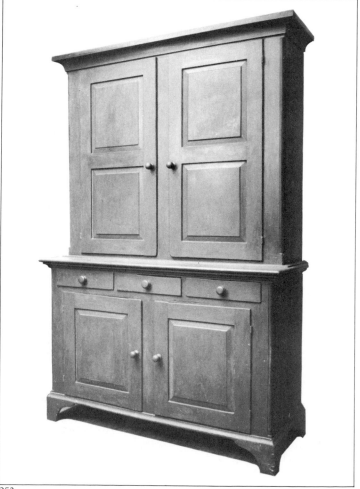

953

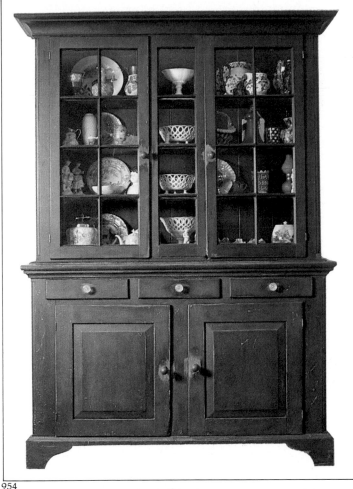

954

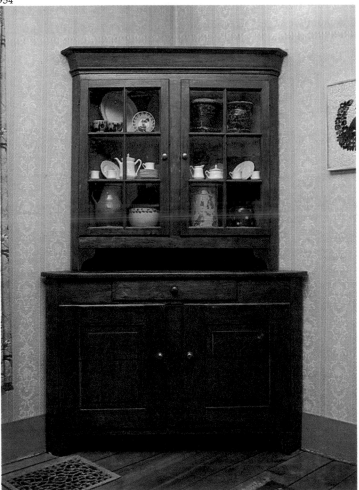

955

950 A glazed dish dresser from Fisherville in Haldimand County. In several ways, this cupboard departs from the closely related Lincoln County examples. The pie shelf is typical of Pennsylvania designs and was popular in other Germanic communities but seldom used in Niagara. In proportion, as well, this piece departs from the local pattern, being more vertical and thus more formal in its effect. Second quarter 19th century. [P.C.]

951 A dish cupboard from the Niagara Peninsula. (Early family: Fry.) This austere design is similar in its proportions and several details to the glazed dresser before. Both are part of a related group of furnishings found in an area surrounding Fisherville in Haldimand County. Second quarter 19th century. [P.C.]

952 A glazed dish dresser from Selkirk in Haldimand County. This is another well-crafted example of the typically wide Germanic kitchen cupboard form. Second quarter 19th century. [P.C.]

953 A dish cupboard from Lincoln County. This is a more utilitarian piece by a Lincoln County craftsman, illustrating the range of furnishings which they produced, all based on the same vocabulary of proportion and detail. Early 19th century. [P.C.]

954 A glazed dish dresser from Welland County. This cupboard is almost identical to the previous example in plan, measurement and many details. Early 19th century. [P.C.]

955 A glazed corner cupboard-on-cupboard from Wainfleet Township in Welland County. (Early family: Marr.) The corner cupboard form was not widely popular in the Niagara community. This example relates to the Continental German style in which the two parts were sometimes separated, with the top section mounted on the wall. The cupboard-on-cupboard was also used in Pennsylvania, although the one-piece form of British influence was more common. Second quarter 19th century. [P.C.]

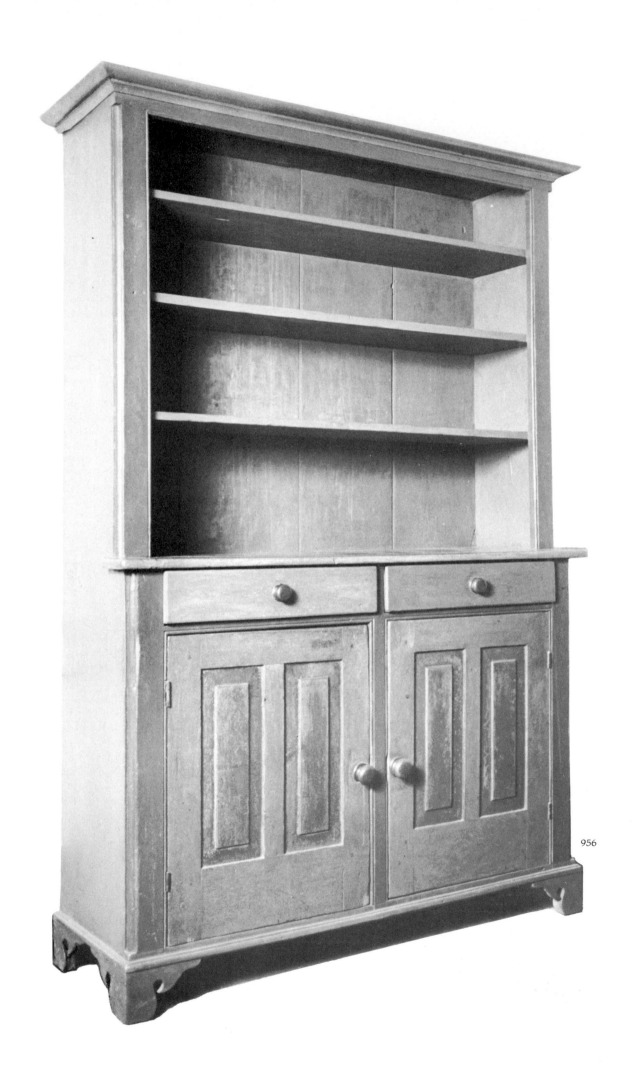

956

956 A dish dresser from Lincoln County. (Signed, *Made by Albert Lane – Gainsborough Shop – 1849.*) This important signed example identifies another Lincoln County craftsman. The dresser is reminiscent of Continental German forms in the weight of the upper section and in the emphasis on the function of the counter by positioning the first shelf to allow access to it. In detail it is consistent with other pieces of the Chippendale-influenced tradition. 1849. [P.C.]

957 A dish dresser from Campden in Lincoln County. Few open dressers were made in the Germanic communities in Upper Canada, which reflects the late 18th century preference in Pennsylvania for those with doors. This example is quite typical of those made in each of the American colonies, while the centred, lapped drawer, lapped doors and Chippendale bracket foot provide a link with other Niagara designs. Early 19th century. [P.C.]

958 A dish dresser from Lincoln County. This simple design is typical of those made in each of the American colonies, the only distinctly Germanic feature being the depth of the counter shelf. The wood is walnut. Early 19th century. [P.C.]

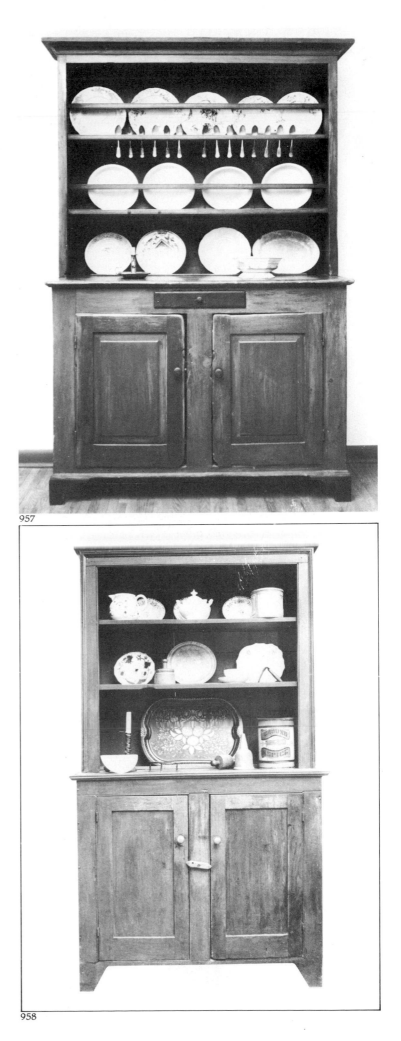

957

958

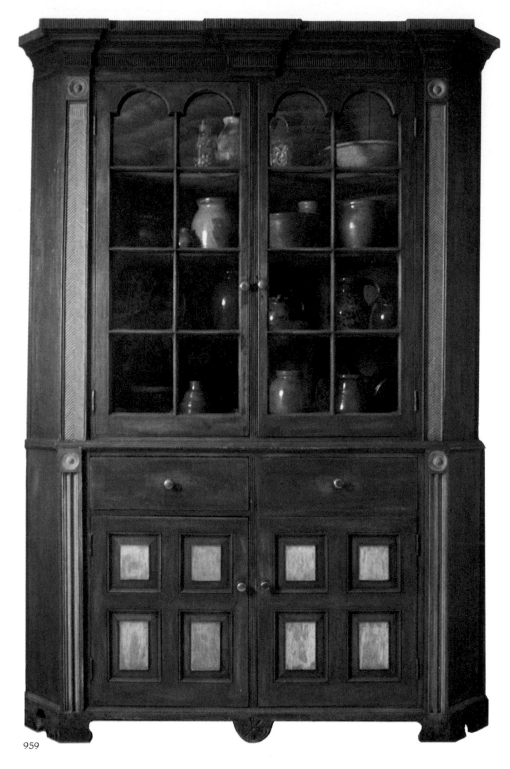

959

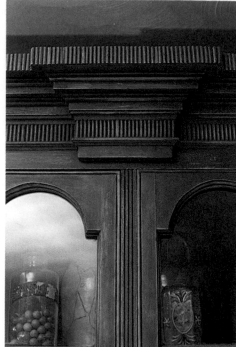

959 a

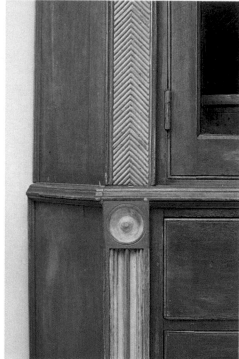

959 b

959 A glazed corner cupboard from Elmira in Waterloo County. This is a fine example of Neoclassical architectural style as expressed in rural Pennsylvania. The cornice, frieze and pilasters are well developed with reeded, herringbone and moulded details. The arched shape in the glazed doors reflects the influence of the Queen Anne style on the Pennsylvania vernacular and was widely adopted by Waterloo craftsmen. Second quarter 19th century. [P.C.]

960 A glazed corner cupboard from Waterloo County. This is another well-articulated survival of rural Pennsylvania Neoclassical style. The basic plan of this cupboard was repeated in considerable numbers up to the 20th century in the Waterloo area. Few approach the soundness of proportion, quality of detail and skilfully painted finish of this example, which is entirely original. Second quarter 19th century. [P.C.]

960

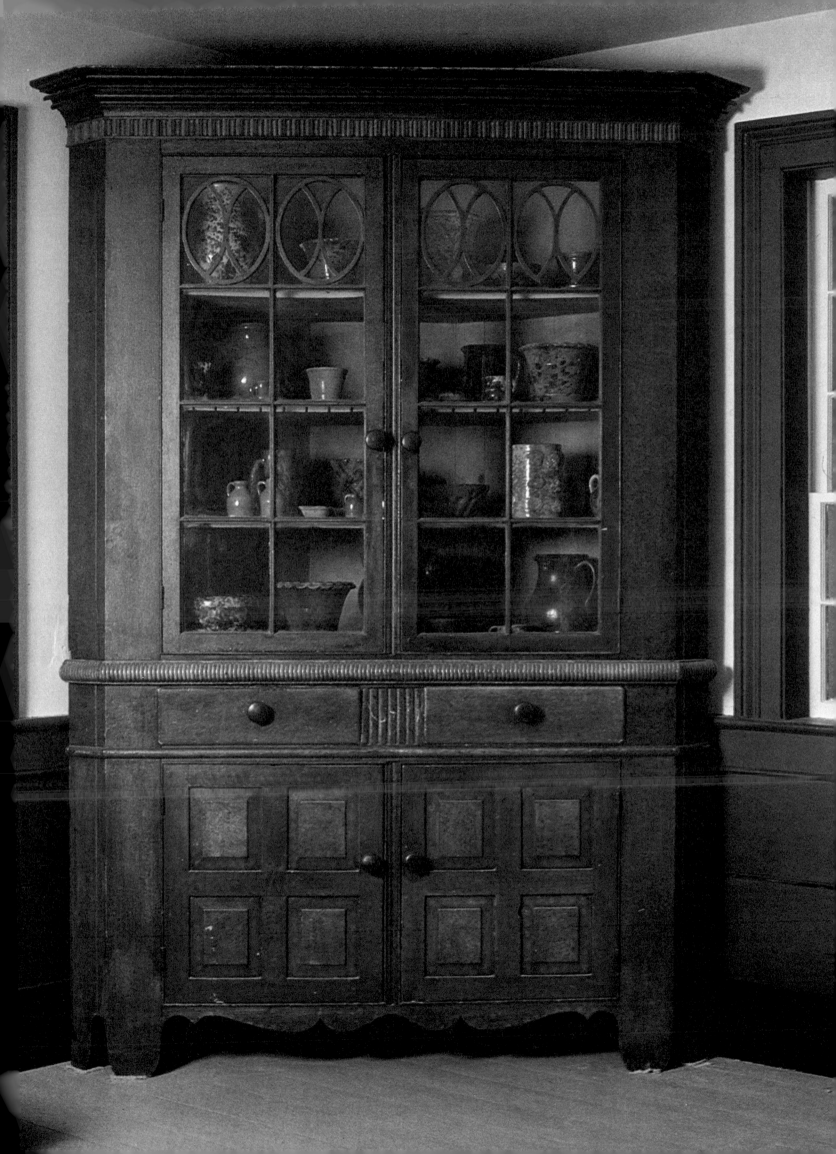

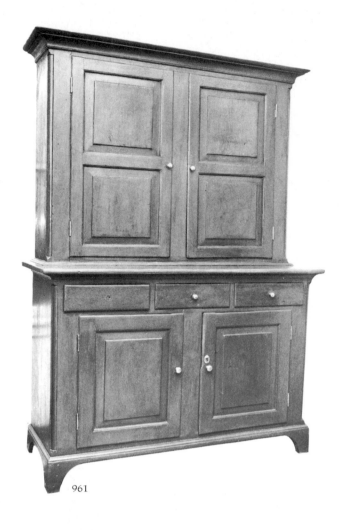

961

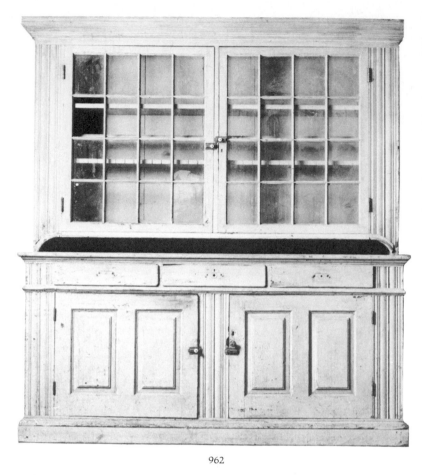

962

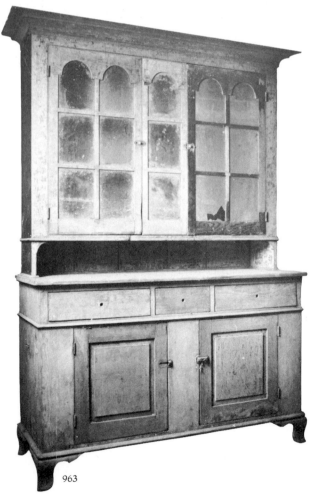

963

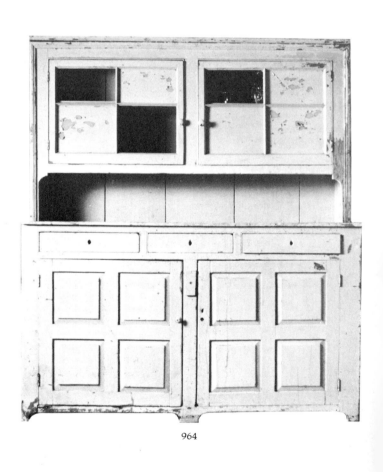

964

961 A dish cupboard from New Dundee in Waterloo County. (Signed, *Mathis Cosier is the maker – Daniel Brundage*.) This is an early example of the style which was so popular in the Waterloo area. The details are unusually fine in execution, including delicately lapped drawers and doors, quarter columns and well-designed mouldings. This understated refinement is more akin to early Niagara pieces than to others of Waterloo origin. Second quarter 19th century. [P.C.]

962 A glazed dish dresser from Heidelberg in Waterloo County. A Germanic cupboard of exceptionally generous proportions and finely drawn details. The moulded treatment of the vertical structural elements is found on early pieces in each of the Germanic communities and was widely employed in 18th century Pennsylvania. The early repair to the base likely replaced a bracket foot. Note similarities to Plate 965. Second quarter 19th century. [P.C.]

963 A glazed dish dresser from Waterloo County. This is a very common cupboard style in the Waterloo area, which is distinguished by ogee bracket feet, rarely found on utilitarian furnishings. Awaiting restoration. Mid-19th century. [P.C.]

964 A glazed dish dresser from Waterloo County. This is an unusual variation on the German cupboard style in its low, wide proportions and deep pie shelf which relate more directly to Continental prototypes than to those of Pennsylvania. In "as found" condition, awaiting restoration. Second quarter 19th century. [P.C.]

965 A dish cupboard from Puslinch Township in Wellington County. A charming country expression of Neoclassical influence. The decorative emphasis of the multiple door panels and the strongly arched pie shelf are important elements in German traditional design which moved from Europe to Pennsylvania and in due course to Upper Canada. Second quarter 19th century. [P.C.]

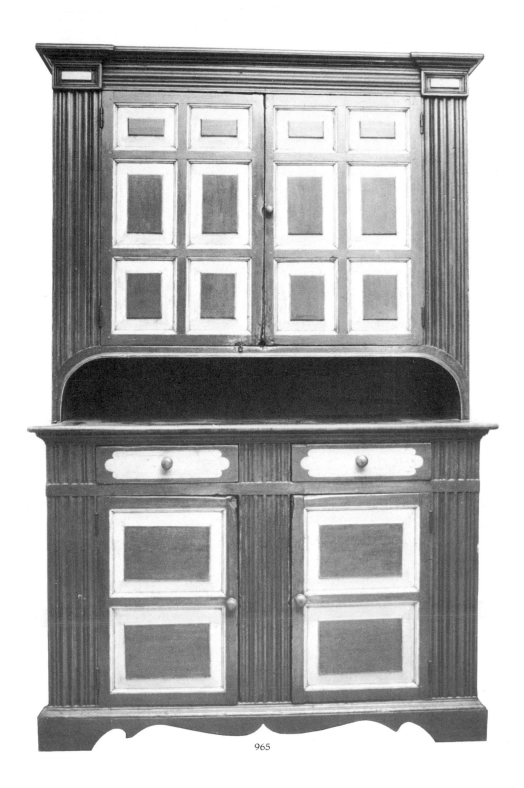

965

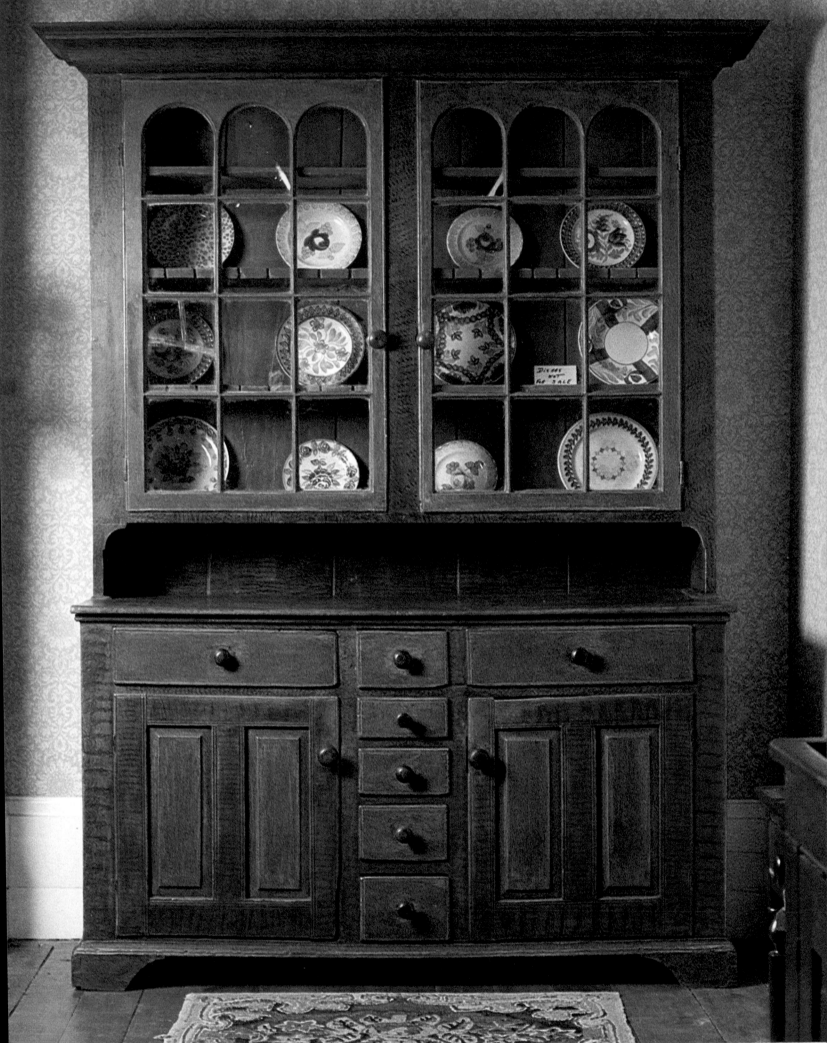

966

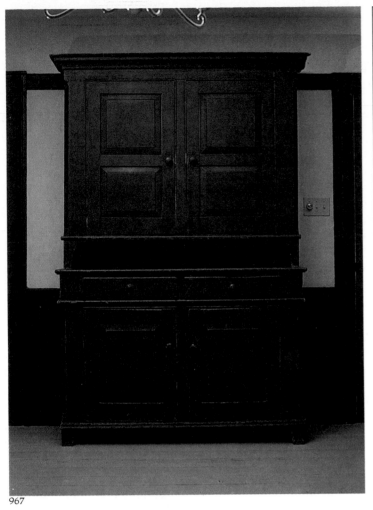

967

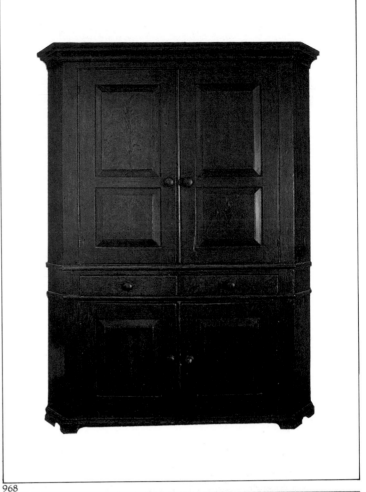

968

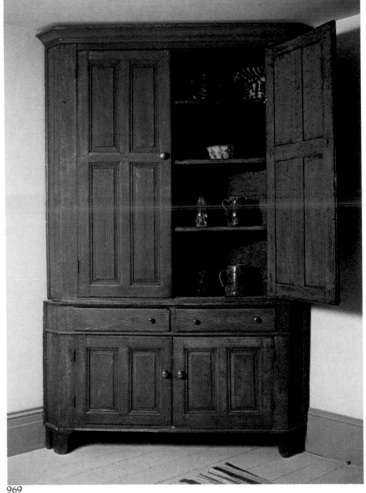

969

966 A glazed dish dresser from the Petersburg area in Waterloo County. This cupboard relates to prototypes which are among the finest developments of Pennsylvania vernacular cupboard design in the 18th century. The colourful painted finish, which includes linear floral motifs on each end, is an important part of its traditional character. Second quarter 19th century. [P.C.]

967 A dish cupboard from Waterloo County. A well-crafted example of a popular Waterloo cupboard type. The fully blown panels, chamfered corners, well-designed pie shelf and strong horizontal mouldings are pleasing features. Second quarter 19th century. [P.C.]

968 A corner cupboard from Perth County. Similar to the preceding example in plan and detail, this large corner cupboard retains an outstanding painted finish in brown-black over vermilion with a fern-like motif on the raised door panels. Second quarter 19th century. [P.C.]

969 A corner cupboard from Waterloo County. (Early family: Yantzi.) A well-crafted cupboard of unusually monumental proportions. Second quarter 19th century. [P.C.]

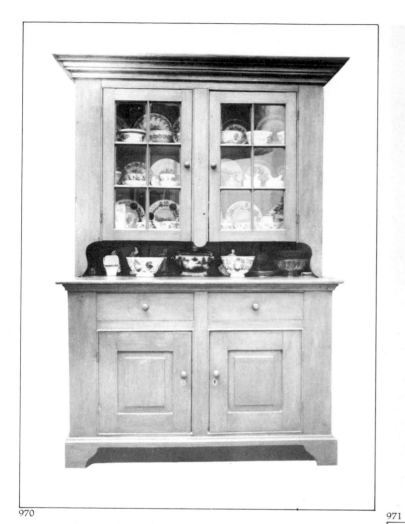

970

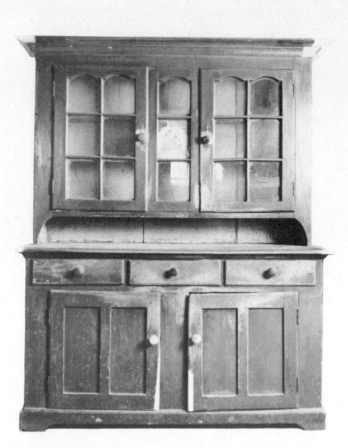

971

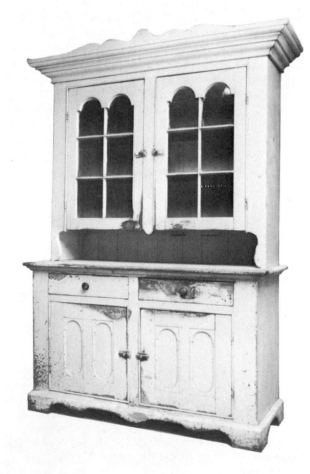

972

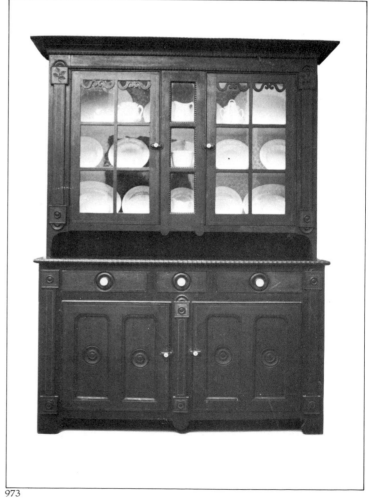

973

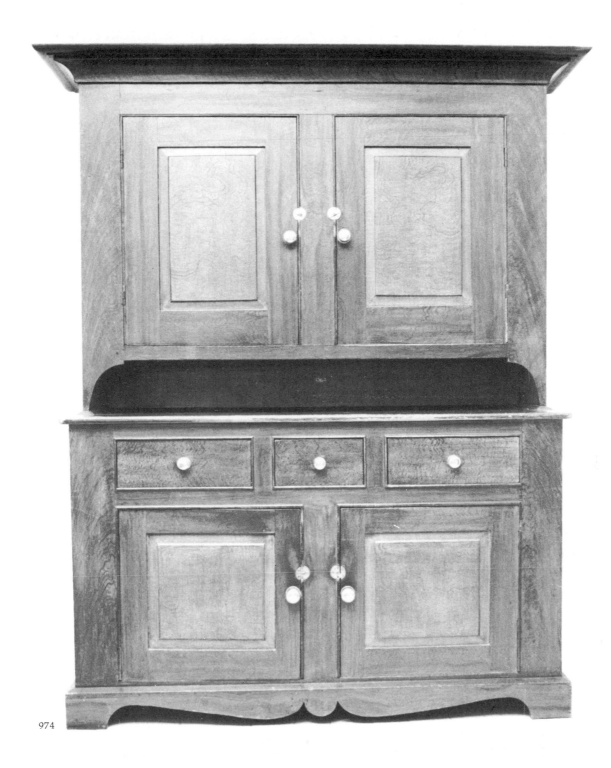

974

970 A glazed dish dresser from Perth County. This cupboard illustrates the sound craftsmanship and sturdy character associated with the Waterloo area in a basic design which became the stereotype Waterloo cupboard in the last half of the 19th century. Second quarter 19th century. [P.C.]

971 A glazed dish dresser from the Erbsville area in Waterloo County. (Early family: Lorenz.) A good Germanic cupboard with the popular arched detail in the glazed doors. Mid-19th century. [P.C.]

972 A glazed dish dresser from Perth County. This cupboard is from the same home as the draw table in Plate 847. It is a variation on the popular Waterloo cupboard style, with design characteristics in the cornice, door panels and bracket base which suggest a maker of Continental origin. Third quarter 19th century. [P.C.]

973 A glazed dish dresser from Grey County. This late example of the Waterloo cupboard form includes a fascinating collection of turned, carved, cutout and inlaid details which are arranged in a highly original manner. As with the previous cupboard, the use of inlay, carving and applied elements

may indicate a maker of Continental origin. Second half 19th century. [P.C.]

974 A dish cupboard from Wellesley in Waterloo County. (Early family: Koehler.) This traditional design embodies careful and generous proportions with a pleasing cornice, bracket foot and beaded details. The most dramatic feature of the piece, however, is the painted finish which contrasts mustard panels with burl graining and drawer fronts of birdseye maple on a background of red-brown feather painting. Mid-19th century. [P.C.]

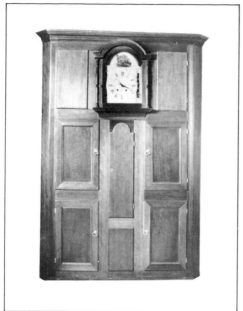

975

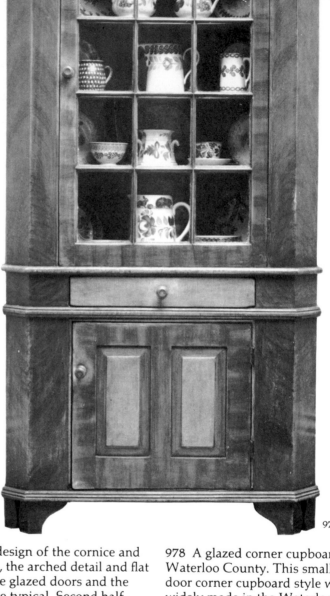

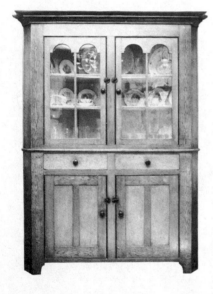

976

977

975 A candle cupboard from Waterloo County. A very few examples of this unusual form are known. It is a concept of Continental origin and is found in Pennsylvania. While this cupboard is from Waterloo, the simple refinement of execution and the use of finely reeded decoration suggest the possibility of a Niagara or Pennsylvania origin. The clockworks appear to be Continental German. First quarter 19th century. [P.C.]

976 A glazed corner cupboard from the Waterloo area. This cupboard is a good example of a design widely made throughout the last half of the 19th

century. The design of the cornice and shaped return, the arched detail and flat mullions of the glazed doors and the simple plan are typical. Second half 19th century. [P.C.]

977 A glazed corner cupboard from Waterloo County. This well-proportioned single-door design is soundly based in the Pennsylvania tradition. The simple cornice profile, horizontal mouldings at the waist and shaped feet are typical details of Waterloo cupboards. It is one of a pair, a rare occurrence in Upper Canada. Second quarter 19th century. [P.C.]

978 A glazed corner cupboard from Waterloo County. This small single-door corner cupboard style was not widely made in the Waterloo area, although in many aspects of design and detail this piece is similar to many wall cupboards and larger corner cupboards made from the mid-century onward. This well-organized design is enhanced by an exceptionally fine execution of wood grain in paint. Second half 19th century. [P.C.]

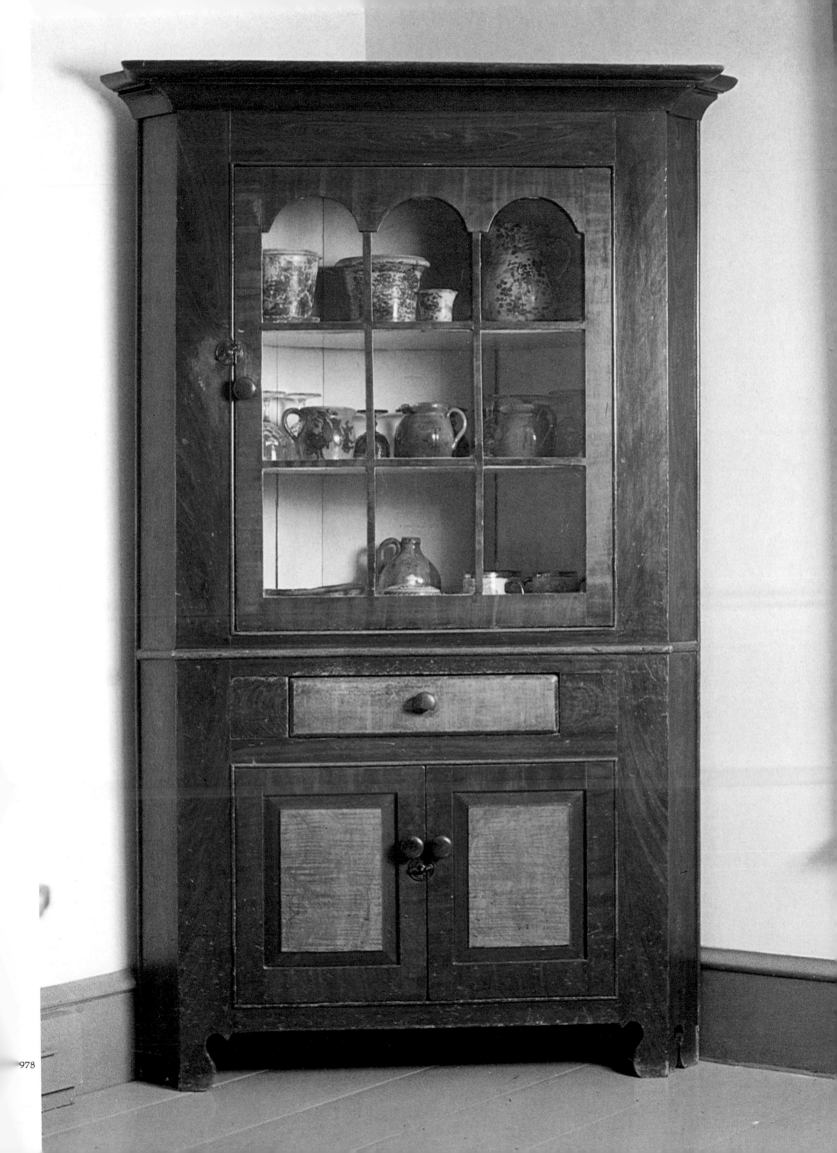

979 A glazed corner cupboard from Waterloo County. The scrolled, broken pediment of Chippendale influence was widely used on various designs, including large corner cupboards in 18th century Pennsylvania. By the end of that century, this design form was well established in the rural tradition.

The scrolled-arch style was made in some numbers by Germanic craftsmen in Upper Canada but only in the Waterloo area. This example, with restrained Neoclassical ornamentation, is possibly the purest local expression of the 18th century prototype. Second quarter 19th century. [P.C.]

980 A glazed corner cupboard from the western area. This cupboard is unusual in its small scale and single-door design. It is fitted with shaped shelves reminiscent of the early tradition. Mid-19th century. [P.C.]

981 A glazed corner cupboard from Waterloo County. Similar to the preceding example, this design is somewhat lighter, with a well-developed pediment and less aggressive Empire elements. It is made entirely of pine. Mid-19th century. [P.C.]

982 A glazed corner cupboard from Waterloo County. This is an imposing design with a large glazed section with shaped shelves. The turnings and details are more refined than those of many of this cupboard type, and the flattened arch of the upper doors is intelligently reflected in the design of the pediment. Mid-19th century. [P.C.]

983 A glazed corner cupboard from the Waterloo area. An unpretentious expression of the style, with a simple pediment incorporating a wheatsheaf motif. The flattened arch in the doors, heavy split columns and architectural roundels are individually awkward, but come together with some success. Mid-19th century. [P.C.]

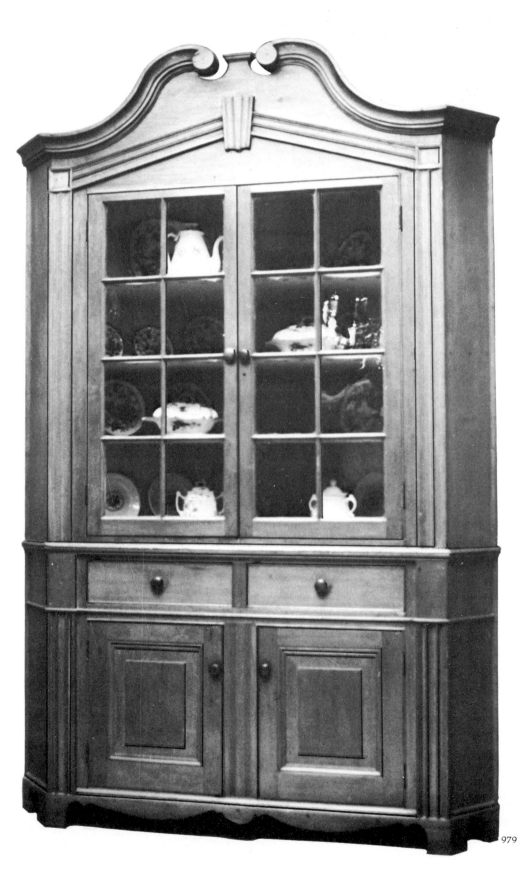

979

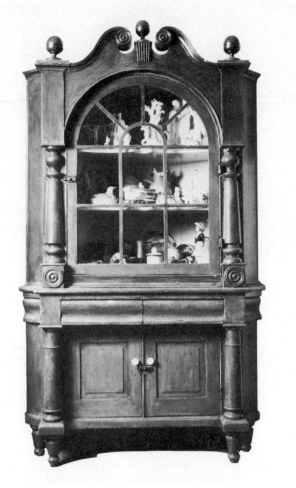

980

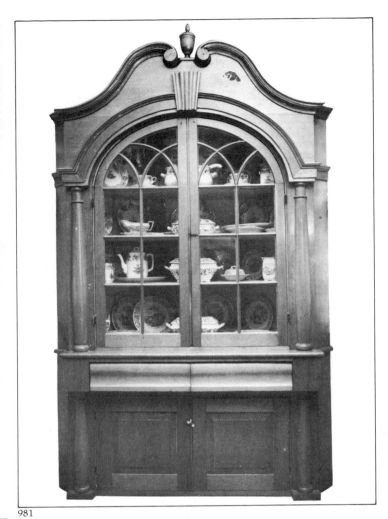

981

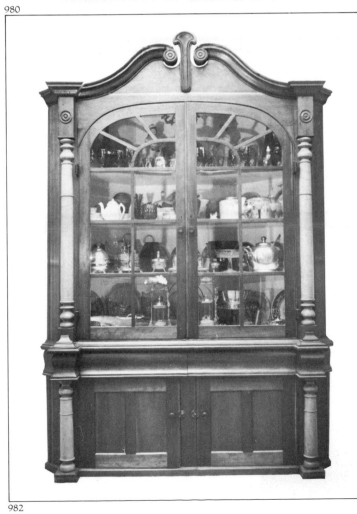

982

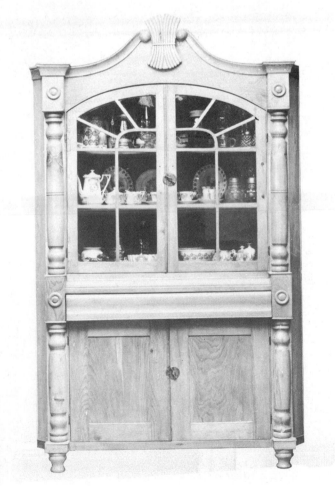

983

984 A glazed corner cupboard from the Waterloo area. This voluptuous example illustrates the introduction of Empire elements to the earlier form which typifies the Upper Canadian expression. It is beautifully crafted in cherry and figured maple with a well-shaped pediment, astragal glazing, shaped shelves and inlaid decoration. An early label tacked under a shelf reads, *Made for Jacob Buckerzson by Abraham Latschaw in 1854 – total cost about $68.* Abraham Latschaw was a furniture-maker in the Baden area. 1854. [P.C.]

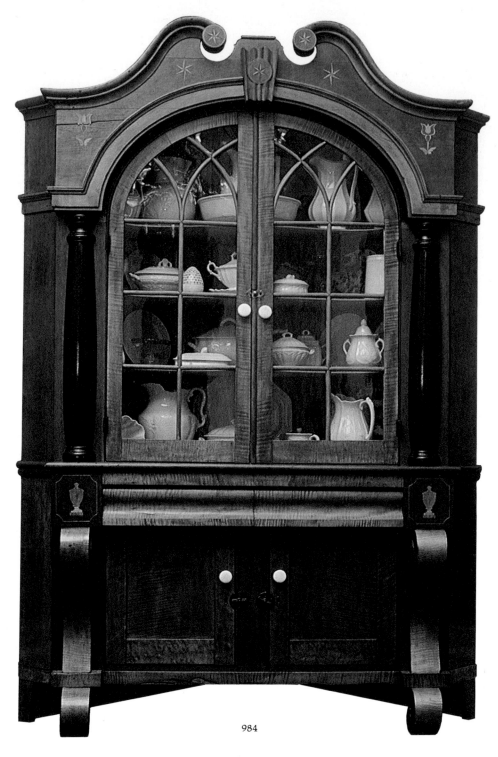

984

984 a

984 b

984c

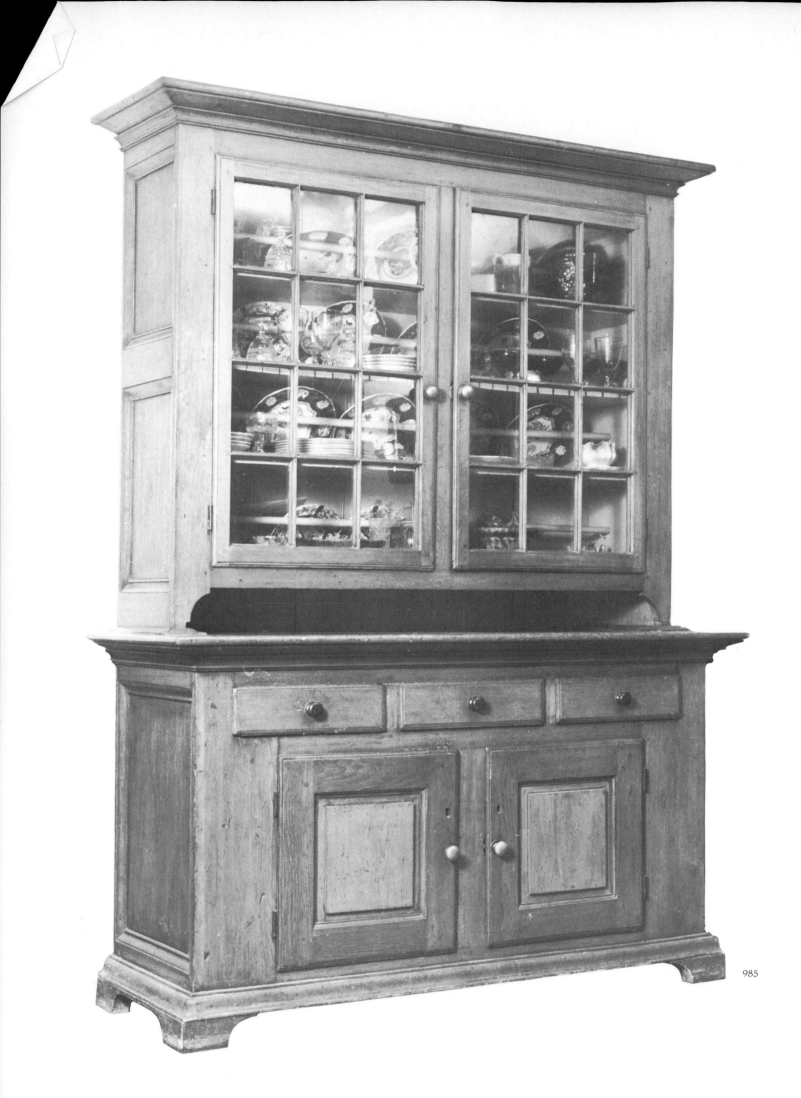

985

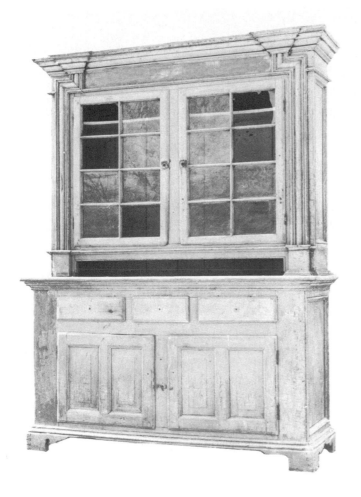

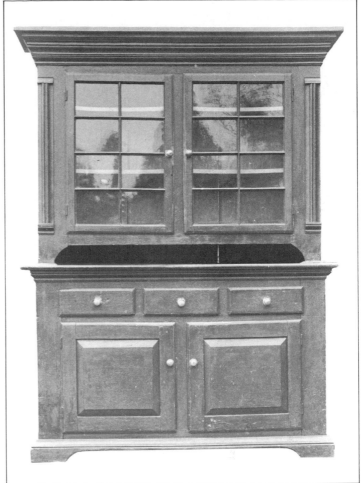

986

987

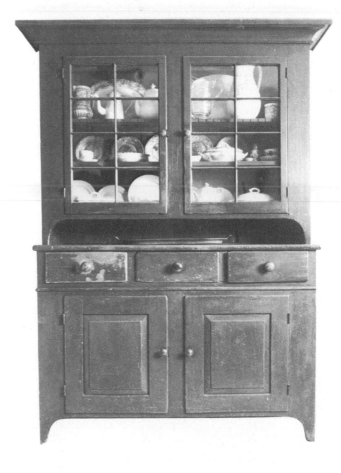

985 A glazed dish dresser from Whit-church Township in York County. This large cupboard is a dramatic example of the survival of the 18th century Pennsylvania-German style. Second quarter 19th century. [P.C.]

986 A glazed dish dresser from Whitchurch Township in York County. The generous traditional Pennsylvania form here is similar to the preceding example, with the addition of a complex Neoclassical treatment of the cornice and pilasters. It is in "as found" condition. Second quarter 19th century. [P.C.]

987 A glazed dresser from Markham Township in York County. The similarities of proportion, the use of mouldings to produce a Classical effect in the upper section and the horizontal glazing plan suggest the same maker for this traditional design as the last one. Second quarter 19th century. [P.C.]

988 A glazed dish dresser from Markham Township in York County. This simple, well-formed cupboard is typical of many made in Markham at the mid-century. Mid-19th century. [M.D.H.M.]

988

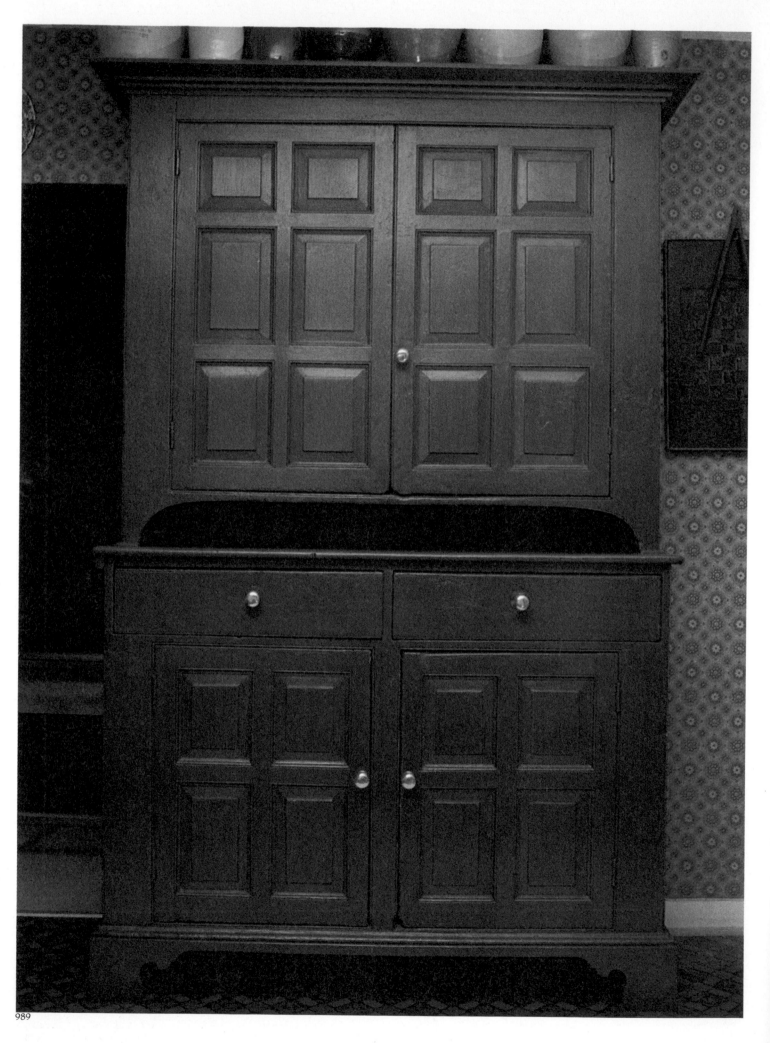

989

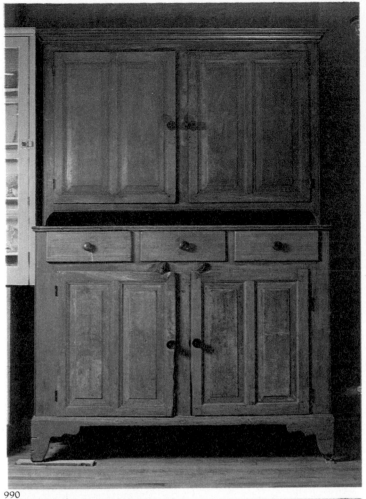

990

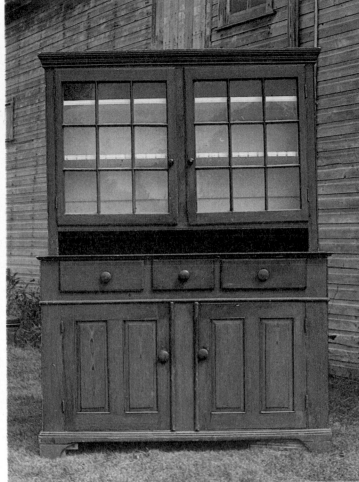

991

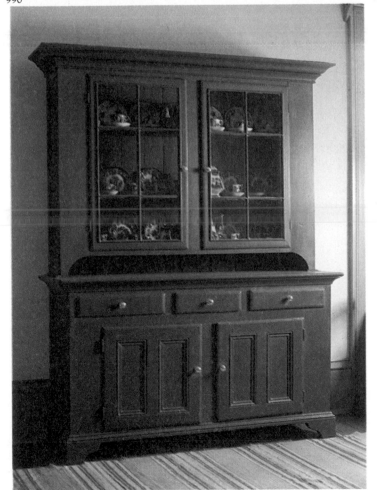

992

989 A dish cupboard from Vaughan Township in York County. A fine Pennsylvania form with well-shaped panels creating a design of strong Germanic character. This cupboard is attributed to Jonathan Baker, Senior, or his father, Jacob. First quarter 19th century. [P.C.]

990 A dish cupboard from Markham Township in York County. This is a fine early example of the popular Pennsylvania form. The mouldings are finely drawn, and the unusual elevation of the bracket foot is evidence of the continuing Continental influence. First quarter 19th century. [P.C.]

991 A glazed dish dresser from Scarborough Township in York County. A strong, simple Germanic cupboard design with the typical spoon holders in the first upper shelf. Second quarter 19th century. [P.C.]

992 A dish dresser from Vaughan Township in York County. A large cupboard of well-balanced design. The small, square lower doors and wide stiles in both lower and upper sections are a common Germanic characteristic. Second quarter 19th century. [B.C.P.V.C.]

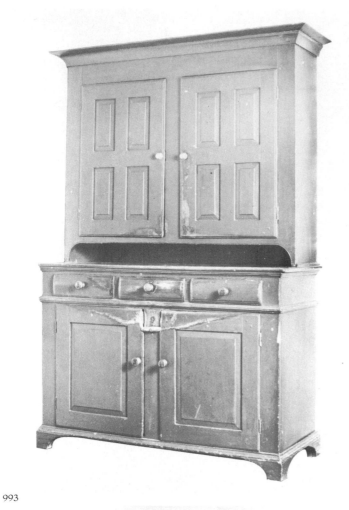

993

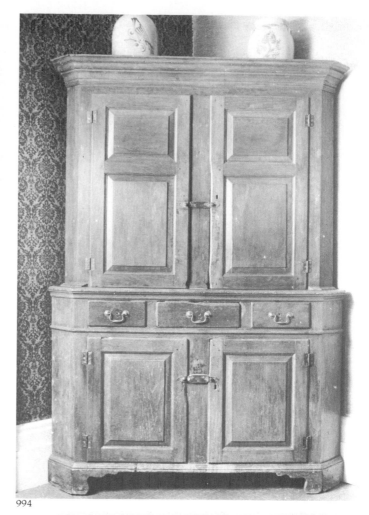

994

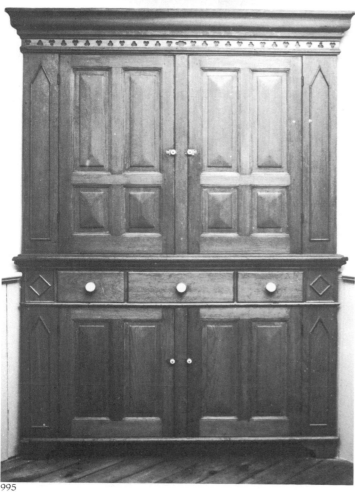

995

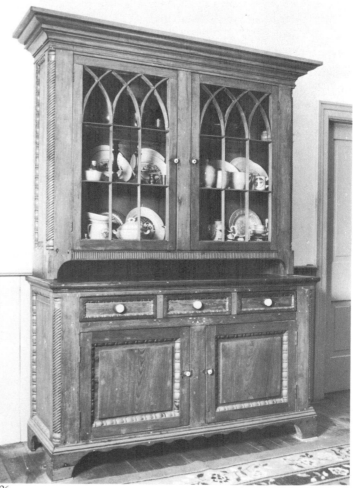

996

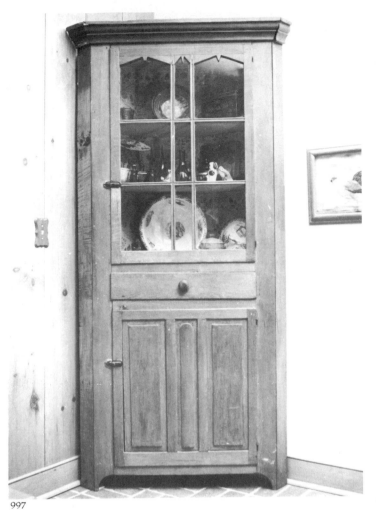

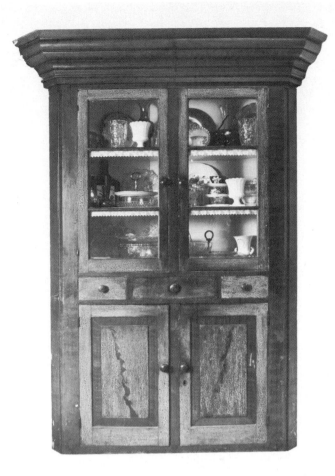

997

998

993 A dish cupboard from Pickering Township in Ontario County. This well-crafted Germanic cupboard comes from a part of Ontario County which saw some settlement by Pennsylvania immigrants related to the early Markham community. The horizontal mouldings above and below the drawers are design features also found in Waterloo, yet the heavy, convex drawer fronts are unusual. Second quarter 19th century. [P.C.]

994 A corner cupboard from Bethesda in Markham Township, York County. This is an impressive example of 18th century Pennsylvania style in the Markham community. It illustrates the influence of English style on the Pennsylvania tradition and its survival in Upper Canada. Second quarter 19th century. [P.C.]

995 A dish cupboard from Pickering Township in Ontario County. This unusual design is more similar in plan to Germanic wall cupboards than to other corner cupboards. The arrangement of three lapped drawers over two doors with a horizontal moulding between is a common feature of cupboards in the Pennsylvania style, but the shaped door panels, cutout frieze and applied mouldings suggesting a mock pilaster are effective departures from that tradition. Mid-19th century. [P.C.]

996 A glazed dish dresser from Pickering Township in Ontario County. This is a most unusual expression of the Pennsylvania vernacular cupboard form in the formality of its detail. The bead and reel mouldings, diagonal-reeded quarter columns, reeded insert and Gothic glazing plan are elements of 18th century Neoclassical style seldom seen in such profusion in country furnishings. Mid-19th century. [P.C.]

997 A glazed corner cupboard from Markham Township in York County. This design is a rather unconventional interpretation of the small Pennsylvania corner cupboard, with characteristic shaping to the upper glazing. The workman employed lapped door and drawer construction, but the craftsmanship is not of the standard found in most Germanic examples. Mid-19th century. [P.C.]

998 A glazed corner cupboard from Markham Township in York County. (Early family: Brilinger.) This cupboard was moved from an early house, with contents intact, during a fire which destroyed the home. With its boldly massive cornice, it is another interesting example of the acceptance in the Markham Germanic community of stylish influences from outside the Pennsylvania tradition. The original painted finish is retained. Mid-19th century. [P.C.]

999 A dish dresser from Renfrew County. Made by Mr. Jenup for the Luloff wedding in 1912. The survival of the German folk culture in Renfrew County is well illustrated by this late cupboard. The style is directly based in the 18th and 19th century German vernacular, and the association with a special family event is a significant facet of that furniture tradition. The reeded and cross-hatched panels in the upper section are drawers, as are those below the counter. The leaf and heart motifs are popular elements in the painted decoration on German traditional furnishings. 20th century. [C.F.C.S., M.O.M., N.M.O.C.]

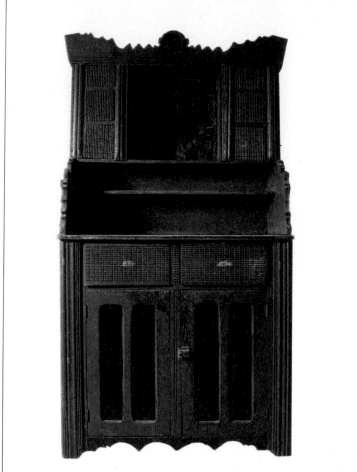

999

1000 a

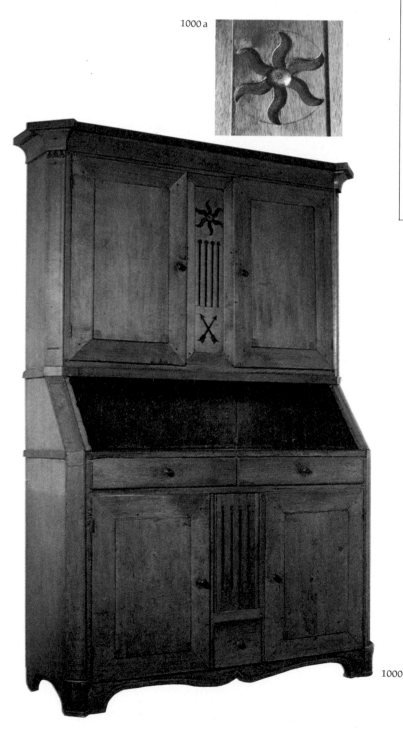

1000

1000 A dish cupboard from Fort Erie in Welland County. This distinctly European design could have been made by an immigrant of German, Alsatian or Swiss origin. It is finely crafted of walnut with cherry crossbanding and saw-tooth motif on the chamfered corners and in blocks at the corners of the flush-fitted door panels. A tambour panel between the lower doors conceals a wine storage cupboard. The swirling star and arrow are often seen on traditional Germanic furnishings. First half 19th century. [P.C.]

1001 A glazed dish dresser from Palmer Rapids in Renfrew County. Attributed to August Boehme, an immigrant from Germany, this charming small cupboard is a direct reflection of a common dresser form in the German rural tradition. The deep pie shelf, shaped sides and naïvely Baroque pediment and base are distinctive characteristics of the style and the simply carved rosettes and cutout hearts are common decorative motifs. Third quarter 19th century. [P.C.]

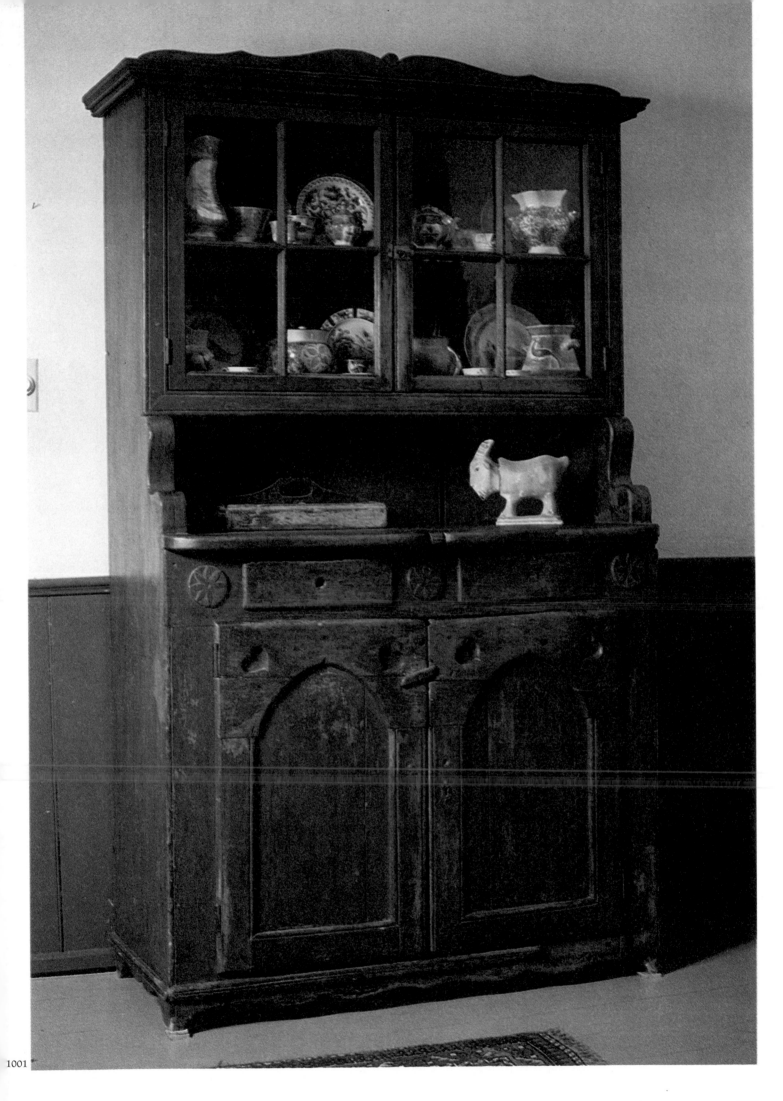

1001

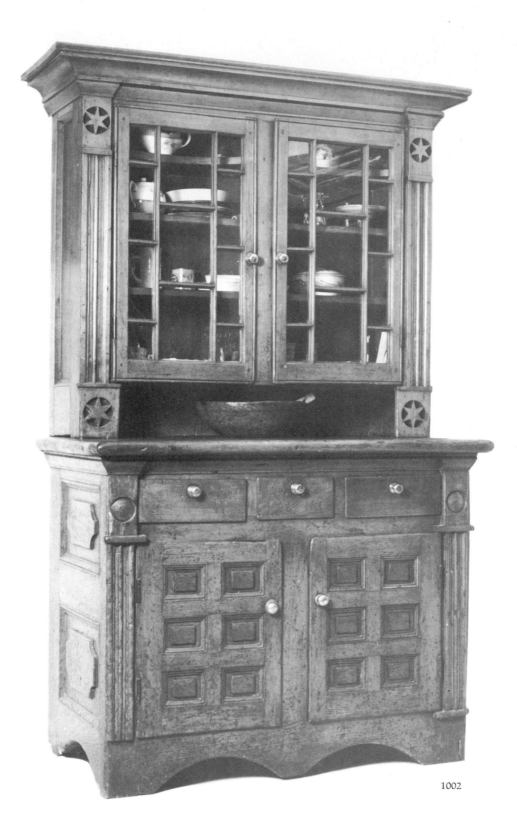

1002

1002 A glazed dish dresser from Good-wood in Ontario County. A strikingly decorative and heavily structured cupboard of distinctly Continental German character. Neoclassical cornices, pilasters and glazing were popular elements in the dressers and cupboards of the 18th and 19th century German tradition. This formality is modified in this design by the characteristic use of panels as a decorative theme and by the emphasis of the six-pointed star roundels of folk tradition origin. Second quarter 19th century. [P.C.]

1003 A glazed dish dresser from Waterloo County. A strong Germanic design incorporating the traditional pie shelf between the lower cupboard and the upper dish storage area. The decorative character of the lower doors is strengthened by deep mouldings and shaped, raised panels. The universally popular Chippendale glazing pattern is similarly scaled to the elements in the lower cupboard so that a uniform visual texture is created overall. Second quarter 19th century. [P.C.]

1004 A glazed dish dresser from Renfrew County. This strong, simple design includes several characteristics which relate it to the German furniture tradition. The multiplicity of panels widely framing rather small glazed doors is seen on many Continental German cupboards, as is the elevation of the massive form on turned bun feet. Third quarter 19th century. [P.C.]

1005 A glazed dish dresser from Waterloo County. The outstanding feature of this Germanic design is the use of carved and cutout elements of folk decoration on the simply stated Neoclassical frieze and pilasters. These elements include fan, fish, birds, coiled serpent and potted plant. All are recurring images in Continental German folk decoration. The use of surface carving relates to regional tradition in Germany. The decorated glazed section has undergone major restoration to the pie shelf and the inconsistent construction of the base suggests an early marriage. Second quarter 19th century. [C.D., R.O.M.]

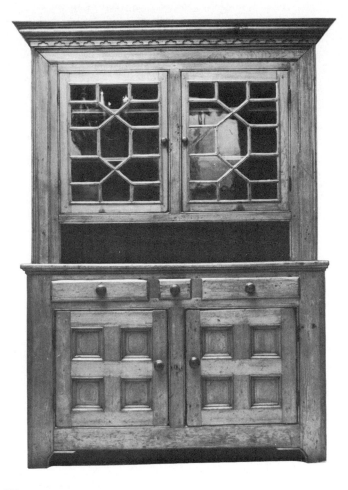

1003

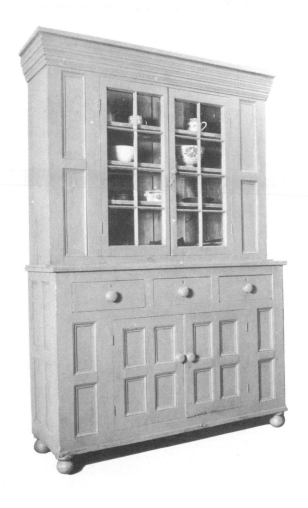

1004

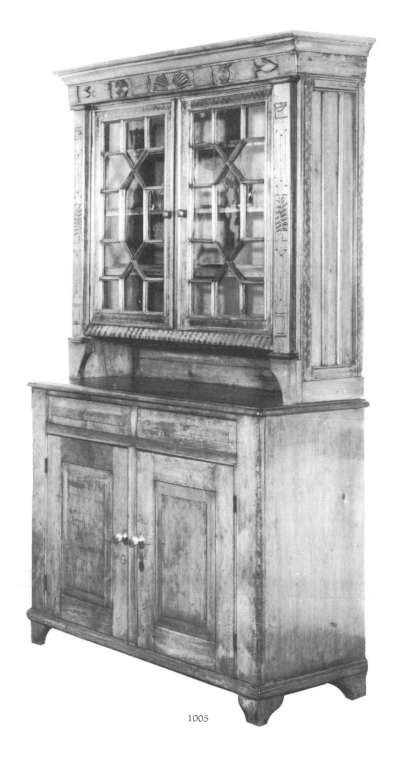

1005

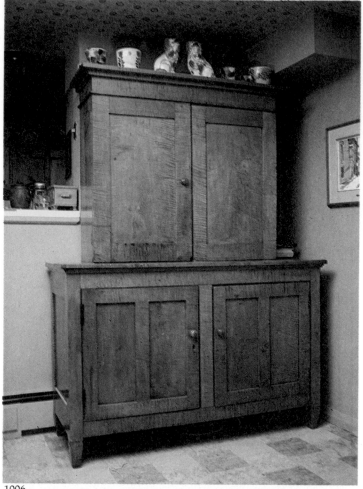

1006

1006 A dish cupboard from the Niagara Peninsula. This functional design is a simple variation on the stylish German Biedermeier style. The appropriate choice of figured maple and the character of the joinery are indications of a Continental German craftsman of some sophistication. Mid-19th century. [P.C.]

1007 A dish cupboard from Waterloo County. A highly individual design which is consistent with German tradition in its scalloped cornice and applied decoration and in the simply executed suggestion of Neoclassical formality. The original painted woodgrain finish is unusually vigorous. Second quarter 19th century. [P.C.]

1008 A linen press from Jordan in Lincoln County. (Early family: Caskey, Jordan Hotel.) Signed, *Jacob*, which may indicate Jacob Fry, a known early Lincoln County cabinetmaker. This is a fine example of the provincial expression of the Chippendale style with Neoclassical influences, which was popular in 18th century Pennsylvania and, in turn, in the Germanic settlements in the Niagara Peninsula. Early 19th century. [P.C.]

1008a

1008b

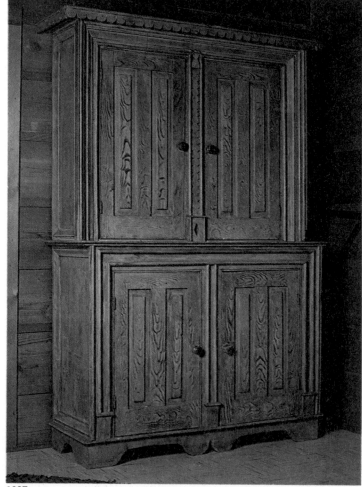

1007

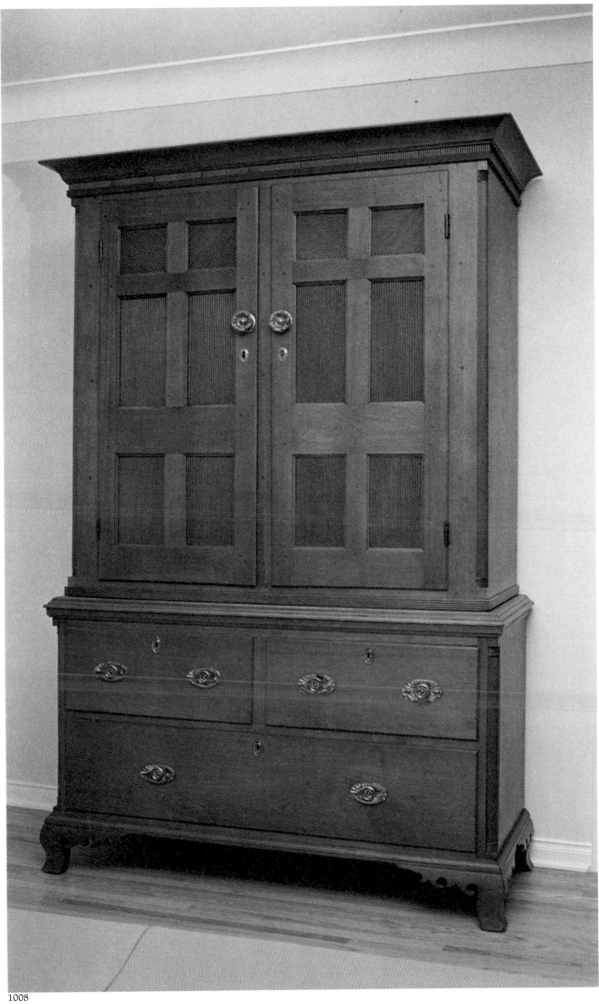

1008

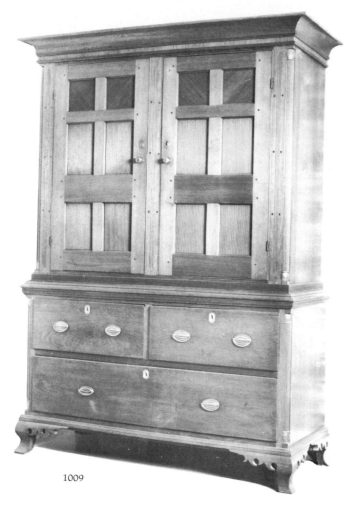

1009

1010

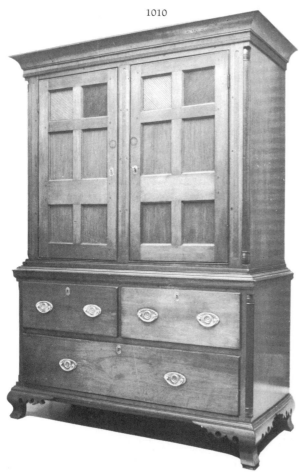

1009, 1010 Linen presses from Lincoln County. These almost identical presses are by the same maker as the preceding example. All are distinguished by well-executed cavetto cornice mouldings, reeded frieze, reeded quarter columns with turned stops, reeded waist mouldings and door panels and well-designed ogee bracket feet. The lapped drawer fronts are consistent with German preference, while the doors are fitted flush. Early 19th century. [P.C.]

1011 A linen press from Lincoln County. This well-proportioned example is subtly detailed and crisply executed with a plain bracket foot. The shaped panels and simple reeded details are seen in other forms, likely made by the same Pennsylvania German craftsman, and illustrate the Neoclassical influences which flowed over the well-established Chippendale style. Early 19th century. [P.C.]

1012 A linen press from Lincoln County. Sharing many similarities in detail with the previous example, this press has lapped doors, drawers and the bracket foot, and while of similar profile, is heavier. The use of paint stain to achieve a bold surface decoration is unusual in Niagara furniture. Early 19th century. [P.C.]

1013 A linen press from Lincoln County. (Early family: Honsberger.) Slight variations in detail and proportion give each of these related examples their own distinctive quality. The combination of square and rectangular panels in the doors of this design lighten the visual impression. Second quarter 19th century. [P.C.]

1014 A linen press from Campden in Lincoln County. Signed, *J. G. – 1830*, and attributed to John Grobb, a known Lincoln County maker. Similar details are incorporated in this design as in the two preceding. The plain panelled doors and high, slightly splayed bracket foot give this piece a severe character. 1830. [P.C.]

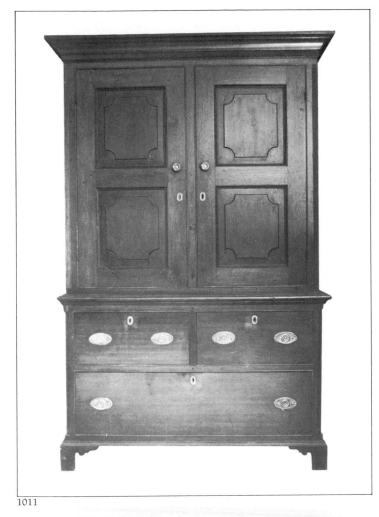

1011

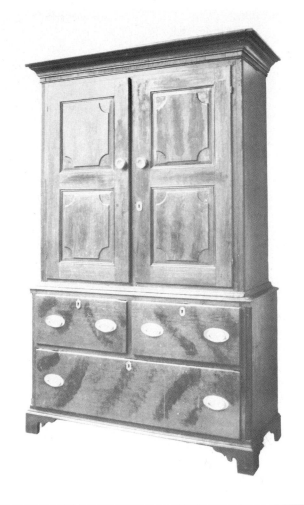

1012

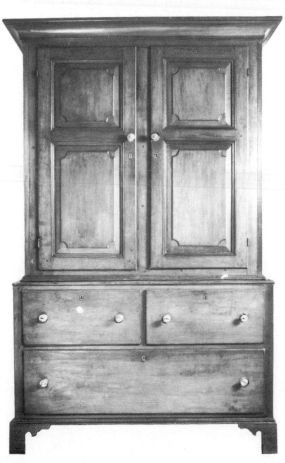

1013

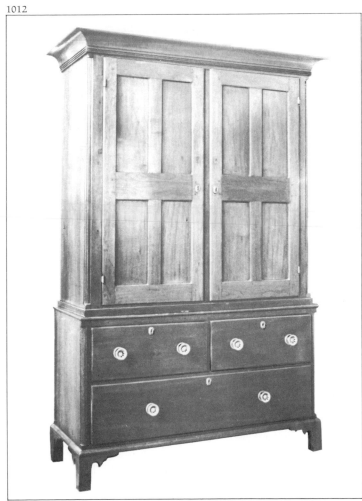

1014

1015 A linen press from York County. This finely crafted press of single-piece design introduces another facet in the survival of the Pennsylvania furniture tradition in Upper Canada. This piece is tentatively attributed to John Doan, a Pennsylvania Quaker and later member of the Children of Peace associated with the Sharon Temple. The design is based on the popular Pennsylvania Chippendale style but incorporates a strong Neoclassical influence, particularly in the design and detail of the cornice and frieze and in the use of crossbanded inlay on the flush-fitted drawer fronts. Early 19th century. [P.C.]

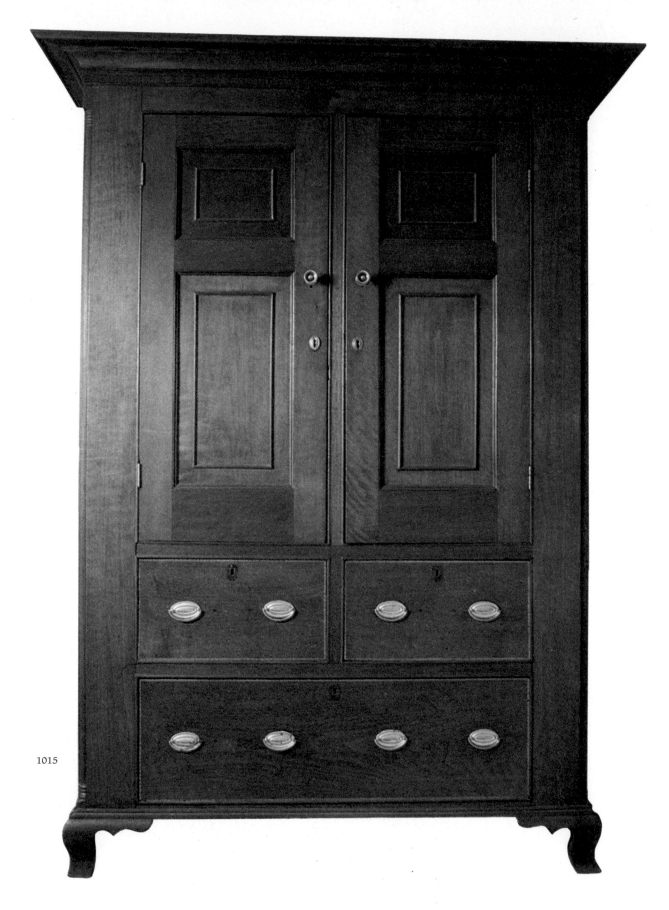

1015

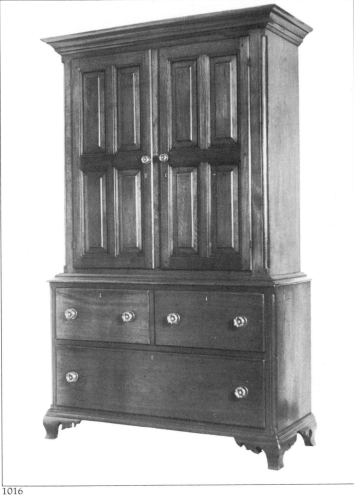

1016

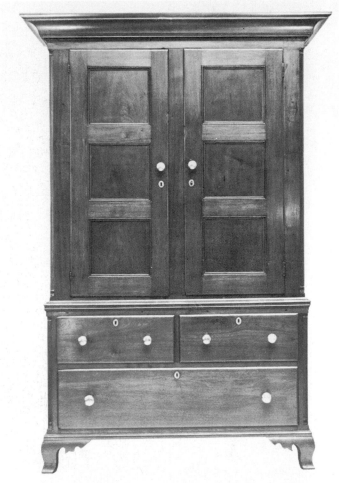

1017

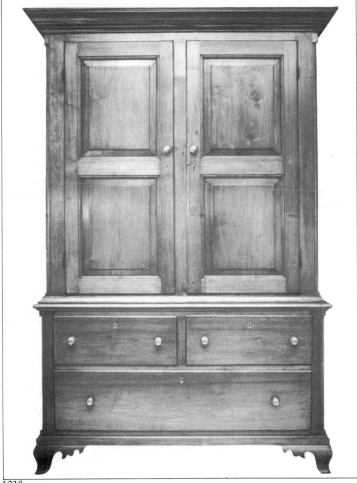

1018

1016 A linen press from Lincoln County. Several presses are known of almost identical design to this pleasing example and the similarity in detail to the dish cupboard in Plate 940 is notable. Second quarter 19th century. [P.C.]

1017 A linen press from Campden in Lincoln County. The vertical emphasis in the proportions of this design are not seen in other Niagara examples. The use of simple stopped quarter columns and slightly less refined detail overall suggest a later date of manufacture than for the preceding examples. Second quarter 19th century. [P.C.]

1018 A linen press from Vineland in Lincoln County. (Early family: Moyer.) A well-balanced design with the simplified and slightly heavier detail which is further removed from the 18th century tradition. Second quarter 19th century. [P.C.]

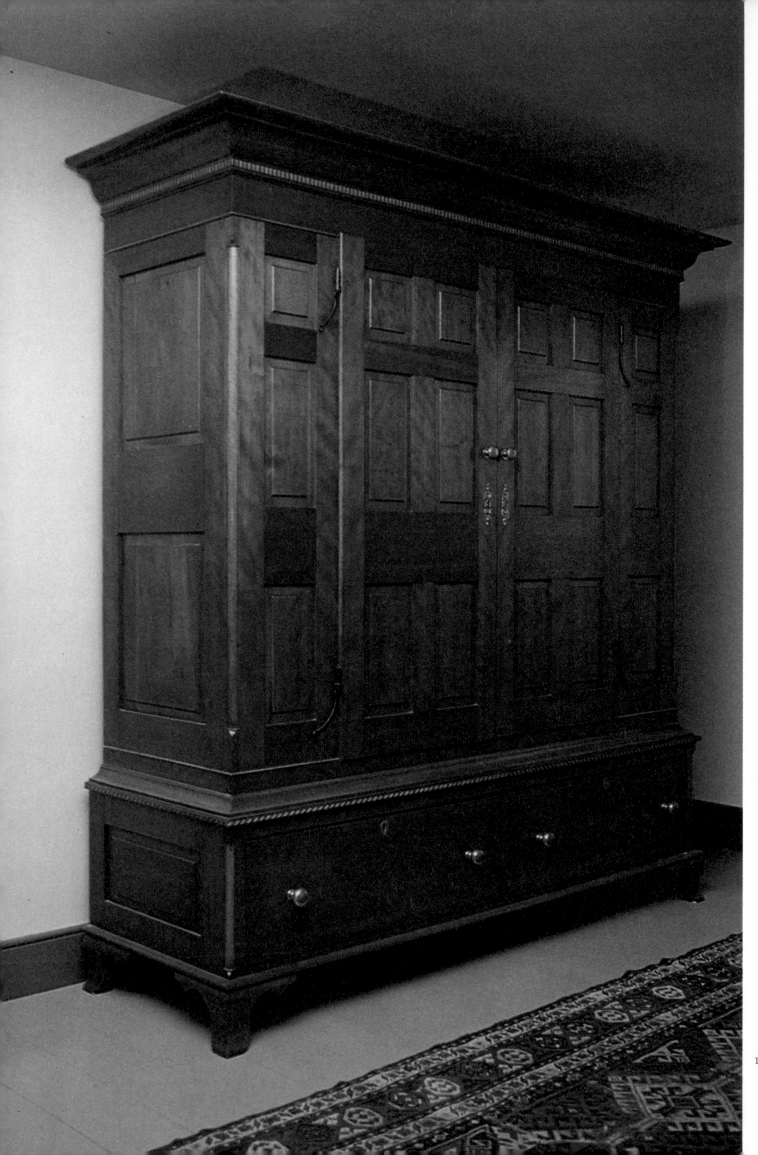

1019 A *Schrank* or wardrobe from
Waterloo County. A finely crafted
example of the Pennsylvania develop-
ment of this traditional German form.
The inlaid detail in the cornice and
waist mouldings are of American
Federal influence, while the ogee
bracket feet and chamfered corner
details are evidence of the Chippendale
influence in the Pennsylvania tradition.
Early 19th century.[P.C.]

1020 A *Schrank* from Waterloo County.
Of less imposing proportions than the
preceding one, this related example
includes the same details in a design of
similarly refined character. Early 19th
century.[P.C.]

1021 A *Schrank* from Waterloo County.
The same craftsman who made the
preceding pieces used pine and a
colourful painted treatment in this less
formal result. Early 19th century. [P.C.]

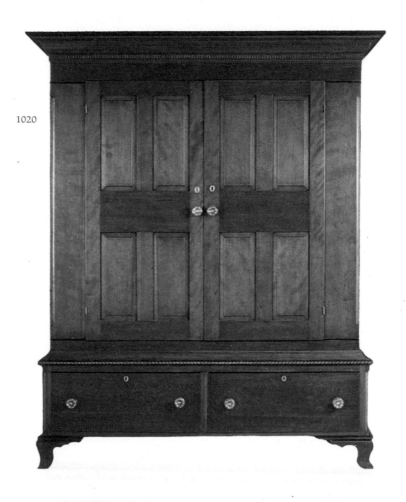

1020

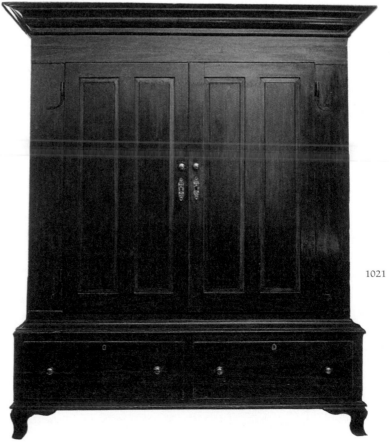

1021

1022 A *Schrank* from Welland County. This *Schrank* is finely crafted in walnut with carefully matched panels providing a subtle decorative emphasis in the two doors, which have inlaid escutcheons indicating a craftsman trained in that part of the Continental tradition which employed unpainted hardwoods. Some evidence of Neoclassical influence is seen in the design of the foot and in the proportions of the cornice and frieze. The hinges are the baluster type, which allow the door to be readily removed, a rare occurrence in Upper Canadian furnishings. Second quarter 19th century. [P.C.]

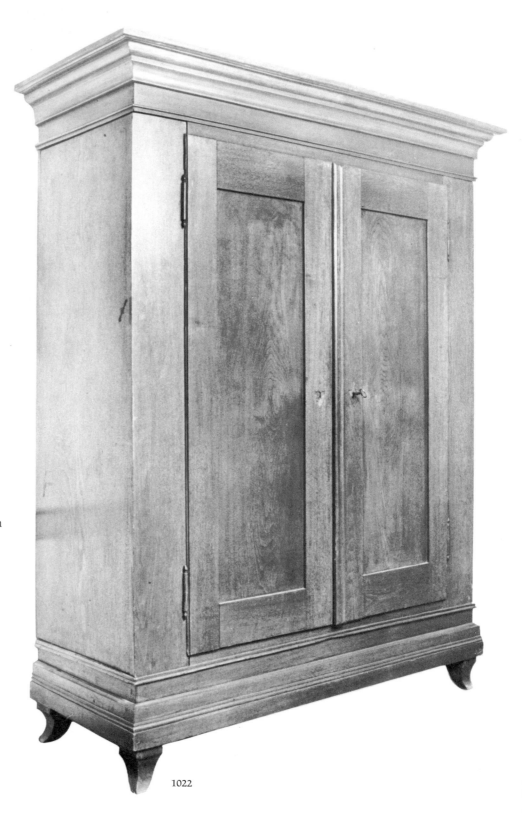

1022

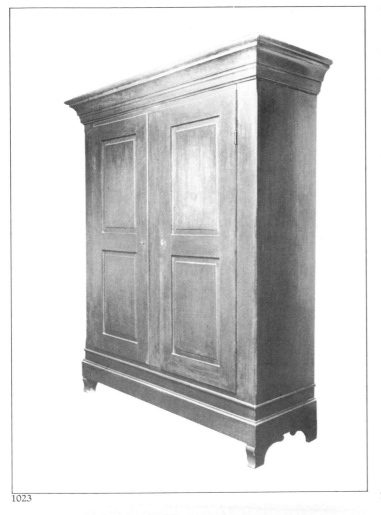

1023

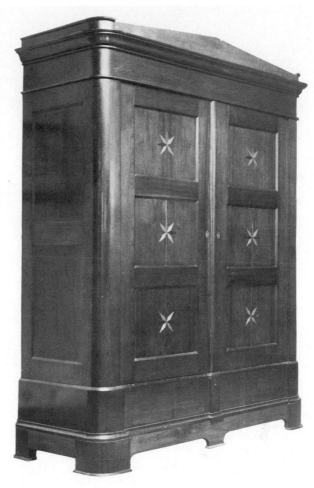

1024

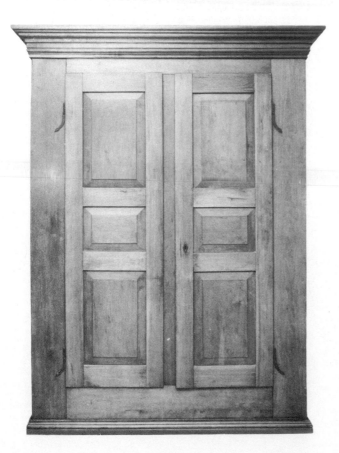

1025

1023 A *Schrank* from Fisherville in Haldimand County. This strong, simple design with two fielded panels in the doors and well-developed cornice is quite typical of *Schränke* made in southern Germany early in the 19th century. The foot reflects the universal Neoclassical influence. The original red paint is retained. Mid-19th century. [P.C.]

1024 A *Schrank* from Louth Township in Lincoln County. (Early family: Disher.) Attributed to G. Bender. This finely crafted cupboard illustrates the stylish Biedermeier influence which made its impact on the traditional German forms in the 19th century. The resulting impression created by this design is more formal than most Upper Canadian examples. The inlaid star motif is a recurring Germanic element. Mid-19th century. [P.C.]

1025 A *Schrank* from Waterloo County. The crisp simplicity of this design mirrors that of 19th century Swiss and German examples. The tradition includes regional preference for furnishings made in hardwoods, as well as the elaborately decorated softwood types. This cupboard is made of cherry which was originally stained. Second quarter 19th century. [P.C.]

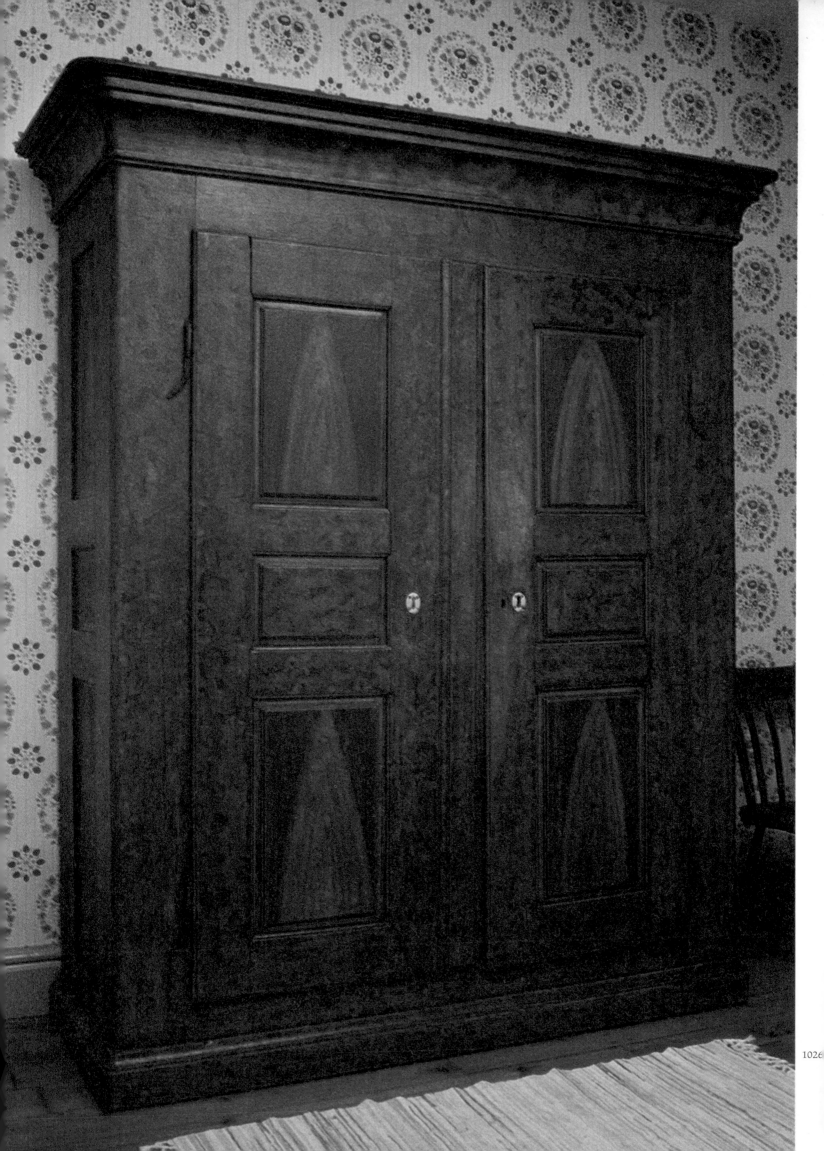

1026

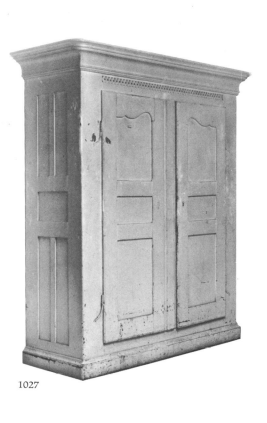

1027

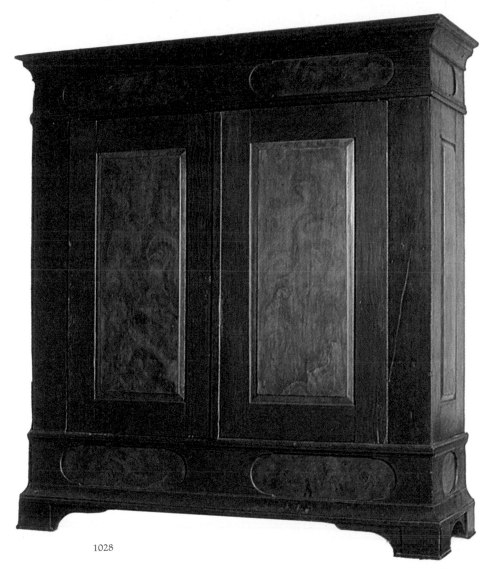

1028

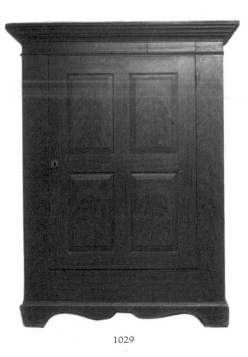

1029

1026 A *Schrank* from Waterloo or Perth County. The slightly rounded mass of this well-crafted *Schrank* was a popular style in southern Germany and Alsace in the early 19th century. There is a notable influence from the German Biedermeier style in the heavy moulded cornice. The impressionistic painted decoration is an excellent example of the combination of brush, sponge and smoke techniques which were an important part of the tradition. Second quarter 19th century. [P.C.]

1027 A *Schrank* from Waterloo County. This large *Schrank* includes a shaped panel in the doors in the Louis XV style. The decorative frieze panel is carved in the Classical ''line of eternity'' design. The original painted woodgrain finish is intact under the present overpaint and will be restored. Second quarter 19th century. [P.C.]

1028 A *Schrank* from Waterloo County. The massive scale and square proportions of this design are found in 18th century *Schränke* in Germany and are seen with large bun feet as well as the bracketed block type here. The shaped panels in the frieze and base are more typical of 19th century styles. The large panelled doors are suspended on wooden dowel hinges fitted to the upper and lower frame. Second quarter 19th century. [P.C.]

1029 A *Schrank* from New Hamburg in Waterloo County. An unusual example of the single-doored style. The painted decoration is exceptionally good, with leaf fronds in the four raised door panels. Mid-19th century. [P.C.]

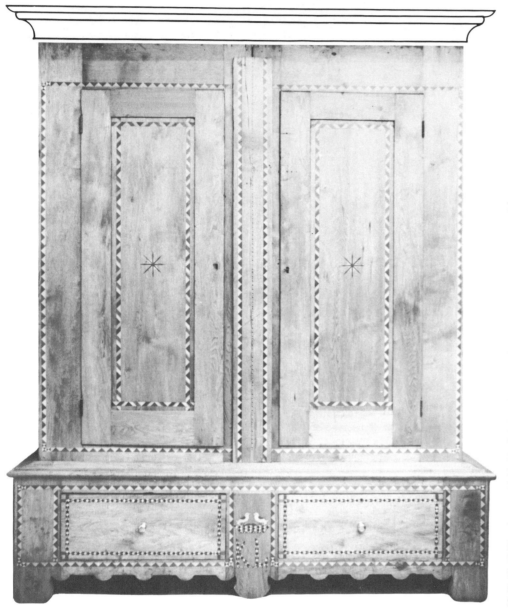

1030

1030 A *Schrank* from the Hanover area in Grey County. This elaborately inlaid design relates to that part of the Continental German tradition in which hardwoods were used with carved or inlaid decoration in place of the colourful painted techniques. The Upper Palatine and parts of northern Germany are particularly associated with this type of furniture. Here, variations on the chevron motif are used to create complex linear patterns, stars are centred in the door panels and two birds with nest and the initials K.L. appear between the drawers. The cornice unit which simply sat on the cupboard section is missing. Second half 19th century. [P.C.]

1031 A *Schrank* from St. Petersburg in Waterloo County. The cut-back corner seen on this wardrobe is a common characteristic of those made in the 19th century in Germany. Further evidence of that tradition is seen in the inclusion of the name – *Elizabeth Litwieler, Petersburg* – with decorative motifs on the frieze. The reeded mouldings flanking the panelled doors are also typical. Mid-19th century. [F.I.C.]

1032 A *Schrank* from the Stephensville area in Welland County. This *Schrank*, made of figured maple, illustrates a Neoclassical influence in traditional German style. The chevron device incorporated in the Classical pilasters is not uncommon in Germanic design. Second quarter 19th century. [P.C.]

1033 A *Schrank* from Wellesley in Waterloo County. The height, vertical proportions and shaped door panels in this design suggest an Alsatian prototype. The painted decoration includes a subtle fern motif in the door panels. Second quarter 19th century. [P.C.]

1034 A *Schrank* from Waterloo or Wellington County. The heavy, rounded door panel mouldings give this simple traditional form a distinctly North American character. The painted decoration is effective, but lacks the proficiency of earlier examples. Second half 19th century. [P.C.]

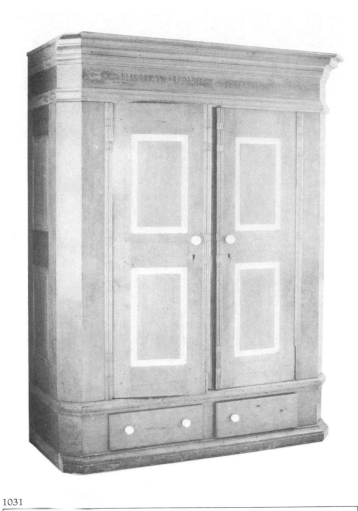

1031

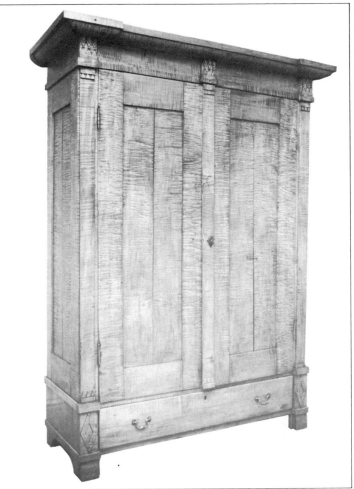

1032

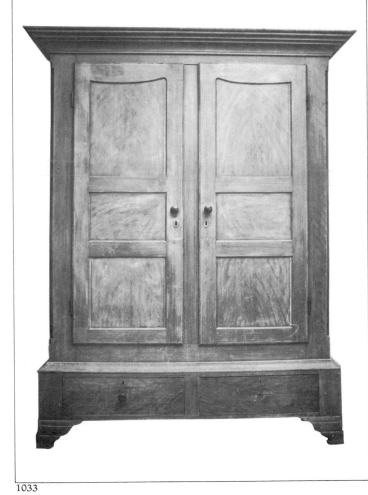

1033

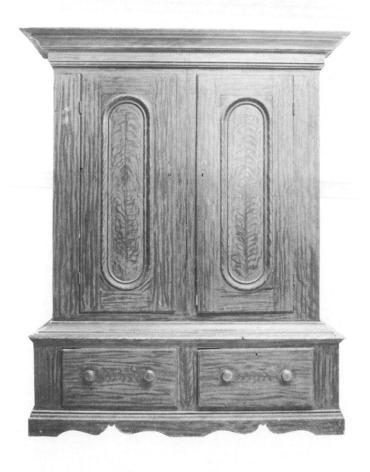

1034

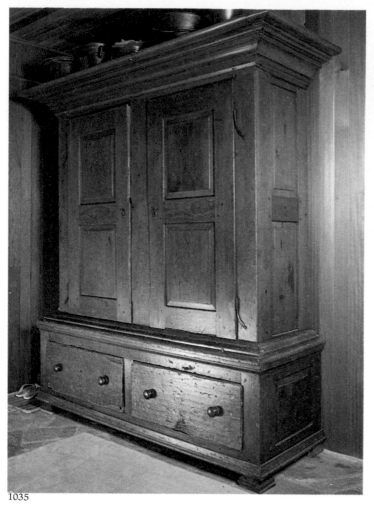

1035

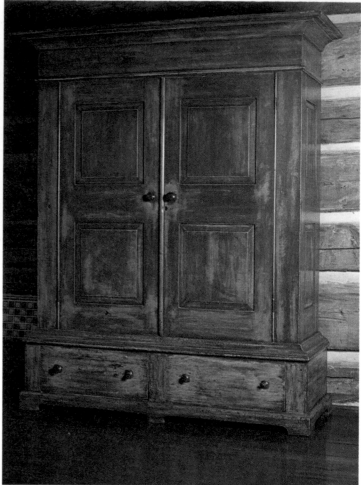

1036

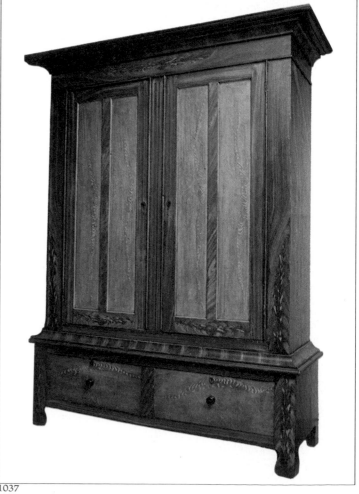

1037

1035 A *Schrank* from the western counties. This strong design has the massive, square proportions and heavy cornice and waist mouldings which suggest an 18th century German prototype. The section of drawers below the cupboard is a separate unit, as are the cornice and frieze. Mid-19th century. [P.C.]

1036 A *Schrank* from Waterloo County. Similar to the preceding example, this design incorporates a subtle Classical influence in its simple, wide frieze. The well-worn painted finish illustrates the practice of underpainting to provide depth and contrast to the final finish coats. Second quarter 19th century. [P.C.]

1037 A *Schrank* from the Tavistock area of Waterloo County. (Early home: Swartzendruber.) This quite common mid-century form is spectacular with its vigorous and inventive painted finish. Second half 19th century. [P.C.]

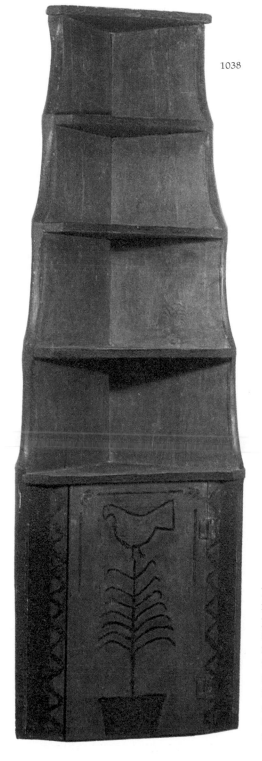

1038

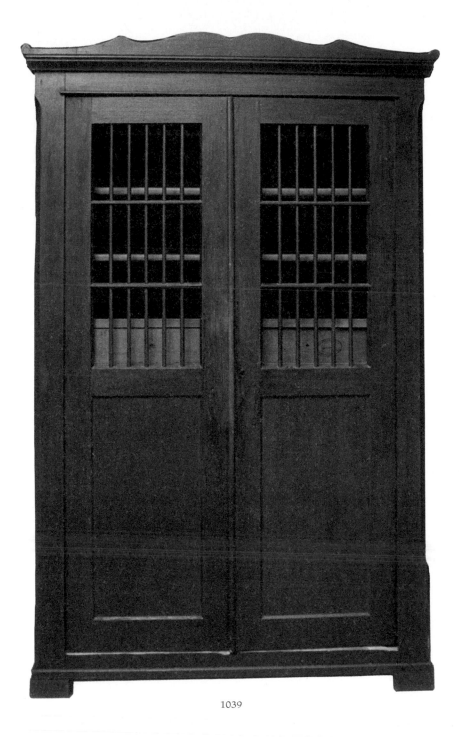

1039

1038 A corner dish dresser from Wellington County. This charming primitive piece is the only known example of this form in the Ontario Germanic communities. It relates to prototypes both on the Continent and in Pennsylvania. The naïve character of the painted decoration is consistent with the simple carpentry, suggesting the work of an unskilled layman with a clear memory of his tradition. Mid-19th century. [P.C.]

1039 A food locker or *Milchschrank* from Rankin in Renfrew County. A well-crafted example of the traditional form particularly common in northern Germany. The interior is fitted with drawers in addition to shelves and the doors are mounted on wooden dowel hinges similar to those on many clothes *Schränke*. The pediment shows traces of the popular country Baroque style. Third quarter 19th century. [P.C.]

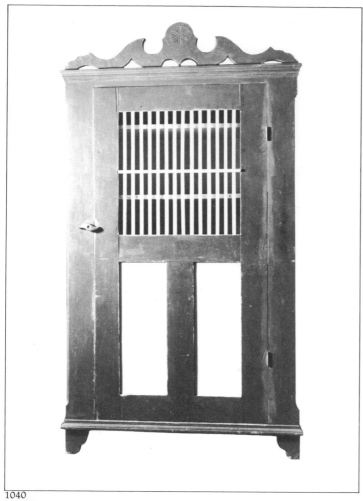

1040

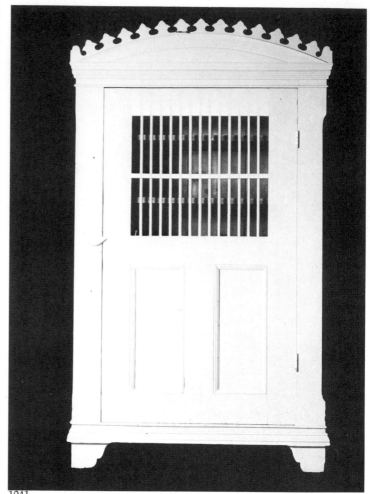

1041

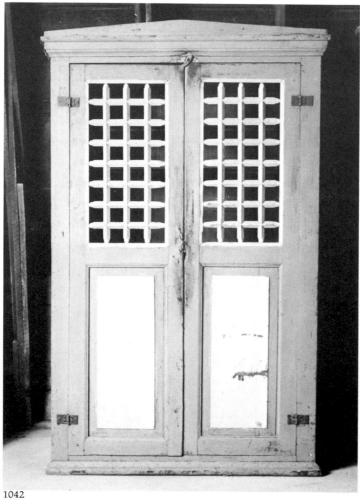

1042

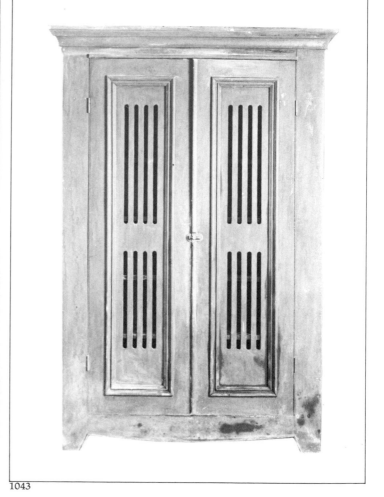

1043

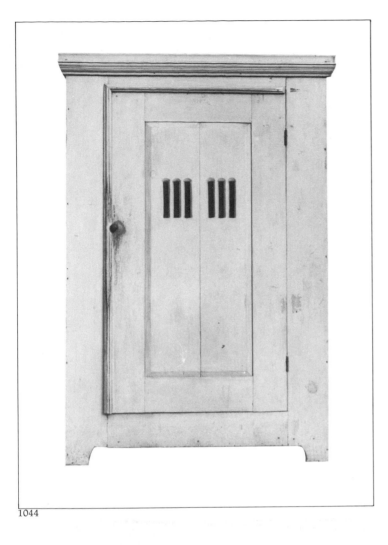

1044

1040 A food locker from Augsburg in Renfrew County. A simple traditional form with a naïve Baroque pediment, surface carved with the popular rosette motif. Second half 19th century. [C.F.C.S., M.O.M., N.M.O.C.]

1041 A food locker from Augsburg in Renfrew County. (Early family: Hoelke.) The decorative cornice on this simple form is an early replacement and its appropriate design illustrates the survival of the German tradition for many years. Second half 19th century. [P.C.]

1042 A food locker from Renfrew County. The intricate grill design is identical to an example in the Marburger Universitätsmuseum in Germany and comes originally from the Schwalm district and dates from the first half of the 19th century. Second half 19th century. [P.C.]

1043 A food locker from Renfrew County. The characteristic grill design is accomplished in this example by simple cut-outs in the door panel. The shaped base is notable. Second half 19th century. [P.C.]

1044 A food locker from Palmer Rapids in Renfrew County. An almost Gothic character is achieved by the sturdy simplicity and carved grill. Second half 19th century. [P.C.]

1045 A food safe from Haldimand County. Although this simple storage cupboard with decorative, punched, tin panels has long been owned by a Scottish family (Smith), the style is typically associated with Pennsylvania-Germans. Mid-19th century. [P.C.]

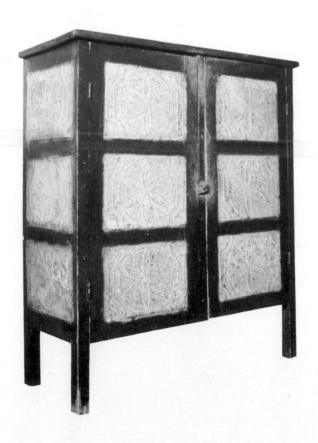

1045

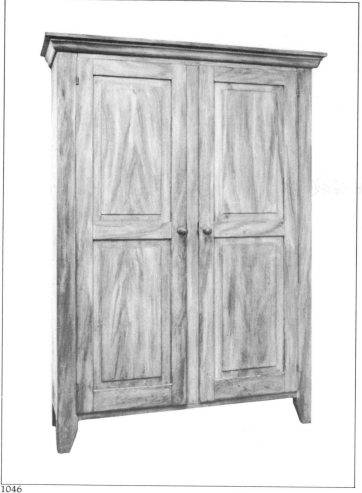

1046

1046a

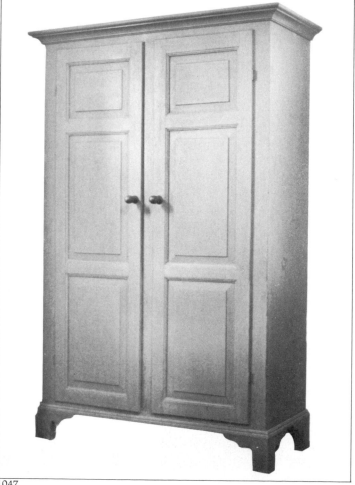

1047

1046 A storage cupboard from Lincoln County. Similar to the European food storage form, the ventilation grill is omitted from this Pennsylvania style. The nicely crafted, all-wood lock knobs are found on many Lincoln County pieces. Second quarter 19th century. [P.C.]

1047 A storage cupboard from the Niagara Peninsula. (Early family: Fretz.) This cupboard may have been made for the storage of linens or for kitchen use. The excellent condition of its original red paint would suggest the former. It is a fine example of utilitarian furniture from the Lincoln County community with characteristic moulding details, fielded and blown panels and bracket feet. Early 19th century. [P.C.]

1048 A pail cupboard from the Niagara Peninsula. This utilitarian form is found in the Niagara area and does not appear to have occurred elsewhere in the Germanic communities. Mid-19th century. [P.C.]

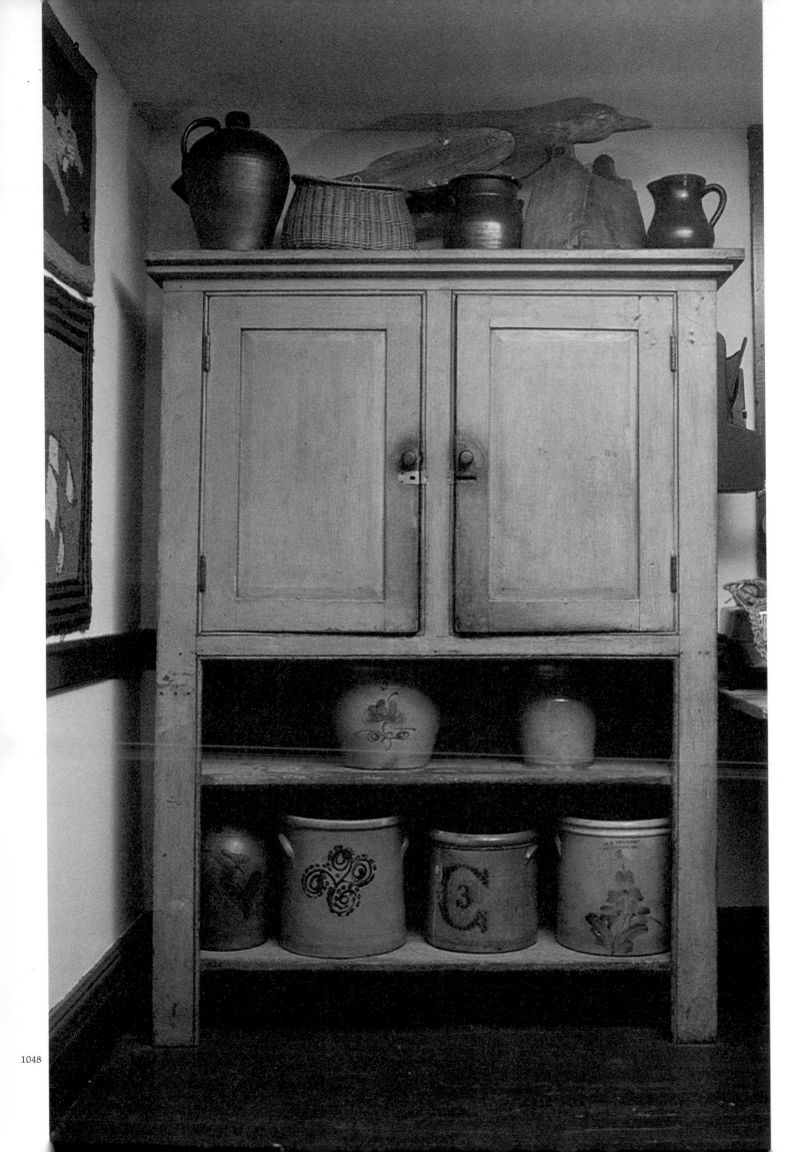

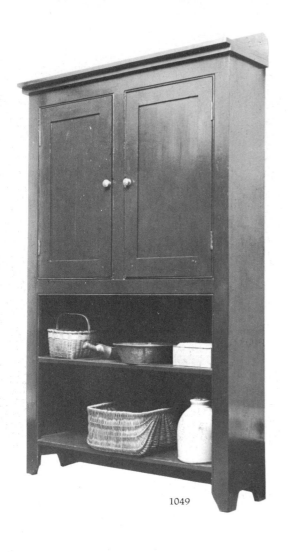

1049

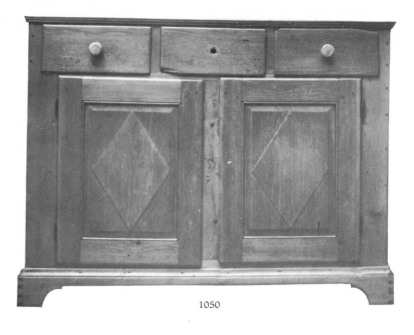

1050

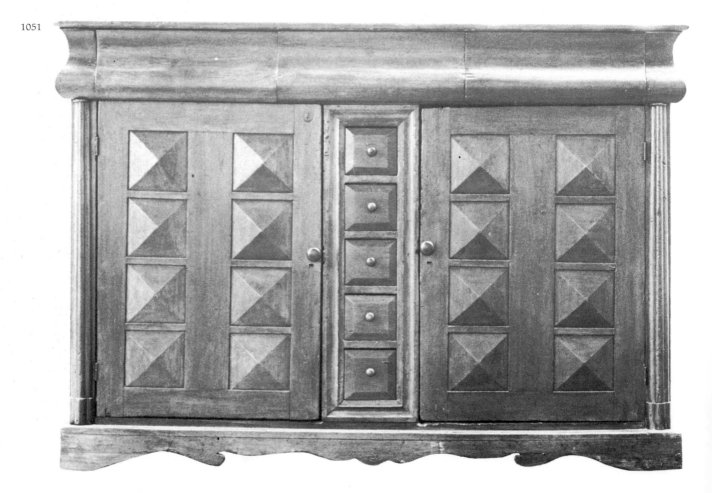

1051

1049 A pail cupboard from Louth Township in Lincoln County. The simple detail and construction suggest a later date for this example than for the previous one. Third quarter 19th century. [P.C.]

1050 A buffet from St. Jacobs in Waterloo County. This buffet form is prevalent in the Alsatian tradition, as is the raised diamond-shaped panel design. Second quarter 19th century. [P.C.]

1051 A buffet from Welland County. This unusual and highly decorative design is of German or Swiss origin and combines elements of 19th century style with those of 18th century tradition. The bold ogee moulding, including the upper drawers and fluted half column below, are typical Central European expressions of late Neoclassical taste. The richly panelled doors flanking a central row of small drawers are traditional in plan and execution. Mid-19th century.[P.C.]

1052 A storage cupboard from Vaughan Township. (Early family: Snider.) Of simple design and construction, the major feature of this small cupboard is the painted finish, which combines closely related shades of red and dark blue with a sponged texture on the door panel. Mid-19th century. [P.C.]

1053 A storage cupboard from Waterloo County. The small multi-drawered cupboard is another popular form of *Küchenschrank* in the Continental tradition. The shaped base and simple French foot are North American influences. Second quarter 19th century. [P.C.]

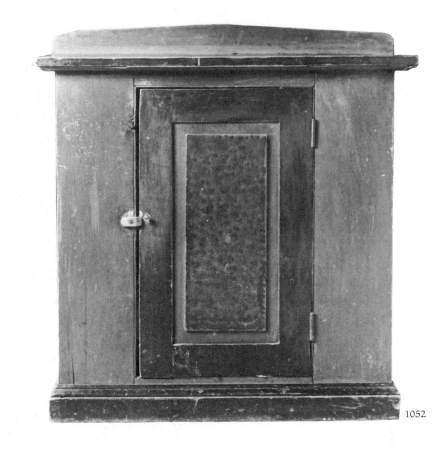

1052

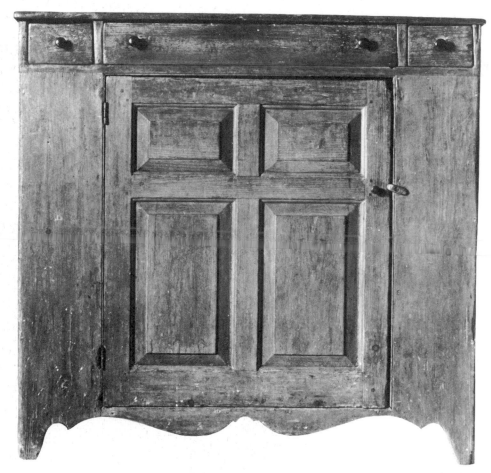

1053

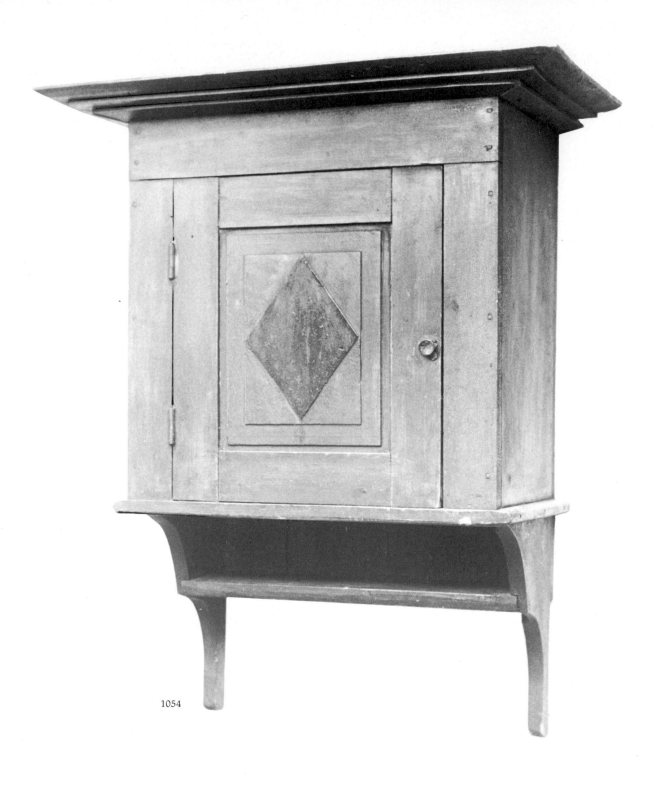

1054

1054 A hanging wall cupboard from Waterloo County. This example of the Germanic vernacular cupboard style has a raised lozenge panel on a rectangular field in the single framed door. The original paint includes three shades of green-blue in decorative contrast. Mid-19th century. [P.C.]

1055 A hanging corner cupboard from the Stevensville area in Welland County. An exceptional example of Continental German form and traditional wood-dowelled construction. Second quarter 19th century. [P.C.]

1056 A hanging wall cupboard from Selkirk in Haldimand County. (Early family: Schweyer.) This carefully crafted walnut cupboard was used for the storage of herbal medicines. The simple cornice and quarter column details relate to those of major case pieces in the Niagara community. Second quarter 19th century. [P.C.]

1057 A hanging corner cupboard from Wellesley in Waterloo County. (Early family: Erb.) The small hanging cupboard with a "fishtail"-shaped extension of the backboards is a Conti-

nental German form which was also popular in Pennsylvania. Second quarter 19th century. [P.C.]

1058 A hanging corner cupboard from Welland County. This strong design is a good example of the combination of Continental German and Anglo influences in the Pennsylvania vernacular. The form is reminiscent of Continental examples, as is the use of multiple panels in a vertical plan, while the quarter columns relate to the Chippendale influence. Second quarter 19th century. [P.C.]

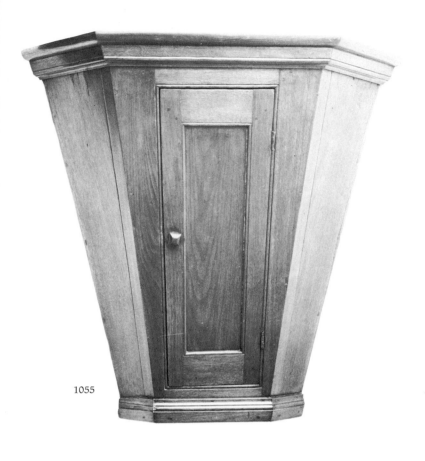

1055

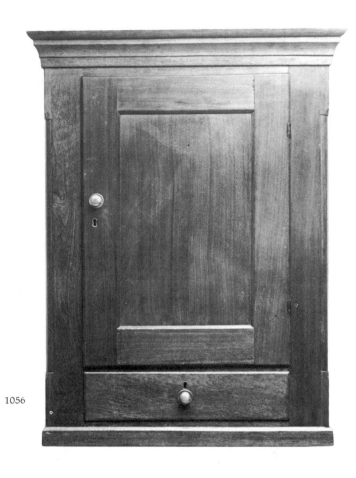

1056

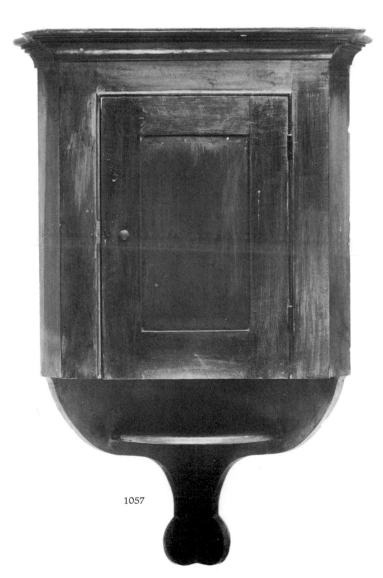

1057

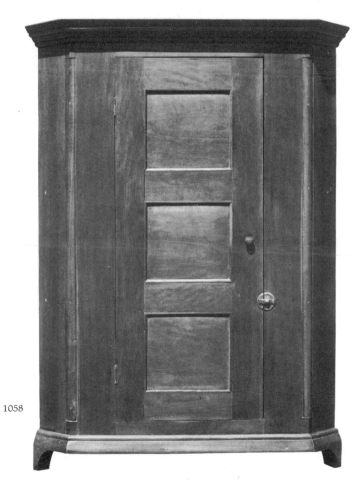

1058

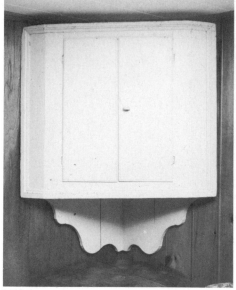

1059

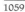

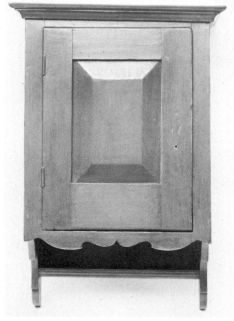

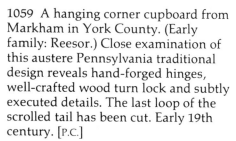

1061

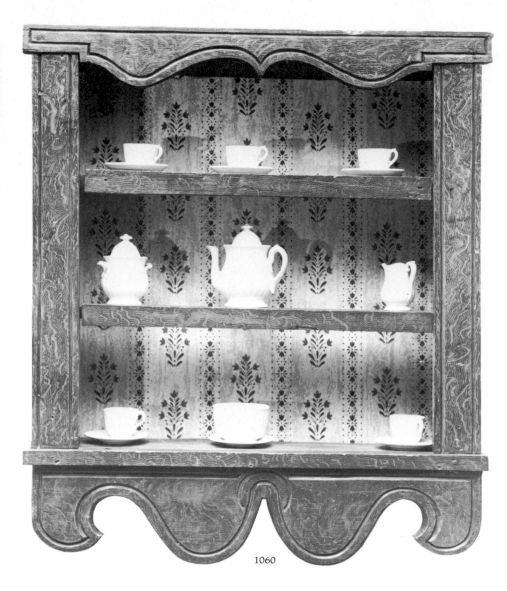

1060

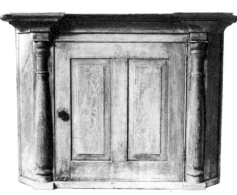

1062

1059 A hanging corner cupboard from Markham in York County. (Early family: Reesor.) Close examination of this austere Pennsylvania traditional design reveals hand-forged hinges, well-crafted wood turn lock and subtly executed details. The last loop of the scrolled tail has been cut. Early 19th century. [P.C.]

1060 A hanging wall shelf or *Tassenbord* from the Cayuga area in Haldimand County. An emphatic statement of traditional German decoration. The Baroque scrolls are enhanced by deeply cut incised detail. Second quarter 19th century. [P.C.]

1061 A hanging wall cupboard from Sebringville in Perth County. A pleasingly simple expression of a common Continental German form with the small shelf below. The door panel has been mistakenly reversed in restoration. Second quarter 19th century. [P.C.]

1062 A hanging corner cupboard from Waterloo County. Large hanging corner cupboards are common in the German and Alsatian tradition and the introduction of Neoclassical columns and cornice was widely practised there in the early 19th century. Mid-19th century. [P.C.]

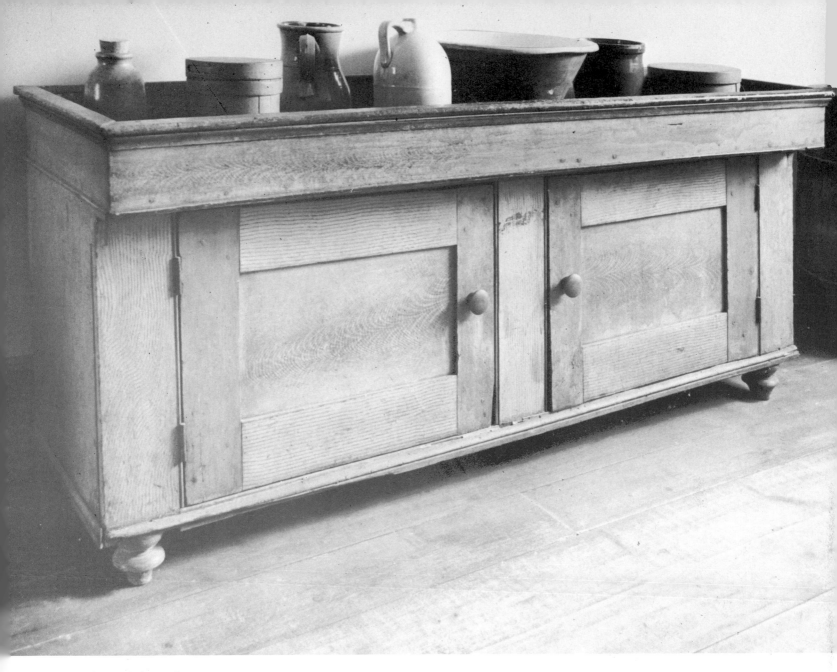

1063 A dry sink from the western counties. This exceptionally large piece has the set back design which is a functional improvement over the straight front. The turned foot was introduced into traditional designs in Pennsylvania early in the 19th century and this development occasionally was adopted in Upper Canada. Mid-19th century. [P.N.M.E.C.]

1064 A dry sink from the Jordan area in Lincoln County. (Early family: Wismer.) The distinctive character of Lincoln County craftsmanship is seen in the bracket foot, quarter columns and well-panelled, lapped doors. First half 19th century. [P.C.]

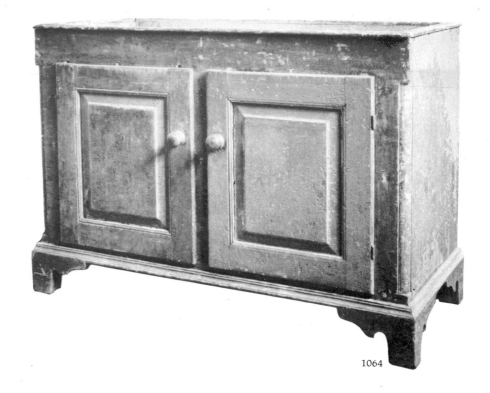

1064

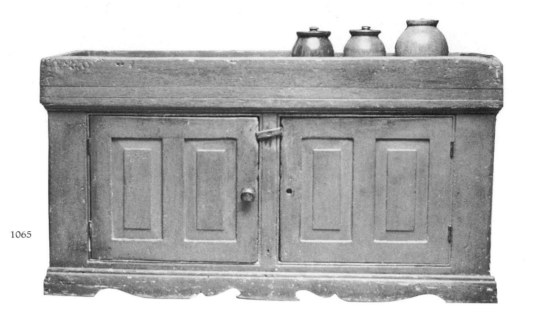

1065

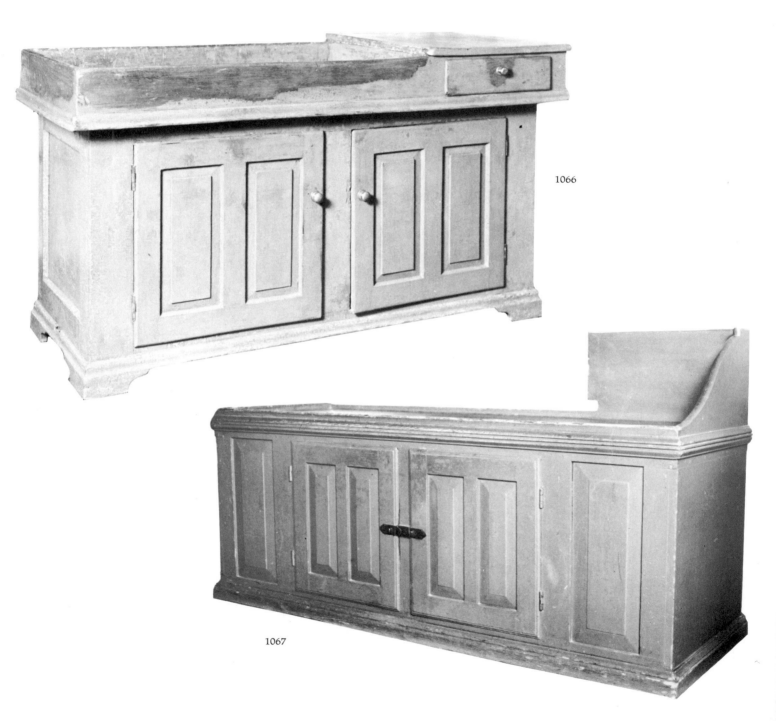

1066

1067

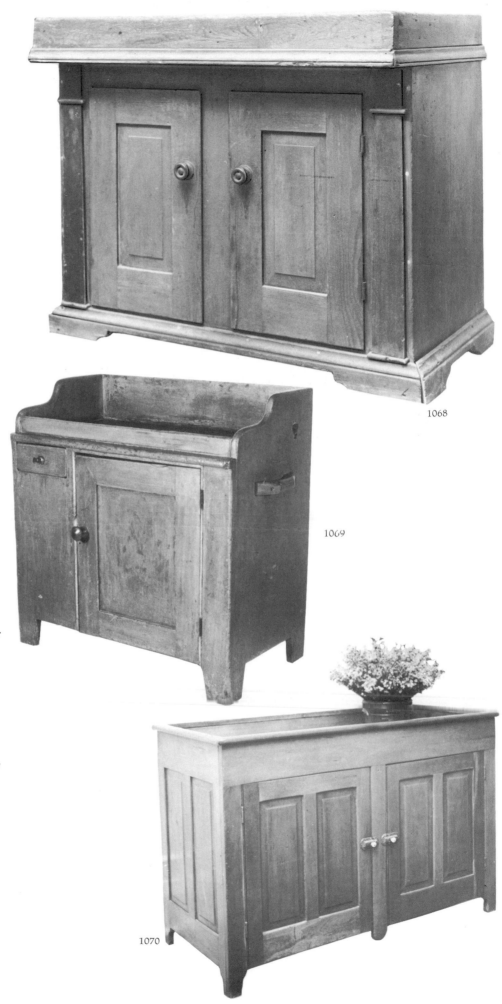

1065 A dry sink from the western counties. This large sink with blown panel door construction and nicely shaped bracket base is a good example of those found in Waterloo and neighbouring counties. Mid-19th century. [P.C.]

1066 A dry sink from Markham Township in York County. This is a good example of the most common Pennsylvania-German dry sink style. The overhung sink trough is fitted with a drawer to one side with a small counter above. This design includes panelled ends and a well-formed bracket base. Mid-19th century. [P.C.]

1067 A dry sink from Vaughan Township in York County. The style and techniques of the Pennsylvania tradition are combined with an intuitive sense of functional design in this dry sink, which was made to sit under a window by Jonathan Baker, Senior. Second quarter 19th century. [P.C.]

1068 A dry sink from Waterloo County. The flat pilaster and heavy bracket base add a Continental Germanic character to this typical form. On the pilasters, which are painted a green-blue, is a neatly lettered "1846" and several tiny *fleurs-de-lis*. 1846. [P.C.]

1069 A dry sink from Elmira in Waterloo County. This efficient vernacular design was probably used as a kitchen washstand with the shaped piece on the end holding a towel. The placement of the small drawer in the lower cupboard is a variation on the more common plan in which the drawer is above the counter to one side of the open well. Mid-19th century. [P.C.]

1070 A dry sink from Waterloo County. This well-panelled example is very typical of those used in Waterloo Mennonite homes throughout the 19th century. Probably made to match a glazed dish dresser, this sink is carefully made of cherry. Second half 19th century. [P.C.]

1068

1069

1070

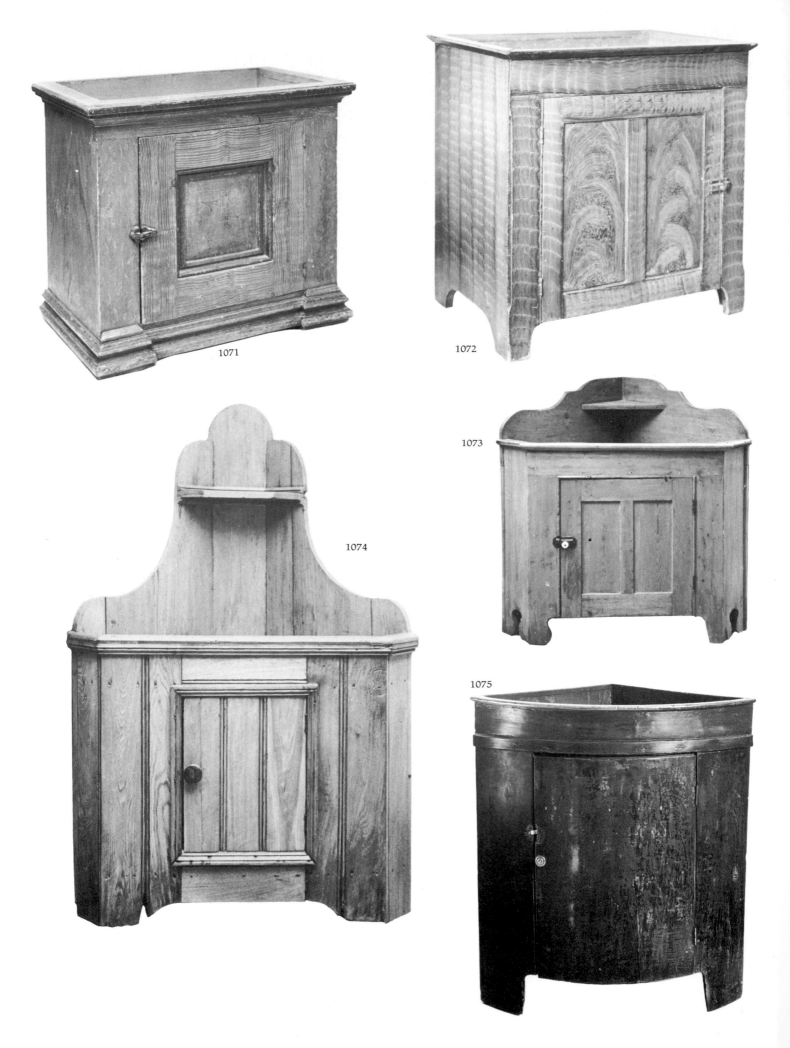

1071

1072

1073

1074

1075

1071 A dry sink from Waterloo County. A solidly Germanic design with a heavy moulded base similar to Continental cupboards and *Schränke*. Mid-19th century. [P.C.]

1072 A dry sink from Perth County. Similar in design to many late examples; the painted decoration here is particularly pleasing. Second half 19th century. [P.C.]

1073 A dry sink from Prince Edward County. It is unusual to find Pennsylvania-German forms such as this in the eastern counties. The shaped back, scalloped foot, construction and hardware are all typical of Waterloo and may indicate the transportation of this piece from there at an early date. Mid-19th century. [P.C.]

1074 A dry sink from Waterloo County. This corner dry sink is based on a corner buffet form with a shaped back which was widely used in the German and Alsatian traditions. Second half 19th century. [P.C.]

1075 A dry sink from Perth County. This unique bow-front design comes from an area of Alsatian settlement. Bow-front forms are common in Alsatian furniture of Louis XV and XVI influence. Second quarter 19th century. [P.C.]

1076 A dough box from Markham Township in York County. A number of these well-crafted boxes with turned legs and lapped drawers occur in this area. Mid-19th century. [P.C.]

1077 A dough box from the village of Germanicus in Renfrew County. (Early family: Raglan.) The shaped trestle clearly identifies this basic form with the Continental tradition. Second half 19th century. [C.F.C.S., M.O.M., N.M.O.C.]

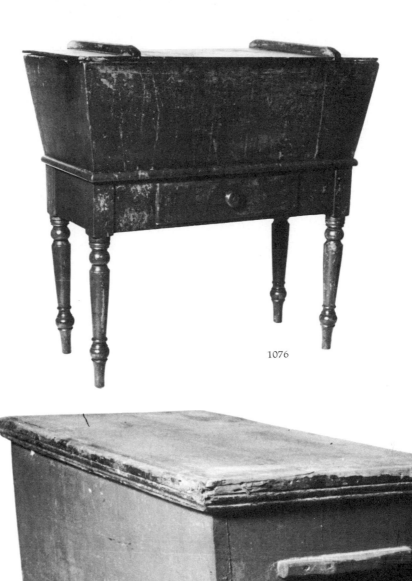

1076

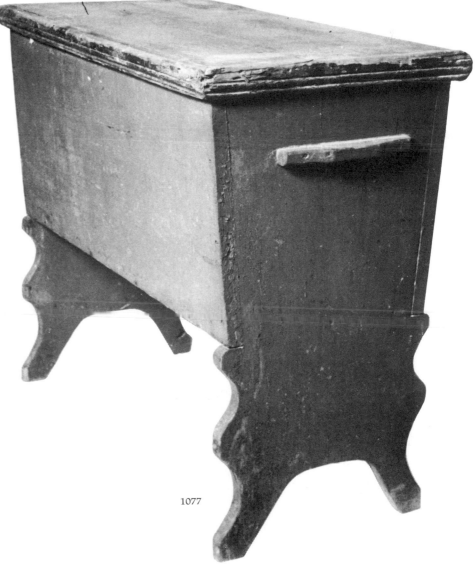

1077

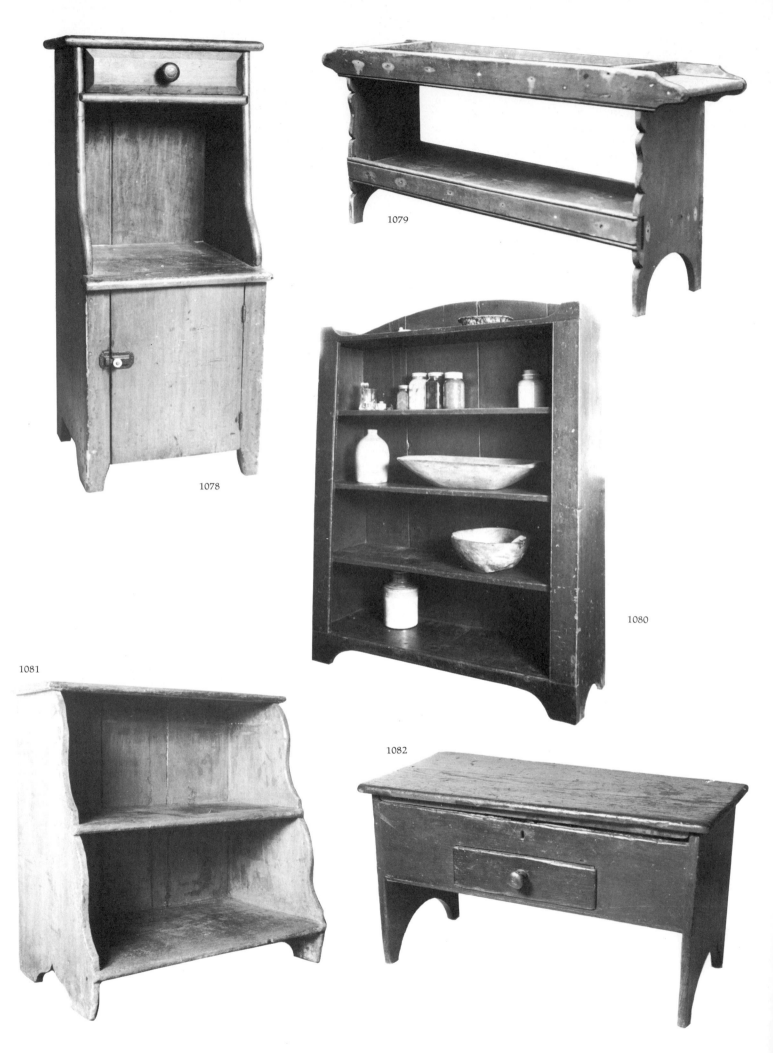

1078

1079

1080

1081

1082

1078 A pail cupboard from Waterloo County. An excellent example of functional design in the traditional idiom. Mid-19th century. [P.C.]

1079 A pail bench from Philipsburg in Waterloo County. (Early family: Ezra Wettlaufer.) A simple form with characteristic detail from the Continental German tradition. Second quarter 19th century. [P.C.]

1080 A pail cupboard from the Niagara Peninsula. This is a well-executed example of a popular form in the Niagara area. This design slopes back from base to top, providing shelves of different widths. Second quarter 19th century. [P.C.]

1081 A pail bench from Waterloo County. This is a good example of form and detail from the Continental tradition. Mid-19th century. [P.C.]

1082 A pail bench from Markham Township in York County. The top of this simple trestle-end bench lifts to a storage space and the deep apron is fitted with a drawer. A similar form is illustrated as a Continental prototype on page 313. First half 19th century. [P.C.]

1083 A pail bench from Renfrew County. A further example of functional design and sound joinery in the Continental tradition. Second half 19th century. [P.C.]

1084 A pail bench from Waterloo County. A pleasing design of Continental origin. Mid-19th century. [P.C.]

1085 A pail bench from Waterloo County. A simple variation on the traditional form. Mid-19th century. [P.C.]

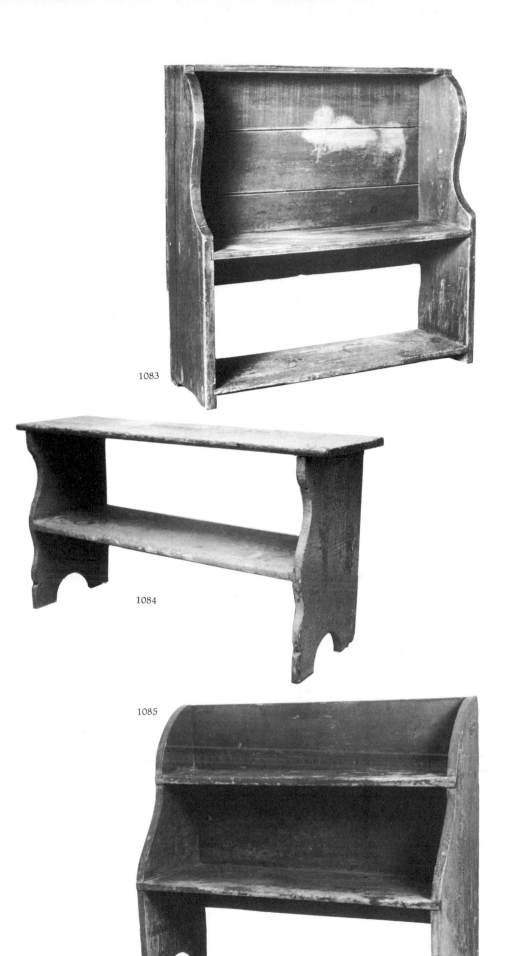

1083

1084

1085

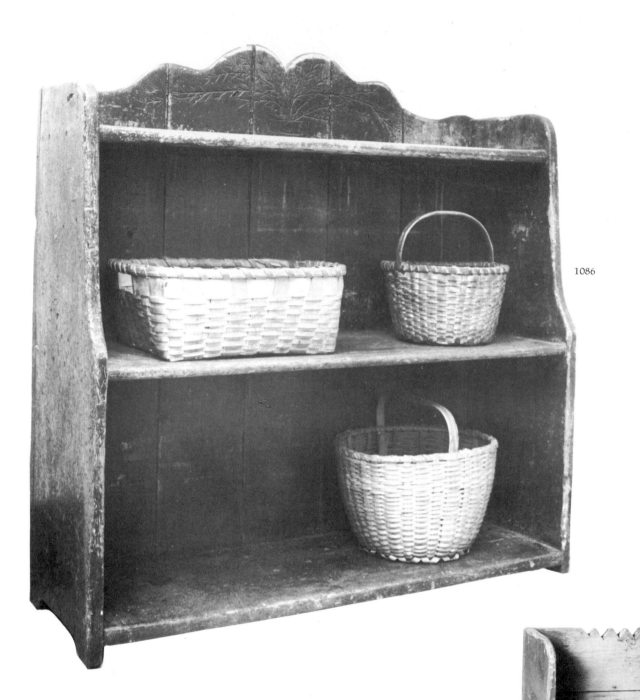

1086 A pail bench from Renfrew County. This simple design is elevated by the carving of a traditional floral motif in the backboard. Second half 19th century. [P.C.]

1087 A pail bench from Renfrew County. The German homeland tradition survived well into the 20th century, as illustrated by this simple structure made with wire nails. 20th century. [P.C.]

1086

1087

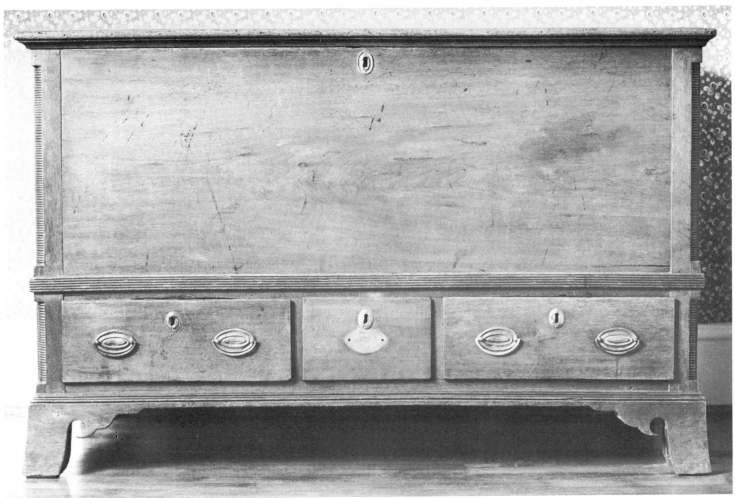

1088

1088 A three-drawer storage chest from Haldimand County. (Early family: Hoover.) This is an exceptionally fine Pennsylvania Chippendale design, including horizontal reeded quarter columns and bracket feet with a subtle flair. Early 19th century. [P.C.]

1089 A storage chest from the Niagara Peninsula. This strong vernacular design of Chippendale influence exhibits precise Germanic technique in its dovetailed box and feet and cleated top. Early 19th century. [P.C.]

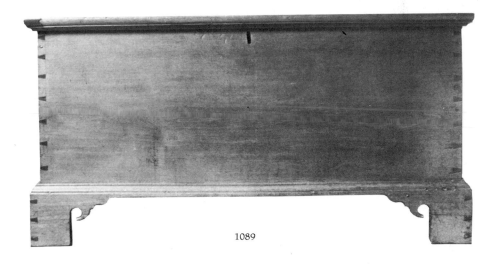

1089

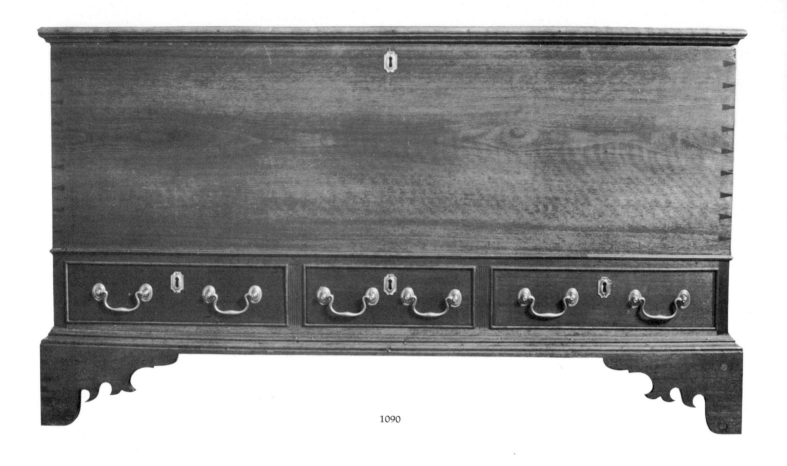

1090

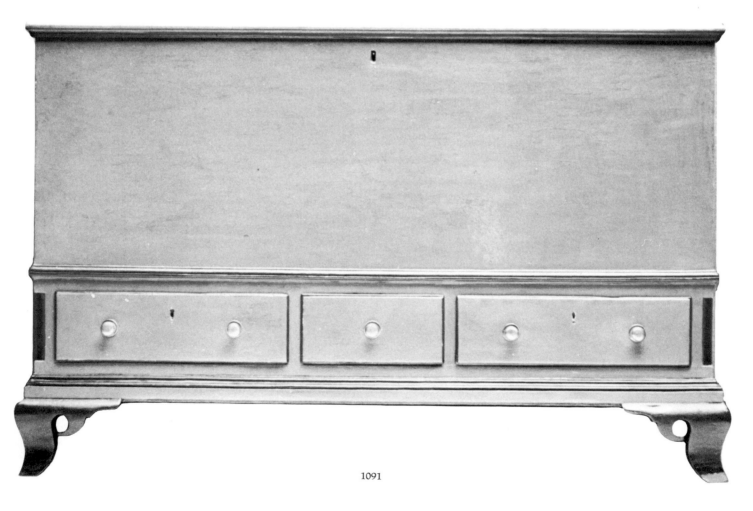

1091

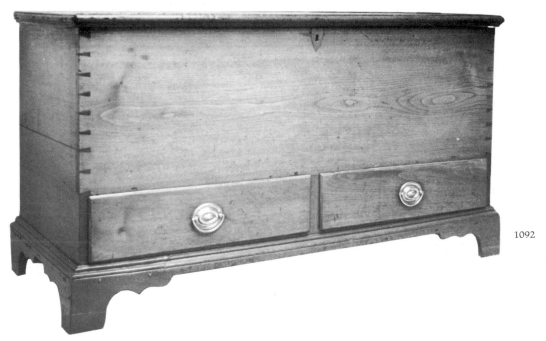

1092

1090 A three-drawer storage chest from the Niagara Peninsula. A striking example of the survival of 18th century Pennsylvania Chippendale style in Upper Canada. The well-delineated bracket foot, finely drawn mouldings and reeded inserts between the drawers are characteristic of the early products of the Niagara community. Early 19th century. [P.C.]

1091 A three-drawer storage chest from York County. Comparison of details and construction clearly establishes this as a product of Lincoln County and its occurrence in York illustrates the movement among the Germanic communities which was common throughout the years. The well-balanced and quite formal Chippendale survival design is made entirely of pine. Early 19th century. [P.C.]

1092 A two-drawer storage chest from Pelham Township in Welland County. (Early family: Gilmore.) This is a pleasing survival of 18th century style. The heart-shaped escutcheon is inlaid in cherry. Early 19th century. [P.C.]

1093 A two-drawer storage chest from Markham Township in York County. This traditional chest from a Mennonite home includes drawers of figured maple providing decorative contrast to the dark-stained pine. The well-shaped bracket foot is slightly convex. Second quarter 19th century. [P.C.]

1094 A three-drawer storage chest from Waterloo County. This large chest is a simple, well-proportioned survival of the early Pennsylvania style executed in pine and painted red. Second quarter 19th century. [P.C.]

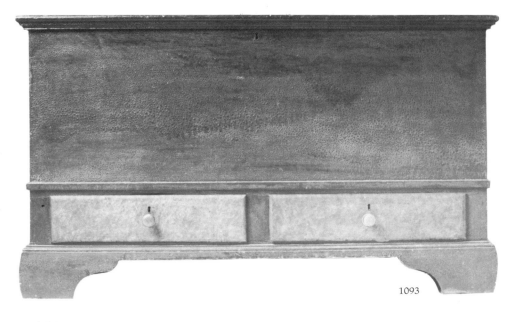

1093

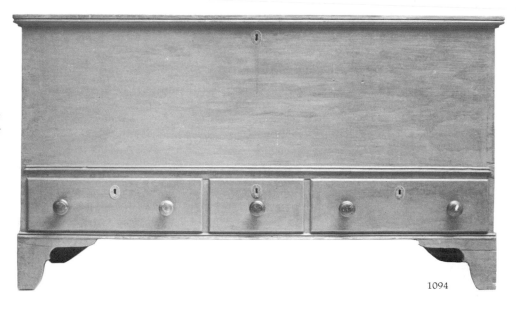

1094

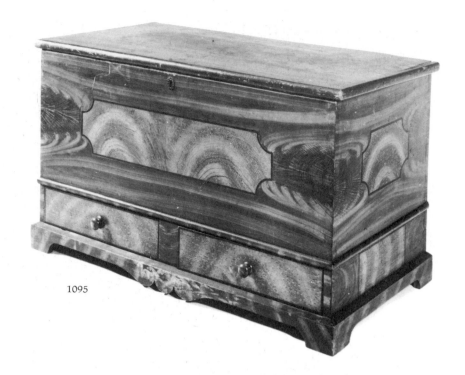

1095

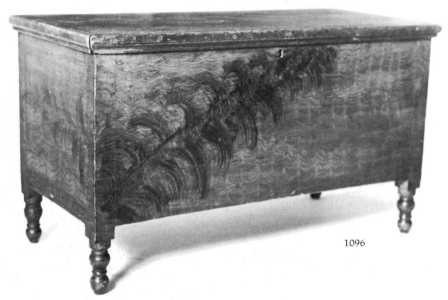

1096

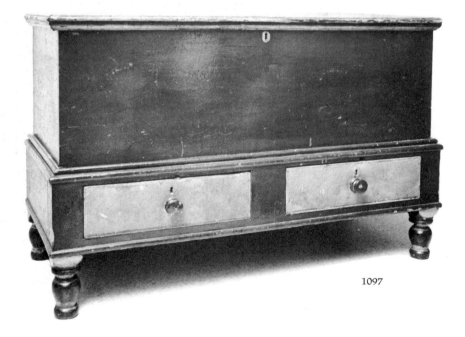

1097

1095 A two-drawer storage chest from Waterloo County. The simplified moulding details indicate a mid-century or later date for this chest which retains the popular traditional form. The proficient and elaborate painted decoration is the work of a skilled professional, who probably was primarily employed in decorating architectural woodwork. Mid-19th century. [C.D., R.O.M.]

1096 A storage chest from Welland County. Chests of post construction with turned feet following influences from the Sheraton style were made by some Germanic craftsmen in the Upper Canadian communities. This example is enhanced by emphatically designed painted decoration. Second quarter 19th century. [P.C.]

1097 A two-drawer storage chest from Waterloo County. The dovetailed chest with wider frame containing the drawers is seen in both Pennsylvania and Continental German examples. This design, with the turned legs of Empire-style influence, is unusual in Waterloo. Mid-19th century. [P.C.]

1098 A storage chest from Haldimand County. In form and colour, this example reflects the Continental German tradition most effectively. One wonders why the painter did not complete the impression of the traditional decorative panels by adding some simple motif. Second quarter 19th century. [P.C.]

1099 A storage chest from Wellington County. This is a rare example of a fully developed decorative motif from the Continental German tradition in which the potted bouquet is a popular recurring theme. Mid-19th century. [P.C.]

1100 A storage chest from Waterloo County. While of naïve character, this painted chest is an outstanding survival of the Continental German decorative tradition. The stencilled leaf motifs create the impression of the repeated panels seen on elaborately painted European examples, just as the abstract treatment of the end panels and the linear delineation of the scalloped bracket base are common elements of traditional chest decoration. Mid-19th century. [P.C.]

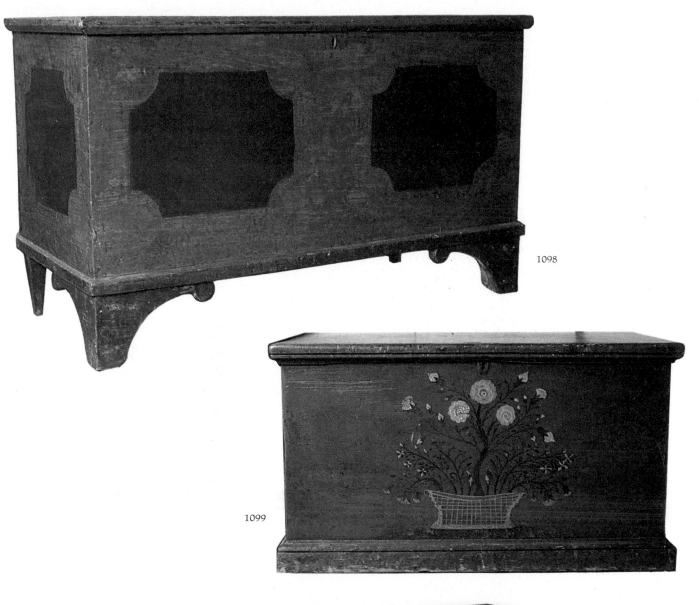

1098

1099

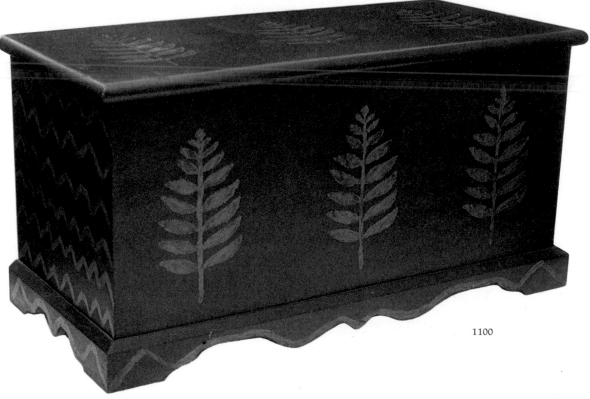

1100

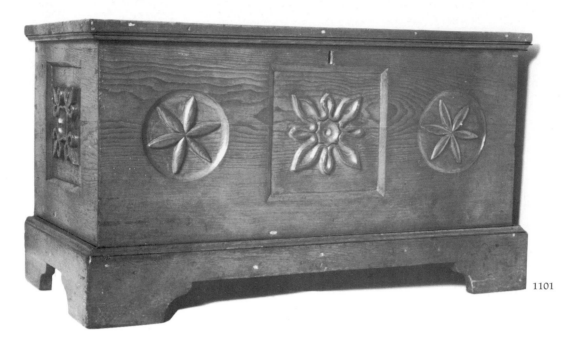

1101

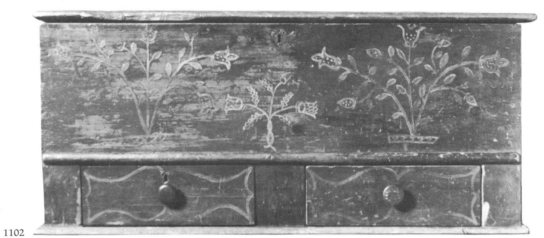

1102

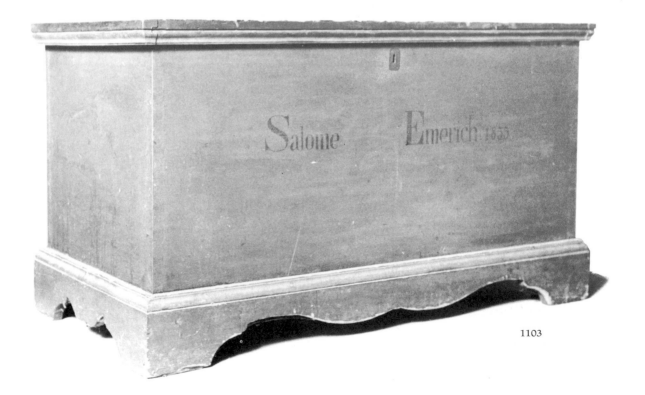

1103

1101 A storage chest from the western counties. This is an important example of the survival of that part of the Continental German tradition in which surface carving was used rather than painted decoration. The basic chest is a common form and the placement of panel and roundels completes the traditional concept. The motifs are soundly based in the decorative vernacular and well-articulated in deep relief. While the piece was found with several layers of paint in multi-coloured combinations, it appears that the original finish was a simple stain. Second quarter 19th century. [P.C.]

1102 A two-drawer storage chest from Puslinch Township in Wellington County. While the form of this box is typical of the Pennsylvania vernacular, the painted decoration relates to the Continental German tradition in motif and technique. The winged-heart escutcheon is noteworthy. Second quarter 19th century. [P.C.]

1103 A dower chest from Welland County. The careful inscription – *Salome Emerich 1855* – places this chest of otherwise simple design in the category of dower chest, as it was likely made in preparation for the marriage of a young lady. The complex, scalloped bracket base, inscription and cleated lid suggest a maker of Continental German origin. 1855. [P.C.]

1104 A storage chest from Waterloo County. This domed form is common in the Continental German tradition, although some examples have Pennsylvania associations as well. The simple, shaped bracket base on this chest suggests a maker of European origin. Mid-19th century. [P.C.]

1105 A storage chest from Welland County. Marked, *Stevensville, Upper Canada*. A distinctly Germanic interpretation of the Chippendale bracket foot. Second quarter 19th century. [P.C.]

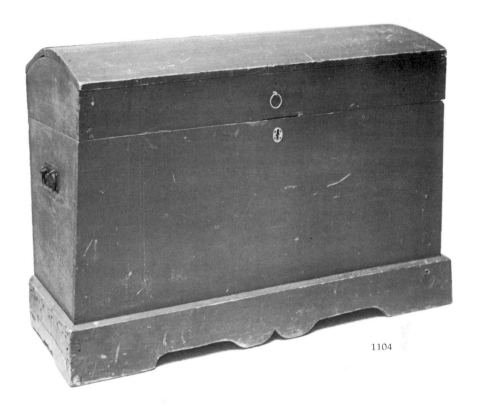

1104

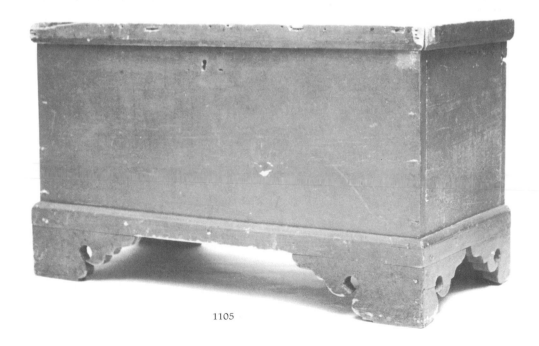

1105

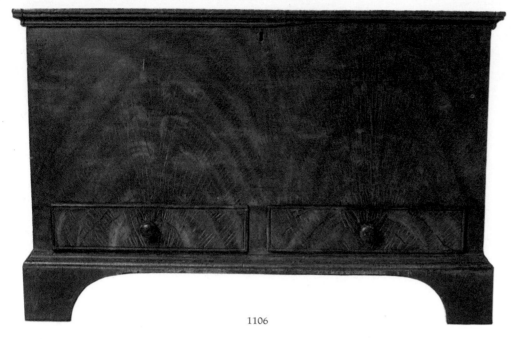

1106

1106 A two-drawer storage chest from Oxford County. This is another very typical Waterloo area chest. The subtly executed sunburst decoration is an overpaint, probably added sometime after the mid-century when wood graining was particularly popular. Second quarter 19th century. [P.C.]

1107 A two-drawer storage chest from Waterloo County. This is another example of the two-drawer chest as found in Mennonite homes in the Waterloo area. The boldly impressionistic painted decoration was home-done long after the original finish, illustrating the survival of traditional techniques. Mid-19th century. [P.C.]

1108 A two-drawer storage chest from Vaughan Township in York County. This Pennsylvania-German style occurs in each of the Upper Canadian Germanic communities. This example retains a boldly combed painted decoration. Second quarter 19th century. [P.C.]

1109 A storage chest from Markham Township in York County. This six-board chest style with a well-shaped bracket base was popular in the Markham community. The painted decoration is by the same hand as Plates 1153, 1154. Mid-19th century. [P.C.]

1110 A storage chest from York County. This design includes an influence from Neoclassical style in its graceful bracket base and has unusually graphic painted decoration. It sits in the room for which it was made with the chest in Plate 1151. Mid-19th century. [P.C.]

1111 A document or jewel chest from Markham Township in York County. This chest form is common in the Continental German tradition and may be decorated with carved, inlaid or painted motifs. The superb relief carving here includes hearts, birds, vines and floral elements. 19th century. [P.C.]

1112 A document or jewel chest from Lambton County. This is a strong Germanic chest form made of walnut with appropriate simple elements of the folk tradition inlaid in applewood. 19th century. [P.C.]

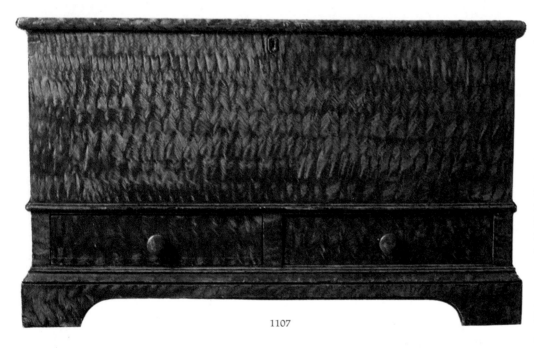

1107

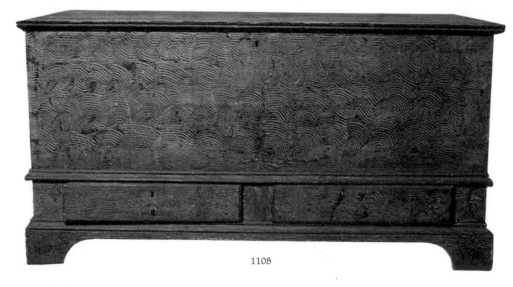

1108

1113 A document or jewel chest from Amherst Island in Lennox and Addington County. Little is known about this decorative object; however, it survives in an area where evidence of early Germanic settlement occasionally occurs, although there was little continuing traditional expression. The character of the individual elements as well as the geometric form of the decoration suggest a German hand. 19th century. [P.C.]

1114 A document chest from Markham Township in York County. This popular storage chest form in miniature includes carefully scaled, painted woodgrain decoration. Mid-19th century. [P.C.]

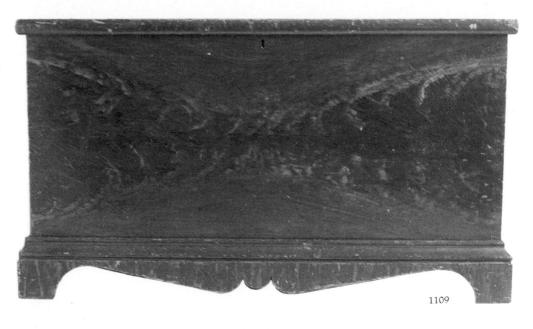

1109

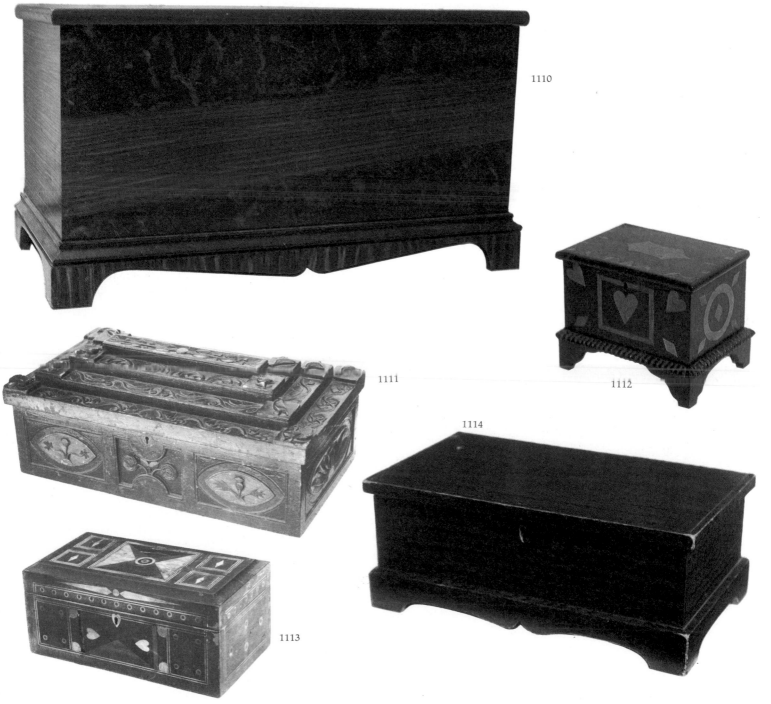

1110

1111

1112

1114

1113

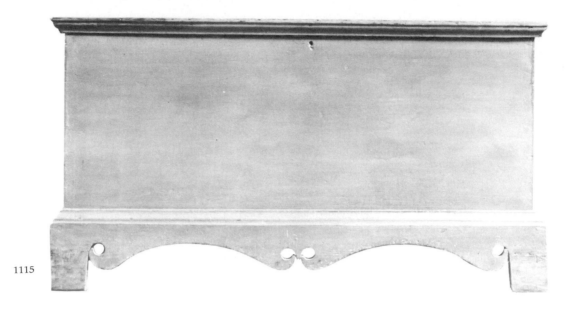

1115

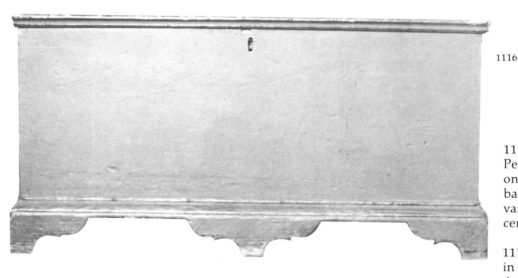

1116

1115 A storage chest from the Niagara Peninsula. This is a pleasing variation on the Chippendale-inspired bracket base widely employed by the Pennsylvania-Germans. Second quarter 19th century. [P.C.]

1116 A storage chest from Stevensville in Welland County. (Early family: Ort.) A well-considered variation on the traditional bracket base which is seen on 18th century Pennsylvania examples. Dated 1818. [P.C.]

1117 A small storage chest from Goodwood in Ontario County. This is a crisply executed example of rural Pennsylvania Chippendale style as it survived in Upper Canada. Second quarter 19th century. [P.C.]

1118 Hanging drawers from Vaughan Township in York County. Likely made by Jonathan Baker, Senior, this set of 19 lapped drawers of cherry with neatly turned wooden pulls and turnbuckles was made to fit an area of waste space in the 1840-period home. Second quarter 19th century. [P.C.]

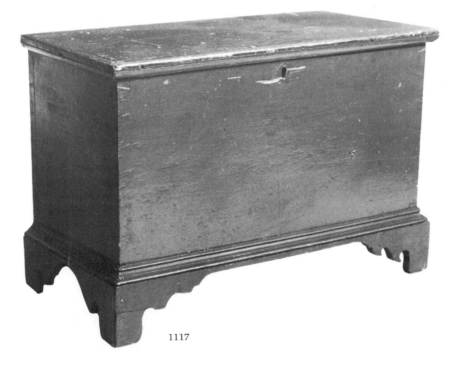

1117

1118

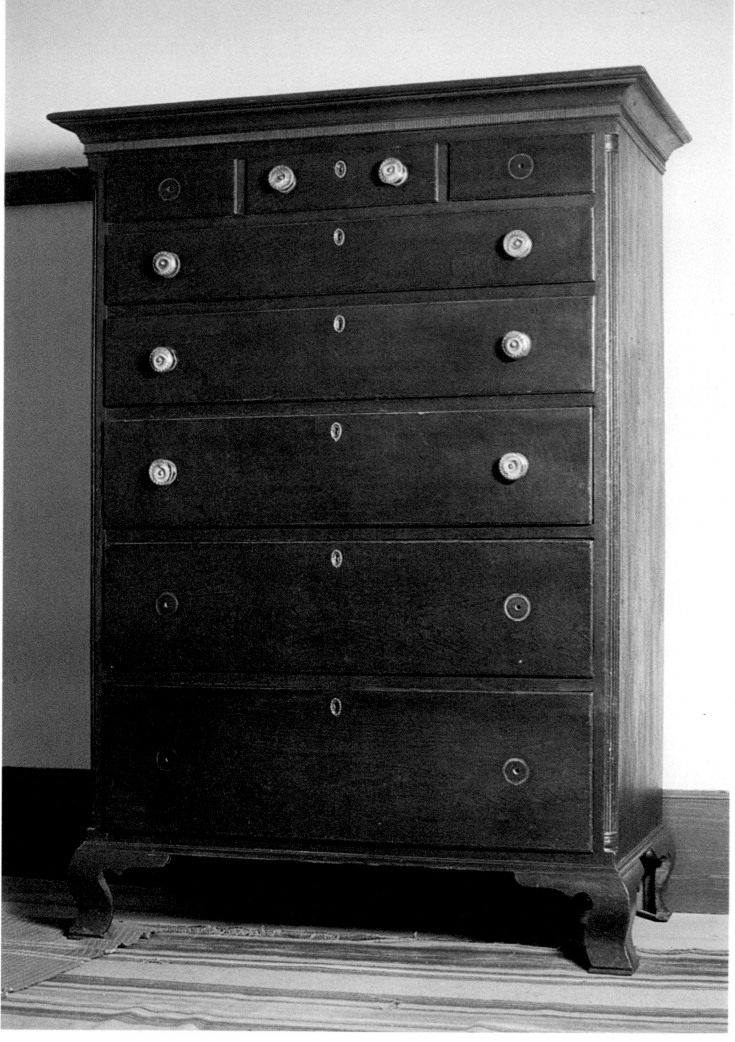

1119 A high chest of drawers from the Niagara Peninsula. This strong design is typical of provincial Pennsylvania style of the last decades of the 18th century in plan and detail. Distinctive features are the vigorous ogee bracket feet, reeded quarter columns with barrel shaped stops and the reeded frieze. Possible Pennsylvania origin. Late 18th or early 19th century. [P.C.]

1120 A chest of drawers from the Dunnville area in Haldimand County. A well-detailed variation on the Pennsylvania Chippendale style. The horizontal reeding of the top board occurs with some frequency in Niagara Peninsula chests, and the plain bracket foot, although widely used on blanket chests, was less popular on chests of drawers. Early 19th century. [P.C.]

1121 A chest of drawers from Selkirk in Haldimand County. (Early family: Rittenhouse.) This smaller chest includes almost identical details to the preceding example. Early 19th century. [P.C.]

1122 A chest of drawers from Haldimand County. (Early family: Schweyer.) This fine design relates favourably to the earlier prototypes in its proportions and details which include reeding on the cornice, frieze and quarter columns. Each of the elements is sensitively scaled to the others, creating an unusually pleasing result. Early 19th century. [P.C.]

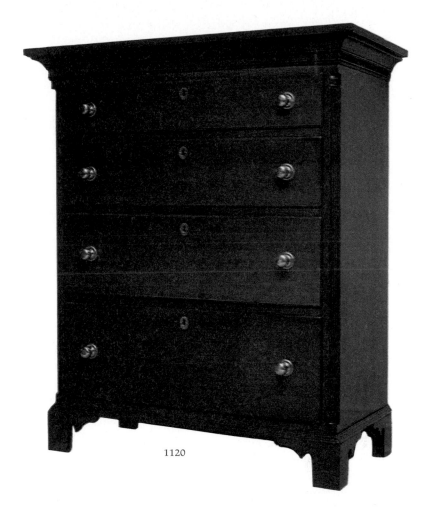
1120

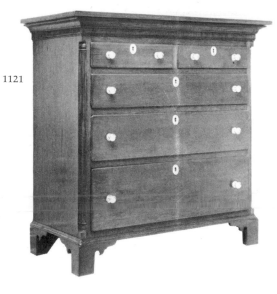
1121

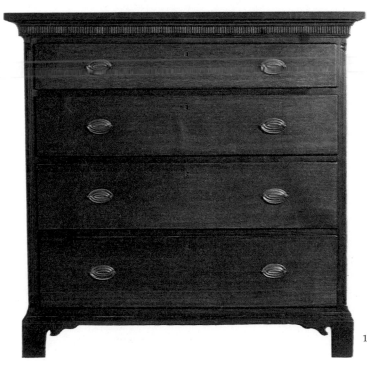
1122

1123 A chest of drawers from Clinton Township in Lincoln County. A fine example of the Chippendale survival style with the multiplicity of drawers echoing 18th century designs, while the ebonized quarter columns and mouldings are much simplified. The dressing slide on this example was also used as a writing surface. First half 19th century. [P.C.]

1124 A chest of drawers from the Niagara Peninsula. This example includes several similarities in detail to the preceding piece. The flush-fitted drawers with mouldings seen here are not often found on furniture made in the Germanic communities in the Niagara area. First half 19th century. [P.C.]

1125 A chest of drawers from Selkirk in Haldimand County. This simple, well-balanced example of the Chippendale style as it survived in Lincoln County retains its ebonized quarter columns and mouldings and the pressed glass pulls which were widely used in that craft community. Second quarter 19th century. [P.C.]

1126 A chest of drawers from Lincoln County. (Early family: Grobb.) Signed, *John Grobb, Nov. 2nd, 1846* – a known cabinetmaker. This is an important, documented example which provides a reference base for many related pieces. The addition of backboard and spindled gallery illustrates the influence of the American Empire style superimposed on the simple Chippendale survival. 1846. [P.C.]

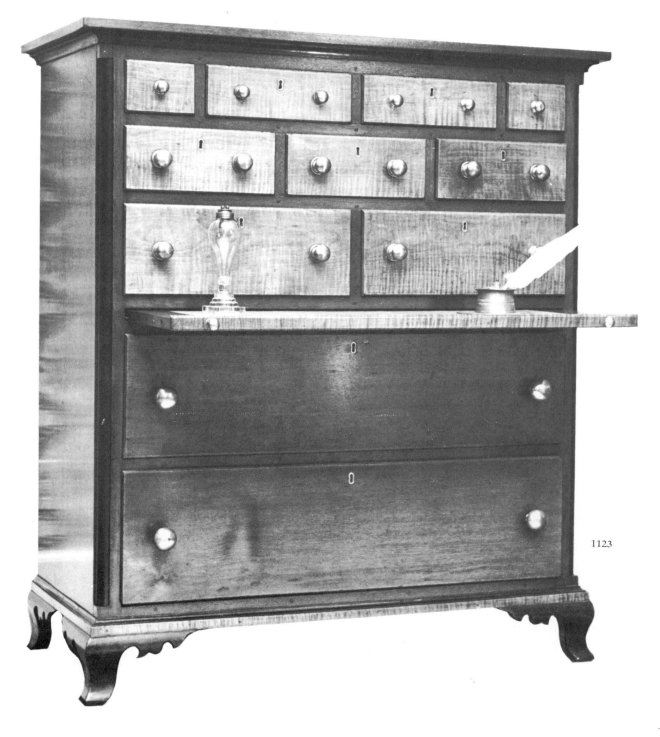

1123

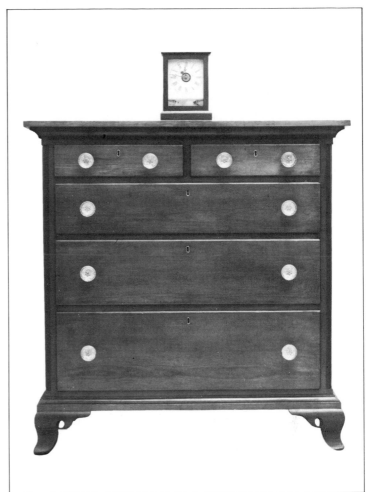

1124

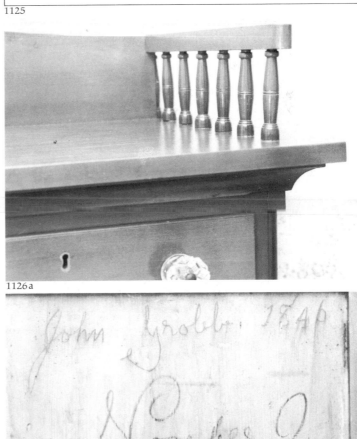

1125

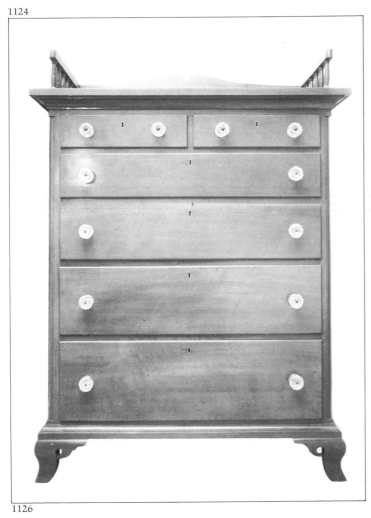

1126

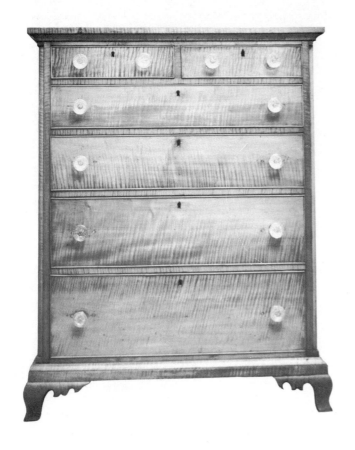

1126a

1126b

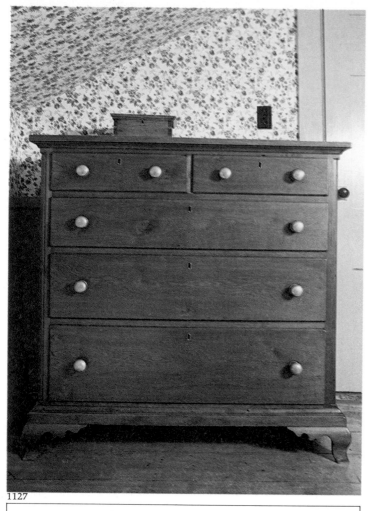

1127

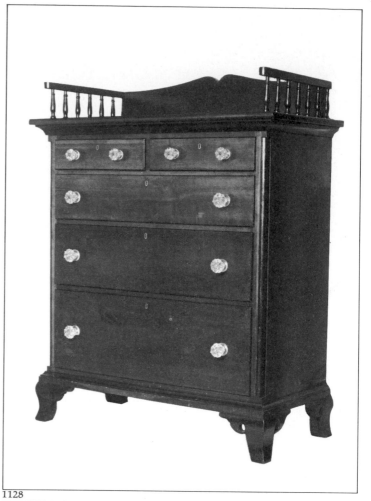

1128

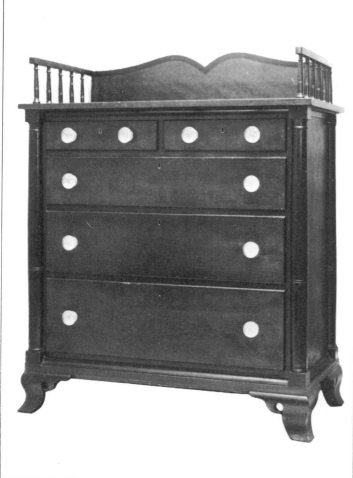

1129

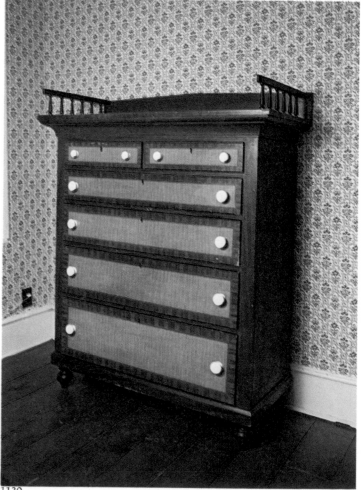

1130

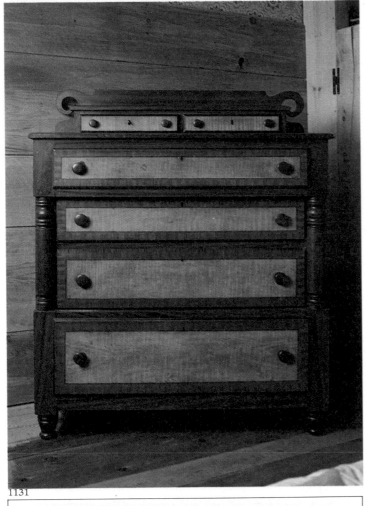

1131

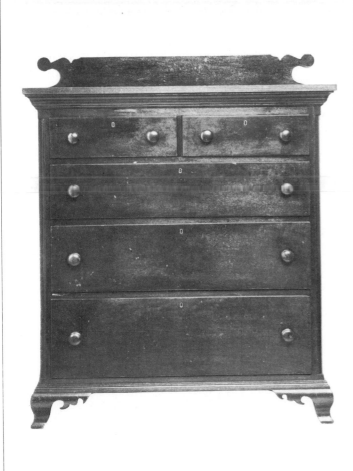

1132

1127 A chest of drawers from Waterloo County. (Early family: Sherk.) This chest was undoubtedly made in Lincoln County, possibly by the maker of the two preceding examples, and taken to Waterloo through one of the many family connections between the Germanic communities. First half 19th century. [P.C.]

1128 A chest of drawers from Jordan in Lincoln County. (Early family: Honsberger.) Signed, *Albert Lane – Gainsborough 20 Mile Creek – Made Feb. 29th, 1844 –* leap year. The similarities between this and Plate 1126 indicate that known Lincoln County craftsmen worked together and produced similar designs, possibly as master and apprentice. In 1849, Lane signed a dish dresser, *Albert Lane – Gainsborough Shop* (see Plate 956). 1844. [P.C.]

1129 A chest of drawers from Lincoln County. The simply turned columns at each corner with spindled gallery and backboard add a strong Neoclassical character to this typical Lincoln County chest form. Second quarter 19th century. [P.C.]

1130 A chest of drawers from Lincoln County. Signed, *Israel Moyer*; known as a painter. This example is exceptional in this group of furnishings for its finely executed painted finish and simplified style. The turned feet are restored. Mid-19th century. [P.C.]

1131 A chest of drawers from Lincoln County. This design is a dramatic break from the Lincoln County tradition with the introduction of American Empire influences which all but replaced the typical character. The tradition survives only in the simple arrangement of lapped drawers. The fine painted decoration is attributed to I. Moyer: see preceding plate. Mid-19th century. [P.C.]

1132 A chest of drawers from the Niagara Peninsula. The almost whimsical quality of the backboard is a surprising break from the sober consistency of the Chippendale idiom. Mid-19th century. [P.C.]

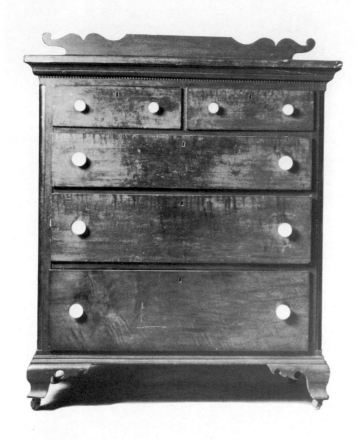

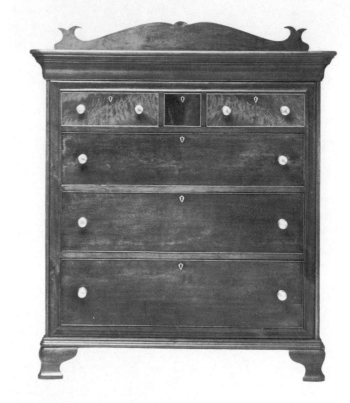

1133

1133 A chest of drawers from Jordan in Lincoln County. The single strip of pressed moulding on the frieze rail indicates the maker's cautious interest in the capabilities of contemporary machines and the inevitable decline of a tradition which had survived for almost a century in Canada. Third quarter 19th century. [P.C.]

1134 A chest of drawers from Haldimand County. (Early family: Klein.) This finely crafted chest combines a Victorian quality in the heaviness and roundness of the details with a clearly visible influence from the Pennsylvania vernacular. The eccentric backboard design with horn-like ends and central fan motif is unique. Mid-19th century. [P.C.]

1135 A chest of drawers from Welland County. While the style here is a restrained expression of American Empire influences, the unusual character of the turned columns and the scrolled feet suggests a Continental German maker for this and several related pieces in this area. Second quarter 19th century. [P.C.]

1134

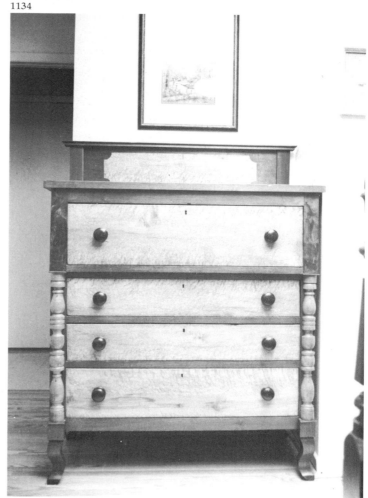

1135

1136 A high chest of drawers from Waterloo County. This provincial, Hepplewhite-inspired style with the flared French foot was widely adopted in the United States in the late 18th and early 19th centuries. The lapped drawer construction here suggests a maker from the Pennsylvania tradition, or the chest may well have been brought from there by an early immigrant. Early 19th century. [C.D., R.O.M.]

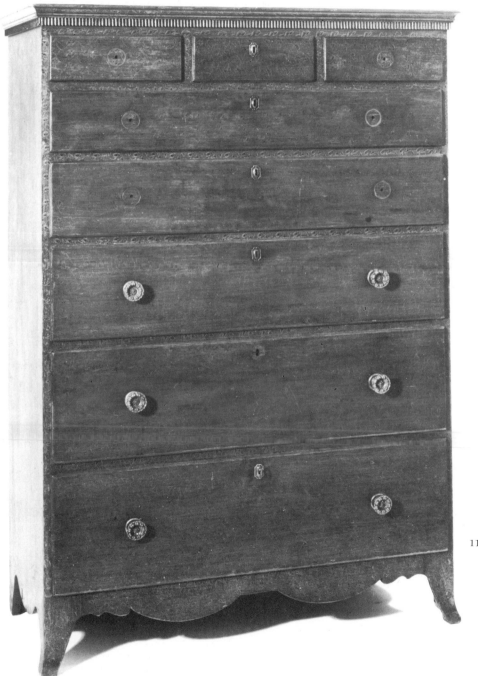

1136

1137 A chest-on-chest from Waterloo County. (Early family: Steckley.) This fine example of provincial German craftsmanship incorporates influences from the Sheraton and Hepplewhite Neoclassical styles which became the popular Federal style in the United States. The slim turned legs, shaped skirt, Neoclassical cornice, cock-beaded, flush-fitted drawers and inlaid decoration are typical details. This is one of several related pieces made in Waterloo County. (See S. K. Johannson, "Waterloo County Furniture Master," *Canadian Collector*, July/Aug. 1977.) Early 19th century. [P.C.]

1138 A chest of drawers from Waterloo County. This simple and typical Neoclassical form is enhanced by rather stylized elements of Classical decoration inlaid in contrasting woods. Second quarter 19th century. [P.C.]

1138

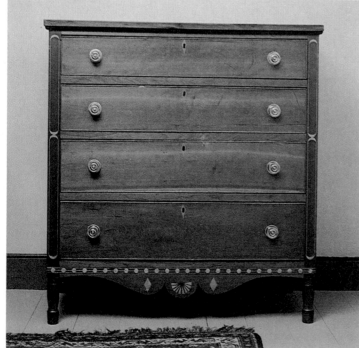

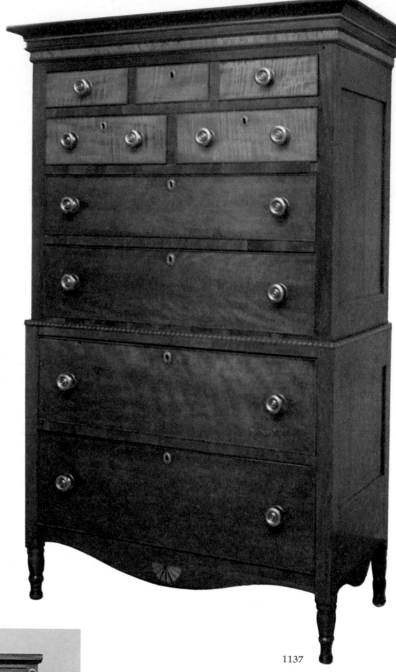

1137

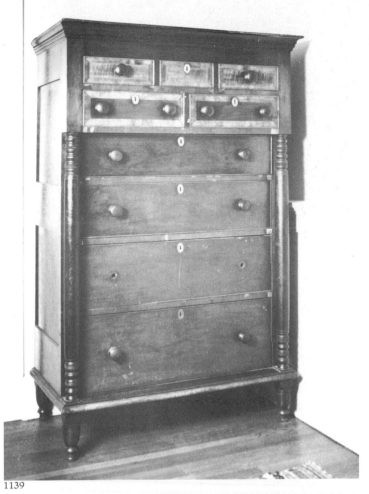

1139

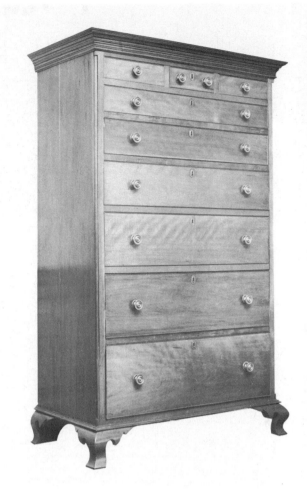

1140

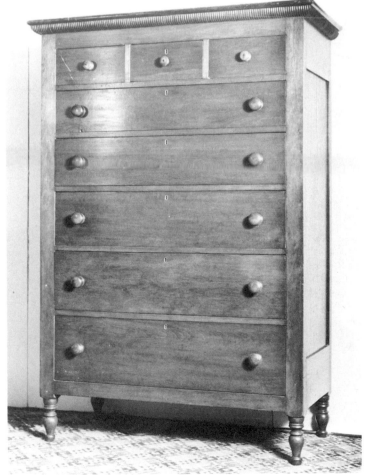

1141

1139 A high chest of drawers from Waterloo County. This is a most unusual example of the marriage of 18th century form and late American Empire style. Equally interesting is the probability that this piece was also made by the same Waterloo craftsman as the preceding examples. Second quarter 19th century. [P.C.]

1140 A high chest of drawers from Wentworth County. The Chippendale revival style rarely occurs outside the Niagara community. This example probably comes from Waterloo and is similar in several aspects of detail and construction to the preceding illustrations. Early 19th century. [P.C.]

1141 A high chest from Waterloo County. The simple Neoclassical style of this chest was widely used by Pennsylvania-German furniture-makers in the Waterloo area in various sizes. Typical characteristics are the framed and panelled construction and the turned feet. Second quarter 19th century. [P.C.]

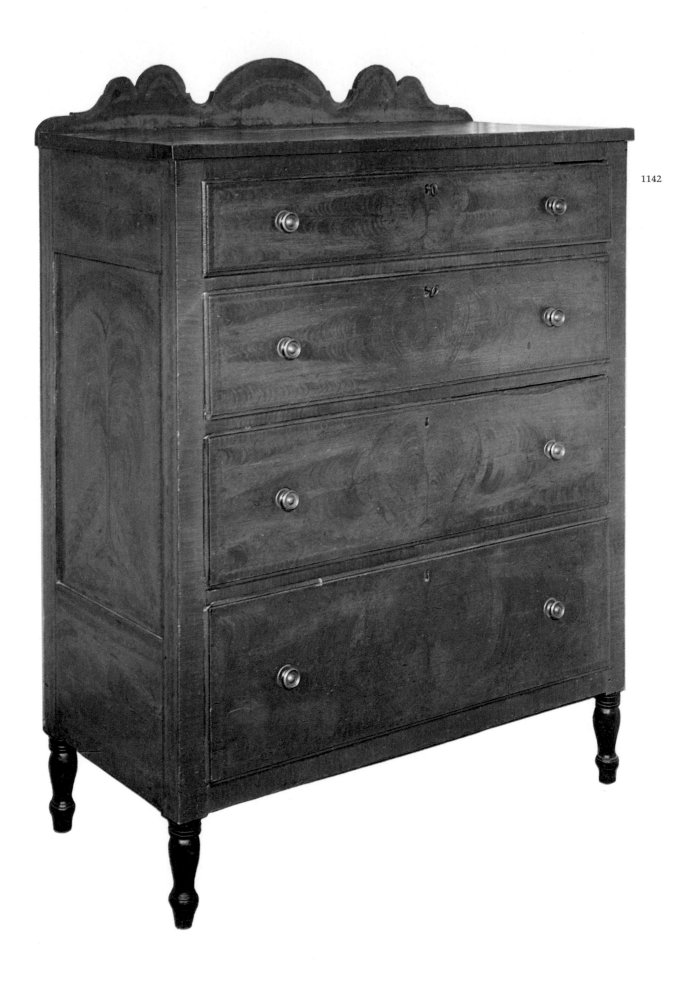

1142

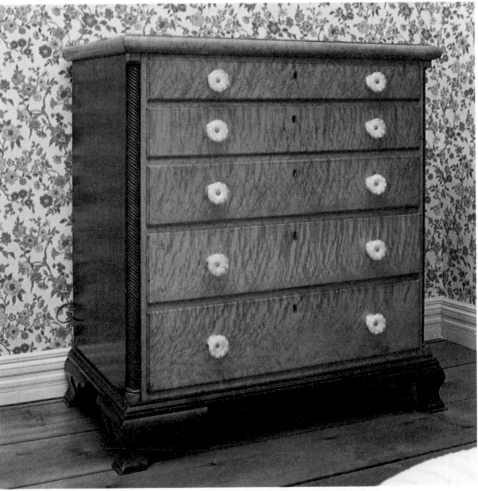

1142 A chest of drawers from Waterloo County. This charmingly provincial Neoclassical chest includes lapped drawers which are characteristic of rural Pennsylvania-German technique. Its outstanding feature is the imaginative and boldly coloured feather-painted decoration with willow trees and hearts as the central motif on the drawer fronts and end panels. Early 19th century. [P.C.]

1143 A chest of drawers from York County. Attributed to John Doan of Sharon. This is a soundly proportioned expression of the Pennsylvania Chippendale style. It is confidently crafted with well-developed, robust ogee bracket feet and spiral-reeded quarter columns. Early 19th century. [P.C.]

1144 A chest of drawers from York County. This example is similar to the preceding one and certainly by the same maker. It is entirely of figured maple except for the pine top, and the quarter columns are plain. These related York County examples possess a vigorous quality in contrast to the quiet refinement which is the mark of the Lincoln County style. Early 19th century. [P.C.]

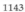
1143

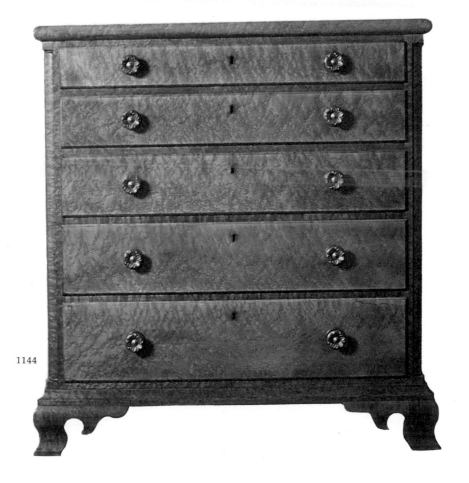
1144

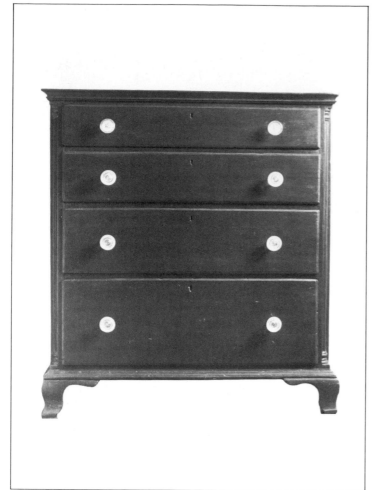

1145

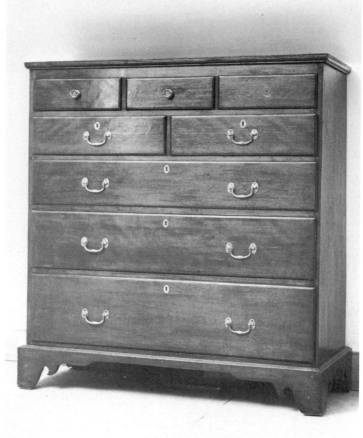

1146

1145 A chest of drawers from Ontario County. This Chippendale survival chest has reeded quarter columns, turned stops and well-designed mouldings of superior character to the ogee bracket feet. It is made of butternut. Early 19th century. [P.C.]

1146 A chest of drawers from Markham Township in York County. (Early family: Abraham Raymer.) This design is based on 18th century provincial Pennsylvania high chest prototypes in the arrangement of drawers, understated mouldings and simple bracket base. Early 19th century. [P.C.]

1147 A chest of drawers from Markham Township in York County. (Early family: Rolph.) This transitional design is directly related to the previous example with the introduction of heavy Empire-style turned feet, indicating a later date. Second quarter 19th century. [P.C.]

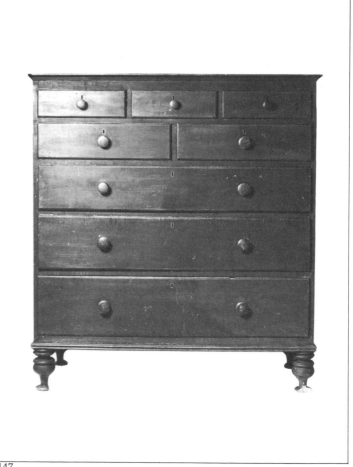

1147

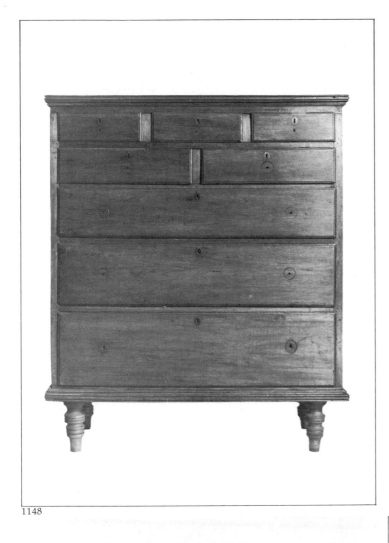

1148

1148 A chest of drawers from Markham Township. This design is of a similar transitional character to the previous illustration. It is interesting that the only known examples of this particular hybrid style are found in the Markham Pennsylvania-German community. Second quarter 19th century. [P.C.]

1149 A chest of drawers from Markham Township in York County. Signed, *Geo. Collard builder, Levi Brillinger writer*. A drawer side inscription reads, *John Cober's drawer and Susannah Cober too*. As do the preceding illustrations, this design combines elements of different influences. The spiral-reeded quarter columns and drawer arrangement survive from the Pennsylvania vernacular, while the shaped backboard and turned feet are typical of late Empire style. Second quarter 19th century. [P.C.]

1150 A chest of drawers from Markham in York County. (Early family: Houser.) This design is a successful simplification of the Pennsylvania Chippendale style with its well-proportioned arrangement of six lapped drawers in reducing depths, stylized bracket foot and built-up cornice. Second quarter 19th century. [P.C.]

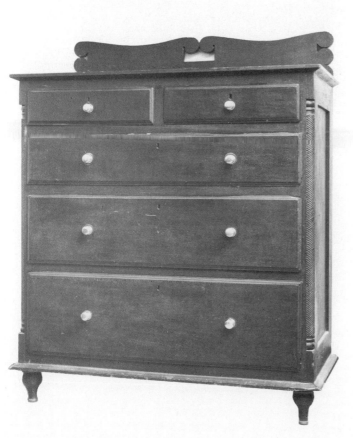

1149

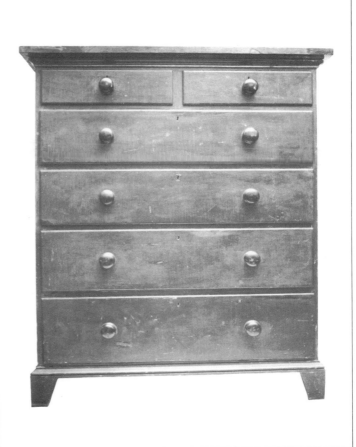

1150

1151 A chest of drawers from Markham Township in York County. A charming transitional style combining the drawer arrangement from the Pennsylvania vernacular with feet and carved backboard of Neoclassical influence. The corners are rounded with a full-depth quarter column. The exceptional painted decoration and the chest construction suggest the work of the Barkeys (see signed example, Plate 882). Mid-19th century. [P.C.]

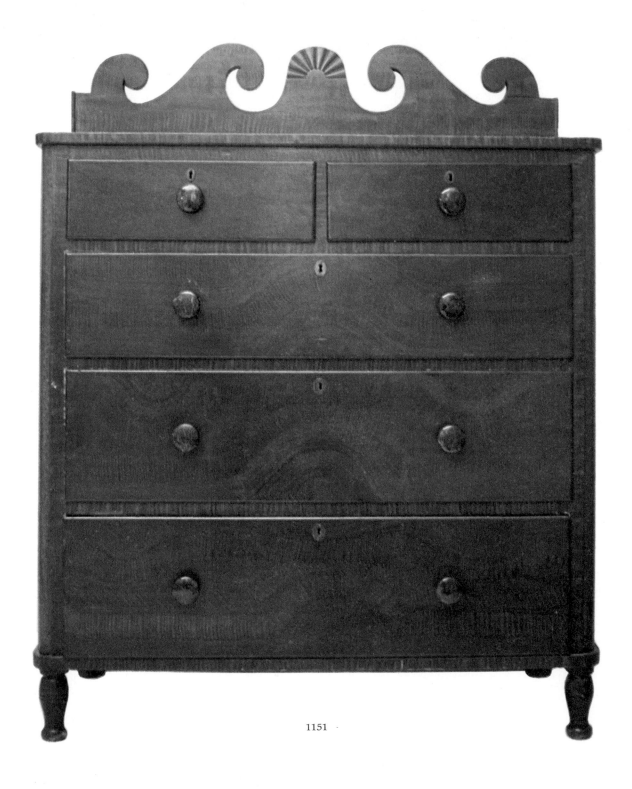

1151

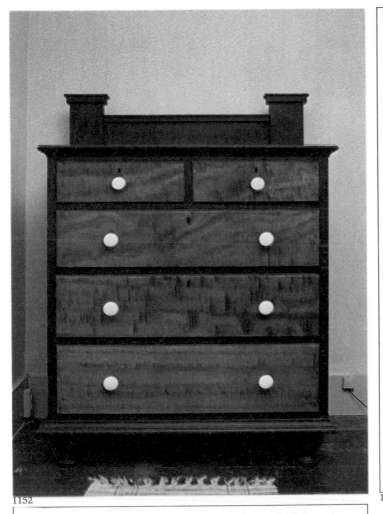

1152

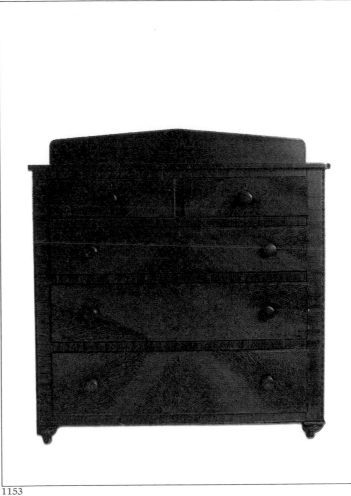

1153

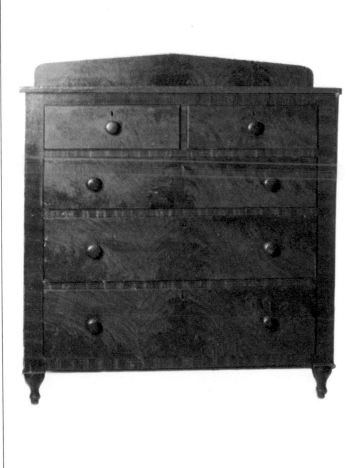

1154

1152 A chest of drawers from Markham Township in York County. A basic vernacular form with chimney-pot backboard and heavy turned feet of late American Empire influence. The original painted finish is typical of the virtuosity found in numerous Markham examples. Mid-19th century. [P.C.]

1153 A chest of drawers from Scarborough Township in York County. The simple design and painted decoration relate this chest to the following illustration. Spool-turned quarter columns add a note of Victorian style. Third quarter 19th century. [P.C.]

1154 A chest of drawers from Markham Township in York County. Signed, *Uxbridge, Nov. 10th, 1863, G. Davis.* In style, this chest is quite typical of the popular "cottage" style which was made in all parts of the province after 1850. The Pennsylvania tradition survives only in the lapped drawer construction and in the exotic painted decoration. Third quarter 19th century. [P.C.]

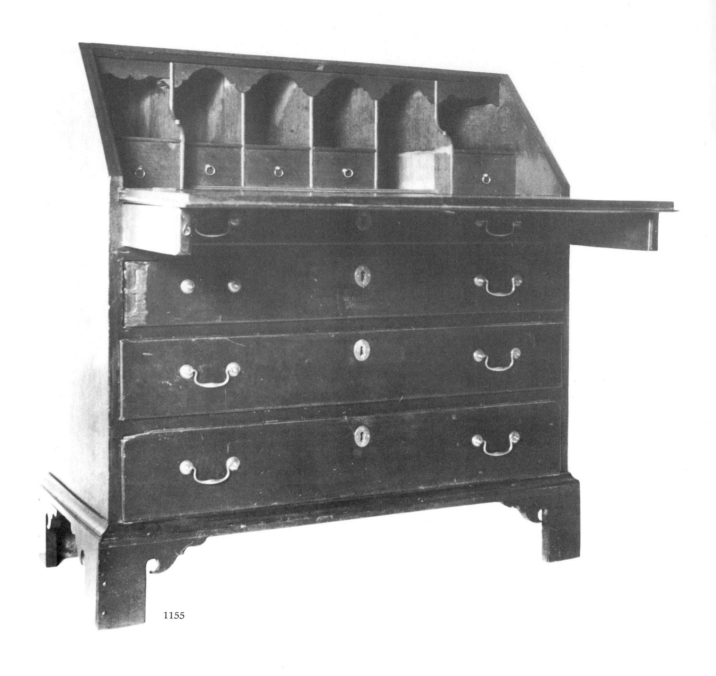

1155

1155 A slant-front desk from Oxford
County. (Loyalist family: Henry Couke.)
The original Loyalist, George Couke,
settled in Thorold, Lincoln County. Of
18th century Anglo-American style, this
strong design possesses well-formed
bracket feet, lapped drawers, a secret
compartment under the writing surface
and a fitted interior. Despite the fact
that similarities may be observed to
other early Lincoln County pieces, this
piece may be of American origin. Late
18th or early 19th century. [P.C.]

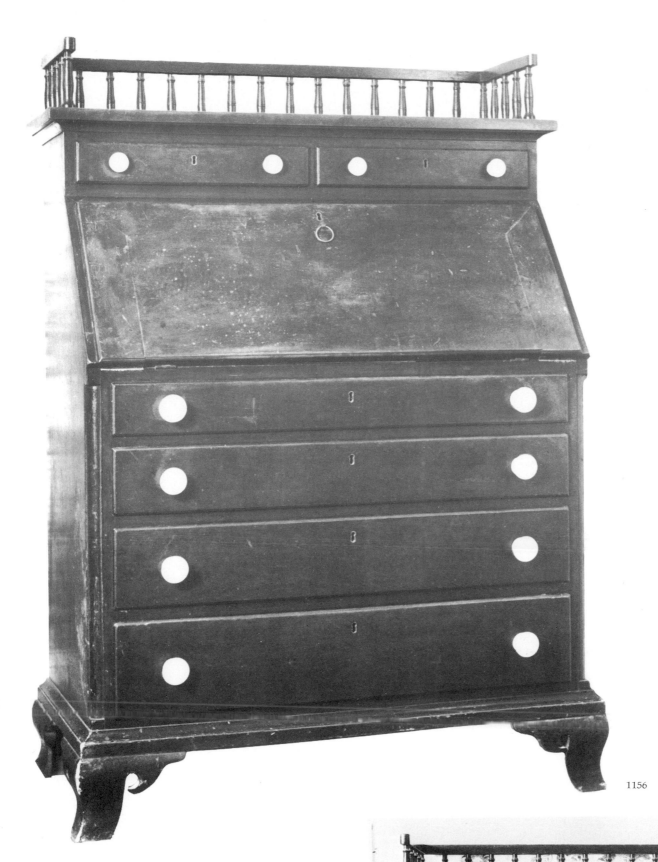

1156

1156 A slant-front desk from Lincoln County. (Early family: Martin.) This well-proportioned high desk retains both its original finish and the ceramic pulls which are seen on numerous Lincoln County pieces. The spindled gallery is also a favoured feature and illustrates the cautious introduction of later Neoclassical influence to the simple Chippendale style. Second quarter 19th century. [P.C.]

1156 a

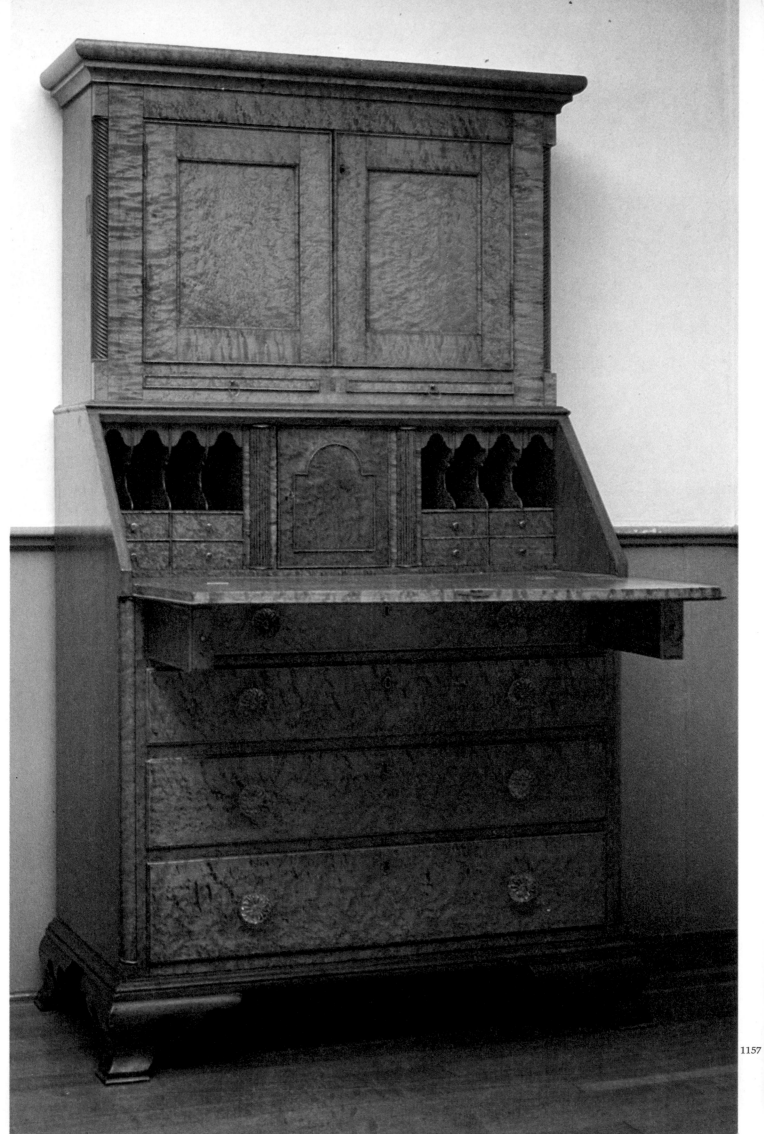

1157

1157 A secretary from York County. This fine example of provincial craftsmanship is attributed to John Doan of Sharon who came to Canada from Bucks County in Pennsylvania. It is a vigorous expression of the Pennsylvania Chippendale style which is consistent with 18th century Bucks County examples. The distinctive design of the ogee bracket foot, diagonal, reeded quarter columns and extensive use of figured maple are common to several pieces attributed to this maker (Plates 1143, 1144). Early 19th century. [P.C.]

1158 A secretary from the Niagara Peninsula. This is a unique example of this imposing form in Lincoln County cabinetmaking, while the lower section is similar in design and detail to several desks which share the 18th century Pennsylvania tradition. Early 19th century. [P.C.]

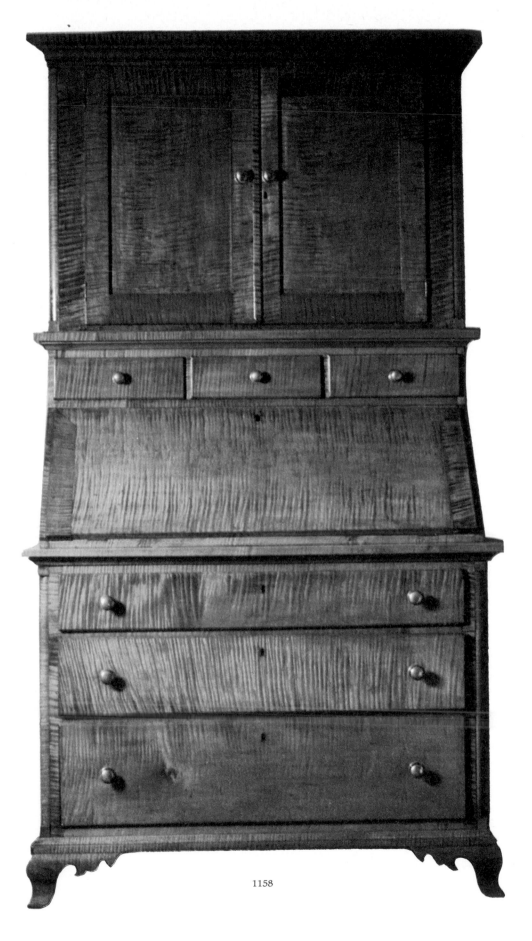

1158

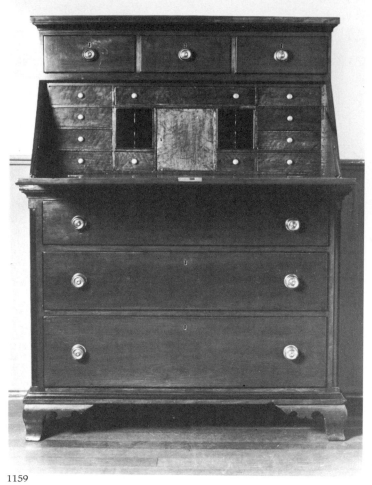

1159

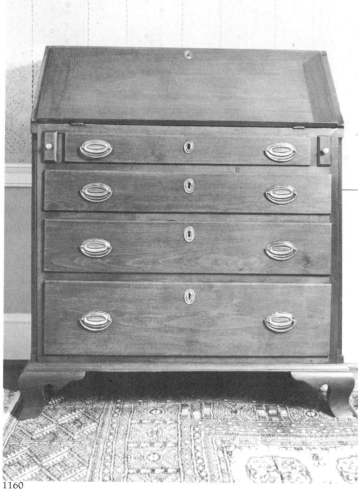

1160

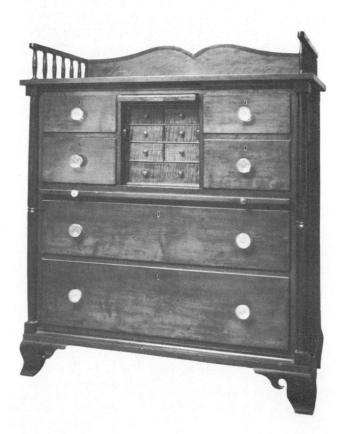

1161

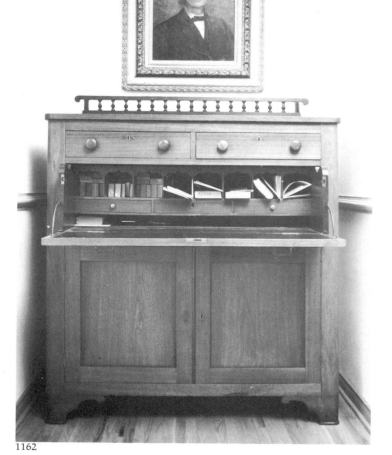

1162

1159 A slant-front desk from the Niagara Peninsula. This three-drawer example of the popular Lincoln County desk form has ebonized mouldings and quarter columns in subtle contrast to the stained cherry used overall. Second quarter 19th century. [P.C.]

1160 A slant-front desk from Lincoln County. This refined slant-front design, with reeded quarter columns and ogee foot was very popular in 18th century Pennsylvania but is rarely found in the Pennsylvania-German communities of Upper Canada. Early 19th century. [P.C.]

1161 A secretary chest from Lincoln County. Signed *Fry* on the inside of a drawer. This transitional design combines Sheraton-inspired columns at the four corners and spindled gallery, an Empire backboard and the recurring Chippendale ogee bracket feet. Second quarter 19th century. [P.C.]

1162 A butler's desk from the Niagara Peninsula. This small desk was probably made in the Niagara area in the last quarter of the 19th century, yet it retains a strong suggestion of the earlier examples in its spindled gallery, interior detail, Chippendale silhouette of the bracket feet and sound, simple craftsmanship. Fourth quarter 19th century. [P.C.]

1163 A secretary chest from Clinton Township in Lincoln County. Marked, *David Grobb.* The chest of drawers fitted with a writing drawer was an 18th century development for the gentleman's bedroom. The dressing slide above the wide drawers is an additional convenience. This handsome example, with its reeded frieze and simple line, is an uncommon departure from the dominant Chippendale style in Lincoln County case furnishings. Early 19th century. [P.C.]

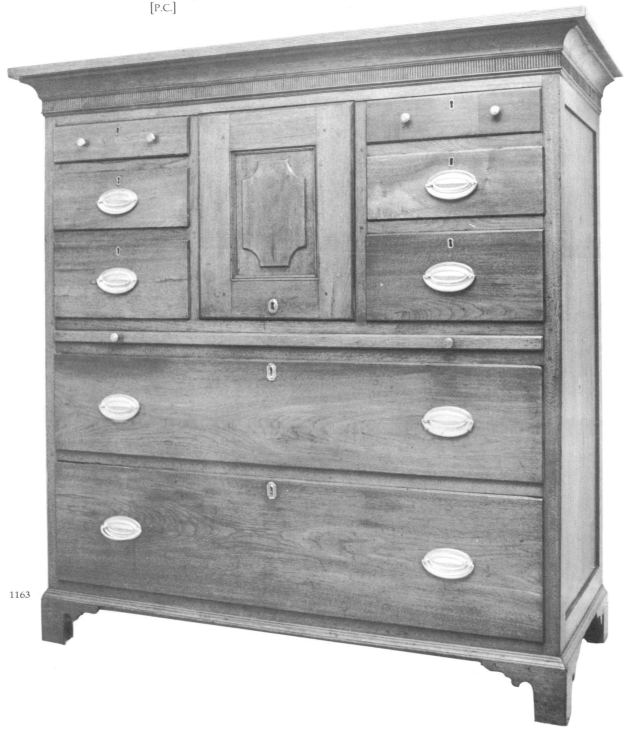

1163

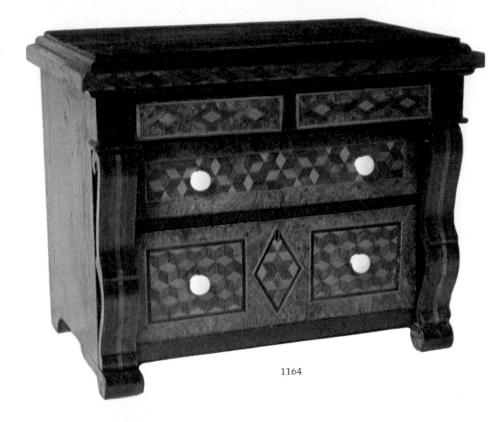

1164

1164 A miniature desk from Perth County. This small Empire desk comes from an early family which emigrated from Darnstadt in southern Germany. The elaborate geometric decoration inlaid in several woods is a common regional characteristic in the Continental tradition, as is the creation of special furniture as a symbol of affection. Mid-19th century. [P.C.]

1165 An escritoire from Perth County. This form was popular in Central Europe in the early 19th century. The late Neoclassical-style corner columns and shaped lower drawer combined with the scrolled pediment and applied leaf motif suggest a competent provincial craftsman of Continental German-Alsatian origin. Second quarter 19th century. [P.C.]

1166 A slant-front desk from Middlesex County. This is a well-crafted example of the widely popular late Empire style which in North America is associated with John Hall's 1840 publication, *The Cabinet Maker's Assistant.* The strong geometric patterns of the inlaid decoration and the star motif are seen frequently in furniture of this period, made in the western counties by craftsmen of Continental origin. Mid-19th century. [P.C.]

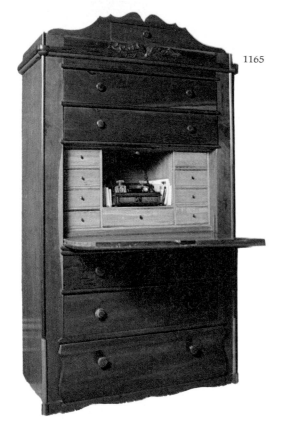

1165

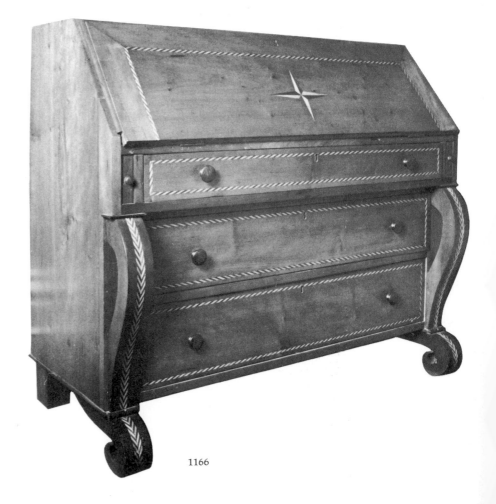

1166

1167 A corner secretary from Waterloo County. This unusual design includes arched glazing details and horizontal mouldings at the waist which are typical of the Pennsylvania vernacular, widely adopted in Waterloo County, while the large form with the deep chamfered returns and wide swelling to the base is reminiscent of Continental German style. Second quarter 19th century. [P.C.]

1168 A secretary from the western counties. This late Neoclassical design incorporates the step-back front and turned columns which were universally popular in the mid-19th century. The scrolled detail of the glazed doors was very popular in the provincial designs of Continental Germany in this period, as was the use of applied decoration seen on the frieze of this example. Mid-19th century. [C.D., R.O.M.]

1169 A secretary from Downie Township in Perth County. Signed, *Ambrene Boos*. This stoutly provincial design is typical of mid-19th century Neoclassical style with several characteristics which suggest a Germanic maker from the Continent. The scrolled panel in the slant front and the shaped pediment are similar details to those of other pieces from this same centre of Alsatian and German settlement (see Plate 972). Mid-19th century. [P.C.]

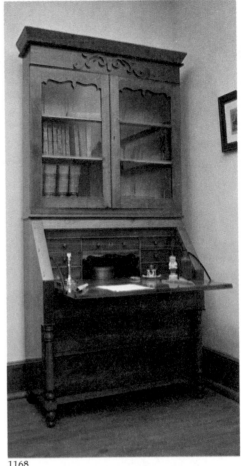

1168

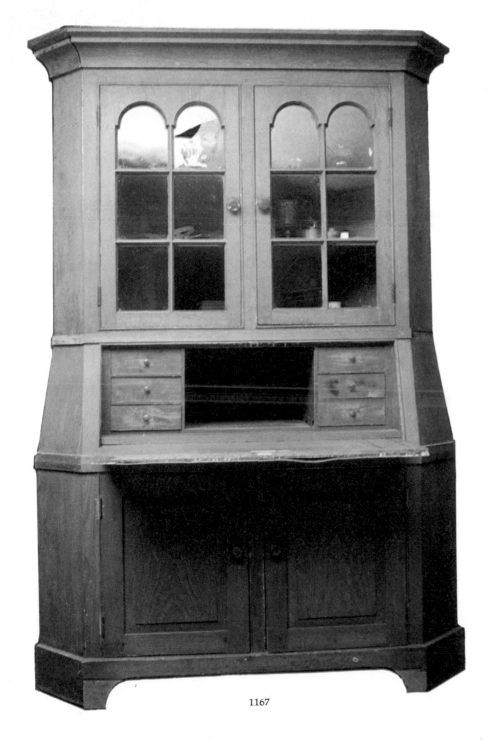

1167

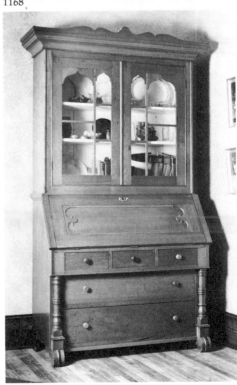

1169

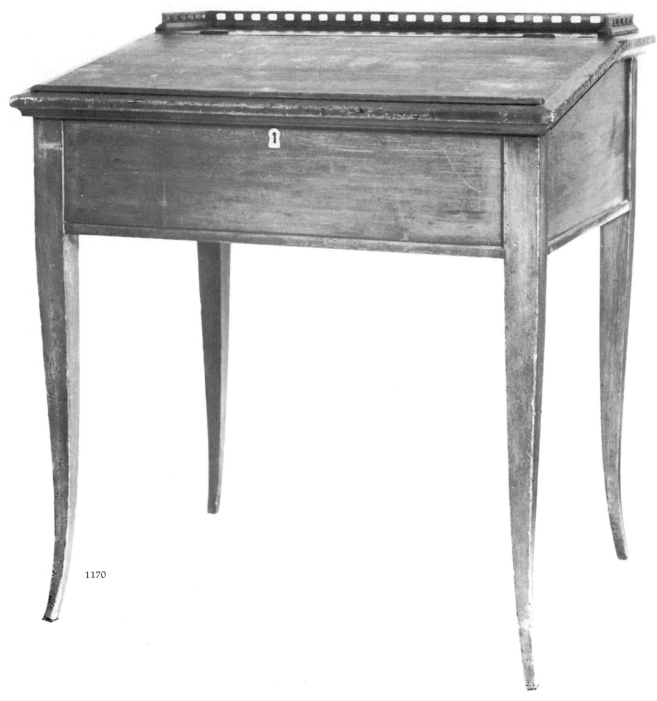

1170

1170 A desk from Perth County. The simple shaped leg of this unusually elegant provincial design was a popular influence from the Louis XV style in Continental Germanic furnishings and was particularly prevalent in Alsatian settlements in Upper Canada. The gallery has been restored to early marks and fragments. Second quarter 19th century. [P.C.]

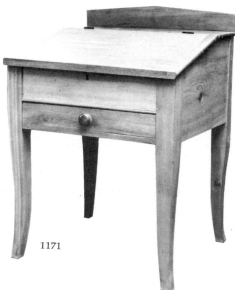

1171

1171 A lift-top desk from Perth County. The same Continental style influence as seen in the previous example is expressed here in a robust country manner by a Continental maker. Mid-19th century. [P.C.]

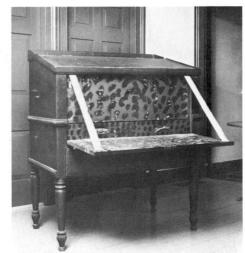

1172 a

1172 A lift-top desk from Vaughan Township in York County. Signed, *John S. Sneider – 1847*. This large, stand-up desk includes a most unusual drop-front feature which reveals a boldly decorated panel fitted with two secret drawers. The style, detail and construction are typically Pennsylvania-German. Second quarter 19th century. [P.C.]

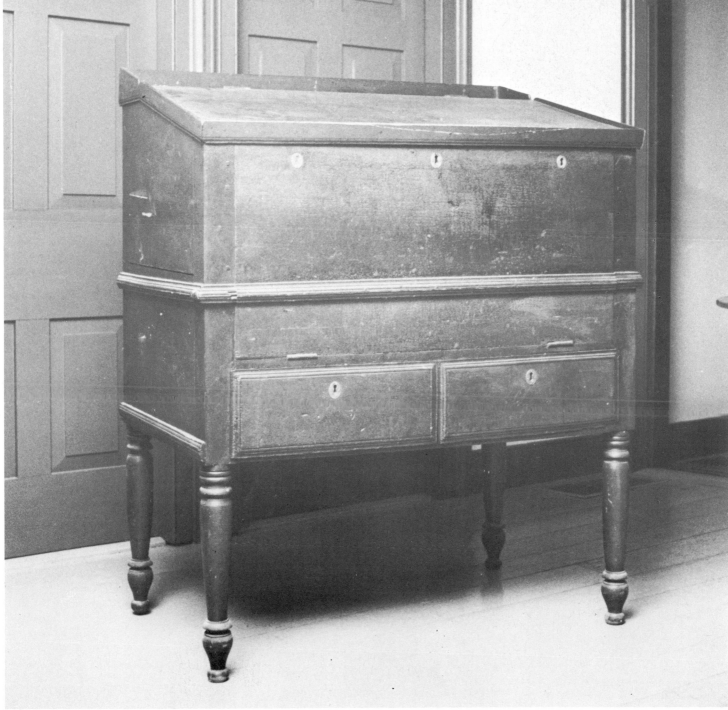

1172

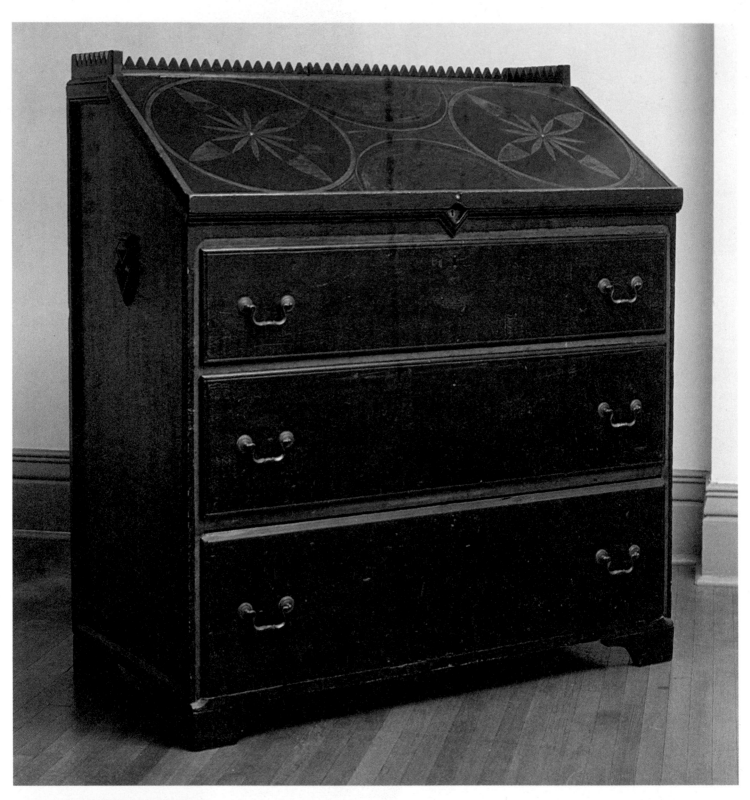

1173a

1173b

1173 A lift-top desk from Markham Township in York County. Signed, *Samuel Snider, 1839*. The tall, lift-top variation of the more formal 18th century slant-top form was a popular country style in the American colonies. The boldly executed decoration of this example, including geometric motif, multi-coloured woodgrain patterns and brilliant contrasting banding and solid colour interior, is a unique example of the Pennsylvania-German decorative tradition in Upper Canada. Second quarter 19th century. [P.C.]

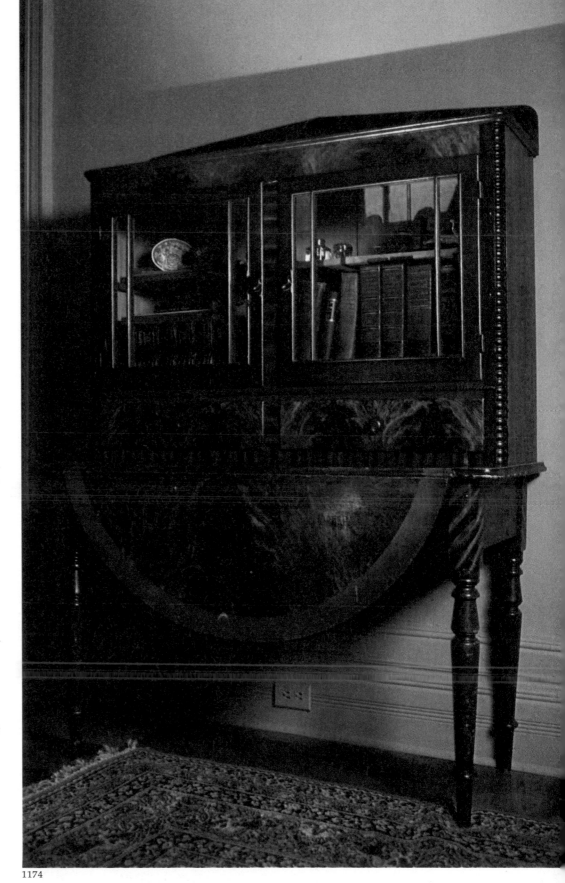

1174 A secretary from Markham Township in York County. There do not appear to be direct style precedents for this unusual combination of table and bookcase forms, although some similarities may be observed to the low bookcases on table-like bases which were designed or inspired by Hepplewhite and Sheraton. This unique provincial expression is the major known work of a local craftsman (or craftsmen, since the decoration may be by another), who produced other furnishings, sharing details of construction, style and decoration. Although typical Pennsylvania-style lapped drawers and doors are evident, such details as the spool-turned quarter columns and the backboard design are distinctive (probably G. Davis, see Plate 1154). The most impressive feature of these related pieces is the dramatic painted decoration, which combines here at least nine skilfully executed patterns and textures to produce a composition that reflects the exotic impact of the most elaborate designs in Neoclassical style. Second half 19th century. [P.C.]

1174

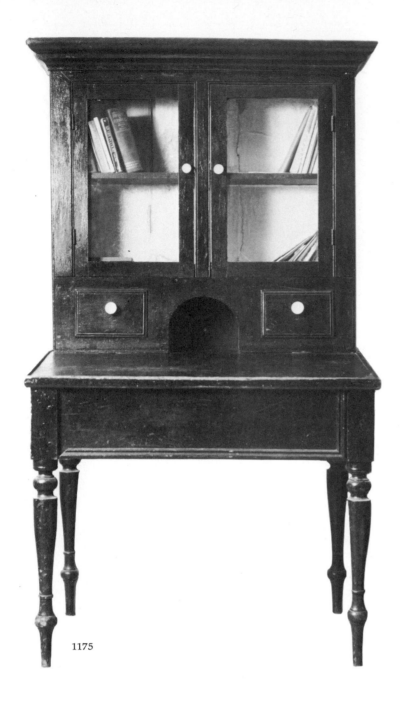

1175

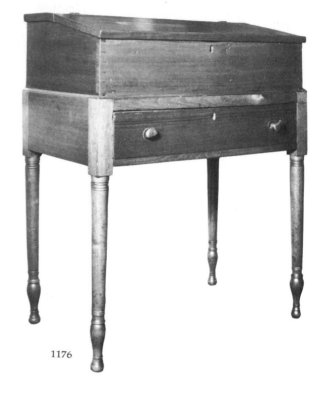

1176

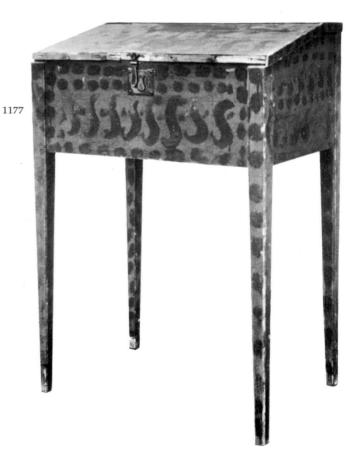

1177

1175 A secretary from Markham Township in York County. The combination of a glazed bookcase and a lift-top desk is a transitional form which was particularily popular among the Mennonites and Dunkards of Vaughan and Markham townships. Mid-19th century. [P.C.]

1176 A lift-top desk on frame from Winona in Lincoln County. The confident sparseness of this design is typical of the work of Lincoln County cabinet-makers. Second quarter 19th century. [P.C.]

1177 A lift-top desk from Lennox and Addington County. Made by chair-maker Henry Walwraith, a German immigrant from Pennsylvania. A boldly painted example of the popular country form. Second quarter 19th century. [P.C.]

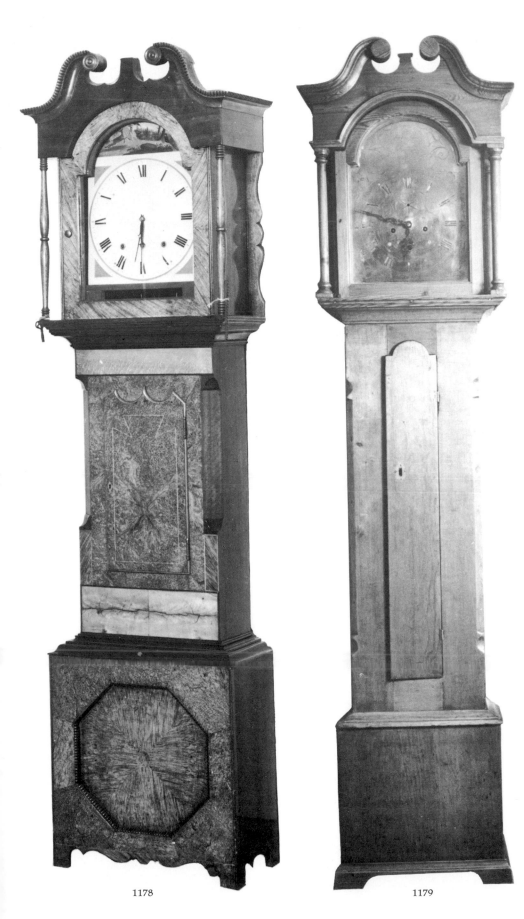

1178

1179

1178 A tall-case clock from Markham Township in York County. Further in the Chippendale idiom, this design is related to the heavy, broad-waisted interpretation which was popular in Pennsylvania. While the detail is typical of 19th century provincial style, the elaborate use of veneers in birdseye maple and walnut with delicate string inlay decoration is unusually sophisticated. Cherry and mahogany are also combined in the exotic approach. The movement is German. Second quarter 19th century. [C.D., R.O.M.]

1179 A tall-case clock from Vaughan Township in York County. (Early family: Dalziel.) This is a confident provincial execution of 18th century style made entirely of pine. Scottish movement. Early 19th century. [P.C.]

1180 A tall-case clock from Lincoln County. (Early family: Lindaburg.) This case and another almost identical example from the same area are fine examples of the survival of the provincial Pennsylvania Chippendale tradition in Upper Canada. Notable features are the scrolled-arch pediment with inlaid roundels and urn-shaped finials, arched hood, reeded quarter columns at the waist and base, shaped door and ogee bracket feet. The movement is British. Early 19th century. [P.C.]

1181 A tall-case clock, signed *Woodruff-Burford U.C.* A number of these clocks are found. The cases are pine with painted wood grain and stencilled decoration in gold on the waist and hood. Typically, the movement here is by R. Whiting, Wincester. Similar cases were made in great numbers by Silas Headley in Connecticut. It is assumed at this time that Woodruff imported and sold these clocks of American manufacture under his imprint. Second quarter 19th century. [P.C.]

1182 A tall-case clock from Waterloo County. This provincial interpretation of mid-18th century Pennsylvania Chippendale style is marked *John Alberth, Clagmacher, Baden.* A good deal of its charm is provided by the deeply shaped panels in the door and lower section. It is made of pine and retains old or original woodgrain paint. Early 19th century. [J.H. M.T.]

1183 A low-post bed from Waterloo County. A Pennsylvania-German bed with Empire influences. Second quarter 19th century. [P.C.]

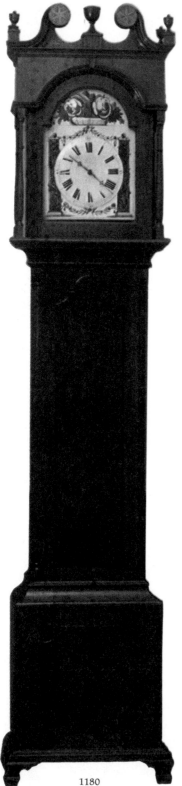

1180

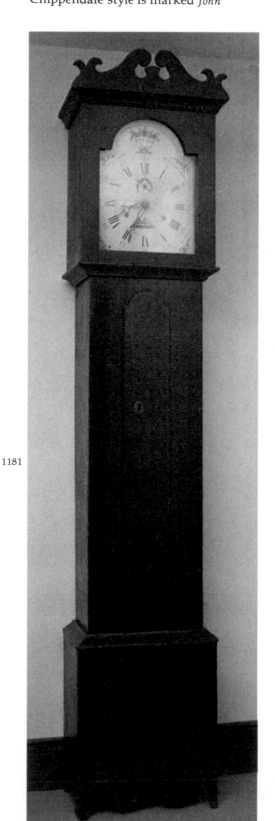

1181

1182

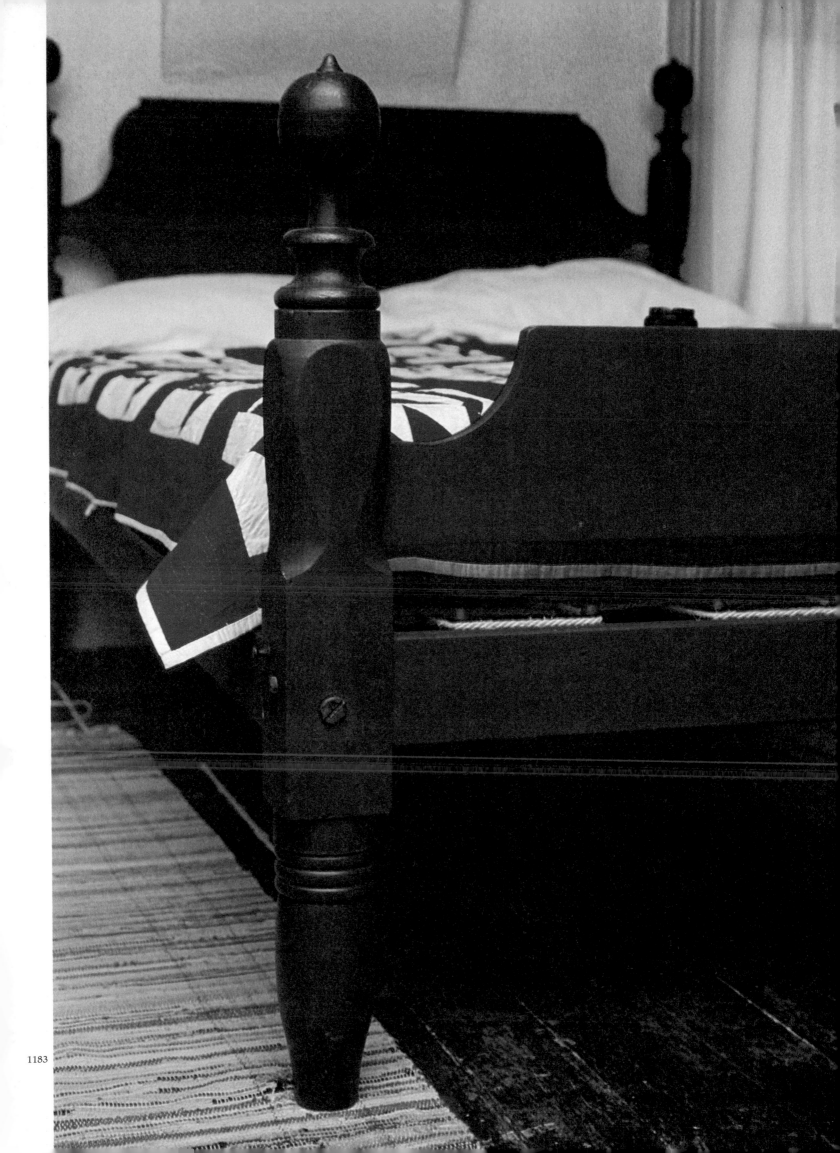

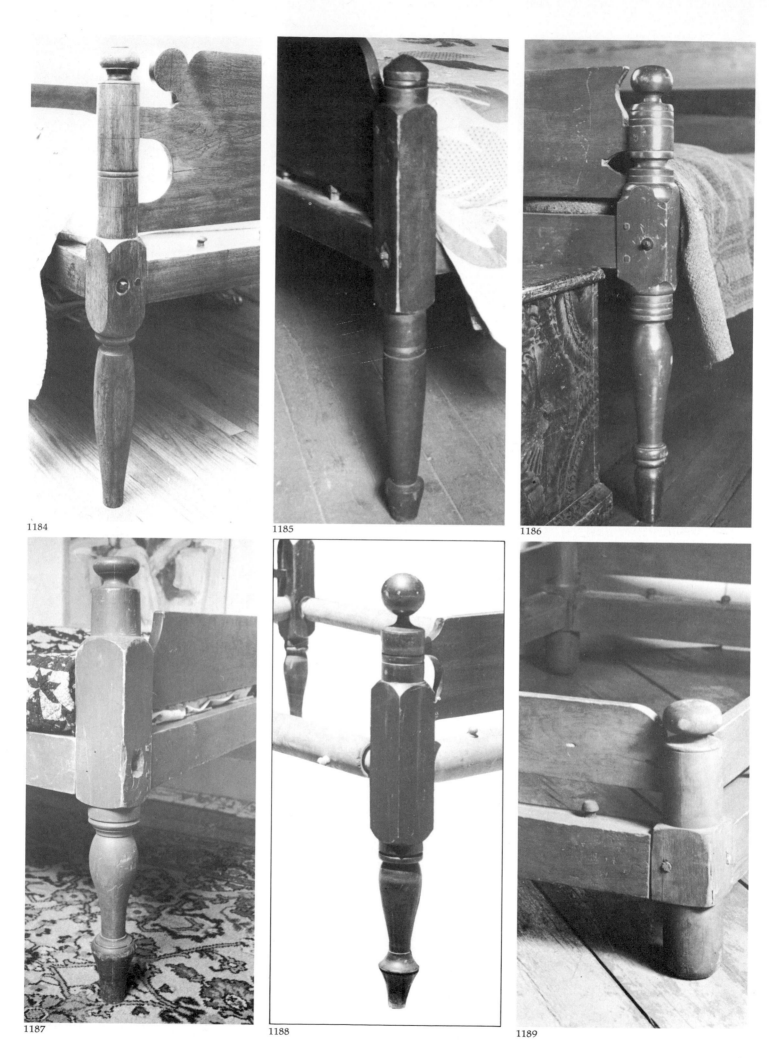

1184

1185

1186

1187

1188

1189

1184 A low-post bed from the Niagara Peninsula. A survival of 18th century Queen Anne style. Variations on this low-post form were popular in each of the Pennsylvania-German communities in Upper Canada. Early 19th century. [P.C.]

1185 A low-post bed from Waterloo County. A typical Pennsylvania-German vernacular bed. Early 19th century. [P.C.]

1186 A low-post bed from Vaughan Township in York County. A Pennsylvania-German bed with restrained influence from the Empire style. Second quarter 19th century. [B.C.P.V.]

1187 A low-post bed from Waterloo County. A Pennsylvania-German bed with Empire influences. Second quarter 19th century. [P.C.]

1188 A low-post bed from Wellington County. (Early family: Shoemakker.) A Pennsylvania-German bed with Empire influences. Second quarter 19th century. [P.C.]

1189 A trundle bed from the western counties. Designed to fit under the full-sized bed during the day, this design with double side rails was intended for children. The post design reflects the typical Germanic low-post style. Early 19th century. [P.C.]

1190 A youth's bed from Lennox and Addington County. This sturdy design is typical of the Continental German tradition in both style and construction. The sides are mortised and tenoned to the end posts and secured by wooden pins. First half 19th century. [P.C.]

1191 A youth's bed from Port Colborne in Welland County. Signed, *J.G.R.* This is a common form from the Germanic tradition in Europe. The square posts have the slightly flared foot seen on German *Schränke* and chests from this same area. The deep side boards and solid head and foot are typical of Continental examples, while the scrolled shaping suggests influence from the popular American Empire styles. Mid-19th century. [P.C.]

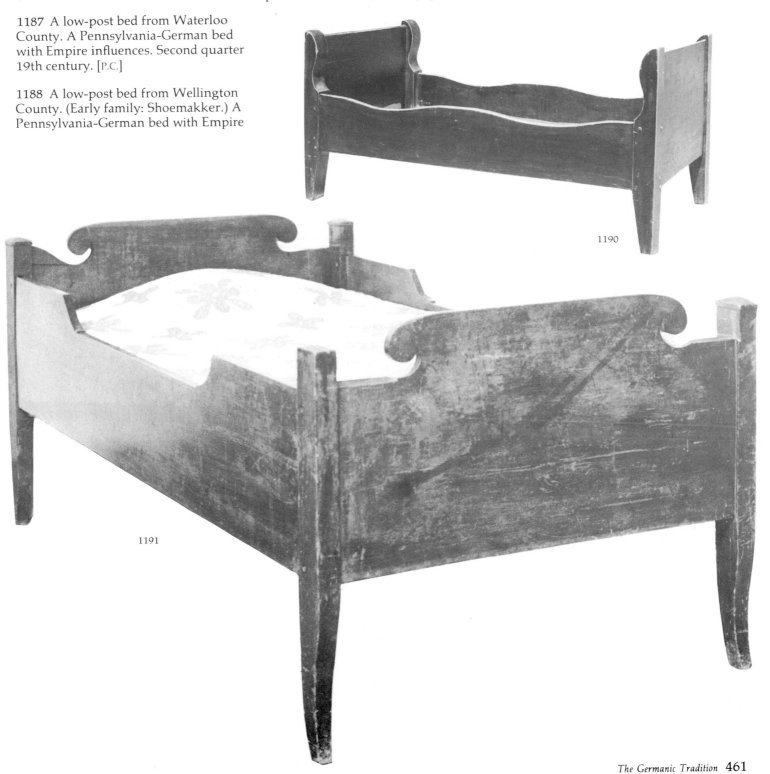

1190

1191

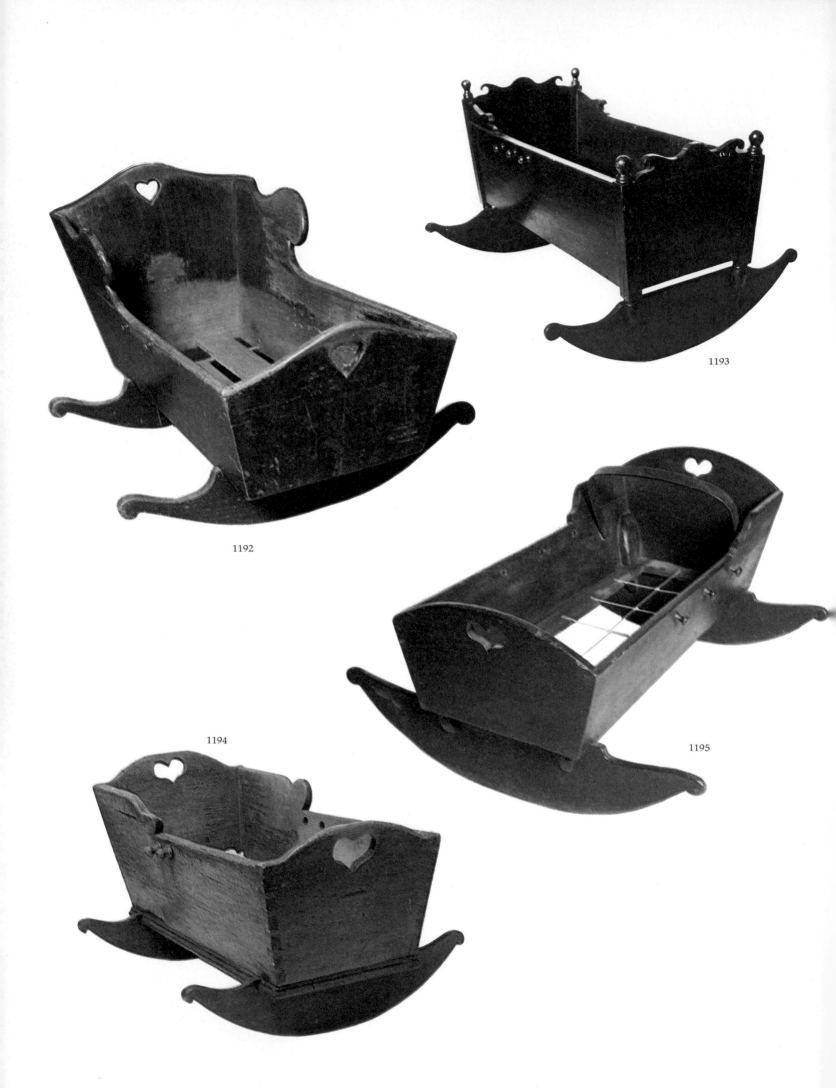

1193

1192

1194

1195

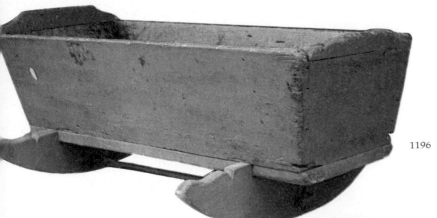

1196

1192 A cradle from Waterloo County. This finely shaped example retains its original painted woodgrain finish. Early 19th century. [P.C.]

1193 A cradle from Lincoln County. (Early family: Barbara and Joseph Moyer, married in 1816.) Although this cradle survives from a Pennsylvania-German community, it is stylistically from the Continental German tradition and almost identical to examples there dating from the late 18th and early 19th centuries. The post construction, with scrolled head and foot boards and the wide, deep rockers, are typical characteristics. Early 19th century. [P.C.]

1194 A cradle from Waterloo County. (Early family: Bauman.) This is a typical Pennsylvania-German form. Early 19th century. [P.C.]

1195 A cradle from Markham Township in York County. The arched hoop to support a fabric canopy is a common Germanic feature. Early 19th century. [P.C.]

1196 A cradle from Roblin in Lennox and Addington County. Made by Henry Walwraith, a German who emigrated to Upper Canada via Pennsylvania in the 1840s. This simple form, with deep rockers secured by a central stretcher, is Continental in origin. Second quarter 19th century. [P.C.]

1197 A cradle from Peterborough County. A traditional Germanic form retaining original stencilled decoration. Second quarter 19th century. [P.C.]

1198 A suspended cradle from Lennox and Addington County. This universal traditional form was particularly popular in Germany. The elaborately shaped trestle-frame design relates directly to 18th and early 19th century examples there. First half 19th century. [L. & A.C.M.]

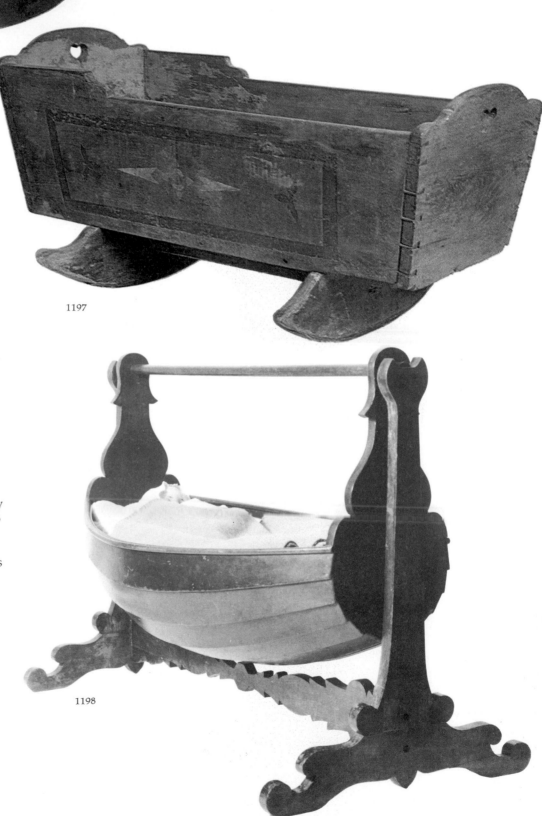

1197

1198

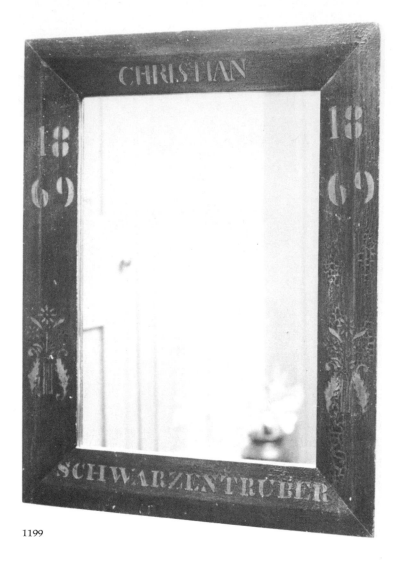

1199

1200

1201

1202

1203

1199 A mirror from Baden in Waterloo County. This is an excellent example of decoration in the Continental tradition, incorporating the name, *Christian Schwarzentruber* (Swiss), the date and a stencilled floral motif in gold and dark red over a painted woodgrain background. 1869. [P.C.]

1200 A frame from Lincoln County. A variety of simple, traditional decorative motifs are used in contrasting inlay. Second quarter 19th century. [P.C.]

1201 A frame from Waterloo County. The Rococo scroll which is so carefully executed here was a recurring theme in traditional design throughout Central Europe. Mid-19th century. [P.C.]

1202 A mirror from York County. In this charming example of folk craft, the heart shape is cut from a single piece of stained pine and decorated with delicate floral elements and shaped corners. 19th century. [B.C.P.V.]

1203 A reliquary from Renfrew County. (Early family: Luloff.) The survival of traditional decorative expression is seen in this naïve object of late manufacture from the northern community. 20th century. [P.C.]

1204 A frame from Vineland in Lincoln County. (Early family: Hipple.) Made specifically for a fine example of *Fraktür*, this handsome frame incorporates the crisp, reeded detail often seen on Lincoln County furniture. Second quarter 19th century. [P.C.]

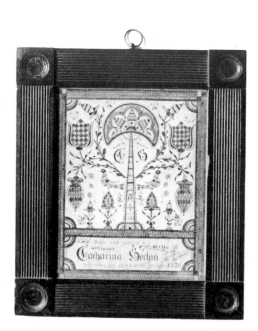

1204

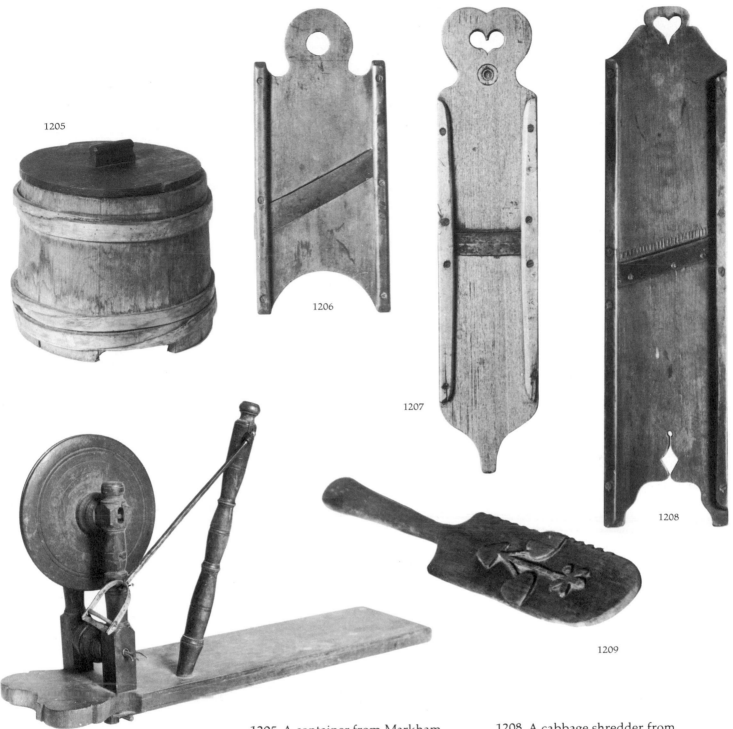

1205

1206

1207

1208

1209

1210

1205 A container from Markham Township. (Early family: Hoover.) A fine example of the cooper's craft with a notched top which allows the top to be tilted to ventilate the contents. Early 19th century. [P.C.]

1206 A cabbage shredder from the Niagara Peninsula. Traditional design. First half 19th century. [P.C.]

1207 A cabbage shredder from Waterloo County. Traditional design with heart cut-out and roundel decoration. First half 19th century. [P.C.]

1208 A cabbage shredder from Waterloo County. Traditional design with heart cutout handle and shaped tail. First half 19th century. [P.C.]

1209 A spatula from Norfolk County. Heart and flower carved decoration. 19th century. [P.C.]

1210 An apple peeler from Markham Township. (Early family: Steckley.) An intriguing convenience with finely shaped elements of early character. Early 19th century. [P.C.]

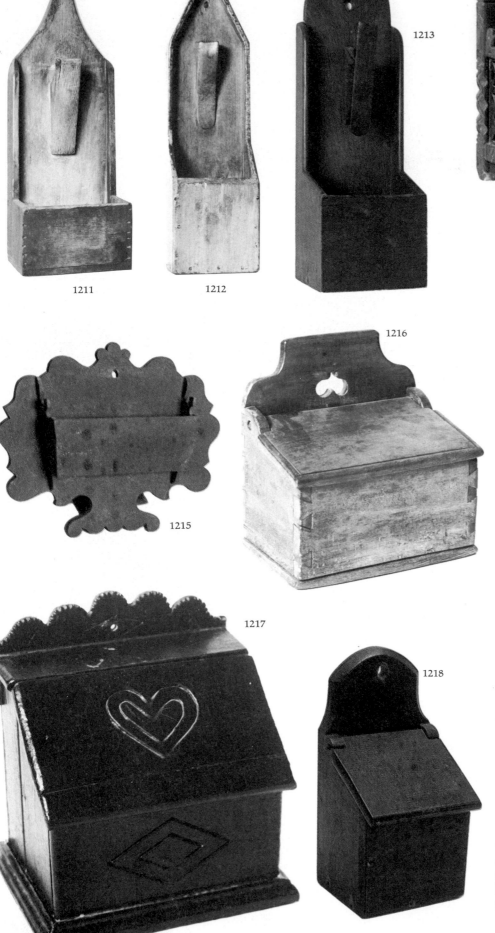

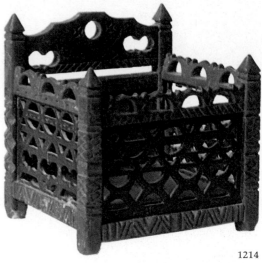

1211 1212

1213

1214

1216

1215

1217

1218

1211 A knife box from Haldimand County. (Early family: Schweyer.) Traditional form. Second half 19th century. [P.C.]

1212 A knife box from the Niagara Peninsula. Traditional form. Second quarter 19th century. [P.C.]

1213 A knife box from Norfolk County. Although not exclusive to the Pennsylvania Germans, this design with the scouring block on the back panel occurs widely in their communities. Second half 19th century. [P.C.]

1214 A spoon tray (*Loffelbehalter*) from Waterloo County. Stamped, *Albert Snyder*. This elaborately carved and fretcut form is directly from the Continental German tradition. A remarkably similar example from the region of Schwalm is seen in the German National Museum in Nürnberg. Second quarter 19th century. [P.C.]

1215 A wall box from Augsburg in Renfrew County. This is a highly decorative example of the Rococo influence from the Continental German tradition, confidently executed. Second half 19th century. [P.C.]

1216 A salt box from Waterloo or Perth County. This is a fine example of the German traditional form with characteristic dovetailed construction and heart motif. Second quarter 19th century. [P.C.]

1217 A wall box from the western counties. This naïve expression of traditional Germanic decoration includes hearts, diamonds, stars and the sawtooth scallop. Mid-19th century. [P.C.]

1218 A salt box (*Salzbehalter*) from Renfrew County. From the Continental German tradition in form and construction, also popular in Pennsylvania. The wooden hinge is a distinctive feature. (See prototype illustrated on page 316.) Second half 19th century. [P.C.]

1219 A candle box from the western counties. This is a fine example of Germanic decoration, incorporating several traditional roundel designs with leaf and heart elements creating a rich visual texture overall. Origin could be European, Pennsylvanian or Canadian. 19th century. [P.C.]

1220 A tea caddy from Lincoln County. While this basic form was widely produced in Britain and America in the late 18th and early 19th centuries, the construction, decoration and source suggest a Germanic maker for this example. Mid-19th century. [P.C.]

1221 A candle box of unknown origin. From the early collection of Joseph Bauer, this superb example of Germanic decoration may be of Pennsylvania or local origin. The scalloped and triangular border designs which surround the traditional geometric symbols are widely used in *Fraktür* compositions. First half 19th century. [P.C.]

1222 A spice box from Mount Forest in Grey County. A carefully crafted wall piece, boldly colourful in green and ochre. Mid-19th century. [P.C.]

1223 A sewing box from Listowel in Perth County. This elaborately decorated example illustrates the facet of the Germanic tradition in which great care and creative effort were applied to the making of everyday objects as gifts for loved ones on special occasions. Late 19th century. [P.C.]

1224 A wall box from Waterloo County. The backboard cut-out is a stylized "Tree of Life" motif, a recurring theme in the Germanic tradition. The bird and leaf elements are carved and applied. Mid-19th century. [P.C.]

1225 A wall box from Renfrew County. The repetition of the scallop motif in the arched backboard is a charming example of intuitive design. Second half 19th century. [P.C.]

1226 A wall shelf from Hanover in Grey County. A simple expression of the decorative tradition. Second half 19th century. [P.C.]

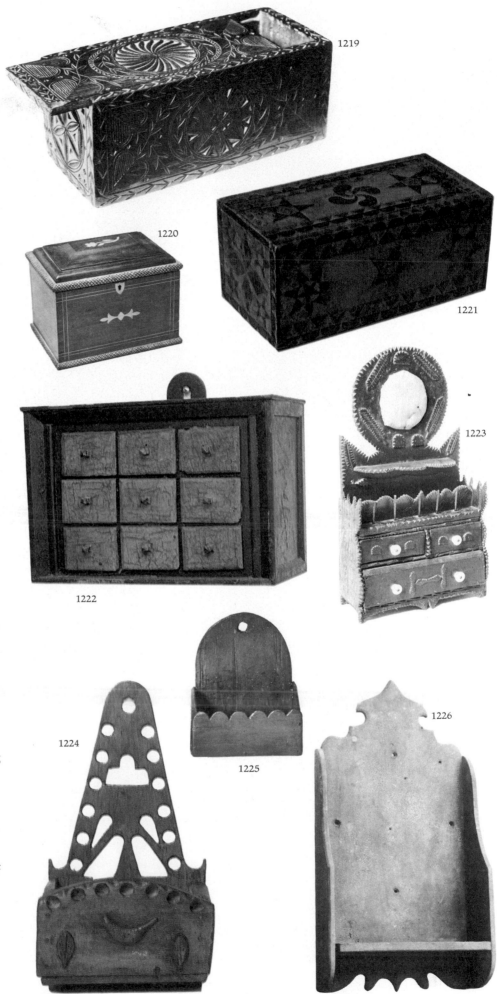

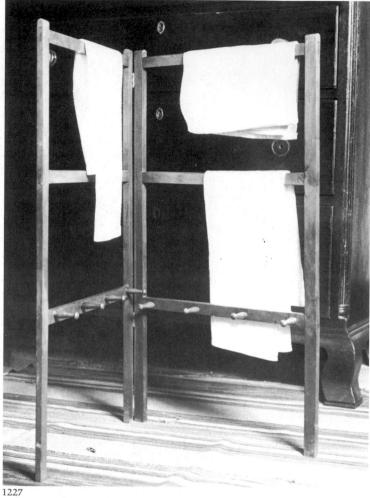

1227

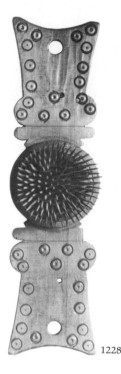

1228

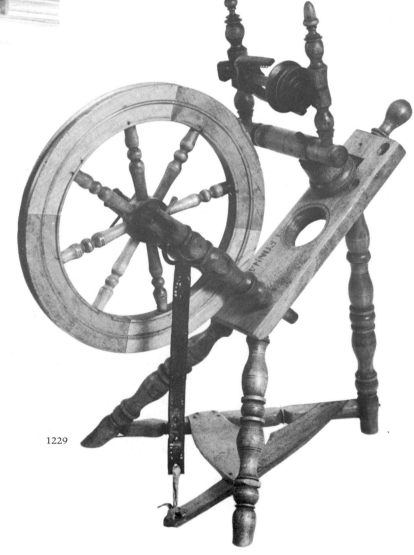

1229

1227 A drying rack from the Niagara Peninsula. A carefully crafted frame with unusual turned pegs. Mid-19th century. [P.C.]

1228 A hackle from Waterloo County. A traditional design with punched decoration similar to that found on Pennsylvania-German ironwork. Late 18th or early 19th century. [P.C.]

1229 A spinning wheel from Renfrew County. Stamped, *Leonhard*. A well-crafted wheel of traditional design. The circular cut-out in the angled centre piece is not often found and is supposed to have held a bowl for moistening the fingers while spinning the flax. Similar wheels are known in the Renfrew area. Second half 19th century. [P.C.]

5 The Polish Tradition

The Poles in northeastern Renfrew County were possibly the smallest group of early settlers to establish a distinct cultural tradition within the Upper Canadian mosaic. Unimpressive as it was in numbers, the furniture that was made in this community during the last half of the nineteenth century provides fascinating evidence of the survival of an ancient culture in Upper Canada. Brenda Lee-Whiting, who has done considerable research on the history of these Renfrew settlements, explains "that the first party of 15 Polish immigrants arrived in 1858. In 1860, they were joined by another 22 families, and by 1864 there were 38 family units totalling 182 individuals."[1] This was the nucleus of the community that attracted an additional 250 families from Poland in the 1890s and another forty families, during the same years, from an unsuccessful settlement in Webster, Massachusetts.

The one-hundred-acre lots[2] that were made available free to the first Polish immigrants were located along the newly opened Opeongo Road which had been started in 1851 as a route from the Ottawa River to Georgian Bay.[3] The total plan was never completed, but by 1859 ninety-nine miles of road were passable from Farrell's Landing through Renfrew Village on into the rugged northern interior. The more desirable lots, closer to the established commercial centres, had already been taken by Scots, Irish and some Germans. The Poles waited in Renfrew Village for the last few miles of road to be completed and for their lots to be surveyed. They moved some sixty to sixty-five miles down the road and, finally, settled together on the bleak frontier. The village that developed around them was called Wilno; in later years this community increased in numbers and settlement spread west to Barry's Bay and northward to Killaloe and Round Lake.[4]

Inconclusive evidence indicates that a large number of the earliest immigrants originated in that part of present-day Poland known as Kazuby. Support for this claim is seen in the fact that a hamlet in Renfrew County is called Kaszuby. The Kazuby region in Poland lies to the west of the Vistula River and touches the Baltic Sea on the north. It is the home of the Kazubians, a distinct Slavic racial group who have retained their language and customs throughout a long history of oppression.[5] In the light of current knowledge, it seems likely that this was the homeland of the original Polish settlers, especially since Kazubian cultural tenacity would explain the surprising survival of Old World ways, including the language, in the Renfrew communities.

The Kazubian peasant tradition has much in common with that of Germany and other parts of north-central Europe. The traditional house in Kazuby was built of squared logs in the same northern European manner that was widely adopted in North America. The interior plan was similar to the German, with a utilitarian kitchen and a large central room for all other family activities. The kitchen itself was dominated by a raised cooking hearth in a corner position. Kitchen furnishings included a table and benches (placed against the wall), dish racks, dish dressers or *kredens*, food cupboards and pail benches. The major room would contain: a stove, a table or *stol*, chairs or *zydel*, a storage chest or *skrynia*, a wardrobe or *szafa*, and the best bed. More prosperous houses might perhaps afford some element of formality, such as a more elaborate table and chairs for dining. In houses with a separate bedroom, the bed would be replaced in the main

LIX Polish, Kazuby region – farmhouse interior, 19th century. [E.M.T.]

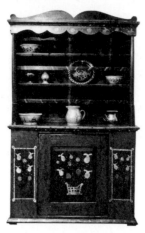

LX Polish, Kazuby region – dish dresser,
19th century. [E.M.T.]

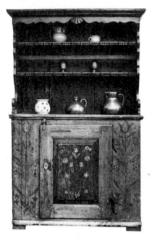

LXI Polish, Kazuby region – dish dresser,
19th century. [M.K.K.]

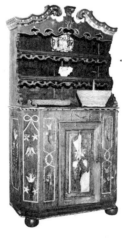

LXII Polish, Kazuby region – dish dresser,
19th century. [E.M.T.]

room by a bench-bed, or *szlaban*. As in many European peasant traditions, the house would have similar, but separate, accommodation for the older generation. But the furnishings did not move with the generations, and the houses, therefore, changed little throughout the years.

Basic Kazubian traditional forms are found throughout Poland, Germany, Czechoslovakia, Hungary, Romania and Yugoslavia, and regional vernacular expressions might place specific emphasis on one form or another, as was noted, for example, in the German tradition. Kazubian craftsmen developed their own unique interpretation of the naïve Baroque style that was popular in the Baltic region. The Baroque spirit is seen in the complexity of the interesting off-set arches and scrolls of arched pediments on dish dressers and wardrobes. Similar waltzing rhythms are visible on sofa backs and storage chest bases as well as in the finials and simply carved fans, shells and leaves that adorn the basic forms.

Also consistent with Baroque idiom in the European peasant tradition is the elaborate painted decoration concentrated in Poland in particular on dish dressers, wardrobes, storage chests and chairs. The Kazuby region style is based on floral motifs which frequently take the form of bouquet and basket arrangements. These elements are connected to the overall design by painted panels and the use of dramatically contrasting colours on mouldings and other structural details. Stylized in both form and colour, these motifs are articulated in a naïve manner when compared with other areas where professional painters were part of the local craft tradition. The colours, nonetheless, are pure and brilliant with rich backgrounds of burgundy, Prussian blue, brown and green.

While it is important to recognize that some pieces are more typical of other regional styles, many of the forms that have been found in the Polish farmhouses in Renfrew County are direct descendants of those in collections of nineteenth century Kazubian furnishings in Poland.[6] The construction characteristics in the Renfrew materials are seen in most examples of craftsmanship in Kazuby. The use of soft wood is traditional, and the marks of the hand-plane may be seen on the backboards of cupboards and chests. Few nails are used, most joints are mortised and tenoned or dovetailed, and mouldings are secured by wooden pins. The top edges of drawer sides are often moulded and the corners of case pieces are often chamfered with lambs-tongue stops. Typical hardware includes turned or carved square wooden knobs and the butt-hinges are cast in the standard design. Although the forged rat-tail hinge is seen on some Polish Kazubian pieces, it is not common in Renfrew.

Further comparison of the Renfrew Kazubian pieces with homeland examples establishes a similarity in painted decoration, extending to both the floral bouquet compositions and the simple, stylized technique. Many examples of painted decoration in Renfrew are likely the work of a single person[7] or family, since the same floral bouquet appears in different colours on many nearly identical storage chests (Plate 1254). The technical proficiency of these decorations, however, varies sufficiently that different people may have copied an original design. Other chests use simple, stencil-like flowers and sun and star motifs in linear panels with looped corners also reminiscent of Polish Kazubian examples (Plate 1252). Only one decorated dish dresser is known from the Wilno area, and the flower and vine design on it is somewhat disorganized and the technique insecure. It was, perhaps, a rather tentative effort to re-create a distant memory. However, the peasant decorative mood is retained in other dressers and cupboards that combine several colours to give emphasis to the Baroque character of form and detail (Plate 1231).

Glazed dish dressers were widely adopted in Upper Canadian Polish settlements, a departure from the country tradition of the homeland.

Glazed cupboards were not ordinarily used in Poland until the last quarter of the nineteenth century when glass became readily available in rural areas. The use of glass in Renfrew suggests the Renfrew dressers date from the last decades of the nineteenth century, by which time Polish immigrants would have been accustomed to glazed dressers.

Renfrew storage chests were made in only two of the many different styles seen throughout Poland. These are, first, the simple six-board type with a high, shaped bracket base; and second, those displaying three panels on the front and having a more refined bracket base of dovetailed construction. The first is very typical of nineteenth century Kazubian chests, but the panelled style is rarely found in that area. A type of panelled effect is more often achieved in Kazuby by painting than by actual framed and panelled construction.

In the Wilno area of Upper Canada, several wardrobes and cupboards have been discovered that display influences from Polish forbears. These incorporate the Baroque arched pediment and columns at the corners running from the base to the typical finials. As forms, they are protractions of the traditional *szafa*, found in many different Polish styles which are not dissimilar to the German *Schränke*. These early traditional Polish wardrobes are painted and decorated, while the later, more stylish types related to the Wilno pieces are usually decorated only with woodgrain patterns.

The Polish vernacular contains several table forms, very like those of most of Central Europe, which remained fairly constant during the eighteenth and nineteenth centuries. In the Kazubian region, the sawbuck or "X" stretcher style was the most widespread in country applications. One of the most puzzling inconsistencies in the relationship between Wilno and Kazubian furnishings is the absence of Renfrew tables showing traditional origins. The tables which are found in Renfrew County in some numbers have cleated tops, secured by pegs to the tapered-leg base. The skirt is fitted with one or two drawers and may be scalloped, shaped or straight with a Rococo bracket at the junction of skirt and leg (Plate 1244). This distinctive style is not seen among the furniture in Polish collections and is unfamiliar to authorities consulted there, although smaller tables with tapered legs and shaped skirts do occur there, particularly in southern areas.

The Baroque influence is also visible in the low-post bed that usually occurs in Polish peasant homes. The posts themselves are quite simple, but the finials are held in common with the cupboards. The solid or panelled head and foot boards copy the flamboyant pediment profiles of the cupboards and wardrobes. A few of these vernacular beds appear in the Renfrew area, yet complete survivals are rare (Plate 1261).

Polish tradition also stresses the bench-bed. Despite the fact that it is very like the Irish settle-bed, the Polish version does not fold forward by means of hinges at the base, but rather the seat slides away from the back, forming a box-like bed. The Polish style usually has an open back, pleasingly varied with splats or grillwork, and the arms often curve outward in a graceful scroll consistent with other Neoclassical elements that occur in the nineteenth century Continental vernacular. A number of these carefully crafted benches have been discovered in the Renfrew communities, but only one example is known to have survived intact. The high mortality rate and the frequent instance of repair and modification suggest that these bench-beds were in continual use over many years in Upper Canadian Polish homes (Plate 1249).[8]

Other popular Polish vernacular seating forms are plank chairs and related benches, which are the same as those found in Germany and other parts of Central Europe. It is both intriguing and puzzling to find that these basic, common traditional forms are not often found in Polish Upper

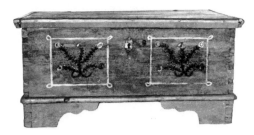

LXIII Polish, Kazuby region – storage chest, 19th century. [M.K.K.]

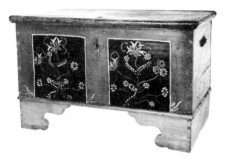

LXIV Polish, Kazuby region – storage chest, 19th century. [E.M.T.]

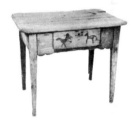

LXV Polish – table, 20th century. [P.M.E.]

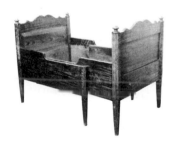

LXVI Polish – bed, 19th century. [M.K.K.]

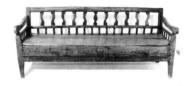

LXVII Polish – settle-bed, 20th century. [P.M.E.]

Canada, just as they are absent from the Germanic traditions in Canada. The rare examples of seating forms which have been preserved in the Renfrew area include a country-Neoclassical style which enjoyed some popularity in Poland around the last half of the nineteenth century. Among these are the plank-seated *Klismos* chair and a related sofa form in which elements from the Grecian style and those from the prevalent Baroque are intuitively combined by careful craftsmanship to produce a very satisfying result (Plate 1250).

Various small furnishings are found in the Renfrew settlements which incorporate the decorative naïve Baroque influence. Utilitarian pail benches, clock shelves and wall cupboards are memorable and distinctive for their exuberantly scalloped and scrolled designs. Hanging cupboards and reliquaries were fashioned as miniature versions of large case pieces with their scrolled pediments and other decorative details reproduced in small.

Comparatively speaking, the consistency of construction and style that existed in the nineteenth century furniture tradition of rural Poland makes it extremely difficult to assign a date or attribution to the Wilno furnishings. That is, several different craftsmen might produce almost identical objects at widely separated times, both in Poland and in Upper Canada. The name of John Kozloski is frequently mentioned by the older Wilno generation as the maker of dish dressers and other pieces for their homes.[9] One small wall cupboard bears the inscription, "Made on the Mud Flat by John Kozloski." Certainly, many of the glazed dressers appear to be the work of the same man, as do a large number of the storage chests. It is probable that John Kozloski or his workshop made a major part of this remarkable group of furnishings. In a period of over fifty years that is represented in these pieces, however, it is clear that several craftsmen were active and that some of them brought influences from different locations in northwestern Poland.

The chests, dressers, cupboards, tables and other furnishings from the Wilno area of Renfrew County are important to the history of Upper Canadian furniture for several reasons. They are pleasing examples of provincial craftsmanship that must be admired for their own qualities – qualities that place some of them in the upper level of North American country furniture. In style, construction and decoration, they compare favourably with the traditional furniture of the Kazubian homeland. It is amazing that some of these objects, with their exotic peasant flavour, were created on the remote northern edge of the Canadian Shield when the Renfrew community numbered less than two hundred souls. It is even more remarkable to consider that this tradition has survived into our own century within one hundred miles of the capital city of Canada. The Renfrew-Wilno furnishings comprise a small but extremely significant contribution to the total of Upper Canadian furniture.

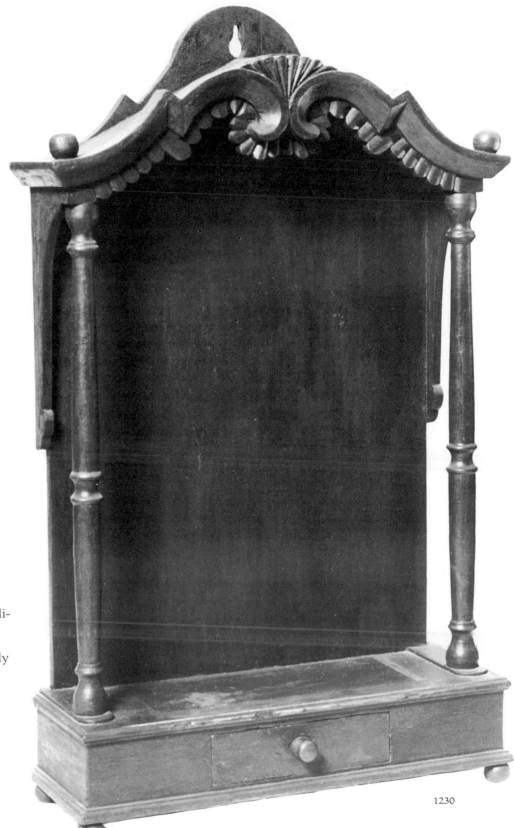

1230 A reliquary from the Wilno area in Renfrew County. Made to hold a religious figure, the traditional Baroque idiom has inspired a rich variety of decorative details which are charmingly combined in this architectural design. Second half 19th century. [P.C.]

1230

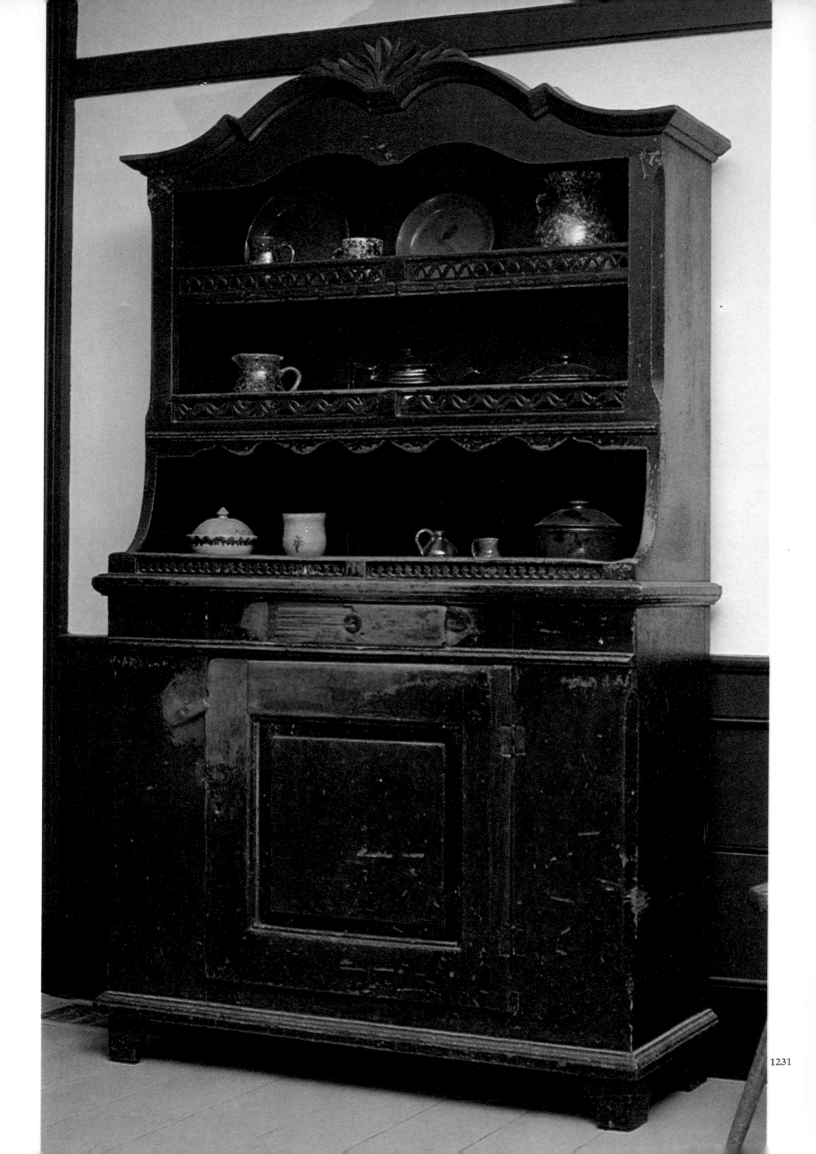

1231

1231a

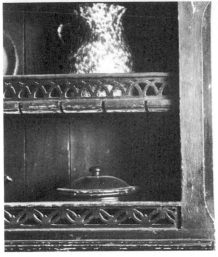
1231b

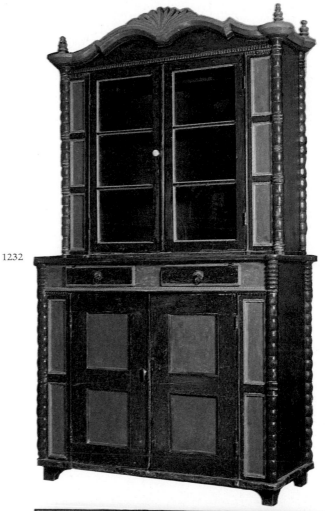
1232

1231 A dish dresser (*kredens*) from the Wilno area in Renfrew County. This is a fine expression of the provincial Baroque style which was central to the rural tradition in northeastern Europe in the 18th and 19th centuries. The characteristic carved and scrolled pediment, fret-cut galleries, lapped doors and drawers and chamfered corner details are combined with confident traditional craftsmanship. Third quarter 19th century. [P.C.]

1232 A glazed dish dresser from the Wilno area in Renfrew County. The Baroque idiom is enthusiastically explored here in the scrolled and carved pediment and finials which are related at the four corners to boldly turned columns. The tradition of colourful surface decoration is simplified to the use of vibrant blue, vermilion and ochre, gaily applied to the complex structure. Second half 19th century. [C.F.C.S., M.O.M., N.M.O.C.]

1233 A glazed dish dresser from the Wilno area in Renfrew County. This is the only known example of traditional floral decoration on a Renfrew cupboard. The use here of vine-like motifs on the major panels, in light colour against the deep red background, is consistent with Kazubian examples. Second half 19th century. [P.C.]

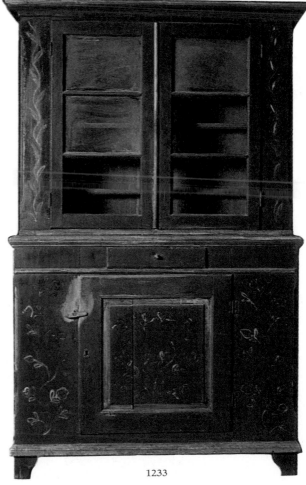
1233

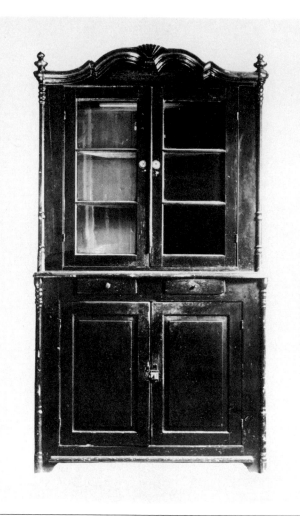

1234

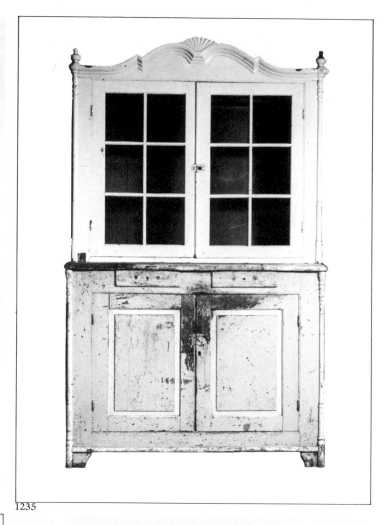

1235

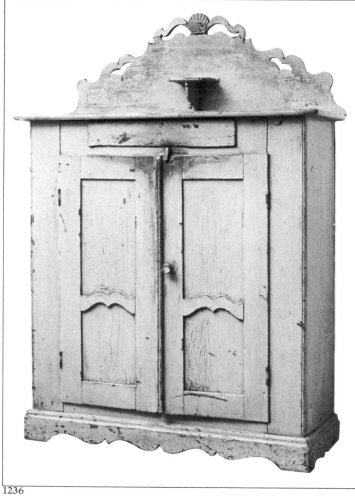

1236

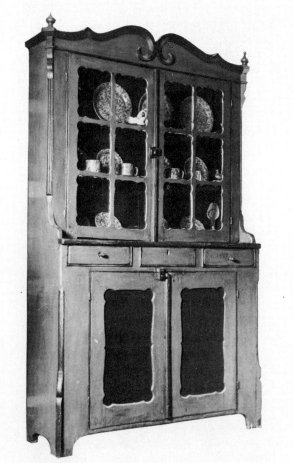

1237

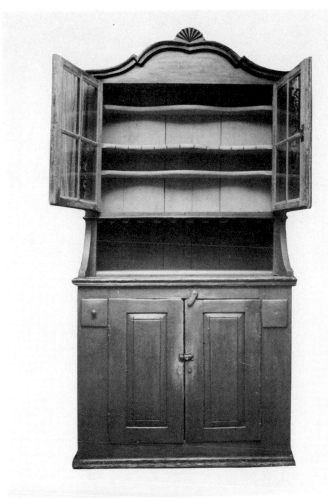

1238

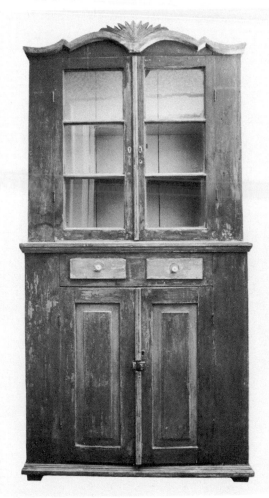

1239

1234 A glazed dish dresser from the village of Kazuby in Renfrew County. This cupboard is attributed by local tradition to John Kozloski. Several cupboards are known which combine the same plan, scrolled pediment with fan carving, turned corner columns, finials and construction details. Second half 19th century. [C.F.C.S., M.O.M., N.M.O.C.]

1235 A glazed dish dresser from Renfrew County. Almost identical to the last design with the addition of vertical glazing bars. Second half 19th century. [P.C.]

1236 A buffet cupboard from the Wilno area in Renfrew County. This form is unusual in the Renfrew community, although it does relate to buffet-like cupboards in the Polish tradition as well as to the small wardrobes. The scrolled backboard design is subtly reflected in the shaped door panels. Second half 19th century. [P.C.]

1237 A glazed dish dresser from the Wilno area in Renfrew County. The pediment in this design is a departure from the typical, since the completed scrolls meet as the central feature. The chamfered corners are extended with shaped brackets creating a diagonal emphasis which was popular in the European tradition. Similarly, the Rococo shaping of the door-framing was widely used there in the later part of the 19th century. Second half 19th century. [P.C.]

1238 A glazed dish dresser from Round Lake in Renfrew County. Found in a lodge auditorium, it bears the inscription *L F T* on the frieze. This design is basically the traditional open dresser form with glazed doors added. The shelves are shaped with spoon racks on one of them. The two small drawers are not original but are early additions, and the pie shelf brackets and fan are restored. Second half 19th century. [P.C.]

1239 A glazed dish dresser from the Wilno area in Renfrew County. This is a simple design with the scrolled pediment, drawers and door panels broken out in blue from the overall red colour. Late 19th century. [P.C.]

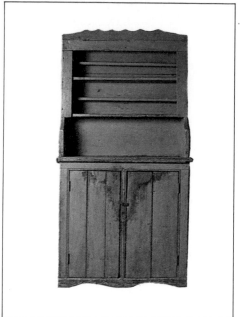

1240

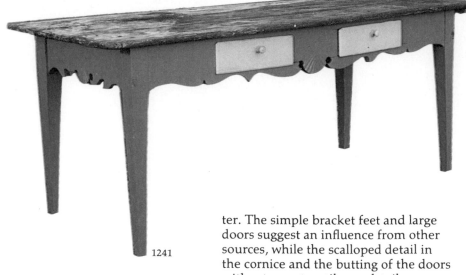

1241

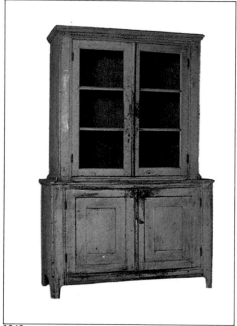

1242

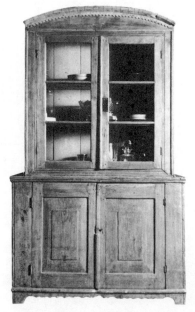

1243

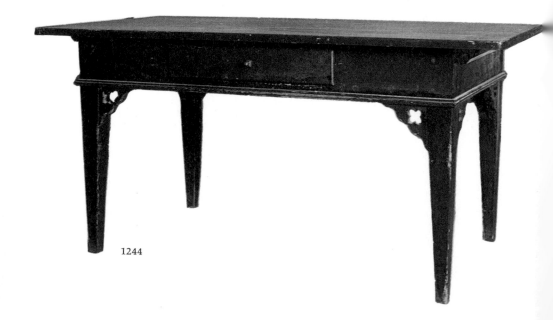

1244

1240 A dish dresser from the Wilno area in Renfrew County. This simple design relates to the homeland tradition in its simply shaped pediment but more particularly in the form that provides a deep counter space between the lower cupboard and the dish rack. Second half 19th century. [P.C.]

1241 A table from Renfrew County. The scrolled shaping and fan detail, which are commonly seen on the dressers and wardrobes, are adopted here to provide traditional decorative emphasis all around the apron. The top boards are nailed directly to the table frame, rather than cleated and pegged in the traditional manner. Late 19th century. [P.C.]

1242 A glazed dish dresser from the Wilno area in Renfrew County. This design does not relate to the traditional dresser and is of a more formal charac-

ter. The simple bracket feet and large doors suggest an influence from other sources, while the scalloped detail in the cornice and the butting of the doors without a centre stile are details seen on traditional wardrobes. Wooden-pin construction throughout. Second half 19th century. [P.C.]

1243 A glazed dish dresser from the Wilno area in Renfrew County. The carefully arched pediment and scalloped skirt are decorative features from the tradition. In other details of plan and construction, this example is similar to the one before. Second half 19th century. [P.C.]

1244 A table (stol) from the Wilno area in Renfrew County. The distinctive features of this fine example of the typical Wilno table are the shaped brackets between the apron and the square tapered legs. Consistent with the European tradition, the top is cleated and pegged to the frame. A single drawer is lapped and a horizontal emphasis is created at the bottom edge of the apron with an applied moulding. Second half 19th century. [P.C.]

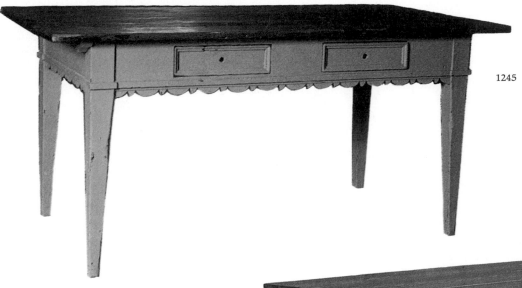

1245 A table from Renfrew County. This design is related to traditional Polish prototypes in its decorative scalloped apron. The cleating is of the heavy, dovetailed type, and the drawer fronts are framed with moulding. Second half 19th century. [P.C.]

1246 A table from the Wilno area in Renfrew County. Similar in style to the preceding examples, this table shows minor variation in detail and retains its original brown, green and burgundy paint. Second half 19th century. [P.C.]

1247 A table from Renfrew County. This is likely an early example among this group of tables, as the cleating is of the sturdy, traditional, dovetailed type. Second half 19th century. [P.C.]

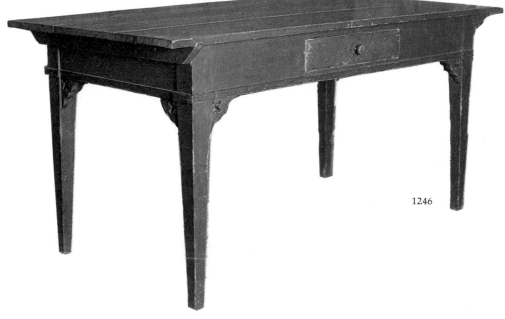

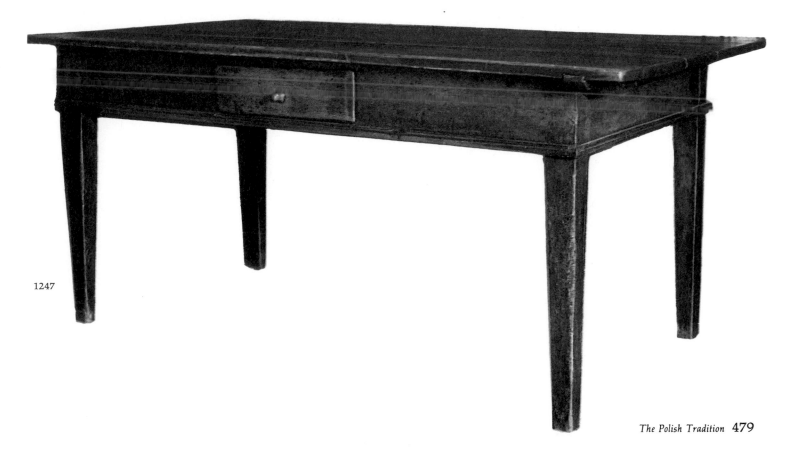

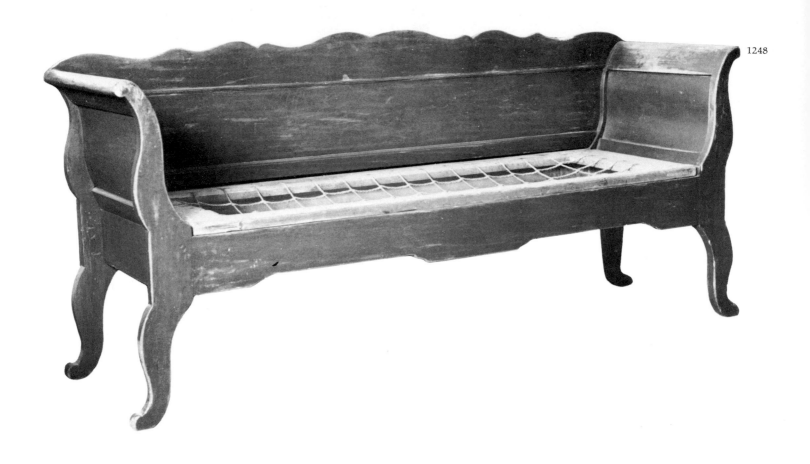

1248

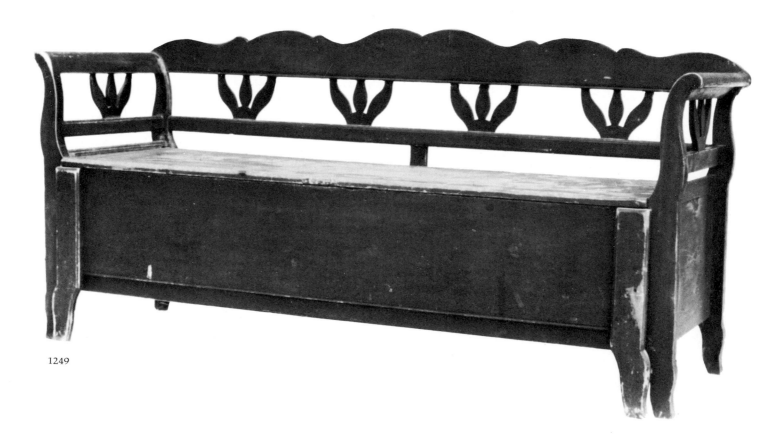

1249

1248 A sofa (*lawa*) from Wilno in Renfrew County. Found in an early inn built of logs. The Neoclassical style of the scrolled arms and legs is combined with a familiar Baroque line on the backboard, producing a pleasing hybrid. The seat frame with roping is original. Second half 19th century. [P.C.]

1249 A settle-bed (*szlaban*) from the Wilno area in Renfrew County. The settle- or bench-bed was an important form in the homeland tradition throughout the 19th century. This design brings Neoclassical style elements together with Baroque flourishes consistent with the country vernacular. Unlike the Irish settle-bed which folds forward from the base, here the seat lifts up and the front slides forward like a trundle bed. Second half 19th century. [P.C.]

1250 A side chair (*zydel*) from the Wilno area in Renfrew County. This provincial interpretation of the Classical *Klismos* form is a rare example of a chair made in the Wilno community. Although not of traditional importance, this universally popular style was widely used in rural Poland in the 19th century. Made of oak. Late 19th century. [P.C.]

1251 A bench from Wilno in Renfrew County. Benches were widely used as seating in the early Polish settlements, just as they were in the German. This example of the traditional trestle-end form includes a busy shaped apron of naïve Baroque character. Second half 19th century. [P.C.]

1250

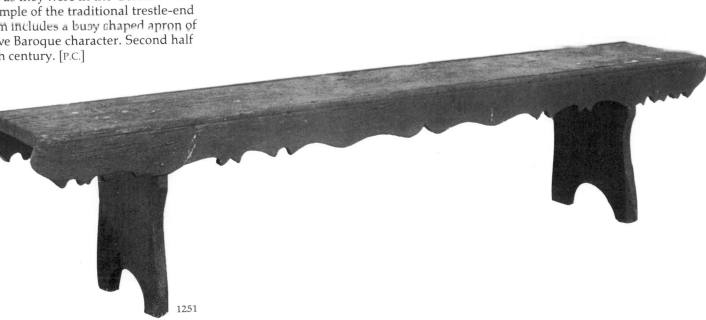

1251

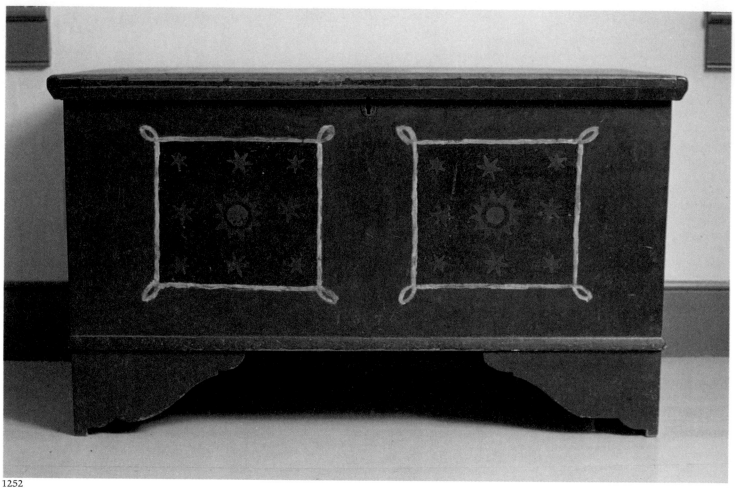

1252

1252 A storage chest (*skrzynia*) from Wilno in Renfrew County. In form, construction and decoration, this example relates directly to the style of Kazuby in northern Poland. The box is dovetailed and mouldings are applied with wooden pins. The decorative panels outlined with loops at the corners are a distinct regional character-istic. See prototype on page 471. Second half 19th century. [P.C.]

1253 A storage chest from the Wilno area in Renfrew County. Similar to the last illustration, this chest is butt-joined and nailed. Second half 19th century. [P.C.]

1254 A storage chest from the Wilno area in Renfrew County. This panelled design is found in considerable numbers in the Wilno community. The boxes are dovetailed with framing applied to create the panels, and the base is a separate dovetailed structure. The painted decoration includes various combinations of colours and back-ground techniques with a recurring floral motif. Second half 19th century. [P.C.]

1255 A Wilno storage chest. Second half 19th century. [P.C.]

1256 A Wilno storage chest. Second half 19th century. [P.C.]

1257 A Wilno storage chest. Second half 19th century. [P.C.]

1258 A Wilno storage chest. Second half 19th century. [P.C.]

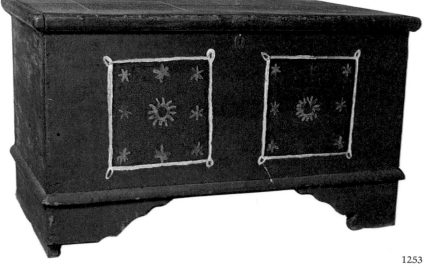

1253

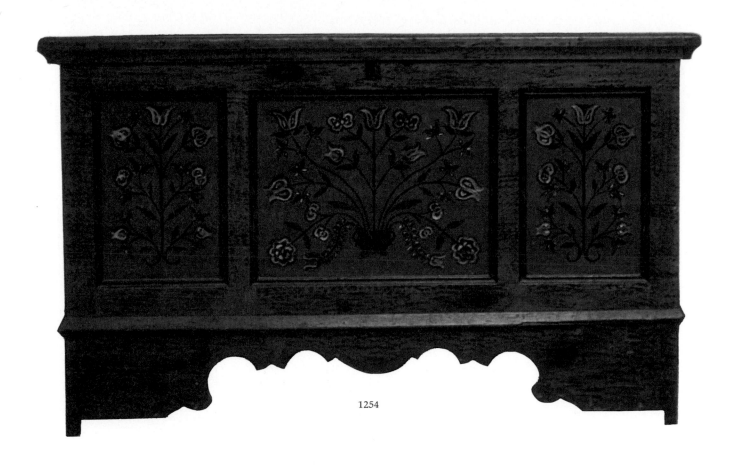

1254

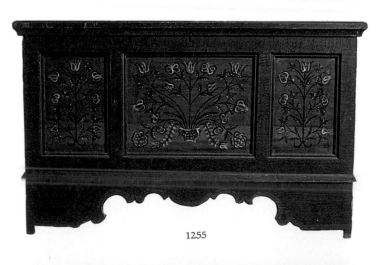

1255

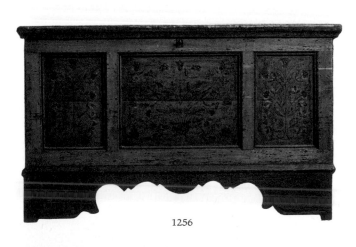

1256

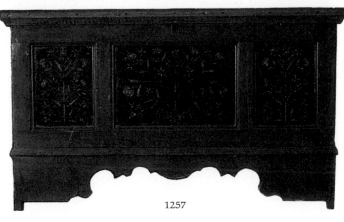

1257

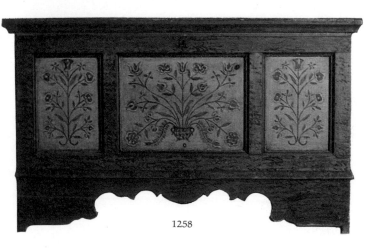

1258

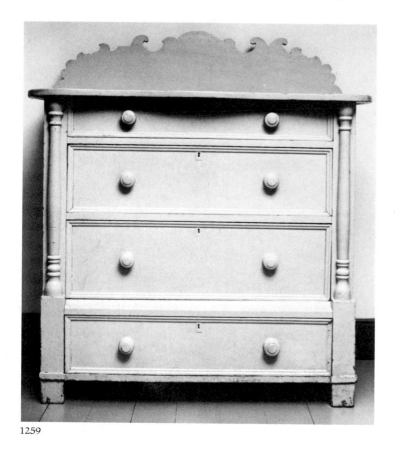

1259

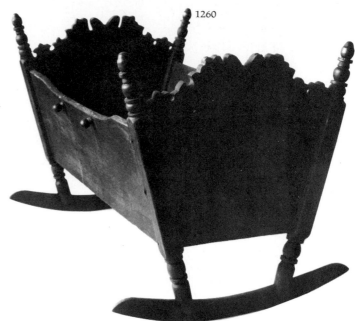

1260

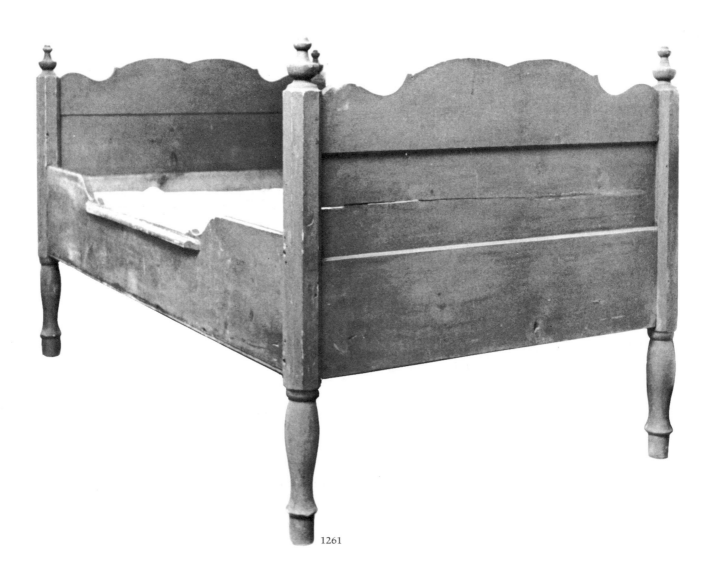

1261

1259 A chest of drawers from the Wilno area in Renfrew County. This was not a familiar form in the homeland tradition, so the Polish craftsman combined the typical mid-19th century chest form with an arrangement of split columns with heavy plinth and stepped-out bottom drawer taken from traditional Polish wardrobe design. The scalloped and scrolled backboard is less formal in character, borrowed as it is from traditional designs for utilitarian objects. Second half 19th century. [P.C.]

1260 A cradle (*kolyska*) from the Wilno area in Renfrew County. The traditional cradle design mirrors that of the bed with fret-cut end boards and turned posts. Second half 19th century. [P.C.]

1261 A bed (*lozko*) from the Wilno area in Renfrew County. Found in the same house as the open dresser in Plate 1231 this design is similarly linked to the homeland tradition. The identical panelled and shaped head and foot boards, turned and chamfered posts and deep, shaped side boards are the distinctive features. Second half 19th century. [P.C.]

1262 A wardrobe from Barry's Bay in Renfrew County. In this imposing design, influences from late Neoclassical style are superimposed on the traditional style in the heavy split columns and architectural character. The interior is fitted with one shelf and wooden pegs for hanging clothes. Late 19th century. [P.C.]

1263 A wardrobe from Renfrew County. This simple wardrobe shows a simplification of detail consistent with a late date but retains a Baroque character in the fluid scrolls of its pediment and carved fan. Late 19th century. [C.F.C.S., M.O.M., N.M.O.C.]

1264 A wardrobe (*szafa*) from the Wilno area in Renfrew County. Unassuming refinement of detail and confident traditional craftsmanship are apparent in this small wardrobe. The division of the large single door into panels is an interesting departure from the tradition, probably inspired by Upper Canadian architecture. Second half 19th century. [P.C.]

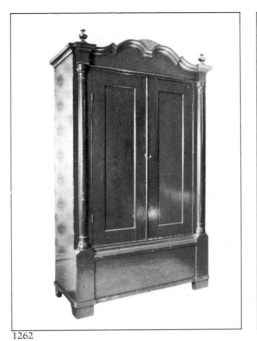
1262

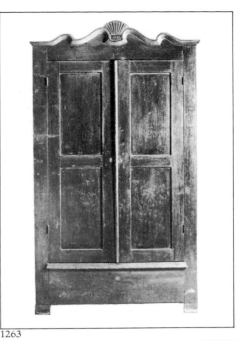
1263

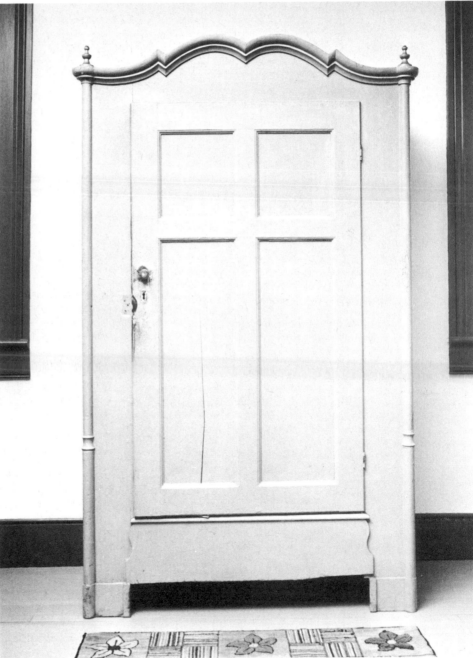
1264

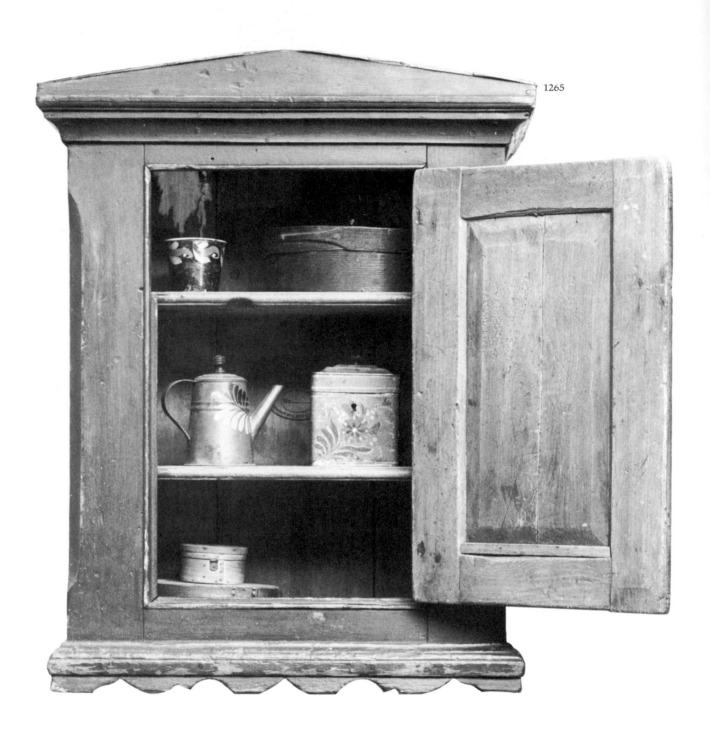

1265

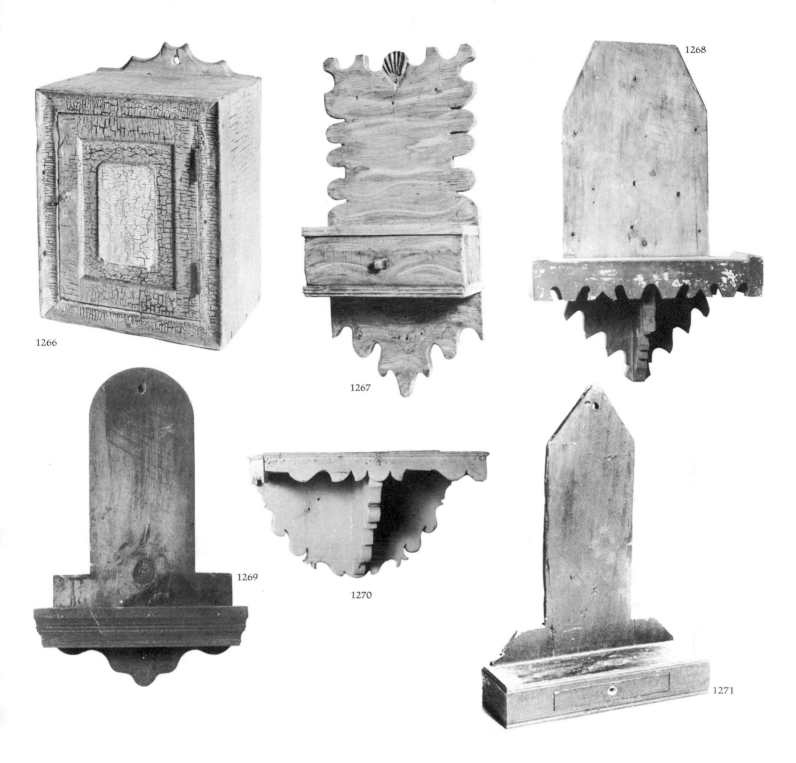

1265 A hanging cupboard from the Wilno area in Renfrew County. This small cupboard is a perfect miniaturization of one of many wardrobe styles in the rural Polish tradition. The peaked pediment above a moulded cornice is popular, as is the chamfered corner detail and the base moulding over a shaped skirt and foot. Second half 19th century. [P.C.]

1266 A hanging cupboard from the Wilno area in Renfrew County. This cupboard hangs from a scalloped extension of the backboard. The door, with shaped and raised panel, is surrounded by a picture-frame moulding treatment. Dated 24th March 1882. [P.C.]

1267 A clock shelf from the Wilno area in Renfrew County. This primitive expression of the traditional theme includes simple fan carving on the scrolled backboard. The ends of the shelf compartment are reeded and the front slides to open. Second half 19th century. [P.C.]

1268 A clock shelf from Wilno in Renfrew County. Probably made for an American "OG" mantel clock, this design, joined by wooden pins, is a very individual and naïve expression of traditional style. Second half 19th century. [P.C.]

1269 A clock shelf from the Wilno area in Renfrew County. Neatly scrolled with moulded shelf. Second half 19th century. [P.C.]

1270 A clock shelf from the Wilno area in Renfrew County. The Rococo profile of this simple structure captures a clear impression from the past. Second half 19th century. [P.C.]

1271 A clock shelf from the Wilno area in Renfrew County. This well-crafted shelf of restrained design is an unusual departure from the typically decorative tradition. Second half 19th century. [P.C.]

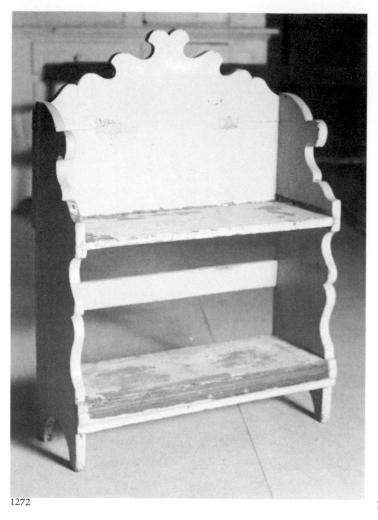

1272

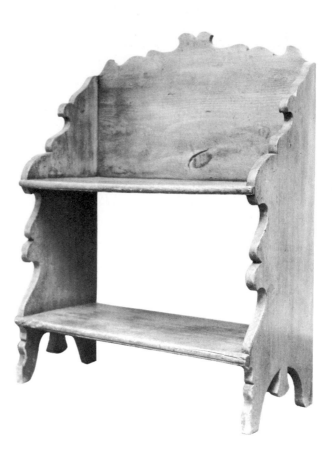

1273

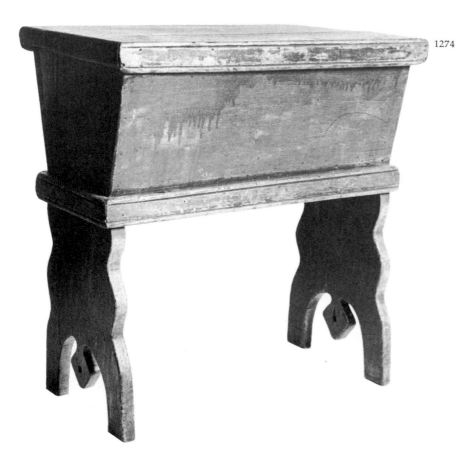

1274

1272 A pail bench from the Wilno area in Renfrew County. A pleasing combination of Rococo scrolls. Second half 19th century. [P.C.]

1273 A pail bench from the Wilno area in Renfrew County. Likely by the same maker as the previous example. Here, his careful craftsmanship is visible in the housed joints, moulded edges and crisp fretwork. Second half 19th century. [P.C.]

1274 A dough box from the Wilno area in Renfrew County. This trestle-end style occurs widely in European tradition. The similarity of the foot design in the preceding plate is interesting. Second half 19th century. [P.C.]

6 The French Canadian Tradition

Fifty years or more before the British created the Province of Upper Canada in 1791, there were French settlers in the western part of the region, along the Detroit River. These settlements were organized under seigneurial tenure and, due to the protection offered them by Fort Detroit, were able to prosper and become largely self-sufficient.

By the end of the eighteenth century, good land was scarce in Lower Canada, because of the dramatic growth of the French Canadian population that resulted from one of the highest per capita birth rates ever recorded. Many French Canadians, whose families had formed the seigneuries of what was to become the Province of Quebec, were attracted to the newly formed upper province by the availability of cheap farmsites and by jobs in the lumber industry. These early French Canadian settlers moved into the eastern counties of Prescott, Russell and Carleton along the Ottawa River. Later, pockets of French Canadian settlement occurred right across the province. With the exception of a number who settled near the old French communities in Essex County in 1837, settlers from Lower Canada moved to the northern frontier of current settlement. These lands were the most inexpensive and they were often near the centre of lumbering operations. As a result, there were northern townships of primarily French Canadian make-up in Lanark, Frontenac, Lennox and Addington, Hastings, Victoria, Simcoe, Waterloo and Perth counties.

The French Canadian furniture tradition that flowered in the late seventeenth and eighteenth centuries arose from a nucleus of artisans who had arrived with the first colonists from France. The furnishings they made were in the provincial French tradition and were similar to the basic forms of other European cultures. The chest and the armoire were used for the storage of clothing and linens; the buffet (glazed or solid-doored), the dresser (*vaisseliers*) and the food locker contained dishes, utensils and food. There were different table forms used with benches and chairs, while the familiar forms of high- and low-post beds as well as cradles were also crafted. Utility pieces, such as wall shelves, wall boxes, dough boxes, bucket benches and spinning wheels, completed the range of provincial furnishings.[1] In more prosperous houses, commodes, desks, clocks and other more formal furnishings would be used in addition to the traditional forms.

All of these were made by the French Canadian woodworkers in the French country style, but they also included influences from the court furnishings of the Louis XIII, XIV, XV and XVI periods. In addition to the skilled joiners who had come to Canada from France, there were the woodcarvers who provided the richly carved panels, cornices and other decorative elements which were just as central to the French tradition as painted decoration in other European cultures.

Until the last quarter of the eighteenth century, the furniture of French Canada was a pure extension of the Continental tradition. The English conquest brought an influx of skilled Scottish, Irish and English joiners and cabinetmakers to Lower Canada; they were soon producing furniture in the popular eighteenth century English styles, at the same time that American influences were introduced from the New England states. These new styles were adopted by the French Canadian elite and had an immediate impact

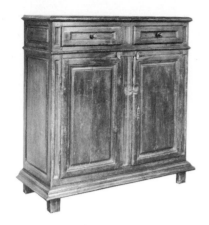

LXVIII Quebec – buffet bas,
late 18th century. [P.C.]

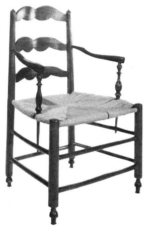

LXIX Quebec – armchair à la Capucine,
mid-19th century. [C.D., R.O.M.]

on the French Canadian craftsman. While the traditional French forms continued to be made throughout most of the nineteenth century, many pieces made after 1790 have a strong English influence. The deeply carved diamond-point panels of the Louis XIII style and the graceful arabesques of Louis XV were replaced by the restrained geometry and Classical motifs of Adam on armoires and buffets. Chests of drawers in the Hepplewhite style and Windsor chairs were soon common; new forms, like the *banc lit* and the rocking chair appeared in the French Canadian kitchen.

By 1830, little of the rich early French tradition was visible in the everyday furnishings made in Lower Canada, and, because this was the time of the major migration to Upper Canada, the same degraded forms were used there. A few very rare examples of the eighteenth century French styles have been preserved from the early Upper Canadian settlements, but the greater part of the French Canadian material is from the later period.

Later furnishings take the form of armoires, chests and buffets, and they are identifiable by their French construction techniques. That is, they are framed and panelled with very heavy corner posts or stiles running from top to bottom and extending below the base moulding as feet. Sometimes the panels are shaped, and the cornices are often complex, with nicely carved dentil, rope and scalloped details. Some pieces possess the hand-forged hardware, like rat-tail hinges, draw bolts and escutcheons so typical of Quebec furniture.

Chests of drawers found in the French areas of Upper Canada frequently display decorative elements and construction details from the Quebec vernacular. For example, the drawers are seldom dovetailed, but are butt-joined and nailed. Drawer fronts are often finished with an applied cock-bead moulding, or given a panelled effect with flat moulding fixed to the face. Decorative characteristics of the Louis XV and XVI styles are seen in the shaping of skirt boards, backboards and bracket feet.

In the eastern counties, a distinctive French Canadian chair style appeared which is a variation of the Capucine style and has squared and chamfered posts and shaped splats. The seats are either woven elm bark or hide, and the backs are raked to produce a simple, yet comfortable and attractive chair. Other chairs occasionally discovered in the eastern counties are the product of a curious marriage between Scottish country Sheraton and arms and other elements from the rural French style. These interesting hybrids are found in the earlier settlements in Carleton, Glengarry, Prescott and Lanark counties where French Canadians and Scots settled in close proximity.

An imported form from Lower Canada, the *banc lit* was widely used by the French in Upper Canada. As has been discussed earlier, the *banc lit* form was probably due to Irish influence in Quebec, and is likely a nineteenth century addition to the vernacular there. Since French Canadian settlements in Upper Canada were often near those of the Irish as well as the Scots, who also adopted the settle-bed, many examples are found in these areas. The French Canadian *banc lit*, however, may be identified by its smaller scale, panelled construction and open back with splats and arms reminiscent of rustic Québecois chairs.

Of all the national groups in Upper Canada, the French Canadian presence is least visible in the survival of a distinct furniture tradition. This may be explained by the fact that many French Canadian immigrants were transients involved in lumbering and other industries requiring frequent movement. This did not encourage or permit the development of traditional communities. It is true, as well, that many of the centres of French settlement were extensions of earlier, well-established communities where furnishings and other requirements of life were already readily available.

The demand for carpenters and builders during the mid-nineteenth century had a tendency to take French Canadian furniture-makers away from their craft, just as it did with many immigrant craftsmen from other backgrounds. Nevertheless, a distinctive French flair may be discovered in a variety of furnishings from different parts of the province where French Canadians settled, and rare examples of traditional French Canadian forms do exist.

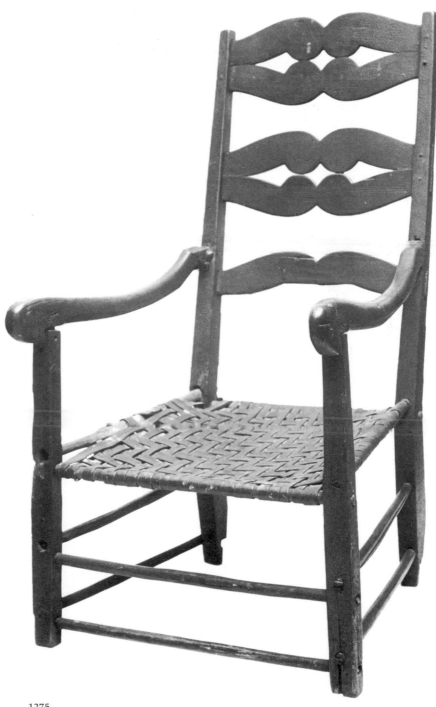

1275 An armchair "A La Capucine" from Niagara-on-the-Lake in Lincoln County. This rustic, French Canadian chair survives with associations to the first Legislative Council in the Simcoe era, according to local tradition. It is much worn, with damage to the bottom back splat, back stretcher and feet. 18th century. [N.H.S.M.]

1275

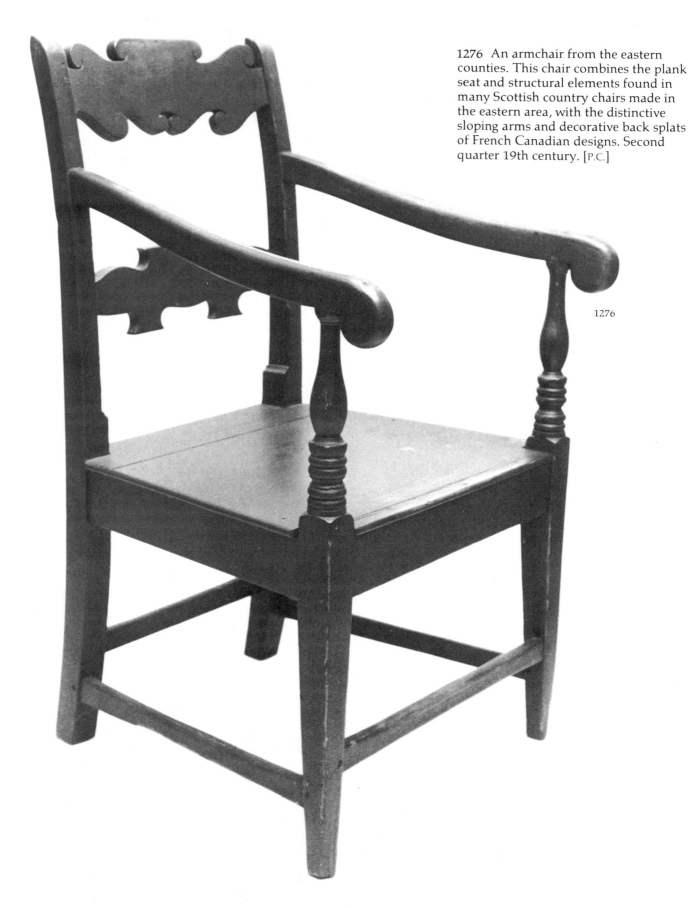

1276 An armchair from the eastern
counties. This chair combines the plank
seat and structural elements found in
many Scottish country chairs made in
the eastern area, with the distinctive
sloping arms and decorative back splats
of French Canadian designs. Second
quarter 19th century. [P.C.]

1276

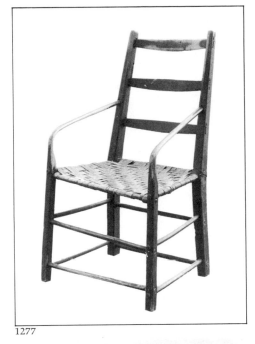

1277

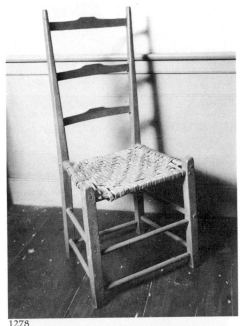

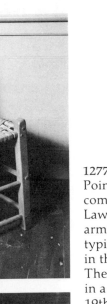

1278

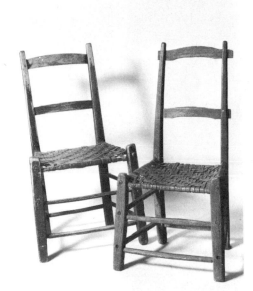

1279

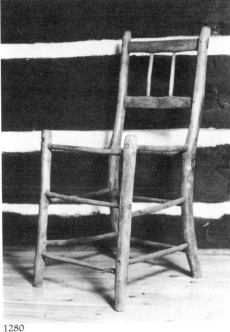

1280

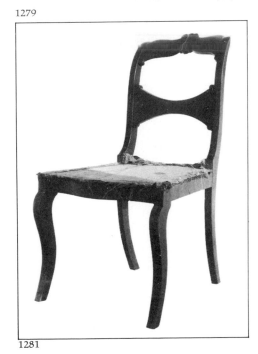

1281

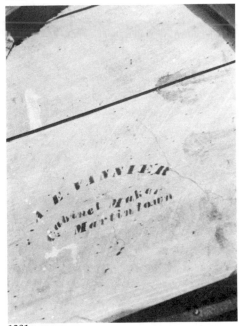

1281 a

1277 A slat-back armchair from Farrans Point in Stormont County. This community was flooded by the St. Lawrence Seaway project. The sloping arms and simple slat-back design are typical of rustic chairs made in Quebec in the late 18th and early 19th centuries. The integration of the front leg and arm in a single element is noteworthy. Early 19th century. [P.C.]

1278 A slat-back side chair from the eastern counties. This is a pleasing example of the slat-back style which was popular in Lower Canada throughout the 19th century. It is frequently found in the areas of French settlement in Ontario. Early 19th century. [P.C.]

1279 Slat-back side chairs from Glengarry County. Small, low, rustic chairs of French Canadian style. Late 18th or early 19th century. [G.C.M.]

1280 A rustic side chair from Muskoka County. Found in an area of French settlement, this primitive example shows the influence of 19th century American style in the design of the back, as do many rural Quebec designs. Mid-19th century. [P.C.]

1281 A side chair from Martintown in Glengarry County. Stamped, *A. E. Vannier, Cabinet Maker, Martintown*. This late example of the popular *Klismos* style made by a French craftsman shows a distinctive flair in the back splat and crest rail, which is quite different from those made in other parts of the province. Second half 19th century. [P.C.]

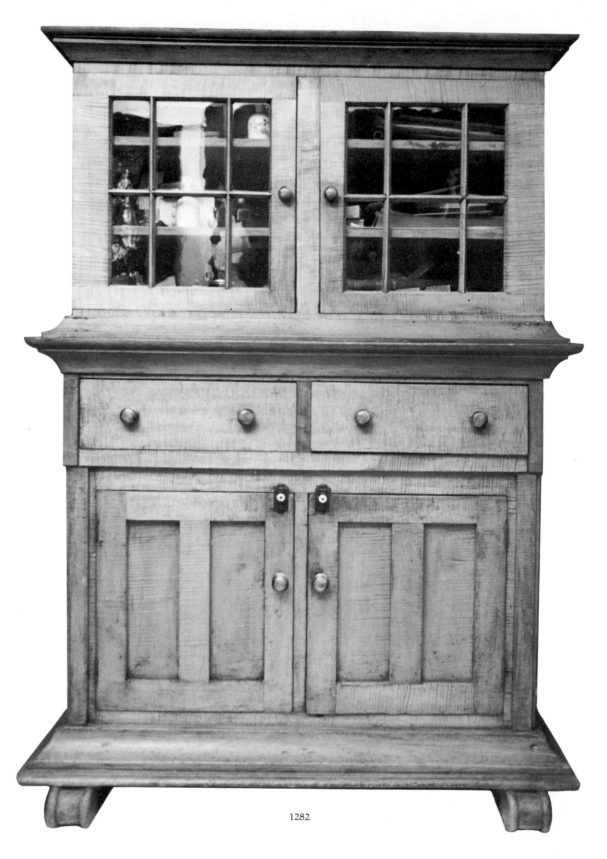

1282

1282 A glazed buffet from Prescott County. This unique design shows a strong influence from 18th century French Canadian style in the overall plan, proportions and in the use of heavy mouldings at the base, waist and cornice. The scrolled feet and stepped-out drawer section with simple pilasters below are Empire influences which were popular in 19th century Quebec. Second quarter 19th century. [P.C.]

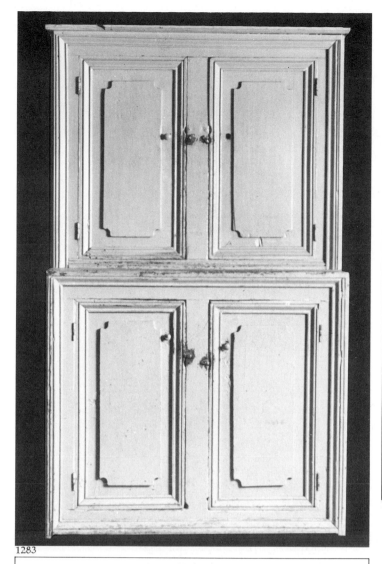

1283

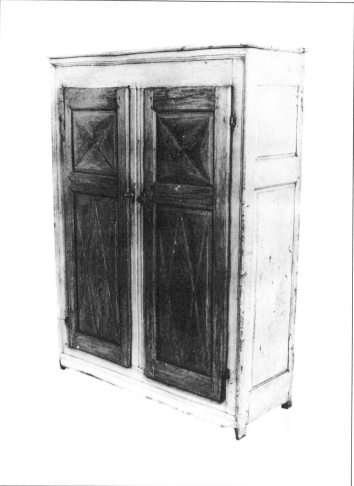

1284

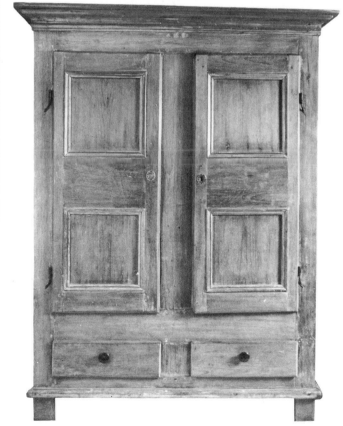

1285

1283 A buffet from Pembroke in Renfrew County. This design is typical of the simplification of earlier traditional styles which is seen in provincial French Canadian furnishings made in the 19th century. An impression of the richly crafted early style is achieved by the repetition of applied mouldings which create a strong linear shadow effect with the shaped door panels. Second quarter 19th century. [P.C.]

1284 An armoire from Hastings County. This popular 18th century French Canadian style combines diamond-point panels in the doors with simple raised panels on the ends. Examples of this type probably were brought as settlers' effects by French Canadian immigrants, but such simple examples of the early style may well have been made on arrival. Late 18th century. [P.C.]

1285 An armoire from Maxville in Glengarry County. Typical French traditional construction is seen in the heavy post framing of this 19th century armoire. The lapped and panelled doors and forged rat-tail hinges are also distinctive features of provincial French Canadian craftsmanship. Early 19th century. [P.C.]

1286 An armoire from the eastern counties. This simple design with dentil cornice and plain panelled construction is typical of the traditional forms made by French Canadians under the influence of 19th century Anglo-American styles. Second quarter 19th century. [P.C.]

1287 A buffet from Lanark County. This is a 19th century expression of a traditional French Canadian form with characteristic post construction and complexity of panel details. Second quarter 19th century. [P.C.]

1288 An armoire from the Penetanguishene area in Simcoe County. This is a late example of traditional, French Canadian form and construction. The bracket base, of English influence, is applied over the heavy post feet and the corners are moulded as quarter columns. Mid-19th century. [P.C.]

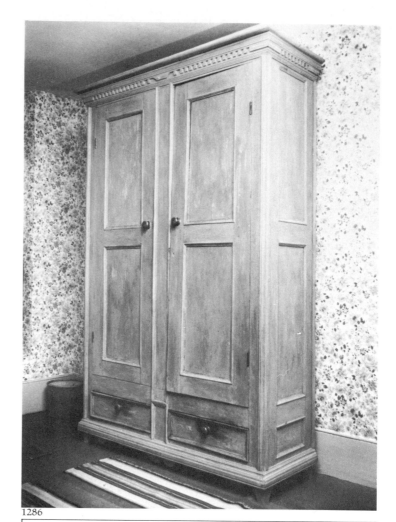

1286

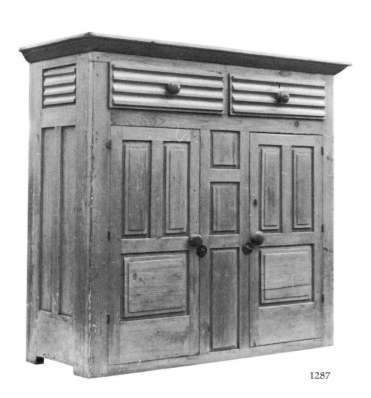

1287

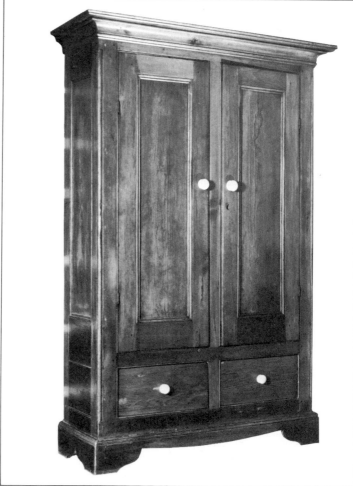

1288

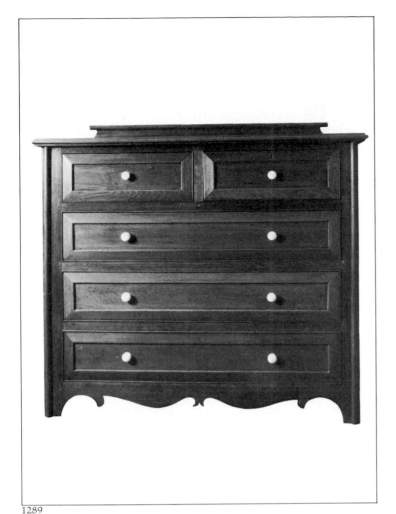

1289

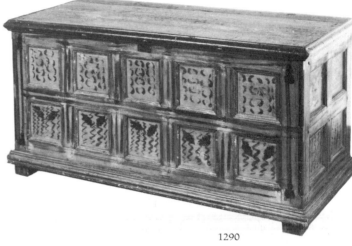

1290

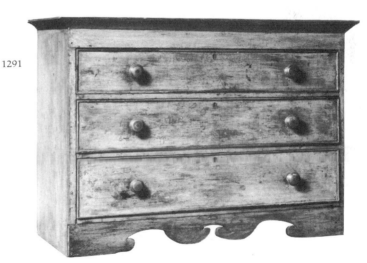

1291

1289 A chest of drawers from La Fontaine in Simcoe County. Made for the Catholic rectory in this French community, this simple design includes a complex shaped skirt, moulded drawer fronts and cock-beading which were popular elements in mid-19th century French Canadian furniture. Mid-19th century. [P.C.]

1290 A storage chest from the eastern counties. Specific origin or associations are unknown. The style and construction, however, leave little doubt that this chest belongs to the French Canadian tradition. Early 19th century. [C.D., R.O.M.]

1291 A chest of drawers from Prescott County. The shaping of the bracket base and cock-beaded drawers are typical French Canadian details in this simple country chest of characteristic low, wide proportions. Early 19th century. [P.C.]

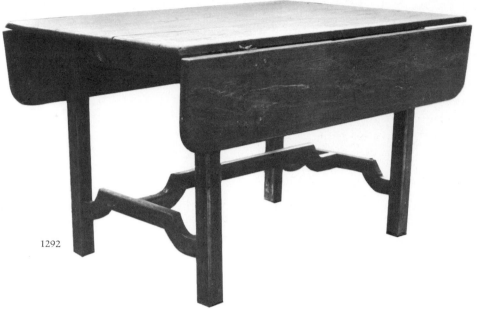

1292

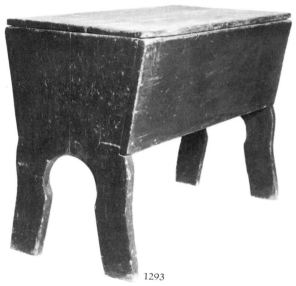

1293

1292 A rustic table from Prescott County. A naïve impression of the turned, stretcher-base style of 18th century fashion. First half 19th century. [P.C.]

1293 A dough box from Glengarry County. This style was popular in 18th and 19th century French Canada. First half 19th century. [P.C.]

1294 A settle-bed or *banc lit* from Hawkesbury in Prescott County. This distinctly French Canadian version of the form, which was likely adopted from the Irish immigrants, has the small scale and rustic charm often seen in rural Quebec chairs and benches. Second quarter 19th century. [P.C.]

1294

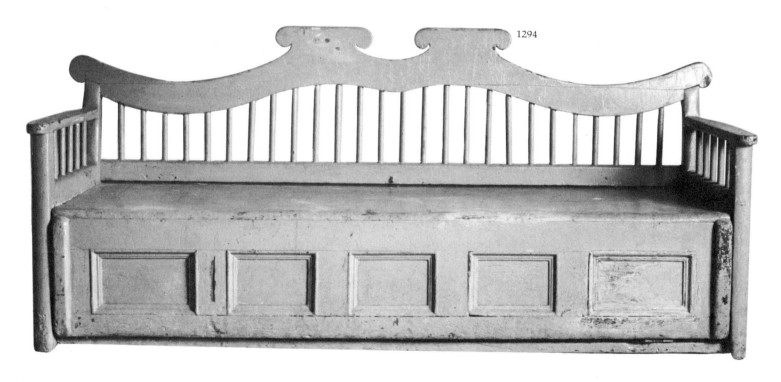

7 Furniture from Other Lands

The first permanent dwellings in Upper Canada were related to the early military establishment. Part of the tradition of the British Colonial Service was that the officers should live in some comfort, and therefore considerable effort was spent creating an environment which embodied familiar elements, no matter how remote the location. Although some of the furnishings of this environment were made to standard British Ordinance designs by military craftsmen stationed in Upper Canada, many important items were brought from England. Senior officers, for example, were able to move their own personal furniture with them, particularly such items as chests and beds. A subaltern was allowed one and a half tons of gear; a captain, three tons; a major, lieutenant-colonel or colonel, five tons; and a general, ten tons.[1] Little furniture survives with a definite connection to these early military locations, but in centres such as Niagara, Kingston and Perth, eighteenth century pieces with traditional military associations are not uncommon.

Early government officials and Church of England clergy were part of the British colonial mentality that felt a strong motivation, if not a sense of responsibility, to create a little bit of old England in the far-flung parts of the Empire. Despite the fact that early comments suggest that furniture for these privileged groups was made by local craftsmen in native hardwoods, possessions from England were as necessary to their concept of the genteel life as they were to the military. Early sale advertisements offered the furnishings of both military and government personnel, including such items as elegant mahogany four-poster bedsteads on casters, dining, card and Pembroke tables, presses, wardrobes, double-keyed harpsichords and pianoforte,[2] descriptions which clearly denote old country origins. The inclination to base security, prestige and a sense of style on furnishings brought from Britain lasted well into the nineteenth century among some immigrants of British background and above average means. Pensioned military personnel and Anglican clergymen, for instance, arrived with a level of sophistication and wealth which enabled them to establish homes in Upper Canada that would not have been out of place in the English, Scottish or Irish countryside.

Thomas W. Magrath, an early Irish settler in Erindale, observed in 1831 of his family's immigration that their luggage "totalled 7 tons, 3 cwts!!! The largest quantity ever landed by a single family on the wharf at York"[3] This amount must have included furnishings in some quantity.

Even immigrants of modest means brought utilitarian furniture, apparently assuming that it would not be available in the province, as indicated by the following early observation:

Other parties, supposing that furniture must necessarily be expensive in a new country, bring all the old lumber they can lay their hands on. Some even carry their folly to the extreme of carrying out with them their heavy kitchen tables and dressers, long school-room desks, etc., — (do they fancy timber is *scarce* in Canada?) and find, to their astonishment and vexation when they arrive in Toronto, or whatever may be their place of destination, that it would have cost them far less to purchase the articles where they intended to settle, than the mere expense of transport; and that it would have been much more to their advantage to have made a bonfire of their goods and chattels than to have brought them across the Atlantic. Common furniture of all kinds is

remarkably cheap; and that of a superior kind is consistently lower in price than the same quality in England.[4]

Little evidence of the "common furniture" mentioned here survives today; most of it was likely replaced by locally made products at an early date.

However, items of special importance continued to be imported. In 1842, the Good family of Brantford requested that their relatives in Ireland select and ship a piano for their newly completed home, "Myrtleville." The London-made instrument (Plate 1321) arrived in the following year to considerable family excitement and pleasure, as indicated by surviving correspondence related to the event.[5] Of course, pianos were available in York, Montreal or New York at this time, but the Good family's preferences indicate just how much old country furnishings were valued by those with a strong sense of British tradition. Tall-case clocks were often brought or sent later by relatives and, like the Scottish example brought to "Woodside" in Markham by the Milne family (Plate 1314), survive as treasured heirlooms.

Imported British furniture is readily identifiable by style and the distinctive characteristics of construction, hardware and material. It is much more difficult to positively identify the much larger quantity of furniture that came to Upper Canada from the United States. American immigration over many years as well as continuous commercial involvement caused a large percentage of the more formal furniture in Upper Canadian homes to be of American manufacture.

Family stories are legion of the clock or chair that was carried through the wilderness by Loyalist ancestors, surviving all sorts of adventures. Often the object does not support the story. Many pieces, however, do reflect their Loyalist associations in style and period. As with the British immigrants, the most common objects the Loyalists brought with them were those with emotional associations, like a tall-case clock (Plate 1311), a favourite chair (Plate 1295), a writing desk (Plate 1319) or a chest of drawers which would have been packed with precious flatware, china and linens. Later immigration from the United States often saw the arrival of immigrants' wagons piled high with equipment and furnishings of all kinds; this was particularly the case with the Conestoga wagons of the Pennsylvania-Germans.

American furniture-makers and dealers maintained a keen interest in the Upper Canadian market from the earliest times. Early correspondence suggests that well-to-do, style-conscious Upper Canadians found the prices, quality and style of furniture available in New York, Buffalo and Rochester most attractive, despite the substantial import duties on manufactured goods. This tendency led to some rather sarcastic nationalistic comments, witnessed by a letter in the *Canadian Freeman* of December 6, 1827:

> The Marquis of Wellesley and Lady Wellesley take a pride in receiving their friends, at Dublin, dressed in home manufacture, and spread before them their splendid entertainments on Irish tables – but the Receiver General of Upper Canada, our "*little* Attorney General" and Lady Strachan, forsooth, must entertain the *little* officials of *little* York, on *Yankee* tables, made in *Buffalo!*[6]

Individual purchases in the stylish American shops often included chairs (Plate 1299), sofas (Plate 1308), dining and parlour tables and case pieces such as chests, secretaries and desks. Most often these were in the American Empire styles so popular in New York State during the first decades of the nineteenth century. Upper Canadian furniture dealers also imported from these sources, and the Yankee pedlar was a familiar sight on the side roads of the new townships.

An important factor in the attractive pricing of American-made pieces

was the much lower cost of mahogany there. This, combined with the larger scale of American manufacturing, made it difficult for Upper Canadian cabinetmakers to compete. Groups of local craftsmen attempted to alter the situation by lobbying for higher tariffs, but they apparently had little success.[7]

The most popular American-made items were fancy and Windsor chairs, clocks and mirrors. Few Upper Canadian homes were without a mantel clock produced in the Connecticut clock-manufacturing complex. The later Victorian and Empire styles and the inexpensive cottage suites produced in the United States were also imported in some quantities; however, local factories quickly began successful competition. Evidence of the productivity of these local manufacturers may be found on stamped and labelled examples from all parts of the country.

During the period 1800 to 1840, stylish furniture was also brought into the province from the older centres in Lower Canada. A highly developed furniture-making tradition existed in Montreal and Quebec City, as well as Nova Scotia and New Brunswick. Montreal had a reputation for style similar to that of the New York State centres, particularly among the well-to-do residents of the eastern counties. In addition, commerce with Montreal had been well established for many years, and it was, after all, the port of entry for British goods. In 1840, the Mathesons in Perth bought a walnut banquet table and chairs in Montreal for their fine new Georgian home (Plate 1305). Two identical mahogany games tables in the Sheraton style purchased for an early Glengarry home are also typical of early nineteenth-century Montreal furniture (Plate 1303). These examples indicate a conservative English influence very different from the more flamboyant American Empire styles then being made in and exported from Buffalo and other northern towns in the United States.

It is interesting to note that Continental Europeans apparently lacked either the means or the inclination to bring furniture from their homelands, the exceptions being chests and some German and Swiss clock-works. These last were brought to Upper Canada and fitted with locally made cases. Overall, their reluctance to import may have stemmed from practicality and the confidence they had in their ability to produce whatever would be required in the new land.

Possibly the most interesting category of furniture brought into Upper Canada is the immigrant chest. Each of the national and cultural groups brought distinctive chest forms from their homelands, many of which were already very old when they crossed the ocean. Surviving examples span several centuries and embody the mystique of treasure, ancient religious symbolism, travel and adventure. The immigrant chest often tells us a great deal about the original owner, while the style identifies the country of origin and often provides an indication of the owner's social and financial status. In some cases, the chest's decoration incorporates the name, date and city of origin or destination. To the Upper Canadian immigrant, the chest was a sturdy container for the essential items needed for the new life and, possibly, for a few mementoes of the old. The chest was frequently the only piece of real furniture in the first crude homes, and many served for some time as storage, bench and table.

There are three categories of furniture brought into Upper Canada from other lands: pieces brought by immigrants as personal effects, family heirlooms sent by relatives over the years, and goods imported by individuals or merchants, mostly from the United States. The first two categories comprise but a small quantity of furniture, but they are both important dimensions of the cultural tradition. The last category accounts for a significant percentage of the furniture of a formal character which survives from the period prior to 1850.

Because of the similarities of style, material and hardware used in Upper Canada and the United States at this time and due to the scarcity of examples with makers' labels or marks, many examples of early furniture which have long associations with local families cannot be definitely identified as Upper Canadian or American. Still, research on a local level often allows the comparison of related examples and results in the identification of a local maker. A great deal more research of this specialized nature is required. Nevertheless, all the furnishings, no matter what their origin, used in the early homes of the province are important facets of Upper Canadian heritage.

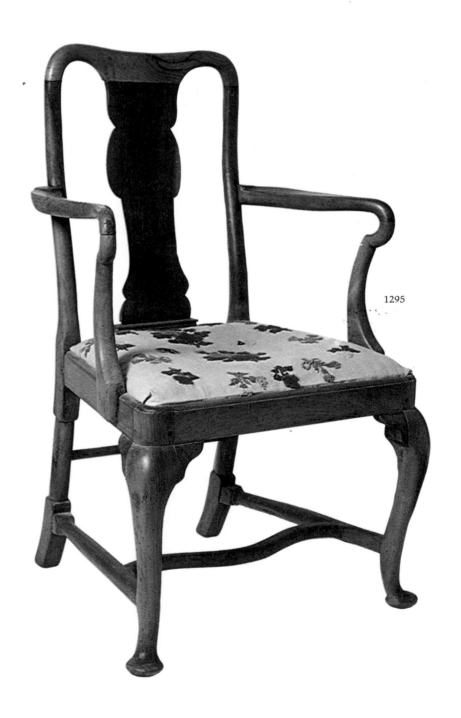

1295

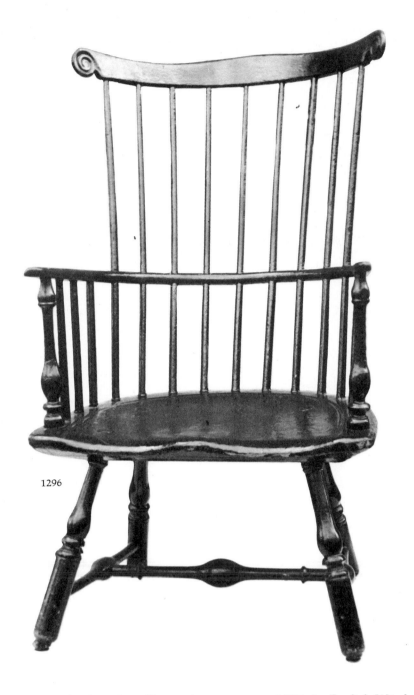

1296

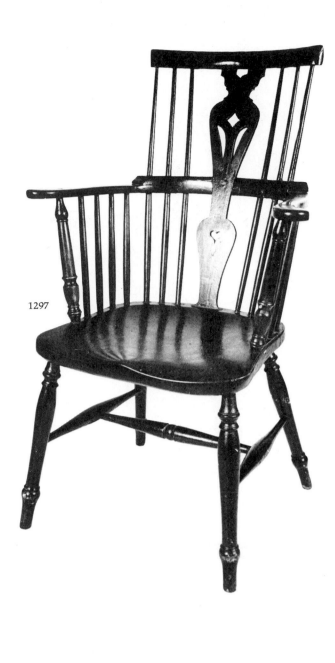

1297

1295 An American Queen Anne armchair. This chair in walnut was found neglected in an early Brockville house, suggesting a long history in Upper Canada. Mid-18th century. [P.C.]

1296 An American Windsor comb-back armchair. This chair arrived in Upper Canada through a Loyalist family from New England via New Brunswick. Damaged feet. 18th century. [P.C.]

1297 An English Windsor comb-back armchair which Sir John Johnson presented to Christina Merkeley and Jacob Ross as a wedding gift in May 1784. 18th century. [C.D., R.O.M.]

1298 An English, Chippendale-Hepplewhite transitional armchair, part of the furnishings of the early Stewart home in Barrie. 18th century. [P.C.]

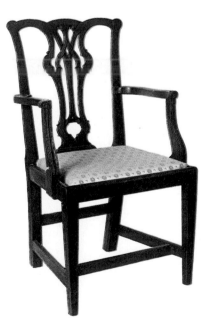

1298

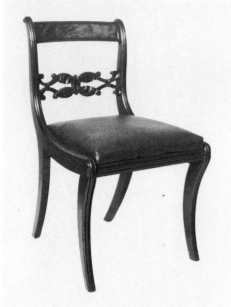

1299

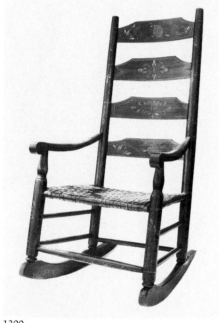

1300

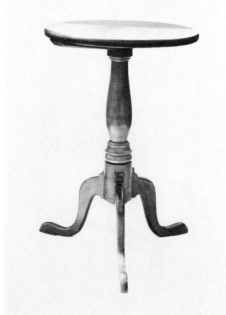

1301

1299 A Neoclassical side chair. One of a set of chairs from Brantford, this refined interpretation of the popular *Klismos* style in mahogany was brought from the United States at an early date. Early 19th century. [P.C.]

1300 A New York State rocking chair. The De Longs, a Quaker family from New York State, brought this decorated chair to Oxford County in the 1820s. 19th century. [P.C.]

1301 A cherrywood candlestand of New York State origin. It was brought to Oxford County by a Quaker settler. Early 19th century. [P.C.]

1302 A tilt-top tea table of New York State origin. This exceptional example of burl maple came to Oxford County with an early settler. Late 18th or early 19th century. [P.C.]

1303 A card table of Sheraton influence. This table in mahogany and another identical example came from an early Glengarry County home and are believed to have been purchased in Montreal. Early 19th century. [P.C.]

1304 A Hepplewhite-style side table in mahogany. Of English or Scottish origin, this table was brought to Perth by an early immigrant. 18th century. [P.M.]

1305 A banquet table and chairs of late Neoclassical style. The Mathesons of Perth purchased this walnut furniture in Montreal for their handsome Scottish Georgian home at Perth, probably in 1840. [P.M.]

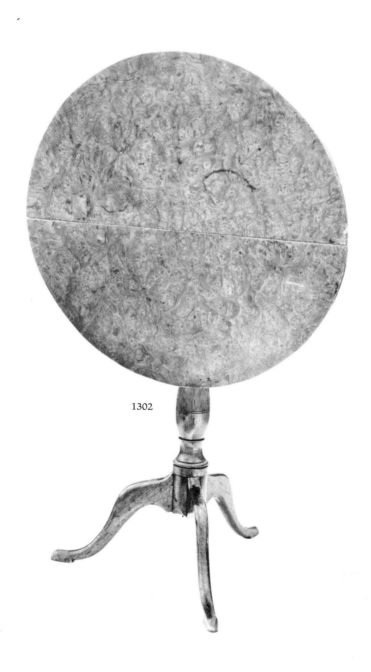

1302

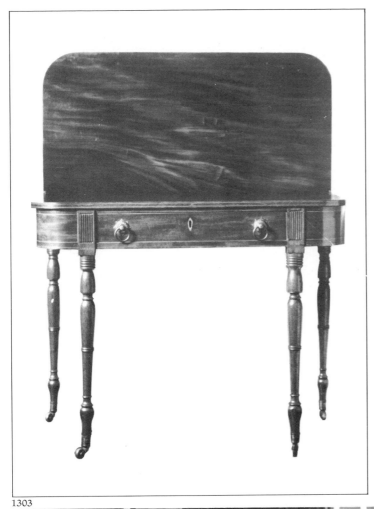

1303

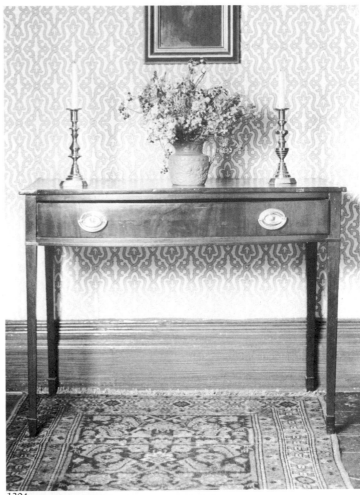

1304

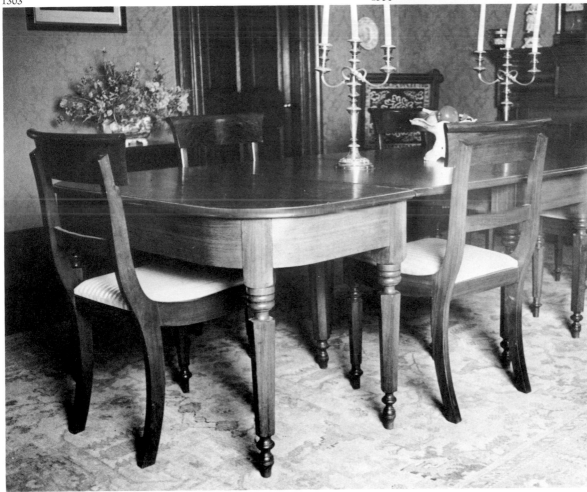

1305

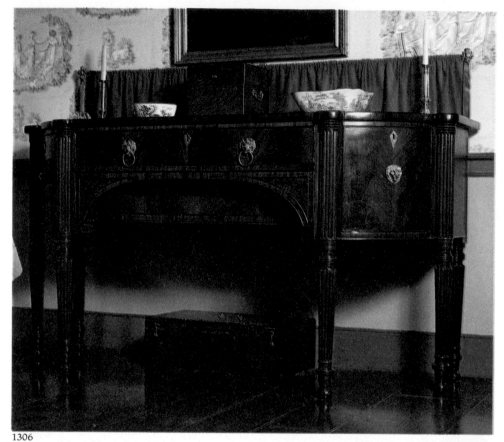

1306

1307

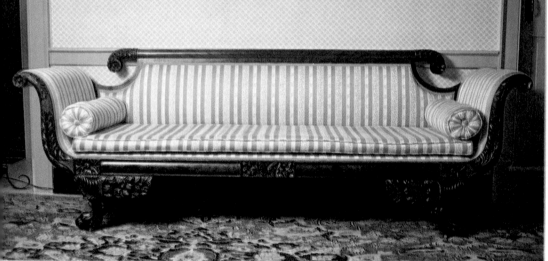

1308

1306 A sideboard of Sheraton influence, probably of English origin. Long associated with an early military family, the Leslies, in Kingston. Early 19th century. [U.C.V.]

1307 A cherrywood secretary of New York State origin. Local tradition indicates that this secretary was the property of an early Lutheran minister, who brought it with him from the United States. This was probably Rev. Herman Hayunga, whose name it bears, who arrived in Dundas County in 1826. Early 19th century. [P.C.]

1308 An American Empire sofa from New York State. Typical of stylish furnishings bought in New York State centres, this sofa was owned by the Dycer family in Beamsville. Early 19th century. [P.C.]

1309 An American Empire sofa. Found in Kingston, this elaborate design in walnut is almost certainly of American manufacture. Early 19th century. [P.C.]

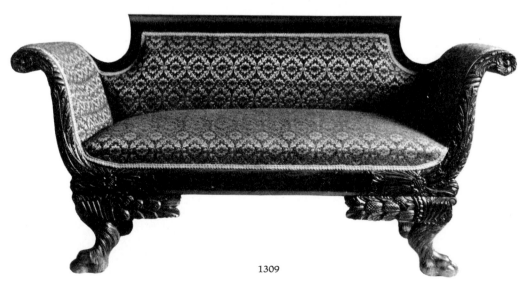

1309

1310 A tall-case clock, marked *S. Thomas, Plymouth.* Brought to Dundas at an early date. The inscription, *Pro Regiat Grege*, and symbolic decoration on the door suggest Loyalist sentiments. Early 19th century. [P.C.]

1311 An 18th century tall-case clock. This fine walnut clock was brought to the Niagara Peninsula from New Jersey by C. Book in 1797. 18th century. [P.C.]

1312 A Philadelphia tall-case clock. Associated with the Martin family who settled in Waterloo County. 18th century. [P.C.]

1313 A tall-case clock by J. & H. Twiss of Montreal. Painted pine cases, usually with wooden movements, were produced inexpensively and in great numbers by the Twiss family in Lower Canada and Connecticut. Some were sold in Upper Canada. Early 19th century. [U.C.V.]

1314 A Scottish tall-case clock. This large oak and mahogany clock was sent by relatives to "Braeside," the early Markham home of the Milne family. Late 18th or early 19th century. [P.C.]

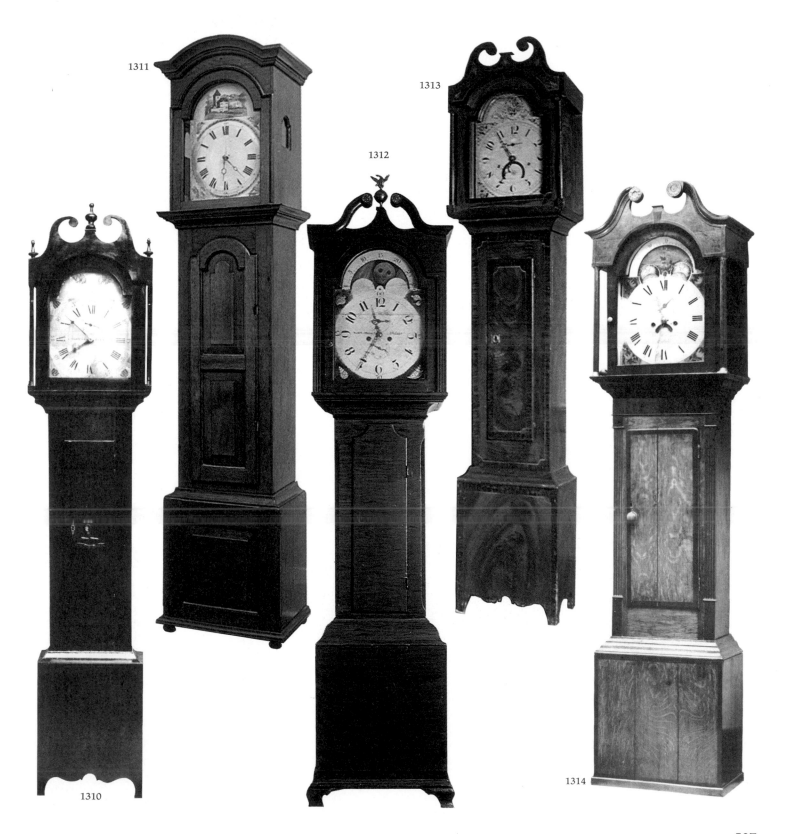

1311

1313

1312

1310

1314

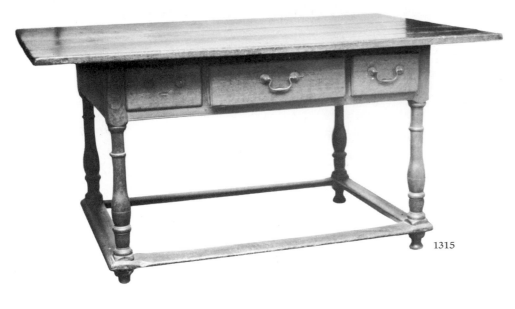

1315 A Pennsylvania peg-top table with box stretchers. A Pennsylvania-German immigrant brought this walnut table to Black Creek near Niagara Falls. 18th century. [N.H.S.C.]

1316 An 18th century draw table of American origin. This fine early table in walnut and maple was found in Guelph. [P.C.]

1317 A pair of brass andirons. These fine andirons survive from the Peterborough County home of Catherine Parr Traill and are probably English. Mrs. Traill observed in *The Canadian Settlers' Guide*, "If you wish to enjoy a cheerful room, by all means have a fireplace in it. A blazing log fire is an object that inspires cheerfulness." 18th century. [P.C.]

1318 An oak spinning wheel of Irish origin. Wheels such as this one, which was brought to the eastern counties, could be dismantled and packed in a chest and were among the most important items in settlers' effects. 18th century. [U.C.V.]

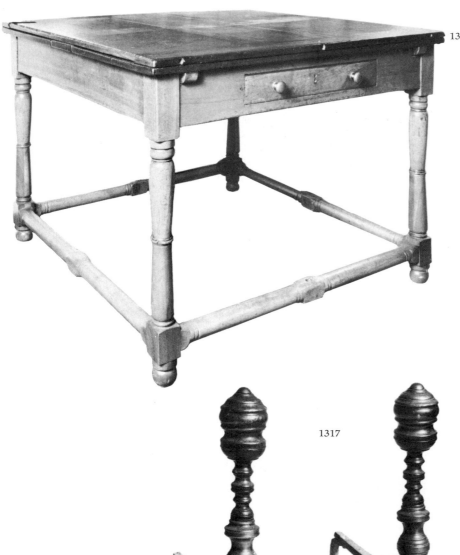

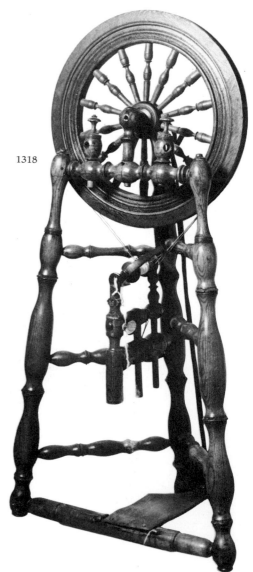

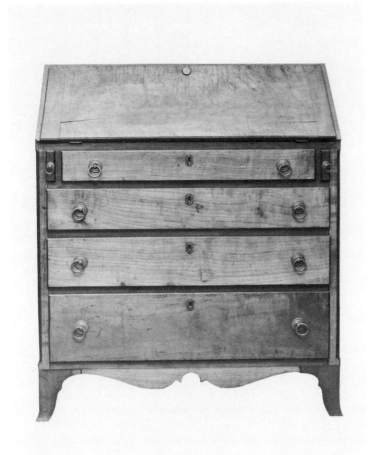

1319

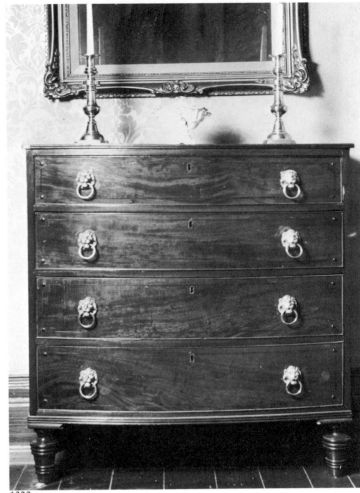

1320

1319 A slant-front desk in cherry and figured maple of American origin. Brought as settlers' effects to the western counties. Late 18th or early 19th century. [P.C.]

1320 A bow-front chest of drawers in mahogany. Of British origin, this chest was brought to Perth by Colonel Taylor, the first postmaster there. Early 19th century. [P.M.C.]

1321 A piano of London manufacture. In the 1840s, it was sent from Ireland by relatives of the Good family for their new home, "Myrtleville," in Brantford. Second quarter 19th century. [P.C.]

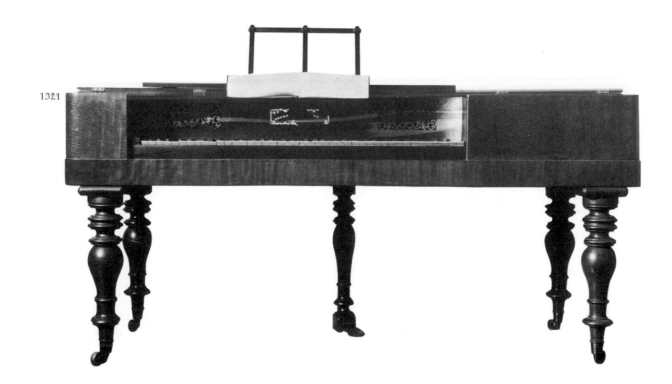

1321

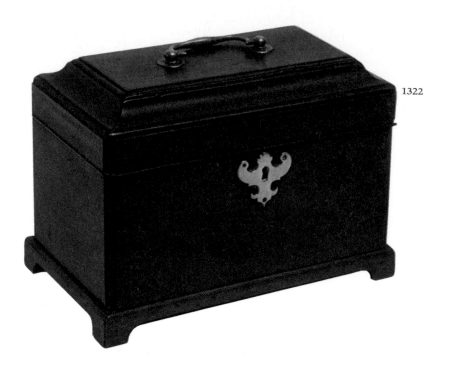

1322

1324 An architectural mirror of Sheraton influence from the eastern counties. Of American or British origin. Early 19th century. [P.C.]

1325 An architectural mirror of American origin. This provincial design alludes to Sheraton elegance. It comes from an early farm home at Quaker Hill in Ontario County, an area of settlement from the United States. Early 19th century. [P.C.]

1326 An American Empire mirror. Mirrors of this modest character occur in some numbers in those areas where connections with the United States were maintained, particularly among the Pennsylvania-Germans. This mirror belonged to the Honsberger family in Lincoln County. Second quarter 19th century. [P.C.]

1327 A mirror of American origin. From the Hausser home in Haldimand County. Second quarter 19th century. [P.C.]

1328 An American pillar and scroll mantel clock. A popular style made by Seth Thomas in Connecticut, this clock was brought to Dunnville by the Pettit family. Early 19th century. [P.C.]

1329 An American mantel clock made by Henry Terry in Connecticut. Clocks of this type were moderately priced, and many were sold in Upper Canada by local merchants and travelling pedlars, while many were brought as settlers' effects. This one was owned by the MacPherson family in Beaverton. Early 19th century. [P.C.]

1330 An American mantel clock made by Elisha Hotchkiss in Connecticut. Owned by Peter Amey, a second-generation Loyalist, of Lennox and Addington County. Second quarter 19th century. [P.C.]

1331 An American mantel clock made by Seth Thomas in Connecticut. This clock bears the label of Vantassel, Brockville, C.W., who, like other local merchants, bought clocks directly from American manufacturers who prepared special labels for them. Second quarter 19th century. [P.C.]

1332 An American mantel clock made by Seth Thomas in Connecticut. This clock in a popular style bears the label, *Made for and sold by R. W. Patterson & Co., Toronto, Canada West.* Second quarter 19th century. [C.M.R.P.D., M.H.F.]

1322 A tea caddy in walnut. Found in Northumberland County; the nature of early settlement there, as well as the style and material of the object, suggest an American origin. Late 18th or early 19th century. [P.C.]

1323 A bride's box from Germany. This beautiful example of traditional German decoration was brought to the western counties. Second quarter 19th century. [P.C.]

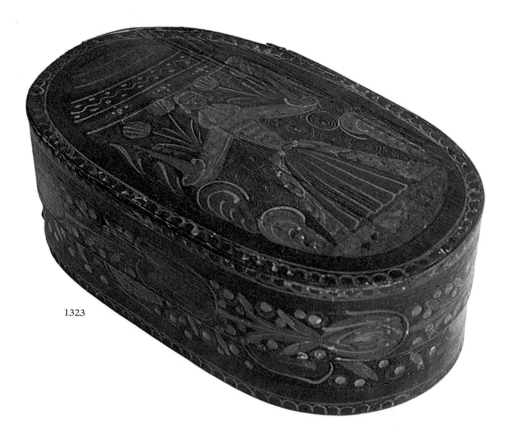

1323

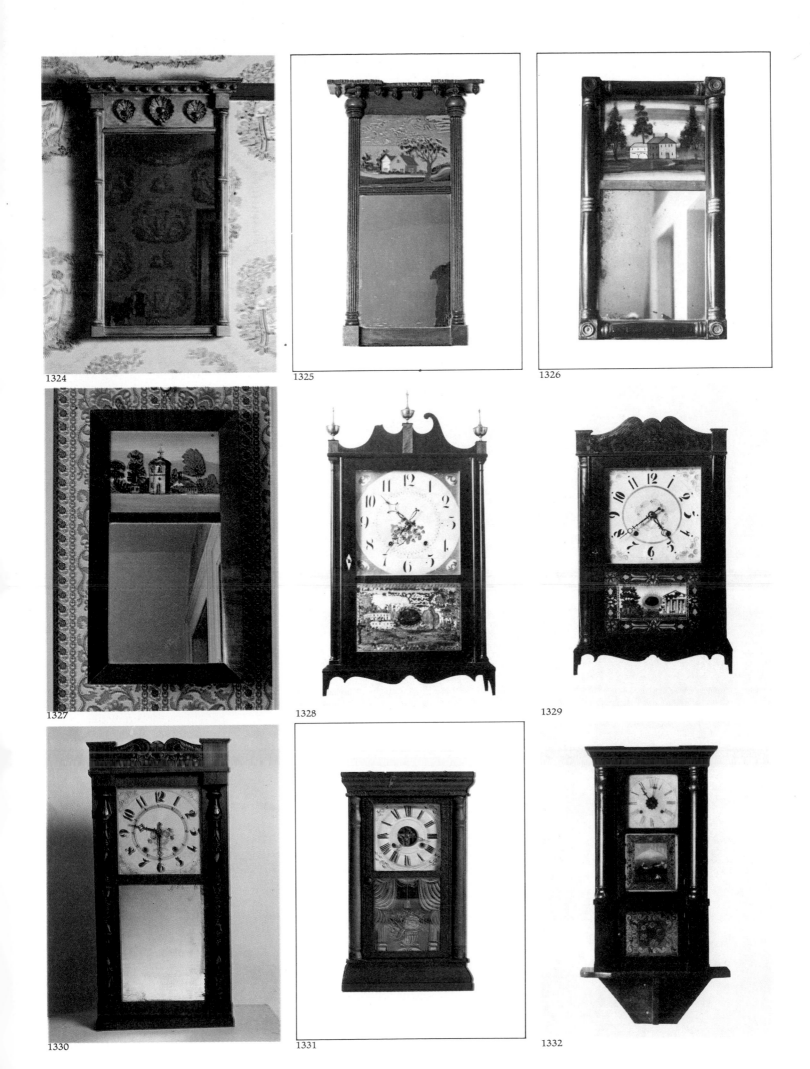

1324

1325

1326

1327

1328

1329

1330

1331

1332

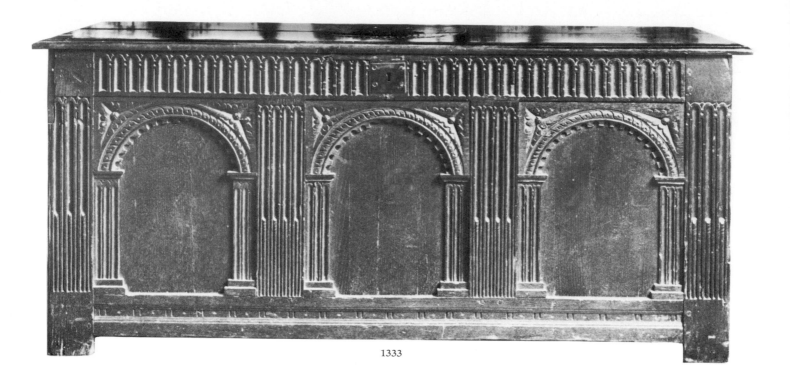

1333

1333 An oak chest of English or American origin. This fine, arcaded chest was taken by Myndent Harris, a Loyalist, from Poughkeepsie, New York to Nova Scotia in 1786. Later, in 1793, he came to Port Hope in Northumberland County. The chest's feet are somewhat shorter than the original. Probably 17th century. [P.C.]

1334 An oak chest of Irish origin. The Garland family brought this chest, panelled on four sides, to Pickering Township in 1830. The base was carefully fitted with protective boards for the crossing and it remained thus disguised until recently. Probably 17th century. [P.C.]

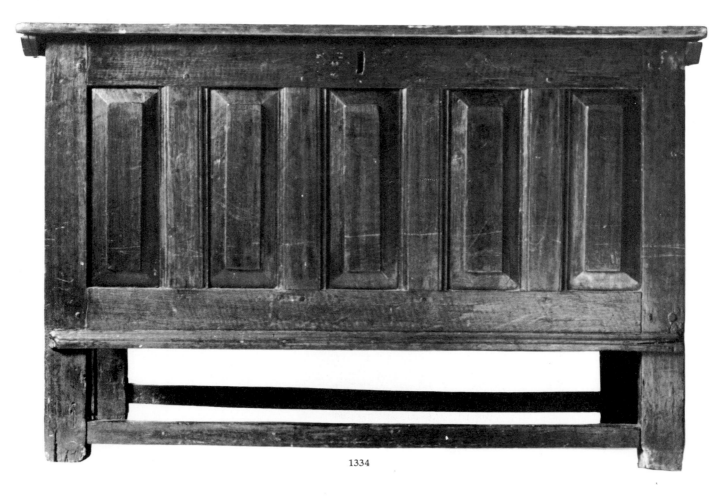

1334

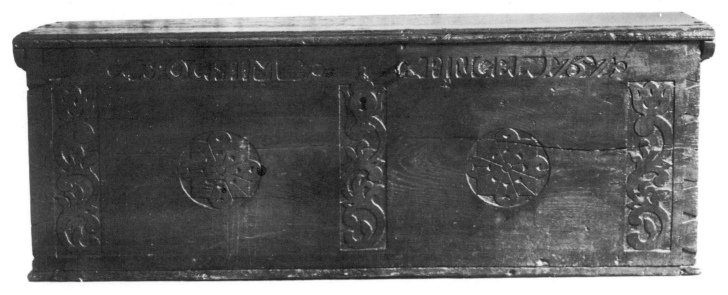

1335

1335 An oak chest of Danish origin. This chest bears the name Jochim Pingle, a Dane, who arrived in Upper Canada with William von Mol Berczy and his German group in 1794 to settle in Markham Township. The carved chest retains its original reddish stain. Dated 1757. [P.C.]

1336 A pine storage chest of American origin. Fitted with forged-iron handles and a sturdy lock, this chest is marked *P.F.*, for Peter Fralick, who emigrated from Staten Island to Prince Edward County and later to Scugog Island. Late 18th century. [P.C.]

1337 A pine storage chest of British origin. Retaining original painted decoration, this sturdy chest comes from the Oxford County home of a Scottish immigrant. Second quarter 19th century. [P.C.]

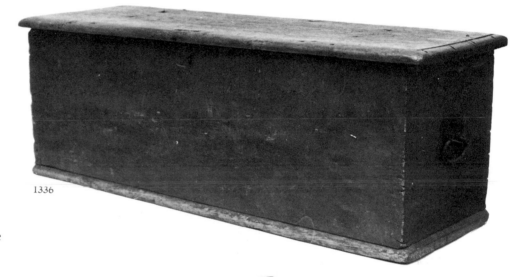

1336

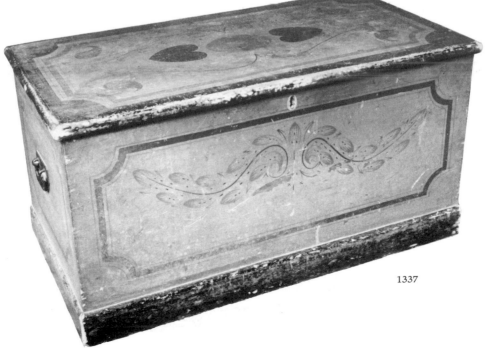

1337

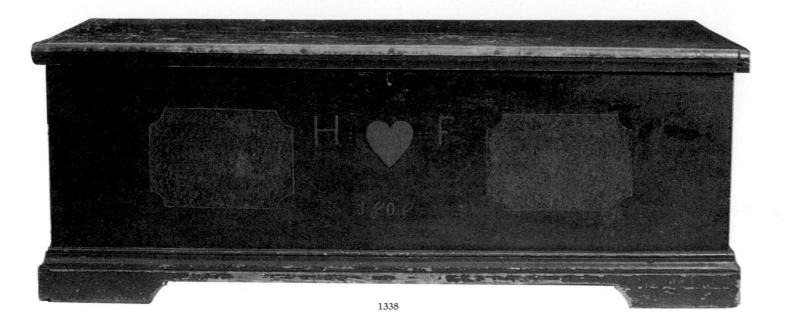

1338

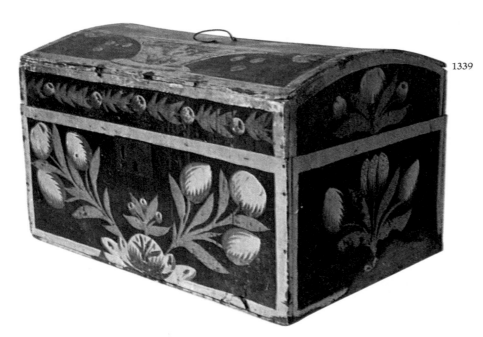

1339

1338 A pine storage chest of American origin. Found in Dundas County, this simple chest retains its original paint and decoration in red over black-green. Dated 1808. [P.C.]

1339 A small chest, probably of European origin. Chests of this style and decoration were made in France, Germany, Holland and America. This example was found in Leeds County. Early 19th century. [P.C.]

1340 A decorated immigrant's chest from Germany that bears a shipping label to Hamilton, C.W. Typical German construction with wooden pins and forged-iron hardware. Mid-19th century. [P.C.]

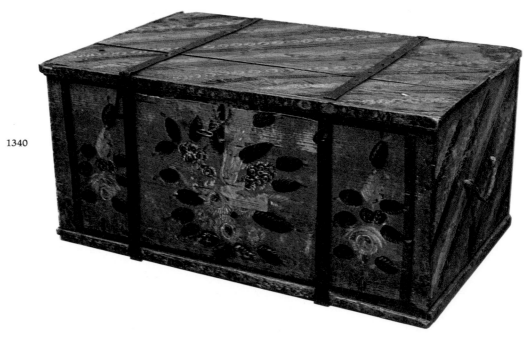

1340

1341 A decorated storage chest of European origin. The *trompe l'oeil* panels are a distinctive feature on this chest which was found in Waterloo County and may be from any one of the German-speaking regions in Europe. Dated 1801. [C.F.C.S., M.O.M., N.M.O.C.]

1342 A panelled storage chest from Germany. This brilliantly decorated softwood chest was found in the Bayfield area of Huron County. A chest from Hesse in the Marburg Museum, Germany, is of identical construction, detail, hardware, style of decoration and calligraphy. Dated 1838. [P.C.]

1343 A panelled storage chest from Germany. Similar in size and detail and certainly decorated by the same artist as the preceding example, this chest was found at Milverton in Perth County. Dated 1838. [P.C.]

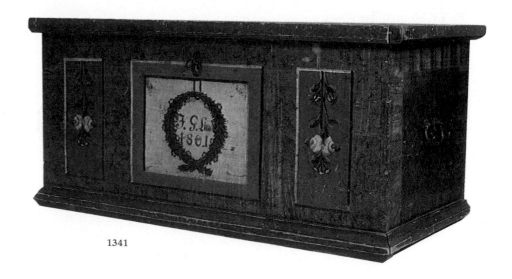

1341

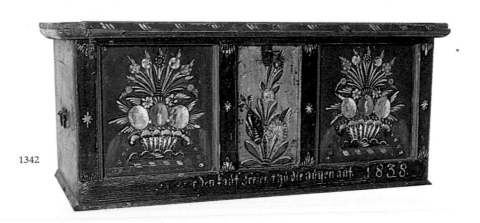

1342

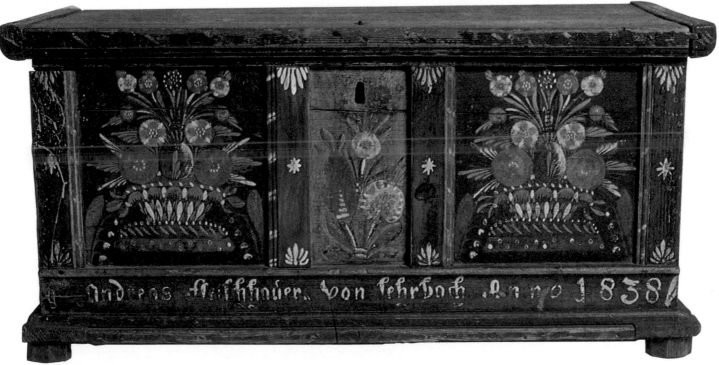

1343

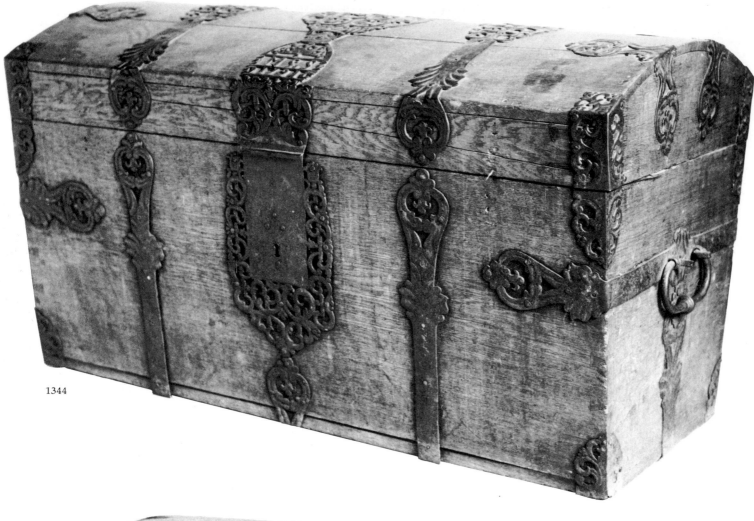

1344

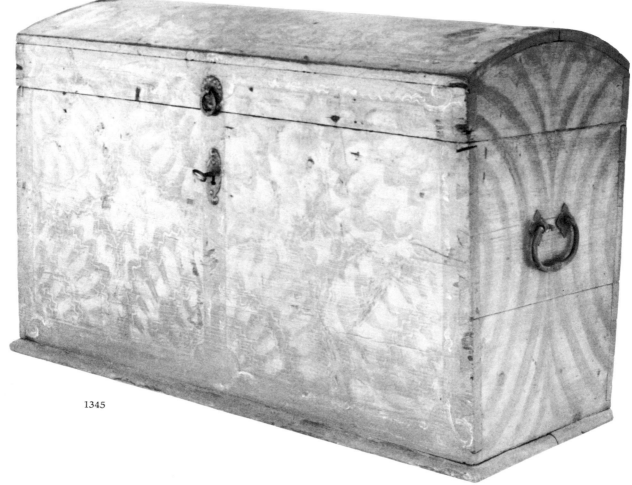

1345

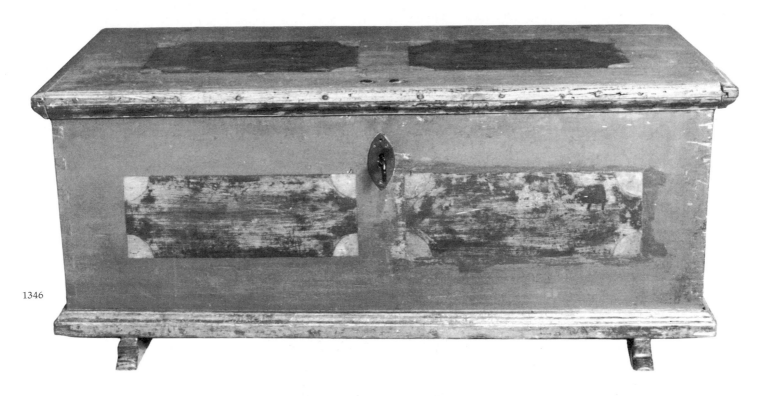

1346

1344 An oak, domed-top chest from Germany. This chest was made in 1791 by Michael S. Schmeidel. It was used as an immigrant chest by his son, who emigrated to Pennsylvania in 1859 and later to Waterloo County in 1861. The ironwork is particularly fine. [C.F.C.S., M.O.M., N.M.O.C.]

1345 A domed-top chest of European origin. Boldly painted decoration and typically fine iron fittings. Found in Chippawa in Welland County. Early 19th century. [P.C.]

1346 A storage chest on shoe feet from Germany or Pennsylvania. Painted red with green and vermilion panels. Found in the Niagara Peninsula. Early 19th century. [P.C.]

1347 A panelled oak storage chest from Germany. This decorated chest was found in the Waterloo area. Early 19th century. [P.C.]

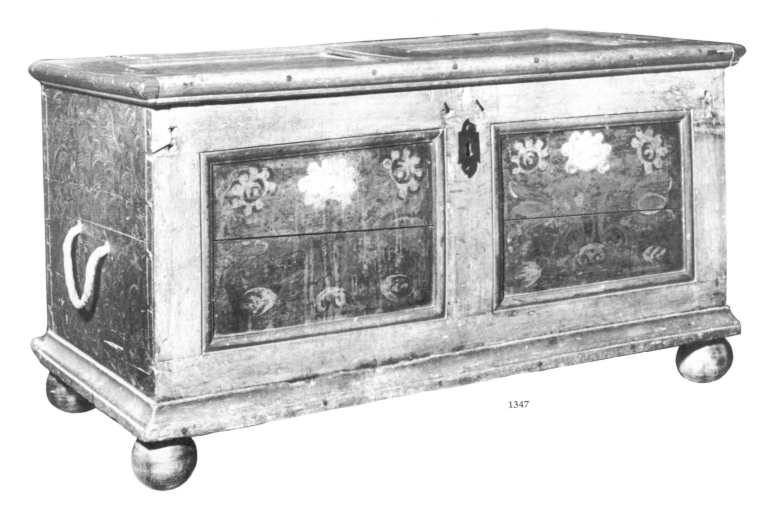

1347

Notes on the Text

Wilderness to Cultural Mosaic (pages 17 to 27)

1 J. K. Johnson, ed., *Historical Essays on Upper Canada* (Toronto: University of Toronto Press, 1975), p. vii. According to Johnson, "The Order in Council in 1791 divided the new provinces of Upper and Lower Canada along the line of the Ottawa River, drew an extended line north from Lake Temiskaming to Hudson Bay and gave Upper Canada [in the words of the Order] 'all territory to the westward and northward of said line to the utmost extent of the Country commonly called or known by the name Canada.'"

2 For further information on the backgrounds of the Loyalists, see W. H. Nelson, *The American Tory* (London: Oxford University Press, 1961) and Wallace Brown, *The King's Friends* (Providence, R.I.: Yale University Press, 1966).

3 See J. K. Johnson, ed., *Loyalist Narratives from Upper Canada* (Toronto: University of Toronto Press, 1946) and Gerald M. Craig, *Upper Canada: The Formative Years 1784-1841* (Toronto: McClelland and Stewart, 1963), pp. 1-65, *passim*.

4 *Ontario Archives Report*, 1905, p. 379.

5 E. A. Cruikshank, ed., *The Correspondence of Lieut. Governor John Graves Simcoe, with Allied Documents Relating to His Administration of the Government of Upper Canada* (Toronto: Ontario Historical Society, 1923-31), I, 27.

6 Simcoe's opening Speech from the Throne, 1792.

7 S. R. Mealing, "The Enthusiasms of John Graves Simcoe," *Canadian Historical Association Annual Report* (1958), pp. 50-52.

8 See Cruikshank, *The Correspondence of Lieut. Governor Simcoe.*

9 Johnson, *Historical Essays*, p. ix.

10 Helen I. Cowan, "British Immigration Before Confederation," The Canadian Historical Association, *Historical Booklet No. 22*, pp. 18-19.

11 Lloyd H. Schaus, "By-Passing Pennsylvania," Canadian German Folklore Society, *Canadian German Folklore*, I (1961).

12 Cowan, "British Immigration Before Confederation," p. 14.

13 Edwin C. Guillet, *Pioneer Settlements in Upper Canada* (Toronto: University of Toronto Press, 1933), p. 7.

14 A muster of the disbanded troops of the King's Royal Regiment of New York held in Dundas County in 1784 revealed that there were nearly one thousand German Loyalists then living in the townships of Cornwall, Osnabruck, Williamsburg and Matilda combined. Of these, there were 433 men, 160 women, 368 children and 11 servants. See Alexander Clark Casselman, "The German U.E. Loyalists of the County of Dundas, Ontario – Part II," *United Empire Loyalists Association Annual Transaction*, 1900, p. 68.

15 W. A. Langton, ed., *Early Days in Upper Canada; Letters of John Langton from the Backwoods of Upper Canada and the Audit Office of the Province of Canada* (Toronto, 1926), p. 21.

16 Michael Smith, *A Geographical View of the Province of Upper Canada and Promiscuous Remarks Upon the Government* (Hartford, 1813), pp. 62-63.

17 W. Wood, *Selected British Documents of the Canadian War of 1812* (Westport, Conn.: Greenwood Press, 1926), III, Pt. 1, 305.

18 Ibid., 785-87. A letter from Bathurst to Prevost dated 8 September 1814.

19 Bill Moyer, *This Unique Heritage: The Story of Waterloo County* (Kitchener, Ontario, 1971), p. 35.

20 The term *Schrank*, plural *Schranke*, will be used throughout this study to denote the various wardrobe forms made by the Germanic people.

The Anglo-American Tradition (pages 34 to 50)

1 Marion Macrae and Anthony Adamson, *The Ancestral Roof* (Toronto: Clarke Irwin and Company, Ltd., 1963), p. 3.

2 Adam did not necessarily overthrow the Rococo, for there are identifiable remnants of this style in his work. Rather, he was a participant in the general Neoclassical movement toward linear expression that was visible, for example, in the highly structured heroic couplets of the poet Alexander Pope. Before Adam's work began its widespread effect, pictorial artists had affirmed a belief in what William Hogarth called the "line of beauty" in his *Analysis of Beauty* (1753). It is fascinating to note that the revival of historical styles during the late Romantic and early Victorian periods included the revival of a type of "line of beauty". As an aside, it is worthwhile to explore Hogarth's engravings for their accurate depictions of both urban and country English furniture. See Sean Shesgreen, ed., *Engravings by Hogarth* (New York: Dover Publications, 1973).

3 George Henry, *The Emigrant's Guide, Or Canada As It Is* (Quebec, [1835?]), p. 109.

4 Edwin Tunis, *Colonial Craftsmen* (New York: World Publishing Company, 1965), p. 92.

5 *Upper Canada Herald*, July 28, 1840.

6 *Upper Canada Gazette*, York, 1823.

7 An extension of this type of attitude may be found in Britain during the Second World War and immediate postwar years (1941-1951). Large quantities of furniture were required to replace the losses in bombed-out areas. A team of highly skilled designers returned to the English vernacular tradition for inspiration in creating the famous Utility Furniture Scheme. This was not the first time such a scheme was tried. William Morris (1834-1896), the famous English author and typographer, tried to end what he considered the decadence of his age by returning to the time-honoured forms of the vernacular.

8 Jane Toller, *English Country Furniture* (Cranbury, N.J.: A. S. Barnes and Co., Inc., 1973), p. 11.

9 In England, the term deal is often used to describe soft wood of any kind in board form. It was used for drawer linings, the backs of cupboards, entire pieces of vernacular furniture and the carcasses prepared for veneering. A great quantity of North American pine was imported into the British Isles in this form.

10 E. Estyn Evans, *Irish Folk Ways* (Boston: Routledge and Kegan, 1961), p. 88.

11 I. F. Grant, *Highland Folk Ways* (Boston: Routledge and Kegan, 1961), p. 177.

12 John Gloag, *A Short Dictionary of Furniture* (London: George Allen and Unwin Ltd., 1952), p. 124.

13 Catherine Parr Traill, *The Canadian Settlers' Guide* (Toronto, 1855). Reprinted by McClelland and Steward Ltd., Toronto, 1969; the quote is taken from this edition, p. 18.

14 *Upper Canada Gazette*, York, 23 January 1802.

15 A. Gailey, *Ulster Folklife* (Belfast: Ulster Folk Museum, 1966), Vol. 12, p. 29.

16 Ibid.

17 The origin of the term *banc lit* is not known, although Palardy states that the form does not occur in French tradition and suggests that its appearance in French Canada was the result of Irish influence. See Jean Palardy, *The Furniture of French Canada* (Toronto: Macmillan Company of Canada, 1963), p. 20.

18 A. Gailey, *Ulster Folklife*, p. 22.

19 In *Great Expectations*, Charles Dickens has given us a minutely described and highly accurate picture of this type of room in the form of the tiny, rarely used Gargery parlour.

The Germanic Tradition (pages 305 to 316)

1 The term palatine means belonging to a palace. The German Palatine was the area around the Rhine which belonged to the court of the German emperors.

2 Mary Quayle Innis, ed., *Mrs. Simcoe's Diary* (Toronto: Macmillan Company of Canada, 1965), p. 69.

3 Ibid., p. 115.

4 G. Elmore Reaman, *The Trail of the Black Walnut* (Toronto: McClelland and Stewart Ltd., 1957), p. 84.

5 The importation and evolution of *Fraktür* in Upper Canada is itself an important and interesting subject. Primarily written from the point of view of illuminated books and manuscripts, Michael S. Bird's *Ontario Fraktur: A Pennsylvania-German Tradition in Upper Canada* (Toronto: M. F. Feheley Publishers Ltd., 1977) makes a thorough study of forms and variations.

6 Reaman, *Trail of the Black Walnut*, p. 84.

7 Ibid., p. 143.

8 Barbara F. Coffman, "Some Early Industries at the Twenty," in *Canadian German Folklore* ([Waterloo]: Pennsylvania Folklore Society, 1961), Vol. I, 92.

9 Reaman, *Trail of the Black Walnut*, p. 33.

The Polish Tradition (pages 469 to 472)

1 I am indebted to Brenda Lee-Whiting for permission to study and quote from her unpublished research on the Polish Renfrew settlements. See also, Brenda Lee-Whiting, "First Polish Settlement in Canada," *Canadian Geographical Journal* (September 1967) and her "The Opeongo Road: An Early Colonization Scheme," *Canadian Geographical Journal* (March 1967).

2 According to a government advertisement in the area: "One hundred acres will be given FREE to any settler, 18 years of age, who shall take possession of the Lot within one month from the date of

his application, erect on it a house 18 by 20 feet, put in a state of cultivation at least 12 acres in the course of four years, and live on the Lot during that period. Should he fulfil these conditions he will obtain an indisputable title to the land, but failing to do so, it will be sold or given to another."

3 Described in the "Records of a Meeting of the United Counties of Lanark and Renfrew" (1851) held in Perth as a road "from the Ottawa River, through the townships of Horton and Renfrew Village, then westward to Opeongo Lake, and by connections beyond, opening a route to Georgian Bay." Quoted in Allan Lynn McMurray, "Wilno Furniture," *Canadian Collector* (November-December 1975), p. 14.

4 McMurray, pp. 10-16.

5 Richard Kosydor, University of Minneapolis, unpublished research, 1968-69.

6 The major Polish collections are:
The National Museum in Gdańsk
The Museum in Grudziadz
The Kashubian Museum in Kartuzy
The Archeological-and-Historical Museum in Koszalin
The Museum in Kwidzyn
The Museum of Country Architecture in Olsz-tynek
The Museum of Middle Pomerania in Slupsk
The Masurian Museum in Szczytno
The Ethnographic Museum in Toruń
The Kachubian Ethnographic Park in Wdzydze
The Museum of Zlótow Region in Zlótow
The director of the Toruń museum, Aleksander Blachowski, was particularly helpful in identifying the characteristics of traditional Kazubian furniture. He is the author of *Dawne Meble Ludowe Pólnocnej Polski* (loosely translated as "Country Furniture of Northern Poland"), published in Toruń by the Ethnographic Museum in 1976. This important study deals with a major exhibition held at the museum in 1975 and speaks at length about the museum's and borrowed exhibits of northern Polish country furniture.

7 Possibly the early Wilno resident, John Kozloski, traditionally said to have made furniture there.

8 The origin of the bench-bed is unknown at this time. In both the Polish and the Irish traditions, it is considered a late (i.e., nineteenth century) innovation. Polish authorities, like Mr. Blachowski, suggest that its occurrence is a result of influences from Germany. Similar forms are also known in Alsace. Numerous examples are currently being discovered in the Russian Mennonite communities of western Canada.

9 McMurray, "Wilno Furniture," p. 10.

5 I am referring here to the collection of family documents in the possession of the Good family.

6 Quoted by Edith Firth, *The Town of York, 1815-1834* (Toronto: The Champlain Society, 1966), II, 55-56.

7 George Henry, *The Emigrant's Guide, Or Canada As It Is* (Quebec, [1835?]), p. 109.

The French Canadian Tradition (pages 489 to 491)

1 Jean Palardy, *The Furniture of French Canada* (Toronto: Macmillan Company of Canada, 1963), pp. 26-27.

Furniture from Other Lands (pages 499 to 502)

1 *Regulations and Orders for the Army*, Adjutant-General's Office, 1 January 1816.

2 *York Gazette*, 1811.

3 Thomas Radcliffe, ed., *Authentic Letters from Upper Canada* (Toronto: MacMillan Company of Canada, reprinted 1952), p. 3 (first published 1833).

4 W. H. Smith, *Smith's Canadian Gazetteer* (Toronto, 1846), p. 251.

Technical Notes on the Plates

The list below contains technical information on each of the pieces with Ontario associations. The prototype examples have not been listed. The plate number is followed by the type(s) of wood used; a description of the original finish; original hardware where necessary; and the dimensions (inches and centimetres).

1 Wood – oak, pine top; original finish – none; W. 90″, H. 30″, D. 37″ (229, 76, 94 cm); pine top restored, two inches cut from top of trestles

2 Wood – pine; original finish – red; W. 30½″, H. 30″, D. 36″ (77, 76, 91 cm)

3 Wood – pine; original finish – none; W. 70½″, H. 26″, D. 29½″ (179, 66, 75 cm)

4 Wood – pine; original finish – pale yellow; W. 72″, H. 30″, D. 28½″ (183, 76, 72 cm)

5 Wood – pine; original finish – walnut stain, scrubbed top; original hardware – wooden pull; W. 75½″, H. 28¼″, D. 41½″ (192, 72, 105 cm)

6 Wood – pine top and hardwoods; original finish – red, scrubbed top; W. 77″, H. 30″, D. 31″ (196, 76, 79 cm)

7 Wood – pine; original finish – grey, scrubbed top; original hardware – wooden pulls; W. 65″, H. 29½″, D. 34½″ (165, 75, 88 cm)

8 Wood – pine; original finish – red, scrubbed top; original hardware – wooden pulls; W. 64″, H. 30″, D. 32″ (163, 76, 81 cm)

9 Wood – pine; original finish – red-brown; original hardware – cast hinges, wooden pulls; W. 72″, H. 29½″, D. 34″, 12″ leaves (183, 75, 86, 30 cm)

10 Wood – pine; original finish – black, scrubbed top; W. 40″, H. 29″, D. 29″ (102, 74, 74 cm)

11 Wood – pine; original finish – red; original hardware – cast hinges; W. 67″, H. 28″, D. 24″, 9″ leaf (170, 71, 61, 23 cm)

12 Wood – pine; original finish – brown-red with scrubbed top; original hardware – cast hinges, wooden pulls; W. 66″, H. 29″, D. 28″, 12″ leaf (168, 74, 71, 30 cm)

13 Wood – pine; original finish – red-brown base, scrubbed top; original hardware – wooden pull; W. 69″, H. 29½″, D. 31″ (176, 75, 79 cm)

14 Wood – cherry; original finish – dark stain and varnish; original hardware – ceramic pull; W. 64½″, H. 30″, D. 35″ (164, 76, 89 cm)

15 Wood – white ash, pine top; original finish – grey-blue; presently remnants of original; W. 47″, H. 28½″ (119, 72 cm); stretchers replaced

16 Wood – pine top and maple; original finish – stain and varnish; W. 50″, H. 29″ (127, 74 cm); front stretcher missing

17 Wood – pine; original finish – red; presently stripped; W. 30½″, D. 23″ (77, 58 cm)

18 Wood – pine top and hardwoods; original finish – brown-red; original hardware – iron casters; W. 49″, H. 29½″ (124, 75 cm)

19 Wood – pine top and hardwoods; original finish – brown paint stain; W. 38″, H. 29½″ (97, 75 cm)

20 Wood – pine; original finish – red; presently stripped; original hardware – wooden pulls; W. 49″, H. 29″, L. 60″ (124, 74, 152 cm); top restored

21 Wood – pine; original finish – mustard; W. 61½″, H. 29″, D. 44″ (156, 74, 112 cm)

22 Wood – pine top, white ash; original finish – dark stain; presently stripped; W. 41″, H. 25″, D. 29″ (104, 63, 74 cm)

23 Wood – cherry top and hardwoods; original finish – red; presently stripped; W. 35½″, H. 30″, D. 22″ (90, 76, 56 cm)

24 Wood – pine; original finish – dark green; W. 32″, H. 24″, D. 22″ (81, 61, 56 cm)

25 Wood – pine; original finish – brown; presently stripped; original hardware – wooden pull, brass escutcheon; W. 28″, H. 29½″, D. 25″ (71, 75, 63 cm)

26 Wood – pine top and birch; original finish – red; W. 40″, H. 26½″, D. 26″ (102, 67, 66 cm)

27 Wood – pine top, birch and cherry; original finish – red; W. 36″, H. 29″ (91, 74 cm)

28 Wood – pine top and birch; original finish – red; original hardware – wooden pulls (restored); W. 30½″, H. 28½″, D. 24″ (77, 72, 61 cm)

29 Wood – pine; original finish – red-brown, scrubbed top; W. 40″, H. 27″ (102, 69 cm)

30 Wood – pine; original finish – red; W. 41″, H. 27″, D. 27″ (104, 69, 69 cm)

31 Wood – cherry; original finish – stain and varnish; original hardware – cast leaf hinges; W. 112″ (full extension), H. 29″, D. 48″ (284, 74, 122 cm)

32, 33 Wood – cherry; original finish – stain and varnish; original hardware – brass cup casters, cast leaf hinges, brass clips; W. 24″ (each board), H. 29″, D. 48″ (61, 74, 122 cm)

34 Wood – cherry, figured maple; original finish – stain and varnish; original hardware – cast leaf hinges, brass clips; W. 111½″ (full extension), H. 30″, D. 46″ (283, 76, 117 cm)

35 Wood – maple, figured maple, rosewood (veneer), walnut and pine secondary; original finish – stain and varnish; original hardware – cast leaf hinges, casters, brass clips; W. 23″ (each section), H. 29″, D. 48″ (58, 74, 122 cm)

36 Wood – cherry, walnut inlay, pine secondary; original finish – stain and varnish; original hardware – cast leaf hinges, brass cup casters; W. 20″, H. 29″, D. 50″, 22″ leaf (51, 74, 127, 56 cm)

37 Wood – cherry, figured maple; original finish – stain and varnish; original hardware – cast leaf hinges; W. 36″, 13½″ leaf, H. 28½″, D. 18″ (91, 34, 72, 46 cm)

38 Wood – figured maple; original finish – stain and varnish; original hardware – cast leaf hinges, ivory casters; W. 21″, 12½″ leaves; H. 29″, D. 64″ (53, 32, 74, 163 cm)

39 Wood – butternut and figured maple; original finish – stain and varnish; original hardware – brass casters

40 Wood – figured maple; original finish – stain and varnish; original hardware – cast leaf hinges; W. 62″, H. 29″, D. 39″, 24″ leaf (157, 74, 99, 61 cm)

41 Wood – figured maple, birch; original finish – stain and varnish; original hardware – cast leaf hinges; W. 22″ (each leaf), H. 30″, D. 41½″ (56, 76, 105 cm)

42 Wood – figured maple, butternut; original finish – stain and varnish; original hardware – cast leaf hinges; W. 20″, 12″ leaf, H. 29″, D. 40″ (51, 30, 74, 102 cm)

43 Wood – cherry; original finish – stain and varnish; original hardware – cast leaf hinges; W. 18″, leaf 12″, H. 28″, D. 36″ (46, 30, 71, 91 cm)

44 Wood – figured maple, pine secondary; original finish – stain and varnish; original hardware – cast leaf hinges, wooden pull; W. 21″, leaf 12″, H. 29″, D. 43″ (53, 30, 74, 109 cm)

45 Wood – cherry, birch, mahogany veneer, pine secondary; original finish – stain and varnish; original hardware – cast leaf hinges; W. 21″, leaf 16″, H. 29″, D. 46″ (53, 41, 74, 117 cm)

46 Wood – pine; original finish – brown-black; original hardware – cast leaf hinges; W. 18½″, leaf 13″, H. 28″, D. 42″ (47, 33, 71, 107 cm)

47 Wood – maple and figured maple, pine secondary; original finish – stain and varnish; original hardware – cast leaf hinges, wooden pull; W. 16″, H. 28″, D. 42″ (41, 71, 107 cm)

48 Wood – pine top, elm and basswood; original finish – dark brown; presently stripped; original hardware – cast leaf hinges; W. 36″ (open), H. 27½″ (91, 70 cm)

49 Wood – figured maple, mahogany cock-beading and inlay, pine secondary; original finish – stain and varnish; original hardware – cast leaf hinges, brass pulls (restored); brass feet and casters; W. 32″, leaf 9¼″, H. 28″, D. 26″ (81, 23, 71, 66 cm)

50 Wood – pine; original finish – stain and varnish; original hardware – cast leaf hinges, brass feet and casters, wooden pull; W. 22″, leaf 12″, H. 29″, D. 41″ (56, 30, 74, 104 cm)

51 Wood – mahogany, maple inlay, pine secondary; original finish – stain and varnish; original hardware – brass leaf hinges, brass pulls (restored), brass escutcheons, brass feet and casters; W. 37½″, leaf 11″, H. 28″, D. 26¼″ (95, 28, 71, 67 cm)

52 Wood – butternut, pine secondary; original finish – walnut stain and varnish; original hardware – brass foot casters, brass pulls (restored); W. 50½″, H. 30″ (128, 76 cm)

53 Wood – figured maple; original finish – stain and varnish; original hardware – cast leaf hinges; W. 14″, leaf 8½″, H. 28½″, D. 35″ (36, 22, 72, 89 cm)

54 Wood – figured maple, walnut and maple inlay, pine secondary; original finish – stain and varnish; original hardware – wooden pull, brass casters; W. 18½″, leaf 10″, H. 28½″, D. 32″ (47, 25, 72, 81 cm)

55 Wood – cherry; original finish – stain and varnish; original hardware – brass latch; W. 34¼″, H. 28″ (88, 71 cm)

56 Wood – cherry; original finish – stain and varnish; W. 28½″, H. 29¼″ (72, 74 cm)

57 Wood – birch; original finish – stain and varnish; W. 30″, H. 29″ (76, 74 cm)

58 Wood – mahogany; original finish – stain and varnish; W. 36″, H. 29½″ (91, 75 cm)

59 Wood – cherry; original finish – stain and varnish; W. 30½″, H. 30″ (77, 76 cm)

60 Wood – figured maple and oak; original finish – stain and varnish; original hardware – brass latch; W. 46″, H. 31″ (117, 79 cm)

61 Wood – walnut and figured maple; original finish – stain and varnish; original hardware – brass latch; W. 37½″, H. 28½″ (95, 72 cm)

62 Wood – figured maple; original finish – dark stain and varnish; original hardware – brass latch; W. 35″, H. 28¾″ (89, 73 cm)

63 Wood – birch; original finish – stain and varnish; W. 41″, H. 28½″ (104, 72 cm)

64 Wood – walnut veneer, pine secondary; original finish – stain and varnish; original hardware – iron casters; W. 36″, H. 29½″, D. 36″ (91, 75, 91 cm)

65 Wood – figured maple, birch, pine secondary; original finish – stain and varnish; original hardware – brass hinges, wooden pull; W. 42", H. 29½", D. 21" (107, 75, 53 cm)

66 Wood – birch, maple, pine secondary; original finish – stain and varnish with pumpkin end panels and black mouldings; original hardware – brass pulls (restored); W. 36", H. 29", D. 18" (91, 74, 46 cm)

67 Wood – pine; original finish – brown; W. 46", H. 30", D. 13" (117, 76, 33 cm)

68 Wood – figured maple, pine secondary; original finish – stain and varnish; original hardware – wooden pulls; W. 35½", H. 29½", D. 17½" (90, 75, 44 cm)

69 Wood – birch; original finish – stain and varnish; original hardware – wooden pull (early drawer addition); W. 42", H. 29½", D. 21½" (107, 75, 55 cm)

70 Wood – figured maple; original finish – stain and varnish; W. 37", H. 28½", D. 18" (94, 72, 46 cm)

71 Wood – pine; original finish – green; W. 31", H. 28", D. 14½" (79, 71, 37 cm)

72 Wood – walnut and figured maple; original finish – stain and varnish with painted decoration; original hardware – brass cup casters; W. 40½", H. 26", D. 20" (103, 66, 51 cm)

73 Wood – mahogany; original finish – stain and varnish; original hardware – brass cup casters; W. 21", H. 28", D. 14" (53, 71, 36 cm)

74 Wood – cherry, butternut, maple inlay, pine secondary; original finish – stain and varnish; original hardware – brass cup casters, wooden pulls, brass pulls; W. 23", H. 31", D. 16½" (58, 79, 42 cm)

75 Wood – figured maple; original finish – stain and varnish; original hardware – wooden pulls; W. 18½", H. 30", D. 17" (47, 76, 43 cm)

76 Wood – birdseye and figured maple, pine secondary; original finish – stain and varnish; original hardware – wooden pulls, ivory escutcheons; W. 23", H. 28½", D. 16½" (58, 72, 42 cm)

77 Wood – walnut, figured maple, pine secondary; original finish – stain and varnish; original hardware – wooden pulls; W. 18", H. 30", D. 18" (46, 76, 46 cm)

78 Wood – walnut; original finish – walnut; original hardware – brass pulls and escutcheons; W. 23", H. 28", D. 20" (58, 71, 51 cm)

79 Wood – mahogany, solid and veneer, pine secondary; original finish – stain and varnish; original hardware – glass pulls, brass escutcheons; W. 20", H. 27½", D. 17½" (51, 70, 44 cm)

80 Wood – figured maple, birch, rosewood veneer, pine secondary; original finish – stain and varnish; original hardware – brass foot casters, pulls (presently restored), brass escutcheons; W. 22½", H. 31", D. 16" (57, 79, 41 cm)

81 Wood – pine; original finish – black over red; W. 19", H. 31" (48, 79 cm)

82 Wood – pine; original finish – red-brown; W. 18", H. 30" (46, 76 cm)

83 Wood – mahogany and birch; original finish – stain and varnish; original hardware – brass latch; W. 24", H. 27", D. 16½" (61, 69, 42 cm)

84 Wood – figured maple; original finish – stain and varnish; W. 11½", H. 34½" (32, 88 cm)

85 Wood – cherry; original finish – stain and varnish; W. 18", H. 27½" (46, 70 cm)

86 Wood – pine and hardwood; original finish – stain and varnish; presently overpainted; W. 15½", H. 29" (39, 74 cm)

87 Wood – cherry; original finish – painted wood grain and banding; W. 24", H. 26" (61, 66 cm)

88 Wood – birch; original finish – stain and varnish; W. 26", H. 26", D. 20" (66, 66, 51 cm)

89 Wood – cherry and maple; original finish – stain and varnish; W. 22", H. 29" (56, 74 cm)

90 Wood – pine and walnut; original finish – stain and varnish; original hardware – wooden latch; W. 25½", H. 29" (64, 74 cm)

91 Wood – cherry; original finish – stain and varnish; W. 16", H. 29" (41, 74 cm)

92 Wood – walnut; original finish – stain and varnish with portrait; W. 19½", H. 28¼" (50, 72 cm)

93 Wood – cherry; original finish – stain and varnish; W. 19", H. 26" (48, 66 cm)

94 Wood – cherry and figured maple; original finish – stain and varnish; W. 13", H. 27", D. 11" (33, 69, 28 cm)

95 Wood – pine; original finish – dark stain and varnish; original hardware – brass pull; W. 24", H. 29" (61, 74 cm)

96 Wood – cherry; original finish – stain and varnish; original hardware – wooden hinge and latch; W. 17", H. 29½" (43, 75 cm); top and latch restored

97 Wood – birch; original finish – stain and varnish; W. 30", H. 29", D. 30" (76, 74, 76 cm)

98 Wood – pine, birch and walnut; original finish – stain and varnish; W. 17½", H. 32" (44, 81 cm)

99 Wood – birch, flame birch top; original finish – stain and varnish; W. 18½", H. 27½", D. 17½" (47, 70, 44 cm)

100 Wood – birch and cherry; original finish – red paint stain; W. 21½", H. 28½", D. 16½" (55, 72, 42 cm)

101 Wood – mahogany; original finish – stain and varnish; original hardware – brass latch; W. 25", H. 29", D. 22" (63, 74, 56 cm)

102 Wood – pine; original finish – painted wood grain; presently stripped; W. 24", H. 30½" (61, 77 cm)

103 Wood – figured maple; original finish – stain and varnish; W. 18", H. 26", D. 16" (46, 66, 41 cm)

104 Wood – figured maple top and walnut; original finish – stain and varnish; W. 15", H. 24½" (38, 62 cm)

105 Wood – mahogany; original finish – stain and varnish; W. 22¼", H. 29", D. 14¼" (57, 74, 36 cm)

106 Wood – birch; original finish – red; W. 20", H. 31", D. 16½" (51, 79, 42 cm)

107 Wood – pine; original finish – none; W. 19½", H. 24", D. 18" (50, 61, 46 cm)

108 Wood – pine; original finish – red; W. 16½", H. 29¾", D. 16½" (42, 76, 42 cm)

109 Wood – pine; original finish – red; W. 21", H. 30", D. 16" (53, 76, 41 cm)

110 Wood – birch, maple, oak; original finish – red-brown; W. 18", H. 27½", D. 18" (46, 70, 46 cm)

111 Wood – pine; original finish – grey-green; W. 20", H. 28½", D. 18" (51, 72, 46 cm)

112 Wood – pine; original finish – black; W. 15½", H. 28½" (39, 72 cm)

113 Wood – pine and hardwoods; original finish – brown-black; W. 12", H. 31¼" (30, 79 cm)

114 Wood – maple burl, figured maple; original finish – stain and varnish; W. 15¼", H. 27½" (39, 70 cm)

115 Wood – pine; original finish – brown; W. 20", H. 27½" (51, 70 cm)

116 Wood – ash and maple; original finish – stain and varnish; W. 16", H. 23" (41, 58 cm)

117 Wood – pine and elm; original finish – brown and red; W. 20", H. 23", D. 13½" (51, 58, 34 cm)

118 Wood – pine; original finish – red; W. 16", H. 28½" (41, 72 cm)

119 Wood – pine; original finish – red; W. 16", H. 28", D. 16" (41, 71, 41 cm)

120 Wood – pine; original finish – green and yellow; W. 14", H. 29", D. 14" (36, 74, 36 cm)

121 Wood – pine; original finish – brown grained stain over light ground; W. 16", H. 28", D. 16" (41, 71, 41 cm)

122 Wood – pine; original finish – green; W. 16½", H. 28½" (42, 72 cm)

123 Wood – pine; original finish – grey-green; W. 16", H. 30" (41, 76 cm)

124 Wood – pine; original finish – apple-green; W. 17", H. 28¼", D. 17" (43, 71, 43 cm)

125 Wood – hardwoods; original finish – green with gold rings; W. 17", H. 27" (43, 69 cm). Top not original to design

126 Wood – walnut; original finish – stain; presently overpainted; W. 19", H. 28", D. 14" (48, 71, 36 cm). Rear stretcher removed early

127 Wood – walnut, figured maple, pine secondary; original finish – stain and varnish; original hardware – wooden pulls; W. 18", H. 29", D. 18" (46, 74, 46 cm)

128 Wood – cherry, figured maple, pine secondary; original finish – stain and varnish; original hardware – cast leaf hinges, brass pulls (restored); W. 21", leaf 8½", H. 29", D. 27" (53, 22, 74, 69 cm)

129 Wood – walnut, figured maple, pine secondary; original finish – stain and varnish; original hardware – brass pulls (restored); W. 24", H. 28½", D. 20½" (61, 72, 55 cm)

130 Wood – pine, birch, birdseye maple; original finish – dark stain and varnish; original hardware – wooden pulls; W. 17", H. 28", D. 17" (43, 71, 43 cm)

131 Wood – pine; original finish – brown with blue and yellow hearts; original hardware – wooden pulls; W. 19½", H. 28½", D. 18½" (50, 72, 47 cm)

132 Wood – walnut, maple inlay, pine secondary; original finish – stain and varnish; original hardware – brass pull (restored); W. 20", H. 29", D. 18" (51, 74, 46 cm)

133 Wood – walnut, pine secondary; original finish – stain and varnish; original hardware – brass pull; W. 20½", H. 27", D. 19½" (52, 69, 50 cm)

134 Wood – walnut (pine secondary); original finish – stain and varnish; original hardware – brass pull; W. 18¼", H. 26¼", D. 17½" (47, 66, 44 cm)

135 Wood – cherry; original finish – stain and varnish; original hardware – brass pull; W. 20", H. 27", D. 18½" (51, 69, 47 cm)

136 Wood – cherry, maple inlay, pine secondary; original finish – stain and varnish; original hardware – wooden pull; W. 18½", H. 27", D. 18¼" (47, 69, 47 cm)

137 Wood – pine; original finish – green (presently overpainted); original hardware – brass pull (restored); W. 23½", H. 29½", D. 21" (60, 75, 53 cm)

138 Wood – pine; original finish – red; original hardware – pressed glass pull; W. 18", H. 26", D. 18" (46, 66, 46 cm)

139 Wood – pine and figured maple; original finish – stain and varnish; original hardware – brass knob; W. 19½", H. 29", D. 19" (50, 74, 48 cm)

140 Wood – cherry; original finish – painted wood grain; W. 30", H. 28", D. 17" (76, 71, 43 cm)

141 Wood – cherry, pine secondary; original finish – stain and varnish; original hardware – brass pull; W. 20", H. 29", D. 17" (51, 74, 43 cm)

142 Wood – cherry, pine secondary; original finish – stain and varnish; original hardware – wooden pulls; W. 21", H. 29", D. 17½" (53, 74, 44 cm)

143 Wood – cherry, walnut, butternut, figured maple veneer, pine secondary; original finish – stain and varnish; original hardware – wooden

pulls; W. 19½", H. 28½", D. 17½" (50, 72, 44 cm)

144 Wood – cherry, figured maple, pine secondary; original finish – stain and varnish; original hardware – wooden pulls (glass replacements); W. 21", H. 28", D. 17" (53, 71, 43 cm)

145 Wood – cherry, pine secondary; original finish – stain and varnish; original hardware – brass pulls (restored); W. 20", H. 30", D. 17" (51, 76, 43 cm)

146 Wood – cherry, figured maple and mahogany veneer, pine secondary; original finish – stain and varnish; original hardware – cast leaf hinges, wooden pulls; W. 18", H. 29", D. 18" (46, 74, 46 cm)

147 Wood – walnut, maple inlay, pine secondary; original finish – stain and varnish; original hardware – wooden pulls; W. 22", H. 29½", D. 20" (56, 75, 51 cm)

148 Wood – birch, figured maple, pine secondary; original finish – stain and varnish; original hardware – wooden pulls; W. 20½", H. 28", D. 19" (52, 71, 48 cm)

149 Wood – birch, figured maple, pine secondary; original finish – stain and varnish; original hardware – brass pulls (restored); W. 20½", H. 26", D. 17½" (52, 66, 44 cm)

150 Wood – cherry, figured maple, pine secondary; original finish – stain and varnish; original hardware – brass pulls; W. 22½", H. 28½", D. 20½" (57, 72, 52 cm)

151 Wood – walnut, figured maple, pine secondary; original finish – stain and varnish; original hardware – brass pull (restored); W. 22", H. 27¼", D. 21" (56, 70, 53 cm)

152 Wood – walnut, figured maple veneer, pine secondary; original finish – stain and varnish; original hardware – wooden pulls; W. 19½", H. 30", D. 17" (50, 76, 43 cm)

153 Wood – cherry, pine secondary; original finish – stain and varnish; original hardware – cast leaf hinges, wooden pulls; W. 18", leaf 11", H. 29", D. 24½" (46, 28, 74, 62 cm)

154 Wood – butternut, figured and birdseye maple, pine secondary; original finish – stain and varnish; original hardware – ceramic pulls; W. 24", H. 28", D. 19½" (61, 71, 50 cm)

155 Wood – cherry, figured maple, pine secondary; original finish – stain and varnish; original hardware – brass pulls (restored); W. 24", H. 29", D. 17" (61, 74, 43 cm)

156 Wood – figured maple, pine secondary; original finish – stain and varnish; original hardware – cast leaf hinges, brass pulls (restored); W. 18", leaf 9", H. 28", D. 21" (46, 23, 71, 53 cm)

157 Wood – figured maple, pine secondary; original finish – stain and varnish; original hardware – cast leaf hinges, wooden pulls; W. 16½", leaf 10", H. 29½", D. 21" (42, 25, 75, 53 cm)

158 Wood – cherry; original finish – stain and varnish; original hardware – brass pulls; W. 20", H. 29½", D. 17" (51, 75, 43 cm)

159 Wood – cherry, birdseye maple, pine secondary; original finish – stain and varnish; original hardware – cast leaf hinges, ceramic pulls; W. 19", leaf 12", H. 28", D. 19" (48, 30, 71, 48 cm)

160 Wood – maple, pine secondary; original finish – stain and varnish; original hardware – wooden pulls; W. 19", H. 28", D. 17" (48, 71, 43 cm)

161 Wood – figured and birdseye maple, walnut veneer, pine secondary; original finish – stain and varnish; original hardware – wooden pull; W. 20", H. 27½", D. 20" (51, 70, 51 cm)

162 Wood – figured and birdseye maple, pine secondary; original finish – stain and varnish; original hardware – wooden pulls; W. 21", H. 28½", D. 17" (53, 72, 43 cm)

163 Wood – pine; original finish – red; original

hardware – wooden pull; W. 21", H. 28½", D. 21" (53, 72, 53 cm)

164 Wood – cherry, pine, figured maple; original finish – dark stain and varnish; original hardware – brass pull; W. 21½", H. 29½", D. 17½" (55, 75, 44 cm)

165 Wood – cherry, figured maple, pine secondary; original finish – stain and varnish; original hardware – wooden pull with ivory insert; W. 19½", H. 29", D. 19½" (50, 74, 50 cm)

166 Wood – cherry, pine secondary; original finish – stain and varnish; original hardware – wooden pull; W. 18¾", H. 28½", D. 18¼" (47, 72, 46 cm)

167 Wood – mahogany, figured maple, pine secondary; original finish – stain and varnish; original hardware – wooden pull; W. 35", H. 35" (89, 89 cm)

168 Wood – cherry, pine secondary; original finish – stain and varnish; original hardware – brass pull; W. 17", H. 31", D. 17" (43, 79, 43 cm)

169 Wood – cherry, original finish – stain and varnish; W. 26", H. 41" (66, 104 cm)

170 Wood – walnut, pine secondary; original finish – stain and varnish; original hardware – brass pull; W. 20½", H. 32½", D. 19" (52, 83, 48 cm)

171 Wood – birch, pine secondary; original finish – dark stippled paint stain; original hardware – brass pulls; W. 22", H. 40", D. 17½" (56, 102, 44 cm)

172 Wood – butternut and birdseye maple, pine secondary; original finish – stain and varnish; original hardware – wooden pulls; W. 25½", H. 37", D. 17½" (64, 94, 44 cm)

173 Wood – basswood; original finish – painted wood grain; original hardware – brass pull; W. 18½", H. 35½", D. 20½" (47, 90, 52 cm)

174 Wood – pine; original finish – red; original hardware – brass pull; W. 16", H. 36", D. 16" (41, 91, 41 cm)

175 Wood – pine; original finish – brown; W. 33", H. 34", D. 17" (84, 86, 43 cm)

176 Wood – pine and hardwood; original finish – red stain and brown-black mouldings; original hardware – wooden pulls; W. 26", H. 39", D. 16" (66, 99, 41 cm)

177 Wood – birch; original finish – dark stain; original hardware – brass pull; W. 17", H. 30", D. 17" (43, 76, 43 cm)

178 Wood – pine; original finish – green; W. 13", H. 27", D. 13" (33, 69, 33 cm)

179 Wood – pine; original finish – none; W. 33½", H. 33", D. 21" (85, 84, 53 cm)

180 Wood – cherry; original finish – stain and varnish; original hardware – cast hinges, brass escutcheon; W. 31", H. 34", D. 17" (79, 86, 43 cm)

181 Wood – birch; original finish – red; W. 21", H. 40½", D. 14" (53, 103, 36 cm)

182 Wood – birch and ash; original finish – dark stain; presently stripped; W. 21", H. 41", D. 16" (53, 104, 41 cm)

183 Wood – hardwoods; original finish – paint; original seat – elm; W. 21", H. 44", D. 15½" (53, 112, 39 cm)

184 Wood – birch; original finish – black-brown; W. 17½", H. 38½", D. 16" (44, 98, 41 cm)

185 Wood – hardwoods; original finish – red; seat – elm; W. 24", H. 39", D. 20" (61, 99, 51 cm)

186 Wood – hardwoods; original finish – red; original seat – elm; W. 21", H. 44", D. 15½" (53, 112, 39 cm)

187 Wood – hardwoods; original finish – red; original seat – elm; W. 21", H. 37", D. 17" (53, 94, 43 cm)

188 Wood – elm and ash; original finish – red; original seat – elm; W. 21", H. 38", D. 15" (53, 97,

38 cm)

189 Wood – hardwoods; original finish – black; original seat – elm; W. 21", H. 37", D. 16" (53, 94, 41 cm)

190 Wood – hardwoods; original finish – red; original seat – elm; W. 17½", H. 33", D. 13½" (44, 84, 34 cm)

191 Wood – hardwoods; original finish – red; original seat – elm; W. 19", H. 39¼", D. 13½" (48, 100, 34 cm)

192 Wood – hardwoods; original finish – red-brown stain; W. 16" H. 34" D. 15" (41, 86, 38 cm)

193 Wood – hardwoods; original finish – red; original seat – elm; W. 19", H. 34", D. 13½" (48, 86, 34 cm)

194 Wood – hardwoods; original finish – blue; original seat – elm; W. 24", H. 43", D. 19¼" (61, 109, 50 cm)

195 Wood – hardwoods; original finish – black-brown; original seat – elm; W. 21½", H. 47½", D. 16" (55, 120, 41 cm)

196 Wood – hardwoods; original finish – black; original seat – elm bark; W. 19", H. 31", D. 16" (48, 99, 41 cm)

197 Wood – figured maple, ash and oak; original finish – stain and varnish; W. 20", H. 42", D. 15" (51, 107, 38 cm)

198 Wood – hardwoods; original finish – black; original seat – elm; W. 21", H. 44", D. 16" (53, 112, 41 cm)

199 Wood – hardwoods; original finish – black-brown; original seat – rush; W. 20½", H. 41", D. 15" (52, 104, 38 cm)

200 Wood – hardwoods; original finish – paint; original seat – rush

201 Wood – oak; original finish – red; original seat – elm; W. 22", H. 44", D. 15" (56, 112, 38 cm)

202 Wood – hardwoods; original finish – green; original seat – rush; W. 21", H. 41", D. 15" (53, 104, 38 cm)

203 Wood – hardwoods; original finish – red; original seat – elm; W. 18", H. 43½", D. 14" (46, 110, 36 cm)

204 Wood – hardwoods; original finish – stain and varnish; original seat – elm; W. 27", H. 44", D. 21" (69, 112, 53 cm)

205 Wood – birch; original finish – pumpkin; original seat – elm; W. 15", H. 42", D. 15" (38, 107, 38 cm)

206 Wood – hardwoods; original finish – red; original seat – elm; W. 20", H. 33", D. 14½" (51, 84, 37 cm)

207 Wood – hardwoods; original finish – brown; original seat – elm; W. 17", H. 25½", D. 11½" (43, 64, 29 cm)

208 Wood – hardwoods; original finish – red; original seat – elm; W. 14½", H. 25", D. 10" (37, 63, 25 cm)

209 Wood – hardwoods; original finish – stain and varnish; original seat – rush; W. 15", H. 24", D.11" (38, 61, 28cm)

210 Wood – hardwoods; original finish – red; original seat – elm; W. 13", H. 32", D. 10" (33, 81, 25 cm)

211 Wood – hardwoods; original finish – red; original seat – elm; W. 15", H. 26", D. 12" (38, 66, 30 cm)

212 Wood – hardwoods; original finish – black; original seat – elm; W. 14", H. 25", D. 10½" (36, 63, 26 cm)

213 Wood – hardwoods; original finish – brown; original seat – rush; W. 14½", H. 37½", D. 10" (37, 95, 25 cm)

214 Wood – hardwoods; original finish – black-brown stain and varnish; original seat – elm; W. 14", H. 38", D. 11" (36, 97, 28 cm)

215 Wood – hardwoods; original finish – brown-

black; original seat – rush or elm; W. 14″, H. 34½″, D. 11″ (36, 88, 28 cm)

216 Wood – hardwoods; original finish – red; original seat – elm; W. 13″, H. 35″, D. 10″ (33, 89, 25 cm)

217 Wood – hardwoods; original finish – brown; original seat – elm; W. 12½″, H. 32″, D. 11″ (32, 81, 28 cm)

218 Wood – hardwoods; original finish – red; original seat – rush; W. 12″, H. 33″, D. 12″ (30, 84, 30 cm)

219 Wood – hardwoods; original finish – red; original seat – elm; W. 12″, H. 31″, D. 12″ (30, 79, 30 cm)

220 Wood – hardwoods; original finish – red; original seat – elm; W. 13″, H. 31″, D. 11″ (33, 79, 28 cm)

221 Wood – oak; original finish – red; original seat – leather; W. 12″, H. 24″, D. 10″ (30, 61, 25 cm)

222, 223 Wood – oak; original finish – brown; original seat – elm; high chair – W. 14″, H. 31″, D. 13″ (36, 79, 33 cm); rocker – W. 13″, H. 24″, D. 12″ (33, 61, 30 cm)

224 Wood – pine; original finish – brown-black; forged nails; W. 13″, D. 11″ (33, 28 cm)

225 Wood – oak; original finish – dark brown; original seat – leather; W. 18″, H. 27″, D. 16″ (46, 69, 41 cm)

226 Wood – oak; original finish – green; W. 16″, H. 18″, D. 11″ (41, 46, 28 cm)

227 Wood – pine; original finish – red; presently stripped; W. 21″, H. 23″, D. 21″ (53, 58, 53 cm)

228 Wood – pine; original finish – dark stain; presently overpainted; W. 14½″, H. 19″, D. 11″ (37, 48, 28 cm)

229 Wood – pine, hardwood supports; original finish – stain and varnish; H. 21½″, H. 48″, D. 19″ (55, 122, 48 cm)

230 Wood – elm; original finish – red; presently stripped; W. 23″, H. 43″, D. 16¾″ (58, 109, 42 cm)

231 Wood – basswood seat, hardwoods; original finish – red; W. 21″, H. 42½″, D. 15″ (53, 108, 38 cm)

232 Wood – pine seat and hardwoods; original finish – green; W. 20″, H. 40″, D. 15″ (51, 102, 38 cm); legs originally about 2″ (5 cm) longer

233 Wood – pine seat and hardwoods; original finish – dark stain and varnish; W. 20″, H. 42″, D. 14½″ (51, 107, 37 cm)

234 Wood – pine seat and hardwoods; original finish – black; W. 21″, H. 39″, D. 15″ (53, 99, 38 cm)

235 Wood – basswood seat and hardwoods; original finish – paint; presently stripped; W. 16″, H. 37″, D. 17″ (41, 94, 43 cm)

236 Wood – pine seat and hardwoods; original finish – black; W. 18″, H. 36″, D. 18″ (46, 91, 46 cm)

237 Wood – pine seat and hardwoods; original finish – green; presently stripped; W. 20″, H. 38″, D. 14½″ (51, 97, 37 cm)

238 Wood – pine and hardwoods; original finish – paint; presently stripped; W. 20″, H. 38″, D. 14½″ (51, 97, 37 cm)

239 Wood – pine seat and hardwoods; original finish – green; W. 19″, H. 34″, D. 14″ (48, 86, 36 cm)

240 Wood – pine seat and hardwoods; original finish – painted, grained and striped; W. 21½″, H. 35½″, D. 16½″ (55, 90, 42 cm)

241 Wood – pine seat and hardwoods; original finish – red; W. 17½″, H. 35″, D. 17½″ (44, 89, 44 cm)

242 Wood – pine seat and hardwoods; original finish – dark stain; W. 17½″, H. 34″, D. 16½″ (44, 86, 42 cm) (foot cut, casters added)

243 Wood – pine seat and hardwoods; original finish – brown; W. 18½″, H. 38½″, D. 18″ (47, 98, 46 cm)

244 Wood – pine seat and hardwoods; original finish – paint; presently stripped; W. 15″, H. 29″, D. 16″ (38, 74, 41 cm)

245 Wood – pine seat and hardwoods; original finish – black with multi-coloured stencil decoration; W. 19″, H. 46″, D. 17″ (48, 117, 43 cm)

246 Wood – pine seat and hardwoods; original finish – black; W. 19″, H. 35½″, D. 18″ (48, 90, 46 cm)

247 Wood – pine seat and hardwoods; original finish – red; presently stripped; W. 17″, H. 33″, D. 17″ (43, 84, 43 cm)

248 Wood – pine seat and hardwoods; original finish – black with striped and painted decoration; W. 19″, H. 33″, D. 18½″ (48, 84, 47 cm)

249 Wood – pine and hardwoods; original finish – black with striping; W. 18″, H. 33″, D. 17″ (46, 84, 43 cm)

250 Wood – pine seat and hardwoods; original finish – black; W. 19″, H. 45″, D. 18″ (48, 114, 46 cm)

251 Wood – pine seat and hardwoods; original finish – black; W. 33″, H. 44″, D. 28″ (84, 112, 71 cm)

252 Wood – pine seat, collar and hardwoods; original finish – green with yellow and red striping; W. 19″, H. 28″, D. 17″ (48, 71, 43 cm)

253 Wood – pine seat, collar and hardwoods; original finish – green; W. 23″, H. 29″, D. 18″ (58, 74, 46 cm)

254 Wood – pine and hardwoods; original finish – brown; W. 20″, H. 33½″, D. 19½″ (51, 85, 50 cm)

255 Wood – pine seat, collar and hardwoods; original finish – black with stencilled and painted decoration; W. 18½″, H. 30″, D. 19″ (47, 76, 48 cm)

256 Wood – pine seat, collar and hardwoods; original finish – black with striping; W. 24″, H. 30½″, D. 19″ (61, 77, 48 cm)

257 Wood – pine seat, collar and hardwoods; original finish – black; W. 20″, H. 29½″, D. 17½″ (51, 75, 44 cm)

258 Wood – pine seat, collar and hardwoods; original finish – red; W. 19″, H. 30″, D. 18″ (48, 76, 46 cm)

259 Wood – pine seat, collar and hardwoods; original finish – black; W. 19″, H. 33″, D. 18″ (48, 84, 46 cm)

260 Wood – pine seat, collar and hardwoods; original finish – brown; W. 18½″, H. 30″, D. 17″ (47, 76, 43 cm)

261 Wood – pine seat and hardwoods; original finish – black with gold painted decoration; W. 22″, H. 29½″, D. 19″ (56, 75, 48 cm)

262 Wood – pine seat and hardwoods; original finish – dark green; W. 17″, H. 37½″, D. 17″ (43, 95, 43 cm)

263 Wood – oak; original finish – stain and varnish; W. 14″, H. 33½″, D. 17″ (36, 85, 43 cm)

264 Wood – pine seat and hardwoods; original finish – brown; W. 13½″, H. 33″, D. 14½″ (34, 84, 37 cm)

265 Wood – pine seat and hardwoods; original finish – red; W. 15″, H. 37″, D. 16″ (38, 94, 41 cm)

266 Wood – pine seat and hardwoods; original finish – black; W. 16″, H. 36″, D. 19″ (41, 91, 48 cm)

267 Wood – pine seat and hardwoods; original finish – black; W. 14″, H. 33½″, D. 15″ (36, 85, 38 cm)

268 Wood – pine seat and hardwoods; original finish – dark green; W. 16″, H. 32″, D. 16″ (41, 81, 41 cm)

269 Wood – pine seat and hardwoods; original

finish – black with stencilled decoration; presently restored; W. 16″, H. 34½″, D. 16″ (41, 88, 41 cm)

270 Wood – pine seat and hardwoods; original finish – black with striping and brush decoration; W. 14½″, H. 33½″, D. 14¾″ (37, 85, 38 cm)

271 Wood – basswood seat and hardwoods; original finish – red; presently stripped; W. 15″, H. 29″, D. 15″ (38, 74, 38 cm)

272 Wood – pine seat and hardwoods; original finish – black with stencilled decoration; presently restored; W. 15″, H. 34″, D. 16″ (38, 86, 41 cm)

273 Wood – pine seat and hardwoods; original finish – black over red; W. 15″, H. 34″, D. 15″ (38, 86, 38 cm)

274 Wood – basswood seat and hardwoods; original finish – red; presently stripped; W. 15½″, H. 32″, D. 15½″ (39, 81, 39 cm)

275 Wood – pine seat and hardwoods; original finish – black with gold striping; W. 14″, H. 33″, D. 16″ (36, 84, 41 cm)

276 Wood – pine seat and hardwoods; original finish – black with stencils and painted crest rail; W. 17″, H. 34″, D. 15″ (43, 86, 38 cm)

277 Wood – pine seat and hardwoods; original finish – paint (decoration); W. 14″, H. 34″, D. 15″ (36, 86, 38 cm)

278 Wood – pine seat and hardwoods; original finish – black over red with gilt wash on crest rail; side chair: W. 15″, H. 32″, D. 15½″ (38, 81, 39 cm); desk chair: W. 15″, H. 41″, D. 15″ (38, 104, 38 cm)

279 Wood – pine seat and hardwoods; original finish – black with green and yellow decoration; W. 15″, H. 34″, D. 15″ (38, 86, 38 cm)

280 Wood – pine seat and hardwoods; original finish – red; W. 15″, H. 33½″, D. 16″ (38, 85, 41 cm)

281 Wood – pine seat and hardwoods; original finish – black; presently stripped; W. 15″, H. 34″, D. 15″ (38, 86, 38 cm)

282 Wood – pine seat and hardwoods; original finish – black; W. 14″, H. 32″, D. 14″ (36, 81, 36 cm)

283 Wood – pine and hardwoods; original finish – yellow with dark striping and feather painting; W. 17″, H. 33″, D. 17″ (43, 84, 43 cm)

284 Wood – pine seat, arms and hardwoods; original finish – black with painted and stencilled decoration; W. 19¼″, H. 44″, D. 17¼″ (50, 112, 44 cm)

285 Wood – pine seat, arms and hardwoods; original finish – black; W. 18″, H. 41½″, D. 19″ (46, 105, 48 cm)

286 Wood – pine seat and hardwoods; original finish – black; W. 18″, H. 41″, D. 19″ (46, 104, 48 cm)

287 Wood – pine seat and hardwoods; original finish – black with stencilled decoration and striping; W. 18½″, H. 41″, D. 19″ (47, 104, 48 cm)

288 Wood – pine seat and hardwoods; original finish – black with stencilled decoration; W. 18½″, H 40½″, D. 17½″ (47, 103, 44 cm)

289 Wood – pine and hardwoods; original finish – brown; W. 17″, H. 39″, D. 15½″ (43, 99, 39 cm)

290 Wood – maple; original finish – green with brush decoration; W. 20″, H. 42″, D. 18″ (51, 107, 46 cm)

291 Wood – pine seat and hardwoods; original finish – woodgrained paint with stencilled and painted decoration; W. 17½″, H. 41″, D. 16″ (44, 104, 41 cm)

292 Wood – pine seat and hardwoods; original finish – black with stencilled decoration and striping; W. 18″, H. 41½″, D. 18″ (46, 105, 46 cm)

293 Wood – pine seat and hardwoods; original finish – black with stencilled and painted decoration; W. 20″, H. 45½″, D. 19″ (51, 116, 48 cm)

294 Wood – pine seat and hardwoods; original

finish – black; W. 22", H. 41", D. 18½" (56, 104, 47 cm)

295 Wood – pine seat and hardwoods; original finish – black with stencilling and striping; W. 20½", H. 41", D. 19" (52, 104, 48 cm)

296 Wood – pine seat and hardwoods; original finish – black with stencilled decoration; W. 21½", H. 39½", D. 21" (55, 100, 53 cm)

297 Wood – pine seat and hardwoods; original finish – red; W. 18", H. 42", D. 18" (46, 107, 46 cm)

298 Wood – pine seat, collar and hardwoods; original finish – black with stencilling and striping; W. 19", H. 40", D. 17½" (48, 102, 44 cm)

299 Wood – pine seat and hardwoods; original finish – black with stencilled decoration; W. 18½", H. 44", D. 19" (47, 112, 48 cm)

300 Wood – pine seat and hardwoods; original finish – red; W. 17", H. 41", D. 17" (43, 104, 43 cm)

301 Wood – basswood seat and hardwoods; original finish – red; presently stripped; W. 22½", H. 40", D. 21½" (57, 102, 55 cm)

302 Wood – pine seat and hardwoods; original finish – red; W. 15½", H. 32", D. 15½" (39, 81, 39 cm)

303 Wood – pine seat and hardwoods; original finish – red; W. 17", H. 30", D. 16" (43, 76, 41 cm)

304 Wood – pine seat and hardwoods; original finish – black with stencilled decoration and striping; W. 17½", H. 39", D. 17" (44, 99, 43 cm)

305 Wood – pine seat and hardwoods; original finish – black with stencilled and striped decoration; W. 11", H. 17", D. 11" (28, 43, 28 cm)

306 Wood – pine seat and hardwoods; original finish – painted wood grain; W. 12", H. 19", D. 12" (30, 48, 30 cm)

307 Wood – pine seat and hardwoods; original finish – black with stencilled and striped decoration; W. 13", H. 25", D. 14" (33, 63, 36 cm)

308 Wood – pine seat and hardwoods; original finish – red; W. 13", H. 34½", D. 12" (33, 88, 30 cm)

309 Wood – pine seat and hardwoods; original finish – black with striping; W. 14", H. 28", D. 13" (36, 71, 33 cm)

310 Wood – pine seat and hardwoods; original finish – black with striping; W. 12", H. 31", D. 12" (30, 79, 30 cm)

311 Wood – pine seat and hardwoods; original finish – black with stencilled and striped decoration; W. 12", H. 32", D. 11" (30, 81, 28 cm)

312 Wood – oak; original finish – dark green; presently overpainted; W. 13½", H. 23", D. 11" (34, 58, 28 cm)

313 Wood – pine seat and back rail, hardwood legs and spindles; original finish – red; W. 23", H. 26", D. 15½" (58, 66, 39 cm)

314 Wood – ash; original finish – none; W. 24", H. 30" D. 16" (61, 76, 41 cm) (approx.)

315 Chair: wood – pine seat with hardwoods; original finish – black; forged nails; W. 19", H. 27½", D. 14½" (48, 70, 37 cm). Stool: wood – hardwoods; original finish – none; W. 11", H. 9", D. 4½" (28, 23, 11 cm)

316 Wood – pine seat and hardwoods; original finish – dark green; W. 20", H. 31", D. 15" (51, 79, 38 cm)

317 Wood – pine and oak; original finish – none; W. 26", H. 20", D. 15" (66, 51, 38 cm)

318 Wood – pine and hardwood; original finish – none; W. 8", H. 11", D. 12" (20, 28, 30 cm)

319 Wood – pine and hardwood; original finish – Windsor green; W. 12", H. 9", D. 9½" (30, 23, 24 cm)

320 Wood – pine and oak; original finish – none; W. 18", H. 9½", D. 14" (46, 24, 36 cm)

321 Wood – pine; original finish – paint; W. 12", H. 7", D. 8" (30, 18, 20 cm)

322 Wood – walnut and pine; original finish – none; W. 12", H. 18½", D. 12" (30, 47, 30 cm)

323 Wood – maple; original finish – red; W. 11", H. 22" (28, 56)

324 Wood – pine and hardwoods; original finish – dark green; W. 38", H. 27", D. 18" (97, 69, 46 cm)

325 Wood – basswood seat and hardwoods; original finish – brown with striping; presently remnants of original; W. 38½", H. 29½", D. 15" (98, 75, 38 cm)

326 Wood – pine seat and hardwoods; original finish – red over black; W. 38", H. 40", D. 15" (97, 102, 38 cm)

327 Wood – pine and birch; original finish – dark green; W. 93½", H. 33½", D. 16" (237, 85, 41 cm)

328 Wood – pine seat and hardwoods; original finish – black; W. 74", H. 36", D. 17" (188, 91, 43 cm)

329 Wood – pine seat and hardwoods; original finish – black over red graining with stencilled and striped decoration; W. 54", H. 31", D. 18" (137, 79, 46 cm)

330 Wood – pine seat and hardwoods; original finish – red; W. 79", H. 36", D. 18½" (201, 91, 47 cm)

331 Wood – pine seat and hardwoods; original finish – light brown paint; W. 80", H. 27", D. 16" (203, 69, 41 cm)

332 Wood – pine seat and hardwoods; original finish – black over red graining with stencilled decoration; W. 76", H. 35", D. 22½" (193, 89, 57 cm)

333 Wood – birch; original finish – stain and varnish; H. 38", W. 20", D. 17" (97, 51, 43 cm)

334 Show-wood – hardwood; original finish – stain and varnish; W. 24", H. 42", D. 21" (61, 107, 53 cm)

335 Wood – cherry; original finish – stain and varnish; W. 19", H. 37½", D. 14½" (48, 95, 37 cm)

336 Wood – mahogany; original finish – stain and varnish; W. 26", H. 46", D. 22" (66, 117, 56 cm)

337 Wood – birch, pine (seat); original finish – stain and varnish; W. 20", H. 33½", D. 17" (51, 85, 43 cm)

338 Wood – birch; original finish – stain and varnish; W. 20½", H. 34", D. 21½" (52, 86, 55 cm)

339 Wood – birch, pine (seat); original finish – stain and varnish; W. 19½", H. 33", D. 18½" (50, 84, 47 cm)

340 Wood – walnut and mahogany; original finish – stain and varnish; W. 21", H. 34", D. 18" (53, 86, 46 cm)

341 Wood – walnut; original finish – stain and varnish; W. 20", H. 33½", D. 16½" (51, 85, 42 cm)

342 Wood – oak, pine (seat); original finish – dark stain and varnish; W. 20", H. 35", D. 18" (51, 89, 46 cm)

343 Wood – birch, pine (seat); original finish – dark stain and varnish; W. 22", H. 36", D. 17½" (56, 91, 44 cm)

344 Wood – walnut; original finish – stain and varnish; W. 20", H. 34½", D. 18" (51, 88, 46 cm)

345 Wood – cherry; original finish – dark stain and varnish; side chair: W. 19", H. 35", D. 15" (48, 89, 38 cm); armchair: W. 21", H. 35", D. 17" (53, 89, 43 cm)

346 Wood – figured maple; original finish – stain and varnish; W. 20", H. 35", D. 20" (51, 89, 51 cm)

347 Wood – cherry; original finish – dark stain and varnish; W. 20½", H. 41", D. 18½" (52, 104, 47 cm)

348 Wood – birch, pine (seat); original finish – dark stain and varnish; W. 19", H. 35", D. 15½" (48, 89, 39 cm)

349 Wood – birch; original finish – dark stain and varnish; W. 19", H. 36", D. 15" (48, 91, 38 cm)

350 Wood – oak; original finish – brown paint stain; W. 19", H. 33", D. 14½" (48, 84, 37 cm)

351 Wood – cherry; original finish – stain and varnish; armchair: W. 19½", H. 36", D. 17½" (50, 91, 44 cm); side chair: W. 17½", H. 35", D. 15½" (44, 89, 39 cm)

352 Wood – birch; original finish – stain and varnish; W. 18½", H. 34½", D. 14½" (47, 88, 37 cm)

353 Wood – birch, pine (seat); original finish – dark red stain and varnish; W. 21½", H. 38", D. 17½" (55, 97, 44 cm)

354 Wood – birch, pine (seat); original finish – reddish dark stain and varnish; side chair: W. 17", H. 33", D. 15" (43, 84, 38 cm); armchair: W. 20", H. 33", D. 17" (51, 84, 43 cm)

355 Wood – birch and pine; original finish – dark brown; W. 22", H. 39" (56, 99 cm)

356 Wood – walnut; original finish – stain and varnish; W. 13½", H. 21¾", D. 11" (34, 55, 28 cm)

357 Wood – walnut; original finish – stain and varnish; W. 19", H. 36", D. 17" (48, 91, 43 cm)

358 Wood – walnut and mahogany; original finish – stain and varnish; side chair: W. 18½", H. 34¼", D. 17" (47, 88, 43 cm); armchair: W. 20½", H. 34¼", D. 18" (52, 88, 46 cm)

359 Wood – figured maple; original finish – stain and varnish; W. 17", H. 34", D. 16" (43, 86, 41 cm)

360 Wood – figured maple; original finish – stain and varnish; W. 20", H. 42½", D. 22" (51, 108, 56 cm)

361 Wood – figured maple; original finish – stain and varnish; W. 17", H. 33", D. 16" (43, 84, 41 cm)

362 Wood – walnut (solid and veneers); original finish – stain and varnish; W. 18", H. 33", D. 16½" (46, 84, 42 cm)

363 Wood – hardwoods; original finish – black with gilt stencil; W. 17", H. 33", D. 16½" (43, 84, 42 cm)

364 Wood – walnut (solid and veneer); original finish – stain and varnish; W. 17", H. 32", D. 17" (43, 81, 43 cm)

365 Wood – hardwoods; original finish – painted and decorated; W. 17½", H. 35½", D. 15" (44, 90, 38 cm)

366 Wood – hardwoods; original finish – black with multi-coloured stencil decoration (restored); W. 18", H. 34½", D. 14" (46, 88, 36 cm)

367 Wood – hardwoods; original finish – black with gilt striping; W. 17½", H. 34½", D. 15" (44, 88, 38 cm)

368 Wood – hardwoods; original finish – black with painted vignettes and striping; W. 17", H. 34", D. 15" (43, 86, 38 cm)

369 Wood – hardwoods; original finish – black with multi-coloured stencilled and painted decoration; W. 21", H. 34", D. 15½" (53, 86, 39 cm)

370 Wood – hardwoods; original finish – black with multi-coloured stencilled and painted decoration; W. 18½", H. 33½", D. 15" (47, 85, 38 cm)

371 Wood – pine seat and hardwoods; original finish – black over red with striping; W. 15", H. 34", D. 15½" (38, 86, 39 cm)

372 Wood – maple; original finish – stain and varnish; W. 17", H. 34½", D. 17" (43, 88, 43 cm)

373 Wood – hardwoods; original finish – painted, grained and striped; W. 17", H. 33", D. 14" (43, 84, 36 cm)

374 Wood – hardwoods; original finish – painted and grained; W. 17", H. 33", D. 16" (43, 84, 41 cm)

375 Wood – hardwoods; original finish – black (?); W. 16", H. 33½", D. 16½" (41, 85, 42 cm)

376 Wood – hardwoods; original finish – cream; W. 17½", H. 34½", D. 14½" (44, 88, 37 cm)

377 Wood – walnut; original finish – stain and varnish; W. 18½″, H. 36″, D. 17½″ (47, 91, 44 cm)

378 Wood – mahogany; original finish – stain and varnish; W. 18″, H. 34½″, D. 16″ (46, 88, 41 cm)

379 Wood – basswood seat and hardwoods; original finish – grey; W. 19″, H. 35″, D. 18″ (48, 89, 46 cm)

380 Wood – pine and hardwoods; original finish – stain; W. 15″, H. 32″, D. 15″ (38, 81, 38 cm)

381 Wood – birch; original hardware – brass casters; W. 74″, H. 39″, D. 32″ (188, 99, 81 cm)

382 Wood – mahogany; original finish – stain and varnish; original hardware – brass casters; W. 76″, H. 34″, D. 34″ (193, 86, 86 cm)

383 Wood – birch; original finish – stain and varnish; original hardware – cast casters; W. 72″, H. 34″, D. 28″ (183, 86, 71 cm)

384 Wood – pine and hardwoods; original finish – red; W. 71″, H. 32″, D. 25″ (180, 81, 63 cm)

385 Wood – mahogany; original finish – stain and varnish; original hardware – brass casters; W. 92″, H. 34½″, D. 24″ (234, 88, 61 cm)

386 Wood – mahogany, pine secondary; original finish – stain and varnish; original hardware – iron casters; W. 79″, H. 34″, D. 24″ (201, 86, 61 cm)

387 Wood – walnut and birch; original finish – stain and varnish; original hardware – cast hinges; W. 78″, H. 22″, D. 30″ (198, 56, 76 cm)

388 Wood – walnut, pine secondary; original finish – dark stain; W. 83″, H. 33″, D. 24″ (211, 84, 61 cm)

389 Wood – birch legs, pine secondary; original finish – stain and varnish; original hardware – iron casters; W. 83″, H. 35½″ (211, 90 cm)

390 Wood – pine; original finish – brown-black; W. 83″, H. 32½″, D. 23″ (211, 83, 58 cm)

391 Wood – figured maple; original finish – stain and varnish; W. 84″, H. 33″, D. 25″ (213, 84, 63 cm)

392 Wood – pine; original finish – grey-blue; W. 70½″, H. 20½″, D. 20½″ (179, 52, 52 cm)

393 Wood – maple; original finish – red; W. 76″, H. 26″, D. 33″ (193, 66, 84 cm)

394 Wood – cherry, figured maple; original finish – stain and varnish; W. 76″, H. 36″, D. 27″ (193, 91, 69 cm)

395 Wood – maple, oak, pine; original finish – dark stain and varnish; W. 76″, H. 32″, D. 26″ (193, 81, 66 cm)

396 Wood – pine and hardwoods; original finish – red; W. 76″, H. 33″, D. 26″ (193, 84, 66 cm)

397 Wood – birch and oak; original finish – stain and varnish; W. 74″, H. 26″, D. 25″ (188, 66, 63 cm)

398 Wood – pine; original finish – red; W. 65″, H. 32″, D. 20″ (168, 81, 51 cm)

399 Wood – ash; original finish – red; W. 84″, H. 30″, D. 23″ (213, 76, 58 cm)

400 Wood – pine; original finish – red; original hardware – forged-iron hooks, latches and strap hinges; W. 74″, H. 42″, D. 18″ (188, 107, 46 cm)

401 Wood – pine; original finish – red with gold stencils, yellow striping; W. 77″, H. 40″, D. 24″ (196, 102, 61 cm)

402 Wood – pine; original finish – red; W. 74″, H. 43″, D. 18″ (188, 109, 46 cm)

403 Wood – pine; original finish – red; W. 77″, H. 38″, D. 22″ (196, 97, 56 cm)

404 Wood – pine; original finish – green; presently stripped; W. 73″, H. 41″, D. 20½″ (185, 104, 52 cm)

405 Wood – basswood and hardwoods; original finish – green with stencil and striping; W. 76″, H. 31″, D. 19½″ (193, 79, 50 cm)

406 Wood – pine and hardwoods; original finish – black with gold stencils and yellow striping; W. 76″, H. 40″, D. 22″ (193, 102, 56 cm)

407 Wood – pine; original finish – none; W. 20″, H. 19″, D. 12″ (51, 48, 30 cm)

408 Wood – birch and pine; original finish – black; original hardware – cast hinges and forged hook; W. 72″, H. 28½″, D. 20″ (183, 72, 51 cm)

409 Wood – pine; original finish – red; W. 26″, H. 18″, D. 10½″ (66, 46, 26 cm)

410 Wood – pine; original finish – red; W. 48″, H. 16″, D. 12½″ (122, 41, 32 cm)

411 Wood – pine; original finish – red-brown; W. 59″, H. 17″, D. 10″ (150, 43, 25 cm)

412 Wood – pine; original finish – red; W. 70″, H. 18″, D. 10″ (178, 46, 25 cm)

413 Wood – pine; original finish – grey paint; W. 19″, H. 17″, D. 13″ (48, 43, 33 cm)

414 Wood – pine; original finish – black; presently stripped; W. 14″, H. 8½″, D. 10½″ (36, 22, 26 cm)

415 Wood – pine and birch; original finish – stain and varnish; W. 16½″, H. 9½″, D. 12″ (42, 24, 30 cm)

416 Wood – pine and cherry; original finish – black-brown; W. 24″, H. 12″, D. 12″ (61, 30, 30 cm)

417 Wood – pine and hardwoods; original finish – paint; left: W. 15½″, H. 7½″ (39, 19 cm); right: W. 21″, H. 11″ (53, 28 cm)

418 Wood – pine; original finish – red; presently overpainted grey; original hardware – cast hinges, brass pulls; W. 59½″, H. 75″, D. 18″ (151, 190, 46 cm)

419 Wood – pine; original finish – red; original hardware – "HL" hinges, forged nails; W. 48″, H. 76″, D. 19″ (122, 193, 48 cm)

420 Wood – pine; original finish – red; original hardware – cast hinges, wooden turnbuckle; W. 44″, H. 81″, D. 18″ (112, 206, 46 cm)

421 Wood – pine; original finish – green and red; original hardware – brass pulls, cast hinges, forged nails; W. 51″, H. 85″, D. 22″ (130, 216, 56 cm)

422 Wood – pine; original finish – red; presently repainted; original hardware – forged surface hinges, wooden turnbuckle, forged nails throughout; present hinges – cast replacements; W. 43½″, H. 72″, D. 16″ (110, 183, 41 cm)

423 Wood – pine; original finish – red with green-blue doors; original hardware – cast hinges and turnbuckles; W. 45½″, H. 73″, D. 16″ (116, 185, 41 cm)

424 Wood – cherry; original finish – red; original hardware – cast hinges, porcelain pulls, porcelain and cast latches; W. 47″, H. 75″, D. 20″ (119, 190, 51 cm)

425 Wood – pine; original finish – red with black impressionistic woodgrain design; original hardware – cast hinges, wooden pulls, wooden turnbuckles; W. 52″, H. 79″, D. 22½″ (132, 201, 57 cm)

426 Wood – pine; original finish – red; original hardware – wooden pulls, cast hinges; W. 55″, H. 76″, D. 19″ (140, 193, 48 cm)

427 Wood – pine; original finish – red; presently early green overpaint; original hardware – cast hinges; W. 56″, H. 74″, D. 23″ (142, 188, 58 cm)

428 Wood – pine; original finish – red; original hardware – cast hinges, forged nails; W. 57″, H. 75″, D. 20″ (145, 190, 51 cm); cornice ends restored

429 Wood – pine; original finish – red, ochre and yellow; original hardware – cast hinges, wooden pulls and turnbuckles; W. 42″, H. 68¾″, D. 17½″ (107, 175, 44 cm)

430 Wood – pine; original finish – red; presently grey overpaint; original hardware – cast hinges, wooden pulls and turnbuckles, forged and cut nails; W. 49″, H. 75″, D. 18½″ (124, 190, 47 cm)

431 Wood – pine; original finish – red exterior, dark green interior; presently apple-green overpaint; original hardware – cast hinges, wooden pulls; W. 51½″, H. 82″, D. 20″ (131, 208, 51 cm)

432 Wood – poplar, walnut, butternut, pine and basswood; original finish – dark green; original hardware – cast hinges, wooden pulls and turnbuckles; W. 61½″, H. 91″, D. 24″ (156, 231, 61 cm)

433 Wood – pine; original finish – red; original hardware – cast hinges, wooden pulls; W. 72″, H. 81½″, D. 32″ (183, 207, 81 cm)

434 Wood – pine; original finish – grey; original hardware – wooden pulls, cast hinges and latches; the shoe foot is not original; W. 74″, H. 104″, D. 21″ (188, 264, 53 cm)

435 Wood – pine; original finish – green; original hardware – cast hinges, likely wooden pulls; W. 64½″, H. 86″, D. 17″ (164, 218, 43 cm)

436 Wood – pine; original finish – black; original hardware – wooden pulls, cut nails, cast hinges; W. 58″, H. 98″, D. 19″ (147, 249, 48 cm)

437 Wood – pine; original finish – greenish-blue and red; presently early brown overpaint; original hardware – cast hinges, brass pulls, forged nails; W. 59″, H. 82″, D. 19″ (150, 208, 48 cm)

438 Wood – pine; original colour – dark green; original hardware – brass pulls, cast hinges; W. 64″, H. 84″, D. 21″ (163, 213, 53 cm)

439 Wood – pine; original finish – red; original hardware – cast hinges, wooden pulls; W. 59″, H. 88″, D. 24″ (150, 224, 61 cm)

440 Wood – pine; original finish – red; original hardware – cast hinges, brown porcelain pulls; W. 54″, H. 82″, D. 15″ (137, 208, 38 cm)

441 Wood – pine; original finish – red; presently stripped; original hardware – wooden pulls, brass turnbuckles, cast hinges; W. 52″, H. 77″, D. 18″ (132, 196, 46 cm)

442 Wood – pine; original finish – grey; presently stripped; original hardware – cast hinges, forged nails, brass pulls (replaced); top cornice restored; W. 55″, H. 81″, D. 25″ (140, 206, 63 cm)

443 Wood – pine; original finish – red; original hardware – cast hinges, forged nails; W. 72″, H. 72″, D. 19½″ (122, 183, 50 cm)

444 Wood – pine; original finish – grey-green; original hardware – cast hinges, brass pulls

445 Wood – pine; original finish – dark grey; original hardware – cast hinges and turnbuckles, wooden pulls; the drawers were originally fixed panels; W. 52″, H. 92″, D. 29″ (132, 234, 74 cm)

446 Wood – pine; original finish – red; original hardware – cast hinges, brass pull; W. 51″, H. 71″, D. 26½″ (130, 180, 67 cm)

447 Wood – pine; original finish – mahogany and satinwood graining; original hardware – cast hinges, brass pulls; W. 53″, H. 114″ (135, 290); entablature altered

448 Wood – pine; original finish – green; original hardware – brass hinges and pulls; W. 55″, H. 88″ (140, 224 cm); upper cornice missing

448a Wood – pine; original finish – green; W. 78″, H. 48″ (198, 122 cm)

449 Wood – pine; original finish – paint (restored); original hardware – cast hinges, brass pull; W. 50″, H. 88″ (127, 224 cm)

450 Wood – pine; original finish – green; original hardware – cast hinges, brass pulls; W. 48″, H. 95″ (122, 241 cm)

451 Wood – pine; original finish – green; presently stripped; original hardware – cast hinges, brass pulls; W. 48″, H. 80″ (122, 203 cm)

452 Wood – pine; original finish – multi-coloured paint (exterior restored); original hardware – cast hinges, brass pulls; W. 58″, H. 83″ (147, 211 cm)

453 Wood – pine; original finish – green; original

hardware – cast hinges, brass or wooden pulls; W. 64½", H. 92" (164, 234 cm)

454 Wood – pine; original finish – exterior blue, interior red; presently late wood graining; original hardware – cast hinges, brass pulls; W. 52", H. 93" (182, 236 cm)

455 Wood – pine; original finish – brown; presently stripped; original hardware – cast hinges, porcelain pulls; W. 58", H. 102" (147, 259 cm)

456 Wood – pine; original finish – painted wood graining; original hardware – cast hinges, porcelain pulls; W. 53", H. 89" (135, 226 cm)

457 Wood – pine; original finish – green; presently stripped; original hardware – cast hinges, brass pulls; W. 57", H. 91" (145, 231 cm)

458 Wood – pine; original finish – red; presently overpainted; original hardware – cast hinges, brass pull; W. 55", H. 92" (140, 234 cm)

459 Wood – pine; original finish – paint; original hardware – cast hinges, ceramic pulls; W. 58", H. 106" (147, 269 cm)

460 Wood – cherry; original finish – stain; original hardware – brass hinges, escutcheons and pulls; W. 53", H. 75" (135, 190 cm)

461 Wood – pine; original finish – paint; presently stripped; original hardware – cast hinges, sandwich glass pull (bottom pull replaced); W. 65", H. 82" (165, 208 cm)

462 Wood – pine; original finish – red; presently overpainted; original hardware – brass hinges and pulls; W. 42", H. 83" (107, 211 cm)

463 Wood – pine; original finish – red; presently stripped; original hardware – brass pulls, hinges and escutcheons; W. 42½", H. 86" (108, 218 cm)

464 Wood – maple; original finish – red, possibly grained; presently stripped; original hardware – cast hinges, wooden pulls; W. 50", H. 90" (127, 229 cm)

465 Wood – cherry; original finish – stain; original hardware – cast hinges, brass pull and escutcheons; W. 42", H. 82½" (107, 209 cm)

466 Wood – butternut, elm, oak and pine; original finish – dark stain; presently light stain; original hardware – brass hinges, pull and escutcheon; W. 33", H. 79½" (84, 202 cm)

467 Wood – pine; original finish – green; original hardware – cast hinges, brass pulls; W. 28", H. 90" (71, 229 cm)

468 Wood – pine; original finish – red exterior, grey interior; original hardware – cast hinges; W. 34", H. 78" (86, 198 cm)

469 Wood – pine; original finish – red; original hardware – cast hinges, brass pull and turnbuckles; W. 31", H. 76" (79, 193 cm); extensive restoration to upper door

470 Wood – cherry; original finish – dark stain; original hardware – cast hinges, wooden pulls; W. 41", H. 86" (104, 218 cm)

471 Wood – pine; original finish – painted wood grain; original hardware – cast hinges, wooden pulls; W. 35", H. 78" (89, 198 cm)

472 Wood – tulip; original finish – red and brown; original hardware – cast hinges, wooden pulls, brass escutcheons; W. 24", H. 72" (61, 183 cm)

473 Wood – pine; original finish – red; presently stripped; original hardware – cast hinges, brass pulls; W. 51", H. 75" (130, 190 cm)

474 Wood – pine; original finish – ochre; original hardware – cast hinges, brass pulls and escutcheons, W. 49", H. 85½" (124, 217 cm)

475 Wood – figured maple; original finish – stain and varnish; original hardware – brass hinges, ceramic pulls, brass turnbuckles; W. 50", H. 94" (127, 239 cm)

476 Woods – butternut and figured maple (pine secondary); original finish – stain; original hard-

ware – brass hinges, wooden pulls; W. 54", H. 82" (137, 208 cm)

477 Wood – pine; original finish – blue exterior, red interior; presently similar overpaint; original hardware – cast hinges, brass pulls; W. 49", H. 90" (124, 229 cm)

478 Wood – pine; original finish – painted and grained; original hardware – cast hinges; W. 47", H. 98½" (119, 250 cm)

479 Wood – butternut; original finish – red; presently stained with original interior; original hardware – brass hinges, pulls and escutcheons; W. 63", H. 82½" (160, 209 cm)

480 Wood – pine; original finish – dark brown stain; original hardware – cast hinges, brass pulls; W. 62", H. 95" (157, 241 cm)

481 Wood – pine; original finish – red; presently stripped; original hardware – cast hinges, wooden pulls, brass turnbuckles; W. 51", H. 81" (130, 206 cm)

482 Wood – pine; original finish – none; original hardware – cast hinges, wooden pulls; W. 53", H. 84" (135, 213 cm)

483 Wood – pine; original finish – dark stain; original hardware – cast hinges, wooden pulls; W. 45", H. 79½" (114, 202 cm)

484 Wood – pine; original finish – stain; presently early ochre overpaint; original hardware – cast hinges, porcelain pulls; W. 54", H. 86" (137, 218 cm)

485 Wood – pine and butternut; original finish – red; original hardware – cast hinges, brass pulls; W. 51", H. 89", D. 17" (130, 226, 43 cm)

486 Wood – butternut, pine (secondary); original finish – dark stain; presently stripped; original hardware – cast hinges, brass pulls, turnbuckles, and escutcheons; W. 56", H. 84", D. 20" (142, 213, 51 cm)

487 Wood – pine; original finish – black graining over red; original hardware – cast hinges, brass pulls; W. 58", H. 87" (2-3" cut from base), D. 20½" (147, 221, 52 cm; 5-8 cm cut)

488 Wood – pine; original finish – dark stain; original hardware – cast hinges, ceramic pulls, brass latches; W. 80", H. 100", D. 22½" (203, 254, 57 cm)

489 Wood – butternut, pine and basswood (secondary); original finish – ochre; original hardware – cast hinges, wooden pulls; W. 50", H. 75", D. 20½" (127, 190, 52 cm)

490 Wood – cherry, maple, birch and pine (secondary); original finish – stain; presently stripped; original hardware – cast hinges, wooden pulls; W. 32½", H. 74", D. 16½" (83, 188, 42 cm)

491 Wood – pine, original finish – dark green exterior, red interior; original hardware – cast hinges, brass pulls; W. 48", H. 83", D. 18" (122, 211, 46 cm)

492 Wood – cherry, pine (secondary); original finish – dark stain; original hardware – brass hinges, wooden pulls, brass escutcheons; W. 43", H. 80", D. 19½" (109, 203, 50 cm)

493 Wood – pine; original finish – red; presently stripped; original hardware – cast hinges, wooden pulls, cast turnbuckles; W. 42", H. 76", D. 16½" (107, 193, 42 cm)

494 Wood – cherry, pine (secondary); original finish – dark stain; original hardware – brass hinges, brass pulls; W. 67", H. 89", D. 20½" (170, 226, 52 cm)

495 Wood – butternut, pine (secondary); original finish – painted wood grain; original hardware – cast hinges, porcelain pulls; W. 63", H. 108", D. 20½" (160, 274, 52 cm); decorative mullions missing from glazed doors

495a Wood – pine; original finish – painted wood grain; original hardware – cast hinges, porcelain pulls, cast-iron latches; W. 61", H. 88", D. 18"

(155, 224, 46 cm)

495b Wood – pine; original finish – painted wood grain; W. 87", H. 67" (221, 170 cm)

496 Wood – walnut; original finish – stain; original hardware – cast hinges, wooden pulls; W. 62", H. 97", D. 22" (157, 246, 56 cm)

497 Wood – walnut, pine (secondary); original finish – stain; original hardware – brass hinges, pulls and escutcheons; W. 43", H. 84", D. 19" (109, 213, 48 cm)

498 Wood – birdseye maple, pine (secondary); original finish – stain; original hardware – brass hinges and escutcheons; W. 60", H. 104", D. 25" (152, 264, 63 cm)

499 Wood – pine; original finish – brown; original hardware – cast hinges, porcelain pulls, porcelain and cast-iron latches; W. 65", H. 92", D. 20½" (165, 234, 52 cm)

500 Wood – cherry, pine (secondary); original finish – stain; original hardware – brass hinges (P. Moore & Co. Improved #2), wooden pull; W. 50", H. 91", D. 21" (127, 231, 53 cm)

501 Wood – pine; original finish – painted and grained; original hardware – cast hinges, wooden pulls; W. 62½", H. 85½", D. 22¾" (159, 217, 57 cm)

502 Wood – pine; original finish – red; presently early grey, blue overpaint; original hardware – cast hinges, brass pulls and escutcheons; W. 43½", H. 76", D. 17" (110, 193, 43 cm)

503 Wood – pine; original finish – dark brown with linear and floral decoration; original hardware – cast hinges, wooden pulls; W. 69", H. 94", D. 21" (176, 239, 53 cm)

504 Wood – pine; original finish – blue-green; original hardware – cast hinges, wooden and brass pulls; W. 42", H. 82", D. 17½" (107, 208, 44 cm)

505 Wood – pine; original finish – red-brown; presently stripped; original hardware – cast hinges, burl pulls, brass escutcheons. W. 53", H. 85½", D. 23½" (135, 217, 60); upper doors restored

506 Wood – pine; original finish – brown; original hardware – brass hinges, porcelain pulls, porcelain and brass latches; W. 60", H. 87½", D. 26" (152, 221, 66 cm)

507 Wood – pine and butternut; original finish – brown; presently stripped; original hardware – cast hinges, wooden pulls; W. 48¾", H. 87", D. 20¼" (123, 221, 52 cm)

508 Wood – pine; original finish – green exterior, ochre interior; original hardware – cast hinges, wooden pulls, brass turnbuckles; W. 52", H. 88", D. 21" (132, 224, 53 cm)

509 Wood – pine; original finish – brown; presently stripped; original hardware – cast hinges, wooden pulls; W. 48", H. 88½", D. 21½" (122, 225, 55 cm)

510 Wood – pine; original finish – blue and red exterior, yellow interior; original hardware – cast hinges, brass pulls and turnbuckles; W. 53", H. 79¼", D. 19½" (135, 202, 50 cm)

511 Wood – pine; original finish – grey exterior, red interior; original hardware – cast hinges, brass pulls; W. 48", H. 72", D. 19" (122, 183, 48 cm)

512 Wood – pine; original finish – red; original hardware – cast hinges, brass pulls; W. 49½", H. 83", D. 14" (126, 211, 36 cm)

513 Wood – pine; original finish – brown exterior, ochre interior; original hardware – cast hinges (Clarke), brass pulls and escutcheons; W. 47¾", H. 93½", D. 21" (121, 237, 53 cm)

514 Wood – walnut; original finish – dark stain; original hardware – brass hinges (English), brass locks and escutcheons; W. 62", H. 98", D. 22½" (157, 249, 57 cm)

515 Wood – pine; original finish – painted and grained; presently overpainted; original hardware

– cast hinges, wooden pulls; W. 91″, H. 88″, D. 19″ (231, 224, 48 cm)

516 Wood – pine; original finish – dark brown stain; original hardware – cast hinges, wooden pulls; W. 48″, H. 82″, D. 18″ (122, 208, 46 cm)

517 Wood – pine; original finish – painted wood grain; original hardware – cast hinges, brass pull; W. 45″, H. 84″, D. 16″ (114, 213, 41 cm)

518 Wood – pine; original finish – painted; original hardware – cast hinges, wooden pulls; W. 50½″, H. 89″, D. 20½″ (128, 226, 52 cm)

519 Wood – pine; original finish – painted oak grain over red filler; original hardware – cast hinges, wooden pulls, brass escutcheons; W. 61″, H. 76″, D. 21″ (155, 193, 53 cm)

520 Wood – walnut; original finish – stain; original hardware – brass hinges, wooden pulls; brass and ivory escutcheons; W. 70″, H. 85″, D. 24″ (178, 216, 61 cm)

521 Wood – walnut; original finish – stain; W. 54½″, H. 104″, D. 26″ (138, 264, 66 cm)

522 Wood – pine; original finish – mahogany red paint; original hardware – cast hinges and turnbuckles; W. 42″, H. 99″, D. 21½″ (107, 251, 55 cm)

523 Wood – figured maple, pine (secondary); original finish – stain; original hardware – cast hinges (lower), brass hinges (upper), brass pulls and escutcheons; W. 52½″, H. 95″, D. 19½″ (133, 241, 50 cm)

524 Wood – walnut, figured maple, (pine secondary); original finish – stain and varnish; original hardware – cast hinges, brass pulls and escutcheons; W. 42¾″, H. 82½″, D. 20¾″ (109, 209, 52 cm)

525 Wood – pine; original finish – painted wood grain; original hardware – cast hinges, wooden pulls; W. 35″, H. 81″, D. 20″ (89, 206, 51 cm)

526 Wood – pine; original finish – red; original hardware – cast hinges (top), forged "H" hinges (bottom) stamped *W.S.*, brass pulls; W. 52″, H. 87″, D. 18″ (132, 221, 46 cm)

527 Wood – pine; original finish – dark green; presently early red overpaint; original hardware – cast hinges (Clarke), wooden pulls; W. 35″, H. 72″, D. 13″ (89, 183, 33 cm)

528 Wood – pine; original finish – dark brown; presently stripped; original hardware – cast hinges; W. 34″, H. 76½″, D. 17″ (86, 194, 43 cm)

529 Wood – pine; original finish – red; presently stripped; original hardware – cast hinges, wooden pulls; W. 48″, H. 61″, D. 15″ (122, 155, 38 cm)

530 Wood – pine; original finish – red; original hardware – cast hinges, wooden pulls; W. 49½″, H. 73″, D. 17″ (126, 185, 43 cm)

531 Wood – pine; original finish – red; presently stripped; original hardware – cast hinges, porcelain pulls; W. 42″, H. 61″, D. 18″ (107, 155, 46 cm)

532 Wood – pine; original finish – grey; presently early red overpaint; original hardware – cast hinges, wooden pulls; W. 61″, H. 84″, D. 20″ (155, 213, 51 cm)

533 Wood – pine; original finish – dark brown; presently early grey-blue overpaint; original hardware – cast hinges, wooden pulls; originally one-piece, the cupboard has been cut above the drawers and the end cornice removed; W. 51″, H. 70″, D. 17″ (130, 178, 43 cm)

534 Wood – pine; original finish – brown exterior blue interior, original hardware – cast hinges, brass pulls; W. 50″, H. 74″, D. 20″ (127, 188, 51 cm)

535 Wood – pine; original finish – grey-blue; original hardware cast hinges, wooden pulls, brass escutcheons; W. 50″, H. 76″, D. 16″ (127, 193, 41 cm)

536 Wood – pine; original finish – red; presently early overpaint; original hardware – cast hinges, brass pulls; W. 58″, H. 91″, D. 21″ (147, 231, 53 cm)

cm)

537 Wood – pine; original finish – red; presently remnants of original; original hardware – cast hinges, brass pull and escutcheon, forged nails throughout; W. 50″, H. 78″, D. 19″ (127, 198, 48 cm); cornice restored

538 Wood – mahogany, satinwood, maple, pine (secondary); original finish – stain and varnish; original hardware – brass hinges, pulls and escutcheons (pulls replaced); W. 73″, H. 41½″, D. 24½″ (185, 105, 62 cm)

539 Wood – figured maple, cherry, pine (secondary); original finish – stain and varnish; original hardware – brass pulls; W. 81″, H. 48″, D. 24½″ (206, 122, 62 cm)

540 Wood – walnut, figured maple, pine (secondary); original finish – stain and varnish; original hardware – brass hinges, pulls and escutcheons (pulls replaced); W. 66″, H. 48″, D. 23″ (168, 122, 58 cm)

541 Wood – mahogany; original finish – stain and varnish; original hardware – brass escutcheons, wooden pulls; W. 74″, H. 38″, D. 26″ (188, 97, 66 cm)

542 Wood – cherry, figured maple, pine (secondary); original finish – stain and varnish; original hardware – brass hinges, wooden pulls, brass escutcheons; W. 62″, H. 54″, D. 24″ (157, 137, 61 cm)

543 Wood – walnut, pine (secondary); original finish – stain and varnish; original hardware – brass hinges, wooden pulls, brass escutcheons; W. 73″, H. 60″, D. 21″ (185, 152, 53 cm)

544 Wood – cherry, walnut, (pine secondary); original finish – stain and varnish; original hardware – brass hinges, wooden pulls; W. 71″, H. 52″, D. 22″ (180, 132, 56 cm)

545 Wood – cherry, pine (secondary); original finish – stain and varnish; original hardware – cast hinges, wooden pulls; W. 72″, H. 54″, D. 24″ (183, 137, 61 cm)

546 Wood – walnut, maple escutcheons, pine (secondary); original finish – stain and varnish; original hardware – wooden pulls; W. 65½″, H. 56″, D. 23″ (166, 142, 58 cm)

547 Wood – mahogany, pine (secondary); original finish – stain and varnish; original hardware – brass hinges, wooden pulls, brass escutcheons; W. 44½″, H. 46″, D. 23½″ (113, 117, 60 cm)

548 Wood – walnut, pine (secondary); original finish – stain and varnish; original hardware – brass hinges, wooden pulls, brass escutcheons; W. 48″, H. 52″, D. 20″ (122, 132, 51 cm)

549 Wood – walnut, crotch-grain walnut veneer, pine (secondary); original finish – stain and varnish; original hardware – brass hinges and escutcheons

550 Wood – walnut, pine (secondary); original finish – stain and varnish; original hardware – brass hinges, wooden pulls and escutcheons; W. 72″, H. 57″, D. 21½″ (183, 145, 55 cm)

551 Wood – walnut, pine (secondary); original finish – stain and varnish; original hardware – wooden pulls; W. 39½″, H. 34″, D. 20″ (100, 86, 51 cm)

552 Wood – butternut, cherry, pine (secondary); original finish – stain and varnish; original hardware – brass pulls; W. 40″, H. 33″, D. 21″ (102, 84, 53 cm)

553 Wood – pine; original finish – dark green; presently later yellow ochre graining; original hardware – cast hinges, wooden pulls; W. 43″, H. 49″, D. 19½″ (109, 124, 50 cm)

554 Wood – pine; original finish – green and ochre; original hardware – cast hinges, wooden turnbuckle; W. 48″, H. 51½″, D. 21″ (122, 131, 53 cm)

555 Wood – butternut, pine (secondary); original

finish – brown; original hardware – brass hinges, wooden pulls; W. 48½″, H. 41″, D. 18¾″ (123, 104, 47 cm)

556 Wood – pine; original finish – painted wood grain and striping; original hardware – cast hinges, wooden pulls; W. 47½″, H. 62½″, D. 20½″ (121, 159, 52 cm)

557 Wood – pine; original finish – dark brown; presently grey overpaint; original hardware – cast hinges, wooden pulls, brass escutcheon; W. 50″, H. 50″, D. 21″ (127, 127, 53 cm)

558 Wood – pine; original finish – red; presently stripped; original hardware – cast hinges, wooden pulls; W. 46″, H. 63″, D. 18″ (117, 160, 46 cm)

559 Wood – butternut, maple, basswood secondary; original finish – stain and varnish; original hardware – cast hinges, wooden pulls; W. 75″, H. 81″, D. 22″ (190, 206, 56 cm)

560 Wood – pine; original finish – dark brown; original hardware – cast hinges, porcelain pulls, wooden turnbuckles; W. 56½″, H. 62½″, D. 21″ (144, 159, 53 cm)

561 Wood – pine; original finish – brown; original hardware – cast hinges, wooden pulls; W. 53½″, H. 53¾″, D. 19″ (136, 137, 48 cm)

562 Wood – pine; original finish – blue-grey; original hardware – forged hinges, wooden pull, forged nails; W. 49″, H. 51″, D. 16″ (124, 130, 41 cm)

563 Wood – birch and pine; original finish – dark stain and varnish; W. 14″, H. 8¼″, D. 13″ (36, 20, 33 cm)

564 Doughbox: Wood – pine; original finish – paint; W. 13″, H. 7″, D. 8″ (33, 18, 20 cm); scoop: Wood – birch; L. 10″ (25 cm); cookie cutter: Wood – birch; H. 5″ (13 cm)

565 Wood – pine; original finish – red; original hardware – forged butterfly hinges, forged nails; W. 40″, H. 28″, D. 18″ (102, 71, 46 cm)

566 Wood – pine; original finish – red; W. 20″, H. 32″, D. 14″ (51, 81, 36 cm)

567 Wood – pine; original finish – yellow paint; W. 37″, H. 28″ (94, 71 cm)

568 Wood – pine; original finish – red; W. 36″, H. 36″, D. 12″ (91, 91, 30 cm)

569 Wood – pine; original finish – grey; W. 34″, H. 30″, D. 12″ (86, 76, 30 cm)

570 Wood – pine; original finish – dark brown; W. 24″, H. 29″, D. 14¼″ (61, 74, 36 cm)

571 Wood – pine; original finish – pumpkin; presently early red overpaint; W. 31″, H. 31″, D. 17″ (79, 79, 43 cm)

572 Wood – pine; original finish – red; W. 40″, H. 29½″, D. 20″ (102, 75, 51 cm)

573 Wood – pine and basswood; original finish – painted; W. 29½″, H. 31¼″, D. 14¼″ (75, 79, 36 cm)

574 Wood – pine; original finish – red with yellow striping; W. 23″, H. 31½″, D. 13″ (58, 80, 33 cm)

575 Wood – pine; original finish – red; original hardware – cast hinges, wooden pull and turnbuckle; W. 26″, H. 29″, D. 9″ (66, 74, 23 cm)

576 Wood – pine; original finish – green; original hardware – cast hinges, wooden pull; W. 46″, H. 55½″ (117, 141 cm)

577 Wood – pine; original finish – none; W. 24″, H. 43″, D. 9½″ (61, 109, 24 cm)

578 Wood – pine and maple; original finish – brown; W. 26″, H. 24″ (66, 61 cm)

579 Wood – maple; W. 21″, H. 18″, D. 8¼″ (53, 46, 21 cm)

580 Wood – maple burl; various sizes 11″ to 16″ dia. (28-41 cm)

581 Wood – maple burl; 23″ dia. (58 cm)

582 Wood – maple and elm burl; 20″ dia.; 20″ dia.; 13 ″ dia. (51, 51, 33 cm)

583 Wood – elm and maple burl; original finish – none; 24″ dia.; 16″ dia.; 12″ dia. (61, 41, 30 cm)

584 Wood – elm; L. 21″ (53 cm)

585 Wood – pine; original finish – painted and decorated; W. 15″, H. 22½″ (38, 57 cm)

586 Wood – pine; original finish – painted; W. 15″, L. 18½″ (38, 47 cm)

587 Wood – ash; original finish – painted; W. 14″, L. 14″ (36, 36 cm)

588 Wood – pine; original finish – red; W. 54″, H. 26″, D. 15″ (137, 66, 38 cm)

589 Wood – pine; original finish – brown; presently green overpaint; original hardware – cast hinges, iron lock; W. 31½″, H. 17″, D. 15½″ (80, 43, 39 cm)

590 Wood – pine; original finish – black with painted decoration; original hardware – cast hinges, iron lock; W. 37½″, H. 19″, D. 18″ (95, 48, 46 cm)

591 Wood – pine; original finish – red over ochre, combed; original hardware – cast hinges; W. 42″, H. 20″, D. 18″ (107, 51, 46 cm)

592 Wood – pine; original finish – black with stencilled decoration; original hardware – cast hinges, brass escutcheon; W. 39″, H. 20″, D. 19″ (99, 51, 48 cm)

593 Wood – pine; original finish – dark brown over yellow ochre; original hardware – cast hinges, iron lock; W. 40″, H. 19½″, D. 17½″ (102, 50, 44 cm)

594 Wood – pine; original finish – paint; original hardware – cast hinges, iron lock; W. 40″, H. 20½″, D. 17″ (102, 52, 43 cm)

595 Wood – pine; original finish – sponge painted, brown over red; original hardware – cast hinges, brass escutcheon; W. 43″, H. 26″, D. 20″ (109, 66, 51 cm)

596 Wood – pine; original finish – red with black feather painting; original hardware – cast hinges; W. 43″, H. 23″, D. 19″ (109, 58, 48 cm)

597 Wood – pine; original finish – blue with black base; presently light and dark brown early overpaint with yellow initials; original hardware – cast hinges, iron lock; W. 32½″, H. 18½″, D. 16″ (83, 47, 41 cm)

598 Wood – pine; original finish – green; original hardware – cast hinges; W. 43″, H. 25″, D. 18½″ (109, 63, 47 cm)

599 Wood – pine; original finish – red; original hardware – forged strap hinges, iron lock; W. 40″, H. 20″, D. 19″ (102, 51, 48 cm)

600 Wood – pine; original finish – red; original hardware – brass pulls; W. 47″, H. 29″, D. 21″ (119, 74, 53 cm). Feet restored.

601 Wood – pine; original finish – brown with painted wood grain; original hardware – cast hinges, iron lock, wooden pulls, brass escutcheon; W. 43″, H. 25¼″, D. 21½″ (109, 64, 55 cm)

602 Wood – walnut; original finish – stain and varnish; original hardware – brass bale pulls and escutcheons; W. 41″, H. 28½″, D. 20¼″ (104, 72, 51 cm)

603 Wood – walnut, figured maple, pine secondary; original finish – stain and varnish; original hardware – brass pulls; W. 47½″, H. 26½″, D. 20½″ (121, 67, 52 cm)

604 Wood – figured maple, pine secondary; original finish – stain and varnish; original hardware – brass bale pulls, brass escutcheons; W. 44″, H. 27″, D. 20″ (112, 69, 51 cm)

605 Wood – butternut and birdseye maple; original finish – stain and varnish; original hardware – cast hinges, iron lock, ceramic pulls; W. 42″, H. 26″, D. 18″ (107, 66, 46 cm)

606 Wood – pine; original finish – red; original hardware – cast hinges, iron locks, wooden pulls; W. 32½″, H. 33½″, D. 18″ (83, 85, 46 cm)

607 Wood – pine; original finish – red; presently stripped; W. 26″, H. 36″, D. 16″ (66, 91, 41 cm)

608 Wood – pine; original finish – green; original hardware – wooden pulls; W. 38″, H. 47″, D. 19″ (97, 119, 48 cm)

609 Wood – pine; original finish – black over red painted wood grain; original hardware – cast hinges, iron lock, wooden pulls; W. 39″, H. 40½″, D. 18″ (99, 103, 46 cm)

610 Wood – pine; original finish – black-brown; presently stripped; original hardware – brass pulls, iron lock; W. 42½″, H. 36″, D. 16½″ (108, 91, 42 cm)

611 Wood – pine; original finish – grey-green; original hardware – snipe hinges, iron lock; W. 44″, H. 48″, D. 20″ (112, 122, 51 cm)

612 Wood – pine; original finish – painted (decoration restored); original hardware – cast hinges, iron lock, wooden pulls; W. 37½″, H. 47½″, D. 19½″ (95, 121, 50 cm)

613 Wood – pine; original finish – painted wood grain and varnish; original hardware – cast hinges, iron lock, wooden pulls; W. 41″, H. 40″, D. 23″ (104, 102, 58 cm)

614 Wood – pine; original finish – painted wood grain; original hardware – glass; W. 43¼″, H. 43″, D. 15¾″ (110, 109, 40 cm)

615 Wood – pine; original finish – black; original hardware – cast hinges, iron lock, wooden pulls; W. 43″, H. 47″, D. 19″ (109, 119, 48 cm)

616 Wood – cherry (pine secondary); original finish – stain and varnish; original hardware – brass pulls (restored); W. 41¼″, H. 37″, D. 19″ (104, 94, 48 cm)

617 Wood – pine; original finish – grey-blue (early red overpaint); original hardware – brass pulls (restored); W. 39″, H. 33½″, D. 17″ (99, 85, 43 cm)

618 Wood – pine; original finish – red and black; original hardware – cast hinges, iron lock, wooden pulls; W. 41½″, H. 35″, D. 20″ (105, 89, 51 cm)

619 Wood – pine; original finish – red and green painted wood grain; original hardware – cast hinges, iron locks, wooden pulls; W. 48″, H. 45″, D. 20½″ (122, 114, 52 cm)

620 Wood – walnut, pine secondary; original finish – stain and varnish; original hardware – cast hinges, pulls (?), ivory escutcheons; W. 29″, H. 24½″, D. 16″ (74, 62, 41 cm)

621 Wood – pine; original finish – painted and decorated; original hardware – brass hinges; W. 13¾″, H. 5½″, D. 11″ (34, 14, 28 cm)

622 Wood – tulip; original finish – multi-coloured painted decoration; original hardware – cast hinges, forged iron lock and latch; W. 20″, H. 10″, D. 11″ (51, 25, 28 cm)

623 Wood – pine; original finish – dark green with yellow decoration; original hardware – cast hinges, iron lock; W. 25″, H. 14″, D. 11″ (63, 36, 28 cm)

624 Wood – pine; original finish – painted decoration; original hardware – cast hinges, forged iron lock; W. 33″, H. 14″, D. 13″ (84, 36, 33 cm)

625 Wood – pine; original finish – mustard with smoke graining; original hardware – cast hinges, iron lock; W. 17″, H. 8″, D. 10″ (43, 20, 25 cm)

626 Wood – pine; original finish, black over red; original hardware – cast hinges, iron lock; W. 28″, H. 13½″, D. 13½″ (71, 34, 34 cm)

627 Wood – pine; original finish – brown and sienna painted decoration; original hardware – cast hinges, iron lock; W. 16″, H. 11″, D. 9″ (41, 28, 23 cm)

628 Wood – pine; original finish – multi-coloured painted decoration; original hardware – cast hinges, forged iron lock and latch; W. 26″, H. 11″, D. 13″ (66, 28, 33 cm)

629 Wood – pine; original finish – black over red;

W. 21″, H. 13½″, D. 12″ (53, 34, 30 cm)

630 Wood – birdseye maple, mahogany, cherry, pine secondary; original finish – stain and varnish; original hardware – brass pulls and escutcheons; W. 43½″, H. 46″, D. 19½″ (110, 117, 50 cm)

631 Wood – figured maple, mahogany veneer, pine secondary; original finish – stain and varnish; original hardware – brass pulls (restored), brass escutcheons; W. 42″, H. 44″, D. 18″ (107, 112, 46 cm)

632 Wood – birch, butternut, pine secondary; original finish – stain and varnish; original hardware – brass pulls (restored); W. 43″, H. 47″, D. 20½″ (109, 119, 52 cm)

633 Wood – walnut, maple inlay (pine and chestnut secondary); original finish – stain and varnish; original hardware – unknown; W. 45½″, H. 38″, D. 19¼″ (116, 97, 49 cm)

634 Wood – mahogany, cherry; original finish – stain and varnish; original hardware – brass bale pulls and escutcheons; W. 41″, H. 37½″, D. 20½″ (104, 95, 52 cm)

635 Wood – butternut, figured maple, cherry, walnut, pine secondary; original finish – stain and varnish; original hardware – brass pulls (restored); W. 45¾″, H. 49½″, D. 20″ (116, 126, 51 cm)

636 Wood – pine; original finish – painted wood grain; original hardware – brass pulls and escutcheons (restored); W. 42″, H. 40″, D. 17½″ (107, 102, 44 cm)

637 Wood – butternut, pine secondary; original finish – dark stain and varnish; original hardware – brass pulls and escutcheons; W. 37″, H. 40″, D. 18″ (94, 102, 46 cm)

638 Wood – birdseye and figured maple, birch, pine secondary; original finish – stain and varnish; original hardware – brass pulls (restored); W. 47¼″, H. 43″, D. 19½″ (120, 109, 50 cm)

639 Wood – cherry, walnut veneer, pine secondary; original finish – stain and varnish; original hardware – wooden pulls, brass escutcheons; W. 43½″, H. 40″, D. 21″ (110, 102, 53 cm)

640 Wood – figured maple, flame cherry, walnut, pine secondary; original finish – stain and varnish; original hardware – wooden and brass pulls; W. 46″, H. 55½″, D. 21½″ (117, 141, 55 cm)

641 Wood – figured and birdseye maple, pine secondary; original finish – stain and varnish; original hardware – wooden pulls, brass escutcheons; W. 43″, H. 46″, D. 21″ (109, 117, 53 cm)

642 Wood – crotch walnut and mahogany veneer, figured maple, walnut, pine secondary; original finish – stain and varnish; original hardware – pressed glass pulls, brass escutcheons; W. 46½″, H. 63½″, D. 22½″ (118, 161, 57 cm)

643 Wood – cherry, mahogany veneer, pine secondary; original finish – stain and varnish; original hardware – wooden pulls, brass escutcheons; W. 45″, H 46½″, D. 21″ (114, 118, 53 cm)

644 Wood – butternut, birch, figured maple, pine secondary; original finish – stain and varnish; original hardware – wooden pulls, brass escutcheons; W. 40½″, H. 41″, D. 20½″ (103, 104, 52 cm)

645 Wood – pine; original finish – painted wood grain; original hardware – wooden pulls; W. 45½″, H. 46″, D. 24″ (116, 117, 61 cm)

646 Wood – pine; original finish – red; original hardware – wooden pulls; W. 36″, H. 34″, D. 17″ (91, 86, 43 cm)

647 Wood – figured maple, pine secondary; original finish – stain and varnish; original hardware – wooden pulls, brass escutcheons; W. 37″, H. 38½″, D. 19½″ (94, 98, 50 cm)

648 Wood – figured and birdseye maple, butternut, pine secondary; original finish – stain and varnish; original hardware – wooden pulls, brass escutcheons; W. 47″, H. 49″, D. 19½″ (119, 124, 50 cm)

649 Wood – figured maple, walnut veneer, pine secondary; original finish – stain and varnish; original hardware – wooden pulls, brass escutcheons; W. 42½", H. 44", D. 20" (108, 112, 51 cm)

650 Wood – birdseye and figured maple, pine secondary; original finish – stain and varnish; original hardware – brass pulls and escutcheons; W. 41", H. 46", D. 18" (104, 117, 46 cm)

651 Wood – walnut, pine secondary; original finish – stain and varnish; original hardware – wooden pulls, brass escutcheons; W. 37½", H. 29½", D. 20½" (95, 75, 52 cm)

652 Wood – pine; original finish – painted wood grain; original hardware – wooden pulls; W. 46", H. 52", D. 17½" (117, 132, 44 cm)

653 Wood – butternut, walnut, birdseye maple, pine secondary; original finish – stain and varnish; original hardware – ceramic pulls, brass escutcheons; W. 41½", H. 50", D. 21" (105, 127, 53 cm)

654 Wood – pine; original finish – painted wood grain; original hardware – wooden pulls, brass escutcheons; W. 48", H. 52", D. 22" (122, 132, 56 cm)

655 Wood – pine; original finish – dark brown; presently stripped; original hardware – wooden pulls, brass escutcheons; W. 43", H. 45", D. 19" (109, 114, 48 cm)

656 Wood – pine; original finish – painted wood grain and ebonizing; original hardware – wooden pulls, brass escutcheons; W. 47½", H. 54", D. 22" (121, 137, 56 cm)

657 Wood – cherry, walnut veneer, butternut, pine secondary; original finish – stain and varnish; original hardware – wooden pulls, brass escutcheons; W. 45", H. 54", D. 20½" (114, 137, 52 cm)

658 Wood – walnut veneer, pine secondary; original finish – stain and varnish; original hardware – wooden pulls, brass escutcheons, iron casters; W. 43", H. 48½", D. 18" (109, 124, 46 cm)

659 Wood – basswood; original finish – brown paint stain; original hardware – wooden ceramic pulls, brass escutcheons; W. 40", H. 45", D. 17" (102, 114, 43 cm)

660 Wood – cherry, figured maple, mahogany veneer, pine secondary; original finish – stain and varnish; original hardware – brass leaf hinges, brass or wooden pulls (?) (restored), brass escutcheons; W. 43", H. 47½", D. 21" (109, 121, 53 cm)

661 Wood – walnut, maple inlay, pine secondary; original finish – stain and varnish; original hardware – brass leaf hinges, brass pulls (restored); W. 39½", H. 45½", D. 21" (100, 116, 53 cm)

662 Wood – butternut, mahogany, maple, pine secondary; original finish – stain and varnish; original hardware – brass pulls (restored); W. 46½", H. 44¼", D. 25" (118, 112, 63 cm)

663 Wood – birch, figured maple, walnut veneer, pine secondary; original finish – stain and varnish; original hardware – brass leaf hinges, brass pulls (restored), brass escutcheons; W. 40½", H. 36", D. 17" (103, 91, 43 cm)

664 Wood – pine; original finish – dark painted wood grain; presently stripped; original hardware – brass leaf hinges and lock, brass pulls (exterior restored), brass escutcheons; W. 36", H. 47", D. 18½" (91, 119, 47 cm)

665 Wood – walnut, oak, pine secondary; original finish – stain and varnish; original hardware – brass leaf hinges, brass pulls (restored); W. 40", H. 40", D. 20" (102, 102, 51 cm)

666 Wood – cherry, figured maple, mahogany veneers (pine secondary); original finish – stain and varnish; original hardware – brass hinges, pulls (restored escutcheons); W. 48", H. 43", D. 22½" (122, 109, 57 cm)

667 Wood – walnut, butternut, figured maple, pine secondary; original finish – stain and varnish; original hardware – iron leaf hinges and lock, brass pulls (inside) and wooden pulls; W. 39½",

H. 45", D. 21" (100, 114, 53 cm)

668 Wood – cherry, birch, figured maple, pine secondary; original finish – stain and varnish; original hardware – brass leaf hinges and fittings, wooden pulls, brass escutcheons; W. 48", H. 49", D. 21¾" (122, 124, 55 cm)

669 Wood – cherry, birdseye and figured maple, pine secondary; original finish – stain and varnish; original hardware – brass leaf hinges, brass pulls; W. 48", H. 51", D. 22½" (122, 130, 57 cm)

670 Wood – cherry, pine secondary; original finish – stain and varnish; original hardware – brass hinges, wooden pulls; W. 37", H. 55", D. 19" (94, 140, 48 cm)

671 Wood – pine and birch; original finish – dark stain; original hardware – cast hinges, brass bale pulls; W. 44", H. 60", D. 20" (112, 152, 51 cm)

672 Wood – pine; original finish – red-brown; original hardware – cast hinges, wooden pulls, wire brackets; W. 39½", H. 18", D. 56" (100, 46, 142 cm)

673 Wood – cherry, pine secondary; original finish – stain and varnish; original hardware – cast leaf hinges, wooden pulls, brass escutcheons; W. 24", H. 43", D. 18½" (61, 109, 47 cm)

674 Wood – pine; original finish – ochre with brown graining; original hardware – cast hinges, wooden pulls; W. 43", H. 59", D. 20½" (109, 150, 52 cm)

675 Wood – walnut, pine secondary; original finish – stain and varnish; original hardware – brass leaf hinges and lock, brass and wooden pulls, iron casters; W. 39", H. 44½", D. 20½" (99, 113, 52 cm)

676 Wood – mahogany veneer, pine secondary; original finish – stain and varnish; original hardware – wooden pulls, brass escutcheons; W. 50", H. 93", D. 21" (127, 236, 53 cm)

677 Wood – walnut, mahogany veneer, pine secondary; original finish – stain and varnish; original hardware – brass hinges and escutcheons; W. 54", H. 96", D. 25" (137, 244, 63 cm)

678 Wood – birch, pine secondary; original finish – paint stain and wood graining; original hardware – brass leaf hinges, wooden pulls, brass escutcheons; W. 44½", H. 84", D. 21½" (113, 213, 55 cm)

679 Wood – mahogany veneer over pine; original finish – stain and varnish; original hardware – wooden pulls, brass escutcheons; W. 42", H. 68½", D. 22" (107, 175, 56 cm)

680 Wood – pine; original finish – green with yellow striping; original hardware – cast hinges, forged lock and latch; W. 14", H. 12", D. 18" (36, 30, 46 cm)

681 Wood – cherry; original finish – stain and varnish; original hardware – brass hinges and pull

682 Wood – walnut; original finish – stain and varnish; original hardware – cast hinges, brass pull; W. 31½", H. 48½", D. 26" (80, 123, 66 cm)

683 Wood – pine; original finish – green and red; original hardware – cast hinges (stamped Thompson), brass bale pulls; W. 31¼", H. 52", D. 24¼ (79, 132, 61 cm)

684 Wood – pine; original finish – red; original hardware – cast hinges, wooden pulls; W. 30", H. 49", D. 23" (76, 124, 58 cm)

685 Wood – butternut, birch, pine secondary; original finish – stain and varnish; original hardware – cast hinges, wooden pulls; W. 34", H. 40", D. 22" (86, 102, 56 cm)

686 Wood – pine; original finish – brown; original hardware – cast hinges, wooden pull; W. 37", H.49", D. 25" (94, 124, 63 cm)

687 Wood – walnut; original finish – stain and varnish; original hardware – cast hinges, iron lock; W. 36", H. 46½", D. 30" (91, 118, 76 cm)

688 Wood – cherry, figured maple, walnut (pine secondary); original finish – stain and varnish; original hardware – cast hinges, brass pulls and escutcheons; W. 36", H. 42", D. 21" (91, 107, 53 cm)

689 Wood – figured and birdseye maple, pine secondary; original finish – stain and varnish; original hardware – brass hinges and escutcheon; W. 22", H. 35", D. 22" (56, 89, 56 cm)

690 Wood – pine; original finish – dark brown; presently stripped; original hardware – cast hinges, wooden pulls, brass escutcheon; W. 37", H. 57½", D. 24" (94, 146, 61 cm)

691 Wood – pine; original finish – red; presently stripped; original hardware – cast hinges, wooden pulls; W. 38", H. 39", D. 21" (97, 99, 53 cm)

692 Wood – figured maple, birch, butternut, pine, basswood secondary; original finish – dark stain and varnish; original hardware – brass escutcheons; W. 47½", H. 36", D. 23" (121, 91, 58 cm)

693 Wood – pine; original finish – black-brown; original hardware – wooden pulls; W. 58", H. 29", D. 34½" (147, 74, 88 cm)

694 Wood – pine; original finish – green; original hardware – cast hinges; W. 22", H. 41", D. 16¼" (56, 104, 41 cm)

695 Wood – pine; original finish – red with black decoration; original hardware – cast hinges, wooden pulls; W. 34", H. 68", D. 23" (86, 173, 58 cm)

696 Wood – pine; original finish – red with brown-black painted wood grain; original hardware – cast hinges; W. 32½", H. 45", D. 20½" (83, 114, 52 cm)

697 Wood – mahogany; original finish – stain and varnish; W. 48", H. 81" (122, 206 cm)

698 Wood – walnut posts, pine head and foot board; original finish – stain and varnish; W. 48", H. 76" (122, 193 cm)

699 Wood – maple posts, pine foot and head boards; original finish – stain and varnish; W. 60", H. 84" (152, 213 cm)

700 Wood – oak posts, pine head and foot boards; original finish – red; W. 48½", H. 76" (123, 193 cm)

701 Wood – birch; original finish – red; W. 40", H. 84" (102, 213 cm)

702 Wood – birch posts, pine head and foot board; original finish – dark stain and varnish; W. 40", H. 77" (102, 196 cm)

703 Wood – birch posts, cherry head and foot board; original finish – stain and varnish; W. 52", H. 72" (132, 183 cm)

704 Wood – birch posts, pine head and foot board; original finish – stain and varnish; W. 48", H. 80" (122, 203 cm)

705 Wood – birch posts, pine head and foot board; original finish – stain and varnish; W. 48", H. 83" (122, 211 cm)

706 Wood – figured maple turnings, pine head and foot board; original finish – stain and varnish; W. 52", H. 83" (132, 211 cm)

707 Wood – maple, pine headboard; original finish – stain and varnish; W. 48", H. 75" (122, 190 cm)

708 Wood – maple, pine head and foot board; original finish – light stain; W. 52", H. 66" (132, 168 cm)

709 Wood – mahogany; original finish – stain and varnish; W. 40" H. 44" (102, 112 cm)

710 Wood – maple posts, ash head and foot board; original finish – dark stain and varnish; W. 52", H. 81" (132, 206 cm)

711 Wood – walnut; original finish – stain and varnish; W. 48", H. 62½" (122, 159 cm)

712 Wood – walnut; original finish – stain and varnish; W. 52", H. 67" (132, 170 cm)

713 Wood – maple posts, cherry head and foot board; original finish – stain and varnish; W. 52″, H. 60″ (132, 152 cm)

714 Wood – birch; original finish – stain and varnish; W. 52″, H. 60″ (132, 152 cm)

715 Wood – cherry; original finish – stain and varnish; W. 42″, H. 60″ (107, 152 cm)

716 Wood – birch and figured maple; original finish – stain and varnish; W. 42″, H. 52½″ (107, 133 cm)

717 Wood – figured maple posts, pine head and foot board; original finish – stain and varnish; W. 48″, H. 58½″ (122, 158 cm)

718 Wood – maple posts, pine head and foot board; original finish – red; W. 42″, H. 44″ (107, 112 cm)

719 Wood – birch, pine head and foot board; original finish – brown paint stain; W. 40″, H. 48″ (102, 122 cm)

720 Wood – birch posts, butternut and pine head and foot board; original finish – stain and varnish; W. 42″, H. 43″ (107, 109 cm)

721 Wood – maple posts, pine headboard; original finish – stain and varnish; W. 48″, H. 44″; (122, 112 cm)

722 Wood – birch posts, ash rails, pine head and foot board; original finish – painted wood grain; W. 48″, H. 47″ (122, 119 cm)

723 Wood – birch; original finish – stain and varnish; W. 48″, H. 42″ (122, 107 cm)

724 Wood – figured maple posts, cherry headboard; original finish – stain and varnish; W. 52″, H. 43″ (132, 109 cm)

725 Wood – cherry posts, pine head and foot board; original finish – stain and varnish; W. 52″, H. 47½″ (132, 121 cm)

726 Wood – maple and figured maple; original finish – stain and varnish; W. 48″, H. 48″ (122, 122 cm)

727 Wood – figured maple; original finish – stain and varnish; W. 48″, H. 50″ (122, 127 cm)

728 Wood – birch; original finish – green; W. 36″, H. 38″ (91, 97 cm)

729 Wood – maple; original finish – pumpkin; W. 39″, H. 16″, L. 64½″ (99, 41 164 cm)

730 Wood – birch and pine; original finish – red; W. 21″, H. 28″, L. 42″ (53, 71, 107 cm)

731 Wood – pine; original finish – brown; W. 13″, H. 26½″, L. 36″ (33, 67, 91 cm)

732 Wood – pine, birch posts; original finish – dark brown paint stain; W. 14″, H. 25″, L. 35½″ (36, 63, 90 cm)

733 Wood – pine; original finish – brown; W. 13″, H. 26½″, L. 36″ (33, 67, 91 cm)

734 Wood – pine; original finish – brown; W. 15″, H. 25″, L. 36″ (38, 63, 91 cm)

735 Wood – pine; original finish – red and black painted wood grain; W. 14½″, H. 24″, L. 35″ (37, 61, 89 cm)

736 Wood – butternut; original finish – red and black painted wood grain with yellow striping; W. 23″, H. 29″, L. 41″ (58, 74, 104 cm)

737 Wood – pine; original finish – red; W. 18″, H. 20″, L. 39″ (46, 51, 99 cm)

738 Wood – walnut, oak; original finish – stain and varnish; W. 37″, H. 23″, D. 12½″ (94, 58, 32 cm)

739 Wood – pine; original finish – red; W. 17″, H. 24″, L. 38″ (43, 61, 97 cm)

740 Wood – cherry; original finish – stain and varnish; W. 16½″, H. 22″, D. 43½″ (42, 56, 110 cm)

741 Wood – pine and hardwoods; original finish – black and red painted wood grain with multi-coloured stencilled and painted decoration; W. 22″, H. 30″, L. 34″ (56, 76, 86 cm)

742 Wood – pine and birch; original finish – red; W. 18″, H. 24″, L. 40″ (46, 61, 102 cm)

743 Wood – pine and hardwood; original finish – black-green

744 Wood – walnut; original finish – stain and varnish; W. 19″, H. 24½″, D. 37″ (48, 62, 94 cm)

745 Wood – maple turnings, pine cradle; original finish – brown; W. 23″, H. 36½″, L. 36″ (58, 93, 91 cm)

746 Wood – birch and walnut; original finish – stain and varnish; W. 19″, H. 57½″, L. 37″ (48, 146, 94 cm)

747 Wood – cherry; original finish – stain and varnish; original hardware – brass hinges; W. 14″, H. 31½″ (36, 80 cm)

748 Wood – cherry; original finish – stain and varnish; original hardware – brass hinges and escutcheon; H. 80″ (203 cm)

749 Wood – cherry; mahogany, pine secondary; original finish – stain and varnish; original hardware – brass hinges, escutcheon and pull; H. 85″ (216 cm)

750 Wood – figured maple, birdseye maple, mahogany, cherry, pine secondary; original finish – stain and varnish; original hardware – brass hinges, brass pull and escutcheon; H. 89″ (226 cm)

751 Wood – cherry, pine secondary; original finish – stain and varnish; original hardware – brass hinges and escutcheons; H. 93″ (236 cm)

752 Wood – cherry, figured maple, pine secondary; original finish – stain and varnish; original hardware – brass hinges and pull; H. 86½″ (219 cm)

753 Wood – cherry, figured maple, pine secondary; original finish – stain and varnish; original hardware – brass hinges and escutcheons; H. 93″ (236 cm)

754 Wood – butternut; original finish – stain and varnish; original hardware – brass hinges and pull; H. 86″ (218 cm)

755 Wood – pine; original finish – red mouldings, black case; original hardware – brass hinges; H. 82″; (208 cm)

756 Wood – pine; original finish – painted wood grain; original hardware – cast hinges; H. 77″ (196 cm)

757 Wood – cherry, pine secondary; original finish – stain and varnish; original hardware – brass hinges and pulls; H. 82½″ (209 cm)

758 Wood – pine; original finish – blue-green; original hardware – snipe hinges, brass hinges; H. 78¼″ (199 cm)

759 Wood – pine; original finish – dark stain; original hardware – brass hinges, escutcheon and pull; H. 89″ (226 cm)

760 Wood – mahogany, original finish – stain and varnish with gilt decoration; W. 14″, H. 26″ (36, 66 cm)

761 Wood – mahogany, pine (secondary); original finish – stain and varnish; W. 11½″, H. 20″ (29, 51 cm)

762 Wood – mahogany; original finish – stain and varnish; W. 14″, H. 26″ (36, 66 cm)

763 Wood – mahogany on pine; original finish – stain and varnish; W. 14¼″, H. 25″ (36, 63 cm)

764 Wood – pine; original finish – gilt over gesso; W. 23″, H. 49″ (58, 124 cm)

765 Wood – pine; original finish – gilt on gesso; W. 16″, H. 34″ (41, 86 cm)

766 Wood – walnut, mahogany, figured maple, pine secondary; original finish – stain and varnish; W. 17¼″, H. 41¼″ (44, 105 cm)

767 Wood – figured maple; original finish – stain and varnish; W. 21″, H. 37″ (53, 94 cm)

768 Wood – walnut; original finish – stain and varnish; W. 16″, H. 21″ (41, 53 cm)

769 Wood – walnut; original finish – light stain;

W. 3⅞″, H. 7¼″ (9.5, 18 cm)

770 Wood – pine; original finish – brown; W. 6¼″, H. 10¾″ (16, 27 cm)

771 Wood – pine; original finish – red; W. 6″, H. 10″ (15, 25 cm)

772 Wood – birdseye maple; original finish – stain and varnish; W. 9½″, H. 13½″ (24, 34 cm)

773 Wood – pine; original finish – dark brown; W. 9″, H. 11½″ (23, 29 cm)

774-784 Technical information for these mantel-pieces will be found in the captions

785 H. 15″ (38 cm)

786 H. 9″ (23 cm)

787 H. 15½″ (39 cm)

788 H. 13¾″ (35 cm)

789 H. 17″ (43 cm)

790 H. 21″ (53 cm)

791 H. 17″ (43 cm)

792 H. 15″ (38 cm)

793 H. 20″ (51 cm)

794 H. 13½″ (34 cm)

795 H. 26″ (66 cm)

796 Wood – basswood; original finish – red; presently early blue overpaint; original hardware – brass hinges and pull; W. 11½″, H. 11″, D. 8″ (29, 28, 20 cm)

797 Wood – birch; original finish – stain; original hardware – brass or wooden pull; presently restored; W. 14″, H. 29″ (36, 74 cm)

798 Wood – basswood; original finish – dark stain and varnish; W. 13″, H. 19″, D. 5½″ (33, 48, 14 cm)

799 Wood – pine; original finish – brown; original hardware – wooden pull; W. 14″, H. 32″, D. 5″ (36, 81, 13 cm)

800 Wood – pine; original finish – red; W. 14″, H. 19½″, D. 6″ (36, 50, 15 cm)

801 Wood – pine; original finish – red; W. 8″, H. 12″, D. 4″ (20, 30, 10 cm)

802 Wood – pine; original finish – grey-green; W. 12″, H. 24″, D. 4″ (30, 61, 10 cm)

803 Wood – pine; original finish – brown; W. 14″, H. 18¼″, D. 8″ (36, 46, 20 cm)

804 Wood – pine; original finish – red; W. 8″, H. 11″, D. 3¼″ (20, 28, 8 cm)

805 Wood – pine; original finish – red; W. 12″, H. 20″, D. 5½″ (30, 51, 14 cm)

806 Wood – pine; original finish – blue; W. 13″, H. 20½″, D. 8½″ (33, 52, 22 cm)

807 Wood – pine; original finish – paint; W. 12″, H. 17″, D. 5″ (30, 43, 13 cm)

808 Wood – pine; original finish – red; W. 12″, H. 24″, D. 6¼″ (30, 61, 16 cm)

809 Wood – pine; original finish – red; W. 5″, H. 46″, D. 3½″ (13, 117, 9 cm)

810 Wood – pine; original finish – green with yellow striping; W. 4½″, H. 14½″, D. 4¾″ (11, 37, 12 cm)

811 Wood – pine; original finish – none; W. 11½″, H. 13½″, D. 6″ (29, 34, 15 cm)

812 Wood – pine; original finish – blue; W. 14″, H. 8″ (36, 20 cm)

813 Wood – pine; original finish – red; W. 13″, H. 13″, D. 7″ (33, 33, 18 cm)

814 Wood – pine; original finish – brown-black; W. 6¾″, H. 27½″, D. 4½″ (17, 70, 11 cm)

815 Wood – basswood; original finish – red; W. 8½″, H. 21″, D. 4½″ (22, 53, 11 cm)

816 Wood – pine; original finish – red; W. 7½″, H. 14½″, D. 7½″ (19, 37, 19 cm)

817 Wood – pine; original finish – none; W. 8″, H. 17″, D. 4½″ (20, 43, 11 cm)

818 Wood – oak; original finish – grey; original

hardware – tin pulls; W. 18″, H. 21″, D. 6″ (46, 53, 15 cm)

819 Wood – pine; original finish – red; original hardware – rolled iron hinges; W. 14½″, H. 21″, D. 7″ (37, 53, 18 cm)

820 Wood – pine; original finish – red; W. 17″, H. 26″ (43, 66 cm)

821 Wood – pine; original finish – grey; original hardware – wooden pulls; W. 27″, H. 47″ (69, 119 cm)

822 Wood – pine; original finish – paint; W. 26″, H. 33″, D. 7″ (66, 84, 18 cm)

823 Wood – butternut; original finish – painted wood grain; W. 16″, H. 39″, D. 6″ (41, 99, 15 cm)

824 Wood – pine; original finish – red; presently early blue-grey overpaint; W. 15½″, H. 38″ (39, 97 cm)

825 Wood – pine; original finish – red; W. 18″, H. 18½″ (46, 47 cm)

826 Wood – pine; original finish – red; W. 19¼″, H. 11″, D. 6″ (49, 28, 15 cm)

827 Wood – pine; original finish – mustard with over-varnish; W. 24″, H. 8½″ (61, 22 cm)

828 Wood – pine; original finish – dark green; W. 22″, H. 34″, D. 6″ (56, 86, 15 cm)

829 Wood – pine; original finish – brown; W. 26½″, H. 32″, D. 6″ (67, 81, 15 cm)

830 Wood – pine; original finish – terra cotta with stencil and striping; W. 18½″, H. 14″ (47, 36 cm)

831 Wood – maple and figured maple; original finish – stain and varnish; 15″ (38 cm) (wheel), H. 36″ (91 cm)

832 Wood – hardwoods; original finish – none; W. 65″, H. 60″ (165, 152 cm)

833 Wood – maple and oak; original finish – none; 16″ (41 cm) (wheel), H. 44″ (112 cm)

834 Wood – fruitwood; original finish – dark stain; 19″ (48 cm) (wheel), H. 41″ (104 cm)

835 Wood – hardwoods; original finish – none; 18″ (46 cm) (wheel), H. 45½″ (116 cm)

836 Wood – pine and oak; original finish – none; W. 16″, H. 33″ (41, 84 cm)

837 Wood – hardwoods; original finish – none; W. 20″, H. 25″ (51, 63 cm)

838 Wood – birch; original finish – none; H. 33″ (84 cm)

839 Wood – pine and hardwood; original finish – stain; H. 47″ (119 cm)

840 Wood – pine and hardwoods; original finish – none; W. 30″, H. 32″ (76, 81 cm)

841 Wood – pine or fir; original finish – none; W. 29″ (74 cm)

842 Wood – pine; original finish – painted base, scrubbed top; W. 72″, H. 27¼″, D. 35″ (183, 69, 89 cm)

843 Wood – pine; original finish – red base, scrubbed top; W. 46″, H. 28″, D. 37″ (117, 71, 94 cm)

844 Wood – pine; original finish – red base, scrubbed top; W. 77½″, H. 30″, D. 32½″ (197, 76, 83 cm)

845 Wood – pine top, oak base; original finish – plum base, scrubbed top; presently overpainted base; W. 142″, H. 29½″, D. 36¼″ (361, 75, 92 cm)

846 Wood – pine; original finish – orange-brown; presently early red overpaint; W. 49″, H. 29¼″, D. 36″ (124, 75, 91 cm)

847 Wood – pine; original finish – red; W. 97″ (open), H. 30″, D. 39″ (246, 76, 99 cm); feet restored

848 Wood – pine and maple; original finish – red-brown; W. 65″, H. 29″, D. 34″ (165, 74, 86 cm)

849 Wood – pine; original finish – red-brown; presently stripped; W. 69″, H. 30″, D. 35½″ (176, 76, 90 cm)

850 Wood – cherry; original finish – stain and varnish

851 Wood – walnut; original finish – stain, scrubbed top; original hardware – wooden pulls; W. 39″, H. 29″, D. 68½″ (99, 74, 175 cm)

852 Wood – walnut; original finish – stain and varnish; original hardware – wooden pulls; W. 76″, H. 29″, D. 38½″ (193, 74, 97 cm)

853 Wood – walnut; original finish – stain and varnish; original hardware – wooden pulls

854 Wood – walnut; original finish – stain and varnish; original hardware – wooden pulls, casters (?); W. 63″, H. 29½″, D. 35″ (160, 75, 89 cm)

855 Wood – pine; table: original finish – ochre, scrubbed top; original hardware – wooden pulls; W. 59″, H. 29″, D. 39″ (150, 74, 99 cm); bench: original finish – ochre; W. 66″, H. 17½″, D. 14½″ (168, 44, 37 cm)

856 Wood – oak top and maple; original finish – grey-brown with scrubbed top; original hardware – wooden pulls

857 Wood – pine; original finish – brown-black; original hardware – wooden pulls, iron casters; W. 64″, H. 30″, D. 34″ (163, 76, 86 cm)

858 Wood – cherry; original finish – stain and varnish; original hardware – wooden pulls; W. 60″, H. 29″, D. 35″ (152, 74, 89 cm)

859 Wood – pine; original finish – red; W. 72″, H. 29″, D. 37½″ (183, 74, 95 cm)

860 Wood – pine; original finish – stain over paint; original hardware – wooden pulls; W. 64½″, H. 31″, D. 32½″ (164, 79, 83 cm); lower legs restored

861 Wood – pine; original finish – dark stain; original hardware – wooden pull; W. 23″, H. 28″, D. 23″ (58, 71, 58 cm)

862 Wood – pine; original finish – dark brown; W. 32″, H. 29″, D. 23″ (81, 74, 58 cm)

863 Wood – pine; original finish – painted wood grain; original hardware – wooden pull; W. 41½″, H. 30″, D. 30″ (105, 76, 76 cm)

864 Wood – cherry with walnut and maple inlay (pine secondary); original finish – stain and varnish; original hardware – wooden pull; W. 26½″, H. 29″, D. 20½″ (67, 74, 52 cm)

865 Wood – pine; original finish – red; original hardware – wooden pull; W. 21½″, H. 28½″, D. 19½″ (55, 72, 50 cm)

866 Wood – cherry (pine secondary); original finish – painted wood grain; original hardware – ivory escutcheon; W. 28½″, H. 30″, D. 24″ (72, 76, 61 cm)

867 Wood – cherry (pine secondary); original finish – painted wood grain; original hardware – wooden pull; W. 26″, H. 29½″, D. 29½″ (66, 75, 75 cm)

868 Wood – maple; original finish – brown; original hardware – wooden pull; W. 22″, H. 29″, D. 22″ (56, 74, 56 cm)

869 Wood – figured maple and cherry inlaid with applewood and black ash (pine secondary); original finish – stain and varnish; original hardware – brass pulls; W. 16″, H. 29″, D. 16½″ (41, 74, 42 cm)

870 Wood – cherry with apple inlay (pine secondary); original finish – stain and varnish; original hardware – brass pulls (replaced); W. 20″, H. 29¼″, D. 16″ (51, 75, 41 cm)

871 Wood – cherry, rosewood veneer (pine secondary); original finish – stain and varnish; original hardware – wooden pulls, brass escutcheons; W. 26″, H. 30½″, D. 21″ (66, 77, 53 cm)

872 Wood – pine; original finish – stain and varnish; original hardware – unknown, brass restored; W. 22¼″, H. 29¾″, D. 22¼″ (54, 72, 54 cm)

873 Wood – cherry and maple (pine secondary); original finish – green with yellow and black decoration; original hardware – wooden pull; W.

21½″, H. 30″, D. 20½″ (55, 76, 52 cm)

874 Wood – pine; original finish – painted wood grain; original hardware – wooden pulls; W. 18″, H. 29″, D. 17½″ (46, 74, 44 cm)

875 Wood – pine; original finish – painted wood grain and stencilled decoration; original hardware – wooden pulls; W. 29″, H. 29½″, D. 26″ (74, 75, 66 cm)

876 Wood – cherry; original finish – stain and varnish; original hardware – brass pull; W. 27″, H. 29½″, D. 26½″ (69, 75, 67 cm)

877 Wood – walnut (pine secondary); original finish – stain and varnish; original hardware – brass pull; W. 21″, H. 26½″, D. 21″ (53, 67, 53 cm)

878 Wood – walnut (pine secondary); original finish – stain and varnish; original hardware – brass pull; W. 19½″, H. 29½″, D. 20″ (50, 75, 51 cm)

879 Wood – cherry (pine secondary); original finish – stain and varnish; original hardware – glass knob; W. 20¼″, H. 29½″, D. 20½″ (51, 75, 52 cm)

880 Wood – walnut (pine secondary); original finish – stain and varnish; original hardware – brass pull; W. 20½″, H. 30″, D. 20½″ (52, 76, 52 cm)

881 Wood – walnut (pine secondary); original finish – stain and varnish; original hardware – brass pull; W. 20½″, H. 30¼″, D. 22″ (52, 77, 56 cm)

882 Wood – pine; original finish – painted wood patterns; original hardware – brown ceramic pull; W. 22¾″, H. 28″, D. 22¾″ (57, 71, 57 cm)

883 Wood – pine; original finish – painted wood patterns; original hardware – brass pull; W. 22″, H. 31″, D. 22″ (56, 79, 56 cm)

884 Wood – maple lightly figured; original finish – stain and varnish; W. 29½″, H. 30½″, D. 29½″ (75, 77, 75 cm)

885 Wood – pine; original finish – painted wood grain and bonding; original hardware – wooden pull; W. 26¼″, H. 29″, D. 26¼″ (66, 74, 66 cm)

886 Wood – walnut; original finish – dark brown (paint); W. 18″, H. 28½″ (46, 72 cm)

887 Wood – walnut; original finish – stain and varnish; W. 17″, H. 28½″, D. 17¼″ (43, 72, 44 cm)

888 Wood – cherry and pine; original finish – painted wood grain; W. 13½″, H. 26″ (34, 66 cm)

889 Wood – walnut and pine; original finish – dark stain and mustard paint; W. 16″, H. 29″, D. 16″ (41, 74, 41 cm)

890 Wood – walnut and oak; original finish – stain; W. 16¾″, H. 28½″, D. 16¾″ (42, 72, 42 cm)

891 Wood – pine, cherry tambour; original finish – red; original hardware – brass pulls (replaced); W. 23″, H. 34″, D. 18″ (58, 86, 46 cm)

892 Wood – hardwoods; original finish – green with multi-coloured decoration; W. 15½″, H. 27″, D. 13″ (39, 69, 33 cm)

893 Wood – pine; original finish – none; W. 17½″, H. 35″, D. 15″ (44, 89, 38 cm)

894 Wood – pine; original finish – none; W. 14″, H. 32″, D. 17″ (36, 81, 43 cm)

895 Wood – pine seat and hardwoods; original finish – black; W. 13″, H. 32½″, D. 14½″ (33, 83, 37 cm)

896 Wood – hardwoods; original finish – blue; original seat – elm bark; W. 18″, H. 35″, D. 14″ (46, 89, 36 cm)

897 Wood – hardwoods; original finish – black-brown; original seat – elm bark; W. 13″, H. 20″, D. 10½″ (33, 51, 26 cm)

898 Wood – hardwoods; original finish – red; original seat – elm bark; W. 18″, H. 33½″, D. 14″ (46, 85, 36 cm)

899 Wood – hardwoods; original finish – red; original seat – rush; W. 19″, H. 36″, D. 14″ (48, 91,

36 cm); centre splat incomplete

900 Wood – hardwoods; original finish – black; original seat – rush; W. 18½″, H. 35½″, D. 14½″ (47, 90, 37 cm)

901 Wood – hardwoods; original finish – grey-green with yellow decoration; W. 18″, H. 34¾″, D. 14″ (46, 88, 36 cm)

902 Wood – hardwoods; original finish – blue; original seat – elm bark (restored with leather); W. 18½″, H. 34″, D. 14″ (47, 86, 36 cm)

903 Wood – hardwoods; original finish – grey-blue; original seat – elm; W. 18″, H. 36″, D. 14″ (46, 91, 36 cm)

904 Wood – hardwoods; original finish – red ochre; original seat – rush or elm bark (restored cane); W. 17½″, H. 37″, D. 14½″ (44, 94, 37 cm)

905 Wood – hardwoods; original finish – red; original seat – rush; W. 20″, H. 42″, D. 18″ (51, 107, 46 cm)

906 Wood – hardwoods; original finish – red; original seat – rush or elm bark (present bark seat is likely an early replacement); W. 22½″, H. 45½″, D. 16″ (57, 116, 41 cm)

907 Wood – pine seat and hardwoods; original finish – black over red graining with multi-coloured striping and decoration; W. 20½″, H. 39″, D. 18½″ (52, 99, 47 cm)

908 Wood – hardwoods; original finish – blue-green; original seat – elm bark; W. 20½″, H. 44″, D. 16″ (52, 112, 41 cm)

909 Wood – hardwoods; original finish – blue; original seat – elm bark; W. 20″, H. 41″, D. 16″ (51, 104, 41 cm)

910 Wood – hardwoods; original finish – blue; original seat – elm bark (restored); W. 18½″, H. 39″, D. 15″ (47, 99, 38 cm)

911 Wood – hardwoods; original finish – brown with yellow painted decoration; original seat – elm bark; W. 19″, H. 35″, D. 14″ (48, 89, 36 cm)

912 Wood – hardwoods; original finish – black-brown; original seat – rush; W. 18″, H. 39″, D. 13″ (46, 99, 33 cm)

913 Wood – hardwoods; original finish – stain and varnish; original seat – elm bark; W. 18½″, H. 35″, D. 15½″ (47, 89, 39 cm)

914 Wood – pine seat and hardwoods; original finish – black and red painted wood grain with green and yellow striping (restored); W. 14″, H. 32″, D. 15″ (36, 81, 38 cm)

915 Wood – pine seat and hardwoods; original finish – painted wood grain with striping and leaf decoration; W. 14¼″, H. 33″, D. 15″ (36, 84, 38 cm)

916 Wood – figured maple; original finish – stain and varnish; original seat – cane; W. 17″, H. 34″, D. 17″ (43, 86, 43 cm)

917 Wood – pine seat and hardwoods; original finish – black with stencilled decoration; W. 60″, H. 31″, D. 19″ (152, 79, 48 cm)

918 Wood – basswood seat; original finish – black; W. 75½″, H. 34½″, D. 22″ (191, 88, 56 cm)

919 Wood – oak; original finish – stain and varnish; W. 75″, H. 30″, D. 26″ (190, 76, 66 cm)

920 Wood – beech; original finish – red; W. 70″, H. 29″, D. 23″ (178, 74, 58 cm)

921 Wood – oak; original finish – brown stain; W. 72″, H. 27″, D. 24″ (183, 69, 61 cm)

922 Wood – pine; original finish – blue; W. 72″, H. 28″, D. 24″ (183, 71, 61 cm)

923 Wood – pine and ash; original finish – painted and grained; W. 67″, H. 37″, D. 16″ (170, 94, 41 cm)

924 Wood – pine; original finish – dark green; W. 24″, H. 12″, D. 10″ (61, 30, 25 cm)

925 Wood – pine; original finish – red; original hardware – cast hinges; W. 70″, H. 34″, D. 15″ (178, 86, 38 cm)

926 Wood – pine; original finish – red; W. 77″, H. 33″, D. 17½″ (196, 84, 44 cm)

927 Wood – pine; original finish – blue-grey; W. 10″, H. 9″, D. 19″ (25, 23, 48 cm)

928 Wood – pine; original finish – red; W. 15″, H. 8½″, D. 9½″ (38, 22, 24 cm)

929 Wood – walnut; original finish – none; W. 16″, H. 9″, D. 7½″ (41, 23, 19 cm)

930 Wood – pine; original finish – red; W. 15″, H. 8″, D. 8″ (38, 20, 20 cm)

931 Wood – pine; original finish – light and dark brown; W. 12″, H. 15″, D. 12″ (30, 38, 30 cm)

932 Right: Wood – pine; original finish – yellow ochre; W. 17″, H. 10¾″, D. 9½″ (43, 27, 24 cm). Left: Wood – ash; original finish – red; W. 11½″, H. 9½″, D. 7½″ (29, 24, 19 cm)

933 Wood – pine; original finish – brown stain; W. 47½″, H. 17″, D. 10½″ (121, 43, 25 cm)

934 Wood – pine; original finish – blue-green; W. 78″, H. 18″, D. 12″ (198, 46, 30 cm)

935 Wood – pine; original finish – yellow ochre; W. 96″, H. 18″, D. 12″ (244, 46, 30 cm)

936 Wood – pine; original finish – brown; W. 126″, H. 18″, D. 15″ (320, 46, 38 cm)

937 Wood – walnut (pine secondary); original finish – stain with ebonized details; original hardware – cast hinges, wooden pulls (brass replacements), brass escutcheons; W. 60″, H. 85″, D. 20½″ (152, 216, 52 cm)

938 Wood – cherry (pine secondary); original finish – figured maple simulation with overall stain and varnish; original hardware – wooden pulls, brass pulls (restored), brass escutcheons; W. 60″, H. 90″, D. 22″ (152, 229, 56 cm)

939 Wood – cherry (pine secondary); original finish – stain with ebonized quarter columns, feet and mouldings; original hardware – brass hinges, brass and wooden pulls, brass escutcheons; W. 44″, H. 87″ (112, 221 cm)

940 Wood – walnut (pine secondary); original finish – stain and varnish; original hardware – brass pulls, cast hinges, brass escutcheons; W. 59″, H. 83″, D. 20½″ (150, 211, 52 cm)

941 Wood – pine; original finish – blue-green; presently later woodgrained paint; original hardware – brass pulls; W. 58½″, H. 86″, D. 20″ (149, 218, 51 cm); feet restored

942 Wood – walnut (pine secondary); original finish – stain and varnish; original hardware – cast hinges, brass and wooden pulls; W. 58″, H. 82½″, D. 19½″ (147, 209, 50 cm)

943 Wood – walnut (pine secondary); original finish – stain and varnish; original hardware – brass hinges, brass pulls (restored); W. 57½″, H. 84″, D. 19¼″ (146, 213, 49 cm); feet restored

944 Wood – walnut (pine secondary); original finish – stain and varnish; original hardware – cast hinges, brasses (replaced); W. 73″, H. 84½″, D. 24″ (185, 214, 61 cm)

945 Wood – pine; original finish – red; original hardware – cast hinges, brass pulls; W. 61″, H. 91″, D. 22″ (155, 231, 56 cm)

946 Wood – walnut (pine secondary); original finish – stain and varnish; original hardware – cast hinges, brass pulls; W. 54½″, H. 83″, D. 20½″ (138, 211, 52 cm)

947 Wood – pine; original finish – brown; original hardware – cast hinges, brass pulls; W. 60″, H. 92″ (152, 234 cm)

948 Wood – pine; original finish – red ochre; original hardware – cast hinges, wooden pulls; W. 60″, H. 85″, D. 22″ (152, 216 56 cm)

949 Wood – pine; original finish – blue; original hardware – forged rat-tail hinges, brass bale pulls; W. 64″, H. 90″, D. 22½″ (163, 229, 57 cm)

950 Wood – pine; original finish – red; original hardware – cast hinges, brass pulls (replaced); W.

53″, H. 88″, D. 20½″ (135, 224, 52 cm); glazing bars restored

951 Wood – pine; original finish – blue (restored); original hardware – cast hinges, brass pulls (restored); W. 45¼″, H. 96″, D. 15½″ (115, 244, 39 cm)

952 Wood – pine; original finish – red; original hardware – cast hinges, brass pulls (replaced); W. 61″, H. 81½″, D. 19″ (155, 207, 48 cm)

953 Wood – pine; original finish – green-blue; original hardware – cast hinges, wooden pulls; W. 55″, H. 84″, D. 20″ (140, 213, 51 cm)

954 Wood – pine; original finish – blue; original hardware – cast hinges, wooden and glass pulls; W. 55″, H. 82½″, D. 20″ (140, 209, 51 cm)

955 Wood – pine; original finish – red; original hardware – cast hinges, brass and wooden pulls (brass replaced); W. 57½″, H. 80″ (146, 203 cm)

956 Wood – pine; original finish – red and brown; original hardware – cast hinges, wooden pulls; W. 51″, H. 77½″, D. 16″ (130, 197, 41 cm)

957 Wood – pine; original finish – red with ebonized mouldings and foot; original hardware – cast hinges, wooden pulls (both replaced); W. 57″, H. 80″, D. 17″ (145, 203, 43 cm)

958 Wood – walnut; original finish – stain and varnish; original hardware – cast hinges, brass pulls, wooden turnbuckle; W. 43½″, H. 79″, D. 18″ (110, 201, 46 cm)

959 Wood – pine; original finish – red, blue and ochre; original hardware – cast hinges, brass pulls; W. 48″, H. 89″ (122, 226 cm)

960 Wood – pine; original finish – painted wood grain; original hardware – cast hinges, wooden pulls; W. 59″, H. 90″ (150, 229 cm)

961 Wood – pine; original finish – red (restored); original hardware – brass hinges, brass pulls; W. 62″, H. 90″, D. 22″ (157, 229, 56 cm)

962 Wood – pine; original finish – red; original hardware – cast hinges, brass pulls; W. 82½″, H. 90″, D. 23″ (209, 229, 58 cm)

963 Wood – pine; original finish – red, green and yellow; original hardware – cast hinges, wooden pulls, cast iron and brass latches; W. 59″, H. 85½″, D. 20″ (150, 217, 51 cm)

964 Wood – pine; original finish – red-brown; original hardware – cast hinges, brass pulls; W. 71″, H. 81″, D. 23″ (180, 206, 58 cm)

965 Wood – pine; original finish – brown and pumpkin (restored); original hardware – cast hinges, brass pulls; W. 55″, H. 85″, D. 18½″ (140, 216, 47 cm); pie shelf restored

966 Wood – pine; original finish – painted wood grain (restored) and floral motif; original hardware – cast hinges, wooden pulls; W. 60″, H. 89″, D. 21″ (152, 226, 53 cm); pie shelf and cornice restored.

967 Wood – pine; original finish – red; original hardware – cast hinges, wooden pulls, brass escutcheons; W. 52¾″, H. 84″, D. 20″ (134, 213, 51 cm)

968 Wood – pine; original finish – black-brown over vermilion; original hardware – cast hinges, wooden pulls; W. 60″, H. 83″ (152, 211 cm)

969 Wood – pine; original finish – painted wood grain; original hardware – cast hinges, brass pulls; W. 58″, H. 92″ (147, 234 cm)

970 Wood – pine; original finish – red; original hardware – cast hinges, wooden pulls; W. 57½″, H. 84″, D. 22″ (146, 213, 56 cm)

971 Wood – pine; original finish – red; original hardware – cast hinges, wooden pulls; W. 62½″, H. 81½″, D. 22½″ (159, 207, 57 cm)

972 Wood – pine; original finish – red; original hardware – cast hinges, wooden pulls, cast latches; W. 60″, H. 92″, D. 22½″ (152, 234, 57 cm)

973 Wood – butternut, maple inlay (pine secondary); original finish – dark stain and varnish; original hardware – cast hinges and latches, ceramic

pulls; W. 63″, H. 87″, D. 20″ (160, 221, 51 cm)

974 Wood – pine; original finish – painted wood grain; original hardware – cast hinges, brass pulls and turnbuckles; W. 69″, H. 85″, D. 21½″ (176, 216, 55 cm)

975 Wood – cherry (pine secondary); original finish – stain and varnish; original hardware – brass hinges, brass pulls (replaced), bone escutcheons; W. 55″, H. 82″ (140, 208 cm)

976 Wood – pine; original finish – painted wood grain; original hardware – cast hinges, wooden pulls, cast turnbuckles; W. 60″, H. 84″ (152, 213 cm)

977 Wood – pine; original finish – black-brown; original hardware – brass hinges, wooden pulls; W. 39″, H. 86″ (99, 218 cm)

978 Wood – pine; original finish – painted wood grain; original hardware – cast hinges, wooden pulls, cast turnbuckles; W. 45″, H. 77″ (114, 196 cm)

979 Wood – pine; original finish – orange-red; presently stripped; original hardware – brass hinges, wooden pulls (replaced); W. 65″, H. 100″ (165, 254 cm)

980 Wood – pine; original finish – dark stain; presently early overpaint with graining; original hardware – forged hinges, ceramic pulls, cast latches; W. 47″, H. 84″ (119, 213 cm)

981 Wood – pine; original finish – paint; presently refinished; original hardware – forged hinges, brass latch and turnbuckle; W. 62″, H. 98″ (157, 249 cm); feet missing

982 Wood – cherry, figured maple (pine secondary); original finish – stain and varnish; original hardware – forged hinges, wooden pulls, brass escutcheons and turnbuckle; W. 66″, H. 94″ (168, 239 cm); feet missing

983 Wood – pine; original finish – mustard; presently stripped; original hardware – cast hinges and turnbuckles; ceramic pulls; W. 50″, H. 82″ (127, 208 cm)

984 Wood – figured maple, maple inlay, cherry (pine secondary); original finish – stain and varnish; original hardware – forged hinges, brass latches and escutcheons; W. 72″, H. 99″ (183, 251 cm)

985 Wood – pine; original finish – dark brown; original hardware – cast hinges, brass pulls; W. 67″, H. 86″, D. 24″ (170, 218, 61 cm)

986 Wood – pine; original finish – brown-red; original hardware – cast hinges, wooden pulls; W. 62½″, H. 84¾″, D. 21 ½″ (159, 215, 55 cm)

987 Wood – pine; original finish – red; original hardware – cast hinges, wooden pulls (brass restored); W. 57″, H. 86″, D. 19″ (145, 218 cm)

988 Wood – pine; original finish – red; original hardware – cast hinges, wooden pulls; W. 57½″, H. 87″, D. 19½″ (146, 221, 50 cm)

989 Wood – pine; original finish – red; original hardware – cast hinges, brass pulls (restored); W. 58″, H. 88″, D. 19½″ (147, 224, 50 cm)

990 Wood – pine; original finish – pumpkin; original hardware – cast hinges, wooden pulls; W. 59″, H. 88″, D. 23″ (150, 224, 58 cm)

991 Wood – pine; original finish – red; original hardware – cast hinges, wooden pulls; W. 59″, H. 84″, D. 21″ (150, 213, 53 cm)

992 Wood – pine; original finish – red; original hardware – cast hinges, brass pulls; W. 64½″, H. 86″, D. 22″ (164, 218, 56 cm)

993 Wood – pine; original finish – red; original hardware – cast hinges, wooden and brass pulls; W. 54″, H. 82″, D. 21½″ (137, 208, 55 cm)

994 Wood – pine; original finish – green; original hardware – forged hinges and latches, brass bale pulls (replaced); W. 60″, H. 84½″ (152, 215 cm)

995 Wood – pine; original finish – brown; original hardware – cast hinges, cast and brass latches,

ceramic pulls; W. 63″, H. 87″ (160, 221 cm)

996 Wood – pine; original finish – red-brown; original hardware – brass hinges (top), cast hinges (bottom), cast latches, ceramic pulls; W. 59″, H. 84½″, D. 21″ (150, 215, 53 cm)

997 Wood – pine; original finish – red; presently stripped; original hardware – cast hinges, wooden pull, cast latches; W. 42″, H. 89″ (107, 226 cm)

998 Wood – pine; original finish – painted wood grain; original hardware – cast hinges, wooden pulls, brass escutcheon; W. 53″, H. 84″ (135, 213 cm)

999 Wood – oak; original finish – dark stain and varnish; original hardware – rolled hinges, latch; W. 40½″, H. 78″, D. 20¼″ (103, 198, 51 cm)

1000 Wood – walnut, cherry inlay (pine secondary); original hardware – cast hinges, wooden pulls; W. 54″, H. 85″, D. 19½″ (137, 216, 50 cm)

1001 Wood – pine; original finish – red; original hardware – cast hinges, wooden pulls, brass latch and escutcheon; W. 42″, H. 74″, D. 22″ (107, 188, 56 cm)

1002 Wood – pine, ash drawer fronts; original finish – brown; original hardware – cast hinges, brass pulls; W. 49″, H. 85″, D. 27″ (124, 216, 69 cm)

1003 Wood – pine; original finish – green; presently stripped; original hardware – cast hinges, wooden pulls; W. 52½″, H. 78″, D. 18″ (133, 198, 46 cm)

1004 Wood – pine; original finish – red; original hardware – cast hinges, wooden pulls; W. 60″, H. 90″, D. 20″ (152, 229, 51 cm)

1005 Wood – pine; original finish – stained decoration; original hardware – cast hinges, brass pulls and escutcheons; W. 57″ H. 86″, D. 19″ (145, 218, 48 cm); restoration to pie shelf; inconsistent construction and finish remnants suggest the possibility that the two-piece cupboard is an early marriage

1006 Wood – figured maple; original finish – stain and varnish; original hardware – cast hinges, wooden pulls; W. 63″, H. 83″, D. 23″ (160, 211, 58 cm)

1007 Wood – pine, walnut shelves; original finish – painted wood grain; original hardware – cast hinges, wooden pulls; W. 52½″, H. 79″, D. 19¼″ (133, 201 cm)

1008 Wood – walnut (pine secondary); original finish – stain and varnish; original hardware – cast hinges, brass pulls and escutcheons; W. 50½″, H. 79″, D. 21¾″ (128, 201, 55 cm)

1009 Wood – walnut (pine secondary); original finish – stain and varnish; original hardware – cast hinges, brass pulls and escutcheons; W. 46½″, H. 75″, D. 21″ (118, 190, 53 cm)

1010 B. Wood – walnut (pine secondary); original finish – stain and varnish; original hardware – cast hinges, brass pulls and escutcheons; W. 50¼″, H. 73½″, D. 21¼″ (127, 186, 55 cm)

1011 Wood – walnut (pine secondary); original finish – stain and varnish; original hardware – cast hinges, brass pulls and escutcheons; W. 46″, H. 79½″, D. 22″ (117, 202, 56 cm)

1012 Wood – walnut (pine secondary); original finish – abstract decoration, stain and varnish; original hardware – cast hinges, brass pulls and escutcheons (bottom pulls restored); W. 48″, H. 77½″, D. 20″ (122, 197, 51 cm)

1013 Wood – walnut (pine secondary); original finish – stain and varnish; original hardware – cast hinges, brass pulls and escutcheons; W. 47″, H. 80″, D. 20″ (119, 203, 51 cm)

1014 Wood – walnut; original finish – stain and varnish; original hardware – cast hinges, brass pulls (restored), and escutcheons; W. 46″, H. 79″, D. 19″ (117, 201, 48 cm)

1015 Wood – walnut, maple inlay (pine second-

ary); original finish – stain and varnish; original hardware – brass hinges, brass pulls (restored) and escutcheons; cornice restored; W. 49″, H. 80″, D. 17½″ (124, 203, 44 cm)

1016 Wood – walnut (pine secondary); original finish – stain and varnish; original hardware – cast hinges, brass pulls (restored) and escutcheons; W. 50″, H. 79″, D. 19″ (127, 201, 48 cm)

1017 Wood – walnut (pine secondary); original finish – stain and varnish; original hardware – cast hinges, brass pulls and escutcheons; W. 46″, H. 85″, D. 22″ (117, 216, 56 cm)

1018 Wood – walnut (pine secondary); original finish – stain and varnish; original hardware – cast hinges, brass pulls and escutcheons; W. 46″, H. 80″, D. 20½″ (117, 203, 52 cm)

1019 Wood – cherry, walnut and maple inlay (pine secondary); original finish – stain and varnish; original hardware – forged rat-tail hinges, brass pulls and escutcheons (bottom pulls restored); W. 73″, H. 82″, D. 23¾″ (185, 208, 60 cm)

1020 Wood – cherry, walnut and maple inlay (pine secondary); original finish – stain and varnish; original hardware – brass hinges, pulls and escutcheons; W. 64½″, H. 84½″, D. 23½″ (164, 215, 60 cm)

1021 Wood – pine; original finish – painted wood grain and contrasting panel; original hardware – forged hinges, brass pulls and escutcheons; W. 66½″, H. 83″, D. 23″ (169, 211, 58 cm)

1022 Wood – walnut, (pine secondary); original finish – stain and varnish; original hardware – iron baluster hinges, iron lock, forged draw bolt; W. 58½″, H. 83″, D. 22½″ (148, 211, 57 cm)

1023 Wood – pine; original finish – red; original hardware – cast hinges, iron locks; W. 62″, H. 80½″, D. 19″ (157, 204, 48 cm)

1024 Wood – walnut, white oak (pine secondary); original finish – stain and varnish; original hardware – brass escutcheons; W. 78″, H. 91″, D. 24″ (198, 231, 61 cm)

1025 Wood – cherry (pine secondary); original finish – stain and varnish; original hardware – forged rat-tail hinges, brass escutcheon; W. 56″, H. 81″, D. 19½″ (142, 206, 50 cm)

1026 Wood – pine; original finish – multiple-technique painted decoration; original hardware – forged rat-tail hinges, brass escutcheons; W. 59″, H. 79½″, D. 21½″ (150, 202, 55 cm)

1027 Wood – pine; original finish – painted wood grain; original hardware – forged rat-tail hinges, brass escutcheons; W. 62½″, H. 80½″, D. 22½″ (159, 204, 57 cm)

1028 Wood – pine; original finish – painted decoration; W. 72″, H. 83½″, D. 22″ (183, 212, 56 cm)

1029 Wood – pine; original finish – painted decoration; original hardware – cast hinges, brass escutcheon; W. 48″, H. 72½″, D. 19¼″ (122, 184, 48 cm)

1030 Wood – butternut, walnut and maple inlay (pine secondary); original finish – stain and varnish; original hardware – cast hinges, wooden or brass pulls (restored), brass escutcheons; W. 73″, H. 90″, D. 25½″ (185, 229, 64 cm)

1031 Wood – walnut (pine secondary); original finish – stain and varnish; original hardware – brass pulls (restored), brass escutcheons; W. 47½″, H. 46½″, D. 22½″ (121, 118, 57 cm); outside bracket feet restored

1032 Wood – figured maple (pine secondary); original finish – stain and varnish; original hardware – cast hinges, brass bale pulls, iron escutcheon; W. 51″, H. 79½″, D. 19½″ (130, 202, 50 cm)

1033 Wood – pine; original finish – painted decoration; original hardware – cast hinges, wooden pulls; brass escutcheons; W. 63″, H. 89″, D. 20″ (160, 226, 51 cm)

1034 Wood – pine; original finish – painted deco-

ration; original hardware – cast hinges, wooden pulls; W. 69", H. 85½", D. 26½" (176, 217, 67 cm)

1035 Wood – pine; original finish – dark stain; original hardware – forged, rat-tail hinges, wooden pulls; W. 69", H. 83", D. 24" (176, 211, 61 cm)

1036 Wood – pine; original finish – red; original hardware – cast hinges, wooden pulls; W. 62", H. 82", D. 22" (157, 208, 56 cm)

1037 Wood – pine; original finish – painted woodgrain decoration; original hardware – cast hinges, wooden pulls, brass escutcheons; W. 65", H. 84", D. 21¼" (165, 213, 54 cm)

1038 Wood – pine; original finish – orange with black decoration; original hardware – cast hinges; W. 24", H. 74" (61, 188 cm)

1039 Wood – pine; original finish – red; original hardware – brass escutcheon; W. 44½", H. 74½", D. 17" (113, 189, 43 cm)

1040 Wood – pine; original finish – red; original hardware – cast hinges, wooden turnbuckle; W. 40", H. 73", D. 20" (102, 185, 51 cm)

1041 Wood – pine; original finish – red; original hardware – cast hinges, wooden turnbuckle; W. 42", H. 65", D. 18" (107, 165, 46 cm)

1042 Wood – pine; original finish – red-brown; original hardware – cast hinges, wooden turn-buckle; W. 42", H. 72", D. 14¾" (107, 183, 37 cm)

1043 Wood – pine; original finish – red; original hardware – cast hinges and latch; W. 53", H. 85", D. 16" (135, 216, 41 cm)

1044 Wood – basswood, pine; original finish – red; original hardware – cast hinges, wooden pull; W. 49½", H. 78", D. 18" (126, 198, 46 cm)

1045 Wood – pine; original finish – dark brown; original hardware – cast hinges, wooden turn-buckle; W. 44", H. 51", D. 18" (112, 130, 46 cm)

1046 Wood – pine; original finish – red; presently overpainted and grained; original hardware – cast hinges, wooden pulls; W. 48", H. 72", D. 16" (122, 183, 41 cm)

1047 Wood – pine; original finish – red; original hardware – cast hinges, wooden pulls; W. 48", H. 84", D. 16" (122, 213, 41 cm) (approx.)

1048 Wood – pine; original finish – light green; original hardware – cast hinges, wooden pulls, brass latches; W. 51½", H. 68", D. 14" (131, 173, 36 cm)

1049 Wood – pine; original finish – red; original hardware – cast hinges, wooden pull; W. 30", H. 54", D. 13" (76, 137, 33 cm)

1050 Wood – pine; original finish – red; original hardware – cast hinges, wooden pulls; W. 57", H. 43", D. 23" (145, 109, 58 cm)

1051 Wood – pine; original finish – stain; original hardware – cast hinges, wooden pulls; W. 70", H. 49", D. 19" (178, 124, 48 cm)

1052 Wood – pine; original finish – red, red-brown, sponge texture; original hardware – cast hinges, wooden pull; W. 39", H. 38", D. 18" (99, 97, 46 cm)

1053 Wood – pine; original finish – red; presently remnants of original; original hardware – cast hinges, wooden pulls and turnbuckle; W. 43", H. 42", D. 15" (109, 107, 38 cm)

1054 Wood – pine; original finish – painted green-blue; original hardware – cast hinges, wooden pull; W. 30", H. 37½" D. 16½" (76, 95, 41 cm)

1055 Wood – walnut; original finish – stain and varnish; original hardware – cast hinges, wooden pull; W. 33", H. 33" (84, 84 cm)

1056 Wood – walnut; original finish – stain and varnish; original hardware – cast hinges, brass pulls (restored) and escutcheons; W. 24", H. 35", D. 10¾" (61, 89, 27 cm)

1057 Wood – pine; original finish – blue-green; original hardware – cast hinges, wooden pulls; W. 25", H. 46" (63, 117 cm)

1058 Wood – cherry, basswood (secondary); original finish – stain and varnish; original hardware – cast brass hinges, wooden pull, brass turnbuckle; W. 31½", H. 45", D. 21" (80, 114, 53 cm)

1059 Wood – butternut; original finish – green; presently overpainted; original hardware – forged hinges, wooden pulls; W. 38½", H. 52" (98, 132 cm)

1060 Wood – pine; original finish – combed wood grain; W. 29", H. 36", D. 8" (74, 91, 20 cm)

1061 Wood – pine; original finish – red; original hardware – cast hinges, wooden pull; W. 23½", H. 33½", D. 14½" (60, 85, 37 cm)

1062 Wood – pine; original finish – painted wood grain; original hardware – cast hinges, wooden pull; W. 45", H. 38" (114, 97 cm)

1063 Wood – pine; original finish – painted wood grain; original hardware – cast hinges, wooden pulls; W. 75½", H. 32", D. 24" (192, 81, 61 cm)

1064 Wood – pine; original finish – red and grey; original hardware – cast hinges, wood pulls; W. 43½", H. 30", D. 18½" (110, 76, 47 cm)

1065 Wood – pine; original finish – red; original hardware – cast hinges, wooden pulls and turnbuckle; W. 61", H. 33", D. 21" (155, 84, 53 cm)

1066 Wood – pine; original finish – grey; original hardware – cast hinges, brass pulls; W. 62", H. 33¾", D. 25" (157, 85, 63 cm)

1067 Wood – pine; original finish – stain and varnish; original hardware – cast hinges and latches; W. 65", H. 27", D. 22" (165, 69, 56 cm)

1068 Wood – pine; original finish – red with green pilaster and painted escutcheons; original hardware – cast hinges, wooden pulls; W. 44", H. 32", D. 20" (112, 81, 51 cm)

1069 Wood – pine; original finish – paint; W. 31", H. 31", D. 17" (79, 79, 43 cm)

1070 Wood – cherry; original finish – stain and varnish; original hardware – cast hinges and latches; W. 47", H. 32", D. 21" (119, 81, 53 cm)

1071 Wood – pine; original finish – painted wood grain; original hardware – cast hinges and latch; W. 27½", H. 24", D. 15½" (70, 61, 39 cm)

1072 Wood – pine; original finish – unknown, presently painted decoration; original hardware – cast hinges and latch; W. 18¾", H. 27", D. 25½" (47, 69, 64 cm)

1073 Wood – pine; original finish – red; presently stripped; original hardware – cast hinges and latch; W. 36", H. 36" (91, 91 cm)

1074 Wood – ash and pine; original finish – dark stain; presently stripped; original hardware – cast hinges, ceramic knob; W. 40", H. 60" (102, 152 cm)

1075 Wood – pine; original finish – red; original hardware – brass hinges, brass pull (restored) and turnbuckle; W. 28", H. 27½", D. 16" (71, 70, 41 cm)

1076 Wood – pine; original finish – grey; original hardware – wooden pull; W. 31", H. 31", D. 16" (79, 79, 41 cm)

1077 Wood – pine; original finish – red; presently overpainted; W. 34", H. 29½", D. 18" (86, 75, 46 cm)

1078 Wood – pine; original finish – brown, presently stripped; original hardware – cast hinges, wooden pull, cast latch; W. 16", H. 36", D. 16" (41, 91, 41 cm)

1079 Wood – pine; original finish – red; W. 68", H. 28½", D. 15" (173, 72, 38 cm)

1080 Wood – pine; original finish – pumpkin red; presently early green overpaint; W. 48", H. 65", D. 15½" (122, 165, 39 cm)

1081 Wood – pine; original finish – red; W. 36", H. 38", D. 16" (91, 97, 41 cm)

1082 Wood – pine; original finish – green; orig-

inal hardware – cast hinges, wooden pull; W. 36", H. 16", D. 12" (91, 41, 30 cm) (approx.)

1083 Wood – pine; original finish – red; W. 45½", H. 45½", D. 14" (116, 116, 36 cm)

1084 Wood – pine; original finish – blue-grey; presently early red overpaint; W. 39½", H. 21", D. 12" (100, 53, 30 cm)

1085 Wood – pine; original finish – blue-grey; presently early red overpaint; W. 38", H. 36", D. 13" (97, 91, 33 cm)

1086 Wood – pine; original finish – green-blue; W. 42", H. 39", D. 13½" (107, 99, 34 cm)

1087 Wood – pine; original finish – red; W. 20", H. 30", D. 13" (51, 76, 33 cm)

1088 Wood – walnut (pine secondary); original finish – stain and varnish; original hardware – brass pulls and escutcheons; W. 49½", H. 31½", D. 22¾" (126, 80, 27 cm)

1089 Wood – walnut; original finish – stain and varnish; original hardware – forged strap hinges; W. 49½", H. 25½", D. 18½" (126, 64, 47 cm)

1090 Wood – walnut, cherry cock-beading on drawers (pine secondary); original finish – stain and varnish; original hardware – forged strap hinges, brass pulls and escutcheons (restored); W. 50", H. 28½", D. 21½" (127, 72, 55 cm)

1091 Wood – pine; original finish – blue with ebonized feet, mouldings and quarter columns (restored); original hardware – brass pulls (restored); W. 52½", H. 33", D. 20½" (133, 84, 52 cm)

1092 Wood – walnut (pine secondary); original finish – stain and varnish; original hardware – forged hinges, brass pulls (restored); W. 48", H. 28½", D. 20¼" (122, 72, 51 cm)

1093 Wood – pine and figured maple; original finish – stain and varnish; original hardware – cast hinges, ceramic pulls, brass escutcheons; W. 48", H. 28", D. 23" (122, 71, 58 cm)

1094 Wood – pine; original finish – red; original hardware – wooden pulls, brass escutcheons; W. 53", H. 30", D. 21½" (135, 76, 55 cm)

1095 Wood – pine; original finish – multiple-painted woodgrain patterns; original hardware – cast hinges, wooden pulls, brass escutcheon; W. 47", H. 27", D. 25" (119, 69, 64 cm)

1096 Wood – pine; original finish – mustard and black decoration; original hardware – cast hinges; W. 38", H. 21", D. 17" (97, 53, 43 cm)

1097 Wood – pine; original finish – brown and ochre with stain graining; original hardware – cast hinges, wooden pulls, brass escutcheons; W. 19½", H. 44", D. 28" (50, 112, 71 cm)

1098 Wood – pine; original finish – green, blue, red and brown; original hardware – cast hinges; W. 47", H. 24", D. 19" (110, 61, 48 cm)

1099 Wood – pine; original finish – red with painted decoration; original hardware – cast hinges, brass escutcheon; W. 36½", H. 21¾", D. 22½" (92, 55, 57 cm)

1100 Wood – pine; original finish – green with pumpkin decoration; original hardware – cast hinges; W. 41", H. 21½", D. 18½" (104, 55, 47 cm)

1101 Wood – pine; original finish – stain; original hardware – cast hinges; W. 40", H. 22½", D. 20" (102, 57, 51 cm)

1102 Wood – pine; original finish – brown with peach decoration; original hardware – wooden pulls (restored), brass escutcheons; W. 49", H. 21", D. 20" (124, 53, 51 cm)

1103 Wood – pine; original finish – red and grey-blue; original hardware – cast hinges, iron escutcheon; W. 48¼", H. 27½", D. 23½" (123, 70, 60 cm)

1104 Wood – pine; original finish – red; original hardware – cast handles and hinges, brass pull and escutcheon; W. 20½", H. 36", D. 25" (52, 91, 63 cm)

1105 Wood – pine; original finish – red; original hardware – cast hinges; W. 31″, H. 17¾″, D. 14″ (79, 45, 36 cm)

1106 Wood – pine; original finish – dark green, presently early overpaint and decoration; original hardware – cast hinges, wooden pulls; W. 41½″, H. 27″, D. 21″ (105, 69, 53 cm)

1107 Wood – pine; original finish – brown; presently early overpaint and decoration; original hardware – cast hinges, wooden pulls (restored), brass escutcheon; W. 40″, H. 27″, D. 21″ (102, 69, 53 cm)

1108 Wood – pine; original finish – green over yellow combed graining; original hardware – cast hinges, brass pulls; W. 49½″, H. 26″, D. 20½″ (126, 66, 52 cm)

1109 Wood – pine; original finish – painted decoration; original hardware – cast hinges; W. 39¼″, H. 23″, D. 21½″ (99, 58, 55 cm)

1110 Wood – pine; original finish – yellow with red decoration; original hardware – cast hinges; W. 40″, H. 22″, D. 20½″ (102, 56, 52 cm)

1111 Wood – walnut; original finish – painted and stained; original hardware – brass hinges; W. 18½″, H. 7½″, D. 10″ (47, 19, 25 cm)

1112 Wood – walnut and apple; original finish – stain and varnish; original hardware – brass hinges; W. 7¾″, H. 6¼″, D. 5½″ (19, 15, 14 cm)

1113 Wood – pine, maple and mahogany; original finish – stain and varnish; original hardware – brass hinges, bone escutcheon; W. 12″, H. 7″, D. 5½″ (30, 18, 14 cm)

1114 Wood – basswood; original finish – red with black decoration; original hardware – brass hinges and lock; W. 14½″, H. 6″, D. 9″ (37, 15, 23 cm)

1115 Wood – pine; original finish – paint; original hardware – cast hinges (J.W.); W. 37½″, H. 20″, D. 16½″ (95, 51, 42 cm)

1116 Wood – pine; original finish – pale blue; original hardware – forged strap hinges; W. 43″, H. 21″, D. 19″ (109, 53, 48 cm)

1117 Wood – pine; original finish – red; original hardware – cast hinges; W. 25″, H. 16″, D. 12″ (63, 41, 30 cm)

1118 Wood – cherry (pine secondary); original finish – stain and varnish; original hardware – wooden pulls, turnbuckles and iron interior locks; W. 15″, H. 85″ (38, 216 cm)

1119 Wood – walnut (pine secondary); original finish – stain and varnish; original hardware – brass pulls and escutcheons; W. 44″, H. 67½″, D. 23″ (112, 171, 58 cm)

1120 Wood – walnut (pine secondary); original finish – stain and varnish; original hardware – brass pulls (restored), brass escutcheons; W. 43½″, H. 51″, D. 21½″ (110, 130, 55 cm)

1121 Wood – walnut (pine secondary); original finish – stain and varnish; original hardware – brass pulls (restored), brass escutcheons; W. 45″, H. 45½″, D. 22″ (114, 115, 56 cm); bracket feet and end cornice mouldings restored

1122 Wood – walnut (pine secondary); original finish – stain and varnish; original hardware – brass pulls (restored), brass escutcheons; W. 47½″, H. 46½″, D. 22½″ (121, 118, 57 cm); outside bracket feet restored

1123 Wood – walnut, figured maple (pine secondary); original finish – stain and varnish, ebonized details; original hardware – brass pulls and escutcheons; W. 44½″, H. 50″, D. 21½″ (113, 127, 55 cm)

1124 Wood – figured maple (pine secondary); original finish – stain and ebonized quarter columns and feet; original hardware – brass or pressed glass pulls (glass restored); W. 41″, H. 52″, D. 19¾″ (104, 132, 50 cm)

1125 Wood – cherry (pine secondary); original finish – stain and varnish, ebonized quarter columns and cove mouldings; original hardware – pressed glass pulls, brass escutcheons; W. 44½″, H. 46″, D. 21½″ (112, 117, 53 cm)

1126 Wood – cherry (pine secondary); original finish – stain and varnish, ebonized details (likely); original hardware – pressed glass pulls, brass escutcheons; W. 41½″, H. 65″, D. 20½″ (105, 165, 52 cm)

1127 Wood – walnut (pine secondary); original finish – stain and varnish; original hardware – brass pulls and escutcheons; W. 45½″, H. 45½″, D. 21″ (116, 116, 53 cm)

1128 Wood – walnut (pine secondary); original finish – stain and varnish, ebonized quarter columns, feet, cove mouldings and spindles; original hardware – pressed glass pulls, brass escutcheons; W. 39½″, H. 55½″, D. 21″ (100, 141, 53 cm)

1129 Wood – cherry (pine secondary); original finish – stain with ebonized columns, feet and gallery; original hardware – pressed glass knobs, brass escutcheons; W. 44″, H. 54″, D. 21½″ (112, 137, 55 cm)

1130 Wood – pine; original finish – painted wood grain; original hardware – ceramic pulls, brass escutcheons; W. 48″, H. 59″, D. 21″ (122, 150, 53 cm)

1131 Wood – pine; original finish – painted wood grain; original hardware – wooden pulls, brass escutcheons; W. 49½″, H. 60″, D. 21″ (126, 152, 53 cm)

1132 Wood – cherry (pine secondary); original finish – stain and varnish; original hardware – wooden pulls, brass escutcheons; W. 46″, H. 57″, D. 22″ (117, 145, 56 cm)

1133 Wood – walnut and maple (basswood secondary); original finish – stain and varnish; original hardware – ceramic pulls, brass escutcheons; W. 46″, H. 58½″, D. 21″ (117, 149, 53 cm)

1134 Wood – walnut, burr walnut, cherry, maple cock-beading and inlay; original finish – stain and varnish; original hardware unknown (brass restored); W. 45″, H. 54½″, D. 20½″ (114, 138, 52 cm)

1135 Wood – walnut, birdseye maple, (pine secondary); original finish – stain and varnish; original hardware – wooden pulls, brass escutcheons; W. 43″, H. 56″, D. 21″ (109, 142, 53 cm)

1136 Wood – pine; original finish – painted wood grain (figured maple); original hardware – brass pulls and escutcheons; W. 48″, H. 72″, D. 22″ (122, 183, 56 cm)

1137 Wood – cherry, figured maple, walnut (pine secondary); original finish – stain and varnish; original hardware – brass pulls (replaced), brass escutcheons; W. 41″, H. 71″, D. 21″ (104, 180, 53 cm)

1138 Wood – cherry, maple (pine secondary); original finish – stain and varnish, original hardware – brass pulls (replaced); W. 42″, H. 45½″, D. 22½″ (107, 116, 57 cm)

1139 Wood – cherry, maple, walnut (pine secondary); original finish – stain and varnish, ebonized details; original hardware – wooden pulls, brass escutcheons; W. 41½″, H. 70½″, D. 22½″ (105, 179, 57 cm)

1140 Wood – cherry (pine secondary); original finish – stain and varnish; original hardware – brass pulls (replaced), brass escutcheons; W. 41″, H. 71″, D. 20½″ (104, 180, 52 cm); feet restored

1141 Wood – cherry (pine secondary); original finish – stain and varnish, ebonized cornice; original hardware – wooden pulls, brass escutcheons; W. 44½″, H. 70½″, D. 21″ (113, 179, 53 cm)

1142 Wood – pine; original finish – red over orange paint and feather-decorated; original hardware – brass pulls (replaced); W. 44½″, H. 61″, D. 21¾″ (113, 155, 55 cm)

1143 Wood – figured maple, cherry and pine; original finish – stain and varnish; original hardware – pressed glass pulls, brass escutcheons; W. 39¾″, H. 44″, D. 24¼″ (100, 112, 62 cm)

1144 Wood – figured maple and pine; original finish – stain and varnish; original hardware – brass pulls (replaced), brass escutcheons; W. 40″, H. 44″, D. 23″ (102, 112, 58 cm)

1145 Wood – butternut (pine secondary); original finish – dark stain and varnish; original hardware – unknown; W. 41″, H. 46″, D. 24″ (104, 117, 61 cm)

1146 Wood – walnut (pine secondary); original finish – stain and varnish; original hardware – brass pulls and escutcheons; W. 47″, H. 52½″, D. 18½″ (119, 133, 47 cm)

1147 Wood – butternut, figured maple (pine secondary); original finish – stain and varnish; original hardware – wooden pulls (burl), brass escutcheons; W. 45″, H. 51½″, D. 21″ (114, 131, 53 cm)

1148 Wood – butternut (pine secondary); original finish – stain and varnish; original hardware – brass pulls and escutcheons; W. 44″, H. 55″, D. 20″ (112, 140, 51 cm)

1149 Wood – pine; original finish – red; original hardware – brass pulls (restored); W. 44½″, H. 56″, D. 22″ (113, 142, 56 cm)

1150 Wood – pine; original finish – painted wood grain and varnish; original hardware – wooden pulls; W. 47½″, H. 55″, D. 21½″ (121, 140, 55 cm)

1151 Wood – pine; original finish – painted wood grain, crimson over pumpkin base; original hardware – ceramic pulls, brass escutcheons; W. 44″, H. 59″, D. 18″ (112, 150, 46 cm)

1152 Wood – pine; original finish – painted wood grain; original hardware – ceramic pulls, brass escutcheons; W. 43″, H. 59″, D. 22″ (109, 150, 56 cm)

1153 Wood – pine; original finish – painted wood grain; original hardware – wooden pulls, brass escutcheons; W. 46½″, H. 43″, D. 19″ (118, 109, 48 cm)

1154 Wood – pine; original finish – painted decoration; original hardware – wooden pulls, brass escutcheons; W. 46½″, H. 51″, D. 19½″ (118, 130, 50 cm)

1155 Wood – walnut (pine secondary); original finish – stain and varnish; original hardware – iron leaf hinges, brass bale pulls, brass escutcheons; W. 39″, H. 42″, D. 18¼″ (99, 107, 46 cm)

1156 Wood – cherry (pine secondary); original finish – stain and varnish; original hardware – brass hinges, ceramic pulls, brass ring pulls and escutcheons; W. 39″, H. 50½″, D. 20½″ (99, 128, 52 cm)

1157 Wood – figured maple and pine; original finish – stain and varnish; original hardware – brass hinges, brass and glass pulls, brass lock and escutcheons; W. 38″, H. 71½″, D. 22″ (97, 181, 56 cm)

1158 Wood – figured maple (pine secondary); original finish – stain; original hardware – brass hinges, pulls, escutcheons; W. 45″, H. 84″, D. 21″ (114, 213, 53 cm)

1159 Wood – cherry, figured maple interior (pine secondary); original finish – stain and varnish, ebonized columns and mouldings; original hardware – brass hinges, lock, pulls (exterior restored) and escutcheons; W. 42″, H. 56″, D. 20″ (107, 142, 51 cm)

1160 Wood – walnut (pine secondary); original finish – stain and varnish; original hardware – brass hinges, pulls and escutcheons; W. 38¼″, H. 48″, D. 20″ (97, 122, 51 cm); desk lid and feet restored

1161 Wood – cherry, figured maple (pine secondary); original finish – stain and varnish, ebonized details; original hardware – glass pulls, brass pulls

and escutcheons; W. 49", H. 58", D. 23" (124, 147, 58 cm)

1162 Wood – walnut (pine secondary); original finish – stain and varnish; original hardware – brass hinges, lock and escutcheons, wooden pulls; W. 46", H. 53½", D. 20½" (117, 133, 52 cm)

1163 Wood – walnut (pine secondary); original finish – stain and varnish; original hardware – brass lock, pulls (bale type replaced) and escutcheons; W. 54", H. 60", D. 24" (137, 152, 61 cm)

1164 Wood – burl maple, maple, cherry, walnut, hickory (pine secondary); original finish – stain and varnish; original hardware – ceramic pulls, brass escutcheons; W. 21½", H. 17", D. 13½" (55, 43, 34 cm)

1165 Wood – cherry, figured maple (pine secondary); original finish – stain and varnish; original hardware – brass hinges, lock, interior pulls, wooden interior pulls; W. 43", H. 79", D. 18½" (109, 201, 47 cm)

1166 Wood – cherry, maple and walnut inlay (pine secondary); original finish – stain and varnish; original hardware – brass hinges, wooden pulls, brass escutcheons; W. 44", H. 39", D. 20" (112, 99, 51 cm)

1167 Wood – pine; original finish – red; presently stripped; original hardware – cast hinges, wooden pulls, brass pulls (interior); W. 58", H. 85½" (147, 217 cm)

1168 Wood – cherry (pine secondary); original finish – stain and varnish; original hardware – brass hinges, wooden pulls; W. 41", H. 92", D. 19½" (104, 234, 50 cm)

1169 Wood – cherry (pine secondary); original finish – stain and varnish; original hardware – cast hinges, wooden pulls, brass bale pull; W. 49", H. 94", D. 23" (124, 239, 58 cm)

1170 Wood – pine; original finish – dark paint stain; original hardware – cast hinges, brass pulls (interior), ivory escutcheon; W. 33", H. 35", D. 26" (84, 89, 66 cm)

1171 Wood – cherry (pine secondary); original finish – stain and varnish; original hardware – cast hinges, wooden pull; W. 30", H. 42", D. 27" (76, 107, 69 cm)

1172 Wood – pine; original finish – red; interior – black over red abstract decoration; original hardware – cast hinges, brass escutcheons; W. 41½", H. 52", D. 25½" (105, 132, 64 cm)

1173 Wood – pine; original finish – painted wood grain, geometric motif and banding; original hardware – brass hinges, brass lock and bale pulls (restored); W. 45", H. 51", D. 23" (114, 130, 58 cm)

1174 Wood – pine; original finish – painted wood grain; original hardware – cast hinges, wooden pulls, brass escutcheons; W. 46½", H. 66½", D. 20" (118, 169, 51 cm)

1175 Wood – pine; original finish – dark brown; original hardware – cast hinges, ceramic pulls; W. 39", H. 73½", D. 27" (99, 186, 69 cm)

1176 Wood – walnut (pine secondary); original finish – stain and varnish; original hardware – cast hinges, wooden pulls; W. 35½", H. 54½", D. 22" (90, 138, 56 cm)

1177 Wood – pine; original finish – red with black abstract decoration; original hardware – cast hinges, forged lock; W. 31", H. 46", D. 22½" (79, 117, 57 cm)

1178 Wood – cherry, mahogany, birdseye maple, walnut, pine (secondary); original finish – stain and varnish; original hardware – brass hinges and pull; H. 88" (224 cm)

1179 Wood – pine; original finish – stain and varnish; original hardware – brass hinges; H. 86¼" (219 cm)

1180 Wood – walnut; original finish – stain and varnish; original hardware – brass hinges; H. 96" (244 cm)

1181 Wood – pine; original finish – painted wood grain and stencil; original hardware – brass hinges and escutcheon; H. 86" (218 cm)

1182 Wood – pine; original finish – painted wood grain; original hardware – brass hinges, pull and escutcheons; H. 96½" (245 cm)

1183 Wood – hardwood; original finish – red; H. 37" (94 cm)

1184 Wood – walnut; original finish – stain and varnish; H. 31" (79 cm)

1185 Wood – pine; original finish – red; H. 36" (91 cm)

1186 Wood – pine; original finish – red; H. 34" (86 cm)

1187 Wood – pine; original finish – red; H. 34" (86 cm)

1188 Wood – maple and pine; original finish – red and black painted wood grain; H. 37" (94 cm)

1189 Wood – pine; original finish – red; W. 43", H. 14", D. 72" (109, 36, 183 cm)

1190 Wood – pine; original finish – brown; W. 33", H. 29", D. 64" (84, 74, 163 cm)

1191 Wood – cherry; original finish – paint stain; W. 38", H. 28", D. 69" (97, 71, 176 cm)

1192 Wood – pine; original finish – red and black painted wood grain; W. 42", H. 22", D. 16" (107, 56, 41 cm)

1193 Wood – walnut and pine; original finish – stain and varnish; W. 31" (rocker), H. 22", D. 37½" (79, 56, 95 cm)

1194 Wood – pine, cherry rockers; original finish – grey-blue; W. 38", H. 18", D. 16" (97, 46, 41 cm)

1195 Wood – pine; original finish – red; W. 38½", H. 19½", D. 17" (98, 50, 43 cm)

1196 Wood – pine; original finish – green; W. 41", H. 16", D. 16½" (104, 41, 42 cm)

1197 Wood – maple; original finish – painted and stencilled; W. 37", H. 17", D. 16" (94, 43, 41 cm)

1198 Wood – walnut; original finish – stain and varnish; W. 48", H. 36", D. 24" (122, 91, 61 cm)

1199 Wood – pine; original finish – painted wood grain and decoration; W. 16", H. 20" (41, 51 cm)

1200 Wood – cherry and figured maple; original finish – stain and varnish; W. 17½", H. 22" (44, 56 cm)

1201 Wood – cherry and pine; original finish – stain and varnish; W. 12½", H. 16" (32, 41 cm)

1202 Wood – pine; original finish – stain and painted decoration; W. 9¾", H. 10½" (24, 29 cm)

1203 Wood – pine; original finish – painted decoration; W. 15", H. 23", D. 7" (38, 58, 18 cm)

1204 Wood – walnut; original finish – stain and varnish; W. 11", H. 13¼" (28, 34 cm)

1205 Wood – pine and hardwoods; original finish – none; W. 12", H. 12" (30, 30 cm)

1206 Wood – cherry; original finish – none; W. 8", H. 18½" (20, 47 cm)

1207 Wood – oak; original finish – none; H. 29" (74 cm)

1208 Wood – cherry; original finish – none; W. 7", H. 30" (18, 76 cm)

1209 Wood – pine; original finish – none; L. 9" (23 cm)

1210 Wood – maple, cherry and oak; original finish – stain; W. 28", H. 16" (71, 41 cm)

1211 Wood – basswood; original finish – none; W. 6½", H. 19", D. 4" (16, 48, 10 cm)

1212 Wood – pine; original finish – none; W. 5½", H. 20¾", D. 3½" (14, 52, 9 cm)

1213 Wood – pine; original finish – stain and varnish; W. 7½", H. 17¼", D. 5½" (19, 43, 14 cm)

1214 Wood – pine; original finish – green and orange; W. 6¼", H. 7", D. 5¾" (16, 18, 15 cm)

1215 Wood – pine; original finish – red; W. 18", H. 14" (46, 36 cm)

1216 Wood – maple; original finish – stain; W. 10", H. 10", D. 6" (25, 25, 15 cm)

1217 Wood – pine; original finish – blue-green; W. 9", H. 8", D. 6" (23, 20, 15 cm)

1218 Wood – pine; original finish – red-brown; W. 7", H. 14", D. 6" (18, 36, 15 cm)

1219 Wood – walnut; original finish – stain and varnish; W. 10", H. 4½", D. 4" (25, 11, 10 cm)

1220 Wood – cherry, maple inlay; original finish – stain and varnish; original hardware – brass hinges; W. 10½", H. 8½", D. 7¼" (26, 22, 18 cm)

1221 Wood – pine; original finish – painted decoration; W. 10", H. 5", D. 4½" (25, 13, 12 cm)

1222 Wood – pine; original finish – green and ochre; original hardware – wooden pulls; W. 18½", H. 15" (47, 38 cm)

1223 Wood – pine; original finish – dark green; original hardware – ceramic pulls; W. 11", H. 20" (28, 51 cm)

1224 Wood – pine; original finish – brown; W. 7¾", H. 13¾" (19, 34 cm)

1225 Wood – pine; original finish – red; W. 6½", H. 8" (16, 20 cm)

1226 Wood – pine; original finish – red-brown; W. 14½", H. 28" (37, 71 cm)

1227 Wood – walnut; original finish – stain and varnish; original hardware – brass hinges; W. 20", H. 36" (51, 91 cm)

1228 Wood – poplar; original finish – none; W. 6", H. 25" (15, 63 cm)

1229 Wood – birch; original finish – stain and varnish; H. 31" (79 cm)

1230 Wood – pine; original finish – brown; W. 18½", H. 37½", D. 6½" (47, 95, 16 cm)

1231 Wood – pine; original finish – red and green; original hardware – cast hinges, wooden pull; W. 43", H. 78", D. 16" (109, 198, 41 cm)

1232 Wood – pine; original finish – blue, ochre, vermilion; original hardware – cast hinges, brass loop pulls, ceramic pull, wooden turnbuckle; W. 48", H. 86", D. 19" (122, 218, 48 cm)

1233 Wood – pine; original finish – deep red with light floral decoration; original hardware – cast hinges, wooden pulls; W. 44", H. 74", D. 16" (112, 188, 41 cm)

1234 Wood – pine; original finish – red-brown; original hardware – cast hinges, wooden pulls; W. 44½", H. 82", D. 19" (113, 208, 48 cm)

1235 Wood – pine; original finish – red-brown; original hardware – cast hinges, wooden pulls; W. 51", H. 78", D. 20" (130, 198, 51 cm)

1236 Wood – pine; original finish – red; original hardware – cast hinges, brass pulls; W. 44", H. 65", D. 16" (112, 165, 41 cm)

1237 Wood – pine; original finish – ochre and red-brown; original hardware – cast hinges, wooden pulls; W. 47", H. 81", D. 15" (119, 206, 38 cm)

1238 Wood – pine; original finish – red and green with accent colours; presently restored red and green; original hardware – cast hinges, wooden pulls; W. 44", H. 82", D. 21½" (112, 208, 55 cm); pie shelf brackets and shell motif restored.

1239 Wood – pine; original finish – red and blue (restored); original hardware – rolled hinges, brass escutcheons, wooden pulls; W. 43¾", H. 86¼", D. 17¼" (110, 218, 43 cm)

1240 Wood – pine; original finish – blue-black; original hardware – cast hinges, wooden turnbuckle; W. 36", H. 75", D. 15" (91, 190, 38 cm)

1241 Wood – pine; original finish – red-brown with painted wood grain; original hardware – wooden pulls; W. 70", H. 30", D. 30¼" (178, 76, 77 cm)

1242 Wood – pine; original finish – red; original hardware – cast hinges, wooden pull; W. 45", H.

69″, D. 17½″ (114, 176, 44 cm)

1243 Wood – pine; original finish – red; presently stripped; original hardware – cast hinges, wooden pull; W. 43″, H. 75″, D. 18″ (109, 190, 46 cm)

1244 Wood – pine; original finish – brown; original hardware – wooden pull; W. 61″, H. 31″, D. 31½″ (155, 79, 80 cm)

1245 Wood – pine; original finish – brown-red; original hardware – wooden pulls; W. 65″, H. 31″, D. 33½″ (165, 79, 85 cm)

1246 Wood – pine; original finish – brown, green, burgundy; original hardware – wooden pull; W. 62″, H. 31″, D. 32½″ (157, 79, 83 cm)

1247 Wood – pine; original finish – green and brown; original hardware – wooden pull; W. 66″, H. 30″, D. 36″ (168, 76, 91 cm)

1248 Wood – pine; original finish – red; W. 70″, H. 33″, D. 21″ (178, 84, 53 cm)

1249 Wood – pine; original finish – green; W. 74″, H. 32″, D. 25″ (188, 81, 63 cm)

1250 Wood – oak; original finish – grey; W. 16½″, H. 32″, D. 14½″ (42, 81, 37 cm)

1251 Wood – pine; original finish – red; W. 84″, H. 18½″, D. 14″ (213, 47, 36 cm)

1252 Wood – pine; original finish – burgundy with dark blue mouldings and multi-coloured decoration; original hardware – cast hinges, brass escutcheon; W. 42½″, H. 25½″, D. 21″ (108, 64, 53 cm)

1253 Wood – pine; original finish – burgundy with multi-coloured panels; original hardware – cast hinges, brass escutcheon; W. 40½″, H. 27½″, W. 25½″ (103, 70, 64 cm)

1254 Wood – pine; original finish – painted and decorated; original hardware – cast hinges, iron escutcheon; W. 44″, H. 26″, D. 21″ (112, 66, 53 cm)

1255 Wood – pine; original finish – painted and decorated; original hardware – cast hinges, iron escutcheon; W. 43½″, H. 27″, D. 21½″ (110, 69, 55 cm)

1256 Wood – pine; original finish – painted and decorated; original hardware – cast hinges, iron escutcheon; W. 43½″, H. 27″, D. 21″ (110, 69, 53 cm)

1257 Wood – pine; original finish – painted and grained; original hardware – cast hinges; W. 44″, H. 26″, D. 21″ (112, 66, 53 cm)

1258 Wood – pine; original finish – painted and grained; original hardware – cast hinges; W. 44″, H. 27″, D. 21″ (112, 69, 53 cm)

1259 Wood – pine; original finish – painted wood grain; presently overpainted; original hardware – wooden pulls, brass escutcheon; W. 42½″, H. 48″, D. 23″ (108, 122, 58 cm)

1260 Wood – ash; original finish – brown with muted decorations on ends; W. 20″, H. 26″, L. 36½″ (51, 66, 92 cm)

1261 Wood – pine; original finish – brown-red; W. 43″, H. 40″ (109, 102 cm)

1262 Wood – pine; original finish – green; original hardware – cast hinges; W. 45½″, H. 77″, D. 19″ (116, 196, 48 cm)

1263 Wood – pine; original finish – red-brown; original hardware – rolled hinges, brass escutcheons; W. 43″, H. 77½″, D. 17½″ (109, 197, 44 cm)

1264 Wood – pine; original finish – yellow-ochre; original hardware – cast hinges, brass pull and escutcheon; W. 36″, H. 64½″, D. 16″ (91, 164, 41 cm)

1265 Wood – pine; original finish – red; original hardware – cast hinges, wooden pull; W. 22″, H. 30″, D. 11½″ (56, 76, 29 cm)

1266 Wood – pine; original finish – red; original hardware – cast hinges, wooden turnbuckle; W. 13″, H. 18½″, D. 9½″ (33, 47, 24 cm)

1267 Wood – pine; original finish – paint; presently later overpaint and graining; W. 17½″, H. 31″, D. 6½″ (44, 79, 16 cm)

1268 Wood – pine; original finish – red; W. 17″, H. 27½″, D. 6″ (43, 70, 15 cm)

1269 Wood – pine; original finish – red; W. 16½″, H. 27″, D. 7″ (42, 69, 18 cm)

1270 Wood – pine; original finish – red; W. 16″, H. 9″ (41, 23 cm) (original backboard missing), D. 7½″ (19 cm)

1271 Wood – pine; original finish – dark green; W. 17″, H. 25″ (43, 63 cm)

1272 Wood – pine; original finish – red; W. 30″, H. 43″, D. 11″ (76, 109, 28 cm)

1273 Wood – pine; original finish – red; presently stripped; W. 30½″, H. 40½″, D. 15½″ (77, 103, 39 cm)

1274 Wood – pine; original finish – dark green; W. 26″, H. 25½″, D. 16″ (66, 65, 41 cm)

1275 Wood – hardwoods; original finish – brown; original seat – elm; W. 22″; H. 36″ (feet worn), D. 16″ (56, 91, 41 cm)

1276 Wood – pine and birch; original finish – brown; W. 19″, H. 34″, D. 18″ (48, 86, 46 cm)

1277 Wood – hardwoods; original finish – brown-black; original seat – elm; W. 18″, H. 36″, D. 14″ (44, 91, 36 cm)

1278 Wood – hardwoods; original finish – grey; original seat – leather; W. 18″, H. 39″, D. 13½″ (46, 99, 34 cm)

1279 Wood – hardwoods; original finish – red; original seats – elm; W. 16½″, H. 34½″, D. 13″ (42, 88, 33 cm) (approx.)

1280 Wood – oak; original finish – none; original seat – leather or elm (missing); W. 16″, H. 33½″, D. 14″ (41, 85, 14 cm)

1281 Wood – walnut; original finish – stain and varnish; original seat – upholstered; W. 17½″, H. 33″, D. 17″ (44, 84, 43 cm)

1282 Wood – figured maple and pine; original finish – stain and varnish; original hardware – cast hinges, wooden pulls, cast latches; W. 55″, H. 78″, D. 21″ (140, 198, 53 cm)

1283 Wood – pine; original finish – red; original hardware – cast hinges, wooden pulls, brass turnbuckles; W. 44″, H. 76″, D. 25″ (112, 193, 63 cm)

1284 Wood – pine; original finish – painted; original hardware – iron fische hinges, wooden turnbuckles; W. 48″, H. 72″, D. 16″ (122, 183, 41 cm) (approx.)

1285 Wood – pine; original finish – green; presently stripped; original hardware – forged rat-tail hinges, brass escutcheons, ceramic pulls; W. 49½″, H. 86″, D. 16″ (126, 218, 41 cm)

1286 Wood – pine; original finish – orange; original hardware – cast hinges, wooden pulls; W. 53″, H. 90″, D. 19″ (135, 229, 48 cm)

1287 Wood – pine; original finish – paint; presently stripped; original hardware – cast hinges, wooden pulls, iron turnbuckles, brass escutcheons; W. 48″, H. 52″, D. 21″ (122, 132, 53 cm)

1288 Wood – pine; original finish – painted wood grain; presently stripped; original hardware – cast hinges, ceramic pulls; W. 48″, H. 83″, D. 24″ (122, 211, 61 cm)

1289 Wood – pine; original finish – red; original hardware – wooden pulls; W. 58″, H. 56½″, D. 25½″ (147, 144, 64 cm)

1290 Wood – pine; original finish – stain with painted decoration; original hardware – cast hinges, iron lock

1291 Wood – pine; original finish – pale yellow; original hardware – wooden pulls, brass escutcheons; W. 46″, H. 32½″, D. 21″ (117, 83, 53 cm)

1292 Wood – pine and birch; original finish – red; original hardware – cast hinges; W. 48″, H. 28″, D. 29½″, 9½″ leaves (122, 71, 75 cm)

1293 Wood – pine; original finish – red; W. 29½″, H. 30″, L. 39″ (75, 76, 99 cm)

1294 Wood – pine and hardwoods; original finish – red; presently yellow overpaint; W. 72″, H. 31″, D. 21″ (183, 79, 53 cm)

1295 Wood – walnut; original finish – stain and varnish; W. 23″, H. 41″, D. 21″ (58, 104, 53 cm)

1296 Wood″pine seat and hardwoods; original finish – black; W. 24″, H. 42″, D. 20″ (61, 107, 51 cm)

1297 Wood – hardwoods; original finish – stain and varnish

1298 Wood – mahogany; original finish – stain and varnish; W. 20″, H. 36½″, D. 17″ (51, 93, 43 cm)

1299 Wood – mahogany; original finish – stain and varnish; W. 15½″, H. 32″, D. 18″ (39, 81, 46 cm)

1300 Wood – hardwoods; original finish – painted, grained and decorated; W. 20″, H. 41″, D. 15½″ (51, 104, 39 cm)

1301 Wood – cherry; original finish – stain and varnish; W. 17″, H. 27″ (43, 69 cm)

1302 Wood – burl maple and birch; original finish – stain and varnish; original hardware – forged latch; W. 26″, H. 28″ (66, 71 cm)

1303 Wood – mahogany, pine secondary; original finish – stain and varnish; original hardware – brass hinges, pulls and casters; W. 36½″, H. 29″, D. 18″ (93, 74, 46 cm)

1304 Wood – mahogany; original finish – stain and varnish; original hardware – brass pulls; W. 39″, H. 31″, D. 22½″ (99, 79, 57 cm)

1305 Wood – walnut; original finish – stain and varnish

1306 Wood – mahogany; original finish – stain and varnish; original hardware – brass pulls, escutcheons and gallery rail; W. 68½″, H. 37″, D. 30″ (174, 94, 76 cm)

1307 Wood – cherry; original finish – stain and varnish; original hardware – wooden pulls, brass escutcheons (bottom, brass pulls and hinges; top, ivory escutcheons); W. 43″, H. 86″, D. 21½″ (109, 218, 55 cm)

1308 Wood – mahogany, cherry secondary; original finish – stain and varnish; W. 84″, H. 34″, D. 26″ (213, 86, 66 cm)

1309 Wood – mahogany; original finish – stain and varnish; W. 64″, H. 34″, D. 26″ (163, 86, 66 cm)

1310 Wood – pine; original finish – painted rose-wood finish; original hardware – brass hinges and escutcheon; H. 85½″ (217 cm)

1311 Wood – walnut, pine secondary; original finish – stain and varnish; original hardware – brass hinges; H. 84″ (213 cm)

1312 Wood – pine; original finish – painted wood grain; original hardware – brass hinges and finial; H. 93″ (236 cm)

1313 Wood – pine; original finish – painted wood grain; original hardware – iron hinges, brass escutcheon; H. 86″ (218 cm)

1314 Wood – oak, mahogany crossbanding; original finish – stain and varnish; original hardware – brass hinges, rosettes and pull; H. 84″ (213 cm)

1315 Wood – walnut; original finish – stain and varnish; original hardware – brass pulls; W. 56″, H. 28″, D. 35½″ (142, 71, 90 cm)

1316 Wood – walnut and maple; original finish – stain and varnish; original hardware – wooden pulls

1317 H. 18¾″ (48 cm)

1318 Wood – oak; original finish – stain and varnish; H. 47″ (119 cm)

1319 Wood – cherry, figured maple, tulip wood secondary; original hardware – brass pulls and escutcheon; W. 39″, H. 47½″, D. 21″ (99, 121, 53 cm)

1320 Wood – mahogany; original finish – stain and varnish; original hardware – brass pulls and escutcheons; W. 39½", H. 41", D. 21" (100, 104, 53 cm)

1321 Wood – mahogany; original finish – stain and varnish; original hardware – brass casters; W. 69½", H. 38", D. 24" (177, 97, 61 cm)

1322 Wood – walnut; original finish – stain and varnish; original hardware – brass pull and escutcheon; W. 9½", H. 7", D. 5½" (24, 18, 14 cm)

1323 Wood – pine; original finish – painted decoration; W. 16¾", H. 6", D. 10" (43, 15, 25 cm)

1324 Wood – pine; original finish – gilt over gesso; W. 16½", H. 31" (42, 79 cm)

1325 Wood – walnut; original finish – stain and varnish; W. 12", H. 27" (30, 69 cm)

1326 Wood – pine; original finish – stain with ebonized split columns and gilt details; W. 11", H. 20½" (28, 52 cm)

1327 Wood – mahogany veneer; pine secondary; original finish – stain and varnish; W. 10¾", H. 20" (27, 51 cm)

1328 Wood – mahogany veneer, pine secondary; original finish – stain and varnish; W. 17¼", H. 31" (44, 79 cm)

1329 Wood – mahogany veneer, pine secondary; original finish – stain and varnish, ebonized quarter columns, stencilled decoration; W. 16½", H. 28½" (42, 72 cm)

1330 Wood – mahogany veneer, pine secondary; original finish – stain and varnish, ebonized split columns, stencilled decoration; W. 16½", H. 34½" (42, 88 cm)

1331 Wood – walnut veneer, pine secondary; original finish – stain and varnish, gilt split columns; W. 15", H. 25" (38, 64 cm)

1332 Wood – mahogany veneer, pine secondary; original finish – stain and varnish; W. 18¾", H. 32½" (48, 83 cm)

1333 Wood – oak, original finish – stain and varnish; W. 57", H. 25¼", D. 21¼" (146, 64, 54 cm); deterioration to feet

1334 Wood – oak, pine top (early replacement); original finish – stain and varnish; W. 47½", H. 30½", D. 21" (121, 77, 53 cm)

1335 Wood – oak; original finish – red paint stain; original hardware – forged iron handles, hinges, lock, escutcheon; W. 54", H. 23", D. 21" (137, 58, 53 cm)

1336 Wood – pine; original finish – black-green with red decoration; original hardware – forged iron handles, hinges and lock; W. 50", H. 19", D. 20" (127, 48, 51 cm)

1337 Wood – pine; original finish – painted and decorated; original hardware – cast iron hinges, forged iron handles, brass escutcheon; W. 38", H. 20", D. 20" (97, 51, 51 cm)

1338 Wood – pine; original finish – red; original hardware – forged iron handles and hinges; W. 52", H. 19", D. 18" (132, 48, 46 cm)

1339 Wood – uncertain; original finish – painted with stencilled decoration; original hardware – snipe hinges, forged iron lock, wire pull; W. 24", H. 16", D. 16" (61, 41, 41 cm)

1340 Wood – pine; original finish – painted and decorated; original hardware – snipe hinges, forged iron strapping and lock; W. 32", H. 15½", D. 20" (81, 39, 51 cm)

1341 Wood – pine; original finish – painted and decorated; original hardware – forged iron hinges, handles and lock; W. 53½", H. 26", D. 27½" (136, 66, 70 cm)

1342 Wood – pine; original finish – painted and decorated; original hardware – forged iron hinges, handles and lock; W. 42", H. 19", D. 22" (107, 48, 56 cm)

1343 Wood – pine; original finish – painted and decorated; original hardware – forged iron hinges and lock; W. 36½", H. 18½", D. 17½" (93, 47, 44 cm)

1344 Wood – oak; original finish – none; original hardware – forged iron hinges, handles, lock and strapping; W. 45½", H. 26½", D. 24" (116, 67, 61 cm)

1345 Wood – pine; original finish – painted and decorated; original hardware – forged iron hinges, lock, handles and escutcheon; W. 46", H. 28", D. 22" (117, 71, 56 cm)

1346 Wood – pine; original finish – red background with green and vermilion panels; forged iron hinges and lock; W. 48", H. 20", D. 23" (122, 51, 58 cm)

1347 Wood – oak; original finish – stain with red mouldings, abstract graining and floral decoration; original hardware – forged iron hinges, lock and escutcheon; W. 43", H. 21", D. 21" (109, 53, 53 cm)

Glossary of Terms

Upper Canadian furniture is in a unique position, standing as it does as one of three points on an influence triangle, with Britain and the Continent as the second and the United States as the third. Canadian furniture collectors, dealers and students have their own terminology, and this is equally true of Europe and the United States. Because of the many influences that bear on the body of Upper Canadian furniture, the terminology employed throughout this study and listed here in this glossary reflects a decision, perhaps an arbitrary one in some cases, to cull the best and most descriptive words from all three sources.

Acanthus Conventionalized leaf of Classical architecture, much used as a carved decoration on 17th and 18th century furniture.

Anthemion Ornament related to honeysuckle; much used in the Adam and Regency periods.

Apron Ornamental rail connecting tops of legs on tables and chairs, and bracket feet on chests.

Armoire French name, dating from the 16th century, for any large press or cupboard.

Astragal Small semicircular moulding, loosely descriptive of glazing bars of the late Georgian period.

Baluster Turned column, straight, spiral, vase-shaped, etc.

Banding Decorative border in inlay or marquetry contrasting in colour or grain with main surface.

Band-saw A reciprocating saw with a narrow flexible blade capable of cutting complex, curved elements according to a stencilled pattern.

Baroque Later (and more florid) version of Renaissance decoration; characterized by much ornamentation and curved rather than straight lines.

Beading Small moulding or incised detail of semicircular section.

Bevel A slanted cut on the edge of a board to reduce thickness.

Biedermier Style Mid-19th century German, essentially a heavy, solid variation of French Empire.

Blanket Rail A transverse rail between the foot posts of a bed (sometimes also the head posts) used for hanging a blanket.

Blind Door A solid door, usually panelled, used on a cupboard or dresser.

Blown and Fielded Panels Those having flat centres surrounded by bevelled edges.

Bracket Foot A two-piece support which may be mitred, dovetailed or butt-joined and cut from base moulding or attached separately.

Buffet A French term to describe a side or serving table.

Bun Foot A flattened ball foot introduced in the late 17th century.

Bureau A piece of furniture with the writing space or flap hinged so that it rests at an angle of 45° when closed. The space behind the flap has pigeonholes with small drawers below them. Often includes a bookcase with glazed or blind doors above.

Burl An abnormal protrusion on a tree caused by its attempt to cure a disease or cover a broken limb, producing various grain characteristics.

Butted or Butt-joined Formed by two boards simply joined with squared edges.

Butt Hinges Intended to be recessed into the edge of a door so that only a thin line of metal is visible externally.

Cabinetmaker A highly skilled and specialized maker of furniture whose craft was largely created and developed by the technique of veneering, introduced into England during the second half of the 17th century.

Cabriole The double curve on a furniture leg; the upper part swelling out, the lower swinging in

towards the foot.

Captain's Chair A low-backed Windsor characterized by ring legs, spindles and stretchers and a continuous U-shaped arm often surmounted by a crest rail on short spindles.

Carver Chair A rush-seated chair with turned legs that rise vertically above the seat to support spindle arms and to frame complex arrangements of spindles forming the back.

Caster Small, solid wheels of brass, iron, wood or ceramic, usually pivoted and screwed to the ends of chair and table legs, or the feet of case furniture.

Cat An 18th century trivet or plate stand.

Cavetto Concave moulding, quadrant of circle in profile, used prominently on cornices.

Chamfer Term for smoothed-off edge or bevelled angle.

Cleat A wooden member, either pinned, nailed or dovetailed at right angles to strengthen or secure butt-joined or tongue-and-grooved board surfaces as in table tops, desk lids, etc.

Cock-beading Small, half-rounded projecting moulding applied to the edges of drawers.

Corner Cupboard A free-standing, built-in or hanging cupboard made to fit the shape of a room's corner.

Cornice Top member of entablature – i.e., moulded projection surmounting frieze.

Court Cupboard Originally a sideboard with two open tiers and a pot board below; later a much larger press cupboard with doors below and a recessed superstructure containing two or three small cupboards.

Colonette A miniature column, circular or quadrangular, which may reproduce on a small scale the characteristics of one of the Classical orders.

Cove Moulding A large concave moulding used on the cornices of case furniture.

Crest Rail The top rail of chairs, sometimes decorated or carved.

Cricket Table A small, plain three-legged table.

Crossbanded A strip or band of decorative veneer, so called when cut across the grain.

Crotch-grained A grain characteristic accomplished by cutting with the intersection (or crotch) of a tree's major limbs.

Cupboard Originally a "board for cups"; later a generic term for all receptacles fitted with doors.

Cyma A reverse ogee, see Ogee.

Deal A general term for soft wood in board form.

Dentil Moulding of small rectangular blocks ("teeth"), with spaces between.

Dish Dresser A type of cabinet with open shelves above for the display of dishes and cupboards or drawers below.

Dovetailed A joint formed by a fan-shaped projection at the end of one member, fitting into a corresponding slot cut at the end of another. A cabinetmaker's technique.

Dowel A wooden peg used to join two pieces of wood; often used in place of mortise and tenon in machine-made furniture.

Dower Chest A chest made to commemorate or anticipate a wedding. Usually incorporating names and dates in its decoration.

Draw-Table An extending table with the top divided into three leaves, those at each end sliding under the centre leaf when the table is closed; when open, the centre leaf occupies the space left by drawing out the leaves.

Drop-leaf Table A table with one or two hinged leaves, supported when extended by hinged legs or arms.

Drum Table Supported on a pillar and tripod, with a deep circular top and drawers in the frieze. Also called a rent table.

Dry Sink A recessed tray usually above a closed cupboard to contain pans for dishwashing. Particularly associated with the Pennsylvania-German tradition.

Eastlake Style Named after Charles Locke Eastlake (1836-1906), furniture designer, who advocated a return to simple, joined construction.

Ebonized Stained black to imitate ebony.

Elizabethan A general term for English Renaissance architecture, decoration and furniture of the latter part of the 16th century.

Empire The style created by furniture-makers and decorators during the first French Empire in the early 19th century. In Canada the term is most often used relative to the American interpretation of these Neoclassical influences known as American Empire.

Entablature The horizontal upper part of an order of architecture supported by columns and consisting of an architrave, frieze and cornice.

Escutcheon The fitting over a keyhole or back of a handle.

Facia Architectural term for the slightly projecting flat band on an architrave.

Fancy Chair A family of chairs made in America influenced by the delicate painted chairs of the Sheraton period. Usually of Neoclassical style, painted and decorated with striping and stencils.

Feather Painting A technique of furniture decoration involving the use of a feather to create linear patterns, often imitating wood grain over a contrasting undercoat.

Federal Period The Classical revival in the United States which coincided with the rise of Federal government (1790-1810).

Finial Decorative knob ornament (various shapes) used at tops of rear chair posts, and also on tops of cabinets, clock cases, etc.

Fluting Concave grooves used particularly on friezes and columns.

Fraktür The Continental and Pennsylvania-German decorative and script tradition.

French Foot Curved foot similar in basic shape to the cabriole leg.

Fret Decorative pattern, either perforated or in solid.

Frieze Horizontal section below table tops and cornices of cabinets.

Gate-leg Table A table with drop leaves, supported by hinged gates when open.

Georgian A generally descriptive term for the characteristic architecture, interior decoration and furniture of the long Georgian period that began in 1714 and ended with the death of George IV in 1830.

Glazing Bars The narrow wooden members in windows, or the doors of a cupboard which frame the glass panes.

Gothic A revival of taste for medieval architecture begun in the middle years of the 18th century.

Greek Key Classical frieze ornament of repeated patterns of lines at right angles to one another.

Guilloche Ornament of interlaced circles or ovals.

Hackle A steel flax comb.

Highboy An American term (English, tallboy) used to describe a high chest of drawers.

Inlay A method of decorating a surface with various ornamental forms, cut into a wooden ground, with the cuts or grooves filled by other materials, either woods of different colours, or ivory, mother-of-pearl or metals.

Joiner A craft that evolved from that of the carpenter, the joiner specialized in joining pieces of wood together to make furniture and panelling.

Joint Stool A stool of joined construction with four turned legs, held by rails above and stretchers below.

Klismos A design invented by Greek designers about the 6th century B.C., it has concave legs that splay outward with uprights crossed by a shallow, concave back rest.

Lambs Tongue A simple stop detail for a chamfered corner which follows a cymo-curve from the full width of the chamfer to the point of the right angle resembling a tongue shape.

Lapped or **Lipped** Doors and drawers which overlap the frame, usually with a moulded edge.

Lozenge Diamond-shaped panel decoration.

Lowboy American term for a small dressing table with several drawers.

Marbling Descriptive term for the painting of wood to imitate the colour and characteristics of various marbles.

Marquetry A process similar to inlay, where floral patterns and arabesques are cut into a veneer, various woods and materials are then inlaid, so that veneer and inlaid ornamental pattern form one thin sheet.

Mortise Cavity in wood to take corresponding projecting tenon to form joint (hence "joined" furniture).

Mullion *See* Glazing Bars.

Neoclassical Term applied to revived Classical style and decoration in delicate form.

Ochre Pale brownish-yellow colour.

Ogee Moulding of waved form, convex above, concave below.

Ovolo Concave moulding of quarter-circle section.

Patera Round or oval disc decoration.

Pediment Classical triangular or scrolled member surmounting cornices of cabinets, etc.

Peg-top Table A table on which the top is secured to the base by removable pegs through the supporting cleats. A popular detail in several European traditions.

Pembroke Table A small, light table with a drawer or drawers below the top and two flaps which may be extended on hinged brackets.

Pilaster Flat column applied to case furniture, etc.

Pin A shaped wooden peg, usually hardwood, which is driven into a slightly smaller hole to secure a mortise and tenon joint.

Plinth Foundation of carcase; plinth (or spade) foot of tapered rectangular form used in Hepplewhite period.

Press A word of medieval origin, generally applicable to tall cupboards with doors and shelves for storing linen, clothes and kitchen utensils.

Prince of Wales Feather A decorative motif based on the three ostrich plumes that form the crest of the Prince of Wales.

Quarter Column Plain or detailed columns, the fourth part of a circle in diameter.

Queen Anne Style A term generally used to describe fashionable furniture made during the first two decades of the 18th century, which included the reign of Queen Anne. Characterized by the cabriole leg and curvilinear design.

Rail The horizontal members in panelled construction. Also applied to the horizontal members of a chair or table frame.

Rat-tail Hinge A two-part design in which the supporting male element is forged as a curved bracket with a pointed end and is applied to the face of a cupboard.

Rebate Rectangular channel cut along the edge of a piece of wood or framework to receive another piece of material, producing a housed joint.

Reeding Convex raised ornament (opposite of fluting).

Regency Style Description used for furniture fashionable in England when George, Prince of Wales, was Regent from 1811 to 1820. Partially derived from Greek revival, Classical and Egyptian ornament.

Reliquary A receptacle for relics.

Renaissance The revival of interest in the learning, art and architecture of Graeco-Roman civilization that began in 15th century Italy, reaching England in the 16th century, with a marked effect on architectural design.

Rococo Form of style and decoration succeeding Baroque and using "C" and "S" scrolls.

Roundel A term generally applied to carved ornament that occupied a circular space, and includes paterae, plaques and medallions with traditional geometric motifs.

Rule Joint Formed by matching a straight and concave moulded edge of a fixed table top with a straight and convex edge of a table leaf.

Sabre Leg A concave chair leg of rectangular section that resembles the curve of a cavalry sabre.

Sawbuck Table A traditional design in which the table top is supported on X-shaped trestles at either end.

Settle A long bench with arms and a back of varying height that accommodates several people.

Shoe Foot A shaped horizontal element used to raise chests or cupboards from the floor.

Show Wood The exposed parts of a wooden frame on an upholstered chair.

Skirt A horizontal strip of wood below the lowest member of the framework of a chest or cabinet.

Smoke Graining A decorative technique achieved by passing a lighted candle over partially dry varnish applied to an undercoat of light paint.

Snake Foot The S-curved leg with a thin ankle which broadens to a shaped foot not unlike the head of a snake used on tripod tables from the early 18th century.

Snipe Hinge Wire or staple hinge. Found on early storage chests and boxes.

Splat Flat central vertical member in a chair back.

Spline A flat key or strip of wood fitting into lengthwise grooves to join boards as in a table top.

Stile Piece of upright wood joining the framework of a piece of furniture.

Stretcher Cross pieces or rungs connecting legs of tables, chairs, etc.

String Inlay A thin line of inlay.

Tenon *See* Mortise.

Tester A flat wooden canopy over a bedstead.

Tongue-and-groove A joint of two boards made by slotting the edge of one and narrowing the edge of the other to fit into it. Used on table tops.

Trafalgar Chairs (also called Waterloo) Various types of single and elbow chairs with nautical symbols such as anchors and coiled ropes made after the Battle of Trafalgar in 1805.

Trestle Connecting and stabilizing supports for tables.

Trompe l'oeil A painting that creates a strong illusion of reality.

Turnbuckle A shaped bar on a central pin used to fasten doors.

Turner A craftsman whose furniture is characterized by dowelled, sometimes pegged joints, rather than the mortise and tenon technique of the joiner.

Umber A dark brown colour.

Vermilion A brilliant red colour, made by grinding cinnabar.

Veneer To veneer is to apply a thin sheet of decorative wood to another surface, which is not necessarily the same material. The veneer is a skin held in place by glue.

Viridian Veronese green.

Windsor Chair A generic name for chairs and seats of stick construction with turned spindles socketed into solid wooden seats to form backs, legs and arms.

Acknowledgments

For permission to reproduce photographs of the furniture in their possession, grateful acknowledgment is made to the following:

Adam Haynes Antiques; Mr. & Mrs. A. Armstrong; Miss Jean Armstrong; Mr. and Mrs. Randel Arthur; Mr. & Mrs. A. Baker; Mr. & Mrs. G. Baker; Mr. G. Ball; Mr. R. J. Barr; Mr. & Mrs. B. Beaton; Shiela Bell; Dr. & Mrs. P. Bell; Mr. & Mrs. C. Benson; Mr. Michael Bird; Mr. & Mrs. D. Bird; Mr. & Mrs. F. Blaney; Mr. & Mrs. J. Bos; Mr. E. Boyagian; Mrs. E. Bowlby; Mrs. M. Bowles; Mr. & Mrs. M. Bramham; Mr. W. Brebner; Mr. & Mrs. R. Brilinger; Dr. & Mrs. J. Brisley; Mr. & Mrs. R. Brooks; Mrs. G. Brookes; Mr. & Mrs. K. Burgin; Mr. & Mrs. R. Burkhardt; Mr. & Mrs. Clarence Byington; Mr. Paul Byington; Dr. & Mrs. N. Cameron; Miss E. Carlyle; Miss D. Carson; Mr. & Mrs. R. Cascaden; Dr. & Mrs. D. Chambers; Ms. C. Christie; Dr. & Mrs. P. Clarke; Clay Benson Antiques; Mr. & Mrs. G. Clemens; Mr. & Mrs. S. Cline; Cottage Antiques; Dr. & Mrs. C. Danby; Mr. Ed. Davis; Mr. G. Dingman; Mr. & Mrs. L. Donaldson; Mr. J. Drenter; Mr. & Mrs. M. Dunn; Mr. & Mrs. A. Emerson; Mr. & Mrs. G. Eskarod; Mr. & Mrs. M. F. Feheley; Dr. & Mrs. A. Fell; Dr. & Mrs. R. G. Ferguson; Mrs. J. Flannigan; Mr. Larry Foster; G. B. Garlatti Antiques; Mr. B. Gates; Mr. & Mrs. A. Gerbrandt; Dr. & Mrs. A. Good; Dr. & Mrs. A. Grant; Mr. & Mrs. H. Grass; Mrs. A. Griffith; Mr. & Mrs. J. Hague; Mr. & Mrs. John Harbinson; Mr. & Mrs. E. Harris; Mr. & Mrs. Rick Henemader; Dr. & Mrs. J. Hiscock; Mr. Barclay Holmes; Mrs. H. Howell; Mr. & Mrs. R. Howard; Rev. D. Howsen; Mr. & Mrs. C. Humber; Dr. & Mrs. B. Hutchison; Mrs. C. C. Inderwick; Mr. & Mrs. C. Ingram; Mrs. J. Innes; Mr. & Mrs. T. Jenkins; Mr. & Mrs. S. Johannesen; Mr. D. Kaufman; Mr. & Mrs. D. Kennedy; Mr. & Mrs. J. Kerr; Mrs. Terry Kobayashi; Mr. & Mrs. R. Lambert; Mrs. M. Larmon; Mr. & Mrs. H. Larson; Mr. & Mrs. L. Leidens; Mr. & Mrs. E. Locke; Mr. & Mrs. A. Luke; Mr. & Mrs. C. Lumley; Miss J. Lyall; Dr. & Mrs. B. Lyn, Mrs. K. MacKay; Mr. & Mrs. S. MacLacklan; Dr. & Mrs. D. H. MacLennon; Mr. & Mrs. P. Manley; Mr. & Mrs. A. Mardon; Mr. & Mrs. K. Martin; Dr. & Mrs. J. L. McCans; Miss H. McCuaig; Dr.& Mrs. J. McCullock; Mr. & Mrs. I. McDiarmid; Mr. & Mrs. B. McKendry; Ms. Jennifer McKendry; Mr. & Mrs. L. McMurray; Mr. & Mrs. R. Meickljohn; Dr. & Mrs. R. Merritt; Mr. & Mrs. Milberg; Mr. & Mrs. P. Miller; Mr. & Mrs. J. Morlock; Dr. & Mrs. S. Munro; Mr. & Mrs. R. Nixon; Mr. & Mrs. R. O'Hara; Mr. & Mrs. R. O'Neil; Mrs. L. M. Pain; Mr. & Mrs. D. Palmer; Patricia Price Antiques; Mr. & Mrs. J. W. Pearse; Miss J. Pemberton; Mr. & Mrs. R. G. Perkins; Mr. D. Pero; Mr. & Mrs. M. Philip; Mr. & Mrs. T. Potter; Dr. & Mrs. R. Price; Mrs. M. Rae; Ms. Myrtle Reeve; R. G. Perkins Antiques; Mr. & Mrs. D. Ripley; Mr. & Mrs. L. Rombough; Mr. & Mrs. M. Rowan; Mr. J. Russell; Rutter Collection; Mr. & Mrs. F. Ryan; Mr. & Mrs. W. Schlomb; Mr. & Mrs. M. Shakespeare; Mr. L. Shaver; Mr. & Mrs. W. Siegel; Mr. & Mrs. R. Simpson; Mr. & Mrs. V. Smart; Mr. Paul Smith; Mr. & Mrs. N. Snider; Mr. & Mrs. L. Stacey; Mr. & Mrs. C. Stanton; Mr. & Mrs. R. Starr; Mr. & Mrs. Ted Stewart; Mr. & Mrs. A. Stuart; Mr. & Mrs. R. Symes; Mrs. Vera Taylor; Mr. & Mrs. D. Teakle; Mrs. J. Teather; Mr. & Mrs. W. Thompson; Mr. & Mrs. J. Townshend; Mr. & Mrs. N. Treanor; Mr. & Mrs. B. Turner; Mr. & Mrs. D. Twilley; Mr. D. Tyrer; Mr. & Mrs. G. Vosper; Mr & Mrs. M. Walton; Dr. Walton-Ball; Mr. & Mrs. R. B. West; Mr. P. White; Mr. & Mrs. Ted Williams; Mr. & Mrs. A. Wilson; Mr. John J. Wine; Ms. J. Woods; Mrs. D. Young; Mr. Robert Young.

Acknowledgment is also made to the following museums in Ontario, the United States and Europe for permission to reproduce photographs of material in their collections. The abbreviations that follow the names listed below have been used in the captions to the plates to identify the owners.

The abbreviation P.C. indicates Private Collection.

Ontario

The Allan Macpherson House, Napanee [L & A.C.M.]

Archibald A. Campbell Memorial Museum (Matheson House), Perth [P.M.]

Black Creek Pioneer Village, Downsview [B.C.P.V.]

Canadiana Collection, Royal Ontario Museum, Toronto [C.D., R.O.M.]

Centre of Folk Culture Studies, National Museum of Man, Ottawa [C.F.C.S., M.O.M., N.M.O.C.]

Fryfogel Inn Collection, Shakespeare, Ontario [F.I.C.]

Glengarry County Museum, Dunvegan [G.C.M.]

The Grange, Toronto [G.C., A.G.O.]

Hastings County Museum, Belleville [H.C.M.]; Corby Collection [C.C.]

Historical, Naval and Military Establishments, Penetanguishene [H.N. & M.E.P.]

Jordan Historical Museum of the Twenty, Jordan [J.M.O.T.T.]

Lennox and Addington County Museum, Napanee [L & A.C.M.]

Lewis Bradley Pioneer Museum, Mississauga [C.M.R.P.D, M.H.F.]

Markham District Historical Museum, Markham [M.D.H.M.]

McLaughlin Woodwork Museum, Kingston [M.W.M.]

Montgomery's Inn, Toronto [M.I.C.]

National Historic Sites, Fort George [N.H.S., F.G.]

Niagara Historical Society Museum, Niagara-on-the-Lake [N.H.S.M.]

Niagara Parks Commission, Battlefield House, Stoney Creek [N.P.C., B.H., S.C.]

Scugog Shores Historical Museum, Port Perry [S.S.H.M.]

Upper Canada Village, Morrisburg [U.C.V.]

The United States

Greenfield Village and Henry Ford Museum, Dearborn, Michigan [G.V. & H.F.M.]

Historic Deerfield, Inc., Deerfield, Massachusetts [H.D.I.]

Pennsylvania Farm Museum of Landis Valley [P.F.M.O.L.V.]

William Penn Memorial Museum, Harrisburg, Pennsylvania [W.P.M.M.H.]

Europe

Geffrye Museum, London, England [G.M.]

Victoria and Albert Museum, London, England [V. & A.]

National Museum of Ireland, Dublin, Ireland [N.M.O.I.]

Ulster Folk and Transport Museum, Northern Ireland [U.F.T.M.]

National Museum of Antiquities of Scotland, Edinburgh [N.M.O.A.O.S.]

Germanisches Nationalmuseum, Nürnberg, Germany [G.N.]

Heimatmuseum-Stadtchronik-Villingen-Schwenningen, Germany [H.S.V.S.]

Tauberlander-Dorfmuseum, Weikersheim, Germany [T.D.W.]

Musée Alsacien de Strasbourg, France [M.A.D.S.]

Schiez Landesmuseum, Zürich, Switzerland [S.L.]

Ethnographical Museum, Toruń, Poland [E.M.T.]

Museum Kasubskie, Kartuzy, Poland [M.K.K.]

Planstwows Ethnographical Museum, Warsaw, Poland [P.M.E.]

Bibliography

Furniture

ANDREWS, EDWARD DEMING, and FAITH ANDREWS. *Shaker Furniture: The Craftsmanship of an American Communal Sect.* New York: Dover Publications, 1950.

BECK, DOREEN. *A Book of American Furniture.* London: The Hamlyn Publishing Group, 1973.

BISHOP, ROBERT. *Centuries and Styles of the American Chair, 1640-1970.* New York: E. P. Dutton and Co., 1972.

BLACHOWSKI, ALEKSANDER. *Dawne Meble Ludowe Polnocnej Polski* [Country Furniture of Northern Poland]. Toruń: Ethnographic Museum, 1976.

BURROWS, G. EDMOND. *Canadian Clocks and Clockworks.* Oshawa, Ontario: Kalabi Enterprises, 1973.

BUTLER, JOSEPH T. *American Furniture.* London: Triune Books, 1973.

CHIPPENDALE, THOMAS. *The Gentleman and Cabinet-Maker's Directory.* London, 1754.

COMSTOCK, HELEN. *American Furniture: Seventeenth, Eighteenth, and Nineteenth Century Styles.* New York: The Viking Press, 1962.

DAVIDSON, MARSHALL B. *The American Heritage History of Colonial Antiques.* New York: American Heritage Publishing Co., 1967.

DENEKE, BERNWARD. *Bauernmöbel: Ein Handbuch für Sammler und Liebhaber.* München: Keysersche Verlagsbuchhandlung, 1969.

DOBSON, HENRY, and BARBARA DOBSON. *The Early Furniture of Ontario and the Atlantic Provinces.* Toronto: M. F. Feheley Publishers, 1974.

DOLZ, RENATE. *Bauernmöbel.* München: Wilhelm Heyne Verlag, 1972.

EASTLAKE, CHARLES L. *Hints on Household Taste in Furniture, Upholstery and Other Details.* New York: Dover Publications, 1969.

FALES, DEAN A., JR. *American Painted Furniture, 1660-1880.* New York: E. P. Dutton and Co., 1972.

—————. *Essex County Furniture.* Salem, Mass.: Essex Institute, 1965.

—————. *The Furniture of Historic Deerfield.* New York: E. P. Dutton and Co., 1976.

GLOAG, JOHN. *A Short Dictionary of Furniture.* London: George Allen and Unwin, 1952.

HALL, JOHN. *The Cabinet-Maker's Assistant.* Baltimore, Md., 1840.

HARRIS, JOHN. *Regency Furniture Designs, 1803-1826.* London: Alec Tiranti, 1961.

HARRISON, JOHN K. *A History of English Furniture.* London: Mills and Boon, 1972.

HEPPLEWHITE, GEORGE. *Cabinet-Maker and Upholsterer's Guide.* London, 1788.

HOPE, THOMAS. *Household Furniture and Decoration.* London, 1807.

HORNUNG, CLARENCE P. *Treasury of American Design.* New York: Harry N. Abrams, 1950.

JOY, EDWARD T. *The Country Life Book of English Furniture.* London: Country Life, 1964.

—————. *Furniture.* New York: Hearst Books, 1972.

—————., and Geoffrey Wills. *The Collector's Book of English Antiques.* South Brunswick and New York: A. S. Barnes and Co., [1965].

KETTELL, RUSSELL H. *The Pine Furniture of Early New England.* New York: Doubleday, Doran & Co., 1929.

KIRK, JOHN T. *Early American Furniture: How to Recognize, Buy, and Care for the Most Beautiful Pieces – High Style, Country, Primitive, and Rustic.* New York: Alfred A. Knopf, 1970.

KOVEL, RALPH, and TERRY KOVEL. *American Country Furniture, 1780-1875.* New York: Crown Publishers, 1965.

LOUDON, J. C. *Encyclopaedia of Cottage, Farm and Villa Architecture and Furniture.* London, 1833.

LIPMAN, JEAN. *Techniques in American Folk Decoration.* New York: Dover Publications, 1951.

LYON, IRVING W. *The Colonial Furniture of New England.* New York: E. P. Dutton and Co., 1977.

McMURRAY, ALLAN LYNN. "Wilno Furniture." *Canadian Collector* (November/December, 1975), pp. 10-16.

MERCER, HENRY C. *Ancient Carpenters' Tools.* [n. pl.]: Bucks County Historical Society, 1975.

MILLER, EDGAR G., JR. *American Antique Furniture.* 2 vols. New York: Dover Publications, 1966.

MINHINNICK, JEANNE. *At Home in Upper Canada.* Toronto: Clarke, Irwin & Co., 1970.

MONTGOMERY, CHARLES F. *American Furniture: The Federal Period, 1785-1825.* New York: The Viking Press, 1966.

NUTTING, WALLACE. *Furniture of the Pilgrim Century.* Framingham, Mass.: Old American Co., 1921-1924.

—————. *Furniture Treasury.* 2 vols. New York: The Macmillan Co., 1928.

OLIVER, LUCILE. *Mobilier Alsacien.* Paris: Editions Ch. Massin, [1965].

ORMSBEE, THOMAS H. *Field Guide to Early American Furniture.* Boston: Little, Brown and Co., 1952.

PALARDY, JEAN. *The Furniture of French Canada.* Toronto: Macmillan Co. of Canada, 1963.

PRAZ, MARIO. *An Illustrated History of Furnishing from the Renaissance to the 20th Century.* New York: George Braziller, 1964.

RITZ, GISLAND M. *The Art of Painted Furniture.* Toronto: Van Nostrand Reinhold, 1970.

SACK, ALBERT. *Fine Points of Early American Furniture.* New York: Crown Publishers, 1950.

SHACKLETON, PHILIP. *The Furniture of Old Ontario.* Toronto: Macmillan Co. of Canada, 1973.

SCHIFFER, MARGARET BERWIND. *Furniture and Its Makers of Chester County, Pennsylvania.* Philadelphia: University of Pennsylvania Press, 1966.

SHERATON, THOMAS. *Cabinet-Maker and Upholsterer's Drawing Book.* London, 1791-1794.

SMITH, GEORGE. *The Cabinet-Maker and Upholsterer's Guide: Being a Complete Drawing Book.* London: Jones & Co., 1826.

—————. *A Collection of Designs for Household Furniture.* London, 1808.

STEVENS, GERALD. *In a Canadian Attic.* Toronto: Ryerson Press, 1963.

STOUDT, JOHN JOSEPH. *Early Pennsylvania Arts and Crafts.* New York: A. S. Barnes and Company, 1964.

TOLLER, JANE. *English Country Furniture.* Cranbury, N.J.: A. S. Barnes & Co., 1973.

WATSON, ALDREN A. *Country Furniture.* New York: New American Library, 1974.

WEBSTER, DONALD BLAKE, ed. *The Book of Canadian Antiques.* New York: McGraw-Hill Co., 1974.

YEAGER, WILLIAM. *The Cabinet Makers of Norfolk County.* Simcoe, Ontario: The Norfolk Historical Society, 1975.

History

BOVAY, E. H. *Le Canada et les Suisses, 1604-1974.* Suisse: Editions Universitaires Fribourg, 1976.

BROWN, WALLACE. *The King's Friends.* Providence, R.I.: Yale University Press, 1966.

BURNET, JEAN R. *Ethnic Groups in Upper Canada.* [Toronto]: Ontario Historical Society, 1972.

COFFMAN, BARBARA F. "Some Early Industries at the Twenty." *Canadian German Folklore.* [Waterloo]: Pennsylvania Folklore Society, 1961.

COWAN, HELEN I. *British Immigration Before Confederation.* The Canadian Historical Association, Historical Booklet No. 22, Ottawa, 1968.

CRAIG, GERALD M. *Upper Canada: The Formative Years.* Toronto: McClelland and Stewart, 1963.

CRUIKSHANK, E. A., ed. *The Correspondence of Lieut. Governor John Graves Simcoe, with Allied Documents Relating to His Administration of the Government of Upper Canada.* 5 vols. Toronto: Ontario Historical Society, 1923-1931.

DAVIES, BLODWEN. *A String of Amber: The Story of the Mennonites in Canada.* Vancouver: Mitchell Press, 1973.

DUNHAM, MABEL. *The Trail of the Conestoga.* Toronto: McClelland and Stewart, 1942.

EPP, FRANK H. *Mennonites in Canada: The History of a Separate People.* Toronto: Macmillan Co. of Canada, 1974.

EVANS, E. ESTYN. *Irish Folk Ways.* Boston: Routledge and Kegan, 1961.

FIRTH, EDITH G., ed. *The Town of York, 1815-1834.* Toronto: The Champlain Society, 1966.

FROESCHE, HARTMUT, ed. *German-Canadian Yearbook.* 3 vols. Toronto: Historical Society of Mecklenburg, Upper Canada, 1976.

GUILLET, EDWIN C. *Pioneer Settlements in Upper Canada.* Toronto: University of Toronto Press, 1933.

HENRY, GEORGE. *The Emigrant's Guide, Or Canada as It Is.* Quebec: William Gray & Co., [183-?].

INNIS, MARY QUAYLE, ed. *Mrs. Simcoe's Diary.* Toronto: Macmillan Co. of Canada, 1965.

JOHNSON, J. K., ed. *Historical Essays on Upper Canada.* Toronto: McClelland and Stewart, 1975.

JOHNSON, J. K., ed. *Loyalist Narratives from Upper Canada.* Toronto: University of Toronto Press, 1946.

KILBOURN, WILLIAM. *The Firebrand: William Lyon Mackenzie and the Rebellion in Upper Canada.* Toronto: Clarke, Irwin & Co., 1956.

LANGTON, W. A., ed. *Early Days in Upper Canada: Letters of John Langton from the Backwoods of Upper Canada and the Audit Office of the Province of Canada.* Toronto: Macmillan Co. of Canada, 1926.

RADCLIFF, THOMAS, ed. *Authentic Letters from Upper Canada.* Toronto: Macmillan Co. of Canada, 1953.

REAMAN, G. ELMORE. *The Trail of the Black Walnut.* Toronto: McClelland and Stewart, 1957.

SCHAUS, LLOYD H. "By-Passing Pennsylvania." *Canadian German Folklore,* I (1961).

TRAILL, CATHERINE PARR. *The Canadian Settler's Guide.* Toronto, 1855.

Index

Numbers given in ordinary type refer to pages, those that are italicized indicate plates.